Ninth Edition

AN INTRODUCTION TO

MUSIC AND ART

IN THE WESTERN WORLD

Ninth Edition

AN INTRODUCTION TO
MUSIC AND ART

IN THE WESTERN WORLD

Milo Wold
Linfield College, Emeritus

Gary Martin
University of Oregon

James Miller
University of Oregon

Edmund Cykler
deceased

 Wm. C. Brown Publishers

Book Team

Editor *Meredith M. Morgan*
Developmental Editor *Dean Robbins*
Production Editor *Reneé Menne*
Art Editor *Jess Schaal*
Photo Editor *Mary Roussel*
Permissions Editor *Karen L. Storlie*
Visuals Processor *Andreâ Lopez-Meyer*

WCB Wm. C. Brown Publishers

President *G. Franklin Lewis*
Vice President, Publisher *George Wm. Bergquist*
Vice President, Publisher *Thomas E. Doran*
Vice President, Operations and Production *Beverly Kolz*
National Sales Manager *Virginia S. Moffat*
Advertising Manager *Ann M. Knepper*
Marketing Manager *Kathleen Nietzke*
Managing Editor, Production *Colleen A. Yonda*
Production Editorial Manager *Ann Fuerste*
Production Editorial Manager *Julie A. Kennedy*
Publishing Services Manager *Karen J. Slaght*
Manager of Visuals and Design *Faye M. Schilling*

Cover photo by Marc Chagall, *Snowing*, 1939. Gouache on cardboard, 26½″ × 20¼″. The Saint Louis Art Museum—Museum purchase.

Cover design by Carolyn St. George
Text Art 1.1, 3.1, and 4.1 by Alice Thiede
Figures 3.6 and 4.1 by McCullough Graphics

CONTENTS

FIGURES

COLORPLATES

(Colorplates follow page numbers listed.) xiii

MUSICAL EXAMPLES

PREFACE

More than thirty years have passed since the first edition of this book was published. The technical media, including television, sound recordings, and radio broadcasting, have become so highly developed that scarcely anyone anywhere is without music of all periods and types. Rapid communication and transportation as well as reproduction techniques have also brought visual artworks to the public or the public to the artworks, and have made all forms of art available to everyone. As a result, we have been inundated with music and art as never before. As in the past, the art-consuming public will "winnow the wheat from the chaff." The examples of past traditions should help us in this task so that not only future generations might benefit from our selection but might recognize and enjoy the best works of contemporary artists in all varieties of style. The perspective of time will prove our choices right or wrong.

In order to make some sense of the present age, it was necessary to divide the twentieth century into two chapters. Without the perspective of time it is difficult to decide among works, styles, and trends. The last chapter should challenge readers to compare lasting and significant art with the plethora of pseudoart that surrounds us.

This book is not intended as a history of the fine arts or as a history of music. It is an introduction to the stylistic character and cultural climate of the important art epochs of Western civilization. In addition, it attempts to show how the various arts reflected the same sociocultural conditions and how each art is related to the others in the patterns of cultural history.

Many examples of representative works of music and art have been included in this text. However, for true familiarity with music and art, additional examples of each should be sought out for further study and enjoyment. Readers are urged to supplement the text's illustrations of painting, sculpture, and architecture with inexpensive prints available from most bookstores.

In this ninth edition, there is a substantial increase in the number of color reproductions and an updating of black and white prints. In some cases, visual representations of musical compositions have been added to assist those who are not able to read musical notation.

Each chapter includes a pronunciation guide, study objectives, terms in boldface, a summary, and suggested readings. Many chapters begin with a chronology of people and events. The glossary includes both art and music terms which are bold-faced within the chapters the first time they appear.

At the suggestion of professors and students, some of the more technical musical analyses have been revised. The Instructor's Manual also features additional musical and visual sources and suggested examples for further analysis along with a Test Item File containing over 500 questions including multiple choice, true/false, matching, and essay questions.

Acknowledgments

We are deeply indebted to our many colleagues and friends who have given their time and knowledge to assist in various ways. A special word of appreciation is due to those colleagues in numerous colleges and universities who have used the material in their classrooms and have offered constructive criticism and suggestions.

List of Reviewers

Thomas Atwater
LaMar Barrus
H. Kenneth Benjamin
W. M. Brown
Leland Chou
Dee M. Connett
Jamie L. Connors
William Ellis
Eloy Fominaya
Dudley E. Foster, Jr.
Gerhard W. Franzmann
D. E. Hill
Lawrence Horn
James S. Horner
Marion B. Howe
James A. Jarrell
Wallace N. Johnson
Dale A. Jorgenson

A. D. Macklin
Helen Trotter Midkiff
Shirley M. Mihok
Lois Muyskens
Ronald W. Phillips
Joseph Sabatella
Andrea H. Savage
Orville H. Schanz
Dan M. Schultz
JoAnn M. Soloski
Willametta Spencer
Donald Walpole
Frederick W. Westphal
Robert A. Whisnant
Warren W. Whitney
Jan Helmut Wubbena
Louis A. Zona

GENERAL READINGS

Arnold, Denis, ed. *The New Oxford Companion to Music.* 2 vols. New York: Oxford Press, 1983.

Bowers, Jane, and Tick, Judith, eds. *Women Making Music.* Chicago: University of Illinois Press, 1986.

Byrnside, Ronald L. *Music: Sound and Sense.* Dubuque, Ia.: Wm. C. Brown Publishers, 1985.

Clark, Kenneth. *Looking at Pictures.* New York: Holt, Rinehart & Winston, 1960.

Dallin, Leon. *Listener's Guide to Musical Understanding.* 6th ed. Dubuque, Ia.: Wm. C. Brown Publishers, 1986.

De la Croix, Horst, and Tansey, Richard G. *Gardner's Art through the Ages.* 7th ed. New York: Harcourt Brace Jovanovich, 1980.

Ferris, Jean. *Music: The Art of Listening.* Dubuque, Ia.: Wm. C. Brown Publishers, 1985.

Fleming, William. *Arts and Ideas.* 7th ed. New York: Holt, Rinehart & Winston 1986.

Grout, D. J. *A History of Western Music.* 3d ed. New York: W. W. Norton, 1980.

Harris, A. S. *Women Artists: 1550–1950.* New York: Knopf, 1977.

Hartt, Frederick. *Art, a History of Painting, Sculpture, and Architecture.* 2 vols. Englewood Cliffs, N.J.: Prentice-Hall, 1985.

Janson, H. W. *History of Art.* 3d ed. Englewood Cliffs, N.J.: Prentice-Hall, 1986.

Kostof, Spiro.*A History of Architecture: Settings and Rituals.* New York: Oxford University Press, 1985.

Lamm, Robert C.; Cross, Neal M.; and Turk, Rudy H. *The Search for Personal Freedom.* 7th ed. 2 vols. Dubuque, Ia.: Wm. C. Brown Publishers, 1984.

Lang, Paul Henry. *Music in Western Civilization.* New York: W. W. Norton, 1940.

Machlis, Joseph. *The Enjoyment of Music.* 5th ed. New York: W. W. Norton, 1984.

Pevsner, Nikolaus. *An Outline of European Architecture.* Baltimore: Penguin Books, 1950.

Phipps, Richard, and Wink, Richard. *Invitation to the Gallery.* Dubuque, Ia.: Wm. C. Brown Publishers, 1987.

Pierce, J. *From Abacus to Zeus: A Handbook of Art History.* Englewood Cliffs, N.J.: Prentice-Hall, 1968.

Randel, Don M., ed. *The New Harvard Dictionary of Music.* Cambridge, Mass.: Harvard University Press, 1986.

Sadie, Stanley, ed. *The New Grove Dictionary of Music and Musicians.* 6th ed. 20 vols. New York: Macmillan, 1980.

Trachtenberg, Marvin, and Hyman, Isabelle. *Architecture: From Prehistory to Post-Modernism, The Western Tradition.* Englewood Cliffs, N.J.: Prentice-Hall, 1986.

Wold, Milo; Martin, Gary; Miller, James; and Cykler, Edmund. *An Outline History of Western Music.* 7th ed. Dubuque, Ia.: Wm. C. Brown Company Publishers, 1990.

KEY TO PRONUNCIATION

Vowels

ay = a in rate

a = a in rat

ah = a in rah

aw = aw in raw

e = e in red

ee = e in be

i = i in rid

ih = i in ride

o = o in rot

oh = o in rote

oo = oo in root

ow = ow in now

oy = oy in toy

u = u in rut

yoo = u in mute

ü = German ü

oe = German oe

Consonants

B,D,F,H,K,L,M,N,P,R,T,V,W,Z as in English

g = g in go

s = s in so

ch = ch in check

sh = sh in shut

zh = z in azure

th = th in thin

kh = ch in Scottish loch.

The breve mark (ˇ) over a vowel denotes a nasal sound; i.e., ă = a in bang, ŏ = o in song

The acute (´) mark designates the accented syllable when there is a stress accent.

1
THE ARTS AND SOCIETY

Pronunciation Guide

Bach (Bakh)
Beethoven (Bay'-toh-ven)
Boucher (Boo-shay)
Dali (Dah-lee)
Debussy (Deh-byoo-see)
Esterházy (Es'-ter-hah-zee)
Goya (Goy'-yah)

Handel (Han'dle)
Haydn (High-dn)
Mozart (Moh'-tsahrt)
Picasso (Pee-kah'-soh)
Vinci, Leonardo da (Veen'-chee,
　Lay-oh-nahr'-doh dah)
Wagner (Vahg'-ner)

Study Objectives

1. To explore how the arts are the result of the dominant sociocultural climate of any particular art epoch.
2. To learn to understand the arts through study and direct experience.

This book is intended to correlate music and art with history and to provide a useful understanding of the meaning of the arts. Specifically, it has three basic aims: (1) to develop a breadth of understanding and appreciation of the cultural patterns of the Western world; (2) to develop insight into actual works of music and art; and (3) to develop techniques of critical analysis for evaluating and judging works of art. It is in no sense a history of music or a history of the fine arts. Its aim is to introduce the various kinds and periods of art with the hope that the reader will be encouraged to seek more aesthetic experiences.

One of the dangers to democratic society is the lowering of its values by the very means that have made its existence possible, namely, mass education, mass communication, and mass production. At no time in history have the humanities been challenged more than now, and it is this problem of values with which the fields of literature, philosophy, and the arts deal.

The recent resurgence of interest in the humanities has focused on the study of the arts as a means of broadening our understanding of the heritage of the past and the exigencies of the present. This emphasis has also focused attention on the problem of correlating music and art in the pattern of cultural history on a level that takes into consideration the nonprofessional person's technical knowledge and experience.

Sociocultural Aspects

Art, in any age, is the expression of the characteristic attitudes of the people of that age toward important aspects of life. The dominant class usually sets the cultural taste for the masses. This class usually is not the largest numerical group. More often than not it is the class that holds economic, political, or religious power and therefore imposes its likes and dislikes on the rest of society. Consequently, religious and social patterns often determine the function of music and art. For example, in an age when the Church is the principal social institution, the task confronting artists is that of expressing religious sentiments in harmony with the particular doctrine of the dominant religious group. Bach's *Passion According to St. Matthew* was written for the Lutheran church at Leipzig in the early eighteenth century. This great work is much more than a sincere expression of Bach's own spiritual devotion. It is a musical revelation of a literal acceptance of the doctrines and spiritual beliefs of the Lutheran church. Court life provides another illustration of the social fabric as a determining force in the function of art. In an age when courtly activity is prevalent, the artist's role is to create music and art for dancing and for other essentially social activities. Boucher's delicately molded nudes in playful poses represent the sensual spirit of the French Rococo court. *Eine kleine Nachtmusik*, a serenade by Mozart, is charming, graceful music for the gay social gatherings of Viennese court life.

The period immediately following World War II illustrates the strong effect of economics on the arts. There was tremendous buying power in the hands of youth, thanks to a growing economy and the advertising success of the mass media. As a result, the so-called pop culture emerged as a vital force in the business of art, especially in the United States. While the popular arts usually have limited lasting qualities, the pop culture movement may influence the artistic endeavors of other artists. The widely acclaimed musical *Mass* by Leonard Bernstein, for example, incorporates a number of elements from the rock music of the fifties and sixties.

In addition to the influence of the dominant group, the arts are affected by their inheritance from the past. Each cultural pattern leaves its mark on the following generation, and the artistic characteristics of any age are influenced in some degree by earlier traditions, and forms. Furthermore, the influence of one art on another is important in determining the artistic trends of a particular art. The music of Debussy, for example, reflects the influence of **Impressionism** in painting. The aesthetic theories and artistic ideals that control the destiny of one of the arts, such as literature or visual art, often exert the same kind of influence on the other arts. When artistic features coalesce to the degree that they are identifiable with a particular epoch, place, or individual, the result is known as a **style**. Consequently, style is that combination of characteristics that makes works of art recognizable for what they are.

In order to understand the sociocultural conditions from which art springs, we must look on history as something more than a chronicle of past events. History also describes the social, political, economic, religious, and artistic environment out of which grew music, painting, sculpture, and architecture. Each facet of history leaves its unmistakable imprint upon the role that art plays in an epoch and on the very character of art itself.

As the pattern of economic, political, spiritual, and intellectual life changes, so does the art pattern. The art of ancient Greece, for example, is very different from that of the Gothic period. An investigation of the dominant attitudes toward important aspects of life in these two periods reveals differences also found in their art. The study of Greek social and intellectual life will enhance our understanding of the character and quality in their art.

Conversely, an intimate knowledge of art will provide clues to the intellectual and social life. The music that Bach wrote for his Lutheran congregation during the early eighteenth century is very different from that which Haydn wrote for the court of Prince Esterházy fifty years later. Their music reflected different attitudes toward religion and other institutions, yet both of these men were great creative artists. Both were following closely the patterns of their own age, and both composed for patrons who made specific demands upon them. No one will deny that the paintings of Boucher for the court of Louis XV are very different from those of Picasso in the twentieth century, for each in his own way represents the culture of his time. Boucher portrays charming flirtatious subjects to enhance the art of love, whereas Picasso, putting his artistic finger on the pulse of the scientific age, seeks to produce a style commensurate with its spirit.

One often finds that a particular event or crisis will elicit a creative response. Picasso's *Guernica*, (fig. 13.2), painted in reaction to the mass bombing during the Spanish civil war of 1937, and Penderecki's *Threnody for the Victims of Hiroshima*, a musical response to that holocaust, are two such works in the twentieth century. These two works recall or deepen our understanding of these two historical events.

The artist's individual personality, of course, causes differences within a certain style and period. All creative artists leave the stamp of their own personalities and ideals on their art, and yet they have much in common with their contemporaries. Bach and Handel lived at the same time. Although their personalities and their music were very different, they both expressed characteristics of the Baroque. The paintings of Rivera and Dali are certainly not alike, yet the work of each represents an aspect of contemporary life that we can all recognize. Every great artist is to a certain degree the child of his or her age, and yet every great artist helps to create his age. This is a matter of interaction between cause and effect. Leonardo da Vinci helped to make the Renaissance a great artistic age, and in turn he was made great by the humanism that was set in motion during the Gothic and eventually flowered in the Renaissance. Richard Wagner, to cite another example, epitomized German nationalism through opera, but at the same time he was borne up on a rising tide of nationalism. In the post-World War II era of the twentieth century, the music of the Beatles represented a cultural protest against the past, but their music still was derived from traditional harmonic and rhythmic sources. Even visual **pop art** represented a type of Realism that was prevalent in the late nineteenth century. All artists have something very personal to say, but each communicates through the medium of the accepted style of the age. Even iconoclasts have their roots firmly set in the traditions of their own time.

In view of this very close connection between art and life, it is obvious that an understanding of art involves many different facets of experience. It involves all the forces that were brought to bear on any individual artist: religion, economic status, and social status of both the artist and the artist's public. These forces and many others, such as geographic location, mechanical advancement, and political ideas, all play important roles. After World War II, for instance, the emergence of developing countries and cultural exchange programs of various kinds brought about a kind of cross-fertilization of cultures. Artists and composers whose indigenous culture was non-Western began to create works in Western idioms, and Western artists in turn began to incorporate non-Western points of view into their artistic creativity. If you add to these forces the personal history of the artist and try to hear or see the result of these forces on art, you will arrive at a better understanding of the cultural heritage of Western civilization. You must be able to project yourself into the period of art being examined. This flexibility can be cultivated by study and practice.

Function

To gain insight into works of art, you must become familiar with the various functions of the arts. What were they used for, and who were the people for whom they were created? Obviously, a church is built for religious purposes,

but for what kind of religion? A Gothic cathedral serves a different purpose than a Protestant church, and a Buddhist temple is different from a Jewish synagogue.

Architecture is a living art in that during its lifetime a building often undergoes considerable change. It may be redecorated or used for a different purpose and remodeled to meet the needs of new functions. In some instances, a building may be damaged by fire, war, or some disaster and then restored in a different style according to the cultural pattern of that period.

A painting may serve many purposes. It may be used for religious education; it may satisfy the ego of some wealthy merchant who commissioned it; or it may be propaganda against the horrors of war, as are several works of both Goya and Picasso. The same thing is true of sculpture. It may commemorate a historic event or symbolize the function of a building. Under certain conditions, artists create pure artworks without a practical objective but as a deep and abiding expression of humanity's idealism. In any event, artists have certain well-defined functions in mind that are influenced by such things as personality, patronage, and epoch.

Music is also a functional art. There is music for war, for religion, for dancing, for love, for comedy, and for a host of other purposes. In the case of the visual arts, function can usually be determined by subject matter. Instrumental music, being abstract, defines its function in terms of form, melody, harmony, rhythm, and expressive quality, and sometimes by means of announced programs or stories. The function of vocal or dramatic music is determined by the meaning of the text itself.

Not all art has a high purpose. There is a great wealth of art, especially music and painting, that aims merely to amuse and to provide a pleasant diversion from life's everyday problems. Popular music, musical comedy, salon music, illustrations, caricatures, and cartoons are by their very nature diversionary and as such are rarely of lasting quality. While their purpose is not denied, the very fact of their timeliness militates against their consideration as artworks of real consequence. This is especially true of the so-called protest music and art of the 1960s and 1970s. They achieved popularity in their time, but as the events that triggered the protest were forgotten, or the conflicts were partially resolved, or new crises arose, the artistic representations in either visual arts or music dimmed in importance.

The term **kitsch** refers to bad art and is sometimes applied to art that caters to the masses. This kind of art is usually aimed at the aesthetically illiterate and is often commercially-produced and distorted copies of other works. Kitsch caters to those whose judgment prevails through their tremendous buying power. Those artists who appeal to the general public through the popular arts in the world of entertainment give the public what they think they want. In general, this kind of art is of little aesthetic value and will not be considered in the present study.

The function of any art is inseparably connected with the social, economic, political, and religious patterns of its age. In the pattern of history there are periods during which certain artistic functions are most prominent. For example, the Romanesque and the Gothic demanded religious art because the Church was the one all-powerful institution. As the Church lost leadership, art for religious purposes diminished both in quantity and quality. Likewise, the Romantic period of the early nineteenth century laid bare such things as social injustice, exploitation of labor, and the struggle for democratic idealism. Consequently, artists provided works of art that highlighted these abuses and served both as propaganda for social reforms and as documents of faith in democratic ideals. Nationalistic art served the function of uniting minority peoples into social, cultural, and political units. During the periods when specialized functions may have been the prominent reasons for art, we also find music and art that serve other common purposes. As we progress through the pages of history, we will be constantly aware of the function of art as the consequence of cultural patterns.

Art Epochs

In this study we will survey the various aspects of art in terms of the great historical periods or epochs. For the sake of convenience, history will be divided into large and broadly defined periods that are generally accepted. In each of these, the dominant trends in religion, economics, and other important areas will be reduced to a few general statements. We will then demonstrate how each of the important arts is affected by these trends. In order to avoid too many complexities, we will emphasize only the most important arts in each period, for not all the arts are of equal importance in all times. For example, while painting was considered a major art in the time of the Greeks, it was not as important as sculpture. From the point of view of the modern concert stage, Greek music almost ceases to exist. Painting was considered a major art in the Renaissance, but in the twentieth century architecture is perhaps more influential. There are also certain minor arts and crafts that, while no one denies their existence and their beauty, do not represent the most important artistic productivity of the age. Because we are mainly concerned with a broad and generalized picture, some of these can be left for a later and more intensive study.

It is impossible to divide history arbitrarily into periods of time with exact dates as boundaries. It is equally difficult to mark off one period of art from another. History is a process of change that is slowly revealed as time progresses. While one period of art reaches its zenith, another is being born, the result of normal cultural growth and change. While Gothic ideals were gradually waning, for example, Renaissance humanism was emerging, and during the High Renaissance of the middle and late sixteenth century, the seeds of

the Baroque were being germinated; and so on through the centuries. The process of stylistic change moves slowly and often characteristics of one artistic period overlap those of another.

Terms such as Gothic, Renaissance, Baroque, and Rococo will be used to designate certain artistic styles in periods of time. It will be practical to use dates for this purpose. The dates are used only to mark off the span of time that we can say, with some degree of certainty, represented the dominant cultural pattern of that age. The following periods and dates are those with which we will be concerned:

The Greeks and Their Predecessors (Antiquity–100 B.C.)
Roman and Early Christian (100 B.C.–A.D. 500)
Medieval–Romanesque (500–1100)
Medieval–Gothic (1100–1400)
Renaissance (1400–1600)
Baroque (1600–1750)
Rococo and Classic (1725–1800)
Romantic/Realist/Nationalist/Impressionist (1800–1900)
Modern to 1945 (1900–1945)
The Arts Today (1945–)

A Laboratory of Experience

The second aim of this study is to develop insight into actual works of music and art. This will involve much more than biographical studies of great composers, painters, and sculptors, or the recognition of their works by title, although these are important steps. Only when you are on intimate terms with art through seeing and hearing does it become a part of your experience. What does the eye see and the ear hear? What constitutes an aesthetic experience in terms of art? These are questions with which we will be concerned, for real insight can come only by perceiving the forms and sounds the artist creates. One must become a hearer and observer as well, spending hours in the laboratory of the concert hall and art museum or the equivalent time acquainting oneself with recordings and art reproductions. Musical works must be heard again and again until the details are easily recognized by the ear. The themes and texture of such a work as Beethoven's *Symphony No. 6 (Pastoral)*, for example, should be so indelibly impressed upon the memory that they will never be forgotten. Reproductions of painting and sculpture should not remain in bound volumes but should take their place on the walls of the home, where they become a part of everyday experiences. Even better would be a few originals by little-known artists, chosen with discrimination and taste. The object is to become so familiar with the spirit and character of a few well-chosen works that their messages become a part of daily life and lead to full awareness of the meaning of such art. For the study of architecture, the various

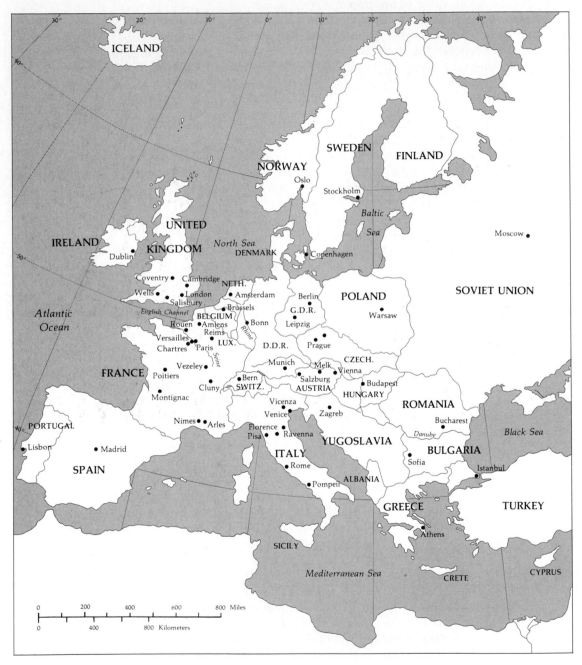

Art Centers of Europe

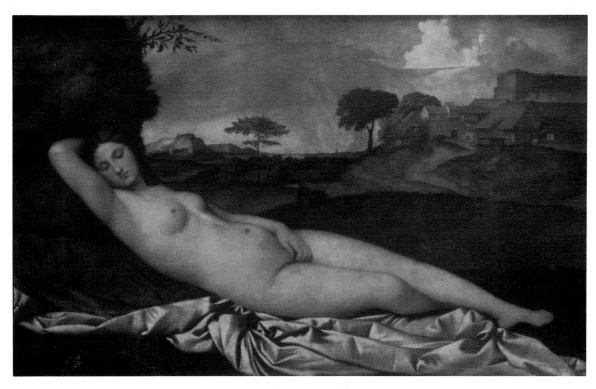

Colorplate 1 *Venus* [1508–1510]—Giorgione. 42½″ × 68⅞″. (Kavaler/Art Resource, N.Y.)

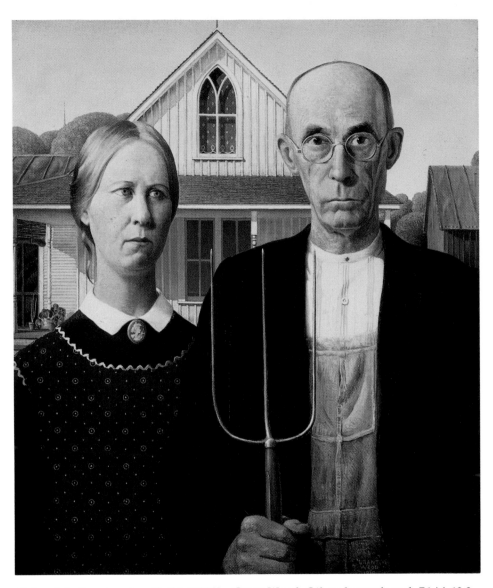

Colorplate 2 *American Gothic* [1930]—Grant Wood. Oil on beaverboard, 76 × 63.3 cm. (Friends of American Art Collection, 1930. 934. © The Art Institute of Chicago, All Rights Reserved)

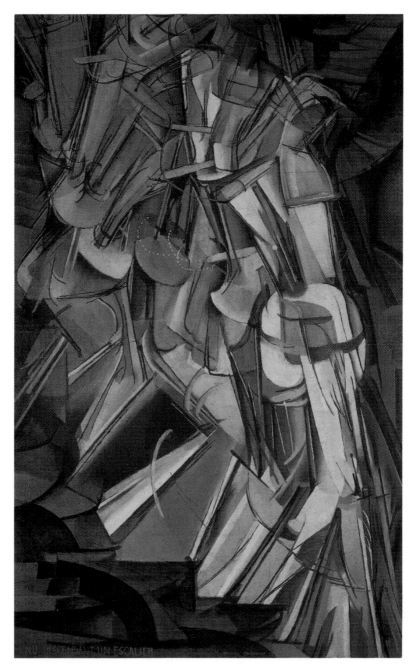

Colorplate 3 *Nude Descending a Staircase* [1912]—Marcel Duchamp. 58″ × 35″.
(Philadelphia Museum of Art: Louise and Walter Arensberg Collection)

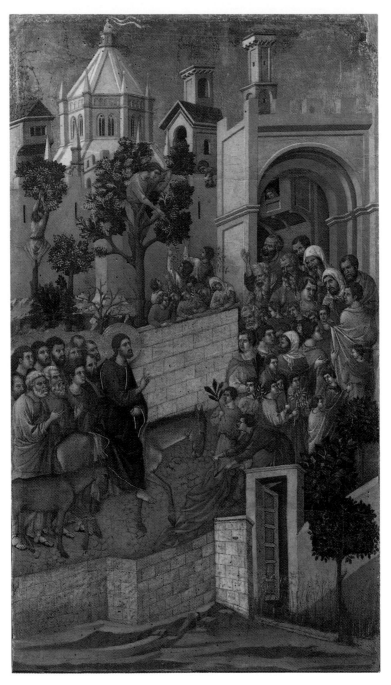

Colorplate 4 *Christ Entering Jerusalem* from the *Maestà altar* [1309–11]—Duccio. 39″ × 22″. (Scala, Art Resource, N.Y.)

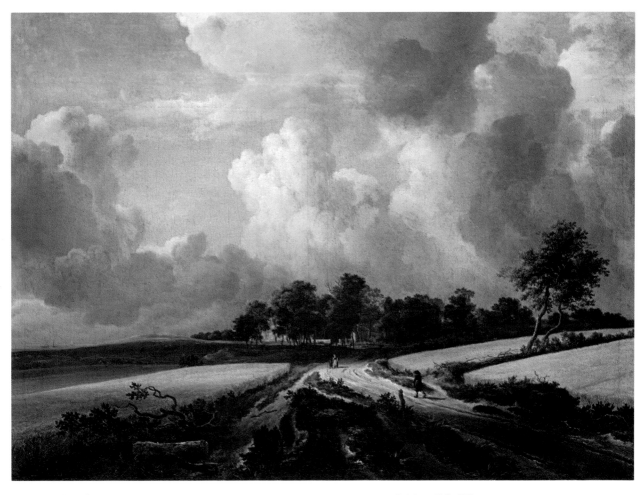

Colorplate 5 *Wheatfields* [1670]—Ruisdael. Oil on canvas, 51¼″ × 39⅜″. (The Metropolitan Museum of Art, Bequest of Benjamin Altman, 1913)

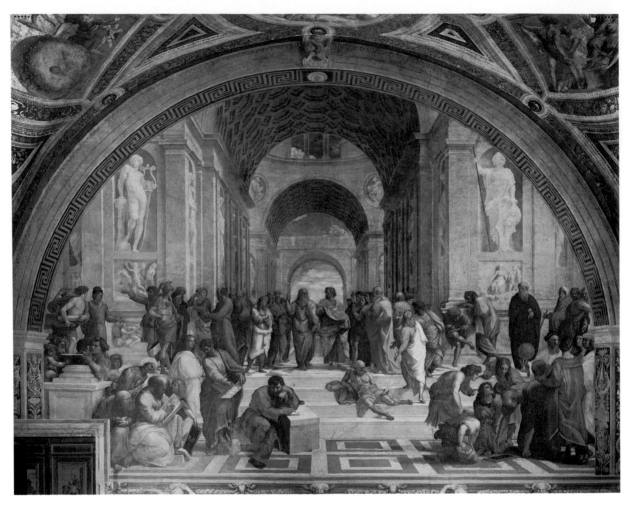

Colorplate 6 *School of Athens* [1510–1511]—Raphael. c. 26′ × 18′. (Scala/Art Resource)

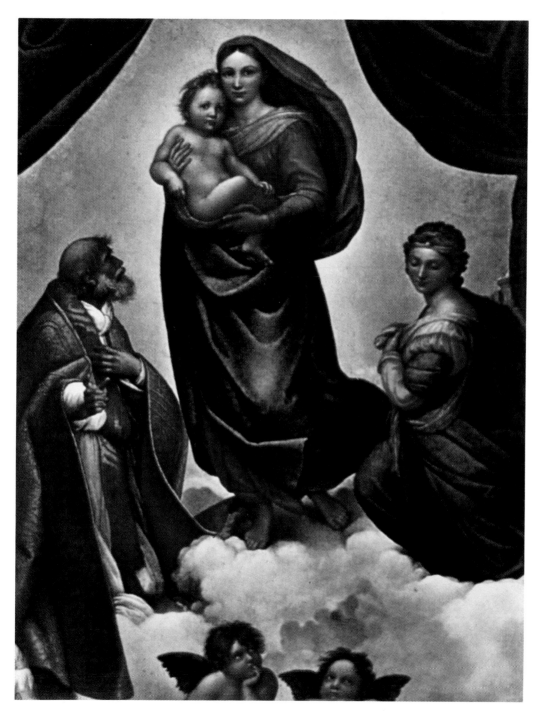

Colorplate 7 *Sistine Madonna* [1513]—Raphael. 8'8" × 6'5". (Scala/Art Resource, N.Y.)

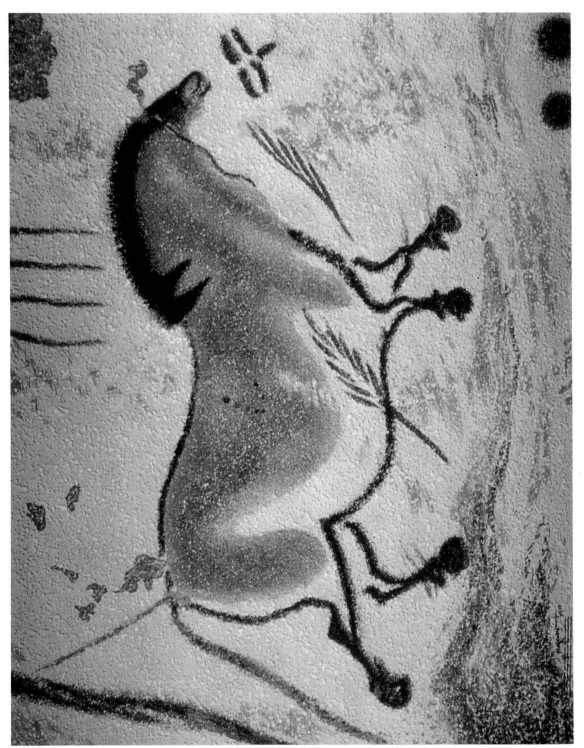

Colorplate 8 Lascaux cave painting [c. 1500 B.C.]. (Mazonowicz/Art Resource, N.Y.)

styles and examples in the local community can be sought out and studied. What is experienced will, in turn, become more meaningful in the light of the historical background and personal history of the artist.

Another facet of artistic insight is the ability to analyze the materials of art and to experience the various ways of organization within the context of the cultural pattern. Just as the artist uses the methods of synthesis in creating, so one must learn to synthesize and be able to account for what one sees and hears in terms of the larger forces and monuments in Western civilization. The ideal is to see and hear with the eyes and ears of the creators. The aesthetic experience reaches full bloom by absorbing into one's own experience all the aspects of an artwork: function, material, form, cultural milieu, and the artist's personality.

What techniques can be employed in an effort to bring about this synthesis? What practical tools of hearing and seeing can be utilized in the laboratory of experience? These questions bring us to the subject of the following chapter and to the third aim of this study: to develop a technique of analysis as a means to general critical judgment.

Summary

The history of the human race is much more than a chronicle of political, economic, and military successes and failures. The record of intellectual, spiritual, economic, and political life has been revealed in the artistic activities of that age. A study of the arts in relation to the life and times that produced them helps us to develop a more profound understanding of the human behavior of the past and a temporary evaluation of the present. The purpose of this study is to correlate the arts with cultural history in order to develop a breadth of understanding of the cultural patterns of the Western world. This can be accomplished by the study of specific works of music and art that represent the important trends and styles of artistic activity in the major historical epochs of Western civilization.

Suggested Readings

In addition to the specific sources that follow, the general readings on pages xxi and xxii contain valuable information about the topic of this chapter.

Elsen, Albert E. *Purposes of Art*. 4th ed. New York: Holt, Rinehart & Winston, 1981.
Langer, Susanne K. *Problems of Art*. New York: Scribner, 1977.
Mellers, Wilfred. *Music and Society*. New York: Roy Pub. Co., ca. 1950.
Raynor, Henry. *A Social History of Music from the Middle Ages to Beethoven*. New York: Schocken Books, 1972.
Raynor, Henry. *Music and Society Since 1815*. London: Barrie and Jenkins, 1976.
Reed, Herbert E. *Art and Society*. 2d ed. New York: Pantheon Books, 1950.

2

THE ORGANIZATION OF THE ELEMENTS OF ART AND MUSIC

Pronunciation Guide

Bartók (Bahr′-tok)
Berlioz (Bayr-lee-ohz)
Delacroix (De-lah-krwah)
Duccio (Doo-choh)
Duchamp (Doo-chahm)
Dufay, Guillaume (Dü-fah-ee, Gwee-ohm)
Giorgione (Johr-joh′-nay)
Penderecki (Pen-der-et′-skee)

Praetorius (Pray-tor′-ee-us)
Raphael (Rahf′-ah-el)
Rembrandt (Rem′-brant)
Schubert (Shoo′-bert)
Stockhausen (Shtock′-how-zen)
Strauss (Shtrows)
Stravinsky (Strah-vin′-skee)
van Gogh (van Gokh)

Study Objectives

1. To understand the principles of design and to learn how they are applied to works of art.
2. To develop techniques for analyzing the elements of art and music as they appear in specific works.

As we gain an understanding of relevant social forces, a knowledge of the artists' lives, and an awareness of the various functions of art, we must also examine some of the devices by which we can actually see or hear those forces as they are expressed in artworks. We must further examine some principles

of sensory perception that are involved in an aesthetic experience. This brings us to the third specific aim of this book: to develop techniques of critical analysis for a personal evaluation of artworks. There is no formula by which this can be done, for art is much too subjective. There are, however, a few fundamental techniques of observation and analysis that can serve as practical tools of understanding. The artist uses raw materials such as stone, paint, or musical tones. From these materials, the artist creates a work of art according to principles of design for an expressive end.

Every work of art worthy of the name must have some special characteristic of artistic form and arrangement that distinguishes it from nonartistic forms. For some observers, form can often be an end in itself: there is pleasure and delight in the sheer magic of technical perfection, or pleasure in the awareness of the elements alone. Rhythmic movement, "voice" movements in music, the interplay of color, or the movement of dynamic lines can give us a certain amount of aesthetic pleasure. Technical competence alone, however, does not evoke an aesthetic response.

Art deals with the whole spectrum of human experience, and the artist interprets and expresses these experiences in a distinctive manner. This can range from the kinds of experiences that we associate with idealism to the ordinary experiences of life, even to those that are ugly and revolting. While the arts vary in their characteristic subject matters because of the differences of media, they are alike in their basic objective. Many are preoccupied with interpreting human experiences. The stimuli for such experiences may vary because of sociocultural influences, but whatever they are and whenever and wherever they occur, artists seek to re-create and interpret them for their contemporaries.

To artists, life consists of a variety of sensations that can be reproduced by many different physical means. A shape, a color, a melody, or a chord are only a few of the means by which sensations can be evoked. It is true in music that sound, melody, and chords become meaningful only upon being heard. The success of a work of art—be it painting, sculpture, or music—can be measured by the extent to which our senses perceive and respond to the experience the artist seeks to evoke. In this way, our senses become a means to an aesthetic experience. Normal sensations are not artistic in themselves, but by selecting and transforming materials, artists can intensify our sensations and thus impress upon our memories the responses that they seek to evoke. It follows that creative artists can arouse moods of agitation or calm, of majesty or delicacy, with reasonable assurance of our reactions.

The Aesthetic Response

Aesthetics is the study of the nature of the beautiful, but the aesthetic experience deals primarily with human feelings. There are some who look upon the experience of art merely as pleasurable sensation. For other people, the

response to art is more complex, involving qualities of human feeling common to all humanity. While each feeling is a very personal matter, all people can, and usually do, experience the same feelings at one time or another as a result of similar if not identical stimuli. The creative artist arouses in us specific emotional states, moods, or feelings, and only when we experience these emotive states can we achieve a real appreciation of the artistic content of a work of art. In music, these emotive states can be achieved by tonal and rhythmic patterns. Because of music's inherent abstraction, the response to music varies greatly with individuals. Time and place, moreover, can vary each individual response. In painting and sculpture, representational forms as well as pure formal patterns awaken feelings. Architecture depends upon the power of architectural form, size, proportion, and social use.

According to Stephen Pepper (*Principles of Art Appreciation*), there are four ways of producing emotions through art. (1) Artists can use direct stimulation, such as the excitement of a march with its military rhythms and clear-cut phrases or the lilting pattern of a dance tune. In painting, this kind of stimulation occurs through the use of colors and agitated lines. In *Liberty Leading the People* by Delacroix (colorplate 53), the forward diagonal movement from left to right and the atmosphere of somber colors against the smoke-filled background intensify our own feelings about the subject. (2) Types and symbols that through common usage are charged with emotional meaning can also stimulate emotion. For example, the broken sword, the dying horse, and the dead child in Picasso's *Guernica* (fig. 13.2) all suggest a feeling of terror and carnage that was a part of the artist's message. This type of stimulation does not usually apply to music, unless the music has a text that suggests these symbols. Except for a few obviously imitative sounds, instrumental music, by its very abstract nature, refuses to be so objectively associated with specific symbols. But even in abstract music, rhythmic or melodic patterns can be symbols of emotion; an obvious example of this is the rhythmic **motive** at the opening of Beethoven's *Fifth Symphony*, which, by tradition, suggests Fate knocking. (3) Feeling can also be aroused by representation of emotional behavior in a work of art. In Delacroix's *Liberty Leading the People*, the grim determination in the facial expressions and the upraised arm with weapons, together with the shadowy bodies of fallen citizens, provide an emotional climax to the painting that has already been suggested by line and color. Berlioz does this musically in the first movement of the *Symphonie fantastique*, in which the fragmentary and vague harmonies are contrasted with the lyric and intense melody of the "beloved" to call forth a feeling of reverie and passion. He even suggests these states of emotional response by the title "Reveries and Passions." (4) Artists can also evoke an emotional response by providing evidence of their own feelings. In Beethoven's Third Symphony (*Eroica*), the dynamic power and majesty of the music can be readily associated with the composer's own idea of heroism. In the visual arts, van Gogh is noted

for paintings that reveal his feelings, such as *The Starry Night* (colorplate 74). Bold, swirling strokes and heavy, contrasting colors give a kind of elemental strength to the painting that reflects van Gogh's attitude toward life.

There are other and more subtle ways in which aesthetic responses can be awakened, and we must remember that the artist does not rely on any one of these to the exclusion of others. Furthermore, the artist depends upon a gradual awareness of the various facets of an artwork gained by repeated observations. No work of art can be inherently meaningful to the uninitiated observer, for no work of art can communicate with an observer who is not qualified to understand and speak its language. Beethoven's *Eroica* becomes meaningful aesthetically only as the listener becomes acquainted with its musical language. This may come in part unconsciously because the listener is a member of the society of the Western world and in part because of the listener's personal effort. The greater the mastery of the musical language, the more understanding can be brought to the experience of hearing, and the greater is the listener's aesthetic response.

Virtually all relevant information can help conscientious and sympathetic observers enlarge and heighten their aesthetic responses to any art object—visual or aural. It is therefore important to understand that the appreciation of art, the realization of an aesthetic experience, and the awareness of the communication of the work of art are phenomena for which one must work, for which an effort must be made. These phenomena do not occur through the efforts of the creative artist alone. The completed communication depends upon the efforts of both creator and observer. It is never passive and can be made real only through active participation. One person uses talents to create communicative objects, and the other uses talents to understand the communication.

In the creative process artists must constantly make choices or judgments with regard to the content and organization of the artwork. Some judgments may be logical, justifiable on a rational basis. Others are intuitively felt on a deeply personal level and lend themselves much less readily to logical argument.

Artists arrange materials to combat boredom and fatigue, and to awaken emotional states in the observer. At the same time they may assist the observer in relating the parts to the whole. The observation of principles of design and the elements of the arts, when fused into the perceptual process, contribute further to artistic understanding.

The listener or viewer employs a mode of judgment very similar to the creative process. These judgments are sometimes logical and rational, but are intuitive and personal as well. In our scientific age it is sometimes difficult to convince people to rely on their intuitive conclusions about artworks. Intuitive responses, when based on long experience, may be regarded as credible and valid.

Elements and Materials of the Visual Arts

There is no general agreement among authors about the rudiments of the visual arts. Some authors would include only line, shape, and color. Others would add volume, texture, and direction. In this book the authors will use medium, line, space, and color. These artistic elements or rudiments must have some physical form, and the materials that artists choose to work with are varied and many. The way in which these materials are manipulated and relate to one another within the work of art may be referred to as its formal organization.

Medium

The word **medium** refers to the artist's physical materials, such as stone, wood, metal, paper, cloth, glass, and plastic, whose properties influence the manner in which the elements will be organized. In painting, the physical properties of such materials as oil and watercolor determine the technique and provide the artist with a discipline that is reflected in the expressive qualities of the artwork.

Line

One of the most simple and common elements used by all artists to create form is line. Painters use line to delineate forms. Sculptors create line by defining form with their material. Even the architect's organization of space results in the lines of a building. There are many different manifestations of line. Lines may be curved, with a smooth-flowing rhythm, or they may be straight, with sharp, dynamic angles; they may be clearly defined or vague and diffused; they may be simple and direct or they may show great detail and ornamentation.

By the use of line, artists can create geometric shapes such as spheres, triangles, and squares. Shapes created by line may be representational or non-representational and abstract. They may also be two-dimensional or three-dimensional, and, in the case of some twentieth-century art, they may suggest a fourth dimension, imaginatively adding the illusion of action to three-dimensional forms. The quality of line may be delicate and refined or it may be broad, showing great strength and solidity. Color, texture, and intensity of line also affect quality.

Colorplates 1, 2, and 3 follow p. 8. Line also has expressive significance. Horizontal lines suggest repose and stability (colorplate 1). A sense of strength is shown by vertical lines (colorplate 2). Diagonal lines reflect tension and action (colorplate 3). Long curves express relaxation and a sense of calm, while short, quick curves are often used to express dynamic agitation. Whatever the line qualities may be, each artist utilizes line in conformity with his or her personality, philosophy, and epoch.

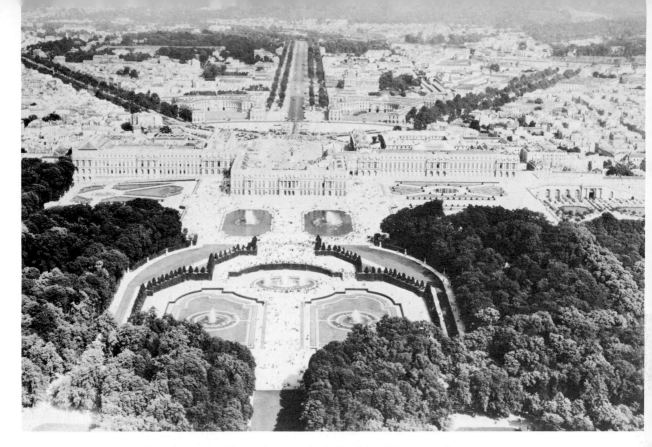

Figure 2.1 *Versailles*—Aerial view. The palace on the left of the "Parterres du Nord"; on the right, the "Parterres du Midi." In front are the water gardens, the Fountain de Latone, and at the bottom of the picture, the beginning of the Green Carpet. (Courtesy French Tourist Office)

Space

Space is the three-dimensional volume that can be experienced physically in sculpture and architecture but can only be suggested in painting. The architect deals with the organization of space, as do the landscape architect and city planner (fig. 2.1). For example, space may appear restricted by being enclosed within heavy walls with few windows. In contrast, it may be expanded by letting one room flow into another, eliminating doors and using large amounts of glass, as in much modern architecture. The landscape architect can contract space by restricting portions of the garden with borders and hedges, or expand the sense of spatial volume by providing easy access to all areas, both physically and visually. In painting, space may be an illusion of the third dimension, as recession into the distance or as projection forward.

Medieval paintings reveal a much more primitive understanding of space and perspective than do more recent works of art. For example, Duccio's *Christ Entering Jerusalem* (colorplate 4) presents three groups of people on shallow

Colorplate 4 follows p. 8.

shelves of space at the very front of the picture plane. Rows of people are placed like flat images laid one upon another. The architectural fragments only minimally employ **linear perspective,** and unlike the aerial photograph of Versailles (fig. 2.1), there is no **aerial perspective.**

Very different techniques are employed in more modern paintings. Looking through an opening into a landscape without end gives the observer a sensation of infinite space. In Ruisdael's *Wheatfields* (colorplate 5), this is accomplished by the relationship of size and position, lack of detail in the distance, overlapping of shapes, and receding color intensity. Raphael's *School of Athens* (colorplate 6) demonstrates a more controlled, three-dimensional spatial character by following rules of linear perspective. Groups of figures are organized so that the figures of Plato and Aristotle are framed by the rounded arch in the background. In contrast, three-dimensional space may be denied by a flat plane on which figures and objects are placed so as to have relationships on only two dimensions. Most visual art suggests space that seems either to expand or to contract. Vertical and horizontal space is contracting if the eye is drawn inward; it is expanding if objects or scenes are suggested to exist outside the boundaries of the artwork.

Colorplate 5 follows p. 8.

Colorplate 6 follows p. 8.

Color

The element of **color** can be understood best by examining its three constituents; **hue, saturation** (sometimes called intensity), and **value.** The property of reflected light that allows persons to distinguish a color is called hue. The names we give to colors (violet, green, red) are also called hues. There are three **primary colors**—red, blue, and yellow. If any two of these colors are combined, the resultant colors are known as secondary colors. Blue and yellow create green; red and blue, violet; red and yellow, orange. Differing combinations of the primaries can, of course, create infinite variants. An examination of the light traveling through a prism cast on a surface will confirm this fact.

Saturation refers to the relative purity or vividness of a color with respect to its appearance in the spectrum. The reddest red separated by a prism would be described as possessing a high saturation level. If a small amount of blue were added to it, the hue would still be recognizable as red, although a keen eye might detect that small amount of blue.

In addition to hue and saturation, all colors have black and white present to some degree. The more white that is present, the higher is the value of that color. Conversely, the more black present, the lower the value. In their natural, refracted states, some colors (e.g., yellow) have higher values than others (e.g., blue). The value of any color can be changed by the addition of black or white.

In painting, there are two types of color organization: **monochromatic** and **polychromatic.** Monochromaticism means that the colors are derived

mainly from one color, with different values and a unity of hues. Polychromaticism results from many contrasting colors. In addition to contributing to the reality of form, color has a great number of other functions. It can define form and line; it can create eye rhythm by cleverly shifting the emphasis from one color mass to another; it can add to the sense of motion by expanding or contracting space, using dark colors for contraction and lighter colors for expansion.

Color also contributes to the emotional or expressive quality of a work. For example, high intensities of bright colors evoke a sense of excitement, while low intensities and somber colors suggest serenity, calmness, or even mystery. In traditional art, color is often used to symbolize ideas, such as purple for royalty, blue for faith, and white for purity; there are a host of other symbolic ideas and objects with color associations.

Form and Design

Form or **design** is the arrangement of materials and elements into a recognizable pattern that conveys the function and meaning of an artwork. While there is an endless variety of artistic possibilities in material, subject matter, and function, there are only several principles of organization by which every artist is guided. Among the principles, these four seem to be paramount: (1) unity, (2) variety, (3) balance, and (4) climax. All works of art have these principles present to some degree, but the importance of individual principles will vary from work to work.

Each work of art must have enough **variety** to interest the observer and enough **unity** to avoid chaos. In other words, every artist seeks enough coherence to achieve unity in the work, and, at the same time, enough variety to combat monotony. Unity and variety are by no means independent of one another. Certain art epochs reveal strong tendencies toward the dominating use of one or the other of these principles.

Repetition and contrast are important methods of achieving unity and variety. A painting may achieve unity by repeating colors, patterns, and lines. Raphael's *School of Athens* (colorplate 6) uses the repeated diminishing arch form as an element of repetition at the same time as it emphasizes linear perspective. Repetition is enhanced by the decorative patterns on the floor and in the first arch. The human forms are painted in greatly contrasting poses.

The theme and variation principle of achieving unity and variety is one of the most technically demanding accomplishments required of the artist, for it consists of a skillful handling of one motive with the ever-present danger of monotony. A painter may use many variants of a single color as did Rembrandt. On the other hand, the artist may use only one motive of line in varying patterns, sizes, and positions.

Balance in the visual arts may be achieved through simple symmetry or near symmetry as in Grant Wood's *American Gothic,* (colorplate 2) Raphael's

School of Athens, (colorplate 6) or his *Sistine Madonna* (colorplate 7). Less symmetrical balance is evident in *Wheatfields* by Ruisdael (colorplate 5) and Giorgione's *Venus* (colorplate 1). Painters may use such things as shapes, implied masses, and blocks of light and dark to achieve balance.

In the visual arts the principle of climax is expressed in the point or points of focus in the painting. In the *School of Athens* the perspective, the implied lines in the groupings of people, and the framing in the arch all lead to the two central characters, which are a primary point of focus. Paintings frequently have multiple points of focus. The two faces in *American Gothic* (colorplate 2) exemplify the principle of multiple focus. In Duchamp's *Nude Descending a Staircase* (colorplate 3) there is no central focus, but rather a general sense of movement from upper left to lower right.

Form has two meanings in art. The first meaning refers to the way in which all the elements of an artwork are organized into an expressive whole. This organization may draw attention toward a focal point, creating closed form, or it may lead the observer out and beyond the immediate scope of the artwork. The latter creates open form. Form may have balance of mass and void or it may be unbalanced and asymmetrical.

The second meaning, plastic form, is used to designate the shape or mass of an object. Many objects approximate forms, such as the sphere, cone, cylinder, or square. The sculptor molds materials into these shapes. The architect encloses space within the confines of these primary forms. The painter creates the illusion of plastic forms with line and color. The differences between these two definitions must be kept in mind: Form is a method of organizing the total picture; plastic form designates shapes or masses.

Not all of the foregoing concepts apply to the visual arts in the same degree. For example, color is less important in sculpture than in painting, whereas the physical character of material is more important in sculpture and architecture than in painting. It must also be remembered that all the elements add to the total character of each individual element.

Expressive Content in Visual Art

In addition to the elements, artworks have expressive content that results from such things as organization, function, and the artist's creativity. This is an intangible but very real quality of art, for expressive content is the heart of what the artist wishes to convey. Whether the work is a character study in painting, a heroic group in sculpture, or a private dwelling, the respective object of each artist is to make the character real, to evoke a sense of heroism, or to give the building the warmth and intimacy of a home. The success of the works of art is in direct proportion to the artists' achievement of these aims. The creative artist possesses the intuitive power to sense relationships and the technique to organize materials so that a work of art communicates

some message or experience. In the final analysis, the only really important aspect of art is its expressive content; all other elements and devices are only a means to that end.

The various ways in which artists employ principles of design and the most commonly used elements determine artistic styles. Artists who are subjected to similar cultural forces usually organize the materials and elements in much the same manner—subject, of course, to the function of the artwork as well as to the individual differences and personalities of the artists. There are cases in which an artist continues in a style that was prevalent in a bygone era and refuses to conform to the present culture, but quite often such artists are not the accepted great masters of art. More often great artists go ahead of their time and provide the connecting link between one artistic age and another. They have the intuition and the courage to recognize that times are changing, that new forces are at work. A Leonardo da Vinci or a Beethoven, then, becomes a prophet of a new era. In such cases, an analysis of the elements will reveal nonconformity to the accepted contemporary style and will show some stylistic characteristics of the subsequent art epoch. Leonardo was such a prophet of a new era. His *Mona Lisa* does not display all the characteristics of Renaissance painting, but it does exhibit some of the qualities later identified with the Baroque. The same is true of Beethoven. He was trained in the classicism of eighteenth-century music, and yet his later works fulfill many of the demands of Romanticism. Thus he became the prophet of the new Romantic spirit in music. Some twentieth-century artists, such as Picasso and Stravinsky, reveal in their works a variety of styles as they keep pace with the extremely rapid cultural changes that characterize this century.

Enough suggestions have been made here to give some idea of the elements and principles of design in the visual arts. The important things to remember are that everything cannot be grasped at once and that all elements are not always of equal importance. A general conception of these elements is all that is necessary for the beginner. By analyzing more works of art, you will study these principles and elements in more detail.

An Example in Painting

Taking Raphael's *Sistine Madonna* (colorplate 7) as an example, let us make an analysis of its organization, function, and elements according to what we actually see. The function of this work is religious. The subject is the Madonna and the baby Jesus. The artist, in order that there will be no doubt as to the subject, has surrounded the head of each figure with a halo, which is faintly discernible—all except the two little angels, whose wings identify them as heavenly. There is nothing else to identify the figures as being holy. They are mere humans—real people whom Raphael knew and chose to use as models.

Line

One of the prominent elements of this work is line. The lines are very sharp, clearly defining the outlines of the various forms, separating them from the background. They are also primarily curved, suggesting a smooth-flowing, vertical motion. Unity is achieved by a rhythm of linear motives, and variety by a contrast of visual pauses among these motives.

Space

Space is not a main feature in this artwork. The figures are bounded by the drapery and by the painted-in frame at the bottom. The background, made up of a myriad of cherub faces, is quite flat and does not suggest any substantial sense of space. The figures, however, are so molded as to seem real in a plastic sense, giving a three-dimensional effect. In addition, they seem to project forward, a projection implied by the gesture and look of the two figures on either side of the Madonna. This spatial quality is also implied by the emergence of the major figure from the sea of cherubic faces.

Color

The painting is polychromatic. The colors give a rich color harmony by means of contrast, especially between the red and blue. The principle of repetition and contrast of color provides both unity and variety.

Medium

In this example, the material is oil on canvas, painted in such a manner that brushstrokes are blended together and are not visible.

Formal Organization

The lines of the figures draw the eye inward toward the figure of the Madonna and Child. All motion is directed toward this group, providing the painting with a dynamic quality. The gaze of the figure on the left, the vertical line of the right figure, the upward look of the cherubs, even the drapery above, bring the eye toward the focal point. This is closed form. It is also balanced form, for the two figures on the side equalize the vertical axis of the central group. Here again the drapery serves to emphasize the perfect balance of form. The organization of this painting is one of separately articulated parts. No figure is merged with another; each is complete in itself and could be removed without destroying the reality of any other—not, however, without destroying the formal balance of the whole.

In summary, this is an oil painting of a religious subject that is primarily linear in character. It has closed form, little spatial sense, and is polychromatic. It utilizes all of the basic principles of design, with repetition and contrast dominating. The reality of the human form is perhaps the strongest

impression one gets. The expression of religious feeling is poetic, beautiful, but not overwhelmingly powerful. Raphael's painting is a good example of Renaissance art and is typical of the sociocultural trends of that period. The religious, intellectual, social, and economic life of the Renaissance and the life of Raphael support this analysis. The synthesis of all elements, both objective and subjective, results in a broader understanding of the artwork and a keener insight into its meaning. If, for example, a work of the Romantic period had been analyzed, we would have found a very different subject and a different function, largely because of the spirit of Romanticism.

Elements and Materials of Music

Music is the most abstract of all the arts and exists only through the medium of performance. It moves in time with constant shifting and changing, which makes it difficult for a listener to make an objective analysis. The scope of our attention is very limited, making it impossible to grasp all the details at once. Consequently, music requires repeated hearings to enjoy the full impact of its message. Nevertheless, there are materials and musical concepts which can be observed and used objectively in making an expressive and stylistic analysis.

Since few persons can look at a piece of notated music and imagine or actually hear what the notation indicates, one must hear all the examples in the book through performance. Compare the musical examples with the analytical schemes and listen to them with the schemes in mind.

The principles of design found in visual art are also inherent in any musical work. The problem of achieving unity and variety is the same, and, in general, composers solve their problems in much the same manner as painters, sculptors, and architects. A composer may use only one simple theme and build variations on that theme by playing it backwards, upside down, in fragments, or in various rhythmic and harmonic permutations. The same harmonic formula may be varied by use of a higher register or different instruments. The presence of **dynamics**, or emphasis is another way in which both unity and variety can be achieved. Dynamics can also contribute to variety by gradations of intensity.

Rhythm

In music, **rhythm** has two common meanings. In the broader sense, rhythm is the movement of the formal organization, the ebb and flow of the musical elements in the overall structure of a composition. In a narrower sense, rhythm refers to a work's **meter,** its patterns of accented and unaccented pulses. The simplest metrical schemes are those of either two or three pulses per **measure.**

Example 2.1: Two Pulses per Measure (Ukranian Folk Song)

In example 2.1, the metric organization is that of two pulses per measure, one accented and one unaccented. In the 2/4 of the **meter signature,** the 4 refers to a quarter **note** and the 2 refers to the number of quarter notes (or their equivalent) that occur in a measure. In the narrow sense of the term rhythm, there are three different rhythmic patterns in this example's metric organization, namely: In patterns *a*, *b*, and *c* there are two metric pulses. Although the notation varies in each pattern, the underlying pulses remain the same.

The following is a diagrammatic representation of the metric scheme and the rhythmic patterns of example 2.1. The ' indicates accented and the ∨ indicates unaccented pulses. The overall *phrase* rhythm is represented by the brackets underlying the diagram.

Metric scheme

Rhythmic scheme

Example 2.2: Three Pulses per Measure (*The Blue Danube*—Johann Strauss)

Example 2.2 has a metric scheme of three pulses per measure, one accented and two unaccented. There are only two rhythmic patterns in this case, and they do not coincide with the metrical divisions. The rhythmic patterns are: (a) ♩ | ♩ ♩ ♩ | 𝅝 and (b) ♩ | ♩ The complete diagram of meter and rhythm follows:

Metric scheme

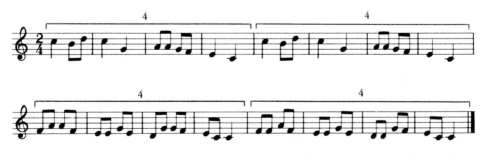

Rhythmic scheme

Even in such a simple melodic idea as example 2.2, the metric and rhythmic schemes are overlapping and not identical. The intriguing charm of the Viennese waltz is the very defeat of the restrictive and repetitive scheme of accented and unaccented pulses by the broader rhythmic organization, and especially by the freedom of interpretation by the performer. Such contrast between meter and rhythm is also recognized by the artistic reader of poetry; one should be conscious of the underlying metric scheme but never subservient to it. It is the difference between reading the words and reading the meaning.

A recognition of the overall sense of rhythm, then, makes for artistic interpretation and for satisfying listening. This overall rhythm may be symmetrical or asymmetrical as in examples 2.3 and 2.4.

Example 2.3: Symmetrical (Hungarian Folk Song)

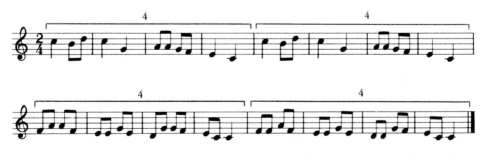

Example 2.4: Asymmetrical (Romanian Folk Song)

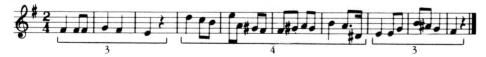

Some periods of Western music have tended to use symmetrical rhythms, while others have made great use of asymmetrical patterns. Some rhythmic patterns, such as those of a march, are very simple, regular, and strongly marked. Complex rhythms are often so subtly marked that the patterns are hardly noticeable.

Not only can overall rhythmic organization be asymmetrical, but metric organization also can be complex in that different metric schemes can be mixed together in a composition, as in example 2.5.

Example 2.5: *Dance #1* from the *Six Dances in Bulgarian Rhythm*—Bartók*

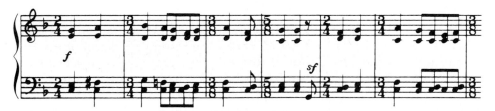

The **tempo** with which the rhythmic patterns recur is an important element of the expressive content of music. Fast tempos or rapidly recurring patterns give a feeling of excitement, while slow tempos tend to suggest repose. It must be remembered that music cannot exist without rhythm. It is an indispensable factor in the character of every other element of music.

Pitch

Pitch is traditionally described as high or low. Actually, it is the frequency of vibrations of the sounding body (a string, a membrane, a column of air, or an electronic modulator, among many others) that determines the pitch of a **tone.** Tones generated by a great number of vibrations are said to be higher than those of fewer vibrations. While the human ear can hear a very large range of vibrations, music up to the advent of electronic synthesizers in the mid-twentieth century has traditionally used only those tones between approximately twenty and eight thousand vibrations per second. Moreover, only a very limited number of sounds or tones from among the infinite possibilities are actually used. The keyboard of the piano, with its eighty-eight pitches a half step apart from each other, approximates the pitch materials that were used in Western music for over one thousand years.

Melody

Melody is a series of single tones sounded successively and organized rhythmically to express a musical idea. It can be either sung or played. It may be simple, without ornamentation, or it may be elaborate, with a great deal of ornamentation. It may be smooth-flowing and lyric in quality, with only small skips or pitch **intervals** between successive tones, or very angular, with many large pitch intervals, or, in extended melodies, a combination of both.

Example 2.6 shows a melody that is simple, without ornamentation, as well as smooth and lyric:

Example 2.6: *London Bridge*

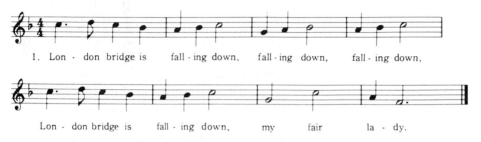

Example 2.7 shows a melody with elaborate ornamentation:

Example 2.7: from Aria, *Every Valley*, from *Messiah*—Handel

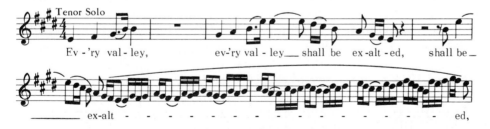

While the human voice is generally restricted to a range of about two octaves, instruments are capable of a much greater range. Example 2.8 is a melody with many large pitch intervals, as is often characteristic in instrumental works:

Example 2.8: *Don Juan* (first theme)—Richard Strauss

Texture

In the history of Western music, melody has been used in three different ways: (1) as a single unaccompanied line, called **monophony;** (2) as a combination of melodic lines, called **polyphony;** and (3) as a single line with chordal harmonic accompaniment, called **homophony.**

The chants of the Roman Catholic Church (ex. 2.9), known as Gregorian chant, are illustrative of monophonic melodies:

Example 2.9: *In adventu Domini,* Hymnus

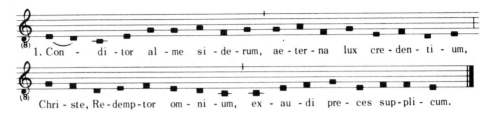

The term **texture** describes the relationship between a melody and its accompanying sounds. Polyphony is a musical texture in which two or more melodic lines are sounded simultaneously. The simplest example of such a texture is that of the **round** or **canon,** in which the same melody is heard in two or more voice parts begun one after the other. Example 2.10 is a canon in three voices. The second and third voices sing the same melody as the first voice, but each enters two measures later than the preceding one. Canons were first written to be sung, but later composers also wrote instrumental canons. Because of their vocal origin, each melodic line continued to be called a **voice.**

Example 2.10: *Viva la musica*—Michael Praetorius

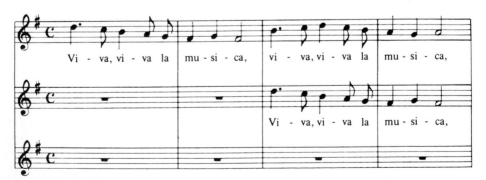

[*Continued*]

Example 2.10 [Continued]

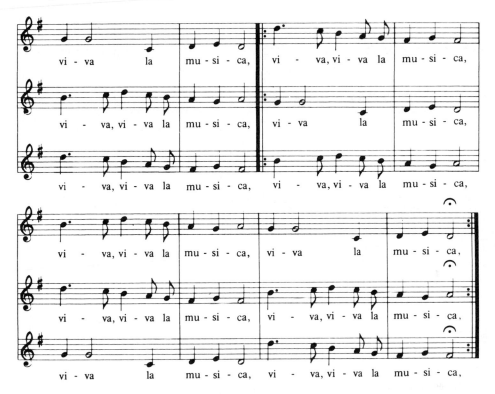

In example 2.11, Guillaume Dufay has taken the melody of example 2.9 and added two different lines of melody to give it a polyphonic (many-voiced) texture. He has changed its rhythmic structure and given it a metric organization of three pulses. At the same time, he has altered the melodic line of the original chant to fit the polyphonic texture:

Example 2.11: *Conditor alme si derum*—Guillaume Dufay

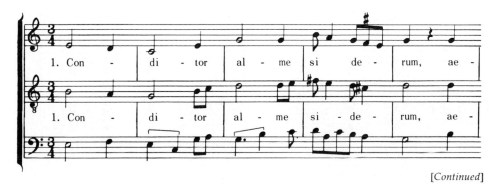

[Continued]

Example 2.11 [Continued]

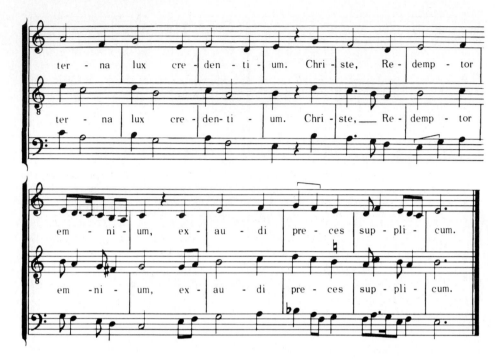

A second form of texture, called homophony, is characterized by a single melody supported by a vertical harmonic accompaniment. Example 2.12, like western folk music and popular song, is an example of homophony:

Example 2.12: *Jeanie with the Light Brown Hair*—Stephen Foster

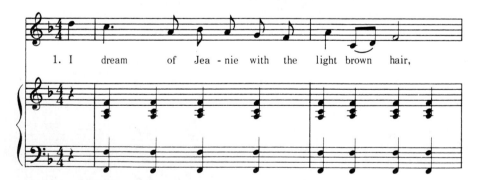

Harmony

While melody is a series of single tones sounded successively, **harmony** is a group of simultaneously sounded tones (a **chord**) of two or more pitches. Harmony may result from the weaving together of melodic lines, from vertical chords, or from a combination of both. Various systems of harmonic organization have been used in Western music. These have been commonly referred to as **modality, tonality,** and **atonality.** Modality is a type of harmony based on the use of the eight church modes (see ex. 5.1), which were scales in common usage during the medieval periods of the Romanesque and Gothic. Each mode gave rise to a slightly different harmonic organization, since each modal scale was different in structure.

While modal harmony predominated in the vocal writing of the polyphonic masters of the fifteenth and sixteenth centuries, tonal harmony (tonality) increasingly displaced it in the seventeenth century and became the controlling practice of the eighteenth and nineteenth centuries. Tonality is a harmonic-melodic system in which the vertical structure of chords and the melodic movement of tones are organized around a central tone, called the **tonic,** to which both the harmony and the melody gravitate. This tone is derived exclusively from the **major** and **minor** scales. Since all major and minor scale patterns gravitate toward a home or tonic tone, tonality is the unified system for all such scales.

Listen to example 2.13 and experience the urge in measures three, four and seven to return to the central tone, G; it is the basis for the harmonic structure of measures one, two, five, six, and, most importantly, eight, as well as the central tone to which the melody relentlessly moves.

Example 2.13: *Here we go 'round the mulberry bush*

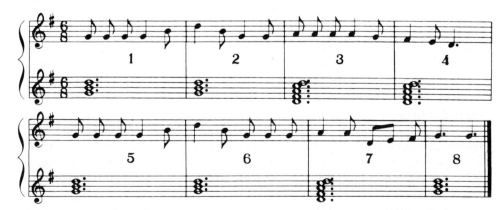

Both modality and tonality employ **consonance** and **dissonance.** Consonance gives a feeling of repose, while dissonance gives a feeling of tension. Atonality, however, combines tones harmonically without the use of the traditional tonal centers of either modality or tonality. Judged on the basis of either modality or tonality, atonal music strikes the listener as completely dissonant. Atonal music, however, uses combinations of pitches as ends in themselves rather than as means to an end as in the modal or tonal systems of harmony. **Twelve-tone,** or **dodecaphonic,** music is often described as atonal. Other harmonic practices less structured than twelve-tone music achieve atonality through the use of experimental devices such as tone **clusters,** chance or **aleatoric** combinations, and electronically produced sounds. Atonal and twelve-tone music belong exclusively to the musical development of the twentieth century.

Dynamics

Dynamics in music means gradations in sound volume. Dynamics became an increasingly important factor in music as the desire for intensity of expression grew in the eighteenth and particularly in the nineteenth and twentieth centuries. Composers found dynamic variation a vital tool for intensifying emotional expression and gave explicit directions about its use in their compositions. While there can be no specific indication of dynamic level, composers usually mark their works with the traditional *p* for the Italian word "piano," meaning soft, and *f* for the Italian word "forte," meaning loud. Multiple use of *p* or *f* signals the degree of loudness or softness the composer intends.

Tone Color

Tone color is the quality of sound produced by various instruments, voices, and all other devices to generate sounds in musical performance. Physically, tone color is determined by many factors that result in the presence or absence, as well as the intensification, of certain overtones in the sound as heard by the human ear. The specific tone color of an instrument depends on the method of producing the sound and on the material and construction of the instrument. Three main divisions have been traditionally recognized based on the method of sound production: (1) strings, (2) winds, and (3) percussion. The sounds may blend together into a single **sonority,** or they may retain their individual qualities even when played or sung together. The tonal quality of the human voice is determined principally by the anatomy of the singer— whether soprano, alto, tenor, or bass—as well as by the way the singer uses his or her voice.

In the twentieth century, a whole new range of tone colors has been introduced into music through the employment of electronic devices. True electronic music is generated by the electronic medium itself. The production of

sound on the electronic synthesizer is of this nature, as in the *Brandenburg Concerto no. 3* by Bach recorded under the title *Switched-on Bach.*

Electronic media are also used for the manipulation of precreated sounds. This can be illustrated by the use of tape recorder, amplification, electronic resonating devices, and filters. An example is *Gesang der Junglinge* by Stockhausen (see page 383).

Traditional instruments have also been used to produce new tonal effects. Performing techniques such as glissandos on both woodwind and brass instruments, bowing on the untuned portion of the strings behind the bridge of stringed instruments, plucking the strings of the piano with fingers, or plectra, are only a few of the new techniques in use today. New tonal effects are also obtained by adding devices normally foreign to traditional instruments.

Beyond this, composers have called for a great number of sounds generated by what have traditionally been considerd nonmusical instruments or devices, such as typewriters, wind machines, automobile horns, and shattering of glass. In their search for new tonal colors and combinations of sounds, composers have often joined together many of these devices. They are also combining these new sounds with those of traditional instruments.

Formal Organization

Musical form is the manner in which the elements of melody, harmony, rhythm, and tone color are organized. While there are many variants, there are only two elementary treatments of formal organization, a fact that indicates the simplicity of all artistic forms. One type of formal organization is theme and variation; the other is repetition and contrast. Obviously, both of these devices can be employed with very brief musical ideas or motives. Moreover, these two means of organization can be quite independently pursued or combined. Both variation and repetition and contrast can be achieved in melody, harmony, rhythm, or tone color, or any combination of these.

Extended formal design leads to such individual and traditional forms as dance, rondo, song form, theme and variation, sonata form, and so forth. In large compositions, such as symphonies, operas, or masses, a number of separate movements, sometimes of different formal design, are joined together for a unified common purpose or expression.

Expressive Content in Music

The expressive quality or musical message depends on our response to the elements and their organization. A musical scholar, or one who has an adequate technical knowledge of music, may enjoy music from an intellectual point of view. Most people, however, respond to music through the emotions and receive their aesthetic experience in terms of subjective feelings, for music

possesses tremendous powers of sensuous appeal through rhythm, melody, harmony, and sonority. It often happens that these feelings become visual by association. A certain rhythmic pattern, for example, may remind one of a galloping horse, evoking a visual impression from the music. An example is the piano accompaniment to Schubert's *Erlkönig*. In *Threnody for the Victims of Hiroshima* by Penderecki, the varying intensities of bands of sound result in a tonal coloring that intensifies the feeling of lament for the victims. For some listeners, it may even trigger the imagination to the degree that they may experience the sounds and sights of that holocaust. In Beethoven's own words, the Sixth Symphony (*Pastoral*) is based on his "feelings when in the country." The average listener associates a visual impression of these feelings with a personal experience in nature. If you have not seen the countryside near Vienna where Beethoven walked, you might associate the music with the nature of your own environment. Even in such abstract emotional feelings as love, tragedy, and joy, you might associate music with particular scenes and events from your own experience.

Composers organize their materials in such a way as to evoke the emotion or visual image that best conveys their message. They do this in much the same manner as visual artists use materials to convey messages. Messages are the expressive content of the music, and composers bring all of their technique, intuition, ideals, and personality into the creative process in achieving this end.

Examples in Music

A simple example of a purely abstract design in musical composition is the first movement of Mozart's *Eine kleine Nachtmusik*, which literally means *A Little Night Music* (a simple nocturne). The entire work, which is in four movements, is written for a four-part string orchestra and constitutes what is known as a classical **sonata.** Without going into a detailed analysis of the first movement, let us observe its features from the standpoint of the basic elements in music just discussed.

Rhythm

The music moves in a very lively four-pulse meter throughout and is absolutely constant and regular. While the overall rhythmic organization gives a distinct feeling of balance, Mozart employed a great number of rhythmic patterns in the narrow sense. Constant variations of the larger patterns are achieved by repetitions of the smaller rhythmic elements, so that a short rhythmic **phrase** is often balanced by a larger one, or vice versa. This constant asymmetry posed against the feeling of complete balance lends rhythmic vitality to the movement.

Melody—Texture
The principal melody is heard almost exclusively in the upper or first violin part. It is characteristically instrumental throughout, with patterns and ranges that preclude any vocal derivation or association. There are many instances of ornamentation—trills, very rapidly repeated notes, and scale patterns—but the movement is basically homophonic in texture. Mozart wrote so skillfully for those instruments not playing the melody that one is rarely conscious of a subordinate accompaniment. His homophonic texture is realized through almost pure **counterpoint,** as each instrument participates in the accompanying structure through a part that is essentially melodic.

Harmony
The harmony is purely tonal. The first part of the movement, which is repeated, presents two groups of thematic materials. The first is in the **key** of G major and the second in the closely related key of D major. A short passage ends the G major section and forms a bridge to the key of D major. The process of moving from one key to another is called **modulation;** the bridge leading to the establishment of the new key of D major is an example. The two keys at first arouse a feeling of contrast and unrest. This feeling is intensified in the short section that follows the repeated first part but is resolved in the final section, where all the thematic material is heard in the tonic key of G major. The final harmonic feeling, then, is repose rather than unrest.

Dynamics—Expressive Content
Mozart made considerable use of dynamic contrasts, but the overall effect is one of conscious reserve rather than dynamic exaggeration. The contrasts tend to suggest coquettishness rather than deep emotional feeling.

Tone Color
There is no attempt to develop any tonal color beyond that of the normal string quality. Mozart naturally exploited a responsive and expressive string quality by employing the most comfortable and typical range for each of the string instruments.

Formal Organization
The movement is that of a very simple sonata-allegro form. The basic treatment is statement, repetition and contrast. This is accomplished through rhythmic, melodic, harmonic, dynamic, and even coloristic statements of very short sections, which constitute the structure known as sonata-allegro form. Subtle variations within the repetitions of materials lends interest to the work, which is, however, decidedly straightforward and simple in presentation.

A second example of the use of musical elements comes from the style known as Impressionism. Debussy's *Nuages (Clouds)* illustrates a much more complex use of the components of music. One may not be completely aware

of all these elements on the first hearing. Repeated hearings are necessary for complete comprehension. The function of *Nuages* is to create a musical impression of the movement of white, fleecy clouds on a summer day—clouds that shift and change without effort. Debussy probably expected his listeners to respond with a serene, languid feeling.

Melody
There are several melodies present, but usually just one at a time. These melodies are not constant; they appear clearly for brief moments and then become lost in the welter of sound. The contour, or lines, of the melodies encompasses a wide range, giving them a distinct instrumental quality.

Harmony
The harmonies of *Nuages* are luxurious, full of rich, mellow sounds built upon chords with many pitches. The sense of consonance and dissonance is very interesting. There is constant harmonic motion, suggesting a slight feeling of tension much of the time. The periods of repose, or consonance, are few and usually very soft. All this lessens the finality of phrasing and adds to the impression of vagueness and constant movement.

Rhythm
In *Nuages*, the rhythm is very complex, even though the music moves rather slowly. This is not dance music. It is difficult to sense the meter because there are few regular accents.

Tone Color
Debussy used many resources of the modern orchestra, including a wide range of instrumental colors. There are distinct melodic lines, most often in the woodwinds. The strings are often used in a sweeping manner, suggesting the feeling of celestial motion.

Formal Organization
The design of *Nuages* follows the principle of modified repetition and contrast. The form is not clear-cut; rather, it is vague and suggestive, like the subject itself. When a climax is expected or a melodic phrase is to be completed, the music suddenly changes, making up a new melody and harmonic background. This near formlessness also reinforces the original idea of the subject matter, providing an example of fused organization applied to music.

Expressive Content
The total effect of the way in which Debussy used these musical materials is the expressive content. He succeeded in the functional task he had set himself. He created a bit of music that suggests the vague, wandering motion of

clouds, a motion that is experienced visually. Because the harmonic tension is never very strong, there is no strong emotional response. Because the melodies are vague and the form indistinct, there is a suggestion of atmosphere.

A Suggested Analogy

Because of the difference in technical terminology and the lack of a traditional correlation among the arts, it is extremely difficult, and often dangerous, to attempt an analogy between the elements of music and the elements of the visual arts. There is agreement that sociocultural forces affect both types of art, but there has been little attempt to draw analogies among the materials and elements of each in a useful manner. It is not necessary that an exact comparison be made, but you will become more aware of the affinity among the arts if some analogy is suggested.

Visual line has its counterpart in the melody and rhythm of music. The spatial element is suggested in music both by gradation of tone color and by the tension of dissonant harmony, which seems to bring things forward in a plastic sense. The same is true of painting. Visual form is closely allied to aural form, for the same principles of design are utilized in both. Unity of organization has no direct counterpart in music, but the sense of either fused unity or separate unity is suggested by the clarity of melody and harmonic texture, by the consistence of rhythm, and by the contrast of one musical element with another. Visual color has a direct analogy in **timbre,** or tone color, of instruments, played both separately and in combination. The materials of visual art are also analogous to the kinds of musical tones produced by a percussive action on a string or other vibrating material or by mechanical devices, such as drawing a bow over a string or setting a column of air into vibration by a reed, lips, or vocal cords.

It is not suggested that a comparative analysis of a symphony and a work of sculpture, both from the year 1800, will reveal conformity in every element. There are too many objective and subjective factors for this to be true. If, however, the two works grew out of much the same social condition, they will show a surprising degree of conformity in design and general organization. Our study will show, for example, the clear relationship between the Gregorian chant and the Romanesque cathedral. We will also see that a Bach fugue and a Rembrandt painting both arise out of the spirit of the Baroque, and both conform to the pattern of organization typical of the period. In the twentieth century, **Op art** and electronic music are both closely related to physics. One produces optical effects of illusion through color and line manipulation through a variety of technological devices, and the other evokes aural sensations by electronic manipulation of sounds. For persons who can both see and hear the objective elements in these works, for those who can relate them to the cultural scene, the resultant aesthetic experience will be unforgettably real.

The three examples of art that we have analyzed, the *Sistine Madonna, Eine kleine Nachtmusik,* and *Nuages,* parallel most other works of their historical periods. Other historical periods have their own patterns that we will try to differentiate, recognize, and understand as we journey through history. An increased awareness of the elements of art and their place within the social milieu will also help us understand our cultural heritage.

Summary

In keeping with the third aim of this study, to develop techniques of critical analysis, we must define and explain the elements of the visual arts and music.

All artists, whether visual or musical, are concerned with principles of design. There are really only two basic principles of design—repetition and contrast, and theme and variation. All creative artists use these principles in some form to achieve enough variety to stimulate interest and enough unity to avoid chaos.

The elements in the visual arts are: line, space, color, medium, and form. After a brief and elementary explanation of each of these elements, we focused on Raphael's *Sistine Madonna* as an example of how an artist used the elements to achieve an expressive message in keeping with the style and function of Renaissance art.

The elements of music are: rhythm, pitch, melody, harmony, dynamics, and tone color. After a brief and elementary discussion of these musical elements, we analyzed two musical compositions to demonstrate how composers can achieve their expressive ends by using these musical elements and the principles of design.

Suggested Readings

In addition to the specific sources that follow, the general readings on pages xxi and xxii contain valuable information about the topic of this chapter.

Arnheim, Rudolph. *Art and Visual Perception.* 2d ed. Berkeley: University of California Press, 1974.

Boyden, David. *Introduction to Music.* 2d ed. New York: Knopf, 1970.

Copland, Aaron. *What to Listen for in Music.* rev. ed. New York: New American Library, 1964, New York: McGraw-Hill, 1957.

Dondis, Donis A. *A Primer of Visual Literacy.* Cambridge: MIT Press, 1973.

Kreitler, Hans, and Kreitler, Shulamith. *Psychology of the Arts.* Durham, N.C.: Duke University Press, 1972.

Langer, Susanne K. *Philosophy in a New Key.* 3d ed. Cambridge: Harvard University Press, 1957.

Myers, Leonard B. *Emotion and Meaning in Music.* Chicago: University of Chicago Press, 1961.

Pepper, Stephen C. *Principles of Art Appreciation.* New York: Greenwood Press, 1949.

Taylor, Joshua C. *Learning to Look: A Handbook for the Visual Arts.* 2d ed. Chicago: University of Chicago Press, 1981.

Wölfflin, Heinrich. *Principles of Art History.* New York: Dover Publications, n.d.

3

THE GREEKS AND THEIR PREDECESSORS
(ANTIQUITY-100 B.C.)

Chronology

Visual Arts	Music	Historical Figures and Events
▪ Venus of Willendorf (c.20,000–18,000 B.C.) ▪ Lascaux cave paintings (c.14,000–10,000 B.C.) ▪ Mycerinus and His Queen (c.2,500 B.C.) ▪ Acrobats and Bull (c.1,500 B.C.)		
▪ Phidias (490–432 B.C.)	▪ Pythagoras (c.582–c.500 B.C.) ▪ (Greek modal scales)	▪ Aeschylus (525–456 B.C.) ▪ Sophocles (496–406 B.C.) ▪ Persian Wars (c.490 B.C.) ▪ Socrates (470–390 B.C.) ▪ Plato (427–347 B.C.) ▪ Athens at War with Sparta ▪ (c.404 B.C.)
▪ Praxiteles (390–330 B.C.) ▪ Lysippus (c.360–c.316 B.C.)		▪ Aristotle (384–322 B.C.)

Pronunciation Guide

Aphrodite (Ahf-roh-dy'-tee)
Apollo (Ah-pol'-loh)
Aristotle (Ah'-ris-tot-tul)
Athena (Ah-thee'-nah)
Dionysus (Dih-oh-nih'-sus)
Hermes (Hur'-meez)
Lysippus (Lih-sip'-pus)
Mercury (Mur'-kyu-ree)
Nike of Samothrace (Ny'-kee of
 Sah'-moh-thrays)

Parthenon (Pahr'-the-non)
Pergamum (Pur'-gah-mum)
Pericles (Peh'-rik-lees)
Phidias (Fi'-dee-us)
Plato (Play'-toh)
Praxiteles (Prax-i'-ta-lees)
Prometheus (Proh-mee'-thee-us)
Pythagoras (Pi-thag'-oh-rus)
Venus de Medici (Vee'-nus day
 May'-dee-chee)

Study Objectives

1. To introduce artistic activity prior to the Greeks.
2. To define humanism and its realization in Greek art.
3. To understand the intellectual concepts revealed in Greek life and art.

Paleolithic Period

Art objects and artifacts are important sources of information about civilizations prior to written history. The number of artworks lost because of their impermanence can only be imagined since many were created using organic materials subject to destruction by fire, flood, and decay. By comparison, objects created from metals or stone are more likely to survive the ravages of time and nature. They too, however, are susceptible to deterioration, and may bring to our eyes a decidedly different appearance than they possessed originally. Among the earliest objects that have survived because of the relative permanance of material and favorable location is the *Venus of Willendorf* (fig. 3.1), a small stone figure found in Austria, dating from roughly 20,000 B.C. (Upper Paleolithic era). It is a symbolic sculpture most probably designed to represent and call forth human fertility. Primitive peoples associated fecundity with the female rather than the male and chose to represent females in their fetishes. The reduction of detail and the exaggeration of aspects of the human form in the *Venus of Willendorf* lend this ancient work features strikingly similar to much twentieth-century sculpture.

Because of their artistic quality, state of preservation, and antiquity, the paintings in the Lascaux caves near Montignac, France, are among the most important art discoveries of the century (colorplate 8). According to one widely accepted story, the paintings were discovered in 1941 by children playing in a field. Deep within those caves, primitive artists had painted human and

*Colorplate 8
follows p. 8.*

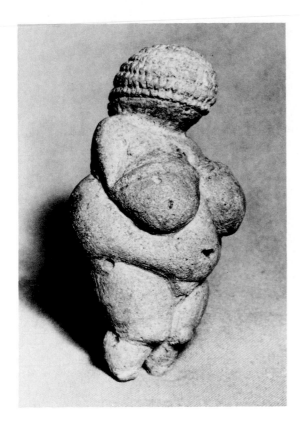

Figure 3.1 *The Venus of Willendorf* [c. 20,000 B.C.]. (Natural History Museum, Vienna)

animal figures and weapons, using mixtures of red and yellow ochre, natural colors found in iron ore. In spite of the fragile nature of the materials used in these paintings, they have survived. In places, the walls are fairly covered with stylized figures that represent animals common to that part of Europe. It is one thing to represent an animal with proportional accuracy, but quite another to express its nature and movement. These unnamed artists captured the essence of the animals, using expressive lines and subtle colors.

Because most of the record of the people of the Paleolithic period has been destroyed, we will never know with certainty the purposes of their art objects. They may have been used in religious rituals related to some aspect of the hunt, they may express recognition of a common spirit among living things, or they may be an emergent effort to express ideas or events in a manner approaching written language. Attempts to establish explanations for the artistic efforts of civilizations that endured many millenia ago risk being flawed, but it seems safe to conjecture that both *The Venus of Willendorf* and the cave paintings of Lascaux were closely related to primitive religion. One thing is known; in those early millenia, art played an important role in life.

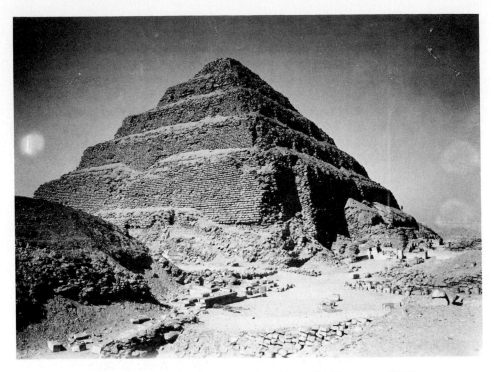

Figure 3.2 The Step Pyramid of Saqqara (Marburg/Art Resource, N.Y.)

Egypt

Fifteen thousand years after the creation of *The Venus of Willendorf,* Egyptian culture began to emerge. It was the first civilization in recorded history to make substantial contributions to art and architecture. For more than four thousand years, Egyptian arts evolved and were refined. Like the Paleolithic period, religion was the primary impetus for Egyptian art. In early dynasties, Egyptians worshiped a huge array of gods and goddesses represented in art by a mixture of human and animal figures. Much of the impulse for worship sprang from an abiding interest in life after death. This interest was manifested by the construction of tombs that, with their decoration, were designed to provide a permanent residence for the deceased. The deification of kings, making them permanent figures in the panoply of gods, was begun during their lifetimes, as they constructed lavish tombs with statuary and paintings for their remains. At the time of their death, these tombs were filled with the art treasures, food, and household goods valued by the King-God.

The Step Pyramid was the dramatic feature of a funerary complex of structures in honor of King Zoser (fig. 3.2). Pyramids are a lasting image associated with Egyptian architecture and have long been considered one of

the seven wonders of the world. The Step Pyramid of Saqqara is the oldest of these grand monuments. This two-hundred-foot high pyramid rises in six steps to its pinnacle. Imhotep, the earliest architect known by name, built this structure of dressed stone c. 2800 B.C.

The simpler, and better-known, geometric pyramidal shape evolved over one thousand years. The construction of these monuments involved the moving, shaping, and elevation of thousands of massive blocks of stone, some weighing over one hundred tons. The external surface appearance of these pyramids was made smooth by the application of thick layers of a plaster-like material. The interior engineering and decoration were carried out with great care and imagination. The Egyptian collection of works at the Louvre museum from the IV Dynasty was entombed in the famous pyramids of Giza. (I. M. Pei has designed pyramidal structures for his recent addition to the Louvre, thereby bringing some fundamental structural images from ancient Egypt to this important museum.)

The second lasting image associated with Egyptian civilization is that of the Great Sphinx at Giza (fig. 3.3). While this sphinx was to represent the facial features of Chephren united with a leonine body, other sphinxes were created in an enormous variety of animal/human combinations. These grand sculptures often combined the faces of deified kings and bodies of magnificent animals to reflect the power of the monarch.

Much of the meaning of these pictorial images was not understood for centuries. Egyptology, the science of archeology applied to Egyptian civilization, began in the late eighteenth century. Napoleon, in his imperialistic frenzy, made an expedition to Egypt in 1798. This led to the exploration of the temples at Luxor and Karnak, two sites three hundred miles southeast of Cairo. These temples, and several others, may be of greater architectural importance to western art than are the more famous pyramids (fig. 3.4). The Greeks most certainly copied the **post-and-lintel** construction of the Egyptians and may have developed their stone **capitals** in response to some seen in Egypt. The several kinds of capitals in Egyptian temple construction served an ornamental as well as structural purpose. Some had the appearance of a single, open flower; others looked like a papyrus bud, a lotus, or a bundle of palm leaves. The columns were grouped for support and to provide shade in the scorching desert. They were often incised, as in the temple of Amon at Karnak. These incised pictorial images collectively presented a narrative, the meaning of which was lost for centuries. It was a French Egyptologist, Jean Francois Champollion, who in several steps involving a series of fortuitous discoveries, deciphered the entire Egyptian alphabet.

The obelisk is another architectural form derived from the Egyptians. It is a slender, tapered square shaft surmounted by a pyramid. Those found in Egypt were often covered with decorative writing and images and were commemorative structures with characteristics of both sculpture and architecture. The Washington Monument in the nation's capital is obviously derived from the obelisk.

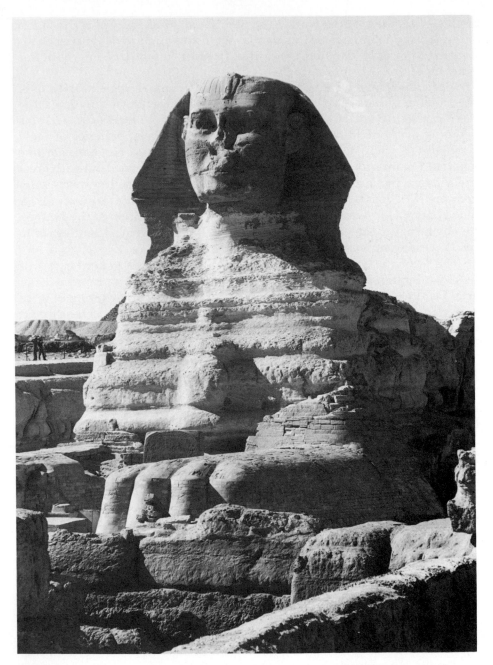

Figure 3.3 Giza, Cheops pyramid, sphinx (Marburg, Art Resource, N.Y.)

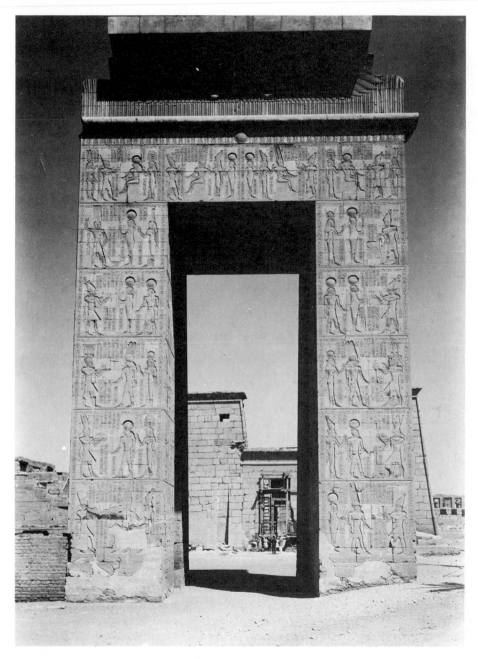

Figure 3.4 Karnak, temple (Marburg, Art Resource, N.Y.)

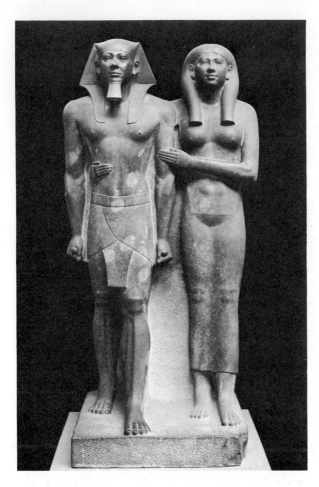

Figure 3.5 *Pair Statue of Mycerinus and His Queen.* From Giza Harvard MFA Expedition [Dynasty IV, 2599–1571 B.C.] Basalt, H (Complete Statue): 54½". (Courtesy, Museum of Fine Arts, Boston)

A feature of many Egyptian art objects is their grand scale: pyramids reaching four hundred feet high, a fifty-six-foot statue of Ramses II, the Temple of Amon (the largest of all Egyptian temples at one thousand × three hundred feet in area). Yet much tomb painting contains pictures of delicacy and refinement. Birds and vegetation may be painted with a considerable degree of realism adjacent to hieroglyphics that are abstracted symbols of familiar objects. (Here again, in spite of Egypt's favorable dry climate, paintings on wood reach us in comparatively small numbers. But relief or incised representations on smooth surfaces (flat or curved) are more abundant.) The Egyptians developed their own conventions of presenting figures in space and in motion, and their treatment of perspective may appear naive and arbitrary to twentieth-century eyes.

The sculpture of *Mycerinus and his Queen* (fig. 3.5) enhanced their power and status and likely aided in their deification. The figures are nearly life-size

and are presented in a rigid formal pose with an emphasis on stasis and solidity. The three-dimensionality of the figures was obtained by imposing frontal and side views of the figures on two facets of a block of stone and carving away the material extraneous to the two views. As is common in Egyptian sculpture, the bodies of these figures are generalizations of the human figure. The faces are the primary sources of individuality, and even they are generalized to some degree. Like much Egyptian art, this statue communicates a feeling of serenity and monumentality.

Since no notated Egyptian music exists, much less is known about music than about the other arts. There is, however, written evidence of music in Egyptian culture, including choral groups in the service of Egyptian kings. There are also visual representations of musicians performing on instruments. *Feast at the Home of Nakht. Detail: Musicians* (colorplate 9) is a painted panel depicting three figures in Egyptian attire playing rudimentary stringed and wind instruments. The faces in profile, the almond-shaped eyes, and the general gracefulness of line are characteristic of Egyptian figure painting.

Colorplate 9 follows p. 56.

Crete

Because of its strategic location in the Mediterranean Sea, the island of Crete, the site of Minoan culture, was a dynamic force in ancient history. Its civilization is almost as old as that of Egypt, but its artistic connection to Greece is much stronger. Our knowledge of Minoan art is based primarily on the ruins of their palaces and the wall paintings. The **fresco** from Knossos, *Acrobats and Bull* (fig. 3.6), features a stylized bull surmounted by an acrobat, between two female figures. The fresco technique is used here to give the wall surface and the bull a varied coloration. However, the most striking artistic impact derives from the elegant attenuated lines that describe the bull's form. The freedom of rendering of this subject is more akin to the style of the cave paintings of Lascaux than to the monumental sculptures of Egypt. Surrounding the figures is a decorative band of recurring shapes, and varied colors and textures.

The Western world has always looked upon Hellenic culture as the cradle of our own cultural development, and as a consequence our first extended study of art epochs will begin with the art of Greece.

The Archaic Age of Greek art, extending from about 1000 to 800 B.C., is the age in which an indigenous Greek art was slowly developing. The second period, often called the Lyric Age and extending from 800 to the sixth century B.C., is noted for its expressiveness and realism. This was the great age of lyric poetry from which the period takes its name. However, neither of these two early cultures reached a pinnacle of quality or perfection to make them an indispensable prelude to our own culture. The Golden Age, or the Age of Pericles, which flourished in the fifth century B.C. and extended into the fourth century B.C., is considered the high point of Greek culture. During this era, there occurred such a development in drama, architecture, sculpture, and

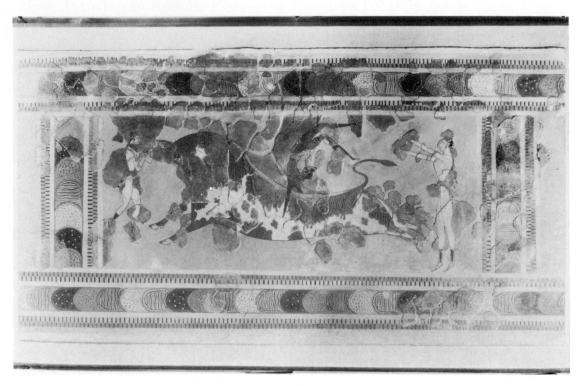

Figure 3.6 *Acrobats and Bull.* Late Minoan fresco from Knossos. (Heracleion Museum)

music that the age is still looked upon as the cultural spring from which our own culture has emerged. The Hellenistic period of Greek culture dates from about 325 B.C. to 100 B.C. and is viewed as a period of decadent Greek art.

The end of the Persian wars in 480 B.C. precipitated a flood of artistic energy resulting in the Golden Age of Greek art. The spoils of war provided the necessary wealth for artistic patronage. Moreover, a feeling of peace settled on the Greeks, which gave them confidence and incentive for artistic production. After all, the gods must have approved of their actions to have given them victory over the Persians. It was a fitting memorial that a great program of public building should be undertaken and dedicated to the gods in appreciation for their protection and guidance. When Pericles came to power about 460 B.C., he embarked on a program designed to make Athens the cultural and artistic center of Greece. The core of the program was the construction of a

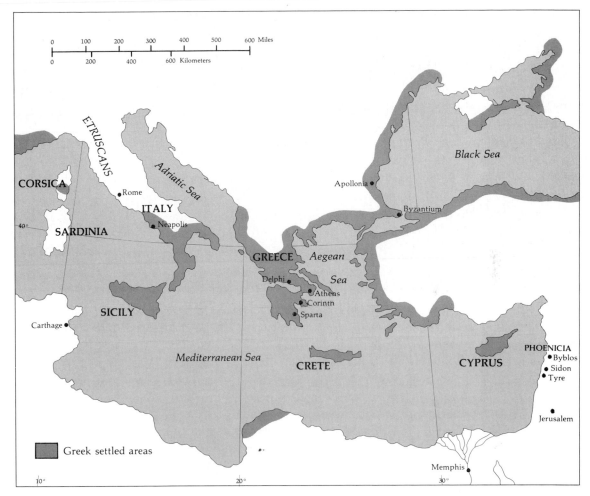

Map of the Mediterranean in the Classic Era

group of buildings on the Acropolis (colorplate 10), of which the *Parthenon* (fig. 3.7) was the largest and most nearly perfect. With such a fertile ground for artistic activity, it is not surprising that Athens attracted the finest scholars and artists from the entire known world. This was the age of Plato, Aristotle, Pythagoras, and Praxiteles, to mention but a few. With the finest minds in the world centered in one city of about 100,000 inhabitants, Athens held the position of the cultural capital of the world.

*Colorplate 10
follows p. 56.*

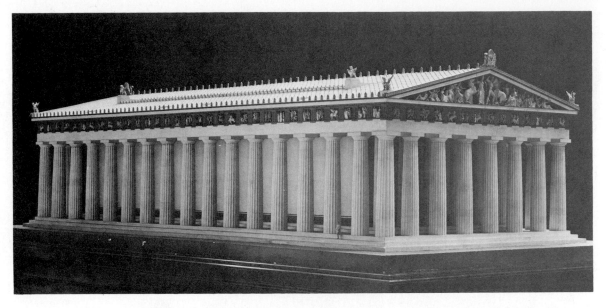

Figure 3.7 Greek architecture. Model of the *Parthenon* in Athens [c. 440 B.C.]—Restored model. (Metropolitan Museum of Art, purchase 1890, Levi Hale Willard Bequest)

Recognizing that art reflects the attitudes of a people toward important aspects of life, we must focus our attention for a moment on the religious, philosophic, social, and economic status of Athenian society. By Athenian society we do not mean all of the people living in Athens. Slavery was an accepted institution, and the peasants were but little better off. Foreigners could live there and transact business but could not hold office or take part in public affairs. It was the freeborn citizens who constituted Athenian society and were patrons of the arts. The dominant attitude of this group can be summed up as one of "this-worldliness." The Greeks were concerned mainly with problems of human life, of life in this world, with all that this implies. To live beautifully and happily was the aim of Athenians, and they believed that man was the measure of all things. The Greek temperament sought to master the world by knowing it and reducing it to a simple mathematical formula.

The Greeks did not harbor the fear and awe of the supernatural found in other early cultures. Life after death held little interest for them, for Greek religion did not confront, as did Christianity, the mystery of death and suffering. The Greek gods and goddesses dwelt in eternal bloom. A Greek tombstone makes no allusions to the darkness of the grave and offers no hope of a glorious resurrection. It shows the commemorated person in some delightful image of the life once lived—a lady selecting a pearl from a basket,

a young man stripped for a foot race with his favorite dog beside him. The Greeks did not look upon death with faith in the future, but neither did they dwell upon it with morbid regret. Sorrow for the departed was dignified by the restrained and simple grace with which their memory was portrayed in marble **relief sculpture.**

The Greek gods were merely human beings endowed with a greater physical beauty and a little more wisdom than ordinary mortals. When the Greeks strove toward the heights of the gods, they sought to rival them for their greater power, not for their moral perfection. The gods themselves were anthropomorphic; that is, they were represented as humans—ideal humans, for the Greeks saw in their gods an idealized likeness of themselves. A different god was created for every aspect of nature and human activity. Zeus was the king of the gods. He ruled from Mount Olympus over such gods as Apollo, the sun god; Mercury, the patron god of commerce and trade; Aphrodite, the goddess of love and beauty; and Athena, the patron goddess of Athens. Besides these, there was a host of lesser gods and goddesses. Greek citizens did not rely on any one god for all their spiritual needs, for the gods themselves were not infallible and could not always be trusted. They could even be outwitted on occasion, as they were by Prometheus when he stole fire from them. Despite their anthropomorphism, the Greeks were a very religious people, building temples and celebrating festivals in honor of the gods. A daily visit to the temple was a part of each day's routine.

Greek thinkers refused to accept the blind will of their gods as an explanation of the universe. They pursued knowledge, finding order and recurrent patterns in all spheres of intellectual activity. It was the basic structure of the universe that they were seeking, and to them geometry and mathematics described it. They brought reason to the fore, using numbers as symbols of the cosmic force that they believed was operating throughout the universe. This mathematical reasoning dominated their whole life, including their art. The Greeks pushed earlier superstitions and magic aside in favor of logic and reason.

It is not difficult to find the results of this basic philosophy in Greek art. It was life that fascinated the Greek artist, and this life was glorified in terms of physical perfection. A perfect body was the incarnation of the perfect mind. What was perfect was both beautiful and good. Their art demonstrates again and again the ideal of youthful physical perfection through which the Greeks expressed eternal love, eternal youth, and eternal play. Interested primarily in the human being, they naturally thought that they should study and theorize about the effects of art, especially music, on people. This belief led to the concepts of **aesthetics** as advanced by such philosophers as Plato and Aristotle. The deep-rooted instinct that the gods were ideal humans was responsible for the emphasis on human form in sculpture—an emphasis that gave rise to the concept of the ideal body in art.

Because Greek philosophy was concerned with the mind, it is natural that their art should reflect proportion and mathematical precision. All Greek art, architecture, and sculpture, as well as music, is permeated with this element of mathematical exactness. On the other hand, the idea of space was difficult for Greeks to comprehend in their limited world, as is shown in their architecture and vase-painting. Space was intangible, without a convincing reality, and was therefore often lacking, especially in architecture.

Architecture

The *Parthenon* (fig. 3.7), dedicated to Athena, the patron goddess of Athens, was the most beautiful and most perfect of all the temples on the Acropolis. Because the highest function of a Greek god or goddess was the protection of the city or state, the temples were actually office buildings that the people occupied for that purpose. The famous maxim about the Greek citizens—"They kept their bodies in hovels but their souls on the Acropolis"—is only another way of saying that religion, exemplified in great public and civic works, was more important in their lives than the desire for personal gain or glory. The idea of a city living under divine sanction and of public service as a virtue implies that artists were also servants of the state. The highest talents of the artist and craftsman were necessary to fulfill the highest duties toward the gods.

We are likely to think of religious buildings as designed to hold congregations. We usually think of the decorations and furnishings of a sanctuary in close association with the particular religious emotion and faith that brings people within its door and possesses their minds during the service. To understand the connection of art with religion in a Greek temple, we must forget this modern version of religious architecture. The Greek temple was definitely the home of the god or goddess who was there, whatever the feeling of the people. Everything in the design and decoration of the temple was based on this belief.

The *Parthenon* was built on a hill to lift it above human dwellings. It is a rectangular chamber of about 220 by 90 feet, surrounded by a freestanding **colonnade.** A considerable portion was walled off and used as a public treasury. The small amount of remaining space in the chamber makes it clear that it was neither intended nor expected to hold a large congregation. Processions and the ritual of popular worship took place outside, with the temple as the center. It was designed to be viewed from outside rather than from within. Consequently, the shed roof and the **column** were the features chosen to give it a quiet serenity, rather than the arch, which shows vigor and strength, especially from within.

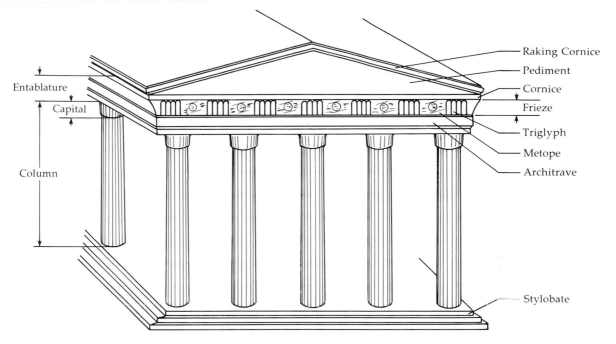

Figure 3.8 Façade of a Greek temple—Beplat.

The main features of Greek architecture and of the *Parthenon* are shown in the accompanying illustration (fig. 3.8). The platform upon which the columns rest is called a **stylobate.** Each column has a capital, an ornate or simple top to the column. Above the capitals and below the roof is the **entablature,** which may have both unadorned and highly decorated spaces.

One of the most important parts of the entablature is the **pediment,** the triangular space at the front and back of the building extending from the cornice, the horizontal line above the columns, to the roof line. The pediment is reserved for some of the most significant sculpture or bas-relief in the building.

All Greek architecture employs a type of construction called post and lintel, in which two or more vertical columns support a horizontal **beam** (fig. 4.1). Because of its availability and quantity, stone was the usual building material, but because of its brittle quality it had limitations. The distance between vertical members was determined by the tensile strength of the horizontal beam. In the case of stone, which is very heavy, the distance could not be great because the weight of the stone itself would cause it to break.

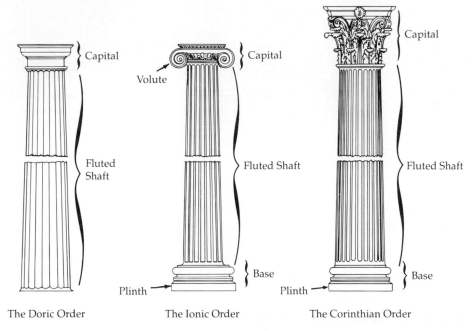

Figure 3.9 The three orders of Greek columns.

Consequently, a building of any size had to have many columns with comparatively little distance between them. Also, buildings of any great height were impractical because of the weight that would be placed on the columns. Nevertheless, the limitations of the material fit into the basic attitudes of the time. There is little sense of space in the *Parthenon* and it stands close to the earth, thus reflecting the Greek concept of this-worldliness. It was only when a different philosophy prevailed, and when different methods and materials were used that religious architecture began to point toward the heavens.

In Greek architecture, special attention was centered on the columns and their elements. There were three orders or types of columns, identified as **Doric, Ionic,** and **Corinthian** (fig. 3.9). Each type represented the culture of the group that used it most extensively. The Doric order was sturdy, strong, and the simplest of all. The fluted columns rested without a base on the stylobate, and were surmounted by a plain capital. The Ionic order, associated with Ionia, was very slender and graceful, rested on a pedestal, and was surmounted by a voluted capital. The Corinthian order, used widely in the luxury-loving city of Corinth, had a very ornate design, with a slender, fluted column resting on a decorated base and a richly ornamented capital, adorned with acanthus leaves.

The most remarkable feature of the *Parthenon*, which utilized the Doric order, is its apparent perfection of proportion. The relationship between the height and thickness of the columns, the height of the pediments, and the dimensions of the temple was determined with such unerring judgment that the whole is neither too light nor too heavy. The lines of the *Parthenon* harmonize so as to give the impression at once of strength and grace. The technical perfection of the temple is no less amazing. The blocks of marble and the drums of the column are joined and adjusted without cement as exactly as in the most delicate of jeweler's art. This feature is even more amazing when we remember that the post-and-lintel type of construction called for the use of heavy stone slabs balanced on marble columns.

The architects were especially concerned with the reality of the viewer's experience. A succession of vertical columns creates an illusion of tilting. In order to avoid this effect, the columns were not placed exactly the same distance from each other. They were also tilted back slightly to give the sense of perfect balance that one does not get from a row of perfectly balanced vertical columns. A slight bulge in each column is evidence of the pressure caused by the weight of the stone pediment on the columns. Walter Teague in his book, *Design This Day*, devotes a whole chapter to the mathematical proportions of the *Parthenon*. The perfection of building again demonstrates the Greek concern for things of this world. Since to the Greeks the human mind is the measure of all things, they believed that it could produce perfection—and they very nearly did.

The *Parthenon* stands as a symbol of a civilization unique in all history because it embodied three facets of life that have never existed simultaneously in any other place in the world. It united religious life with intellectual aims; it reconciled the physical body with spiritual life; and it saturated a whole society with the substance of art as a part of their everyday existence.

The same style, the same general proportions, and the same intellectual and mathematical approach were used in almost all other Greek architecture of this period—never with the same perfection, but with basically the same aim. The philosophy of the Greeks, coupled with their limited knowledge of materials, stabilized their architecture in a pattern that fits almost every example. This style reemerged with force in the Renaissance and in Neoclassicism (figs. 7.7, 8.6, 8.11, colorplates 6, 48). Its more recent impact may be observed in civic, academic and domestic architecture, most specifically in the Greek Revival movement in the United States.

Sculpture

Though Greek sculpture was mainly religious in character, monumental sculpture in honor of national achievements and favorite personalities—important citizens, scholars, athletes, and other people of distinction—was popular. The deep-rooted concept that the gods could be approached through an image in stone brought forth the highest talents of the Greek sculptors.

Of all the visual arts, sculpture was one of the best suited to the embodiment of Greek thought. The most significant sculpture appears to parallel the anthropocentric philosophy of the Greeks that man is the measure of all things. The most significant life experiences were those that could be grasped by the senses, and the degree of their reality depended on the directness of their impact upon the human mind. To be convincingly real, therefore, an object must have convincing form; sculpture had this quality.

Sculpture not only existed as an art by and of itself but also was incorporated into the architectural design of the temple. A sculptural **frieze** was placed in many panels on the exterior as well as on the interior walls of the temple. Because their temples were dedicated to the gods, the Greeks adorned every available space in the pediment and **metope** with figures representing the gods and their activities. In addition, plastic representations of the gods and goddesses were placed in prominent sections or rooms of the building.

There is one notable example where sculpture became part of the structural plan of a temple as well as a decorative addition—the *Erechtheum* (fig. 3.10), with its famous *Porch of the Maidens*. The carved figures carry the weight of the entablature on their heads with such ease that we are completely unaware of the downward thrust. The figures stand gracefully, delicately balanced with one foot behind the other. Each of the bodies carries its burden with the same grace and vitality found in the *Parthenon* columns.

Sculpture also formed an integral part of the *Parthenon* design. The frieze around the wall contained many forms. In addition, each metope was intricately carved with scenes from the life of the gods and incidents pertaining to their origin. There were ninety-two scenes in all, in addition to groups of figures in both the east and west pediments. The artist responsible for the planning and execution of the sculpture of the *Parthenon* was Phidias, one of the greatest of all Greek artists. While he planned and directed most of the work, it is very probable that he was not the sole executor of his own plans. Nevertheless, he left the mark of his genius in the frieze and other decoration of the temple. This was a body of sculpture in quantity and quality superior to that of any other temple in the Grecian world. Color was used as an accessory to carvings in all parts of the building, as some remaining patches indicate. The effect must have been very different from the monotonous whiteness that is a part of current notions about Greek art.

The concern for this life is expressed in these sculptures by the use of the human body and by the lifelike quality achieved. Since the gods were like

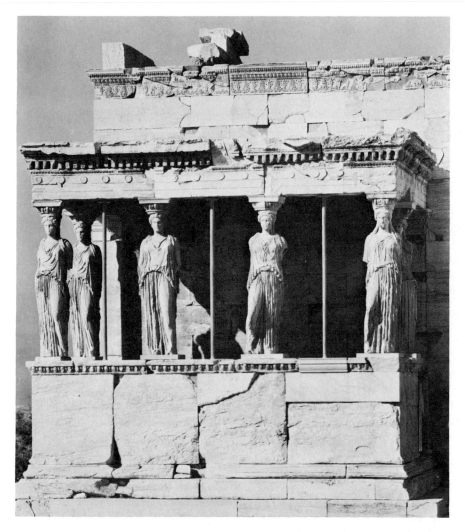

Figure 3.10 *Porch of the Maidens* [421 B.C.]—The *Erechtheum*. (Bildarchiv Foto Marburg/Art Reference Bureau)

humans, their statues must be reasonably realistic. The forms are molded in perfect accord with the proportions of the human body. Even though the statues are executed in stone, one has the feeling that there is flesh and blood beneath the surface. *The Three Fates* (fig. 3.11), which adorns the east pediment of the *Parthenon* and represents the goddesses present at every birth, is an excellent example of realism. The bodies seem warm and lifelike beneath the flowing, realistic robes. The whole group is majestic, serene, and alive, a natural way for Greek artists to portray their goddesses.

The Greeks and Their Predecessors (Antiquity–100 B.C.) 55

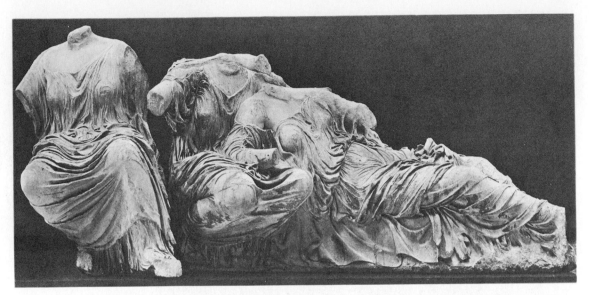

Figure 3.11 *The Three Fates* [c. 440 B.C.]—*Parthenon.* Over life size. (Courtesy of the Trustees of the British Museum)

Praxiteles was another of the great artists of the Golden Age. His statue of *Hermes with the Infant Dionysus* (fig. 3.12) is the only existent statue known to be from the hand of this great master. It is of marble and represents the god Hermes carrying the infant Dionysus on his left arm. The child is reaching for some object, probably a bunch of grapes that Hermes may have held in his missing right hand. Line, always clearly defined in this kind of art, is very delicately molded, as if the skin were stretched over the inner body. The form is human but also closed. There is nothing outside the work itself. All action and direction are centered toward the middle of the statue: the reaching of the child, the direction of the look—even the object, missing as it is, was without doubt in the center of the work. As everything is centered in the plastic form, there is no space-awareness. The parts fuse. One plane melts into another, for the artist was concerned with the total visual effect of the completed perfect body—mind and all—and not with the sum total of separate parts.

Despite the realism of their works, the Greeks did not model their sculpted bodies after real people. They created an ideal human form from their own imagination—an ideal which could only be associated with the gods. For this reason, their sculpture seems to lack personality and individuality of character. These are qualities reserved for humans because they are mortal and possess faults and imperfections of both body and character. The statues of the gods, like the figure of *Hermes*, represent the highest ideal of both mind and body; consequently, no mere mortals could serve as models.

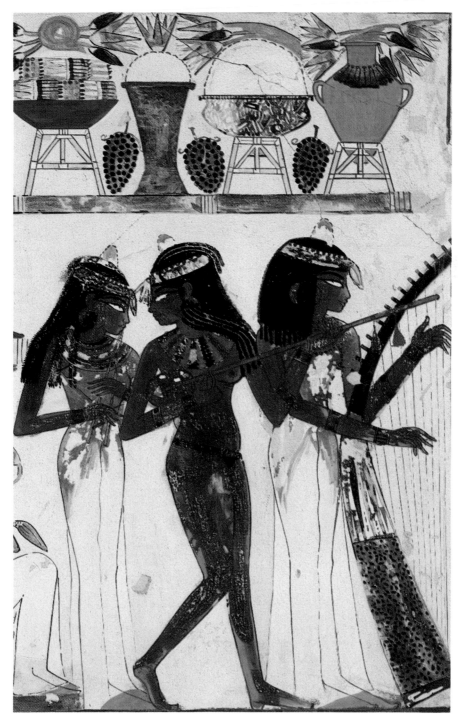

Colorplate 9 *Feast at the Home of Nakht. Detail: Musicians*—(The Metropolitan Museum of Art)

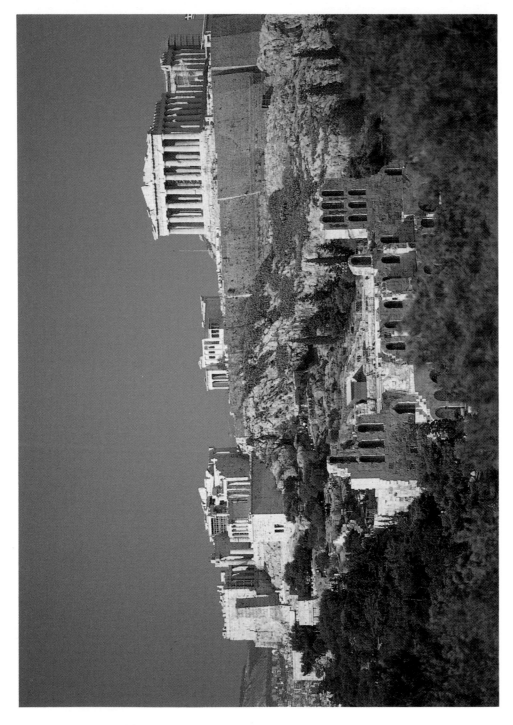

Colorplate 10 View of *Acropolis* and city. (Gian Berto Vanni/Art Resource, N.Y.)

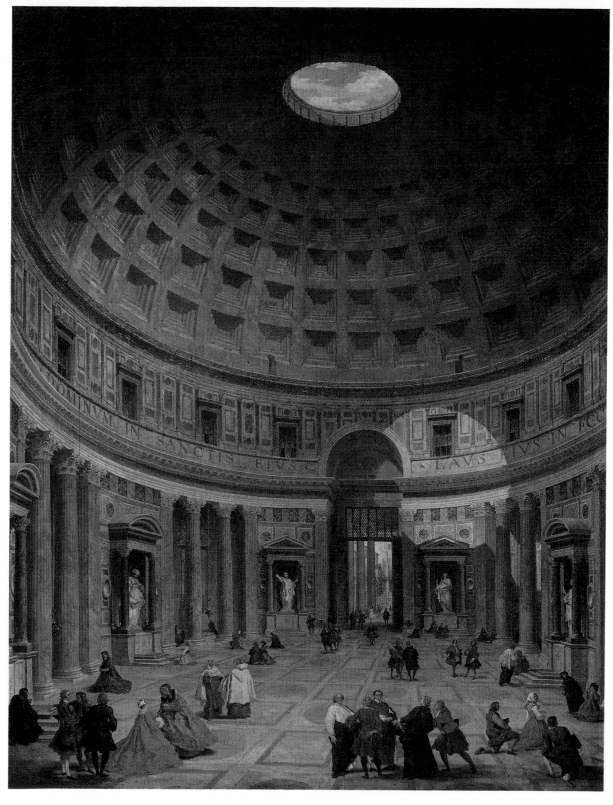

Colorplate 11 Interior of the *Pantheon* [c. 1740]—Giovanni Paolo Panini. Oil on canvas (50½″ × 39″). (National Gallery of Art, Washington. Samuel H. Kress Collection)

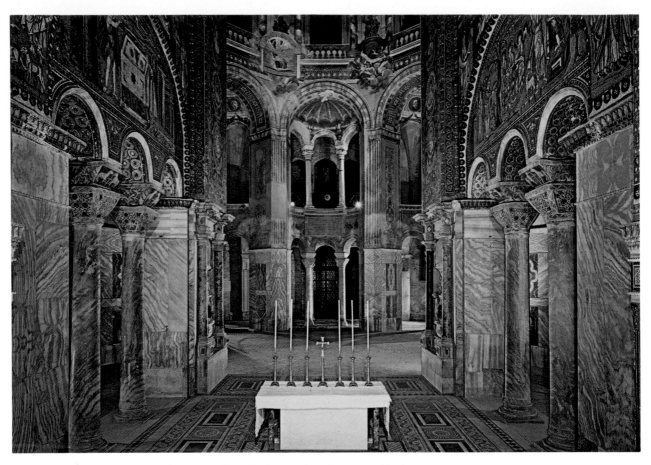

Colorplate 12 *San Vitale* [c. 547]—Ravenna. (Scala/Art Resource, N.Y.)

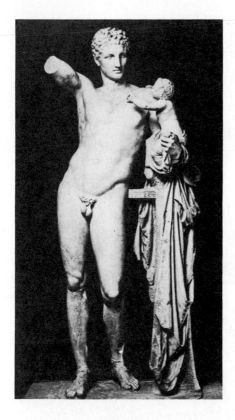

Figure 3.12 *Hermes with the Infant Dionysus* [c. 340 B.C.]—Praxiteles. Height 7'1". Marble copy of probable bronze original. (Archeological Museum, Olympia)

Another great sculptor of the fourth century was Lysippus. The *Aphrodite (Venus de Medici)* (fig. 3.13) is in the style of this master and is quite typical of Greek classicism. The emphasis is on the human form, a posed figure that is static, with no movement. It shows classical proportions of the body, with perfect balance. Its form is closed; there is no interest or suggestion of anything outside of the figure—it is complete in itself. The weight of the body is placed on the left foot, with the right foot slightly behind it, in opposition for the sake of balance. There is little emotion expressed; the figure is serene, refined, and very real, but hardly alive. Several generations later, artists painted facial and bodily expressions that give us a sense of a living person experiencing emotion. The Greek figures of the Golden Age, however, are not yet humanized to that extent, in spite of the dominant attitude of concern for things of this life. The spirit was there, but the method was mathematical. Reason held the answer to all things, and through it everything could be achieved. The spiritual element in the modern sense was lacking, for the gods of the Greeks were too human. The Greeks did not look with awe, or fear, or reverence upon them. They were merely mortals with more intelligence and understanding than humans. The human form was worshipped for itself and not for the soul that dwelt within it.

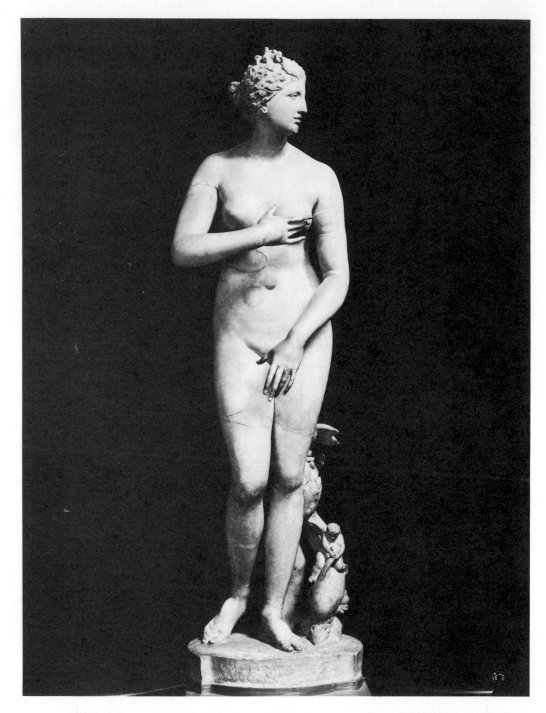

Figure 3.13 *Aphrodite (Venus de Medici)* [c. 200 B.C.]. (Alinari/Art Resource, N.Y.)

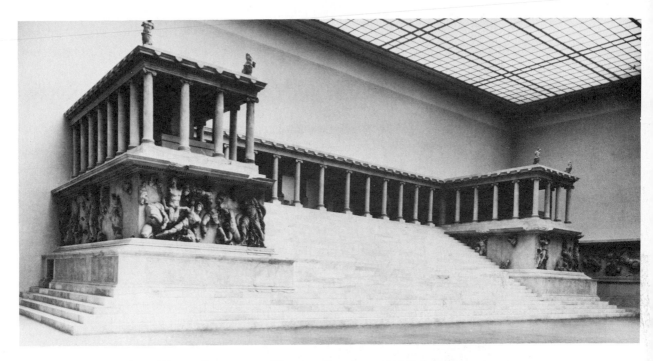

Figure 3.14 *The Altar of Zeus* at Pergamum. (Courtesy Bruchman Art Reference Bureau)

The Athenians were defeated by the Spartans in 404 B.C., triggering the dissolution of Athenian democracy. Because the Spartans—and later Alexander the Great—were conquerors, Greek culture was spread over all of Asia Minor. The Hellenic world became a world of international merchants, industrialists, and warriors. Individualism and personal wealth supplanted civic duty and religious devotion. The calm reason and idealism of the Golden Age faded, and in its place there arose a taste for garish emotionalism, for the exotic, for the vulgar, and for the dramatic.

The temple at Pergamum in Asia Minor shows how the Greek style had changed from the days of the *Parthenon. The Altar of Zeus* at Pergamum, built about 170 B.C. (fig. 3.14), has been reconstructed from archaeological records. It was freestanding, not attached to the temple proper. It stood on a high platform approached by an impressive flight of steps. The sculptured figures, which dominate the altar, represent the struggle among gods and humans; deeply carved figures with wild movement enhance the feeling of violence and agony of the battle. Gone is the restraint of the earlier Greeks. Space, movement, and emotion replace the reasoned balance of the *Parthenon*.

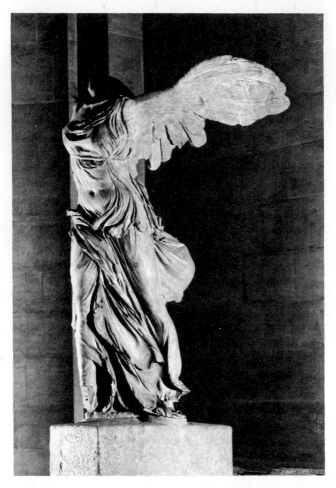

Figure 3.15 *Nike of Samothrace (Winged Victory)* [c. 200–190 B.C.]. Height 8′. (The Louvre, Paris © Reunion des Musees Nationaux)

Perhaps the finest example of Hellenistic sculpture is *Nike of Samothrace* (fig. 3.15), often called *Winged Victory*. The figure of Victory is shown as if at the moment of alighting on the prow of a ship. The spreading wings and the forward movement of the body that causes the drapery to move in the wind give the work a feeling of vibrant life, motion, and space. Greek art had undergone a great change from the Golden Age and was to be further integrated with non-Grecian cultural ideals under the influence of the Romans in the first century B.C.

Painting

A few examples of Greek painting exist in such typical ancient forms as **murals** and panels. The primary sources of information about Greek painting, however, are the many elegant vases that have survived. Although the making of pottery is usually considered one of the minor arts, these vases represent an extraordinary level of artistic ability, rife with creative expression. The vases are adorned with scenes of gods, warriors, heroic events, and myths of endless variety, as well as with scenes from everyday life. The vase paintings cannot be dismissed as repetitive decorations. They demonstrate sophisticated techniques in design and painting and an expression of creative individuality that lifts them beyond the mundane decorations of ordinary painted vases.

In the *Picture on a Greek Urn of a Man Playing the Lyra,* (fig. 3.16), the unknown artist has depicted on this amphora, or wine jar, a rather typical early Greek conception of human and animal forms in the two male figures and the dog. The **lyra** played by the central figure is a simple form of a harplike instrument used by the early Greeks. It had a sound box usually made of tortoise shell, and the strings were struck with a plectrum depicted in the right hand of the performer. The whole of the picture is framed by two bands of designs frequently found in Greek decorations.

Music

The word *music* is of Greek origin, but there is no way of knowing exactly what Greek music sounded like. All the information we have about Greek music comes through the writings of philosophers and scholars, together with a few fragments of stone that contain a version of notation. Two of these fragments, *A Hymn to the Sun* and *Skolion of Seikilos,* have been reconstructed according to the best musical research and made available in recordings, but this reconstruction seems to be merely the product of conjecture.

Greek music was a combination of poetry, music, and dancing—with poetry the ruler, music the accompaniment, and dancing the rhythmical expression of the vocal incantation. As in architecture and sculpture, music was closely connected with religion. It was used as a sort of charm between the Greeks and their gods. Greek festivals were religious and almost always in honor of some god or goddess, such as Dionysus, Apollo, Athena, or Aphrodite. Everyone took part in the festivals as religious and social affairs, and so music had a religious and a social function.

Greek music sounded very different from what we are accustomed to hearing, for it was based on a very different organization of the basic materials. This music was always monophonic and vocal. Most music was accompanied with poetry. Rhythm was determined by the poetic meter of the text.

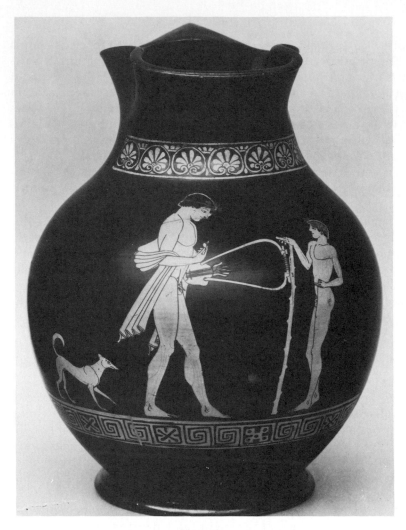

Figure 3.16 *Greek Vase.* Red-figured oinochoe, lyra player, listener, and dog. (The Metropolitan Museum of Art, Rogers Fund, 1922)

The melodic line was determined by the inflection of speech. Since the music was monophonic, there was no harmony in the modern sense. The idea of consonance and dissonance played no part in the musical experience. Notation, based on the letters of the alphabet, was very limited and vague. Some instruments, like the lyra and the aulos, were used, but not harmonically. In performance, they appear to have been limited to imitating what the voice sang. In drama, the music was very important and was probably sung by a number of voices in unison.

In spite of this music's lack of similarity to our own, we owe a great deal to it. Their concern for proportion and mathematical exactness led the Greeks to develop the **diatonic scale,** which is the basis of our modern scale system. Pythagoras, a Greek mathematician, is credited with formulating the mathematical ratios of the fundamental intervals of the scale. The intervals of the octave, fourth, and fifth were considered consonances, or perfect, and all others were dissonances, or imperfect. The interval of the octave, with its ratio of two to one, has been universally accepted as the limit of any scale. Within the octave, all scales, Western and non-Western, are constructed. Pythagoras's conclusions were based on observations of the length of strings and number of oscillations for each note. Our modern science of acoustics is founded on these scientific inquiries into the nature of sound.

Another very important musical concept that came from the Greeks is their doctrine of ethos. The Greeks held the notion that certain scales, or as they were called, **modes,** possessed moral and ethical values in terms of the emotional response of the listeners. Music had a very definite influence on character and, according to Greek writers, could influence the will in at least three ways: music could spur to action; it could lead to the strengthening of the whole being, just as it could undermine mental and spiritual balance; and it could suspend completely the normal willpower, rendering people unconscious of their acts. This doctrine explains the important role music played in the Greeks' system of education and government. Plato, in the *Republic* and the *Laws,* assigns a vital role to the type of music that could be used in education. We still hold to these basic theories, although we do not give this power to scales but to certain combinations of melody, rhythm, harmony, and tone color. Modern science is demonstrating that the values given to music by the Greeks do exist in some measure. Physicians are turning to music as a therapeutic agent in relief of pain, lessening of fatigue, and preservation of mental health. Modern industrialists recognize the value of music in industry as a means of combating fatigue and encouraging greater production.

Summary

The Greeks developed a set of intellectual and emotional concepts that, in their freedom from superstition and intolerance, have never been surpassed. They produced an expressive and lasting art because of a high degree of realism, of imagination, and of humanism. Greek citizens exemplified such real devotion to the principles of truth and beauty and such freedom of intellectual processes that they have become a desirable prototype for all time.

The education of Greek citizens made them aware that what we call culture was an essential part of living, and not something that was to be extraneously sought after, once the material demands of life had been satisfied. It has been said that every free citizen in Athens could play the aulos and take

part in the chorus at the drama. The visual beauties of the *Parthenon* and other temples were matters of ordinary experience to those people. No wonder that creative art flourished as it did and reached the heights of excellence that have seldom been surpassed.

In review of the elements of the arts, we find that, in general, Greek architecture and sculpture showed little sense of space and an almost perfect mathematical balance. Art was, for the most part, calm and ordered, with clarity of line and restrained movement. Even music was subjected to mathematics and avoided the appeal to emotion. Only in the Hellenistic era do we experience violent motion, emotion, and the suggestions of expanding space.

Because the economic and material foundation of Greek life was inadequate, their society collapsed. The artistic glory that lived with Plato and Aristotle faded into an era of sensuality and sentimentality. The Greeks themselves fell victim to their Roman conquerors, but the art of the Golden Age remains as a symbol of a culture that has hardly been equaled for its devotion to truth and beauty.

Suggested Readings

In addition to the specific sources that follow, the general readings on pages xxi and xxii contain valuable information about the topic of this chapter.

Groenewegen Frankfort, H. A. and Ashmole, Bernard. *Art of the Ancient World.* Englewood Cliffs, N.J.: Prentice-Hall, 1984.

Lawrence, A. W. *Greek Architecture.* The Pelican History of Art Series. New York: Penguin Books, 1984.

Pollitt, J. J. *Art and Experience in Classical Greece.* New York: Cambridge University Press, 1972.

Ibid. Art in the Hellenistic Ages. New York: Cambridge University Press, 1986.

Spencer, Harold, ed. *Readings in Art History.* Vol. 1, Ancient Egypt through the Middle Ages. 3d ed. New York: Scribner, 1983.

Teague, Walter. *Design This Day.* New York: Harcourt, Brace & Co., c. 1940.

Thomson, James. *Music Through the Renaissance.* 2d ed. Dubuque, Ia.: Wm. C. Brown Publishers, 1984.

4

THE ROMANS AND EARLY CHRISTIANS
(100 B.C.–A.D. 500)

Chronology of the Romans and Early Christians

Visual Arts	Music	Historical Figures and Events
		■ Carthage destroyed (146 B.C.)
		■ Marcus Tullius Cicero (106–43 B.C.)
		■ Julius Caesar (100–44 B.C.)
		■ Publius Virgil (70–19 B.C.)
		■ Birth of Christ (c.4 B.C.)
		■ Crucifixion of Christ (A.D. c.29)
■ Colosseum built (A.D. 74–80)		■ Publius Hadrian (A.D. 76–138)
■ Pantheon built (A.D. 120)		
		■ Constantine I—The Great (A.D. c.274–337)
		■ Edict of Milan (A.D. 313)
		■ First Council of Nicaea (A.D. 325)
		Constantinople established as capital of the Roman Empire (A.D. 330)
		■ St. Ambrose (A.D. 340–397)
		■ St. Augustine (A.D. 354–430)
		■ Fall of Rome (A.D. 410)

Pronunciation Guide

Ara Pacis (Ah'-rah Pah'-chis)
Constantine (Kahn'-stan-teen)
Etruscan (Et-rus'-kan)
Pantheon (Pan'-thi-ohn)

Pont du Gard (Pont dü Gar)
San Vitale (Sahn Vee-tah'-lay)
Sophia (Soh-fee'-ah)

Study Objectives

1. To learn about the Roman genius for politics and economics as repre-sented in their artistic activities.
2. To learn about the contributions and limitations of the early Christians in art and music.

The rise and fall of Roman civilization, as well as the rise of the Christian church and its spread throughout Europe, are of primary importance to the understanding of the cultural development of the long and mystical period called the Middle Ages or medieval period. Because there were few signifi-cant artistic innovations resulting from Roman domination—Roman art largely imitated Hellenic art—and because the early Church had little orga-nized art, these periods can be covered with a minimum of detail. This does not mean, however, that their contributions were not considerable. A serious investigation of visual art or music reveals tendencies that, while they were not fully developed, eventually played a major role in later epochs. The arts made few aesthetic advances during the days of the Roman Empire, but the manner in which art was utilized was indigenous to the spirit and tempera-ment of its people.

Rome first rose to a position of importance about 400 B.C. A small nation of landowners and farmers, the Romans became aware of their strength by suppressing the Etruscans. They gradually came to think of themselves as a people with a destiny to fulfill—a mission to bring law and order to the world. They set out to conquer and rule the whole then-known world. One of their first aims was to gain economic power by destroying their economic rivals. Carthage, Rome's great commercial competitor, was finally destroyed in 146 B.C. By means of their armies, the Romans further spread their political and economic control. One by one, the Grecian city-states, which were already losing their will to remain free, fell under the Roman yoke.

The influence of Greek culture was spread throughout the Western world by the Roman conquerors. The Romans recognized the superiority of Hel-lenic culture, and they sought to acquire the glories of Greek art by possessing its creators as well as the works themselves. When Greek cities were captured, it was the practice to strip the temples and public buildings of their statues.

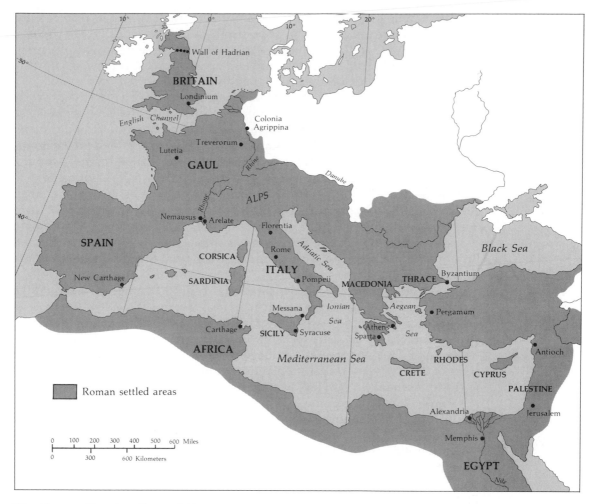

The Roman Empire: Second Century A.D.

There are records of Roman generals returning with enormous quantities of art objects, which then found their way into Roman homes. When this supply was exhausted, the Romans began importing artists to make copies of captured art and to create works in the Grecian style. Scholars, artists, and artisans were brought to Rome as slaves and set the task of supplying the increased demand for Hellenic art. The Imperial City was also immeasurably enriched by the public works engineered by Roman masters and executed by Greek slaves. Some slaves, who gained their freedom through the generosity of their masters, became teachers of Roman youth, thus enriching the cultural and intellectual life of the Italian city.

The Romans were concerned mainly with increasing their power and controlling large geographic areas politically and economically. They were a practical, proud, and mercenary people, with a love for sensual pleasures, lavish living, gladiatorial games, and triumphal parades. They were supreme egoists, spending both time and money in furthering their own ends.

Their religion was akin to that of the Greeks, but they placed more faith in the strength of their armies than in their gods. Like the Greeks, they also were "this-worldly." They had only a vague notion about life after death and put little credence in any idea of immortality. Religion centered on the home, with special household gods for each family activity. Consequently, worship was carried on in the home even more than in the temple. Not content to borrow only art from the Greeks, they borrowed gods as well. Some major Greek gods, like Apollo, were Romanized, and the Romans also took over many other minor gods. They added some of their own to serve their own special interests. The most important of these were Mars, god of war, and Jupiter, god of nature, who could protect them from unseen dangers and the mysteries of nature.

The Romans were also systematizers, excelling in engineering and law. They left monuments of engineering that have become the marvel of the ages. They crisscrossed Europe with a system of military roads, many of which are still extant. They built aqueducts for bringing water into cities from long distances, and they engineered drainage systems that reclaimed thousands of acres of otherwise useless swamplands. These activities were all closely allied with the Romans' self-styled destiny as empire builders.

Roman law has been the basis of all subsequent legal systems of Western civilization. The Romans could never have subjected other peoples had they not perfected a practical system of law and justice. Their law was based on the assumption that standards of justice were determined not by divine revelation but by the common citizen using good sense. As Roman laws were put into practice and legal procedures were standardized, the law was codified and systematized by what we might call "legal engineering." This codification also reveals the Romans' fundamental character as a coldly practical people.

How did these facets of Roman life influence the arts? We shall see that the manner in which the Romans treated the borrowed Greek art demonstrates their basic attitude and character. Furthermore, their own contributions to architecture and sculpture reflect functions that were purely Roman.

Roman Architecture

The architectural needs of the Romans were very different from those of the Greeks. Temples were not so much in demand as were public baths, arenas, and private dwellings. The Romans wanted public buildings where thousands could be accommodated as spectators at public games and entertainments. The Roman arch grew from the needs of a people who excelled in

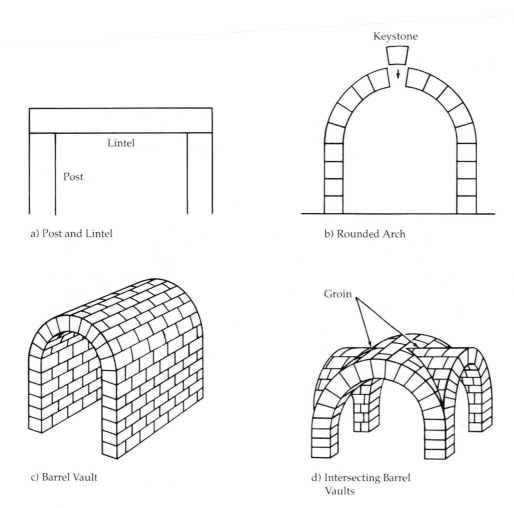

a) Post and Lintel

b) Rounded Arch

Keystone

Lintel

Post

c) Barrel Vault

d) Intersecting Barrel
Vaults

Groin

Figure 4.1 Roman architecture.

large-scale planning and engineering, both materially and politically. The Greek type of post-and-lintel construction was incapable, as we have seen, of spanning large areas of space. The Romans solved this problem by using the **arched vault** of their Etruscan ancestors (fig. 4.1). By crossing two such arches, they produced the **groined vault,** which is capable of spanning large volumes of space, both horizontally and vertically. This technique gave rise to the **dome,** since recognized as a symbol of authority because of its wide use by the Romans in their public buildings.

The *Pantheon* (fig. 4.2) is an excellent example of the adaptation of the Greek design to Roman use. The **portico** is of Greek design, with Corinthian columns supporting a pediment that lacks the proportion and unity of the

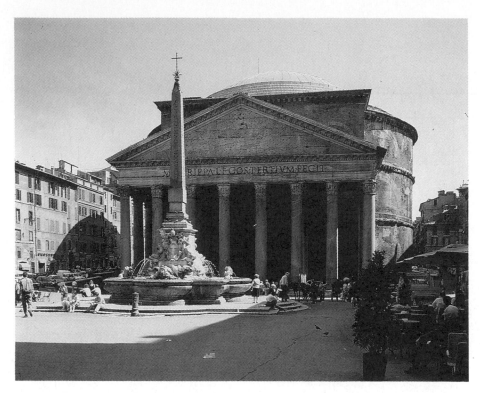

Figure 4.2 *Pantheon* [A.D. 120]—Rome. (Scala, Art Resource, N.Y.)

Parthenon. The main part of the edifice is a huge, oval-shaped structure capped by a dome. Because columns were not necessary to support the roof in this type of building, there was a great, open hall, capable of accommodating huge crowds. The temple, unlike the Greek temple, was to be viewed from within, for the interior is much more impressive than the exterior. It is as high as it is wide, giving a sense of expanding space even more enhanced by the light that streams in through a circular opening in the dome. The plane of the interior wall is broken by semicircular niches that contained the statues of the Roman gods. It is plain that the *Pantheon* was a temple to hold a congregation, more in the manner of our day, rather than an office for a Greek god. While the *Pantheon* (colorplate 11) is one of the best-designed examples of Roman religious building, most others lacked the balance and poise of those built by the Greeks. In spite of the fact that Greek orders were used for the columns, the ornaments were crude in comparison and were not perfectly integrated into the architectural plan. It becomes obvious that the Romans were not natural artists but buyers and borrowers whose copies were always less expressive than the originals.

*Colorplate 11
follows p. 56.*

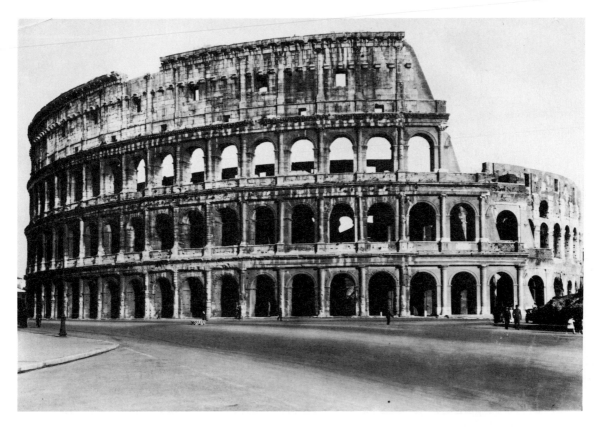

Figure 4.3 *Colosseum* [A.D. 75–82]—Rome. (Art Resource, N.Y.)

Another monument to the Roman urge for space and pleasure is the *Colosseum* (fig. 4.3), the great open-air arena used for games, gladiatorial combats, and for the persecution of the Christians. It is one of the most remarkable structures of its age because of its size and utility. It was constructed on the principle of the round arch. Such arches were placed side by side on columns. By making tiers of arches, it was possible to construct a building four stories high. It is a vast, oval structure about 600 feet long with a seating capacity of about 70,000. Underneath the bleachers there were countless rooms for attendants, cages for wild animals, and even small shops. It was also built in such a manner that the floor of the arena could be flooded. On these occasions the people could enjoy the sight of naval battles being fought before their very eyes. There was little decoration on the *Colosseum,* for the plain, rhythmic flow of columns and arches provided sufficient eye appeal. The whole edifice reflects the Roman efficiency of engineering in solving their spatial and structural problems.

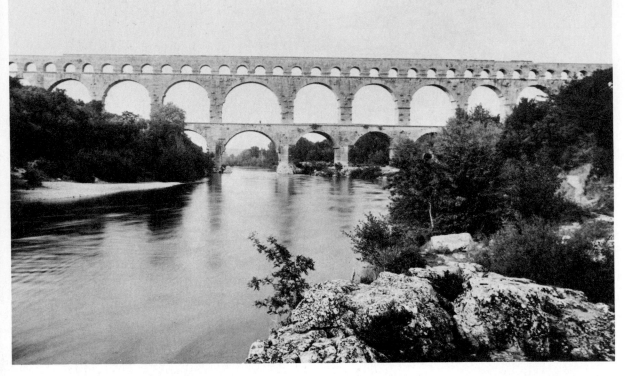

Figure 4.4 *Pont du Gard* [1st Century B.C.]. (Bildarchiv Foto Marburg/Art Resource, N.Y.)

An even more practical use of the Roman arch can be seen in *Pont du Gard* at Nimes, France (fig. 4.4). This was an essentially utilitarian use of the arch. The *Pont du Gard* was built in the first century A.D. as part of a system designed to bring water to Nimes. The portion that crosses the river Gard is about 900 feet long and 180 feet high, certainly a tribute to the Roman engineering skill and sense of order that has an inherent beauty of its own.

The Roman house (fig. 4.5) was more luxurious and spacious than the Greek house. In this respect, it suggests a concern for personal magnificence as well as spatial control. Because much of the owner's personal business as well as worship was carried on in the home, it was natural to spend large sums of money on domestic housing. The lavishly built houses contained many of the conveniences that we think of as modern, such as central heating, running water, and sanitation. The basic plan usually included a central court

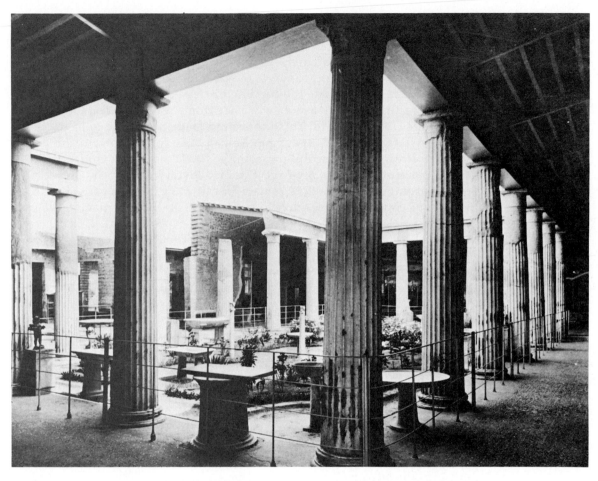

Figure 4.5 *House of the Vettii* [A.D. 65]—Pompeii. (Courtesy University Prints)

surrounded by a columned structure in the Greek fashion. In keeping with the Roman love of luxury, there were elaborate rooms for dining and entertaining. Large parcels of land were reserved for gardens, walks, and pools. The size and extent of the villa were usually in direct proportion to the wealth and political power of its owner. This fact has been confirmed by the excavation of the lava-covered city of Pompeii, as well as by contemporary writings. A sincere appreciation of the finer values of life did not always coexist with wealth and power, however, and it is evident that many Roman villas were sadly lacking in artistic values.

Roman Sculpture

Because art in Rome was not confined to the temples but was in great demand for private use, it was expedient to have copies made of Greek statues and other objects of art brought to Rome as war booty. This was done in part by enslaved artists. To expedite the copying process, the Romans also devised a method of casting in which a mold was made from the original and then plaster copies made from the mold. This innovation made it possible to have copies as they wished. Generally speaking, Roman taste leaned toward the lesser Greek art. It was not the sculpture from the *Parthenon*, for example, that was copied; more often it was art from the first century B.C., when Greece had already lost much of her will to remain free. It was a decadent Greek art that the Romans copied; the more lavish and sensual, the more demand there was for it.

Not all Roman art, however, was imitative. The Romans excelled in portrait sculpture (fig. 4.6, 4.7), and for a very good reason. In order to honor their soldiers, prominent citizens, and merchants, they created sculptural likenesses of them for prominent places in public buildings as well as homes. Moreover, it was not unusual for wealthy people to commission a number of statues of themselves while still living so that a realistic likeness would be available after death. Some even went so far as to have their own tombs constructed and decorated with reliefs showing their heroic deeds. The marble bust of the Roman (fig. 4.6) with its bald head, wrinkled brow, and set jaw depicts their penchant for realistic portrayal. The ideal form did not interest them in the slightest; rather, the heroes were to be portrayed as they actually lived and walked among the people. In order to meet the demands for this kind of sculpture, artists often created a number of torsos of various kinds, such as soldiers and other important citizens. When a certain kind of statue was called for, it was necessary only to model the face. It was then placed on a torso that fit the subject, and the work was finished.

Another lasting innovation was the effect of space created in relief sculptural groups. By making distant figures smaller and placing them behind foreground figures, the illusion of space became quite real. A famous example of this is the *Ara Pacis Frieze* (fig. 4.8), in which there is a sense of recession. The foreground figures are placed in high relief, giving them the appearance of coming forward. The effect is heightened because the artist turned the feet of these figures outward and beyond the flat surface of the marble slab. Furthermore, the background figures are shown in profile while the others have their faces turned toward the observer, adding to the impression of space.

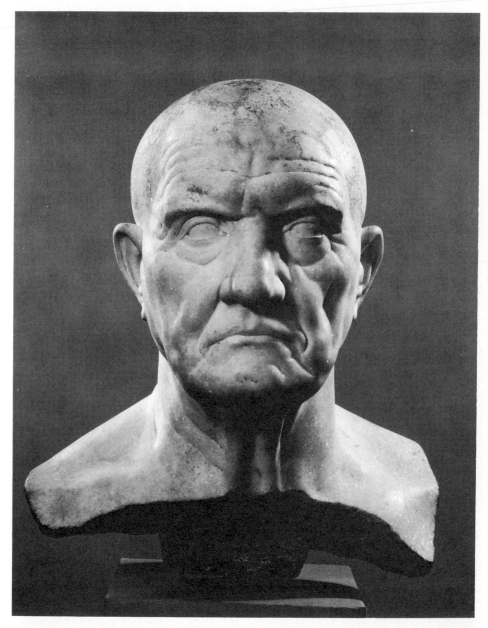

Figure 4.6 Roman bust [1st Century B.C.]. 14″. (The Metropolitan Museum of Art, Rogers Fund, 1912. (12.233))

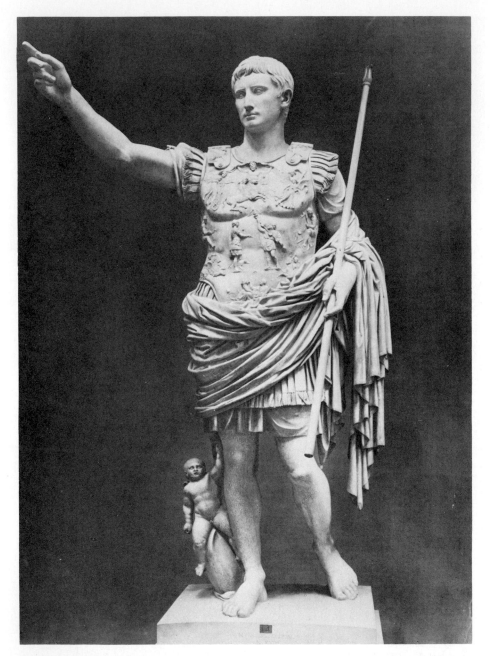

Figure 4.7 *Augustus* of *Primaporta* [c. 20 B.C.]. Height 6'8''. (Alinari/Art Resource, N.Y.)

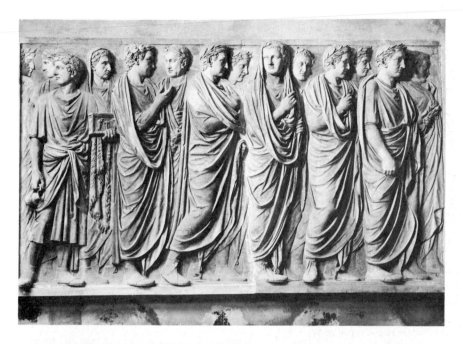

Figure 4.8 *Ara Pacis Frieze*, Procession [c. 10 B.C.]. Width 63″. (Alinari/Art Resource, N.Y.)

We have briefly discussed some Roman artistic activities, although the development of the arch and the dome was as much an engineering feat as an artistic development. The Romans added their concept of space to sculpture, but, in the total picture of Western art, they contributed amazingly little for a nation that was one of the greatest of all time. This perhaps followed from their use of Greek models. A truly great artistic development can come only from the emotional character of a people. The Romans were borrowers, and while they placed the stamp of their own temperament and philosophy on the borrowed Grecian ideals, the original was always more beautiful and glorious than the imitation.

Roman Music

Roman music, like the visual arts, was borrowed mainly from the Greeks, and, as with the visual arts, the decadent Greek music appealed to the Romans more than any other. Roman taste tended toward the spectacular rather than the restrained and balanced lyricism of the Greeks. As might be expected, the function of music was to serve war and pleasure. The trumpet and drum were more useful than the lyra. The Greek tragedies deteriorated into dance pantomimes, which became more popular with the Romans as they became more obscene and sensual. It was this source from which most of Rome's musical life took its nourishment.

Even if it was of rather dubious quality, music was cultivated by the Romans as a mark of education. Witness the emperor Nero, who thought of himself as a great artist above all else. It is one of the ironies of musical art, which was to owe its greatest development to the Christian church, that the early Christians died in flames and at the fangs of wild animals to the accompaniment of music.

Early Christian Art

The rise of Christian art is another story. It combined Greek idealism with that of Christianity, which had a distinctly Oriental flavor and was tinged with Judaism. The early rise of Christianity was phenomenal. From a small group of disciples who were left after the crucifixion of Christ, it mushroomed in less than 300 years to a well-organized religion of universal appeal. The Romans must have felt that the death of Paul, the burning of Jerusalem, and the agonizing death of hundreds of the cult's followers would be sufficient to discourage it. But they were very wrong, and many eventually became converted to the movement.

During its early days, the Church had little place for art of any kind. It had no architecture except the catacombs of Rome, which originally were burial places. It had no wealth, for most of its early converts were from the

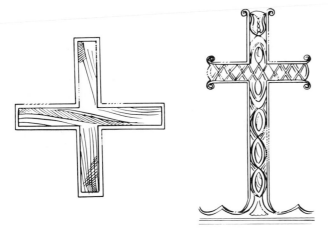

Figure 4.9 Greek and Latin crosses—Sandgren.

lower and middle classes, and art cannot thrive without wealth. Artistic expression had been the prerogative and luxury of the Roman citizen; consequently, the middle class had little or no artistic experience. Another more fundamental reason for the lack of art was its previous association with everything pagan and corrupt. Because Christianity was in direct opposition to the existing religious and social structure, anything that formed an integral part of that structure was damned, together with Roman society itself. It was only after upper-class Romans became converted and after the authorities ceased to persecute the Christians that art began to flourish at all.

Christian art revolves around the ritual and teaching of its various doctrines. Ritual, theology, and symbolism were borrowed freely from the Jews and the Greeks. The part played by Judaism is well known. Needless to say, the Old Testament is Hebraic, and certain portions of the present-day Christian ritual evolve from Jewish practice. The influence of the Hebrew culture came mainly through its literature, especially the Old Testament. Because Jews abided by the Mosaic Law that forbade images, there was hardly any representational art. Since the first Christians were Jews, they brought a good deal of their traditions from the Jewish service to the Christian service. The elaborate chanting of the Psalms was among these contributions.

The religious practices of the Greeks, notably the rites of Baptism and the Eucharist, also contributed to the Christian ritual. The cross itself became, symbolically, the floor plan for the Christian church. Its predecessor, the **basilica,** was derived from the rectangular form of the Greek temples of worship. Most churches in Italy used the design of the Roman cross, in which the upright is longer than the crossarm. Those in the East and in Greece used the Greek cross, in which the arm is equal in length to the upright (fig. 4.9). The floor plan for *Old St. Peter's Basilica* (fig. 4.10) precedes the more elaborate plan for Santa Sophia by some 200 years.

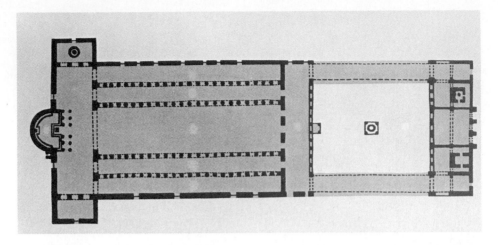

Figure 4.10 Basilica of *Old St. Peter's*, Rome. Fig. 7–4 from *Gardner's Art Through the Ages*, Fifth Edition, by Horst de la Croix and Richard G. Tansey, copyright © 1970 by Harcourt Brace Jovanovich, Inc., reprinted by permission of the publisher.

In A.D. 313, the Roman Emperor Constantine signed the Edict of Milan, an act which legalized Christianity throughout the Roman Empire. Because the center of Roman power was shifting toward the East, Constantine moved his capital to Byzantium, which was later called Constantinople and is now called Istanbul. It was amid these surroundings and under these circumstances that the art of the Orient came to play an important role in Christian art, especially architecture and painting. Later we shall see that the Jews made a substantial contribution in music, for the Asiatic system was previously completely foreign to Western ears.

The style of art and architecture called Byzantine was the result of the influence of Oriental artistic convention on the demands and ideals of the new religion. After the Church became well organized and included more wealthy converts, there was a desire to build churches in a more elaborate fashion. The Asiatic love of brilliant colors, rigid patterns, and feeling for sensuous expression aroused the spirit of mystic exaltation and emotion inherent in a religion that held out the promise of immortality beyond the grave. *Hagia Sophia* (fig. 4.11), located in Istanbul, is the prototype of the influence of the Eastern temperament on Christian art. The floor plan was in the form of the Greek cross, with a huge dome centered over the entire square formed by the cross. Like the Roman *Pantheon, Hagia Sophia* was most impressive from the interior. The marble walls were richly decorated with multicolored **mosaics** of tile against a background of gold leaf. Light, let in by a row of windows set in the base of the dome, played on the jewel-like colors of the interior

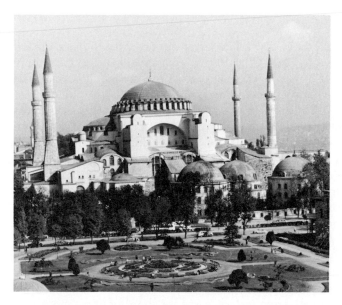

Figure 4.11 *Anthemius of Tralles and Isodorus of Miletos, Hagia Sophia, 532–537,* Constantinople (Istanbul) (Photo © Hirmer Fotoarchiv)

like the rays of sun on a brilliant diamond. In addition, the sacred relics, altars, crosses, and statues were ornamented with precious stones set in backgrounds of richly carved gold and silver.

All of these treasures disappeared during the centuries of Turkish and Arabic rule. Most of the mosaic decoration was covered by decoration symbolic of Mohammedanism. The present-day spires and minarets were added by the Arabs and Moors and have no Christian significance. In recent years, the Turkish government has allowed the layers of later decoration to be removed, showing portions of the original Byzantine art.

Another superb example of the Byzantine style is the church of *San Vitale* in Ravenna, Italy (colorplate 12). It was modeled after *Hagia Sophia* and was richly decorated with colorful mosaics. A sense of great height is intensified by rows of windows at every level that flood the interior with light.

Colorplate 12 follows p. 56.

Mosaics are one of the predominant Byzantine art forms. They consist of small colored bits of tile and glass that were most commonly used to form geometric patterns or natural figures. Their beauty was enhanced by the introduction of controlled light. *Empress Theodora and Retinue* (colorplate 13) is a typical example of this kind of art. There is no lifelike quality, no depth, no movement. It has very sharp lines and is multicolored. The figures stand in isolation even though several of them are in close proximity.

Colorplate 13 follows p. 120.

Early Christian Music

The early Christians, as we have seen, had little opportunity to develop art. This applied equally to music. Early Christian history gives only an extremely vague notion of the use of music, partly because of the inadequate system of notation that made preservation almost impossible. It is known that some of the Jewish chants were used as settings of the Psalms. In fact, these chants probably served as their greatest source of musical material. It is also known that the Byzantine church had some influence on early Church music; just how much is hard to say because of the lack of source material. However, the florid ornaments of the chants are certainly analogous to the brilliant colors and designs of Byzantine architecture.

The melodic lines of this early music spanned a narrow range and emphasized the words at the expense of the music. It was monodic and therefore had no harmony. It was also vocal, for instruments were associated with pagan rites. In Rome, the early Christians were a clandestine group, meeting secretly in the catacombs and always in fear of detection. That they had any music is a wonder, but its power was evident even in the earliest days. Like the Greeks, they saw in music a tremendous force for shaping one's moral life and a means of coming into mystical contact with God.

Early Christian music was intended to be simple and not too emotional. As Christianity grew, there were many who came into the Church knowing the popular songs of the day. Believing these songs to be evil influences, the Church made every effort to purge this popular music from the service. Music existed for one purpose only, and that was to serve God. It could not exist for its own sake as an expressive art form. It is not surprising, then, to find little change in the scope of music during these early times. As an expressive art, music received no encouragement. On the contrary, music for pleasure was a sin, to be dealt with by the Church authorities. It was only after Christianity became the Roman state religion that music, as well as other arts, became an integral part of the ritual and a moving force in the development and spread of Christianity.

As the administration of the church became more centralized, philosophical thought and artistic expression were brought under the aegis of the Church. Of the early leaders St. Ambrose, Bishop of Milan, and St. Augustine, Bishop of Hippo were at the fore of leadership and influence within the Church. St. Augustine was the single most important Christian thinker of his time, synthesizing Christian philosophy and doctrine, and creating an authoritative theology. St. Ambrose is associated with early hymnody.

Summary

The Romans came to be the empire builders of western Europe from about 100 B.C. to A.D. 300. They were mainly concerned with increasing their power and controlling large geographic areas politically and economically. As a result, they became master politicians, lawmakers, and engineers. They were a proud and practical people with ambition for personal wealth and power. Their artistic activity revealed this ambition. Their greatest achievements were in the areas of architecture and engineering. With the invention of the arch and vault, they constructed impressive arenas, baths, and public buildings, and they spanned great areas of space with aqueducts, bridges, and roads.

The Romans admired and copied the Grecian style of sculpture and decoration, especially that of the Hellenic period. However, they made notable contributions in portraiture, sculpting their important citizens, generals, and heroes. They also created monumental friezes that depicted the triumphs of their rulers and armies as they expanded their power over western Europe. There was very little artistic activity that did not serve a functional and practical purpose for the pleasure and glory of the Empire. Space in their art was as real as their ambition to rule the then-known world.

The earliest Christian art did not constitute a style in itself but utilized some of the symbolism of the pagan world. In reality, there was very little artistic activity until Constantine moved the capital of Christianity to Byzantium. Byzantine architecture shows both Roman-Greek and Oriental influence. The multicolored mosaic decorations demonstrate the Oriental love of stylized patterns of brightly contrasted color. While the churches featured the use of great, domed spaces, there was no three-dimensional quality about the mosaic decoration. Music in the early Christian church was confined to vocal chants that were most likely borrowed from the Jewish liturgy. The details of the music are not known for lack of notation and historical records.

Suggested Readings

In addition to the specific sources that follow, the general readings on pages xxi and xxii contain much valuable information about the topic of this chapter.

Ferguson, G. *Signs and Symbols in Christian Art.* New York: Oxford University Press, 1966.

Spencer, Harold, ed. *Readings in Art History.* Vol. 1, Ancient Egypt through the Middle Ages. 3d ed. New York: Scribner, 1983.

Wheeler, Mortimer. *Roman Art and Architecture.* New York: Thames Hudson, 1965.

5

THE MEDIEVAL-ROMANESQUE
(500–1100)

Chronology of the Romanesque

Visual Arts	Music	Historical Figures and Events
	▪ Boethius (c.480–524)	
	▪ Gregorian chant (c.540–1100)	▪ Pope Gregory (c.540–604)
		▪ Rise of the Monasteries (c.650)
		▪ Charlemagne (742–814)
		▪ Second Council of Nicaea (787)
		▪ Feudalism established (c.900)
		▪ Otto the Great (912–1073)
	▪ Guido of Arezzo (c.997–1050)	

Pronunciation Guide

Agnus Dei (Ahn'-yoos Day'-ee)
Ambrogio (Ahm-broh'-joh)
Aquinas (Ah-kwih'-nahs)
Charlemagne (Shar-lah-mayn)
La Madeleine (Lah Mah-de-layn)
Credo (Kray'-doh)
Kyrie eleison
 (Ki'-ree-ay ay-lay'-ee-son)
Gloria in excelsis (Gloh'-ree-ah in
 eks-chel'-sis)

Ite, Missa est (Ee'-te, Mee'-sah est)
Nicaea (Nih-see'-ah)
Notre Dame la Grande (Noh-trah
 Dahm' lah Grahnd')
Pisa (Pee'-zah)
Poitiers (Pwah-tyay)
Sanctus (Sahnk'-toos)
St. Trophime (San Troh-feem)
Vézelay (Vay-ze-lay)

Study Objectives

1. To learn about Romanesque art as the mirror of the religious beliefs and practices of the Church, the dominant medieval patron of the arts.
2. To understand the symbolism in Church architecture.

The Medieval Period

The span of history called the medieval period or the Middle Ages extends from about 500 to 1400. This rather long and mysterious period is divided into two important subperiods, the Romanesque (500–1100) and the Gothic (1100–1400). The medieval period fascinates us not only because of its civilization, but also because of our invisible ties to the institutions and people of that age. Any study of the Middle Ages should include such medieval personalities as St. Thomas Aquinas, St. Francis, and Dante. The middle class emerged from the ranks of the medieval city burghers. Even the condition of the proletariat, which is not merely a by-product of modern industrialism, manifested its burning problems during these times. Furthermore, many of our social, religious, and economic institutions date back to medieval days. Labor unions have their origin in the guild systems of the thirteenth century, and it was also during these times that the Christian church became an organized institution. The universities of today owe many of their traditions to their medieval counterparts; in fact, a few European universities have had a continuous existence since the medieval period.

In contrast to previous art epochs, the Middle Ages wrought a great change in the conditions on which music and the visual arts depended for their prosperous existence and growth. We must survey the basic conditions of social, religious, economic, and political life to have an understanding of the artistic aims and practices of this fascinating age.

The trends of artistic development in the medieval period necessarily include an examination of the basic attitudes of the Church, for the Church was almost the sole patron of the arts and was to remain so for many centuries. All activities of life were inseparably connected with the supreme and new ecclesiastical power, which in a thousand years was to give an entirely new aspect to all of Europe. Soon after large masses of people were moved by the concepts of Christianity, it became an institution for the preservation and propagation of the Christian religion. There then emerged an organization that had the authority to teach, order, and spread its doctrines over the whole then-known world.

The Church was not merely a religious entity. It became the ruler not only over spiritual life but also over economic, political, social, and artistic life. A philosophy of otherworldliness, in contrast to the worldly attitude of

the Greeks and Romans, was the guiding principle. The doctrine of salvation formed the very core of Christianity, and around this doctrine the early rituals and institutions were built. Medieval Christianity did not offer a promise of material well-being. On the contrary, it taught that this life was dirty and sordid—to be endured, not enjoyed, until the final day. Human suffering had the tendency to help Christians concentrate on religion and on the hope of salvation.

Poverty was a virtue because it was less likely that people would be tempted toward evil if they had little of this world's goods. The idea that a rich person had as much chance of going to heaven as a camel had of going through a needle's eye was more than an epigram. If admonition was not enough, there was always the prospect of hell to consider. The medieval Church emphasized the idea of the Devil, who was always on hand to waylay the faithful. He was especially active whenever there were pleasurable pursuits at hand. All avenues of pleasure were therefore closely guarded, and many faithful became hermits in the wilderness to avoid the Devil's persuasive temptations.

The result of this doctrine was the rise of the monastic movement. Groups of devout worshippers banded together in communal enterprises in which they lived, worked, and worshipped jointly. The organization of monastic buildings and their relationships were designed to accommodate this life of work and worship. As the plan of the monastery of Cluny illustrates, a monastery was in a sense a small city, with worship spaces of various sizes, infirmary, bakery, farm, and living quarters (figs. 5.1, 5.2). To a large degree the general plan of monasteries was standardized throughout the Christian world.

The monks, as they were called, took vows of poverty, obedience, industry, and chastity. In this environment one could contemplate God and bring the soul into harmony with the spirit of the Church. One did not labor because labor was a healthy and happy occupation, nor because it would help others; the virtue of labor was that it reduced the fires of passion within one's own soul. The monasteries provided a safe refuge for those who felt the need for spiritual protection.

While the monks spent most of their time in prayer and manual labor, they also found time to pursue intellectual activities. In fact, the learning of the medieval period was centered largely in the monasteries. It was in such an environment that the Church fathers wrote the treatises that were to give them recognition.

Because it was pagan in nature, Greek culture was generally condemned. The works of Plato and Aristotle were banned until the time of St. Thomas Aquinas, in the thirteenth century, and then they were approved only through the interpretation of Aquinas. Doctrines that differed in any way from those laid down by the Church were labeled as heresies. The punishment for such

Figure 5.1 Plan of Cluny Abbey. [Founded 910] Adaptation of Fig. 156 and Fig. 157 from *Arts and Ideas*, Third Edition, by William Fleming, reprinted by permission of Holt, Rinehart and Winston, Inc.

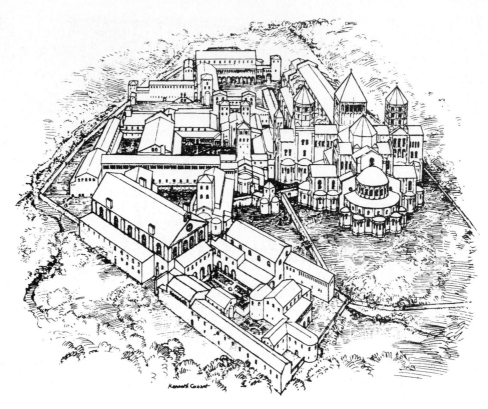

Figure 5.2 Aerial view of Cluny Abbey. Adaptation of Fig. 156 and Fig. 157 from *Arts and Ideas,* Third Edition, by William Fleming, reprinted by permission of Holt, Rinehart and Winston, Inc.

beliefs often was burning at the stake or, at best, some form of torture that would drive out the evil spirits. If the guilty were spared, it was because of repentance and some form of penitence. The Church had an elaborate organization to safeguard the faithful from evil. As H. E. Barnes states in *An Intellectual and Cultural History of the Western World* (p. 295), "It was the great stronghold that guaranteed to the pious the protection against earthly evils and definite assurance of eternal salvation. The Church was like a well-lighted house, looming in the darkness to a man wandering, terror-stricken, in a dark and stormy night."

Another medieval institution that left its imprint on art was feudalism, which reached its zenith about the twelfth century and provided a certain amount of protection and economic stability for the lower classes of society. It also enabled the nobility to exploit the helpless for economic and military purposes. Secular wealth was concentrated in the hands of the feudal lords, who enjoyed complete sovereignty in their own domain. Among the artistic

monuments of feudalism were the massive castles that graced the mountain slopes of medieval Europe. They served much the same purpose as the monasteries in that they provided safety from the hostile forces of neighboring nobles as well as from wandering bands of highwaymen.

Because feudal lords held power by the grace of the Church, it is not surprising to find the Church closely allied to the feudal system. Many of the more powerful lords were also bishops or archbishops who enjoyed a double concentration of wealth and power. The Church and civil authority were, for all practical purposes, one and the same. The nobles often supplied the wealth, while the monks planned and directed the construction and decoration of the churches. The Church and feudalism together were a fortress of economic and political power based on agrarian control. The Church emerged as the guardian of the land as well as the custodian of salvation. To protect its power, it even suggested that people should be content with the station of life into which they were born. As the Church expanded its ecclesiastical, civil, and economic authority, it became the supreme power of medieval Europe.

The Church and Medieval Art

Because the Church was the supreme power, creative art had to have a religious function. This was true in almost every aspect of medieval art and music. Religious architecture was the only type of building that really mattered. Where people lived was of little consequence, for the comforts of life were evil. Illiteracy was almost universal, except among the monks, and thus the biblical stories could best be taught through the visual arts. Painting, stained glass, and sculpture therefore served as tools of religious education.

As sole patron of the arts, the Church could control most aspects of painting and sculpture. In 787, the Second Council of Nicaea established a set of rules for artistic representation of religious subjects that was to be binding upon artists for almost 500 years:

The substance of religious scenes is not left to the initiative of the artists; it derives from the principles laid down by the Catholic Church and religious tradition. . . .His [sic] art alone belongs to the painter, its organization and arrangement belong to the clergy.

This was a very logical rule, since the Church, not the individual, was the guardian of the sacred truth upon which the safety of society and the salvation of the soul depended. Nobody thought of artists as divinely inspired or more knowledgeable than the Church fathers. It was appropriate, therefore, that artists were given exact specifications as to what they could represent.

But this was not all. Having been given subject matter and theme, the artist was bound further by strict conventions governing how sacred subjects were to be depicted. Jesus on the cross had to be shown with his mother on the right and St. John on the left. The soldier pierced the left side of Jesus.

His halo contained a cross as the mark of divinity, whereas the saints had halos without a cross. Only God, Jesus, the angels, and the apostles could be shown with bare feet. It was sheer heresy, therefore, to depict the Virgin or the saints without coverings on their feet. These conventions were intended to help the observer identify religious figures. Thus, St. Peter was given a short beard. St. Paul was always bald, with a long beard. There were numerous other conventions that may seem to have infringed on liberty or imagination in their work.

The structure of the cathedral or the monastic church was also subject to conventions of style and decoration determined not by artistic taste but by theology. The usual floor plan was that of a Latin cross, itself a symbol of salvation in the Church. The Christian **liturgy,** the formal service of worship, determined many of the stylistic practices of the builders. The **chancel,** or **choir,** for example, was designed to separate the clergy from the congregation, as traditional rituals required. The chancel provided a place for the altar, where the service was held, as well as a place for the choir to be seated.

Because it was traditional for the priests and the congregation to face the east, churches were usually oriented with the altar in the east and the main portal to the west. The symbolism of the Holy Trinity was used at every convenient opportunity. Wherever possible, the number three was in evidence— in triple arches, triple portals, and in many other details.

Reverence for holy relics, such as a portion of a holy man's body, was also responsible for architectural detail. Relics had the supposed power of performing miracles for those who paid homage to them, and great crowds of pilgrims would often be attracted to a church because of some special holy relic housed within its walls. To accommodate the many worshippers and pilgrims and to provide altar space for numerous clerics who were required to say daily Mass, small chapels were constructed along the **ambulatory,** the passageway around the **apse** (fig. 5.3). There are other evidences of design arising from religious doctrine or practice, even though most details of design were functional. They served to impress upon the faithful an unquestioning faith in salvation by the cross.

Music also served a religious function during the medieval period, providing a sort of personal communication with God. As with painting and architecture, the Church exercised rigid control over the types and character of music, keeping it simple, unpretentious, and vocal. The liturgical service determined the music's formal structure as well as the subject matter and the text.

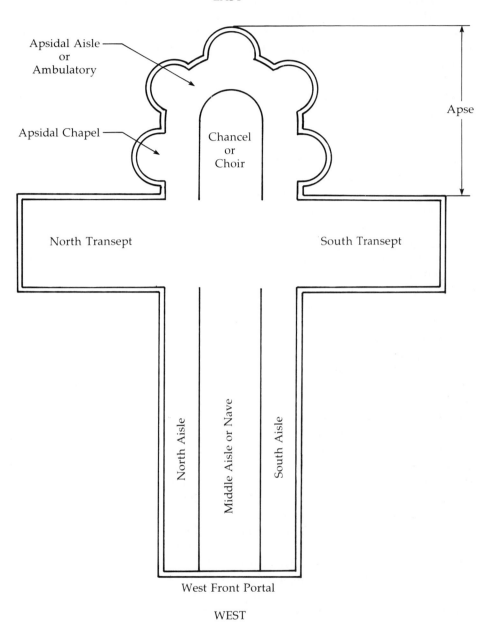

EAST

Apsidal Aisle
or
Ambulatory

Apsidal Chapel

Apse

Chancel
or
Choir

North Transept

South Transept

North Aisle

Middle Aisle or Nave

South Aisle

West Front Portal

WEST

Figure 5.3 Floor plan of a medieval church—Beplat.

Large-scale planning often resulted in a complex of structures around a church. This was especially true in the Italian Romanesque, and a fine example is at Pisa (fig. 5.4), where the Cathedral is flanked on one side by the **Baptistry** and on the other side by the famous Leaning Tower, which contains the carillon.

The Romanesque Period

For the purpose of this study, the Romanesque period can be said to span from about 500 to 1100. The Byzantine style of the early Church remained influential through the formative years, but it was modified by Roman practices and ideas. As events of history moved toward the year 1000, other artistic styles were included in the Romanesque. These styles include the Carolingian, during the reign of Charlemagne, and the Ottoman, which received its name from the Ottoman Empire. The term *Romanesque* refers to the artistic style influenced by the Romans, a style marked by its stark simplicity and its use of the rounded arch. Because the Roman Empire left its imprint on all of Europe during the medieval age, that term designates the period.

Although the Romanesque style dominated from about 500 to 1100, it was not until about the tenth century that there appeared a well-developed body of creative art in the Western church. History has shown again and again that artistic activity is possible only in a well-organized and fairly wealthy society. This society began to appear about 1000. With the gradual reestablishment of law and order after years of barbarian invasions, Europe—which had seen so much of the art and civilization of the Greek and Roman world disappear—was given a foundation for a new and vital civilization. This foundation was brought about by a number of events and achievements. The turning back and assimilation of the barbarians made possible the building of roads in northern Europe and fostered a gradual growth of trade and commerce. The monastic movement and feudalism combined to reclaim the land and to establish a fairly stable, agrarian society. Both of these movements helped to provide economic stability for a new cultural effort.

The Church, now well organized, reeducated its people in the realms of mind, manners, and morals. This reeducation provided moral and spiritual motivation for a new civilization, which then provided the opportunity for creative art forms to develop. Because wealth and social organization were centered largely in the monastic establishments of the Church, it was natural that the architecture, sculpture, painting, literature, and music of the Romanesque should reflect the culture of the cloister.

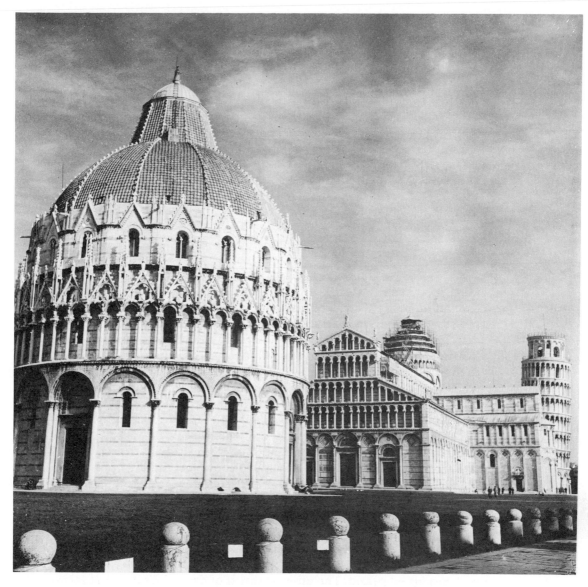

Figure 5.4 *Baptistry, Cathedral,* and *Tower* at Pisa [1053–1272]. (SEF/Art Resource)

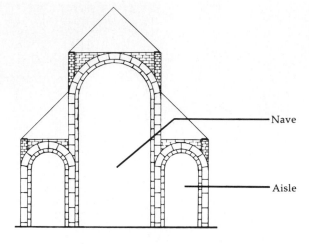

Nave

Aisle

Figure 5.5 Cross section of Romanesque church— Beplat.

Architecture

Romanesque architects and builders, most of them monks or friars, adapted the stone arch of the Romans in much the same manner as the earlier Byzantine builders. They made arches of great solidity and strength, capable of bearing tremendous weight (fig. 5.5). The necessity for fireproof buildings led to the use of heavy stone roofs. To support the great weight, exceedingly thick walls without windows were used. Heavily vaulted ceilings and massive walls reflected the severe asceticism of the monastic builders. The impressive distances and gloomy spaces suggested a spirit of quiet renunciation of the world. A church was a place devoted to the worship of God. There is none of the cheerful brightness of the later Gothic or Renaissance churches. In the dim twilight of the Romanesque aisles, one could feel the very presence of God.

The exterior of *Notre Dame la Grande* at Poitiers (fig. 5.6), built in the eleventh century, is a fine example of the Romanesque spirit in architecture. The triple arches of the **facade** suggest the symbolism of the Trinity. Close examination reveals that the two outer arches are not the same height. This is often the case with Romanesque arches, for the churches were not always planned as an organic unit of perfect symmetry and balance nor built during one, sustained period. The upward thrust of the towers does not seem to give the structure a feeling of height, for the towers are too low for the rest of the building. The total height is about the same as the width. The lines do not seem to flow smoothly from one part to another; on the contrary, there is an abruptness of line that detracts from eye appeal. There is balance between arches and towers, but its effect is minimized by a lack of precision. The church was obviously not planned as a thing of sensuous beauty for the eye but as a retreat in which people could find the presence of God.

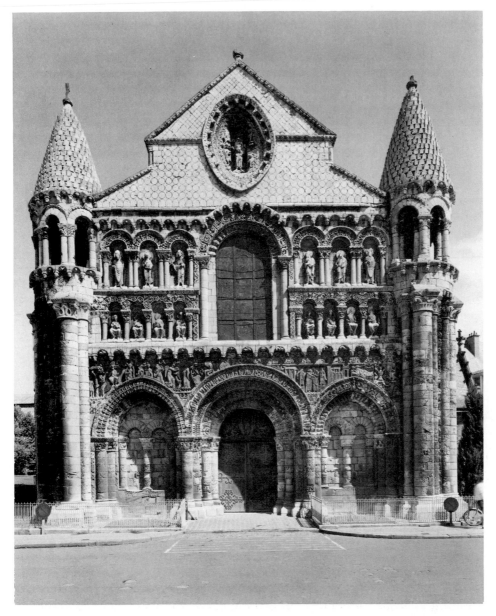

Figure 5.6 *Notre Dame la Grande* [11th century]—Poitiers. (Hirmer Fotoarchiv)

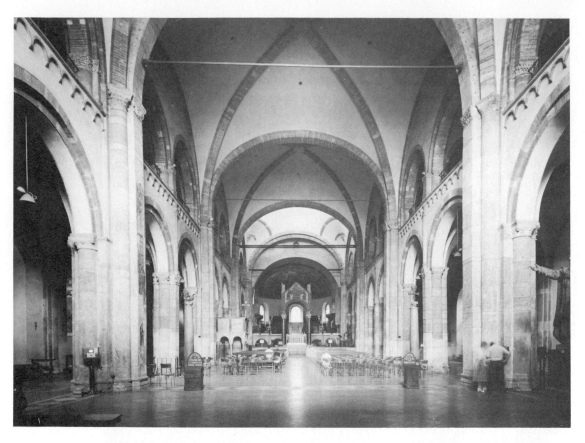

Figure 5.7 Interior of *San Ambrogio* [11th–12th century]—Milan. (Bildarchiv Foto Marburg)

The interior of *San Ambrogio* (fig. 5.7) at Milan demonstrates the treatment of the rounded arch. The **nave** is a series of **bays,** or areas between the heavy **piers.** A system of rounded arches forms the vault for each bay so that the appearance is one of great, hollow areas with a massive ceiling. There is little light from windows, and there are innumerable dark recesses with no illumination except that furnished by burning tapers. Altogether this is a forbidding atmosphere, a cloistered feeling pervades the total enclosed space.

A comparison of these two buildings or any other Romanesque churches with an example from the Greek civilization, such as the *Parthenon*, (fig. 3.7) reveals great differences. The Greek building is open, resting gracefully on

the earth, suggesting a sense of peace and repose. This was a temple that served the needs of the Greeks as they came to worship and then went their way without fear of the wrath of the gods. It was a functional house of the gods but also gave great delight to the aesthetic sense of the Greek citizen. Romanesque buildings, on the other hand, are heavy and dark. They shut out the light of the world around, physically and symbolically. They were places where medieval men and women could come to contemplate God and find a haven from the realities of life. They were functional buildings intended for large group meetings, but with a design and purpose unlike that of the Greek temple. Each in its way reflects the philosophy and beliefs of those who worshiped.

Sculpture

Because sculpture and painting are representational arts, they were expected to deal with the same general subjects in the Romanesque. They were both purely functional in that they served an educational purpose. According to Pope Gregory, who lived around A.D. 600, painting and sculpture were supposed to teach: "What those who can read learn by means of writing, that do the uneducated learn by looking at pictures."

Sculpture was functional in another manner as well. All Romanesque sculpture was subordinated to architecture and was almost always conceived as an architectural decoration as well as an educational device.

Just as the Romanesque churches themselves were architecturally simple, so the sculpture seems archaic in comparison to the rounded forms of a later date. The monks decorated the facades of their churches with sculptural representations of biblical scenes in simple and unsophisticated terms. They reminded all who entered the portals that salvation lay within. The figures portrayed on the facades and columns of the cathedrals were emaciated, elongated, and seemingly more like skeletons covered with fabric than living forms.

This distortion of human form was motivated by two beliefs. First, medieval people denied the importance of this life, and so any human representation need not be realistic. Unlike Greek sculpture, with its delicate, lifelike forms, this sculpture distorted reality to teach a spiritual concept.

The second reason for sculptural distortion is the affinity between sculptor and architect. In most examples, the figures themselves formed a part of the scheme of design and often helped to support the thrust of arches and columns. Because it was general practice to carve columns after they had been placed into position, the form was often dictated by the structural design. However, there seems to have been little conflict, for the limitations of design served only to emphasize the basic forms for which Romanesque faith called.

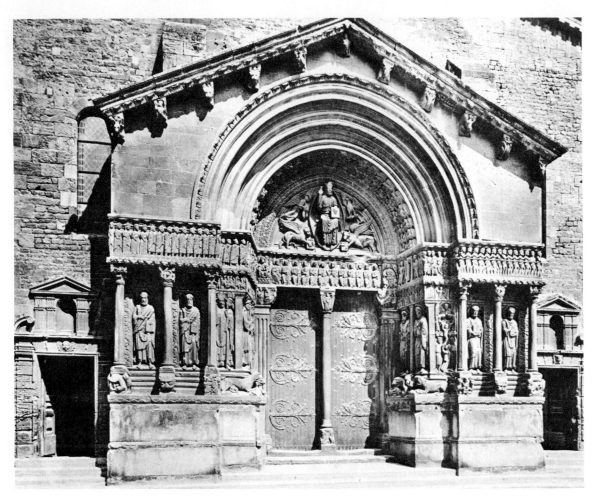

Figure 5.8 Portal of *St. Trophime* [c. 1105]—Arles.

The portal of *St. Trophime* at Arles (fig. 5.8) shows how sculptured figures were brought into the total design as an integral part of the building. Note the stylized rows of elongated figures stretching across the tops of the columns. These figures of the apostles are not realistic. The bodies are flat, with the various members radically out of proportion with each other. One is hardly aware of plastic form. The heads of the figures are greatly enlarged, but they do seem to blend into the massiveness of the total structure. When viewed from directly below, the heads appear more round.

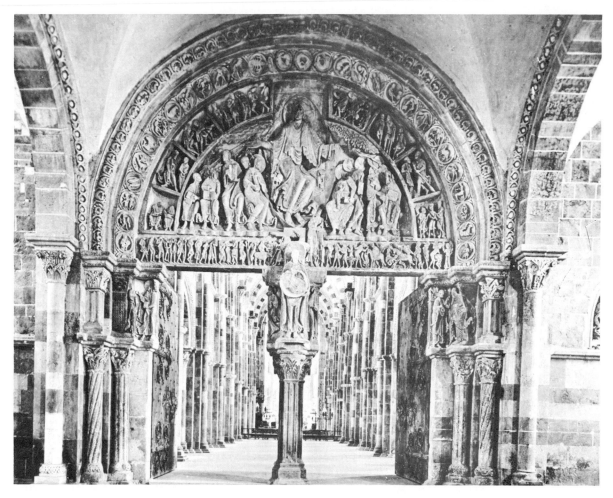

Figure 5.9 Tympanum of *La Madeleine, Christ Sending Forth the Apostles* [c. 1130]—
Vézelay.

The **tympanum,** the area above the doorway and below an arch, of *La Madeleine* at Vézelay (fig. 5.9) is one of the most famous examples of Romanesque architectural sculpture. The subject, the Pentecostal scene, shows Christ bestowing his spirit upon the apostles by means of rays coming from his fingertips. The body of Christ is exceedingly unrealistic. It appears in a very awkward position and gives the impression of a fabric-covered frame of bones. Close examination of the other figures reveals the same lack of realism. The sculptured figures of the tympanum were symbols of faith. They were the spiritual symbols of a faith that denied earthly pleasures but promised eternal salvation to all who accepted its doctrines.

Painting

Painting became more and more important in the scheme of Christian art. It was purely functional, however, and served the same educational purpose as sculpture. There are very few original extant Romanesque paintings because they were usually painted on wood. Either fire or normal decay destroyed most of them.

Colorplate 14 follows p. 120.

The *Crucifixion* from *Santa Maria Antiqua* (colorplate 14) is one fairly good example that has come down to us. Naturally, the crucifixion was a popular subject because its role in salvation was the focal point of the Church's doctrine. Here, as in sculpture, we find a denial of the flesh in art. These figures are not at all real. As in earlier mosaics, there is no sense of space. The painting has a vague feeling of closed form and a slight impression of unity. There is classical balance, with the figure of Christ on the cross as the focal point of interest. The human form has been elongated both to deny the reality of the flesh and to suggest Christ's agony and suffering. This was a painting less likely to please the aesthetic sense than to impress upon the beholders the Christian significance of the cross.

Painting and sculpture were hardly independent arts in the Romanesque. They were an integral part of architecture used to emphasize the spiritual purpose of the church building.

Music

As the medieval Church exerted its influence, the conditions for the development of music changed as they had for the visual arts.

Under the patronage of a fairly well-organized Church, music was ordered according to the liturgy and in keeping with a simple, ascetic faith. The medieval denial of physical matter is again apparent in the lack of instrumental music. Because instruments were commonly used for secular purposes, they were at first banned so that worshippers might not be diverted from their spiritual aim. In addition, the use of instruments by the pagan Greeks and Romans militated against their use as a religious musical medium. Vocal music was the dominant music in the religious service; it had to be simple and unpretentious in its expression of religious sentiment.

In general, Christian music took its forms and liturgical order from the Byzantine church and the Jewish temple. The Byzantines contributed the use of the hymn tune. More importantly, however, many melodies stemmed directly from the highly ornamented Jewish-Oriental chants. The theoretical basis and modal system were acquired from the Greeks. In fact, the names of the modes were taken from the Greeks, but they did not indicate the Greek tonal relationships. The basis of the tonal relationships in Western music was the result of the acoustical mathematics of Pythagoras.

It took a long time for music to reach a degree of importance comparable to that of architecture and sculpture. Several styles of chant were developed in the Western church in keeping with the variety of liturgical practices and languages. In Spain, for example, the chant was known as Mozarabic; in northern Europe as Gallican. The chant used in Rome came to be called Gregorian chant because of the encouragement and leadership of Pope Gregory (540–604) during whose tenure these chants were gathered and codified. The Gregorian chants, which eventually became the exclusive music of the Western church, flourished most from the fifth to the eighth century, but their composition continued until the twelfth century. No composers, however, are attached to these melodies; like folk songs, they have an anonymity that tends to give them a traditional and timeless character.

The function of the Gregorian chant was to express a simple faith in God in keeping with the otherworldly spirit of the age. All chants shared four important characteristics: (1) they were based on the church modes; (2) their rhythms were derived from Latin texts; (3) they were monophonic; and (4) their composers remained anonymous. Their musical forms consisted of settings of the various texts of the service. As an organized body of well-regulated religious practices emerged, one of the important developments was the liturgy, or order of service, called the **mass.** Eleven pieces of music were normally needed for the celebration of solemn Mass. These were divided into two sections. The Ordinary, consisting of the Kyrie, Gloria in Excelsis, Credo, Sanctus, and Agnus Dei, was constant and used the same texts for every service. The second section, the Proper (which may be spoken or sung), changed texts from service to service according to the needs of the Church calendar. It consisted of the Introit, Gradual, Alleluia, Offertory, and Communion (fig. 5.10).

Gregorian chants were based on a series of scale patterns known as the church or ecclesiastical modes (ex. 5.1). Each of the modal scales represented a different arrangement of the seven tones of the octave system (the notes represented by the white keys of the piano keyboard). The octaves D-d **(Dorian),** E-e **(Phrygian),** F-f **(Lydian),** and G-g, **(Mixolydian)** became the basis of the eight church modes. Each mode had its own **dominant** and **final,** which served as the axes around which the other tones moved.

For the medieval Church, as in ancient Greece, each modal scale had particular emotional significance. The melodies or chants constructed on these modal scales assumed these attributed characteristics.

Example 5.2 is a Kyrie from the Ordinary of the Mass and dates from the tenth century. It is written in **neumatic musical notation** on a four-line staff, commonly used in the tenth century and later adopted by the Roman Catholic church. Example 5.3 is the same chant on a five-line staff, written in the modern notation that gradually became the standard. This Kyrie is highly melismatic; the long, florid melodic passages, which are sung to the final vowel *e* of the words Kyrie and Christe, are typical of such chants. In medieval times, words

Sung		Recited	
Proper	*Ordinary*	*Proper*	*Ordinary*
1. Introit			
	2. Kyrie		
	3. Gloria		
		4. Collects, Prayers, etc.	
		5. Epistle	
6. Gradual			
7. Alleluia or Tract (in Lent) with Sequence.			
		8. Gospel	
	9. Credo		
10. Offertory			
			11. Prayers
		12. Secret	
		13. Preface	
	14. Sanctus and Benedictus		
			15. Canon
			16. Pater Noster
	17. Agnus Dei		
18. Communion			
		19. Post Communion	
	20. Ite, Missa est or Benediction		

Figure 5.10 Sung and recited parts in the normal presentation of the Mass.

were often added to these **melismas,** and the first words often gave the name to the chant. Example 5.2 became known as the *Kyrie fons bonitatis* (Kyrie of the fountain of goodness) since these words began the added text that was placed under the notes of the long, decorative melisma. Later Church edicts forbade the use of verbal additions, but the chants often retained the name even though the text disappeared from use. The chant text is in three parts, a form that became traditional in the Mass service. The text is Greek and represents one of the oldest parts of the Mass. Kyrie eleison (God have mercy) is repeated three times, followed by Christe eleison (Christ have mercy) also repeated three times. The opening Kyrie is then repeated again, twice in an altered version of the opening setting and finally in another slightly altered version. Both of the altered versions, however, employ the final half of the opening Kyrie melody. The chant is strictly in the Phrygian mode (see ex. 5.1). The final tone is the note *e*, not only at the final **cadence** but also at the end of each of the three sections. The note *c* is the dominant tone of the mode

Example 5.1: Charts of Modes

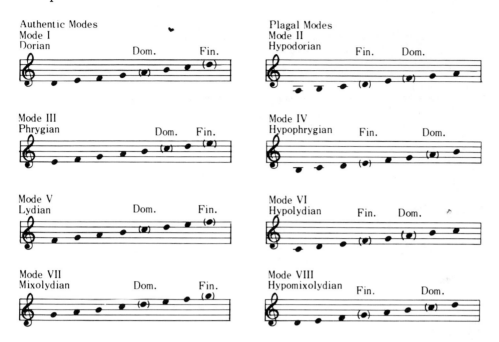

Authentic Modes
Mode I
Dorian
Dom. Fin.

Plagal Modes
Mode II
Hypodorian
Fin. Dom.

Mode III
Phrygian
Dom. Fin.

Mode IV
Hypophrygian
Fin. Dom.

Mode V
Lydian
Dom. Fin.

Mode VI
Hypolydian
Fin. Dom.

Mode VII
Mixolydian
Dom. Fin.

Mode VIII
Hypomixolydian
Fin. Dom.

and provides a center for the musical climaxes of the chant. The range of the chant is predominantly upward from the final tone *e*, which is characteristic of Mode III. The three repetitions of each phrase demonstrate the symbolism of the number three in the art of the Church. The musical structure of A (first Kyrie), B (Christe), and A (final Kyrie) is another example of the symbolic use of the number three. In addition to its religious symbolism, this three-part formal structure is satisfying aesthetically. The familiar pattern of statement-digression-restatement, or statement-tension-repose, appears often in the architecture, sculpture, and painting of the Romanesque and of the following centuries of Western civilization.

The Gregorian chant was used for the setting of the **Proper** and **Ordinary** sung parts of the Mass, and in addition there were many chant settings of hymns, liturgical parts of Office Hours of the Church, and chant settings for other special occasions. The chants varied in style from intonations, in which the same tone was used to set long prose passages, such as the psalms, to simple settings of a single tone for each syllable of the text, to very elaborate chants, in which single syllables were prolonged by the florid vocalizations called melismas.

Example 5.2: Neumatic Notation, *Kyrie fons bonitatis*—X.S.

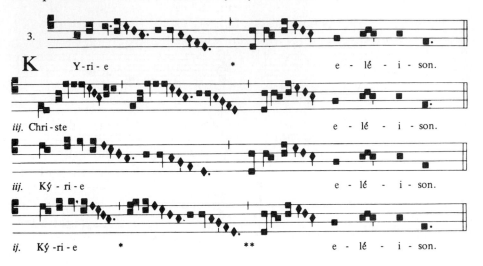

Example 5.3: Modern Notation, *Kyrie fons bonitatis*

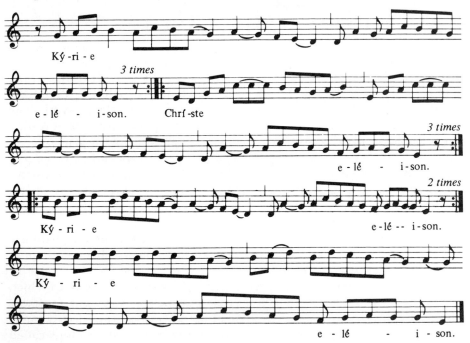

This music, like Romanesque architecture, is simple and straightforward. It is a fitting commentary on the stark beauty of the architecture and sculpture. In the medieval period, the three arts combined to lift the devout into a spiritual exultation completely detached from everyday existence.

Summary

During the medieval period, which includes both the Romanesque and the Gothic, the Church was the primary patron of the arts. Moreover, because the Church held political, economic, social, and spiritual power, it was able to dictate the function, the subjects, and the style of most art and music. A philosophy of emphasizing the spiritual life dominated and permeated both religion and the arts. Almost all the clergy were members of monastic orders that functioned as havens from worldly temptation. We are indebted to the monastic orders for the preservation of classical learning and letters. They were also the principal architects of the nonsecular buildings as well as the secular. All art and education were under the influence and guidance of the clergy; consequently, religious doctrine dictated the rules by which religious personages and subjects were represented. The same is true for music. The growth and development of musical composition and the performance of sacred music were the province of the monastic clergy.

Feudalism was another institution that left its mark on medieval civilization. It gave some stability and economic protection to the lower classes and consolidated the wealth and strength of the nobility. There was usually a close relationship between the feudal lords and the Church, for the lords ruled their domains with the blessing of the Church.

Romanesque builders used the Roman arch and vault, with massive walls and dark interiors, as the principal method of construction. There was little sense of classic balance and symmetry of design. Churches were not planned for their beauty but as havens for the faithful.

The main function of sculpture and painting was religious education. Figures were usually distorted and physically unrealistic, almost to the point of denying the reality of the flesh; this was, of course, in keeping with the Church's denial of the world. Religious symbolism played a great part in all the arts—in architectural plans, in the details of sculptured and painted figures, and even in music.

Music was ordered to the specifications of the liturgy and in keeping with a simple and ascetic faith. The Gregorian chant, based on ecclesiastical modes or scales, emerged as the most widely used music in the Western church. The liturgical texts dictated the choice of modes, formal organization, and style. The chants varied from simple or syllabic to highly ornamental, with many notes to a single syllable. The music of the chants was monophonic, a fitting reflection of the simplicity of Romanesque architecture, sculpture, and painting.

Both the visual arts and the music of the Romanesque are faithful expressions of the early medieval spirit. The monastic simplicity of life was expressed in unsophisticated facades, in ascetic-looking sculpture, and in monodic melodies of the Gregorian chant. As the Christian church fastened its hold on every facet of spiritual life, it also controlled the artistic expression of that faith. As time progressed, though, the feeling of otherworldliness became less powerful. New cultural and intellectual ideas spread over Europe on the heels of the Crusades. New economic forces cast a different light on the social, political, and religious patterns of life. The result was the age of the Gothic—still infused with a medieval spirit but tempered with an intellectualism and humanism that was to reach its full fruition in the Renaissance.

Suggested Readings

In addition to the specific sources that follow, the general readings on pages xxi and xxii contain valuable information about the topic of this chapter.

Barnes, H. E. *An Intellectual and Cultural History of the Western World.* Rev. ed. New York: Reynal and Hitchcock, 1941.
Ferguson, G. *Signs and Symbols in Christian Art.* New York: Oxford University Press, 1966.
Hoppin, Richard H. *Medieval Music.* New York: W. W. Norton, 1978.
Thomson, James. *Music Through the Renaissance.* Dubuque, Ia.: Wm. C. Brown Publishers, 1984.
Zarnecki, George. *Art of the Medieval World: Architecture, Sculpture, Painting, the Sacred Arts.* New York: Abrams, 1976.

6

THE MEDIEVAL-GOTHIC
(1100–1400)

Chronology of the Gothic

Visual Arts	Music	Historical Figures and Events
■ Abbot Suger (1082–1152)		
■ Notre Dame Cathedral (1163)	■ Abbess Hildegard of Bingen (1098–1197)	
■ Wells Cathedral (c. 1190)	■ Bernart de Ventadorn (fl. 1150–1180)	
	■ Perotin (c.1150–c.1240)	
	■ Organum (c.1182)	
	■ Trouvères, troubadours, and minnesingers (c.1200)	
		■ Roger Bacon (1214–1294)
		■ Magna Carta (1215)
■ Salisbury Cathedral (c.1220)		
■ Amiens Cathedral (c.1225)		■ St. Thomas Aquinas (1225–1274)
■ Chartres Cathedral rebuilt (c.1240)		■ Dante Alighieri (1265–1321)
■ Giotto (1266–1337)		
	■ Guillaume de Machaut (c. 1300–1377)	
		■ Francesco Petrarch (1304–1374)
		■ Papacy in Avignon (1305)
		■ Giovanni Boccaccio (1313–1375)
		■ Geoffrey Chaucer (1340–1400)
		■ Black Death (c.1348)

Pronunciation Guide

Amiens (Ah-myăh)

Chartres (Shahr-tr)

Cimabue (Chee-mah-boo'-ay)

Giotto (Joht'-toh)

Machaut (Mah-shoh)

Michelangelo
(Mih-kel-ahn'-jel-oh)

Or la truix (Ohr lah troo-ee)

Perotin (Pay-roh-tăh)

Pisano (Pee-sah'-noh)

Rheims (Răs)

Rouen (Roo-ăh)

Siena (See-en'-ah)

Study Objectives

1. To learn about the Gothic arch, the skeletal frame that made great height and enormous window space possible in architecture.
2. To understand how music became an artistic form in which interwoven melodies and rhythmic elements were organized into polyphony.
3. To study how humanism and secularism found their way into the arts.

The spiritual attitude that dominated the Romanesque was not as strong and sure during the Gothic. In the earlier period, people believed that the world was a God-inspired mystery that could be expressed in simple, direct art. In the Renaissance that followed the Gothic, people believed, as did the Greeks, in cultivating rationalism and humanism for their own sake. Between these two periods came the Gothic, in which there was a gradual swing toward **humanism,** a movement that focused on the accomplishments of humankind, replacing the earlier spiritual or mystical emphasis. In place of a blind faith in the life hereafter, there arose an intellectualism and a religious skepticism that eventually caused the separation of Church and State. The artistic consequence was a body of creative art that was intellectually ordered and full of secular influences but still fundamentally expressed the religious fervor of the age.

This change in the degree of otherworldliness came about through the subtle influence of a variety of trends and events. When the year 1000 passed into history without the predicted end of the world, people began to think in terms of a more pleasurable life. Salvation through the remission of sins was still paramount in their thinking, but they reduced it to a formula. They organized theological doctrines into a scientific system of philosophy called scholasticism. It argued that while religious dogma was unquestionable and infallible, it could be explained and clarified by means of logic and reason. Spiritual life and salvation were thus subject to academic scrutiny.

Scholasticism was the product of the medieval university that had evolved from the earlier monastic schools. The medieval curriculum was divided into the so-called quadrivium and trivium. The quadrivium included arithmetic,

geometry, astronomy, and music—all under the heading of mathematics. The trivium included rhetoric, grammar, and logic. These subjects were looked upon as systematic studies, influenced by the idea of order. Not only religion, but architecture, painting, sculpture, and music were reduced to a set of strict rules and formulas. The same protocol that bound the Romanesque painter applied to the Gothic. In addition, architecture was subjected to an elaborate plan of religious symbolism, and even music was ordered according to strict canons of procedure. The very fact that music was listed under the heading of mathematics is evidence of the influence of scholasticism.

This philosophy gave rise to innumerable rules in all areas of artistic effort. These minutiae lent weight and proof to the tenets of religious doctrine. Consequently, there was less individual creative imagination in the arts than we normally attribute to such endeavor. It is not until the Renaissance that artworks begin to reveal the individuality of their creators and to express the warmth of human emotion. The Gothic was still subject to the collective creative effort of the people, directed and inspired by the Church.

While scholastic philosophy systematized salvation, it did not bring forth the deep and abiding faith that many believed it would. Worship tended toward an empty formalism. The letter of the doctrine superseded the spirit of Christianity. Men like Dante were conscious of the paradox that existed between the Christian ideal and the Christian practice. The clergy themselves were often corrupt beyond imagination; some of them actually engaged in practicing piracy when not reading their services. High positions in the papal state were openly obtained by a process of barter and trade. The Church was losing its moral and political power, as well as its spiritual significance. At one time, three different popes were engaged in the shocking spectacle of trying to excommunicate each other. Even in the face of such conduct, scholasticism gave tacit approval by holding that the sacraments were still valid even if the clergy administering them were immoral.

This decline of spiritual values gave rise to a skepticism regarding spiritual authority and law. It cannot be said that the Church lost its hold, but certainly the faithful were less concerned with the self-denial of the earlier ages and more interested in their own happiness and well-being. The arts, in turn, responded with a more humanistic expression.

Another factor that weakened the focus on the afterlife was the Crusades. These pilgrimages to wrest the Holy Land from infidel Turks were unsuccessful in their main objective, but they did open up new vistas in social and cultural thought. Material wealth through trade, love of a full life, and a sense of high adventure were but a few of the results. The Crusaders came into contact with Oriental civilization. They tasted luxury and experienced a culture and social code that contrasted sharply with the uncouth customs of their own land and with the spiritual concepts in which they had been trained. Upon their return, the Crusaders copied social customs and forms of entertainment that they had come to know in the East.

Moreover, those returning from these pilgrimages showed signs of becoming intellectually and economically more independent. Their new experiences, as well as scholasticism, made them skeptical of the religious doctrine that threatened the punishment of hell for every pleasurable impulse.

The cult of the Virgin Mary was also, at least in part, a consequence of the Crusades. It was related to the idea of courtly love, an Oriental tradition that venerated and idealized the beloved, which made its way westward. People had been fearful of the Church. The spiritual and temporal power of the Church, its authority to save or damn, its teaching of hell, its doctrine of an avenging God—all these awed and frightened medieval people. They feared God but did not love him. Under the influence of the courtly love idea they could, and did, make Mary the object of their affection. Mary, Mother of God, was a humanizing influence because of her sympathy and loveliness. No burden was too great to bring to her in prayer. They loved Mary, admired Jesus, and feared God.

Closely allied with the Crusades was the development of towns and the building of a more adequate system of roads, especially in northern Europe. Romanesque art, as we have seen, was mainly monastic, but the Gothic cathedral of the twelfth to fourteenth centuries was the creation of the towns and bishops. With the growth of commerce and industry and a corresponding growth of towns, especially in northern Europe, the bishops, bourgeoisie, and guilds grew steadily more wealthy. All classes were united in an ardent religious faith and in an equally ardent feeling of local pride. The towns enthusiastically built more churches than we would imagine they needed, partly to express the fervor of their faith and partly to surpass rival towns in magnificence. Thus, a spiritual fervor lasted in spite of a growing secularization and criticism of the clergy. As the product of communal effort, the Gothic cathedral was placed on the public square, surrounded by the homes of its builders and paid for by public subscription. It became the religious, civic, and social center of community life. It functioned as church, picture gallery, concert hall, theater, library, and school—truly a multipurpose artwork.

The influence of the various aspects of Gothic culture on art is revealed in its subjects, forms, and symbols. In fact, the Gothic cathedral was a veritable compendium of symbols. The floor plan of the building is in the shape of a cross. The light flowing through the stained-glass windows symbolized Christ as the light of the world, and a central nave and two side aisles represented the Holy Trinity. Externally, three portals correspond to the three main aisles of the church. These portals were most often filled with sculpture that was both representational and symbolic. Above the central portal the four Evangelists were represented by a man for St. Matthew, a lion for St. Mark, an ox

for St. Luke, and an eagle for St. John. The combination of the symbolic and representational art objects included in Gothic art became a visual history of the people of God.

The same tradition of symbolism prevails in painted art and in music, especially that with texts. Numbers had specific religious references: 1 for God, 2 for the dual nature of Christ, 3 for the Holy Trinity, 4 for the gospels, 5 for the wounds of Christ, 6 for the days of creation, 7 for the deadly sins as well as the joys of Mary, and so forth. Of course, these are not the only symbolic meanings for these numbers. Colors, plants and flowers, animals, and various man-made objects were also frequently invested with symbolic meaning.

The Gothic artist found beauty in the human spirit, not in the physical body. The emotional tone became one of warmth and mystic longing. Gothic artists recreated the adventure and excitement of their age with towering spires, dynamic decoration, and complicated sinews of masonry. Gothic artists sought to integrate religious emotion with the reality of life by putting side by side the noble and ignoble, the real and the mystic. In the spirit of their age, Gothic artists strove to rise above the coarseness of this life and project the observer into the beauties of heaven.

Architecture

The Gothic cathedral, with its towering spires rising majestically over the towns of northern Europe, is a physical testimonial to the urge for rising above the earthly. The Gothic style came into being in France. Ecclesiastic architecture in Italy had been dominated too much by the Byzantine-Romanesque to be a leader in the new movement. In fact, the term *Gothic* was used by the Italians of the Renaissance and later Classicists as a description for a style they thought vulgar and associated with the barbaric Goths. It was only after the Gothic was well established in France, Germany, and England that southern Europe responded at all, and then only mildly.

The rounded arch of the Romanesque was quite inelastic because the height of the arch could not be more than half of its width. This limitation hampered the Gothic builders who sought to reach great heights. Ingenuity and experimentation brought about the pointed arch (fig. 6.1), which made possible the vaulting of large spaces and extreme heights. One of the main problems was how to withstand the lateral thrust of the arch. The heavy walls served this purpose in the Romanesque. Using the pointed arch made the problem even more acute, for the higher the structure, the more lateral thrust

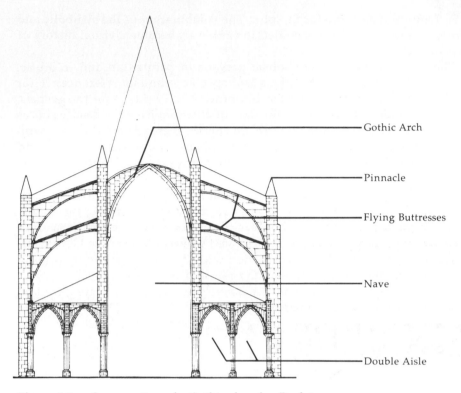

Gothic Arch

Pinnacle

Flying Buttresses

Nave

Double Aisle

Figure 6.1 Cross section of a Gothic church—Beplat.

to be neutralized. Gothic builders solved this problem by a series of sup-
porting arches and **flying buttresses** (figs. 6.1, 6.2) that exerted a counter-
thrust. The building was so delicately balanced by this system of bracing that
theoretically it would collapse if any one of the supporting arches were re-
moved. The ideal location of *Notre Dame* of Paris (fig. 6.2) next to the river
allows the viewer a rare perspective on a complete buttressing system.

These thrusts and counterthrusts suggested a skeletal frame of masonry
piers, ribs, and buttresses that would stand alone and tower toward the
heavens. In place of the massive columns and thick walls of the Romanesque,
the Gothic technique resulted in slender piers; they suggested a web of ribs
that held windows, letting light add to the already expanding sense of spa-
ciousness. The amount of space, both vertical and horizontal, was limited in
many instances only by the wealth and ingenuity of the builders. The Gothic
was so closely allied with the technique of achieving effects of lightness that
it can be called a system rather than a style. Unfortunately, the architects who
developed this system are largely unknown. Despite their anonymity, they
were among the most innovative practitioners of architecture of all times.

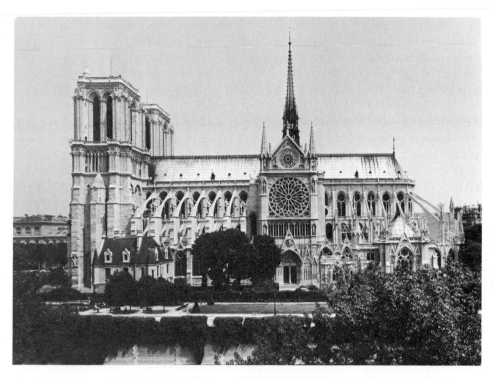

Figure 6.2 *Notre Dame*, Paris [Begun 1163]. (Hirmer Fotoarchiv)

One of the most famous Gothic cathedrals is at Amiens (fig. 6.3), built in Picardy between 1220 and 1269. Its asymmetrical towers are a result of a construction period that extended to nearly half a century, and much of the ornamental design of the exterior was added about a century later. Note the open spaces—the amount of window space and the height of the edifice—in comparison to the Romanesque *Notre Dame la Grande* at Poitiers (fig. 5.6). The plan is the same for both, but *Amiens* reaches upward toward the heavens, while *Notre Dame la Grande* sits heavily on its massive foundations. *Amiens* appears to grow out of the earth, held up by a vast web of piers, ribs, and buttresses. The turrets, pinnacles, and decorative ornamentation combine with the structural details to give a filigree, or lacework effect of clear-cut lines. There is an impression of energy forcing its way upward. Starting at the base, with its trinity of vaulted arches as entrances, this upward movement is assisted by rows of arches alternating with rows of sculptured figures. Above it all stands the intricate rose window, flanked on either side by lofty arches

and stately spires. There is a strong interplay among the vertical and horizontal lines of the facade. Horizontal lines are permitted to exert their influence, but are broken by the predominating upward thrust. The feeling of weight is defeated at every turn. There are separate parts, but they are fused into one gigantic panorama by the impulse for upward movement.

The interior of *Amiens* (fig. 6.4) intensifies and repeats the same energy. The sense of vertical space is even more impressive here than it appears to be from the exterior. The eye of the observer is drawn upward by the massive piers, which become more slender and lighter as they progress higher and higher. Their outline eventually becomes diffused by distance and ornamentation. The sweep of pointed arches leads the eye and the spirit of the observer even higher, suggesting fusion with the heavens. Ribs of masonry frame the multicolored stained-glass windows that capture the sunlight, diffusing its rays into all colors of the spectrum.

The English Gothic evolved from its French counterpart, and is usually thought of as falling into three major style-periods; Early English (a rather plain style), Decorated (with a more ornate use of carving), and Perpendicular (a style that emphasizes long lines, perpendicular to the horizontal). The cathedral at Salisbury, England (fig. 6.5), is in the Early style. Set in the center of a spacious park, its spire over the main transept (added over a century after the construction of the main body of the cathedral) gives an upward thrust to the whole. All lines lead upward until they converge at the very top. The momentum is sufficient to carry the eye up into the heavens.

Each Gothic cathedral had its own personality. The personality of Wells Cathedral is in part determined by its scissor arches, which were added out of engineering necessity around one hundred years after the completion of the main body of the cathedral, (fig. 6.6). In another example, the intricate stonework of the fan vaulting, together with the tall tracery in the windows (Perpendicular Gothic) creates the special personality of King's College Chapel (fig. 6.7).

Each cathedral expressed the communal faith of its builders. The cathedral builders often vied with each other to create buildings of surpassing beauty and magnificence, yet each followed the same fundamental plan and technique of construction. The cathedrals of *Chartres, Rouen, Rheims,* and *Notre Dame* of Paris are among the most glorious examples of this type of ecclesiastical architecture—a type that has become the benchmark of church architecture throughout the whole Christian world. There were many imitations built later, but none were as sincerely wrought as those of the Gothic age.

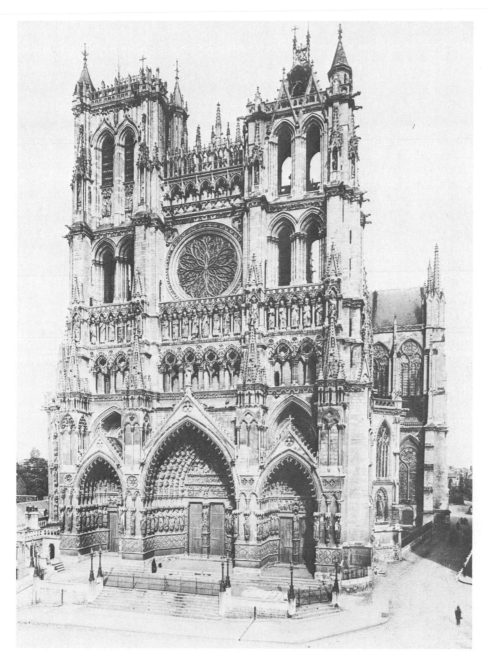

Figure 6.3 *Cathedral at Amiens* [c. 1225].

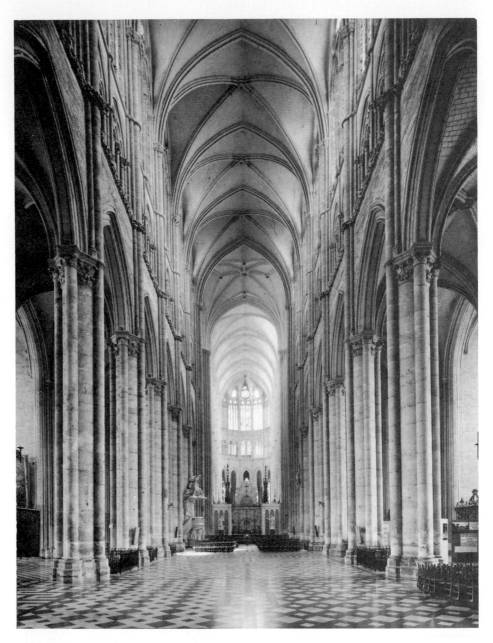

Figure 6.4 Interior of *Amiens Cathedral*. (Hirmer Fotoarchiv)

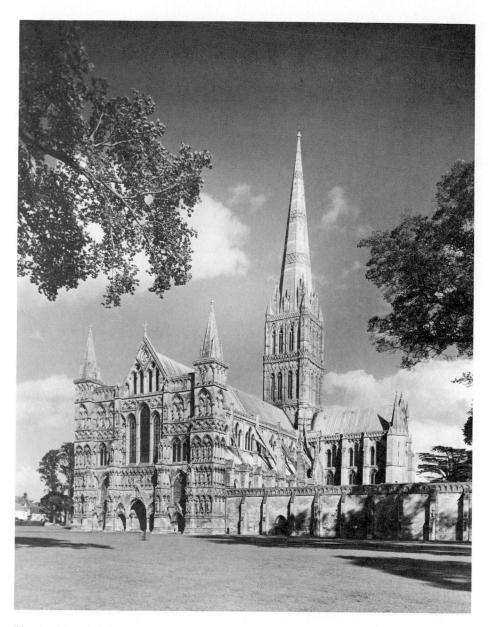

Figure 6.5 *Salisbury Cathedral* [Begun 1220]. (© A. F. Kersting)

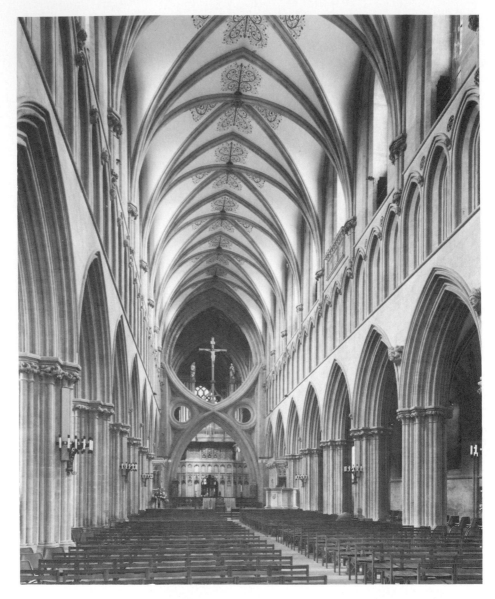

Figure 6.6 Interior of *Wells Cathedral* [Begun c. 1190]. (© A. F. Kersting)

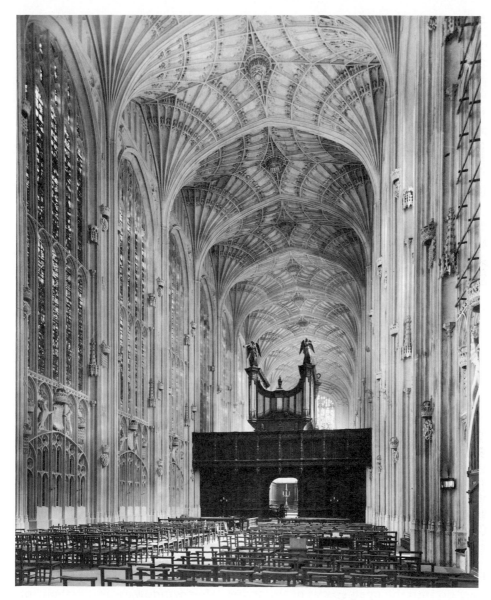

Figure 6.7 *King's College Chapel:* Fan vaulting [Completed 1515]. (© A. F. Kersting)

Stained Glass

Some of the most remarkable artistic efforts in visual representation in the Gothic era are the stained-glass windows. These windows served many purposes: they admitted the much-needed light that was almost absent in the Romanesque; they were magnificent decorations that gave the interior a warm atmosphere; and they were also a means of instruction, serving as illuminated paintings for religious education. More and more the windows took the place of walls; they occupied all the free space between the piers supporting the arches.

Stained glass was a craft that developed from the stylized mosaics of the Byzantine and Romanesque. The glass painter assembled bits of colored, translucent glass into a window panel, defining a subject with the sharp lines of contrasting glass. The lines of the figures were always strongly marked and the draperies clearly indicated. Because line and color had to be so sharply divided, it was very difficult to achieve much expressive detail. The element of space was nearly nonexistent because of the lack of perspective.

As in the Romanesque treatment of the human form, the figures remained out of proportion and distorted. There is little movement suggested. Often there is a juxtaposition of forms with little relationship among the figures.

An interesting device that shows the communal spirit of the Gothic is the trademark of the donor. Many windows, or sets of windows, were the gifts of local guilds or wealthy patrons. The trademark or crest included in memorial windows is a testimony to the personal or collective egos of the donors. Crests were usually placed in a prominent position in each window, often just below the central figure of the panel.

Colorplate 15
follows p. 120.

A window from *Chartres Cathedral* depicting the *Death of the Virgin* (colorplate 15) shows the technique of this remarkable craft. With all its brilliant, polychromatic coloring, the representation is stiff and unreal. The figures are stylized and expressionless, and they show no perspective in the manner in which they are grouped around the deathbed. In spite of what we might consider artistic defects, this was a meaningful message for the faithful. The donor (in this instance, the shoemakers' guild) is memorialized by the figure of a cobbler at his bench.

Colorplate 16
follows p. 120.

The rose window of the south transept of *Chartres* (colorplate 16) shows how the windows were a part of the cathedral's architectural plan, fitting as they do into the open spaces of the arches. Most windows were symbolic of the Scriptures, for they not only stood as barriers against the elements of the world, but they also taught the true way of salvation. The rose window, a signifcant architectural feature of many Gothic churches, was the special symbol of the glories of heaven. As the faithful were bathed in the radiance

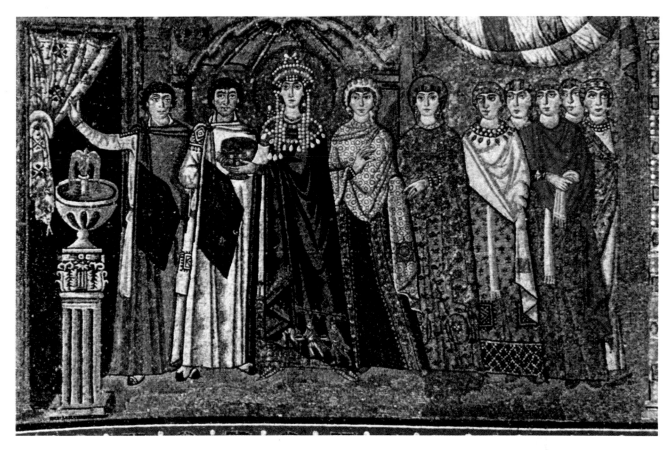

Colorplate 13 *Empress Theodora and Retinue* [c. 547]—San Vitale, Ravenna. (Scala/ Art Resource, N.Y.)

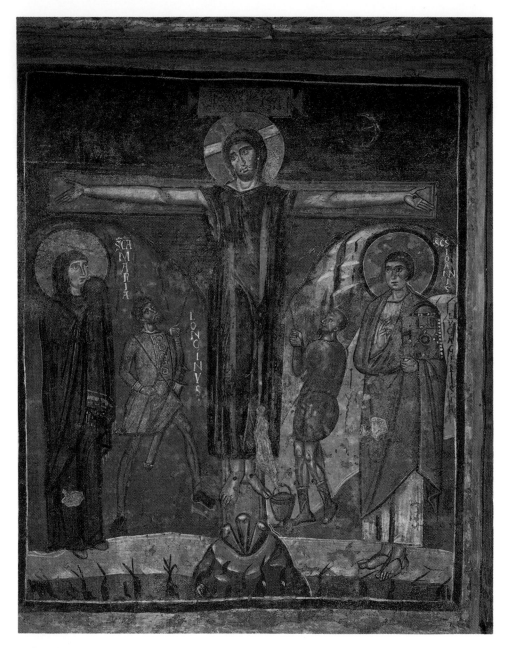

Colorplate 14 *Crucifixion* [c. 800]—Santa Maria Antiqua, Rome. (Scala/Art Resource, N.Y.)

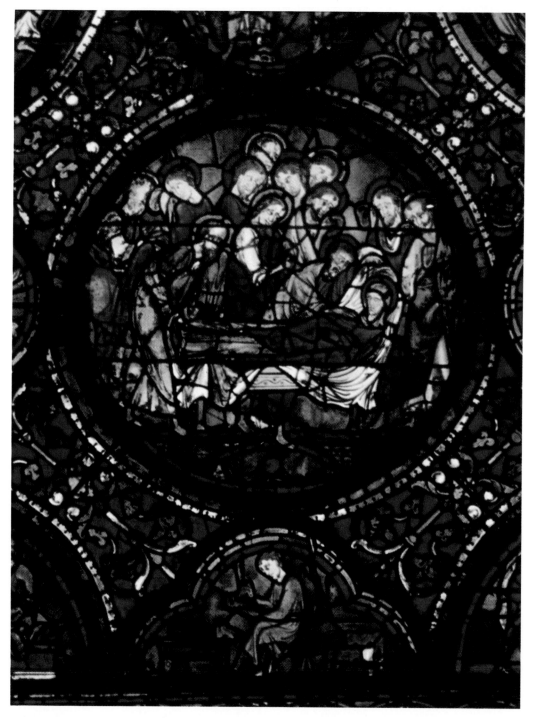

Colorplate 15 *Death of the Virgin* [c. 1200]—Chartres Cathedral. (Scala/Art
Resource, N.Y.)

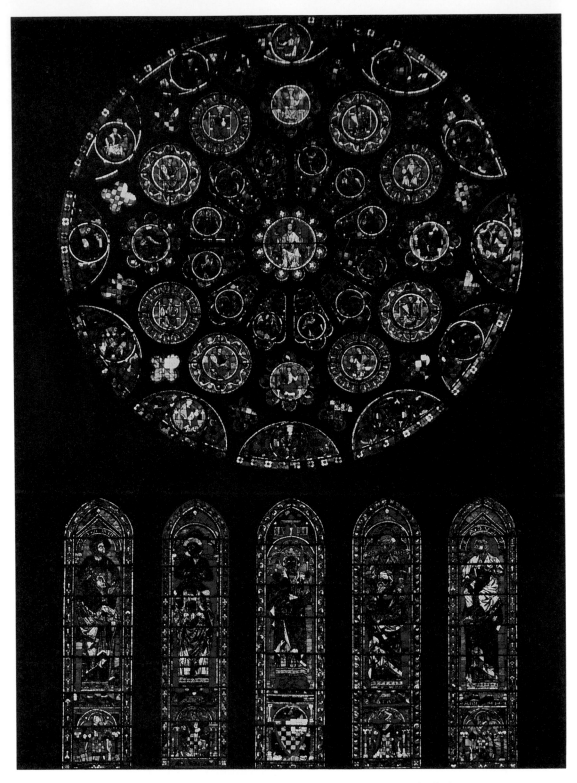

Colorplate 16 South Rose Window and Lancets [c. 1220]—Chartres Cathedral.
(Scala/Art Resource, N.Y.)

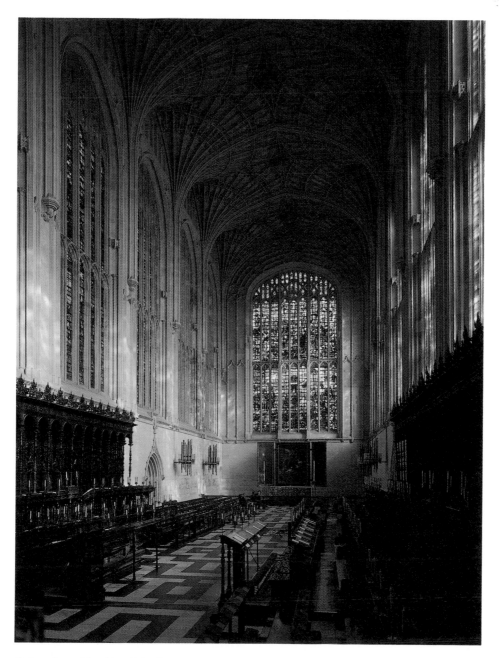

Colorplate 17 East Window, King's College, Cambridge [c. 1526]. (© A. F. Kersting)

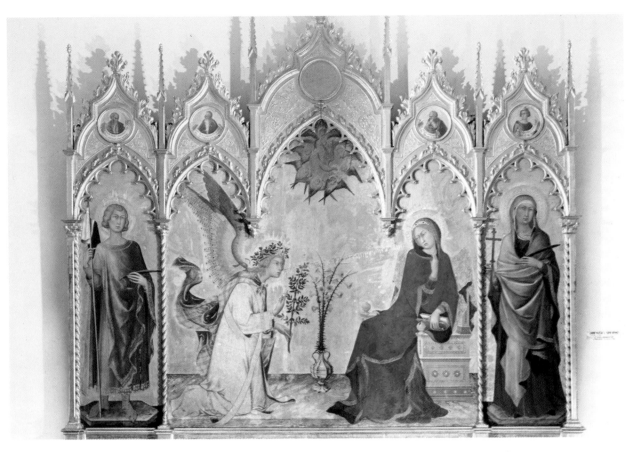

Colorplate 18 *The Annunciation* [1333]—Simone Martini and Lippo Memmi.
Tempera on wood, 8'8⅛" × 10'1⅛". (Scala/Art Resource, N.Y.)

of the sun's rays passing through it, they may have been reminded of the description in Revelation 21:21—"And the twelve gates were twelve pearls; every several gates was of one pearl: and the street of the city was pure gold, as it were transparent glass."

The east windows of King's College Chapel serve similar instructive functions as those in Chartres. Their organization is very different, however. The lancet windows at Chartres (colorplate 17), though related to one another, are independent compositions separated by heavy stonework. The effect is one of light piercing the wall in several distinct locations. The modified lancet windows at King's College are immediately adjacent to one another, giving the appearance of an entire wall flooded with light. The eighteen windows depict six sets of interrelated biblical scenes. The stonework of the screen supporting the windows runs virtually from the floor to the ceiling in one direct line, epitomizing the style of the English Perpendicular Gothic.

Colorplate 17 follows p. 120.

The architecture and stained glass of the Gothic were a complete expression of the people's faith. The spirit of scholasticism was deeply ingrained in the logic of their building technique—a technique in which the thrust and counterthrust were so calculated that the whole edifice stood as a pattern of sinews and ribs, each supporting the other. This system, combined with the rich coloring of the stained glass and the physical reaching for the heavens, attests to the harmonious appeal of the Gothic—an appeal to the mind, eye, and spirit.

Sculpture

The elements of sculpture were treated essentially the same in the Gothic as they had been in the Romanesque. There was, however, an added predilection for expressive feeling and naturalism that was lacking in monastic Romanesque art. Figures were no longer merely symbols. They were people of character who served as reminders of moral truth. The saints came to have countenances and personalities that suggested their spiritual characters. They were presented with naturalism that made them more alive and real. In keeping with their philosophy, however, the soul was still in conflict with the body; therefore, moral character was conveyed by expression, not by bodily form or pure symbolism. Gothic interest was still in the message of faith and in the solace of salvation.

Naturalism was not confined to human personality but was also present in the decorative details that were carved on the moldings and capitals of the pillars. Realistic vines and flowers were often used to break up the smooth surface and to give energy to an otherwise static bit of stone. Nature in perspective was still unknown, but Gothic artists were aware that they were living in an organic world which was in constant flux.

As it was during the Romanesque, sculpture was an integral part of architecture. Almost every portal, niche, and space not occupied by stained glass carried a message in stone. The influence of scholasticism made Gothic artists conscious of minutiae, both artistic and theological. Every movement and detail was made a symbol of faith that conformed to religious doctrine. Stories from the Old and New Testament and scenes from the lives of the saints were depicted as sermons in stone. In addition, the influence of the cult of the Virgin Mary was pervasive. Almost every cathedral had a special Virgin prominently displayed. In fact, the Virgin became so popular that the artistic portrayal of Jesus was largely replaced by that of his Virgin Mother. Unlike the Romanesque, Gothic sculptors created their figures independently of the columns, placing them upon pillars or in niches in the structure. This innovation made it possible to achieve effects of movement and space that were unknown earlier. Movement and plasticity were also enhanced by the Gothic treatment of drapery. Instead of large, ornamental scrolls that seemed only to symbolize form, Gothic drapery was deeply carved, permitting light and shade to suggest space and movement.

The elongation of the body, which has the tendency to endow it with lightness and immateriality, was still used with striking success. Gothic sculptured figures seemed to grow from their bases, as the cathedral itself did from the earth. Elongation also tended to conventionalize bodily form. While there was often real personality revealed in facial features and in the position of the body, no real individuality could be achieved through the form itself. In keeping with the Catholic faith, the Gothic sculptor gave little attention to gender-related characteristics. The madonnas and female saints show only very slight physical indications of gender. Breasts, for example, are usually very small and are often set too high on the chest.

The sculpture of *Amiens* fits well into the structural pattern of the cathedral and also reveals the Gothic spirit in stone. The figures of the Apostles from the central portal of *Amiens* (fig. 6.8) are set apart from the wall and are covered with a Gothic canopy to integrate them with the architecture. While the bodies lack individuality, the position of the hands and turning of the heads make them seem more alive and real. The full folds of drapery, which fall gracefully about the forms, suggest plasticity and refinement.

The central portal is given over to *The Last Judgment*. The space immediately over the door is divided, according to scholastic theology, into three separate panels. The lower one depicts the judgment of souls. The middle panel shows the separation of the saved from the damned. In the upper panel, Christ, the Judge, looks down upon the scene. Flanking the portal are figures of saints and martyrs, each identified by some symbol of their martyrdom or saintly acts.

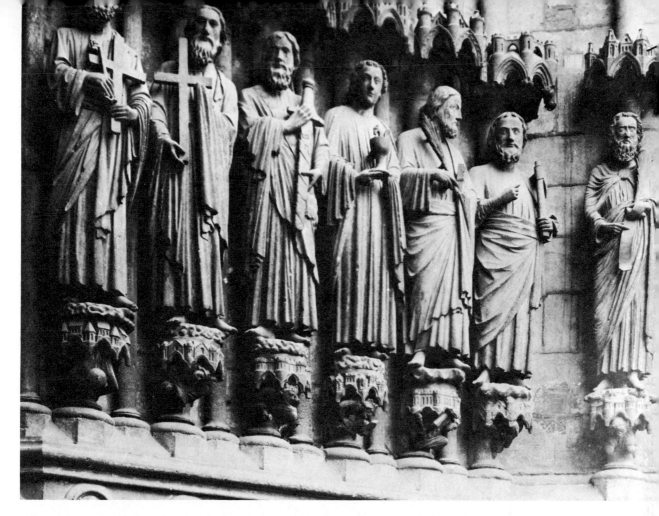

Figure 6.8 *Apostles, Portal of Le Beau Dieu* [1225]—Cathedral, Amiens. (Courtesy University Prints)

The justly famous *Amiens Christ* stands at the center of the main portal, separating the cathedral's main doors (fig. 6.9). It is different from earlier portrayals of the Saviour, for it pictures him as a kindly ruler who judges according to the Book of Laws held in his left hand. He is standing upon the heads of a serpent and a snake, symbols of the evil he vanquished. The figure is modeled in broad, simple forms. The head is a bit too large for the body but commands attention by its deeply carved features and its size. The folds of drapery, which are drawn about the waist, catch and absorb light and shade to suggest space and movement. The body itself, however, remains hidden

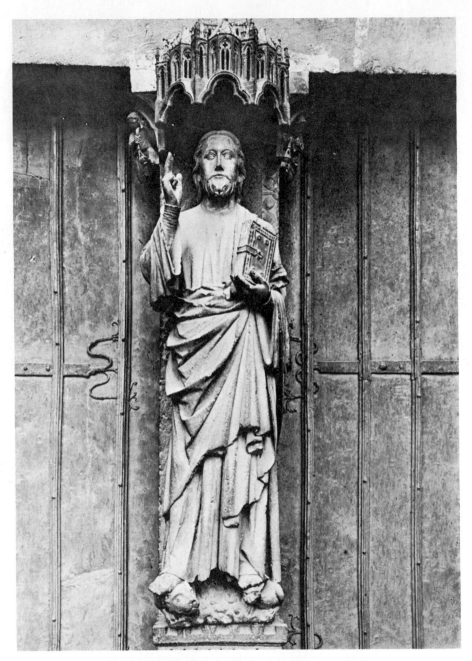

Figure 6.9 *Amiens Christ* [c. 1225]—*Cathedral*, Amiens.

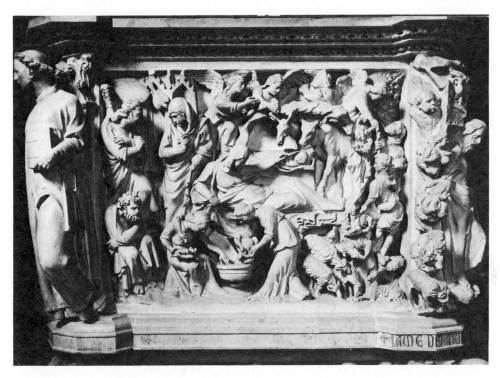

Figure 6.10 *Annunciation, Nativity, and Shepherds* [1260]—from pulpit at Siena—Pisano. (Alinari/Art Resource, N.Y.)

under its covering garments. The kindly face, the hand upraised in a gesture of promise, and the book combine to make a focal area. There is no feeling of asceticism; here is the promise of security and joy for a good life. Here is Gothic humanism in contrast to the Romanesque "fleshless hand."

In Italy, neither the sculptors nor the architects of the Gothic period were influenced by the style of the northern Europeans. However, the wave of humanism was influential in the thirteenth century. The *Annunciation, Nativity, and Shepherds* from the pulpit at Siena (fig. 6.10) is Italian medieval sculpture with the humanistic influence. The artist Giovanni Pisano (1265–1314) made his figures dignified and serene, suggesting the forms of the body beneath the draperies, in the style of the Greeks. In true Gothic style, Pisano shows no spatial perspective, for he crowds the three stories into one scene. Like the figures of Amiens, however, there is freedom of movement in the deeply carved folds and the flow of line from one form to another—a movement that brings the three scenes together.

Painting

During the Gothic, the art of painting, except for the illumination of manuscripts, was a minor art in the north. It remained for the Italians of the thirteenth and fourteenth centuries to raise painting to equal importance with sculpture. Perhaps it was the lack of stained glass in Italy that gave artists the impetus to decorate the walls of churches with biblical scenes as an educational device. In any event, the famous wall paintings in the Arena Chapel at Padua served the same religious purpose as the stained glass of *Amiens*.

Like architecture and sculpture, Gothic painting adhered to the canons of medieval theology. Symbols were arranged according to the traditional manner of biblical storytelling, and the protagonists were presented according to theological specifications. The difference between the painting of Italy and that of northern Europe lay in the areas of naturalism and human emotion. The Italians learned the lesson of expression from the northern sculptors and then applied it to painting.

Colorplate 18 follows p. 120.

The Annunciation of the Siena Cathedral altar (colorplate 18) by Simone Martini (1284–1344) is a case in point. Medieval symbolism is abundantly present. The Archangel Gabriel holds the olive branch as a symbol of peace. The vase of lilies, symbols of virginity, stands between the two figures. Over the central scene stands the trinity of Gothic arches with a dove, the symbol of the Holy Ghost, at the point of the central arch. It is the natural arrangement and the feeling for emotion that take this painting beyond the realm of mediocrity. The Virgin shrinks back with a look of awe as the angel Gabriel raises his hand in preparation for speaking. Expression is real, even if the forms themselves are not plastic in a physical sense. The denial of the flesh is still apparent. The vase and the lilies are more convincingly real than the human forms. Each figure, each item, is separate and complete in itself, reflecting the spiritual implications of the story. Line is clearly defined, and the postures of the central figures reveal the influence of the new humanism.

The most famous painter of the Gothic is the Italian, Giotto (c. 1266–1337). Art historians look upon this Florentine master's work as the beginning of a new era in painting. Major works in several Italian cities established Giotto's contribution to the new movement. He lived during a time when the Gothic spirit was at its peak, but his humanism and individuality were of such a quality that he can rightfully be called the link between the Gothic and the Renaissance.

Giotto's most famous work is the monumental fresco of the *Life of Christ* on the walls of the church at Padua. Fresco is a name for painting that is put on wet or fresh plaster. This technique is exceedingly difficult, for an error

means that new plaster must be applied and then painted over. Another distinct disadvantage of fresco painting is that plaster has the tendency to crack and absorb moisture. We will see in chapter 7 how the works of Leonardo da Vinci and Michelangelo have been damaged in this way.

One of the remarkable scenes from Giotto's *Life of Christ* is the *Deposition*, or the laying away, of Christ's body in the tomb (colorplate 19). Giotto presented this theme in such a natural manner that the viewer becomes a witness to a real drama. He created a three-dimensional group that moves in space. Closed form centers attention on the body of Christ. Every movement and every gaze is focused upon him. Even the angels are drawn toward him. There are expressions of grief on each face. In true Gothic tradition, facial expressions of grief are alike in each—lips parted slightly, eyes narrowed and drawn back. Giotto did not yet express the individuality of grief. The heads of the figures show separate organization, with each apart from the others, but the gazes of the figures as they focus on Christ, the body of Christ, and the rock ledge integrate the various parts. Its lines are clear-cut and sharply define the color. The painting is still Gothic in its essential symbolic features. The halos and angels attest to this. The stylized humans are still unreal in comparison with the Greeks' portrayal of physical reality. Yet there is more humanism than was found in Romanesque sculpture, or even in the Gothic sculpture of *Amiens*. Giotto was on the threshold of the Renaissance. He organized the elements of painting in much the same manner as later artists. However, in adherence to traditional scenes and symbols, he is tied to the spirit of the northern Gothic.

Colorplate 19 follows p. 152.

Music

As the Gothic concept of art broke with the past in its inclination toward humanism and yet held to the scholastic attitude of the Middle Ages, so did Gothic music. In this period are found the first formal expressions of one of the distinctive elements of western European music—the simultaneous sounding of tones of different pitch, or harmony. Although some form of harmony may have been used previously elsewhere, it is probably the most characteristic element that makes European music different from all other musical systems.

In the history of Western music, there are two basic schemes whereby harmony is achieved. One, called polyphony or counterpoint, uses two or more simultaneously sounded melodic lines. The other, called homophony, deals with the musical materials in a melody with chordal harmony. Both result in tones of different pitch sounding simultaneously and thus producing harmony (an element of music described in chapter 2).

Both of these schemes require systematic notation so that composers may communicate their ideas to musical performers. As long as music was made up exclusively of single melodic lines, there was no need for a system of symbols that did more than remind performers of the traditional melodies. Notation became necessary with the advent of musician-composers, who thought of themselves as individual artists concerned with the organization of musical sounds in complex tonal patterns. The countless anonymous composers of the chants of the Middle Ages are an embodiment of a "God-inspired," mysterious creative power disassociated from the human beings through which it worked. Gothic composers, however, saw themselves as individuals struggling with artistic problems, and they needed to communicate their solutions to other people. Notation made possible the preservation of Gothic music. Another manifestation of humanism was the composers' interest in assigning their names to their works. A final example of humanistic expression was the emphasis on the artistic treatment of secular music, both by recognized composers and by the great body of poet-musicians, the minstrel singers of the twelfth and thirteenth centuries.

In contrast to these humanizing tendencies, the rigid subscription to rules and devices of composition can be likened to the acceptance of the stylized symbols of Gothic painting. The organization of the musical materials by composers of the Gothic era was accomplished by strict adherence to arbitrary rules and practices, many of which had symbolic meanings. For example, Church music used triple meter for its rhythmic structure to symbolize the Trinity. Of the two schemes for achieving harmony, the Gothic composers chose polyphony, which was greatly influenced by the traditional music of the medieval Church. The weaving together of lines of melody, one of which is a traditional chant of the Church, is characteristic of the works of the composers of this period. The addition to the original chant, called the **cantus firmus** (basic chant), of one, two, or even three lines of melody, all of which returned at cadence points to the perfect intervals of the unison, fifth, or octave is, in a sense, the musical parallel of the subdivisions of the Gothic tracery so characteristic of architecture at this time (ex. 6.1). This early style of polyphonic music, known as **organum,** was the basic style from the twelfth through the fourteenth centuries.

An example of polyphonic music is the *Alleluia* of Perotin (c. 1170). In this early work, the original modal chant, the cantus firmus, is sung as a very slow-moving voice, while the added parts move in a decorative manner in faster note values, inevitably returning at the cadences to the perfect intervals of unison, fifth, or octave. While the mode of this chant was determined by its final tone, there was no scheme of chordal structure or accompaniment. Unlike the greater portion of Western music with which we are familiar, this music

Example 6.1: *Rex Caeli, Domine,* Organum, Sequence

Original chant in upper voice, organum in lower voice

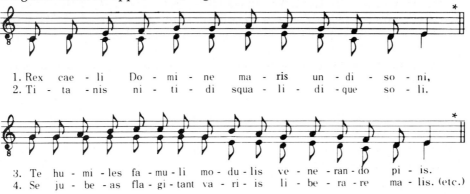

1. Rex cae - li Do - mi - ne ma - ris un - di - so - ni,
2. Ti - ta - nis ni - ti - di squa - li - di - que so - li.

3. Te hu - mi - les fa - mu - li mo - du - lis ve - ne - ran - do pi - is.
4. Se ju - be - as fla - gi - tant va - ri - is li - be - ra - re ma - lis. (etc.)

* = cadence point.

is not organized on the basis of a feeling for tonality or key in which harmonic structure determines the central or tonic tone. There are no vertical chordal considerations that determine the harmony. The organization is one of pure, linear style. The harmony, which results from the combining of the upper melodic line with the traditional chant, is merely coincidental, a by-product of a system concerned only with the intervallic relationships between the original chant and the added, decorative melodies. Moreover, these relationships are of concern only at the beginning and the end of each phrase. The intervals of the unison, fourth, fifth, and octave, are consonant and determine relationships that are further defined by dynamic interpretation. To ears accustomed to tonal organization, this music may sound empty and crude at first. Listen for the accented cadences with their archaic consonances, and soon the intervening melodic passages, with their dissonant, transient harmonies, will reveal themselves.

The rhythmic organization of this *Alleluia* is a fine example of the rigid, scholastic application in the upper two voices of an arbitrary poetic-rhythmic pattern, the dactyl. In the greater portion of this work, the lower voice is unmeasured.

The form of the *Alleluia* is exceedingly free. Its slightly varied repetitions of the rhythmic pattern are so short and so limited in pitch range that only the performer's skill can counterbalance the tendency toward monotony.

While there are no given instructions for the performance of this early polyphonic music, it is obvious from sculpture and paintings of the period that instruments were used. The voice parts could have been doubled or instruments substituted for voices in one or more parts. Certainly the slow-moving note values of a cantus firmus would be well adapted to rendition by such instruments as the viols, sackbuts, or other wind instruments (fig. 7.11).

Another example of a setting for a liturgical text is the *Messe de Notre Dame* by Machaut (c. 1300–c. 77), the greatest composer of the Gothic period. His reputation was equal in both music and poetry. In the latter he was ranked with such notables as Boccaccio and Chaucer. In his time, Machaut had equal recognition as well in theology and diplomacy. After much European travel, Machaut settled in Rheims where he became a canon (clergyman) at the cathedral. His Mass is the first composed polyphonic setting of the Ordinary of the Mass composed by one individual. It represents a much less repetitious and monotonous organization of the musical materials than that of Pérotin, even though the scheme is the same—that of polyphonic linear structure. The composer has employed a much freer and larger rhythmic pattern. Since the harmonic organization is still intervallic, there is as yet no feeling for tonality in our present-day meaning, and the cadences are marked by the perfect intervals, particularly the fifth and octave. There is, however, some concern about the transient harmonies engendered by the flow of the four voices, and the interval of the third, so pleasing to the more modern ear, is to be heard occasionally.

Machaut's Mass, to a large extent, embodies the formal structure of the plainsong or the chant Mass, which begins with the "Kyrie eleison." It is also a good example of the numerical symbolism featured in the arts of the Middle Ages. Its structure consists of three parts: Kyrie eleison, Christe eleison, Kyrie eleison. Each of these is performed three times, an immutable tradition (see ex. 6.2, Notated Polyphonic Version). Each of the sections of the notated polyphonic version is based on a Gregorian chant. In the performance practice of this period, considerable freedom could be exercised, allowing, for example, the substitution of the original chant for any of the polyphonic sections (see ex. 6.2, A Performance Version).

In contrast to these works of Perotin and Machaut is the great wealth of secular songs of the Gothic period. Minstrel singers who were variously known as **troubadours, trouvères,** and **minnesingers,** set poems of secular themes to melodies that they themselves composed or to tunes that were well-known common property. While all medieval secular songs were not the product of these aristocratic and courtly singers, it is from them that most of the settings

Example 6.2: "Kyrie" from *Messe de Notre Dame*—Guillaume de Machaut

Notated Polyphonic Version	A Performance Version
I. Kyrie eleison No. 1 (one polyphonic setting performed three times)	Kyrie eleison No. 1 (4-voice polyphony, triple meter, complex rhythms)
	Kyrie eleison No. 1 (monophonic chant, nonmetric, free rhythms)
	Kyrie eleison No. 1 (as in the beginning)
II. Christe eleison (one polyphonic setting performed three times)	Christe eleison (monophonic chant, nonmetric, free rhythms)
	Christe eleison (4-voice polyphony, triple meter, complex rhythms)
	Christe eleison (monophonic chant, nonmetric, free rhythms)
III. Kyrie eleison no. 2 (one polyphonic setting performed two times)	Kyrie eleison no. 2 (4-voice polyphony, triple meter, complex rhythms)
Kyrie eleison no. 3 (one polyphonic setting performed one time)	Kyrie eleison no. 2 (monophonic chant, nonmetric, free rhythms)
	Kyrie eleison no. 3 (4-voice polyphony, triple meter, complex rhythms)

have come down to us. Bernart de Ventadorn (fl. 1150–1180) was not an aristocrat, but arose from mean circumstances to become the lover of Eleanor of Acquitaine, and a poet of renown (ex. 6.3).

The troubadours originated in southern France, and their influence spread all over Europe. In northern France the comparable singers were known as trouvères and in Germany as minnesingers. These minstrels were often more concerned with poetic expression than with the musical settings. From the

Example 6.3: Troubadour text by Bernart de Ventadorn. Excerpt from *Lyrics of the Troubadours and Trouvères* by Frederick Golden, translation by Frederick Golden, translation copyright © 1973 by Frederick Golden. Used by permission of Doubleday, a division of Bantam, Doubleday, Dell Publishing Group, Inc.

> The winter that comes to me
> is white red yellow flowers;
> my good luck grows
> with the wind and the rain,
> and so my song mounts up, rises,
> and my worth increases.
> I have such love in my heart,
> such joy, such sweetness,
> the ice I see is a flower,
> the snow, green things that grow.

troubadours and trouvères alone a treasury of more than 1,500 melodies and 7,500 poems are known today. The subjects of these lyrics vary from political satire to love, the latter a favorite theme. Many songs are concerned with religious topics. This is especially true of the **laudas** of neighboring Italy. Since they are nonliturgical, however, they are included under the term "secular."

A common characteristic of all these songs, whether from France, Italy, Germany, or Spain, is their monodic, or single melodic line structure. The trouvère song *Or la truix* is representative of this type of musical expression. It is music of the court and is typical of many of the minstrel singers' compositions. It consists of a single line of melody, the form of which is dictated by the poetic construction of the verse. The form of this song is defined by repetition and contrast. The opening phrase contrasts with the second, which is followed by two repetitions of the first phrase. Various patterns of such repetition and contrast are to be found in all these secular songs, depending on the structure of the lyrics. While there is no chordal notation given, the melody may well have been sung to some form of simple accompaniment of harp or lute, since numerous pictures show singers and other performers with such instruments capable of producing chordal harmony. The melodies, while predominantly modal, tend to fall into our present-day concept of minor and even major tonality.

Among the earliest composers of Gothic music known by name was the Abbess Hildegard von Bingen (1098–1197), whose work has been made available through recent research in musicology. She is one of the earliest identified women composers known. Her extant works are devoted primarily to religious music, which are settings of her own poetry, as documented in the recent record album, *A Feather on the Breath of God.*

Summary

During the Gothic, the Church retained its position as the principal patron of the arts. It was still the most powerful political, economic, educational, artistic, and religious institution. While the canons and symbolism by which religious doctrines were realized artistically remained basically the same as in the Romanesque, there was more emphasis on magnificence and beauty. The trend brought greater focus on human creations. The rise of towns and the Crusades were developments that led to more secular ideas and foreign cultural practices in the sociocultural scene of the West. Gothic churches were more the result of the communal effort of the towns than the product of the monasteries. The Gothic church served as the educational, social, and religious center of the community. Its splendor was a testimony to the wealth and power of the Church itself.

The development of the Gothic arch provided a skeletal frame that made it possible to reach great heights with the upward thrust of high ceilings and tall spires. It also made it possible to have whole walls of magnificent stained-glass windows, usually with memorials to the donors, such as trade guilds or noble families, placed in a prominent position below each scene.

Gothic sculpture was usually freestanding, with movement of free-flowing drapery and some evidence of bodily movement. Sculpture was still somewhat distorted but more physically realistic than in the Romanesque. Real beauty was still of the spirit and not of the flesh. The subject matter of both sculpture and painting was influenced by the devotion to the Virgin Mary as an object of courtly love. Painting also showed more three-dimensional character with humanistic tendencies. The spatial concept, however, was still very slight. Clearly defined lines and contrasting colors gave the effect of a controlled space with little sense of movement. The expressive feeling in painting, sculpture, and stained glass was brought about more by symbolism than by the realism of emotional reaction.

The development of polyphony, rhythmic organization, and form were achievements of Gothic music. These innovations were made possible through the invention of a system of notation. Still, music was more a science than an art. Rigid rules controlled the intervallic relationships, rhythm, and formal organization in polyphonic sacred music, which was organized around liturgical texts. There was also a great wealth of secular songs set to the poems of troubadours, trouvéres, and minnesingers. These songs were usually of a courtly nature, but many were related to religious subjects, especially to the love of the Virgin Mary.

We have seen how the architecture, sculpture, painting, and music of the Gothic expressed the religion, mysticism, and scholasticism that permeated the age. All art was a veritable encyclopedia of religious beliefs. Humanism was beginning to blossom, but it remained for the Renaissance artist to capture and fully express this new spirit.

Suggested Readings

In addition to the specific sources that follow, the general readings on pages xxi and xxii contain valuable information about the topic of this chapter.

Branner, Robert, ed. *Chartres Cathedral.* New York: W. W. Norton, 1969.

Ferguson, G. *Signs and Symbols in Christian Art.* New York: Oxford University Press, 1966.

Hoppin, Richard H. *Medieval Music.* New York: W. W. Norton, 1978.

Male, Emile. *Religious Art in France: The Thirteenth Century.* Princeton, N.J.: Princeton University Press, 1984.

Martindale, Andrew. *Gothic Art.* New York: Thames Hudson, 1985.

Piper, John. *Stained Glass: Art or Anti-Art?* New York: Reinhold Book Corp., 1968.

Stubblebine, James. *Giotto: The Arena Chapel Frescos.* New York: W. W. Norton, 1969.

Thomson, James. *Music Through The Renaissance.* Dubuque, Ia.: Wm. C. Brown Publishers, 1984.

7

THE RENAISSANCE
(1400-1600)

Chronology of the Renaissance

Visual Arts	Music	Historical Figures and Events
▪ Lorenzo Ghiberti (1378–1455)		
▪ Donato di Niccolò Donatello (1386–1466)		
▪ Fra Angelico (c. 1387–1455)		
	▪ Guillaume Dufay (c.1400–1474)	
		▪ Rule of the Medici (1430–1495)
▪ Andrea Mantegna (c. 1431–1506)		
▪ Andrea del Verrocchio (1435–1488)		
▪ Sandro Botticelli (1440–1510)	▪ Josquin des Prés (c.1440–1521)	
▪ Donato Bramante (1444–1514)		
		▪ Lorenzo de Medici (1449–1492)
	▪ Heinrich Isaac (1450–1517)	
▪ Perugino (1450–1523)		
▪ Leonardo da Vinci (1452–1519)		▪ Gutenberg Bible (1454)
▪ Tilman Riemenschneider (1460–1531)		
		▪ Niccolo Machievelli (1469–1527)
▪ Albrecht Dürer (1471–1528)		
		▪ Nicolaus Copernicus (1473–1543)
▪ Michelangelo Buonarroti (1475–1564)		
▪ Tiziano Vecelli (Titian) (1477–1576)		
▪ Giorgione del Castelfranco (1478–1511)		

[Continued]

Chronology [*Continued*]

Visual Arts	Music	Historical Figures and Events
■ Mathias Grünewald (1480–1528)		
■ Raphael Sanzio (1483–1520)		■ Martin Luther (1483–1546)
		■ Henry VIII (1491–1547)
		■ First voyage of Columbus (1492)
	■ Johann Walter (1496–1570)	■ Vasco da Gama voyage to India (1497)
		■ Execution of Savonarola (1498)
		■ Julius II as Pope (1503)
		■ *The Prince* by Machiavelli (1513)
		■ Luther posts his *Ninety-Five Theses* (1517)
■ Jacopo Robusti (Tintoretto) (1518–1594)		
■ Andrea Palladio (1518–1580)	■ Andrea Gabrieli (c.1520–1586)	
■ Brueghel, Pieter (c.1524–1569)	■ Giovanni Perluigi Palestrina (c.1525–1594)	
	■ Orlando di Lasso (1532–1594)	■ Church of England separates from the Papacy (1534)
		■ Founding of the Jesuit Society (1540)
		■ Council of Trent (1545)
■ Domenico Theotocopouli (El Greco) (1548–1614)		
	■ Luca Marenzio (1553–1599)	
	■ Giovanni Gabrieli (c.1555–1612)	
	■ Don Carlo Gesualdo (c.1560–1613)	
		■ William Shakespeare (1564–1616)
	■ John Bennet (c.1575–1625)	
		■ Drake starts world voyage (1577)

Pronunciation Guide

Botticelli (Bot-tee-chel′-lee)
Créquillon (Kray-kee-ŏ)
Dürer (Dü′-rer)
El Greco (El Gre′-koh)
Erasmus (E-ras′-moos)
Farnese (Fahr-nay′-zay)
Fra Angelico (Frah Ahn-jay′-lee-coh)
Gabrieli, Andrea (Gah-bree-ay′-lee, Ahn-dray′-ah)
Gesualdo (Jez-wahl′-doh)

Ghirlandaio (Geer-lahn-dah′-ee-oh)
Gott Schöpfer, Heiliger Geist (Got Shöp′-fer, Hih′-li-ger Gihst)
Gozzoli (Goht′-zoh-lee)
Grünewald (Grü′-ne-vald)
Isaac (Ee′-zahk′)
Josquin des Prés (Zhos-kă deh Pray)
Machiavelli (Mah′-kee-ah-vel′-lee)
Magi (Mah′-jee)
Mantegna, Andrea (Mahn-teyn′-yeh, Ahn-dray′-ah)

Medici, Lorenzo de' (May'-dee-chee, Loh-ren'-zoh day)
Palestrina (Pahl-es-tree'-nah)
Palladio (Pahl-lah'-dee-oh)
Perugino (Pay-roo-jee'-noh)
Prinzen-Tanz; Proportz (Print'-zen Tahnz, Proh'-portz)
Riemenschneider (Ree-men-schnyder)
Santa Maria delle Grazia (Sahn'-tah Mah-ree'-ah del-le Graht'-zee-ah)

Savonarola (Sah'-vohn-ah-roh'-lah)
Sforza, Ludovico (Sfor'-zah, Loo-doh-vee'-koh)
Simonetta (See-moh-net'-tah)
Tintoretto (Teen-toh-ret'-toh)
Titian (Tish'-an)
Veni Sponsa Christi (Vay'-nee Spon'-sah Krees'-tee)
Verrocchio (Ver-roh'-kee-oh)
Vicenza (Vee-chen'-zah)
Walter (Vahl'-ter)

Study Objectives

1. To understand how the Renaissance marks a return to the ideals of Greek humanism and individualism and that the search for personal identity dominated the arts during this period.
2. To study how scientific research influenced art through perspective and anatomy, and music in harmonic structure.
3. To understand the varied facets of Renaissance humanism reflected in the creative efforts of its artists.
4. To learn how the artists reveal themselves in the function, subject matter, and expressive content of those works of art recognized as among the greatest of all time.
3. To understand that the patronage of artists and musicians was divided between the Church and the aristocracy for similarly humanistic objectives.

The flowering of humanism, which had its faint beginnings in the Gothic, reached its full bloom in the succeeding epoch, called the Renaissance (1400–1600). Although dominated by the artistic monuments of Italy, the Renaissance found expression somewhat later in northern Europe. Like the spirit of Greek culture, the Renaissance spirit was one of this-worldliness, but it was quite different from the Greek in that individuality and the worth of human personality were its motivating forces. The Greeks were interested in the ideal human, but the Renaissance attitude was one of concern for the real human. Interest was shown in the individual's personality, mind, body, social relationships, personal religion, economic condition, and place in the political

scheme of things. The term *Renaissance* designates a period of time, but it refers to a humanistic spirit even more fully realized than that of the medieval. It was an idea, a philosophy, a way of life that changed and molded the individual's whole outlook and attitude toward self, community, and God.

Because of the complexity of the Renaissance, there have been numerous interpretations of its cultural fabric. The most popular has been that it was the period in history dedicated to the rebirth of classical learning. In fact, the term itself has this connotation. This interpretation is quite true; the scholars of the Renaissance did rediscover the classical learning of the Greeks, but probably only because they were interested in the things of this world, as were the Greeks. It was not merely a veneration for antiquity but the feeling of a kindred spirit that inspired their interest. The *Parthenon* with its magnificent sculpture stood in Athens throughout the Middle Ages, but medieval people denied its beauty and value because of their asceticism. It was too much concerned with worldly affairs and not sufficiently concerned with salvation. Renaissance artists did not discover Greek culture as if it had been long lost; they cultivated it because they found themselves in sympathy with the Greek attitude toward life.

To some writers and scholars, the Renaissance marks a resurgence of interest in people and the world in which they lived. This concern enabled many to look on life as a period of joyous existence, not merely a painful preparation for a life to come. But while this philosophic shift did occur, it is not quite sufficient to explain the humanistic development of the Renaissance. The concern for this life must have arisen from some fundamental cause or causes, from various events that forced the change from medieval philosophy. We have already noted how this humanistic change spread gradually through the influence of Eastern culture and the development of towns.

Another explanation is that it was a period when people began again to show interest in the knowledge of natural phenomena and in the techniques of civilization. The Renaissance spirit brought forth the heliocentric theory of the universe and established beyond a shadow of doubt that the world was round. The voyages of Columbus and Vasco da Gama into unknown seas were outward, physical manifestations of the Renaissance spirit. The introduction into western Europe of gunpowder, the invention of the printing press, and the systematic progress of physical science were also proof that Renaissance people were concentrating on their own minds and their earthly problems. Scholars pursued political as well as natural science. Machiavelli's *The Prince* was much praised as a book of advice for the ambitious ruler.

Others see the Renaissance as a crucible of religious, economic, and social conflict. The Protestant Reformation, for example, was a manifestation of the humanistic spirit in northern Europe and was clearly associated with trends in the economic, social, and political scene. The powerful ruling families of

the Italian city-states were in a continuing struggle with each other for political and economic supremacy—a struggle that often had the control of the Vatican itself as the ultimate prize.

In reality, the Renaissance was all of the above and more. It was a time for change and integration, for new discoveries and for inventions that had a profound effect on every phase of human experience. All these ideas and events were an interaction of cause and effect. Each was partially responsible for the Renaissance spirit of humanism and, at the same time, its result.

The net result of all these activities was a Renaissance individual confronted by change. The gradual spread of humanistic thought and the advances made in astronomy and other sciences removed some of the wonder and mystery from the then current understanding of the universe. This, coupled with a weakening loyalty to spiritual authority, in part caused by the constant struggle between the Church and State for supremacy, created many materialists. The development of trade and commerce, with the resultant increase in the standard of living, also strengthened materialistic philosophy. Set free from the authority of the Church, they began to question all authority. If they could no longer look to either the Church or the State for leadership, they felt free to have confidence in their own rationalizations. Consequently, they became individualists.

Materialism and individualism brought new incentives for living. The acquiring of personal wealth became a goal for which all strived. Worldly wisdom and temporal power were cultivated for the personal satisfaction they could bring. New dreamers rose, but their world was one of business and politics rather than religion.

Because of its fortunate position along the trade route from the East, Italy was the center from which this tremendous activity spread. It was also the home of the financiers who made the activity possible, but the Renaissance movement was not confined to Italy. Northern Europe responded to the same forces in much the same way but with its own stamp of cultural personality. Throughout Europe there was great vitality, forcefulness, unsentimental business, and often extreme cruelty. There arose paradoxes that almost defy explanation. Beauty, whether pagan or Christian, was cultivated for its own sake and not for the sake of what it could teach. The arts were enthusiastically cultivated by the rich patrons of the time—patrons who were often paganized princes, and popes who, even when they were religious, were hardly Christian in spirit. Piero de' Medici, for example, commissioned Fra Angelico to create decorations for a silver chest. This included an *Annunciation* (colorplate 22), a sacred subject on this secular object. As in the Middle Ages, the Church remained as the greatest single patron of all the arts.

*Colorplate 20
follows p. 152.*

One of the most obvious results of the Renaissance spirit is the influence of wealthy patronage upon the function and subject matter of art. The portrait, which had not been in favor since early Roman times, again assumed a prominent place as an art subject. No doubt it was due, in part, to the egotistic desire of the wealthy to leave likenesses of themselves as reminders of their worldly successes. Patrons were eager to have the artist present them in the most favorable light, as devout Christians or as benefactors of humankind, often without any real basis in fact. It was looked upon as a signal honor to be represented as a personage from pagan mythology or as a figure from a biblical scene. Botticelli included the whole Medici family in his *Adoration of the Magi* (colorplate 20) and included himself at the extreme right of the painting. As was characteristic in paintings of this period, all human figures wear clothing of their own time rather than of the time depicted in the painting. Furthermore, the sumptuous dress and jewelry of figures in the painting clearly depict the status of the powerful Medici family.

*Colorplate 21
follows p. 152.*

Artists were retained to furnish designs for elaborate costumes and even to plan parades and festivals to enhance the glory and prestige of the patron. They were called upon to make pictorial records of ordinary events as well as of events that were a part of the social activity of the upper classes. Consequently, much of this art was popular, descriptive, and sometimes superficial. The *Journey of the Magi* (colorplate 21) by Gozzoli is one of this type. Its theme is an elaborate parade in honor of Lorenzo the Magnificent of Florence and his honored guests. The title is religious, for it symbolizes the journey of the wise men to Jerusalem. Obviously, the title was a pretext for celebrating the wealth and power of the ruling Medici family, the artist's benefactors. The most brilliantly colored and largest figure in the group is Lorenzo himself, with the lesser personages painted in a splendor proportionate to their importance. Individual faces are shown very realistically, but the landscape portion is quite primitive from our point of view. Moreover, this mood of worldly culture had little in common with the soul-searching mysticism of the earlier Gothic artists. This art was illustrative, decorative, and popular, and it served as a memorial to the wealth and splendor of its patrons.

Religious painting ceased to be the main concern of artists. There were still a great number of artworks with religious titles but only because the Church was still the richest institution to patronize art, not because of any profound sense of spiritual awareness. Pope Julius II (1503–1513) caused a new St. Peter's to be planned in Rome. It was to be a magnificent structure, not to the glory of God but to the glory of Julius. Ironically, Julius died before his plans could be executed. Even *The Last Supper* (colorplate 25) by Leonardo da Vinci has little to do with the spiritual significance of that event. It was instead a psychological study of the reaction of the disciples to Christ's statement, "One of you shall betray me."

Music was not neglected in the Renaissance, and its function was also strongly influenced by secular patronage. Music moved out of the Church and into the home as a necessary adjunct to social life. Great social importance was attached to making music after meals. Dance music gained popularity both in the home and at festivals and pageants. More composers were attached to wealthy households to provide music for entertainment and to teach youth. Even municipalities retained bands of musicians to announce honored guests and perform for special celebrations.

Art also reflected the humanistic spirit because of the personalities of its creators. The Renaissance has often been referred to as an age of geniuses. Its humanism fostered individualism. For the first time in centuries of art, we come upon creative personalities who capture the imagination, not only of their contemporaries but our own age as well. Leonardo da Vinci, Michelangelo, Raphael, Botticelli—to mention a few—were artists of such strong character that they have affected the whole of subsequent art history. The awakening of the artists' personalities and their own awareness of their creative powers and imaginations are important phenomena. For these reasons we must pay detailed attention to specific artists. From this time on, art was scarcely ever the collective effort of people but was rather the personal creative effort of an individual. Differences among specific works stemmed from the differences among personalities, for all were subjected to much the same cultural pattern.

Besides typifying the spirit of humanism, Renaissance artists also caught the spirit of scientific research and exploration. Realism in art was the direct result. Artists also made extensive studies and measurements of classical architecture and sculpture to arrive at workable rules of proportion and balance. Unity and form were reduced to certain basic laws of art. Rules of perspective and **foreshortening** were formulated with mathematical exactness. These enabled artists to create the illusion of space more realistically. Mantegna's *The Dead Christ* (fig. 7.1) is illustrative of the attention artists gave to this principle. The unique position of the viewer in relation to the body of Christ evokes particularly strong emotional response.

Studies in anatomy were of fundamental importance to Renaissance art. Medieval prejudice and Church opposition were overridden by the thirst for knowledge. Artists believed that realism of the human form could not be fully attained without a sound knowledge of intimate physical details. This of necessity demanded laboratory dissection. Laborious drawings of muscles, tissue, and bony structure were among the required studies of every artist. The studies in anatomy made by Leonardo da Vinci were so meticulously drawn that they have been used in medical textbooks until fairly recent times. Because the Renaissance was interested in the human form, the nude regained its place

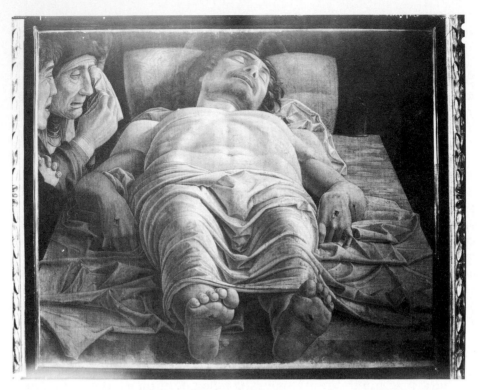

Figure 7.1 *The Dead Christ* [c. 1501]—Mantegna. 26″ × 31″. (Scala/Art Resource)

in art and lost its medieval connotation of shame. The essence of humanism—the entire human being with a perfectly proportioned body—could be completely represented only in the nude. For Renaissance humanists, as for the Greeks, nudity was without self-consciousness.

The entire Renaissance culture was so intimately mirrored in the works of its artists that its history can be told in terms of their creative efforts. Time has proven that of all Renaissance historical figures, its artists have left us the most valuable legacy and the finest interpretation of their age. There were more first-rate artists during this epoch than during any preceding period. However, our study will be confined to a few uncontested great artists and their works. This selection is for the purpose of basing our concepts of Renaissance art on a relatively few representative examples and in no way does it question the importance or the quality of others. The painters whose works will be analyzed are the Italians: Fra Angelico (c. 1400–1455), Benozzo Gozzoli (c.1420–1497), Sandro Botticelli (1440–1510), Leonardo da Vinci (1452–1519), Michelangelo (1475–1564), Titian (1477–1576), and Raphael (1483–1520); followed by the North Europeans: Albrecht Dürer (1471–1528), Mathias Grünewald (1480–1528), and Pieter Brueghel (c. 1524–1569).

Painting

Renaissance artists used the same elements of line, space, color, and formal organization that were used by Gothic artists and by those in the ancient world. Humanism, however, brought a new, fresh approach to the organization of these elements. In order to emphasize form, the element of line was usually clearly defined and curvilinear, creating an effect of smooth-flowing motion. While space was at first organized on several shallow planes, with little sense of recession into the distance, Renaissance artists increasingly explored linear perspective in their paintings (colorplates 22, 25, 30). In Gozzoli's *Journey of the Magi* (colorplate 21) perspective was naive. Form was generally closed, with attention focused on a central figure or point of interest, thus creating a balanced or symmetrical plan of organization. The idea of formal organization is one of juxtaposition of the individual parts into a whole. It is brilliantly polychromatic, a general characteristic of Renaissance painting. More often than not, painters used color as a line to separate figures from one another. This led to a rich palette of contrasting colors that also served to detach principal forms from their backgrounds.

Several other concepts that became integral parts of painting in the Renaissance persisted until late in the nineteenth century. The first of these was the idea that all painting must be based on plastic representation. Subjects had to be presented in a manner that was true to nature, a requirement stemming from the humanism of the period. Another concept followed by painters was the use of objects symbolic of something not actually present in the scene but necessary to its complete understanding. For example, the headgear in the *Sistine Madonna* (colorplate 7) is that of the Eastern church and symbolizes its unity with the Western church. The last of these general concepts is that form, or the total organization of an artwork, must express its function. This is illustrated by Gozzoli's work, which expresses its function as a social painting.

The principle of organization or design most commonly found in Renaissance painting is that of repetition and contrast. Polychromaticism, sharply defined lines, closed forms, and minimal spatial awareness lend themselves to this method of design. We can use the term "classic" to define the stylistic character of such art, for it strives for the complete unity of separate parts in harmony with the whole. As we will observe later, Renaissance artists were occupied with the problem of how to portray a subject more than with what to portray. An analysis of several paintings according to the above elements and principles will show how they differ from the art of earlier periods. It will also reveal the basic differences among the cultures of each epoch.

Raphael's *Sistine Madonna* is a typical example of Renaissance style. It is primarily linear in character, with closed form, and little spatial sense. Its colors are essentially polychromatic. The principle of design, or organization,

is that of contrast and repetition. While the subject is religious, the viewer is impressed more by the beauty of forms and color than by the religious meaning. The impression is one of humanism, of the poetic beauty of human form, of beauty for and by itself.

Fra Angelico

Colorplate 22 follows p. 152.

In contrast to many Italian Renaissance painters, Fra Angelico chose sacred subjects almost exclusively. This was natural, in part, because of his committment to the Dominican Order, and also because many of his works were designed to decorate churches and other religious buildings. A common subject for such buildings was the Annunciation. Fra Angelico's use of this subject (colorplate 22) to decorate a silver chest is not to be confused with the larger altarpiece devoted to the same subject. In our example the angel of the Annunciation, Gabriel, gains the attention of Mary, who is wearing the traditional blue robe. The two figures are at the front of the picture plane, and face one another across deep space, which convincingly, though naively, presents linear perspective. But for these two figures and the footstool the picture is entirely symmetrical. The presence of the Holy Ghost is depicted by a small dove at the top of the picture. Blue is the unifying color in this composition, expressing an intimate, quiet moment in the life of the Virgin. This cool serenity is broken by the angel's garish multi-colored wings.

Botticelli

Colorplate 23 follows p. 152.

Lyric style and a sensitive feeling for poetic beauty are major elements of Botticelli's *Birth of Venus* (colorplate 23). He was enamored of the idealized beauty of pagan mythology and used it to express his own love for the beauty of the human form. Botticelli came under the spell of the reformer, Savonarola, in Florence and turned to religious painting. He actually burned some of his paintings of mythological subjects. On the whole, though, his mythological works best represent his style. His *Birth of Venus* depicts the Greek myth that told of Venus born from the foam of the sea and gently carried to shore on a seashell, with personified Winds rippling the waves and mythical Hours waiting to cover her with a star-studded garment.

Pictorial representation is the dominant force in this painting. Objects such as the seashell and the figures representing the Winds and Hours are used symbolically. The function was to put the Greek myth on canvas and to reveal the beauty of Venus. It is probable that the model for Venus was Simonetta, a great Florentine beauty of the artist's acquaintance. The elements are organized by sharply drawn lines. They are curvilinear and sparkle with life and movement. The figures representing the Winds are almost as one,

not blended, but each defined by structural line and color. There is great detail in this work, and each is made important by clear, flowing lines. While spatial depth is depicted, it is not convincingly real. The shoreline in the background is more artificial than nature's creation. In contrast to the unreal landscape, notice the realism of the human form, even to the color of the flesh. The form is closed, for there is nothing to take the eye outside the picture. While removing any one of the objects would destroy the balance, such removal would not destroy the plasticity of the remaining objects. It is a painting of contrasting colors rather than a blend of different values of the same color.

The *Birth of Venus* also featured the principle of contrast and repetition. The vertically curved lines of Venus contrast sharply with the horizon. Contrast is repeated in the diagonal lines of the figures. The straight lines of the trees repeat and also oppose the curved and vertical lines of Venus. Botticelli has presented his story in a graphic manner, with all the essential symbols of the myth present. The viewer, however, is more enchanted by the physical forms than by the story. True to the Renaissance spirit, the artist reflects the Greek influence in subject matter and humanism in the treatment of it. The human body becomes the real subject. The painting is classic in style, arranging individual forms into a harmonious unity. It is a painting devoted to the ideal of beauty for its own sake.

Leonardo da Vinci

If one person could be singled out as the quintessence of the Renaissance spirit, it would be Leonardo da Vinci. He was a painter, sculptor, scientist, engineer, and poet, to mention only a few of the fields of human endeavor that claimed his attention. Leonardo received his early training in the studio of Verrocchio, the most celebrated teacher of art in Florence. The studio that Verrocchio maintained was a meeting place for the great intellectuals and artists of that time. Thus, Leonardo was able to make contact with the finest minds of the age—minds from which he acquired the habits of scientific investigation as well as the finest training in the canons of painting and sculpture.

Leonardo left Verrocchio's studio to work as an independent artist in Florence. After painting his first masterpiece, *Adoration of the Magi*, he went to Milan under the patronage of the Duke of Milan, Ludovico Sforza. He remained there for seventeen years, and during this time he performed many duties, some artistic and some military. His later years were divided between Milan and Florence, and he maintained studios in both cities. Ironically, Leonardo did not live out his life in Italy. Disappointed by his relations with his patrons and willing to serve anyone who loved beauty, he accompanied Francis I to France, where he ended a long and useful career in 1519.

A recital of Leonardo's activities and accomplishments would fill many pages. He executed designs for public buildings; he built dams and constructed a canal; he rebuilt the fortifications of Milan and devised new instruments of war; he invented an aircraft and a submarine; he wrote treatises on anatomy, optics, geology, physics, and painting. His notebooks, which have been preserved, are an encyclopedia of Renaissance thought and culture. Leonardo even found time to create some of the greatest art masterpieces of all time, including the portrait *Mona Lisa* and one of his greatest works, *The Last Supper* (colorplate 25).

Colorplate 24 follows p. 152.

In the same vein as the *Mona Lisa* is Leonardo's *Ginevra de' Benci* (colorplate 24). He succeeded in capturing her mysterious beauty by subtle gradation of light and dark, together with filigree lines that bring out the character of the subject. He has painted more than a portrait; his is a psychological study of the character of his subject.

Leonardo da Vinci believed that all art should have its roots in the scientific study of nature, human nature included. However, he had no intention of confining himself to surface qualities. His studies convinced him that nature's secrets were well hidden and could be revealed only by painstaking investigation. He spent weeks and often months exploring such minor details as anatomical and psychological peculiarities that lesser men would have ignored. In the process, he added a vast amount of knowledge to the art of painting and to the storehouse of man's intellectual achievements.

Colorplate 25 follows p. 152.

Of the few completed works to come from the hand of Leonardo da Vinci, *The Last Supper* (colorplate 25) is his greatest, and one of the monumental artworks of all time. It is a large work painted on a wall in the refectory of Santa Maria delle Grazie in Milan. Because Leonardo used an experimental method of painting on fresh plaster, the painting has not withstood the ravages of time very well, but we can still get some of the drama of the scene from what is left. *The Last Supper* is a major contribution of Leonardo to the science and art of painting. It is not a photographic study of the twelve disciples and Jesus but a psychological study of the effect of Christ's words: "One of you shall betray me." The sudden shock of those words and the varied response of each disciple, reacting according to his own nature, are the subjects of the painting. The disciples are not merely ordinary men used as models; they are individuals. Leonardo studied each and every personality involved in the scene. He spent long hours probing their personalities according to the biblical record. The whole work took years to complete because there were certain men, especially Judas, whose character Leonardo had difficulty in grasping from a psychological point of view. Strictly speaking, this is not fundamentally a religious picture. It is the scientific observation of one of the most profound scientists of his century. It is a pictorial study of emotional response to a shocking statement. It is a revelation of each man's physical and emotional reaction under the impact of this accusation.

From a formal point of view, the painting is classical in design. The figure of Christ is in the center, his head silhouetted against the sky through the open window. He is isolated physically as well as psychologically. By itself, the room is a masterpiece of perspective. The lines of the walls and table converge to a point behind the head of Christ. This is not infinite space but a carefully controlled chamber of space created by clearly defined lines. The form is closed, with all attention centered on the figure of Christ. The bodies of the men seem to merge together, but their heads are separate and individual. Leonardo's problem was to present an individual portrait of each and yet mold the separate units into a whole. He has done this by means of the table and the narrow room, which force the lines of perspective toward the center. The work is a monument not only to Leonardo's skill as a painter and his painstaking research as a scientist but also to his profound understanding of human nature.

Michelangelo

One of the last of the great sixteenth-century painters was Michelangelo, who stood with Leonardo da Vinci at the pinnacle of the Renaissance ideal. Born in 1475 near Florence, Michelangelo entered the studio of Ghirlandaio at the age of thirteen. He later became a favorite of Lorenzo the Magnificent, who had in his private gallery a large collection of Greek sculpture. Michelangelo's preference for sculpture probably dates from this experience. He also studied the usual canons of art and was given an opportunity to study scientific anatomy. Because of the kindness of a friendly monk, he was permitted to perform dissections of human and animal cadavers to discover for himself the mysteries of the human form.

Michelangelo, like Leonardo, had a variety of talents. He was a painter, architect, and sculptor, but considered himself primarily a sculptor. He saw the human form through the eyes of one who worked with marble and a chisel. His omission of nature as a background, his manner of painting the nude in a strong three-dimensional form, and his preoccupation with the human form has led to his painting being called "painted sculpture." He is said to have stated on more than one occasion, "The only fit subject for an artist is man." He could hardly have made a remark more in keeping with the Renaissance spirit, for the statement is humanism at its most eloquent.

Michelangelo's personal life was filled with hardship. Poverty was his faithful companion, made even more menacing by selfish relatives and friends. He suffered almost constantly from personality conflicts during his eighty-nine years.

Many of his works reveal the conflicting forces of his own consciousness. Some pieces are extremely morbid, while others communicate strength and solidity. As an artist, he was generally above personal problems, for he was

a universalist in outlook. His art transcends the superficial, and he embodies in his painting and sculpture an awareness of the forces of universal tragedy. This is perhaps best expressed in the *Last Judgment* (colorplate 26) painted on the east wall of the *Sistine Chapel*. Here human forms are the artistic motive, as Michelangelo depicts mankind on the day of judgment. There is wave after wave of rhythmic movement as the blessed are separated from the damned. There is unlimited variety of pose and gesture in the figures. The nature of fresco painting is apparent in the knots of figures that were rapidly painted before the plaster had time to dry, giving the work an additive character that contributes to its power.

Colorplate 26 follows p. 152.

The frescos in the *Sistine Chapel*, with scenes depicting the epic of humankind from the creation to the day of judgment comprise his greatest painting. As a sculptor, he protested bitterly when Pope Julius II ordered him to this task, for he claimed he was not a painter. The completed work is testimony enough that he was a great painter as well.

Colorplate 27 follows p. 152.

The *Creation* (colorplate 27) is one of the panels on the ceiling of the *Sistine Chapel*. This composition clearly shows the artist's qualities in painting, as well as his absorbing concern for man. Adam rests upon the earth, symbolic of man, while his outstretched hand receives the life-giving touch from Jehovah. The figures, including Jehovah, have a quality of buoyancy that suggests the infinity of God's world. The face of Adam does not show the joy of life but is, rather, a little pensive in recognition and anticipation of the trials and sorrows of the earthly life he is gaining. The artist has made the physical figures of Adam and Jehovah the focal points of the panel. The bodies are exceedingly plastic and seem molded in a three-dimensional space. The anatomy is superb—perfect in every detail, down to the rippling of flexed muscles. In general, the lines are sharply defined. The painting is currently being restored in an effort to renew its original colors. The form of the *Creation* is closed, and the effect of distance is canceled by the predominance of the two molded figures. The reaching gestures of Jehovah and Adam effectively bridge the distance between them. Despite all its symbolism, this is not a greatly religious painting in the sense that it portrays God's gift of life. It is one of the most perfect representations of the human form, and one feels that the subject is the form itself, not the act of creation as the title suggests. True to the Renaissance ideal, Michelangelo created a great work of art with a religious subject but a secular spirit.

Titian

Florence and Rome were not the only centers of artistic activity in Renaissance Italy. One of the preeminent city-states of the times, Venice, prospered artistically as a consequence of its commercial successes. One of Venice's native sons, Titian, illustrates a departure from the sharply defined line and static quality of the Middle Renaissance. There is more movement, more energy in

his work than is found in the paintings of Botticelli and Michelangelo. During his ninety-nine years, he created thousands of paintings, including portraits, as well as religious and mythological subjects. His *Venus and Adonis* (colorplate 28) treats figures of mythology as human beings of flesh and blood, with a quality of sensuality usually lacking in earlier Renaissance painting. While the principle of design is still closed form with a pyramidal format, lines are less sharply defined and blend into a shadowy background. Titian was a colorist, and his forms, instead of being linear in character, seem to be created as color. His art signaled the end of the High Renaissance and served as a transition to the Baroque of Tintoretto and El Greco. He even anticipated the coloring and sensuousness of Rubens and Delacroix.

Colorplate 28 follows p. 152.

Raphael

Raphael was born into an artistic family, and received artistic training first from his father and subsequently from Perugino, with whom he served an apprenticeship. He, perhaps more than any other painter, epitomizes the High Renaissance in Italian painting. In 1508, following a competition, Raphael was commissioned to provide murals for the papal apartments of the Vatican. Though many of the walls were ultimately painted by his apprentices, the *School of Athens* (colorplate 6) was of his own hand. The concept and rendering are clearly those of a learned Renaissance master. The presentation of Plato (left center) and Aristotle (right center) among scholars, scientists, artists and musicians presents the two great Greek philosophers reconciled in a grand theatrical environment. The architecture represented is reminiscent of that of Rome and at the same time, in its grandeur, seems to express something of the magnificence of St. Peter's. Further, in this presentation of the Renaissance discoveries of perspective and anatomy, the *School of Athens* is also about space and the architectural definition of space. It is even perhaps about the major concern of Renaissance Christian thought—the reconciliation of the Christian with the pagan—presenting as it does Greek thought in the center of the Christian church.

Albrecht Dürer

Renaissance painters of northern Europe did not respond to the revival of the Greek ideals as quickly as did the Italians. While the trend toward humanism and realism was undoubtedly the result of Italian influence, the expressiveness was still Gothic. Religious subjects with an almost morbid focus on suffering and death were common. The Reformation was a great influence in northern Europe, and the problems of sin, suffering, and salvation were still very real, especially in northern Germany, where Luther's teaching precipitated strong religious feelings.

Albrecht Dürer was a German Renaissance artist, a friend of Luther and Erasmus, who embraced the Protestant religion. His early studies in Italy brought him into contact with the humanism of Italian art and, moreover, introduced him to the disciplined objectivity of line and perspective of the Italian Renaissance. Among the arts Dürer practiced, in addition to painting, were the **intaglio** arts of engraving and etching and the relief process of woodcutting. His engraving, *Knight, Death and the Devil* (fig. 7.2), shows his careful molding of physical forms, the controlled spatial effect, and the clear character of line. The subject represents the concern for the eternal struggle between good and evil. In his journey toward the Heavenly City, represented in the remote distance of the picture plane, the Christian knight is undaunted by the specter of the horseman of Death, who holds an hourglass to show the transitory qualities of life, and by the temptation of the grotesque Devil behind him. Even his faithful dog seems unafraid and confident in faith.

Mathias Grünewald

Colorplate 29
follows p. 152.

The Crucifixion by Mathias Grünewald (colorplate 29) communicates the spirit and style of northern Renaissance painting. While Dürer represented the Protestant element, Grünewald was associated with Catholic patronage in Germany. The artist's portrayal of the agony on the cross is medieval, but the emotional response of the onlookers seems more humanistic. The enlarged figure of Christ emphasizes its importance and is shockingly realistic as a festering corpse. On the other hand, the surrounding figures are soft, alive, and grieving as humans. The sweeping curves and polychromaticism are used to highlight line. There is also a sense of perspective and three-dimensional form that was usually absent in medieval painting. The unity of separate parts with figures on either side act as a balance to the central figure of the dead Christ.

Pieter Brueghel

Pieter Brueghel the Elder represents a significant facet of the Protestant North in Renaissance art during the sixteenth century. Many of his works are related to the struggle between the Catholics and Protestants in the Low Countries. These paintings were sometimes filled with symbolic figures related to the conflicts that arose during the Spanish Inquisition.

Colorplate 30
follows p. 152.

Brueghel was a master of landscapes, and some of his finest paintings recorded the scenery of the Low Countries. He was close to the folk customs and the lives of humble people. *Winter* (*Return of the Hunters*) (colorplate 30) shows a landscape with ordinary peasants in simple, everyday activities of a cold and damp winter. However, the Renaissance idea of space, controlled by the repetition of similar shapes and recession into the distance, is very apparent.

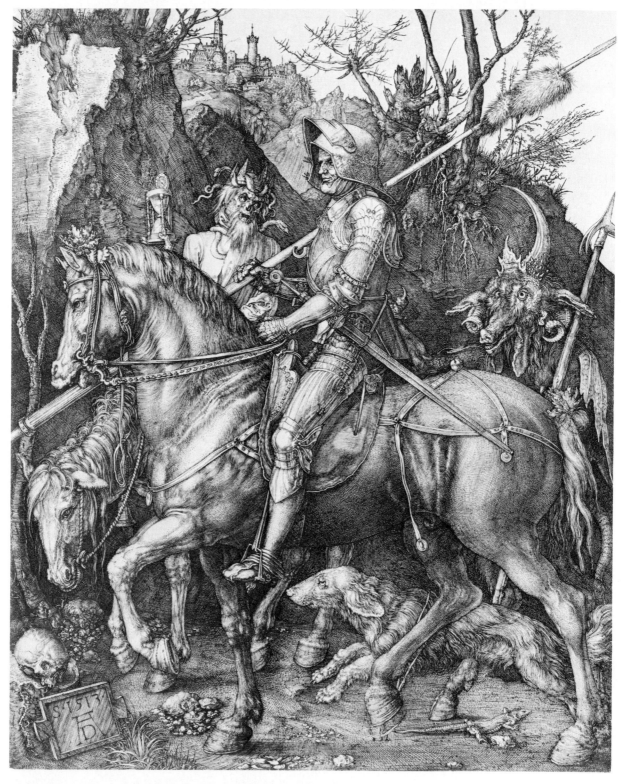

Figure 7.2 *Knight, Death and the Devil* [1513]—Albrecht Dürer. German, 1471–1528 engraving, 250 × 190 mm. (Harvey D. Parker Fund, 68.261. (Courtesy of Museum of Fine Arts, Boston)

Colorplate 31
follows p. 184.

Contrasting with the static and chilly atmosphere of *Winter* is Brueghel's *The Wedding Dance* (colorplate 31). Here peasants move in vigorous and colorful dance, their united purpose and gesture providing some of the unity of the painting. The natural, plain colors in the fabrics are characteristic of the peasant costumes of the period. The viewpoint is from several feet above the characters populating the picture, making visible to the viewer the variegated pattern of colors so typical of Brueghel's work. Both of these paintings exemplify the **genre tradition** popular in the Flemish art of this period.

Sculpture

Renaissance sculpture suggests the same concern for humanism that was found in its painting. Because of the predilection for the molded form in all Renaissance art, it was not uncommon for an artist to be equally facile with a chisel or a brush. Leonardo da Vinci and Michelangelo were examples of such artists. While the medium of sculpture is quite different from that of painting, Renaissance sculpture confirms the character of the elements that we see in painting.

Verrocchio

Leonardo's teacher, Verrocchio (1435–1488), embodied the Renaissance spirit in his sculpture *David* (fig. 7.3). Verrocchio used bronze to depict the youthfulness of David, whom he modeled as a lithe, immature lad, but possessed of great courage and determination. The head of Goliath lies at his feet as a symbol of the encounter and the victory over great odds. We are compelled to believe that this David could not have accomplished such a deed with his adolescent body alone; he must have had divine help in achieving victory. The artist has emphasized the immature qualities of David's body and the boyish candor of his facial expression. Realism of form is shown in the bony structure of the body. Every skeletal portion that would normally appear is present. The collarbone, the elbow, the knuckles, even the ribs are clearly molded beneath the garment. Muscular structure is also very prominent; the veins of the arm stand out, and the muscles of the neck give the effect of tension. Verrocchio was able to portray the human form with life and expression. This is not an ideal David but a real person who has participated in an exciting event. Like the other artists of his epoch, Verrocchio expressed through sculpture the essence of humanism.

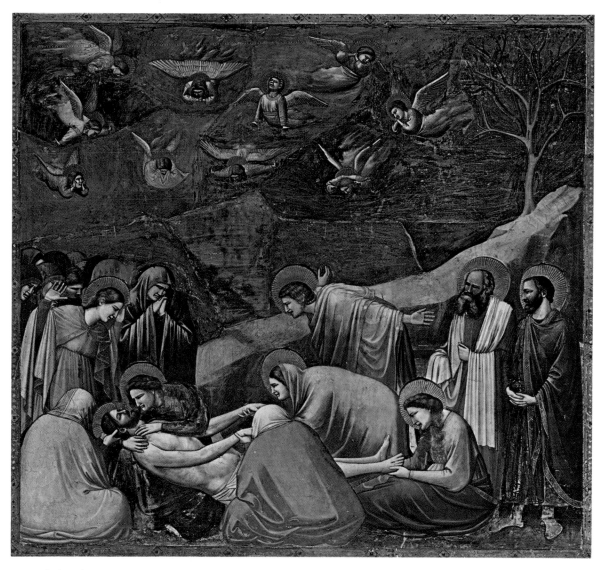

Colorplate 19 *Deposition* [1303–1306]—Giotto. Fresco, 7′7″ × 7′9″. (Scala / Art Resource, N.Y.)

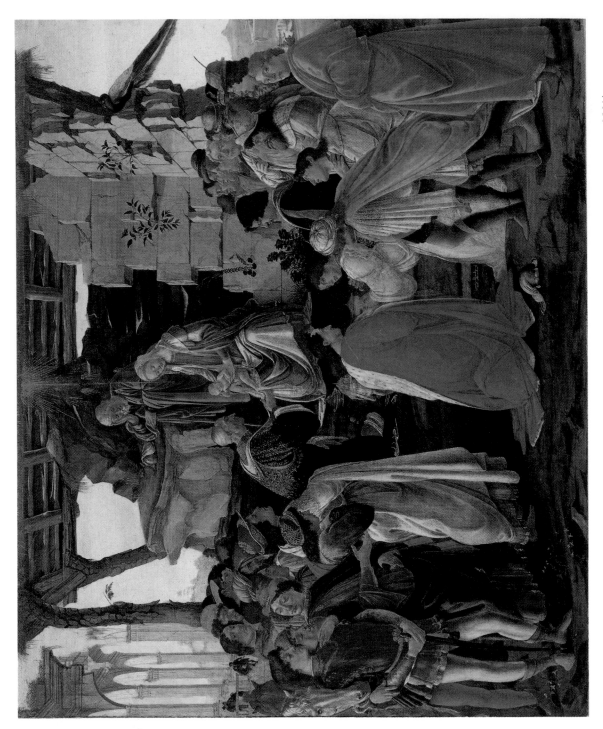

Colorplate 20 *Adoration of the Magi* [1478]—Botticelli. 43¾″ × 52¾″. Florence, Uffizi. (Scala/Art Resource, N.Y.)

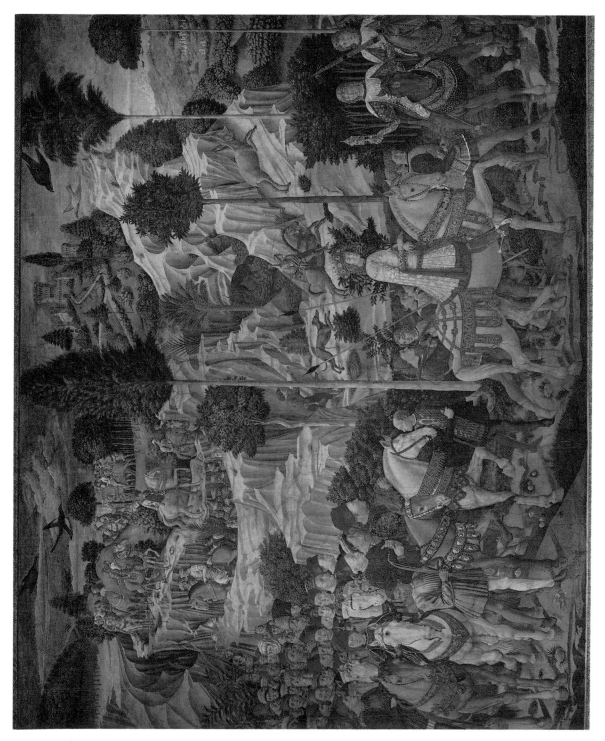

Colorplate 21 *Journey of the Magi* [1469]—Gozzoli. [c. 12'4½" long]. Florence, Palazzo Medici Riccardi. (Scala/Art Resource, N.Y.)

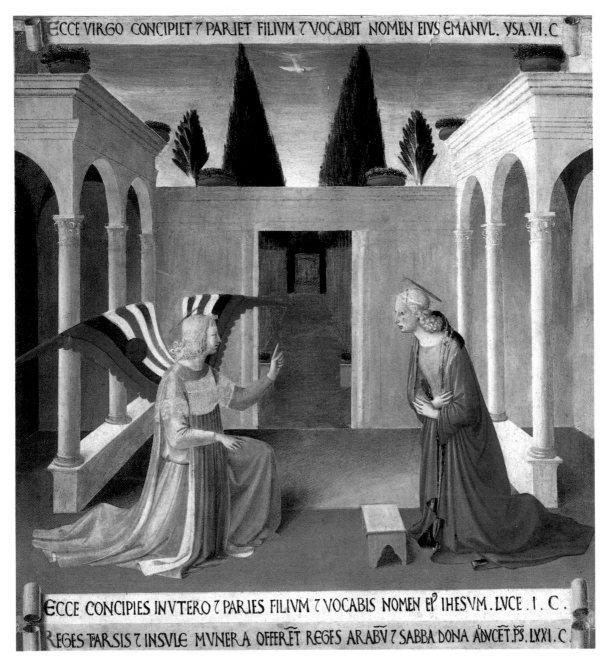

Colorplate 22 *Annunciation*—Fra Angelico. (© Pierre Boulat/Cosmos)

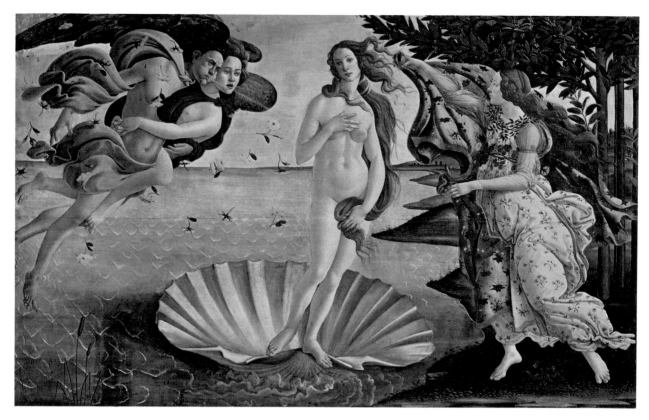

Colorplate 23 *Birth of Venus* [1485]—Botticelli. 6′7″ × 9′2″. (Scala/Art Resource, N.Y.)

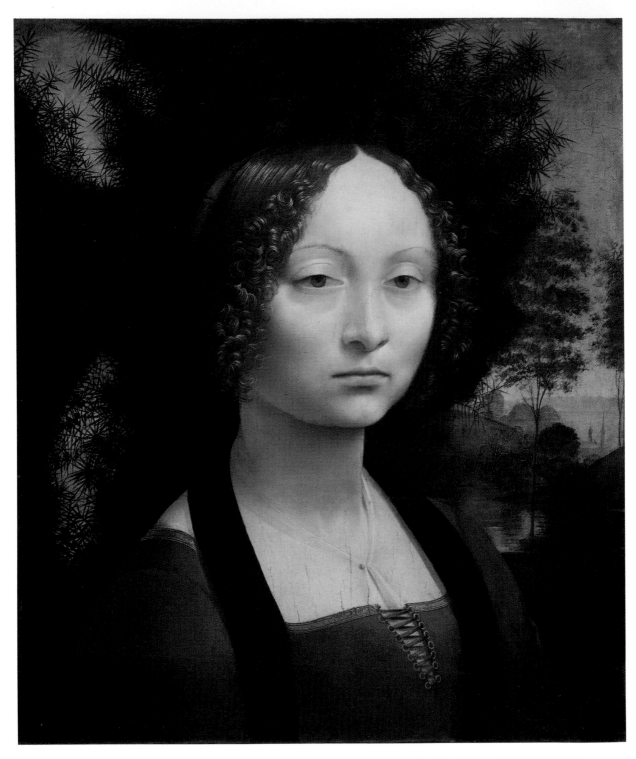

Colorplate 24 *Ginevra dé Benci* [c. 1480]—Leonardo da Vinci. Wood, 15¼″ × 14½″.
(National Gallery of Art, Washington/Ailsa Mellon Bruce Fund)

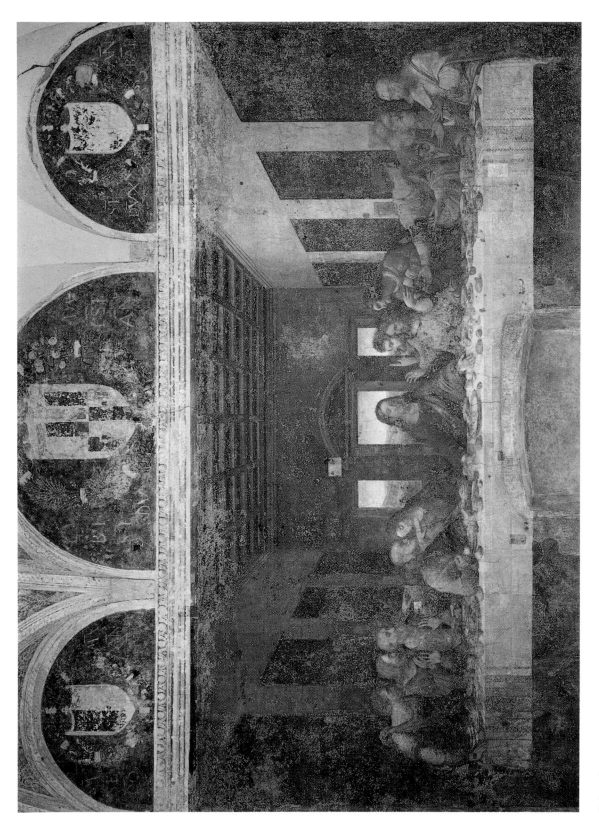

Colorplate 25 *The Last Supper* [1495–1498]—Leonardo da Vinci. 14'5" × 28'¼". (Scala/Art Resource, N.Y.)

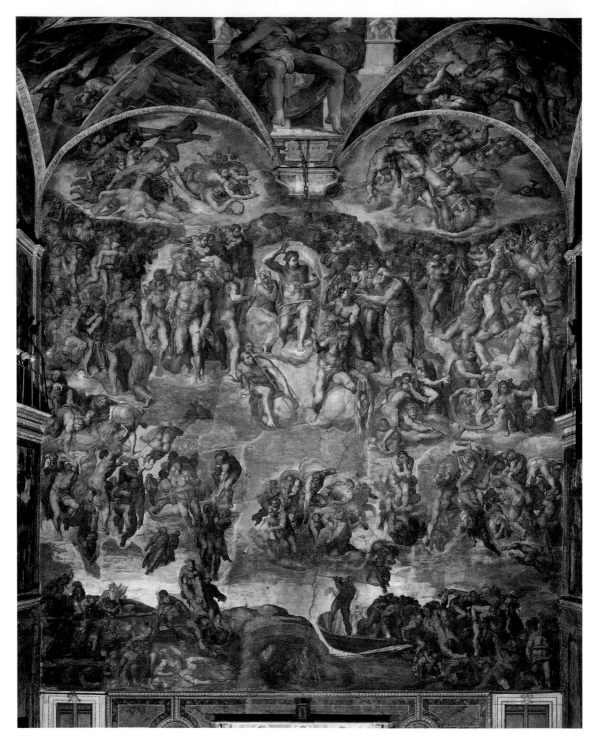

Colorplate 26 *Last Judgment* [1534–41]—Michelangelo. Rome, Sistine Chapel
(Scala/Art Resource, N.Y.)

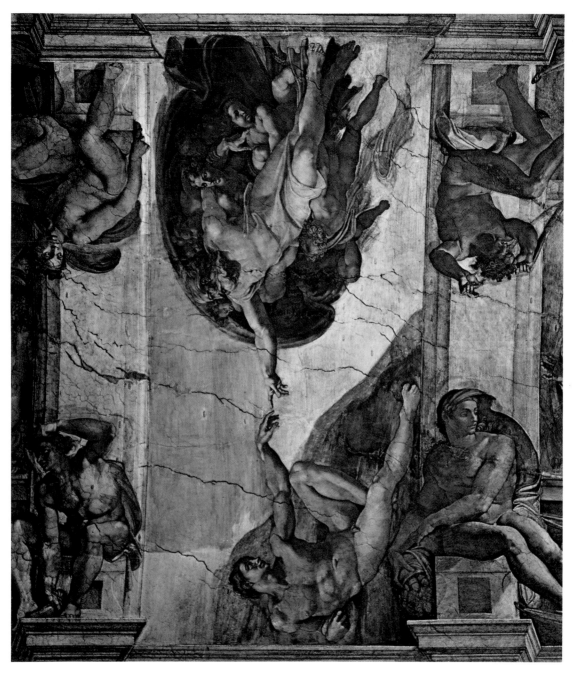

Colorplate 27 *Creation* [1508–1512]—Michelangelo. (Scala/Art Resource, N.Y.)

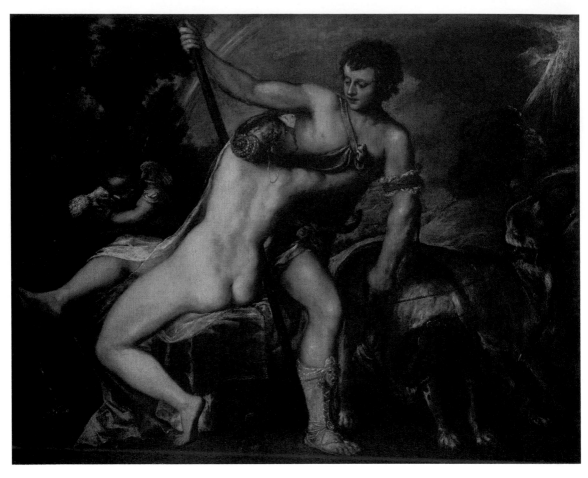

Colorplate 28 *Venus and Adonis* [c. 1560]—Titian. Canvas, 42″ × 53½″. (National Gallery of Art, Washington/Widener Collection)

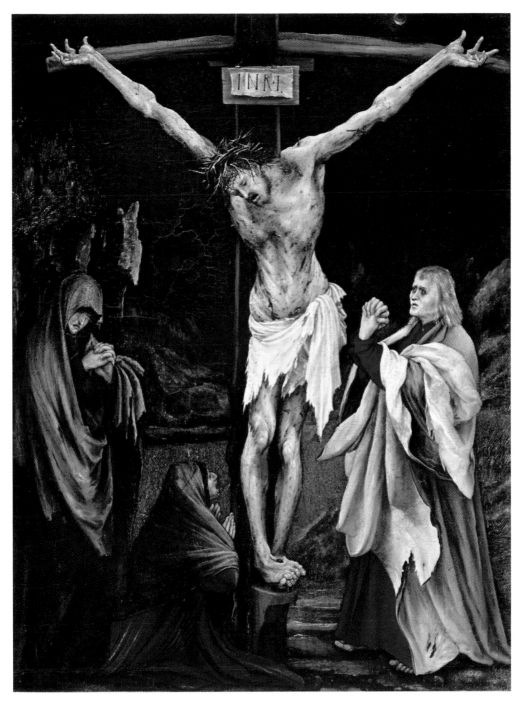

Colorplate 29 *The Crucifixion* [1507]—Grünewald. (National Gallery of Art, Washington, D.C. Samuel H. Kress Collection)

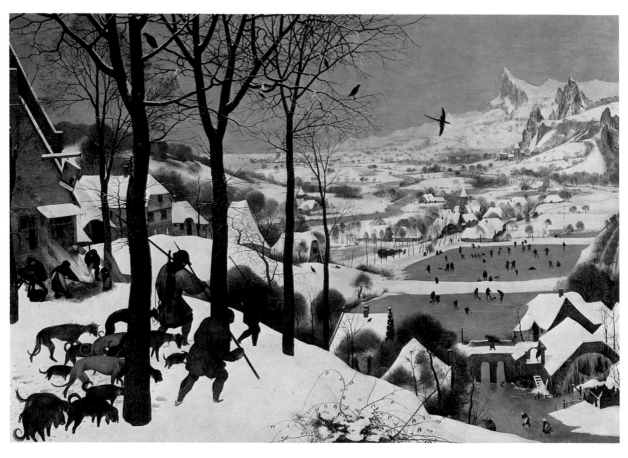

Colorplate 30 *Winter (Return of the Hunters)* [1565]—Pieter Brueghel the Elder. 46″ × 63¾″. (Saskia/Art Resource, N.Y.)

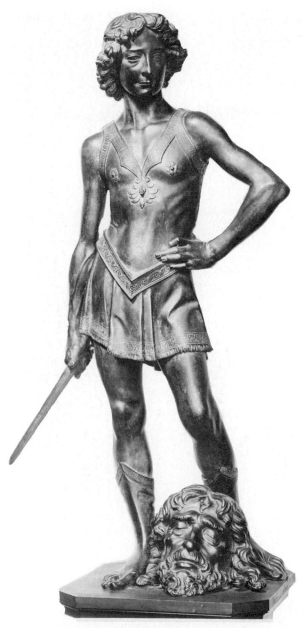

Figure 7.3 *David* [1465]—Verrocchio. Height 62″. (Alinari/Art Resource)

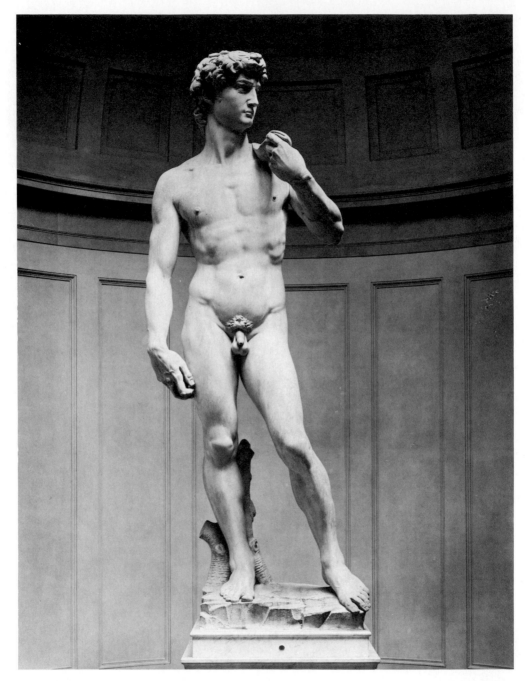

Figure 7.4 *David* [1501–1503]—Michelangelo. Height 18'. (Alinari/Art Resource, N.Y.)

Michelangelo

Michelangelo's *David* (fig. 7.4) is, on the other hand, a different sort of person. The artist saw David as a mature man with great physical strength. This is emphasized by the monumental size of the statue. It is made from a huge block of marble and stands eighteen feet high. Michelangelo also depicted his subject before the action took place. David stands with a stone in his left hand, looking out over the scene in contemplation of the coming action. The highly developed bodily features show a greater degree of physical maturity. David also has real personality; he looks determined to achieve his goal. In a way, Michelangelo's figure is even more in the Renaissance spirit than Verrocchio's, for it is an expression of individualism. David shows confidence in his own physical prowess.

Both of these examples, Verrocchio's adolescent *David* and Michelangelo's adult *David*, are of the same spirit. Yet each represents the individual differences between their creators. Both works have closed form and classic balance. Lines are clear and detailed, and there is a tranquility present in both—perhaps more in Michelangelo's. In the next chapter, we will see how a later artist treats the same subject according to the cultural pattern of the Baroque.

Tilman Riemenschneider

Much of the sculpture of this century was executed in stone, but Tilman Riemenschneider's great works are in wood. Although the dates of his life (1460–1531) make him contemporaneous with the Renaissance in Italy, Riemenschneider's style and spirit, like his German compatriots, are much more closely associated with the Gothic. His *Assumption of the Blessed Virgin* (fig. 7.5), typical of his works, is an altarpiece representing a sacred event. Its pyramidal structure emphasizes symmetry and balance. The figures grouped at the bottom have some individuality, but the carving of the hair and the clothing are stylized. The multifaceted lines on the figures' robes create a rich texture that adds vitality and interest to the work. The subsidiary figures are carved in high relief, while the figure of Mary is more in the round, and thus more realistic.

Architecture

While buildings for religious purposes still held the attention of architects, they also devoted themselves to designing palaces and villas for elaborate and comfortable living. This function of architecture is, in itself, a part of the sixteenth-century scene. Along with individualism and the desire for worldly possessions, there was a natural trend among the wealthy toward elaborate domestic housing. In meeting this demand, architects increasingly employed

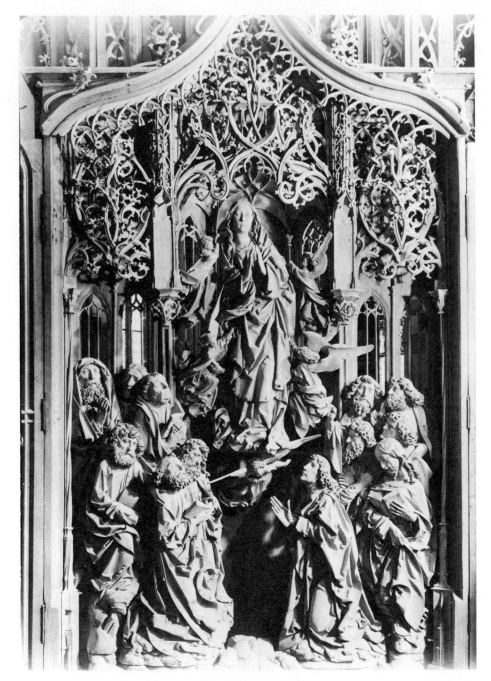

Figure 7.5 *Assumption of the Blessed Virgin* [c. 1505]—Riemenschneider. [Herr Gott's Kirche, Creglingen] (Bildarchiv Foto Marburg)

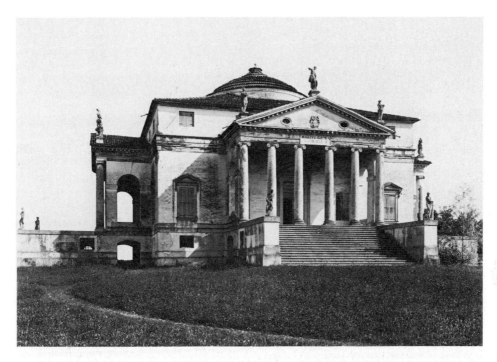

Figure 7.6　*Villa Rotonda* [c. 1550]—Andrea Palladio. (Alinari/Art Resource, N.Y.)

elements of classical Greek architecture, including the orders, frieze, and pediment. As in classical architecture, proportion was often related to the "golden mean," in which height and width are mathematically related at the approximate ratio of 3 to 2.

One of the architects to devote his talents to this type of building was Andrea Palladio (1518–1580). It is most fitting that Palladio be studied in connection with Renaissance architecture because he has had the greatest influence on later generations. In both England and America, the "classic style" can be traced directly to his work. A number of the great estates in seventeenth-century England represent some of the finest examples of the Palladian style of architecture. *Monticello*, Thomas Jefferson's home, is in this style, and Jefferson even suggested a Palladian-type building for the White House. Like many other artists of his time, Palladio wrote treatises about his art. In his *Four Books on Architecture*, he laid down the classic canons of the builder's art in much the same fashion as Leonardo did for painting in his treatise on that art.

The *Villa Rotonda* (fig. 7.6) in Vicenza is the best known of Palladio's works and a fine example of his own theories of architecture. One of the most striking aspects of the *Villa Rotonda* is its debt to antiquity. Its dome is modeled after

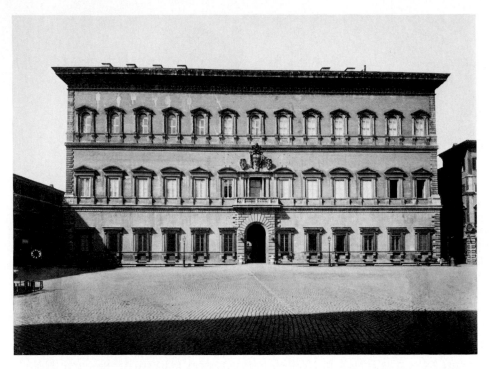

Figure 7.7 *Farnese Palace* [c. 1535]—Antonio da Sangallo and Michelangelo. (Art Resource, N.Y.)

the *Pantheon* in Rome (fig. 4.2). The Greek influence is apparent in the use of freestanding columns that support the pediment of the porticos. The building is classic in proportion, for its various rooms are laid out symmetrically around the central rotunda. Palladio used the cube and cylinder as his basic forms. It is a square plan with four identical porticos placed on the two axes of the rotunda. He did not obscure the simplicity of the plan with elaborate decoration but used ornament sparingly. The structure sits lightly upon the earth with none of the towering spires of the Gothic. This is a functional building, both spacious and formal. It is Renaissance in its classic proportion and dignity and in the absence of mystic symbolism.

Another example of classic proportion in architecture is the *Farnese Palace* in Rome (fig. 7.7). Michelangelo was responsible for a portion of this building; he designed the third story. The facade is symmetrical, with each story clearly separated from the others by a broad band. The window treatment of the first floor exactly repeats the lintel design. The third floor uses the Grecian pediment design. The second floor, however, alternates the pediment with an arch motif. Repetition and contrast is the apparent principle of design for the facade. The eye is relieved as it moves from the top by the contrast of the

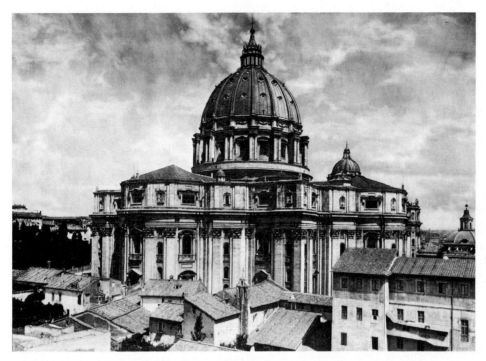

Figure 7.8 *St. Peter's,* Rome [1546–64]—Bramante and Michelangelo. (Alinari/Art Resource, N.Y.)

second floor. This creates variety, through slight change and unity at the same time. In its eye appeal, as well as in its function and arrangement, the *Farnese Palace* mirrors the classic idealism of its age.

Just as Michelangelo came to the *Farnese Palace* after it was near completion, he assumed responsibility for the completion of *St. Peter's,* Rome (fig. 7.8) after the death of Bramante. The final plan for St. Peter's was in the shape of a Greek cross, crowned with a magnificent dome that dominated the structure. Michelangelo did not live to see the completion of the structure, or the dome, which was modified and completed by yet another architect.

Many palatial residences in Italy continued to have the appearance of Greek temples or fortresses. In England, stately homes began to project a very different image. As can be seen in *Hardwick Hall* (fig. 7.9), exterior walls began to be dominated by glass rather than by stone. Feelings of massive power were replaced by elegance and at times opulence. These homes were frequently of such scale that they dwarfed their predecessors. They often included enormous halls or galleries, and that of *Hardwick Hall* was 166 feet long.

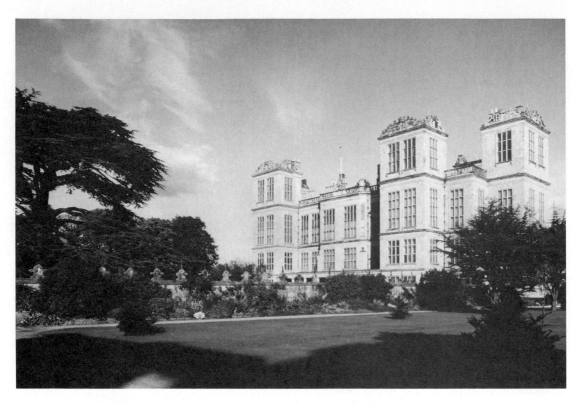

Figure 7.9 *Hardwick Hall* [1590–97]. (James Pipkin)

Music

As suggested earlier in this chapter, during the Renaissance music moved out of the churches and into the households of the aristocracy and the upper classes. Music was still important in the Church but was no longer under its exclusive patronage. As a consequence, a large body of instrumental and vocal music devoted to secular purposes was created.

Music of the Catholic Church

The music of the Catholic church continued to serve much the same purpose in the Renaissance as in previous periods. In **motets** and Masses, composers continued to set those parts of the liturgy that were permitted musical settings. Most Protestant churches regarded music as either popish or satanical,

but in the Lutheran church, music of a folklike simplicity was given back to the congregation as its rightful heritage. Sixteenth-century Lutheran church music became a great fountainhead for the Baroque art of Bach and his contemporaries. The secularization of the Renaissance also carried over into religious works of the Baroque. While the counterpoint of the early Renaissance still had something of Gothic scholasticism in the sixteenth century, a complete mastery of technical devices made possible a truly expressive handling of musical materials.

Religious music spoke not only of the serenity of God but of human serenity, not only of the mysterious detachment of a supreme being but of the anguish, aspirations, and hopes of the human soul. On the other hand, secular music evoked the human joys and sorrows of this earthly existence in song and dance.

Despite the emphasis on humanism, which gave us the great wealth of painting, sculpture, and architecture, the religious music of the Renaissance was rarely heard outside the Roman Catholic church until recent times. This is undoubtedly because of the stylistic disparity between the music of the fifteenth and sixteenth centuries and that of the eighteenth and nineteenth, which constitute the great bulk of musical fare. The disparity rests primarily in the modal polyphony of the Renaissance as against the more familiar tonal polyphony and homophony of the post-Renaissance.

Since the seventeenth century, Western composers have organized their musical materials on the basis of a tonal center. Although some dance forms as well as the vocal *balletto* were homophonically constructed, Renaissance composers dealt primarily with polyphonic treatment of musical ideas. They organized their melodic material not on an underlying or gravitational harmonic concept but on certain intervallic relationships among voices. Certain intervals—the unison, fourth, fifth, and octave—were considered consonant and were specifically named the "perfect" intervals. All others were of varying degrees of dissonance. A great body of practical rules and regulations determined how the dissonant intervals were used and called for both their careful introduction and inevitable resolution into the perfect consonances. It is often suggested that as space was organized on a single plane in painting, so tonal material was organized in a purely melodic way in music. The lack of recession or depth in Renaissance painting is paralleled in music by a lack of tonal harmonic organization. Toward the end of the Renaissance, certain practices already indicated the tendency toward a distinct feeling for tonality. Tonality became a phenomenon that determined the creative thinking of composers until the beginning of the twentieth century. It has largely conditioned the listening attitude of the public to the present.

Josquin des Prés

One of the most important composers of polyphonic technique, and indeed one of the great composers of all time, was Josquin des Prés (c. 1440–1521). Josquin traveled from his native Burgundy to Italy, where he sang at court as well as in the papal choir during the tenure of two different popes. He was an acclaimed composer in his own day, and was among the first to have his works published during his lifetime. The expressiveness of his music, during a period of complex compositional rules, partly explains his popularity among his contemporaries. His motet, *Ave Maria,* illustrates the most generally used principle of organization in Renaissance music, namely, repetition and contrast. This motet is made of a number of contrasting sections, each of which is knit together by rather strict imitation among the several voices. The contrasting sections overlap one another as if to cover up the seams of the work. Actually, the entire work, both music and words, is derived directly from a Gregorian chant setting of the "Ave Maria." The section that uses the words and corresponding melody, "Ave Maria gratia plena," is first treated in close imitation among all voices, and takes up the first few measures of the work. Following this section, the second line of the verse, "Dominus tecum, benedicta tu," and its original melody are introduced, overlapping the conclusion of the first section and constructed out of wholly new and contrasting material, which is treated, however, in the same imitative fashion as the first section. The composer thus treats the chant exhaustively, line by line, until its conclusion. While it would seem that several methods of organization are present in this work, actually the principles of repetition (within each section) and contrast (among the sections) constitute the techniques used. These are techniques peculiar to polyphony that were developed to their ultimate during the Renaissance. This manner of joining together rather unrelated and contrasting sections, which in themselves are closely knit together by imitation, is characteristic of all the vocal forms, whether secular or sacred, and is well suited to musical works that accompany a literary text. There seemed no need for an overall principle of theme and variation or of repetition after contrast. When instrumental music severs the connection between text and music, however, a larger overall design will become necessary.

Palestrina

An example of sacred music from the Mass is Palestrina's (c. 1525–1594) setting of the Agnus Dei from the Mass *Veni sponsa Christi.* This is a work of the High Renaissance. Palestrina, with the exception of a few books of madrigals, devoted his compositions exclusively to sacred music. He has been regarded by the Catholic church as the ideal composer of liturgical compositions. His music has a certain detached and calm sublimity that make it the sacred music par excellence. The lines of melody are smooth-flowing, quite limited in range,

and characteristically devoid of wide steps. The voice parts rarely cross each other, which tends to give a transparency to the texture of the whole work, and dissonance is handled in such a fashion as to make it very unobtrusive. The organization, however, is very like that of the previous two works, particularly the motet. Actually this entire Mass, of which the Agnus Dei is the final section, is based upon a motet of Palestrina's, which he in turn based on a Gregorian chant. There are three sections in the Agnus Dei, each developed in imitative style. The first part is set to the words Agnus Dei ("Lamb of God"); the second, to the words "qui tollis peccata mundi" ("who taketh away the sins of the world"); the third, to "miserere nobis" ("have mercy on us"). There is considerable repetition of text to allow the composer to spin out his musical ideas. The three sections generally contrast with one another, but careful listening will be rewarded by the discovery of a rhythmic-melodic pattern of four notes in each of the three sections. Its appearance is varied; it occurs (1) both as an ascending and descending scale passage, (2) with varied note values, (3) at different pitch levels, and (4) on different accented rhythmic points in each of the four voice parts.

Music of the Protestant Church

Of the several Protestant groups arising from the Reformation, the Lutheran church influenced the musical development of western Europe most. During the period of the Renaissance, this influence consisted almost exclusively of settings of hymn texts in what became known as the German Protestant or Lutheran chorale. Luther was instrumental in building up a large collection of these chorales through his intense interest in music as a vehicle for religious expression and his immediate interest in the writing of chorale texts. The tunes for the chorales came from several sources—one was from the Gregorian hymn tunes of the Catholic church, another from the melodies of secular and folk songs, and a final source was from tunes composed by Protestant musicians. While the tunes with their vernacular texts served as unison hymns for the congregation, they also served the composers as bases for settings in motet style. An example of this is the chorale *Komm, Gott Schöpfer, heiliger Geist (Come, O Creator Spirit)* composed by Johann Walter (1496–1570) to the old Latin hymn text, *Veni Creator Spiritus*, translated into German by Martin Luther. To this text, Walter adapted the original chant tune as a cantus firmus in a polyphonic motet. Every note of the original tune is used as the cantus firmus, presented in the tenor voice. While this is an elaborate use of the simple hymn tune, it was not long before regular four-part settings with the melody in the soprano became the conventional congregational hymn. We shall witness the importance Bach made of such settings in the Baroque period.

Secular folk songs were often adapted by composers as a basis, or cantus firmus, for polyphonic settings both secular and religious. A folk song that in the course of centuries has been used in this fashion innumerable times is the song *Innsbruck, ich muss dich lassen* (*Innsbruck, I Must Leave Thee*). In its original form, it was a love folk song. Its first notated setting was made as a polyphonic **lied,** or song, by Heinrich Isaac to words by the Emperor Maximilian. It is in this form that it has come to be known by the title of the *Innsbruck Lied*. Isaac himself employed it in a polyphonic setting in the Kyrie of the *Missa Carminum,* a polyphonic Mass that employed a number of secular songs. Subsequently, the *Innsbruck Lied* was adapted to other words and choral settings, most noteworthily in Bach's *Passion According to St. Matthew*.

In the secular field, music served a society that actively engaged in its production. Secular music was not a mere pastime or entertainment for a passive patron. Instrumental and vocal secular music, in the form of **chanson, madrigal, canzona, ricercare,** and countless dances, was played and sung by every refined gentleman and lady, all of whose educations included some study of music making. While there were occasions when only professional singers or players would perform, there was, during the Renaissance, no organized social event comparable to the public concert or opera of today. There were, however, royal balls and other social functions that incorporated music and dance (fig. 7.10). Renaissance secular music was an intimate music meant for a small, interested, and, for the most part, participating group (colorplate 31).

The texts of the chansons and madrigals likewise reflected this intimacy, speaking as they generally do of unrequited love and melancholy. Even when they are humorous they are inclined to be wistful, and words such as *sighing, alas, sorrow, cruel, slay, pain,* etc., tend to be stressed by one means or another. All of this indicates the general tendency to inject into these secular works a certain degree of human expression.

There were no large forms comparable to the Mass in the area of secular composition. The madrigal, chanson, and polyphonic lied, however, were secular counterparts to the religious motet. The devices of polyphonic composition in these secular works were the same as those used in the sacred motets (see motet *Ave Maria* by des Prés, p. 162). In secular works, though, the vernacular texts often dealt with themes of love (usually unrequited love), more rhythmic freedom, and in the many attempts to write music reflecting the spirit of the text if not the specific meaning of a word or phrase.

The madrigal, *Thyrsis, Sleepest Thou?,* by John Bennet (c. 1575–1625) is representative of the great flowering of English composition in the late sixteenth century. The madrigal, like the chanson, was social music of a secular nature

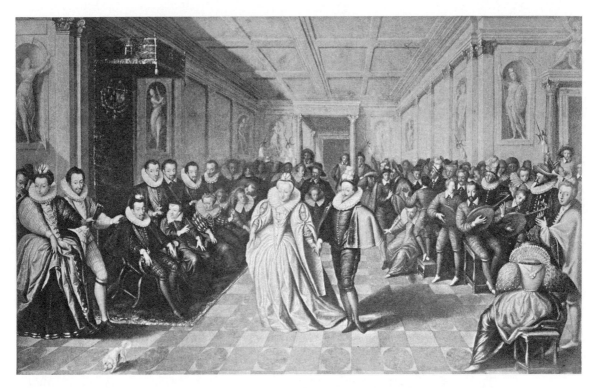

Figure 7.10 Clouet: *The Duc de Joyeuse's Ball* [1581]. (Historical Pictures Service–Chicago)

meant to be sung and played by the upper and middle classes of society. A great many madrigals were published in Italy, where the form originated, and later in England, where it became popular. In Bennet's work, the style common to the motet and chanson is easily recognized. The same imitative devices unify the contrasting section of the textual setting. The intrusion of passages in true chordal style foreshadows the Baroque era with its chordal harmonic technique. Pictorial musical writing in conformity with the words indicate the dissolution of the Renaissance style in favor of the more expressive and dramatic manner of the coming Baroque era. Such devices in the madrigal are well illustrated by from *Thyrsis, Sleepest Thou?* (examples 7.1, 7.2, and 7.3).

Example 7.1: *Thyrsis, Sleepest Thou?*—Bennet

Example 7.2: *Thyrsis, Sleepest Thou?*—Bennet

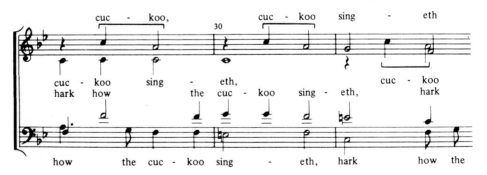

Example 7.3: *Thyrsis, Sleepest Thou?*—Bennet

Example 7.1 introduces a pattern of rhythmic lilt to fit the words "Holla, Holla." In example 7.2, the words "hold up thy head man," are given a melodic fragment that ascends by a wide skip upwards and is imitated in each voice. Example 7.3 is another naive attempt at word imitation or association in the setting of the text, "hark how the cuckoo singeth cuckoo." The last "cuckoo" is actually sung to the musical imitation of the cuckoo's call in the soprano and alto voices, even to the extent of keeping the call, a falling minor third, always at the same pitch as though it were an actual bird.

In a chanson by Créquillon (d. 1557), *Pour ung plaisir (For a delight),* there is extensive, imitative treatment within sections. In this secular work, the textual and musical materials are much more lightly treated than in the motet of Josquin. One recognizes somewhat greater repetition and contrast than in the motet. The music for the first two lines of the poem is repeated literally for the second pair of lines; there follows a contrasting section, and the whole concludes with a third section that repeats both words and music. The entire work is used as an instrumental form known as a **canzona alla francese,** with some changes, mainly in the addition of some faster rhythmic patterns. It shows that the unity of style in the Renaissance extended to all forms, both vocal and instrumental.

While the madrigal, chanson, and polyphonic lied were all meant to be sung and therefore had no instrumental parts written, it was common practice to double the voice parts or even to substitute instruments for some or all of the voices. Among the favorite instruments (fig. 7.11) used for this purpose were the large families of viols and recorders, the lute (fig. 7.12), and such keyboard instruments as the harpsichord or the virginal (fig. 7.13). Their size and construction were in no way standardized, and individual instruments varied greatly from one to another.

These instruments, along with others such as shawms, crumhorns, cornets, and sackbuts that were more often played by professional performers out-of-doors, were also used for an ever-growing supply of purely instrumental works (fig. 7.14). The instrumental forms were largely based on dances and performed on various solo instruments and by small ensembles. The dance named *Der Prinzen-Tanz; Proportz* (c. 1550) is by an anonymous composer, and notated in this instance for the lute, the favorite and typical instrument of the Renaissance. (The lute held a position of importance in the fifteenth and sixteenth centuries that the piano held in the nineteenth.) This short but typical dance, one of thousands of such works that were extremely popular during the sixteenth century, is constructed in a true repetition and contrast design. The first phrase of four measures is repeated, and the second phrase of nine

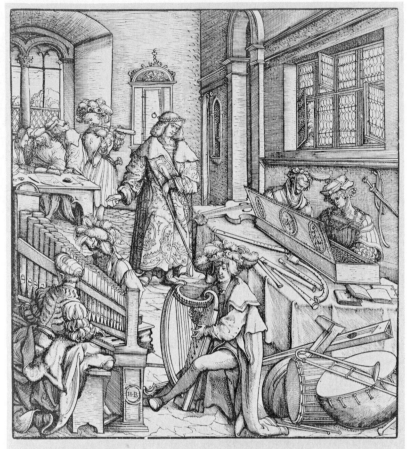

Die geschicklheit in der musiken und was in seinen ingenien und durch
in erfunden und gepessert worden ist.

(Cod. 3033.)

Figure 7.11 Print of Hans Brugkmair. Illustration from *Der Weisskunig*. (The Metropolitan Museum of Art, Gift of William Loring Andrews, 1888)

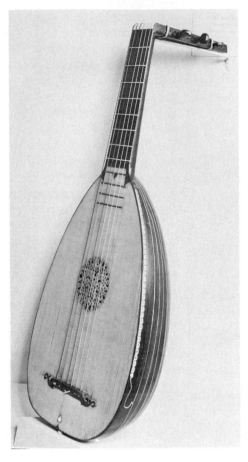

Figure 7.12 German lute; probably made about 1596. Ivory, wood; length 29″, width 12″. (The Metropolitan Museum of Art; The Crosby Brown Collection of Musical Instruments, 1889)

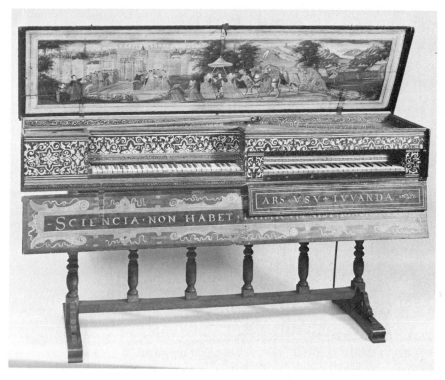

Figure 7.13 Double spinet or virginal made by Ludovicus Grovvelus (Lodewijck Grauwels). (The Metropolitan Museum of Art; The Crosby Brown Collection of Musical Instruments, 1889)

measures is also repeated. While one complements the other, there are readily recognizable elements that are common to both parts. At the conclusion of the second phrase, the whole dance is repeated but in a different meter. While it was originally in a meter of four, it is now in a meter of three. Imitation among what are still essentially four voice parts, even though played on a single instrument, is common throughout the work.

Like the madrigals, the dances reflected the tendency toward a feeling of tonality. Unlike the more truly polyphonic vocal works, the dance forms organized the melodic material in well-defined phrases that tended to balance one another in symmetrical fashion. This was a part of the encroaching Baroque style, which was to sweep away the dependence on modality and substitute an organization of musical materials based on tonality.

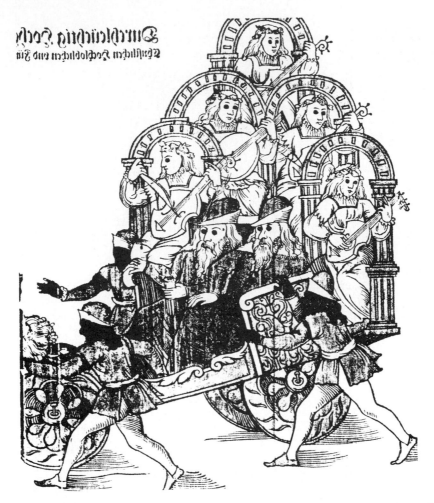

Figure 7.14 Heinrich Wirrich. Pageant wagon with Archduke Ferdinand and Musical Ensemble in procession [1568]. [Note: The illustration is reversed here to show the instruments correctly] (By permission of the British Library, London)

Mannerism — A Transition in Art and Music

Despite the labels we use, we must remember that one art epoch is not usually clearly delineated from the epoch that follows. As the Renaissance ran its course, there were artists who began to imitate the accepted great masters of the time. There were also those who sought to escape from the domination of such masters as Raphael, Michelangelo, and Leonardo da Vinci. There was a searching for freedom from the rational objectivity of the Renaissance, a

moving back toward greater subjectivity and mysticism, and the establishment of personal stylistic idiosyncrasies. Many art historians call this transitional period *mannerism*. The term actually has two meanings. First, it is applied to those who academically imitated the masters of the High Renaissance. Second, it is applied to those who were moving away from the past and were responding to the new movements in religion, politics, economics, and science. Mannerism, consequently, can be interpreted both as the end of the Renaissance and the beginning of the Baroque. Tintoretto and El Greco are sometimes called mannerists because they demonstrated the stylistic changes that were to come to fruition in the Baroque. In music, some composers, such as the madrigalist Gesualdo with his chromatic harmonies, seem to presage the expressiveness of the composers of the Baroque. Giovanni Gabrieli is thought of as a Baroque composer; he lived the greater portion of his life in the late sixteenth century, and his music suggests the sonorities and major/minor tonalities of the Baroque.

Summary

The Renaissance was an age of humanism and individualism characterized by a search for personal identity and a desire for wealth and power. It was also a period of insatiable searching for knowledge in the areas of science, natural phenomena, and human behavior. Because their philosophy was of this world, there was a rebirth of the ideals of the Greeks, especially in philosophy, literature, and art.

Artistic patronage came from the many wealthy Renaissance families who ruled the various city-states, such as the Medici, but the Church was still the most powerful patron of the arts. It was, however, often more concerned with humanism than with salvation, as in the Romanesque and Gothic. Secular and mythological subjects in art were often intertwined with religious scenes. Moreover, portrait painting was popular, even to the point of including prominent people in religious and mythological scenes.

There was almost a "cult of personalities" in the Renaissance. Artists such as Michelangelo and Leonardo da Vinci became prototypes of the "Renaissance man" even in their own time. Their wide range of artistic activities and their intense quest for knowledge about science, nature, and humanity made them almost legendary, and they have remained so to this day.

During the Renaissance there was an emphasis on representational painting and sculpture. In painting, line was clearly defined, smooth-flowing, and curvilinear. Space was earlier organized on a shallow plane, and the development of perspective during the course of the period gave the illusion of an orderly and controlled space. Brilliant, polychromatic coloring of highlighted figures often served as line to separate figures from each other and from their backgrounds. Form was usually closed, with separately articulated parts balanced against each other.

Renaissance sculpture showed the same humanism as painting; in fact, some of the finest sculptors were also painters. Sculpture was closely modeled on that of the Greeks with the finely molded forms showing all the physical details of the human figure. Some were so delicately wrought that the observer can almost sense the living body beneath the stone and metal. Yet, in both painting and sculpture there was an absence of strong emotion. Feeling was expressed, but it was usually well controlled and mild.

Churches continued to hold the major attention of Renaissance architects, but there were a great many palaces and villas built for comfortable living and pleasurable pursuits. The influence of the classic Greek style, with Grecian porticos, symmetry, classic simplicity, and balanced design, was very strong. Religious architecture was sometimes a combination of this classic style and the Romanesque dome and vault.

Sacred music retained its importance, but music moved into the households of the aristocracy and the upper classes. As in the other arts, the Church was no longer the sole patron. As a consequence, a large body of secular music, both vocal and instrumental, arose along with Church music. Composers of sacred music continued to set in polyphonic style those portions of the liturgy that had become standard. Polyphonic style was still used, but with more freedom and individualism in the treatment of intervallic relationships. The sometimes barren and harsh intervals of the Gothic were softened to please the ear. The principle of organization most often used was that of repetition and contrast—repetition of melodic lines by various voices, with a contrast of melodies within the various sections of the text. Expression was often achieved by word-painting, such as a melodic turn, or a harmonic tension to suggest the meaning of individual words. This was especially true in the madrigal and chanson. The dominant musical medium was vocal, but instrumental music was abundant and was usually a transcription of vocal polyphony for instruments such as the harpsichord or consort of viols.

Suggested Readings

In addition to the specific sources that follow, the general readings list on pages xxi and xxii contains valuable information about the topic of this chapter.

Blume, Friedrich. *Renaissance and Baroque Music.* New York: W. W. Norton Co., 1967.
Cuttler, Charles D. *Northern Painting.* New York: Holt, Rinehart & Winston, 1968.
Dewald, Ernest T. *Italian Painting, 1200–1600.* New York: Holt, Rinehart & Winston, 1961.
Gilbert, Creighton, ed. *History of Renaissance Art.* New York: Harper & Row, 1973.
Lowry, Bates. *Renaissance Architecture.* New York: Braziller, 1962.
Thomson, James. *Music Through the Renaissance.* Dubuque, IA: Wm. C. Brown Publishers, 1984.

8

THE BAROQUE
(1600–1750)

Chronology of the Baroque

Visual Arts	Music	Historical Figures and Events
	■ Giovanni Gabrieli (c.1557–1612)	
		■ Francis Bacon (1561–1626)
		■ William Shakespeare (1564–1616)
		■ Galileo Galilei (1564–1642)
	■ Claudio Monteverdi (1567–1643)	
		■ Johann Kepler (1571–1630)
■ Michelangelo da Caravaggio (1573–1610)		
■ Peter Paul Rubens (1577–1640)		
	■ Heinrich Schütz (1585–1673)	■ William Harvey (1578–1657)
■ Clara Peeters (1594–)		■ René Descartes (1596–1650)
■ Giovanni Lorenzo Bernini (1598–1680)		
■ Diego Velásquez (1599–1660)		
■ Francesco Borromini (1599–1667)		
		■ Galilei discovers law of falling bodies (1602)
■ Rembrandt van Rijn (1606–1669)		■ *Macbeth* written by Shakespeare (1606)
		■ John Milton (1608–1674)
		■ Henry Hudson explores the Hudson River (1609)
	■ J. J. Froberger (1616–1667)	

[*Continued*]

Chronology [*Continued*]

Visual Arts	Music	Historical Figures and Events
		■ Thirty Years War (1618–1648)
		■ Pilgrims landed at Plymouth (1620)
		■ Jean Baptiste Molière (1622–1673)
	■ Guarneri family makes violins in Cremona (1625–1744)	
		■ Peter Minuit buys Manhattan Island (1626)
		■ William Harvey discovers circulation of the blood (1628)
		■ Boston founded (1630)
		■ Baruch Spinoza (1632–1677)
■ Taj Mahal begun (1634)		■ Harvard University founded (1636)
	■ First public opera house opens in Venice (1637)	
	■ Dietrich Buxtehude (1637–1707)	
		■ Isaac Newton (1642–1727)
	■ Antonius Stradivarius (1644–1737)	
		■ End of the Thirty Years War (1648)
	■ Arcangelo Corelli (1653–1713)	
	■ Henry Purcell (1659–1695)	
		■ Reign of Louis XIV (1661–1715)
		■ Milton writes *Paradise Lost* (1667)
	■ François Couperin (1668–1733)	
		■ Newton propounds Law of Gravity (1672)
■ Christopher Wren begins St. Paul's Cathedral (1675)		
	■ Antonio Vivaldi (c.1676–1741)	
	■ First German public opera house opens in Hamburg (1678)	
		■ Philadelphia founded (1682)
		■ Peter (The Great), Tsar of Russia (1682–1725)
	■ Jean-Philippe Rameau (1683–1764)	
	■ Johann Sebastian Bach (1685–1750)	
	■ George Frideric Handel (1685–1759)	
	■ Domenico Scarlatti (1685–1757)	
	■ Sauveur measures musical vibrations (1700)	

[*Continued*]

Chronology [*Continued*]

Visual Arts	Music	Historical Figures and Events
		■ Yale University founded (1701) ■ First German public theater opens in Vienna (1708)
	■ Cristofori builds the first pianoforte (1709)	
		■ Reign of Louis XV (1715–1774) ■ Pompeii rediscovered (1719) ■ First spinning machine patented (1738) ■ Methodist church founded by John Wesley (1738) ■ University of Pennsylvania founded (1740) ■ Frederick the Great rules Prussia (1740–1786) ■ Princeton University founded (1745)

Pronunciation Guide

Anhalt-Cöthen (Ahn'-hahlt-Koe'-ten)

Bernini (Bayr-nee'-nee)

Borromini, Francesco (Boh-roh-mee'-nee, Fran-ches'-koh)

Calvin (Kal-vin)

Colbert (Kohl-bayr)

Corelli, Arcangelo (Koh-rel'-lee, Ark-ahn'-jel-loh)

Courante (Koo-rahnt)

Descartes (Day-kahrt)

Frescobaldi (Fres-koh-bahl'-dee)

Froberger (Froh'-ber-ger)

Giacomo della Porta (Jah'-koh-moh del-lah Por'-tah)

Gigue (Zheeg)

Giorgio Maggiore (Jor'-joh Mah-joh'-ray)

Giorgione (Jor-joh'-nay)

Gluck (Glook)

Ignazio (Eeg-naht'-zee-oh)

Il Gesù (Eel Jay-zoo')

Laocoön (Lay-ah'-koh-wahn)

Leipzig (Lihp'-tzeeg)

Leucippus (Loo-tsip'-pus)

Loyola, Ignatius (Loy-oh'-lah, Eeg-nah'-tsee-us)

Monteverdi (Mon-tay-ver'-dee)

Orfeo (Or-fay'-oh)

Pascal (Pahs-kahl)

Passacaglia (Pah-sah-kah'-lee-yah)

Peri (Pay'-ree)

Pozzo, Andrea (Poht'-zoh, Ahn-dray'-ah)

Ritornello (Ri-tohr-nel'-loh)

Rubens (Roo'-benz)

Scarlatti, Domenico (Skahr-laht'-tee, Doh-may'-nee-koh)

Schütz, Heinrich (Shütz, Hihn'-rikh)

Spinoza (Spi-noh'-zah)

Velásquez (Vay-las'-keth)

Vignola (Vee-nyoh'-lah)

Vivaldi (Vee-vahl'-dee)

Study Objectives

1. To study the systematic development of forms and methods of creativity as revealed in specific works of art and music from this period.
2. To learn that perspective in art and tonality in music were fully achieved during this period.
3. To learn that drama and motion permeate all the arts during this period.

The term *Baroque* (from the Portuguese *barroco*, a pearl of irregular form) was first used to describe a style of art overladen with ornament. It was applied especially to the seventeenth-century style of architecture and meant to suggest vulgar or debased Renaissance style. In this century art historians, notably Heinrich Wölfflin in *Principles of Art History*, have rescued the term from connotations of inferiority. It is now used to designate simply an art epoch, along with such terms as *Gothic* and *Renaissance*.

The last decades of the sixteenth century were filled with doubt and contradiction, out of which arose the Baroque. The State and the Catholic church were facing almost certain separation; not only that, their very existence as authoritarian institutions was in jeopardy. New prophets in religion, politics, economics, science, arts, and letters were staging revolutions against the established authority of the Renaissance. The Protestant Reformation, the rise of the capitalistic system, the establishment of absolutism in government, and advances in science were all movements out of which a new spirit was to emerge in the seventeenth century.

What were the causes of this change? The Renaissance had failed to fulfill the hopes, dreams, and ideals of its founders. It had not produced a great spiritual generation. Never had there been a greater patronage of arts and letters by the Church, as well as by wealthy princes. It is ironical that these patrons, many of whom had won the right to the cardinal's hat and the pope's chair, were often the age's greatest scoundrels and most corrupt politicians. The Renaissance had been an age of the cult of beauty in opposition to medieval asceticism. Egocentricity had supplanted humility; Renaissance humanism had taken the place of medieval scholasticism without making men prophets of a better age. The coming changes in social history were the natural development of Renaissance trends. Progress in science had been mainly theoretical; developments in arts and letters had been intellectual. Even the economic and political schemes had been more theoretical than real. For example, Machiavelli's *The Prince* was a theory rather than a practical experiment. The struggle between the Church and the State had as yet been mainly a battle of words. The next step was to cultivate action—action in every sphere of human activity.

The seventeenth century was ushered in on a wave of tremendous intellectual, spiritual, and physical activity. In this age, we find what seems to be

the practical basis of our own systematic civilization. The result in art was a style full of vigor, strong emotions, symbolism, and subtleties, qualities that typify the Baroque.

Some of those who made real and practical contributions to this flood tide of activity were scientists. Bacon's scientific method of inquiry, that of experimentation, laid the foundation for our modern scientific age. Descartes and Pascal made notable advances in mathematics, as did Kepler in astronomy. Harvey heralded a new era in biology, and Newton founded the modern science of physics. Colbert established the mercantile system upon which the world empires of the seventeenth and eighteenth centuries were built. Spinoza systematized modern philosophy. In short, all intellectual activity was concerned with order and the techniques of achieving that order. The Baroque was truly a prelude to the modern age.

There was also great religious activity that marked the seventeenth century as one of the most spiritually minded ages of all history. The Thirty Years War (1618–1648) resulted in the establishment of Protestantism in northern Europe. Calvinism had risen in Geneva, spreading to England, Holland, and, eventually, to America. All of Protestantism was engaged in a vast program of evangelism and expansion. The Catholic Counter-Reformation was the answer to Protestant criticism and that expansion. Out of this movement there rose the powerfully militant order of the Jesuits, which systematically reached into every country of the world, civilized or pagan. Each of these great spiritual revivals was based on the same principle—a systematic marshaling of religious forces toward a more profound and personal religious experience.

The English and Dutch colonization of the Americas and the East Indies is further evidence of the great physical and material activity of the seventeenth century. The application of mercantilism to empire building resulted in a shift of wealth from southern European countries to the Low Countries and to England. Adventurers rose in all parts of Europe and extended their influences to every corner of the globe. Not the least of the effects of this activity was the establishment of absolutism in government. No longer was this a theory: it became a reality on the rising tide of economic and physical expansion. This expansion also depended on a systematic program of action that held great promise of personal rewards in fame and fortune. Given such events in economics, politics, science, and religion, we also can find their echoes in the music and art of the seventeenth and early eighteenth centuries.

We can support the thesis that the arts are an expression of dominant cultural events and attitudes by observing the strong influence of various activities on the arts. Some of the more tangible results are found in the impact of religion on music and art. As has already been stated, the patrons of the Baroque were somewhat different from those of the Renaissance. Religion still provided an outlet for the greatest works of art; it was not the Church as an institution, however, but the Church as a personal religious experience that

provided the impetus. Compared with religious art of the Renaissance, there is growing sincerity in the Baroque. Rembrandt, for example, makes his paintings of religious subjects personal and meaningful experiences to the beholder, not merely symbolic and beautiful scenes. His *Supper at Emmaus* (colorplate 37) breathes the very spirit of personal faith and humility. The Protestant Reformation had placed an emphasis on the individuality of religious expression. To fulfill life's mission one must first conquer the self. Suffering was part of life, and there was an ecstasy and joy in pain. The artistic consequence of this Lutheran attitude was an intense, personalized expression of religious subjects in all the arts—an expression that was filled with the pathos and joy of human struggle and victory over the inner self.

The Jesuit Counter-Reformation, with its spiritual exercises, also closely identified artistic expression with personal religious experiences. The effect of the Jesuit spiritual exercises, especially in Catholic countries, was profound. These exercises were a series of mental states that the devout would assume as a part of daily religious experience. There were rules of conduct for every phase of life designed to intensify concentration on spiritual matters. There were records kept of sins, and there was an examination of conscience according to a schedule that showed weaknesses and progress. Those who consciously practiced these exercises experienced heaven and hell with all the senses. St. Ignatius Loyola, founder of the movement, said, "As the body can be exercised by going, walking, running, so by exercises the will may be disposed to find the divine will." Jesuits lived in a state of intense concentration of mind and believed that visual and emotional revelation were possible for all pious people.

The artistic result of the Jesuit movement was a personalized expression of all human experiences. Jesuits used any and all techniques at their disposal to impress the intensity of emotional expression upon the observer. Domenicos Theotokopoulos (1541–1614), generally known as El Greco because of his Greek origins, lived most of his creative life in Spain, a Jesuit stronghold. He became the ideal artistic voice of the movement, intensifying the mystic asceticism in all of his paintings, whether the subject was religious or not. His

Colorplate 32 follows p. 184.

Laocoön (colorplate 32) expresses the struggle of the high priest of Troy with his sons by the elongation of the human form, by diagonal movement of line, and by the upward movement of light with the view of Toledo in the background. The brownish grey of the body color adds to the feeling of mysticism and asceticism. Art became a living thing by taking on a new vitality. Art and music were luxurious in form, color, melody, and harmony so that people might have a vicarious experience and emotional satisfaction.

The Calvinist movement, however, held a different attitude—one that affected the arts in a negative manner. Calvin preached the doctrine of predestination and freedom of conscience. He set a high value on the individual soul, God's choice as the recipient of salvation. Education in spiritual and civil affairs was the Calvinistic technique of bringing God's will into reality on

earth. This doctrine brought forth a group that was religious, narrow in personal conduct, and successful in business and government. Goodness came to be a matter of following certain rules of conduct, and all avenues of sense perception were carefully guarded and often completely closed. The beauty that Catholicism had utilized as a religious force was looked on as a product of the Devil. Images and figures disappeared from the church and the home; they were looked upon as idols, too easily worshiped for their own sake. Music, because it made its appeal directly to the emotions, was looked upon with great suspicion. Except for psalm singing, "in one voice and with plain tune," music was banished from the Calvinist church. Organs were either destroyed or removed from places of worship. This religious doctrine explains the lack of Church patronage of music and art in those countries, such as Scotland and the Low Countries, in which Calvinism had a strong hold. It remained for the Lutheran and Catholic churches to provide the impetus for artists to embody their religious ideals in art.

The center of wealth had shifted from Italy to the north; consequently the center of art shifted from Italy to Germany and to the Netherlands, where Rembrandt and Rubens represented the Dutch and Flemish, respectively. The arts in these centers reached far greater heights of achievement than any of the Italian arts of the same age. During the great religious struggles of the late sixteenth century, the Low Countries were broken up into two sections according to religious leanings. The Dutch were Protestant, while the Flemish remained Catholic. Consequently, in Holland we find a distinctly anti-royalist, anti-Catholic, middle-class society characterized by the prosperity of the Dutch colonial empire and the middle-class merchant. The art of Holland and North Germany represents this middle-class, Protestant point of view. It is natural, also, that Flanders, south Germany, and Austria would be Catholic and aristocratic. The Flemish artists, such as Rubens, painted their biblical and holy pictures with aristocratic models rather than the poor or middle-class people used by the Dutch painters.

Compared with Renaissance painters, Baroque painters turned more and more toward the common man for patronage because of the concentration of wealth in the middle class, whether Protestant or Catholic. This interest in the middle class also followed from the more important place the average person was taking in the destiny of civilization. Middle-class art appreciation brought new patrons as well as new subject matter. Common everyday scenes, events, and experiences, such as a picnic or a drunken beggar, were sufficient reason for creative effort. As artists became more sensitive to experience, their art became more sensitive in its expression. As the horizon of experience became wider, attention was turned from individuals to include their surroundings. Landscapes became a prominent part of painting. Even portraits were often made with the subject standing next to a tree or on a riverbank, with the rolling expanse of an estate in the distance. This was especially true in the north where a considerable portion of the wealth was concentrated in the land.

Music as well as the visual arts appealed to the uncultivated emotions of the common person. For the same reasons that painting appealed to the middle-class merchant and the aristocrat, music reached out for this kind of an audience. In the north, especially in Germany, music provided the devout Protestant with a personal religious experience through a tonal art. Melodies were broad and singable; harmonies were rich and full of pathos. Bach and Handel, both representatives of Protestant Germany, have given us some of the world's most meaningful sacred music because of this appeal to the emotions. Handel's *Messiah* and Bach's *Mass in B Minor* stand as symbols of the spiritual expressiveness and power of music. In the southern countries, music was still more concerned with spectacle and dancing, reflecting the more aristocratic society for which it was written.

The Baroque urge toward a systematizing of every aspect of human experience also had its effect on the arts. We have seen that science, philosophy, economics, government, and even religion showed a strong urge to methodize. The arts explored a great variety of techniques. The theme and variations principle of design became an artistic creed, whether in painting, sculpture, architecture, or music. The ingenious handling of basically simple materials resulted in a unity of all elements, in a singleness of purpose. The purpose was personal expression, not only for the creator but for the observer. Artists invited the observer to enter into the action and partake of the aesthetic experience, just as the Jesuit was invited to enter into a religious experience and the Lutheran to partake of an inner struggle. The Baroque was not a cult of beauty but an art of energetic realism. The realism of all aspects of Baroque life, from business to religion, is expressed in its art. The *Coronation of King Louis XV* (fig. 8.1) documents an important event in the life of the French nation. It represents the pageantry of the event, including music making, and the processional in the cathedral at Rheims, which was decorated with magnificent tapestries for the occasion.

A desire for magnificence, which was brought about by the rise of a wealthy middle class, was also a characteristic of the Baroque. This led to ornamentation often carried to a point of vulgarity and was responsible for the lack of recognition of the value of Baroque art until recent times. Architecture was often loaded with ornamental "gingerbread"; melodic lines in music were ornamented with trills, turns, and other devices. Such ornamentation sometimes reveals a weakness in Baroque art, but beneath these decorative effects are melodies and visual lines that are truly expressive and beautiful.

Because of the many-sided contradictions of the Baroque, it is difficult to single out one artist, or even one art, as the quintessence of the seventeenth-century spirit. There are, however, a few artists whose works not only reveal the spiritual content of the age but span the breadth of all the contrasts and contradictions. Tintoretto, Rembrandt, Rubens, and Velásquez in painting;

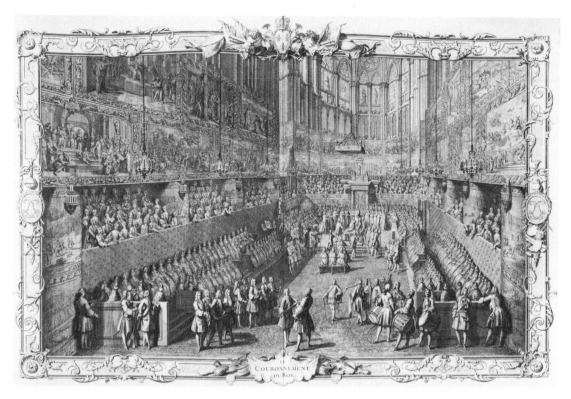

Figure 8.1 *Coronation Service of King Louis XV* [1715]. (Spencer Collection; The New York Public Library; Astor, Lenox and Tilden Foundations) (Photo by Robert D. Rubic, N.Y.)

Bernini in sculpture and architecture; Monteverdi, Froberger, Corelli, Giovanni Gabrieli, Schütz, Vivaldi, Bach, Handel, and Domenico Scarlatti in music—all have won places in the small number of truly great artists of all ages.

Painting

Baroque painters used the same elements of line, color, form, organization, and space that had been used before. Because of different influences on their life and art, however, they used them in a different manner. In Baroque painting, line is generally diffused, one form melting into another without clear lines of demarcation. Color is usually monochromatic, with variations in saturation and value of that one color. The tremendous vitality of Baroque painting is shown in open form, with action implied beyond the visible limits of the canvas. Organization is multiple. The forms are merged into one another. The resulting open form, multiple organization, and diffused line brought a strong sense of space, which is often extended into the distance.

Tintoretto

Colorplate 33
follows p. 184.

Tintoretto's *Last Supper* (colorplate 33) at the Church of San Giorgio Maggiore in Venice is an example of the early Baroque style, in contrast to the Renaissance. Tintoretto (1518–1594) was a Venetian and, as such, was deeply indebted to the spectacular and colorful style that characterized all Venetian art. He was also one of the last of the great Italian painters, for artistic activity was, as we have seen, gradually moving toward the northern countries.

There is a marked difference in concept between Tintoretto's *Last Supper* and that by Leonardo da Vinci. Tintoretto impresses us with the dramatic vitality of the moment. The spiritual impact is apparent as well as the human reaction of the disciples. The figures stand out in sudden lights, like fireworks, and the whole scene suggests a spiritual and emotional interpretation that is quite opposite to the calm and serene expression of Leonardo's work. Tintoretto has moved away from the classic balance of earlier painters and makes his figures move about the canvas, vibrant and alive. Space recedes diagonally into the distance, drawing the viewer into the action. Symbolically, this space is even more extended by the physical presence of angels in motion over the scene, as the figures melt one into another without any great degree of demarcation. This effect calls for diffused lines. There is considerable variety of color but without the sharp contrast usually present in Renaissance art. An analogy might even be suggested between this painting and Baroque music, where sheer sonority arouses and intensifies emotion. Thus Tintoretto, with his force of color, light, space, and dramatic action, leads the spectator into the scene as an actual participant in this deeply moving drama.

Rembrandt

From an early age, Rembrandt (1606–1669) showed a sensitivity to beauty and truth. One of the most important early influences on his life was the memory of his mother reading to him from her Bible. The biblical stories left vivid impressions that were later to bear great artistic fruit. Rembrandt's parents had hopes that he would become a lawyer or a doctor, or perhaps a preacher. They were disappointed when he showed little interest in anything except art. He was finally apprenticed to a painter and later was sent to Amsterdam to study with the great celebrity Lastman. After six months Rembrandt left, disgusted with his teacher's methods and artistic ideals. In 1632 he returned to Amsterdam, where he was launched on a career in art.

Colorplate 34
follows p. 184.

He received many commissions from wealthy families for portraits and scenes representing the business and professional life of Amsterdam. His most famous work of this early period is *Dr. Tulp's Anatomy Lesson* (colorplate 34), in which he painted a well-known doctor demonstrating the technique of surgery. Although this painting is a record of a dramatic event, effectively it

is a group portrait with careful attention to the individual characteristics of several well-known citizens of Amsterdam. Their characteristics are made all the more apparent through the use of a focused bright light on their faces and obscure surrounding details (**chiaroscuro**).

Rembrandt, at this stage of his development, painted in a clear-cut, masterly manner, but without his later expressiveness. He was popular and successful, buying a large home in the Jewish section of the city and marrying into a very wealthy family. Business was good—too good to last. Always a student of people, Rembrandt began to be influenced by the people around him. His style changed from the pleasing manner to one of probing character study. As a result Rembrandt lost favor with his wealthy clients. *Night Watch* (colorplate 35) includes passages of this change in style.

Colorplate 35 follows p. 184.

The subject of the *Night Watch* is a group of merchants who have banded together to patrol the streets of Amsterdam for the purpose of keeping law and order. Rembrandt was commissioned to paint a canvas of the group as a memorial to their patriotic spirit. It was to be hung in the city hall, and he was to have been paid a hundred florins by each member. Rembrandt painted them as they were—a patrol emerging from the shadows of dark streets into a light, but this was not as they wanted to be portrayed. They were prominent men and wished to be painted in a clear light in a flattering way. Rembrandt was a realist and painted only what he truly saw. *Night Watch* is based on reality, not superficiality.

The lines of the painting are diffused, with one body melting into another so that it is impossible to distinguish individual figures. Sharp edges are lost in the atmosphere of shadow and merging color. This is what the eye sees, not what the mind's eye knows. Because of the diffused lines, the organization is fused; there is a total organization of forms and symbols into a unit. It gives a sense of infinite space, of recession into the distance. By the skillful use of light and shade, Rembrandt has given the painting a sense of depth that was unknown in earlier art. He extends space horizontally by representing only a part of the action in the picture. The figures on both right and left are only partially visible and are cut off by the frame. Because of infinite space, the form is open. The center is a highlight with greater detail and larger figures, but attention is also drawn to events outside the space enclosed by the picture. There is life and action, both physical and expressive, in every figure represented. The color, with minor exceptions, is monochromatic. Rembrandt has used one color to fuse the figures together. Besides adding to the sense of fused unity and diffused line, color is also a reminder of the theme and variations technique of the Baroque—variations of shading in one basic color.

With a sense of direction born of the analytical and scientific spirit of the Baroque, Rembrandt strove systematically to make himself a master of reality. He sketched and painted hundreds of works in an effort to perfect a technique

The Baroque (1600–1750) 183

that would bring reality, action, and vigor to his art. With the aid of mirrors, he made innumerable sketches of himself in order to reduce the texture of flesh and hair to a systematic arrangement under various light conditions. He was one of the first artists to realize the function of light and shade as a medium of extending space, both in recession and projection. He was also one of the first artists to recognize light and shade as a unifying agent in painting. He achieved unity through these techniques.

The works of his later period show the results of Rembrandt's intense studies. They are deep and need extended contemplation for a full realization of their meaning. From a purely human point of view, from the standpoint of human sympathy and understanding, nothing can approach the quiet, compassionate beauty of his religious art.

Colorplate 36 follows p. 184.

The Descent from the Cross (colorplate 36) is a fine example of Rembrandt's use of light and shade not only as a unifying agent but as a means of intensifying the powerful, emotional content of the painting. The figure of Christ is highlighted, but still with lost edges and diffused lines. With different degrees of intensity of monochromatic coloring, Rembrandt succeeds in making the faces of all participants in the action reveal their own grief over the tragedy. This is one of Rembrandt's great religious paintings.

Colorplate 37 follows p. 184.

Another excellent example is the *Supper at Emmaus* (colorplate 37). The story of the disciples' meal at Emmaus is one of the tenderest in the New Testament. The two disciples have come together, speaking of the Master who is no longer dwelling among them. Thinking of his words, "Where two or three are gathered together in my name, there am I in the midst of them," the disciples sit at the table with the apparition of the Lord, who has made himself known to them. Rembrandt retains the quiet, tranquil mood of the story. The architecture has solemnity, with the huge arch outlining the figure of the Master. There is only gentle action, including the soft movement of light coming from the radiation of the halo. The disciples are quiet and deeply touched. Christ is presented in the simplest view, full-faced and in the highest light. Space has been dematerialized in this work. Rembrandt has caught not only the spirit of the story but also the atmosphere of the setting. It is a spiritual experience, not only for the disciples but also for the countless thousands who have seen and been moved by this great work.

This painting is only one of the more than 300 works that bear testimony to Rembrandt's greatness. Worldly success did not last. In the end, the artist had only a few faithful friends—just a few who believed in him. But Rembrandt had a great faith in his mission; he believed that his art was his destiny, and he was faithful to that ideal. Finally, in 1669, he painted his last picture, a self-portrait showing an old, broken, wrinkled man—smiling. Society forced him into a pauper's grave, but his faith has brought him into the ranks of the great of all time. Like most prophets, he caught the spirit of his own age and left lasting memorials to it.

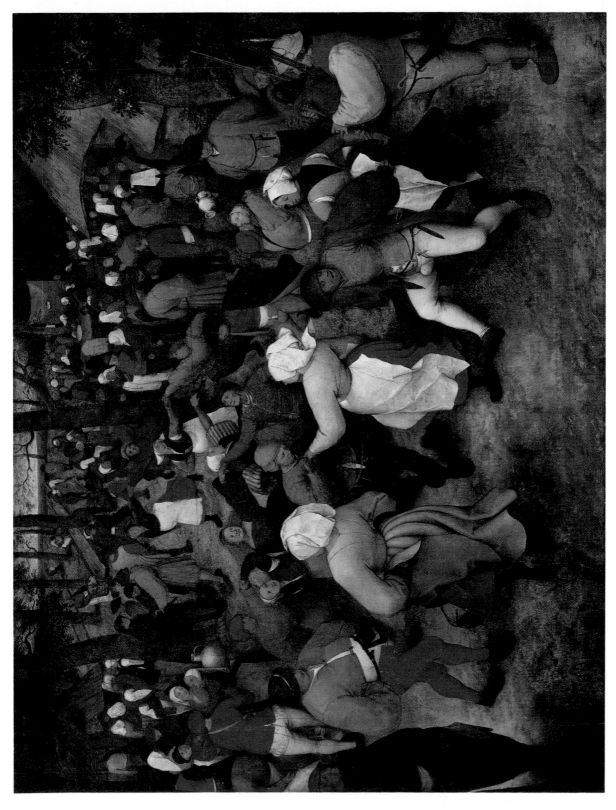

Colorplate 31 *The Wedding Dance* [1566]—Pieter Brueghel the Elder. 47″ × 62″. (© Detroit Institute of Arts, City of Detroit Purchase)

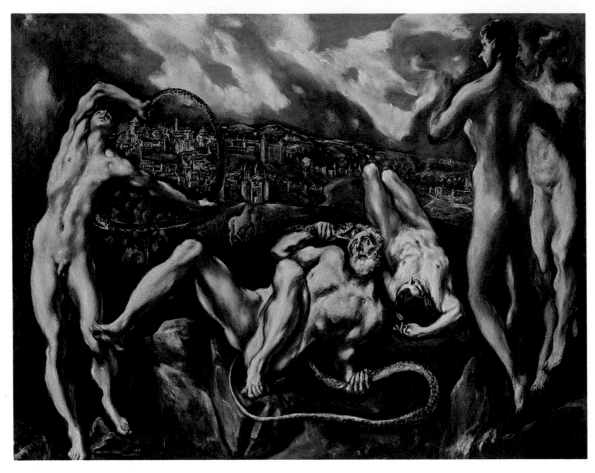

Colorplate 32 *Laocoön* [c. 1610]—El Greco. Canvas, 54⅛″ × 67⅞″. (National Gallery of Art, Washington/Samuel H. Kress Collection)

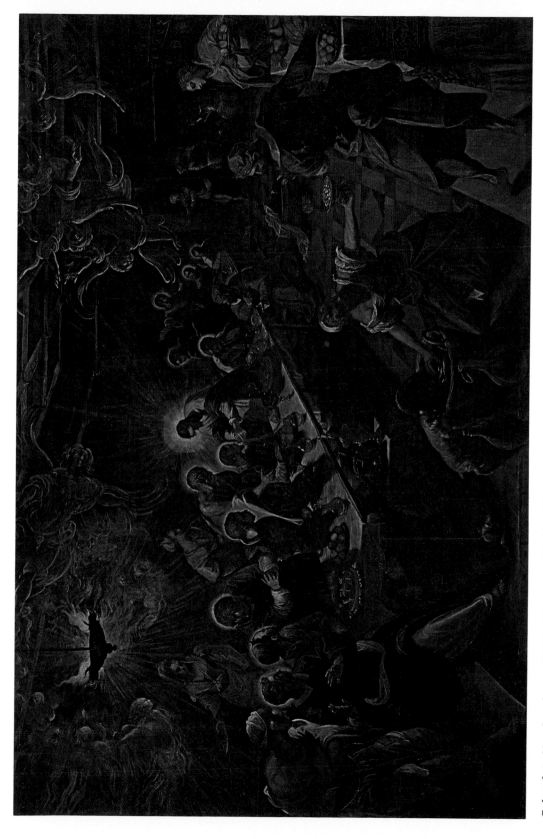

Colorplate 33 *Last Supper* [1594]—Tintoretto. 12′ × 18′8″. (Scala/Art Resource, N.Y.)

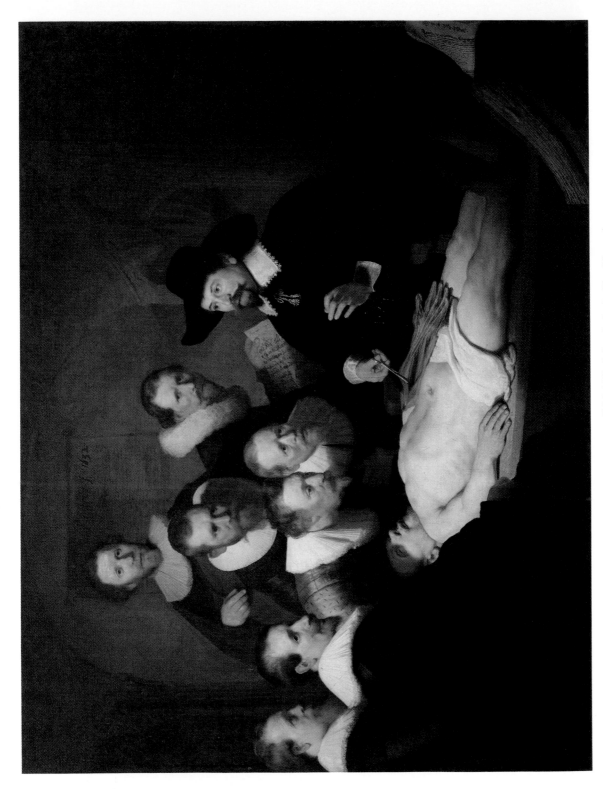

Colorplate 34 *Dr. Tulp's Anatomy Lesson* [1632]—Rembrandt. 63″ × 85″. (Mauritshuis-The Hague)

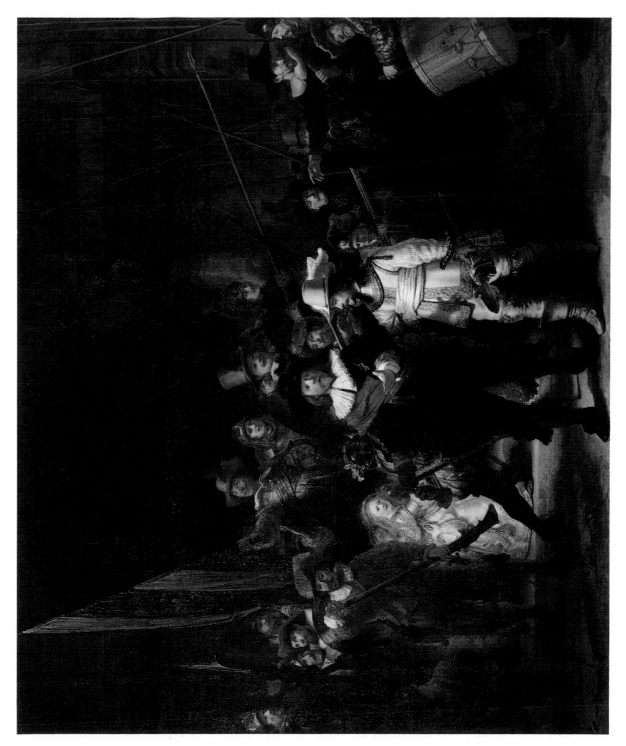

Colorplate 35 *Night Watch* [1642]—Rembrandt. 12′2″ × 14′7″. (Rijksmuseum, Amsterdam)

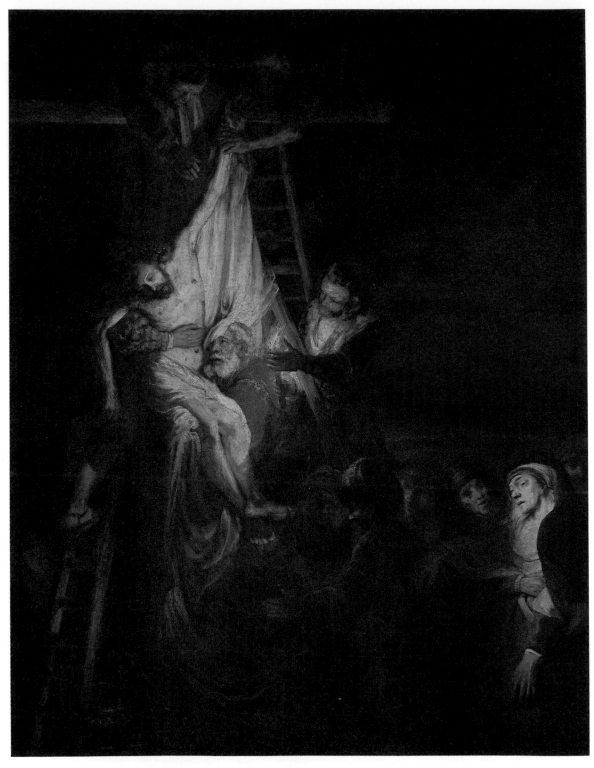

Colorplate 36 *The Descent from the Cross* [1650–1660]—Rembrandt. Canvas, 56¼″ × 43¾″. (National Gallery of Art, Washington/Widener Collection)

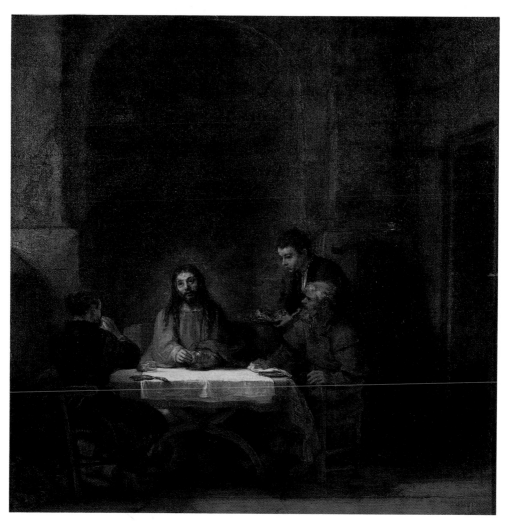

Colorplate 37 *Supper at Emmaus* [1661]—Rembrandt. 26¾″ × 25⅝″. (Scala / Art Resource, N.Y.)

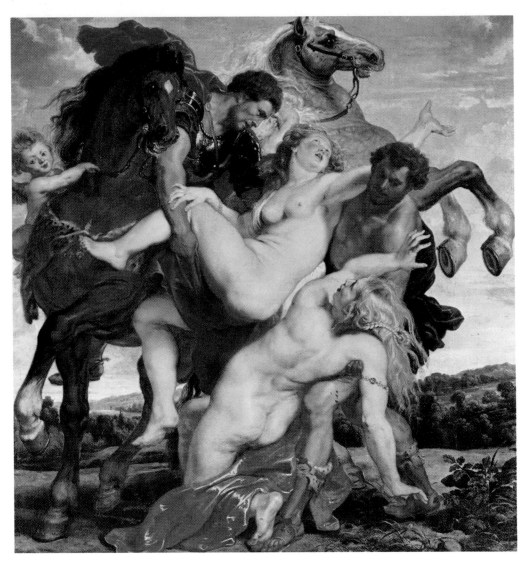

Colorplate 38 *Rape of the Daughters of Leucippus* [1618]—Peter Paul Rubens. 7′3″ × 6′10″. (Scala/Art Resource, N.Y.)

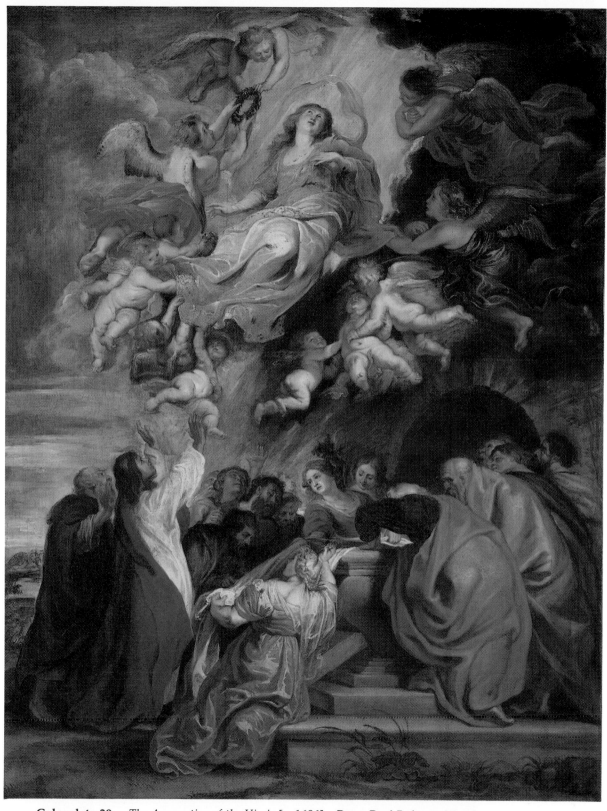

Colorplate 39 *The Assumption of the Virgin* [c. 1606]—Peter Paul Rubens. Wood,
49⅜″ × 37⅛″. (National Gallery of Art, Washington/Samuel H. Kress Collection)

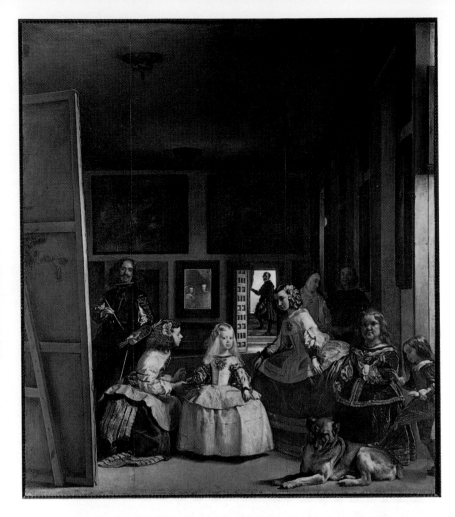

Colorplate 40 *Maids of Honor* [1656]—Velásquez. 10'5¼'' × 9'5⅝''. (Scala/Art Resource, N.Y.)

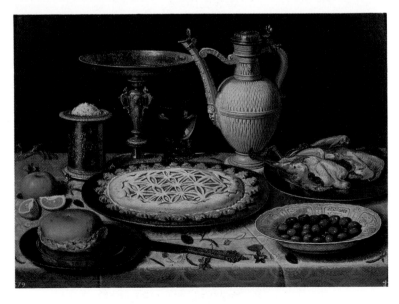

Colorplate 41 Still Life—*Set Table* [c. 1589–1676/Flemish]— Clara Peeters. (Madrid, Prado.)

Rubens

Rembrandt was the product of Dutch Protestantism, and Peter Paul Rubens (1577–1640), on the other hand, was one of the greatest painters to come from the Flemish Counter-Reformation. Combining the best elements of the Italian schools of art, he created some of the most stimulating and significant art of any period. From the point of view of sheer, animal vigor, there is no painter as exciting as Rubens. As an interpreter of the violently anti-Protestant movement of Spanish Flanders, he has left some of the most moving religious art of that period.

At the age of twenty-three, Rubens, already a master painter, went to Italy. He was engaged by the Duke of Mantua in Venice, who gave him every opportunity to travel and to study the work of Italian masters. On one occasion, he made a trip to Spain on a diplomatic mission for the Duke. The success of this trip brought great favor from both the Duke and the Spanish court— favor that was to prove profitable artistically. While in Spain, Rubens did a number of portraits and palace decorations. From there, he traveled to England in the service of the Spanish king and incidentally assumed the job of decorating the ceiling of the banquet hall in Whitehall Palace. He later settled in Antwerp, where artists and students came to him from all over Europe.

Because of his enormous popularity as a painter, Rubens had many more orders than he could fill by his own creative efforts. He organized a commercial art studio operated on the assembly-line method. This studio, which accepted all commissions and orders, demonstrates the Baroque spirit of systematization. The general structure or plan for a work was done by Rubens. He would make preliminary sketches and cartoons, but the canvas was made ready by assistants who executed the underpainting, including the background and figures. There were usually twelve such assistants employed, each with a special capacity for doing certain types of painting. When all was finished, Rubens would put the work together by his own hand, putting on the finishing touches. Needless to say, Rubens continued his own creative work in a personal way, but the studio supplied a vast number of excellent pictures. The patron's ability to pay often determined the extent of Ruben's personal interest and therefore the paintings' degree of excellence.

Rubens was not a Jesuit, but he was in great sympathy with the Jesuit movement. Consequently, he was commissioned to do a number of paintings for a Jesuit church in Antwerp. These works, which are typical of Rubens, abound in colors blended together monochromatically. They are filled with action and movement, suggesting an enormous vigor. The forms are made cohesive with subtle light and shading as well as with the "lost edge" technique. He identified himself with his subject in the Jesuit manner of intense concentration. His effects are so intensely real that the observer is drawn into the feeling and action of the picture.

Colorplate 38
follows p. 184.

The *Rape of the Daughters of Leucippus* (colorplate 38) shows the robust dynamism of the Baroque spirit. This is the essence of physical exuberance and sensual flesh against flesh. There is complete absence of static line; everything moves with a sheer delight in motion. The variation technique is also employed. Every movement is carried on by short, curved lines of arms, legs, and torsos. This technique is applied even to the contour of the ground and the clouds in the sky. The larger movement speeds diagonally across the canvas through the twisted and unnatural positions of the nudes. The physical reality of form is highlighted by the flashing torsos contrasted against the swarthy mass of men and animals. Form melts into form by diffused line and sheer energy. The observer is drawn into the action by its sensuous appeal to the eyes, not to the mind.

Colorplate 39
follows p. 184.

The theme and variation technique is a feature of *The Assumption of the Virgin* (colorplate 39). The human figure is used almost as a musical motive, with each person blending into the other either by motion or by light and shade. Each figure seems to have its own identity, and yet the whole canvas is a fusion of figures into one grand diagonal movement. The human motive creates open form by moving rhythmically in an upward and clockwise motion. The movement expresses vividly the ecstasy of the Virgin's ascent into heaven, accompanied by the cascade of angelic cherubs. Rubens ingeniously uses color, diffused line, fused organization, and a bipartite form that distinguishes between the heavenly and earthly facets of one event.

This most typical Baroque painter died in 1640. It is recorded that the Jesuits of Antwerp said 700 Masses for the repose of his soul. Like Rembrandt, Rubens' greatest works were those created in the service of the Church but created also out of the sincere conviction of his own spiritual experiences.

Velásquez

Another painter of the Baroque was Diego Velásquez (1599–1660), who lived and worked in Spain. He was not a mystic, nor a Jesuit, nor did he express the bold ornamentation and action of the Baroque. Like Rembrandt, he was a master of light and shade, with a feel for space and realism. *Maids of Honor* (colorplate 40) is a portrait of the Infanta Margarita and her attendants, but it is more than that. Velásquez paints a moment in his life as a portrait painter. He is standing on the left, palette in hand, before a large canvas. The King and Queen, who are not shown directly, are reflected in the mirror across the room. The soft pastel dress of the Infanta contrasts with the darker colors of the attendants. However, there are soft edges that blend one figure into another. The refined delicacy of the Infanta also presents a dramatic contrast with the blunted, dumpy features of figures on the right. Velásquez manages a fine illusion of reality by his treatment of space and his arrangement of the figures.

Colorplate 40
follows p. 184.

Clara Peeters (1594–1676), like Rubens, made her home in Antwerp. She is perhaps best known for her still life paintings and is one of the early contributors to this genre. The genre itself had just emerged in Flemish painting and occupied the attention of many creative artists of the time. The still life— *Set Table* (colorplate 41) is painted with a technique that heightens detail almost beyond realism. The lighting is dramatic rather than realistic. Such theatrical manipulation of light has been frequently employed by artists of later periods.

*Colorplate 41
follows p. 184.*

Finally, some of the most spectacular examples of the Baroque's soaring energy and religious ecstasy can be found in the ceiling paintings of many churches, especially those of the Jesuit Order. These ceilings were often created by relatively unknown artists, or even by groups of artists. A fine example is the ceiling by Andrea Pozzo (1642–1709) (colorplate 42) in the Church of Saint Ignatius in Rome. The scene represents the ascension of Ignatius Loyola into heaven and is painted in a style that resembles that of Rubens. The upward motion of saints, angels, and cherubs gives the impression that the dome has been opened to heaven and all its glory. The human figure is used as a motif in a gigantic panorama of religious mysticism.

*Colorplate 42
follows p. 232.*

Sculpture

When compared with the more reserved sculpture of the Renaissance, there is more action, expressiveness, and individuality in the sculpture of the Baroque. The most famous sculptor of this age is Bernini (1595–1680), a Jesuit whose works are imbued with a devout and intense personal religious expressiveness, enhanced by his spiritual exercises. A comparison of Michelangelo's *David* (fig. 7.4) with Bernini's *David* (fig. 8.2) demonstrates the contrast between Renaissance and Baroque styles. Michelangelo's work is monumental but static, while Bernini's shows great physical and nervous reality. In Bernini's there is action—David is tense with pent-up energy about to be released. His eyes are focused on the object of the action, the figure of Goliath, which remains beyond the artwork itself.

One of the most famous works of Bernini is the *Ecstasy of St. Theresa* (fig. 8.3), the sculptured piece above the altar of the Cornaro Chapel, Santa Maria della Vittoria, Rome. The Baroque spirit of intense emotional ecstasy and imagination is expressed in this work. The subject is St. Theresa's dream, in which an angel appeared before her holding a dart, symbolic of divine life, with which he pierced her heart. The saint is in an ecstasy of pain; the pathetic expression on her face and the shoulder upraised in anticipation of the next thrust are testimony to the emotional sensitivity of Bernini's art. The artist has used every device at his disposal to intensify this expression. The impression of infinite space is created by the heavenly cloud on which the

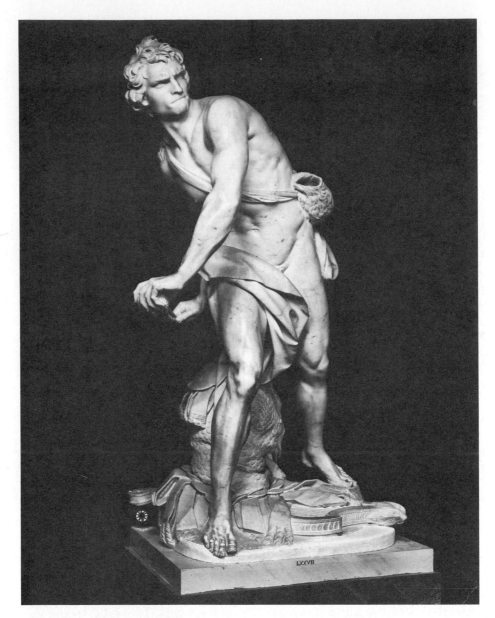

Figure 8.2 *David* [1624]—Bernini. Life size. (Borghese Gallery, Rome)

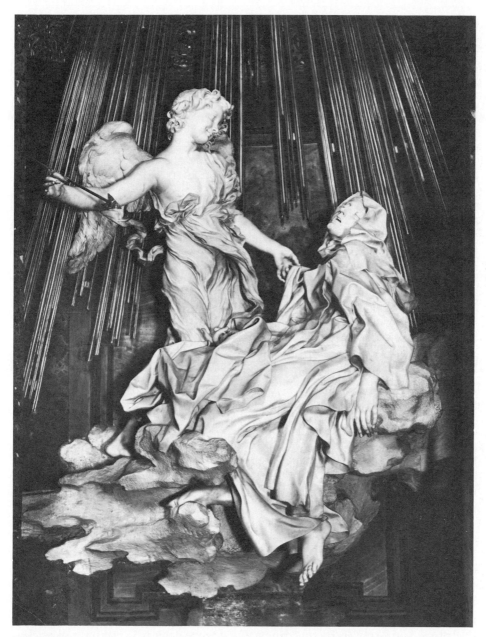

Figure 8.3 *Ecstasy of St. Theresa* [1646]—Bernini. Life size. (Alinari/Art Reference Bureau)

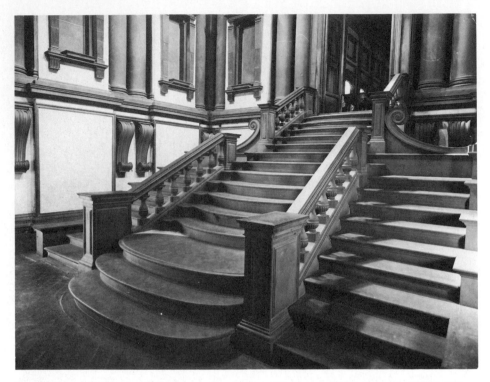

Figure 8.4 Stairway of the *Laurentian Library*, Florence—Michelangelo [1558–59].
(Alinari/Scala/Art Resource, N.Y.)

action takes place. Space is made even more real by the hanging draperies and the suspended feet of the saint. The poised dart, the angelic face, the flowing drapery—all combine to make this a work of dynamic but spiritual motion.

Architecture

While architectural design was to remain classic in its fundamental forms well into the twentieth century, the Baroque spirit added vigor, and at times profuse ornamentation, to architecture. The same predilection for movement, light and shade, and plasticity of form that characterizes Baroque painting and sculpture is present in its buildings. They were designed not only to enclose space but also to present a dramatic spectacle to the eye. Differences between Renaissance and Baroque style are superbly manifest in the grand stairwells of the Laurentian Library in Florence and the Schloss Augustusburg castle at Brühl (figs. 8.4, 8.5). In the former a feeling of serenity and order is projected

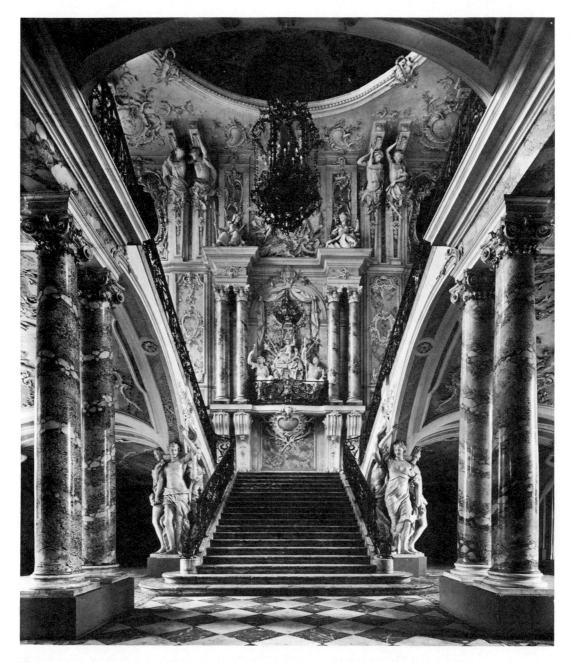

Figure 8.5 Stairway at Schloss Augustusburg, *Palace of Brühl*—B. Neumann, 1687–1753. (Bildarchiv Foto Marburg)

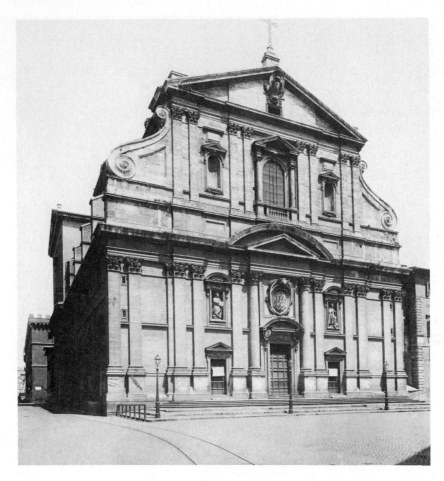

Figure 8.6 *Il Gesù* in Rome [c. 1575–1584]. Giacomo della Porta. (Art Resource, N.Y.)

through uncluttered lines, balance, and symmetry. In the latter, the exuberance and excitement of the Baroque are achieved by an encrustation of ornament or decoration over the structural members of the architecture. The stairs are scarcely noticed in the visually agitated surroundings.

The dramatic spectacle of the Baroque was particularly apparent in the churches. Spiritual salvation lay within the doors, but the glory and magnificence of heaven was also suggested to the eye by the facade.

The Greek temple, along with the Roman dome, was almost always emulated in the structures of Baroque builders. The way they arranged and decorated these basically simple forms, however, suggests the Baroque variation technique. An example of early Italian Baroque, based on classical principles but energized by the Baroque spirit, is the church of *Il Gesù* in Rome (fig. 8.6).

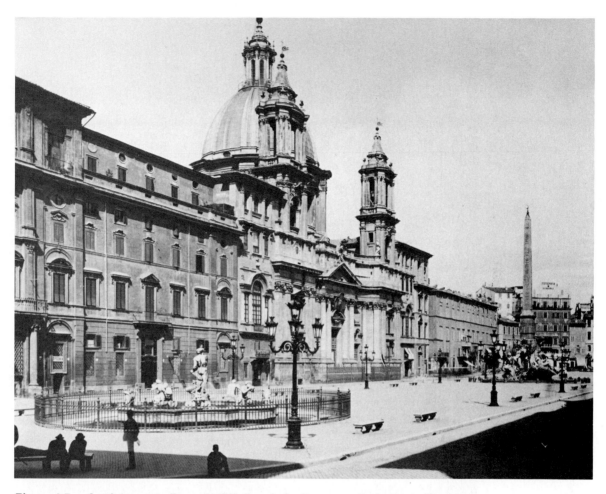

Figure 8.7 *Sant' Agnese* in Rome [1653]. Façade by Francesco Borromini. (Keystone View Company)

A Jesuit church, it was designed by Giacomo da Vignola (1507–1573), but the facade was redesigned by Giacomo della Porta (1541–1604). A mixing of Renaissance and Baroque styles can be seen in the triangular design over a low-arched pediment. The curved scrolls on either side act as buttresses and also draw the eye from the wide base of the nave to a screen that hides the vault over the nave. While *Il Gesù* is not overly ornate, it did become a model from which many other Baroque churches were designed.

Sant'Agnese (fig. 8.7) in Rome is a typical example of the middle Baroque period. It was designed by Francesco Borromini (1599–1667) and completed in 1657. One is immediately conscious of the classic columns and the huge dome. Look carefully, however, for purely decorative design. The columns

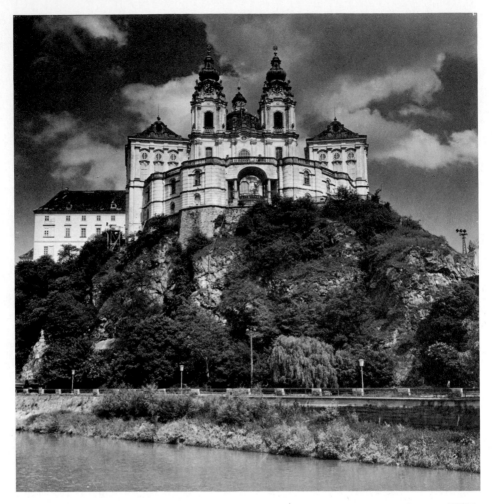

Figure 8.8 Exterior of *Monastery Church of Melk* [c. 1702]—Jacob Prandtauer. (SEF/Art Resource, N.Y.)

have been doubled to make a richer appearance. The towers on either side of the dome are set ahead and the facade is curved to connect with the central section. In a sense, this is comparable to the painter's use of light and shade for depth. While the bottom portion of each tower is square, the top is rounded, suggesting a twisting movement. The whole breadth of the facade is covered with repeated ornamental carvings to mold the component parts together and to give a sense of undulating motion to the eye.

The *Monastery Church of Melk* in Austria (fig. 8.8) is an excellent example of the northern Baroque that followed the basic plan of *Il Gesù*. The richly

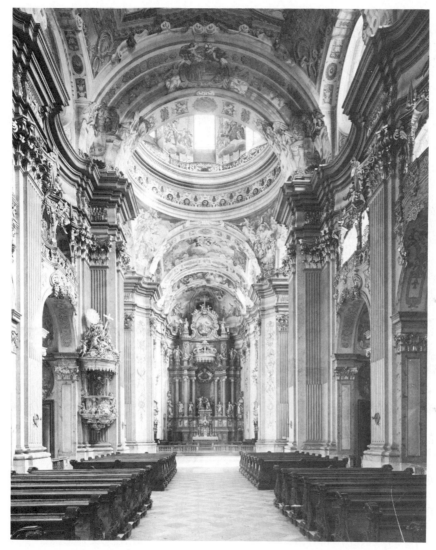

Figure 8.9 Interior of *Monastery Church of Melk* [1702–c. 1738]. (Bildarchiv Foto Marburg/Art Resource, N.Y.)

decorative and ornamental interior (fig. 8.9) embodies a highly complex series of variations on the curve of the round arch. The effect is one of dynamic motion from the floor of the wide nave to the well-illuminated and elaborately decorated vaulting above, perhaps suggesting the splendors of heaven itself.

Bernini's *Plaza of St. Peter's* (fig. 8.10), situated in front of *St. Peter's* in Rome, illustrates the Baroque tendency to strive for monumental forms. It is

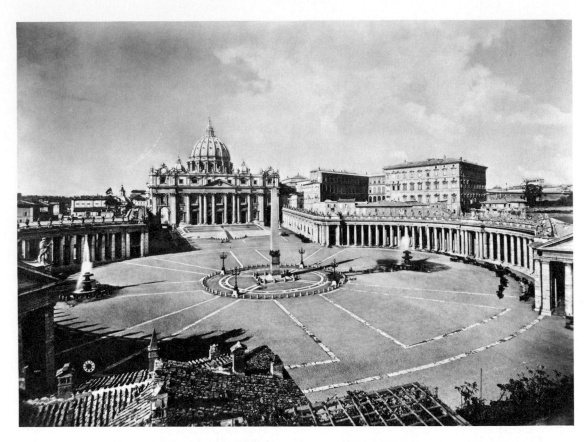

Figure 8.10 *Plaza of St. Peter's* in Rome [1656–1663]—Bernini. (Alinari/Art Resource, N.Y.)

an attempt to dominate great spaces, akin to the Jesuit idea of dominating the world. The facade of *St. Peter's* and the double rows of colonnades, extending outward like great pincers, are all conceived as one gigantic work of art. The colonnades, topped by rows of figures of the saints, sweep up toward *St. Peter's* with a curvilinear motion that swiftly draws the observer into the confines of its portals.

Bernini was working in Paris on the Louvre in 1665 when he was visited by Christopher Wren, the English astronomer and geometrician. Wren was soon to become one of the greatest architects of all time. His response to the tragedy of the fire of London (1666) was to create a plan for a new city. While most of that design was never completed and is now lost, an enormous legacy of building remains. Perhaps the greatest single edifice designed by Wren is *St. Paul's Cathedral* (fig. 8.11). While it is not the cathedral that Wren would

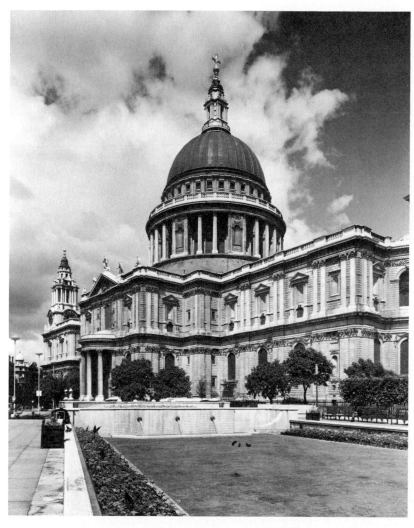

Figure 8.11 Exterior of *St. Paul's Cathedral*—Christopher Wren. [1675–1710].
(© A. F. Kersting)

have preferred, it does have one major feature that was central to his pre-
ferred design—the dome. In a sense this dome is the Anglican's response to
the dome of St. Peter's in Rome, and it was his only church among many to
be without a steeple. Its flying buttresses, not a normal part of Baroque ar-
chitecture, are uniquely concealed behind screening exterior walls. The mas-
sive rounded arches of the interior of the cathedral (fig. 8.12) reiterate the
curve of the surmounting dome. The architectural vocabulary of the Greeks
is evident in the repeated Corinthian features of the nave.

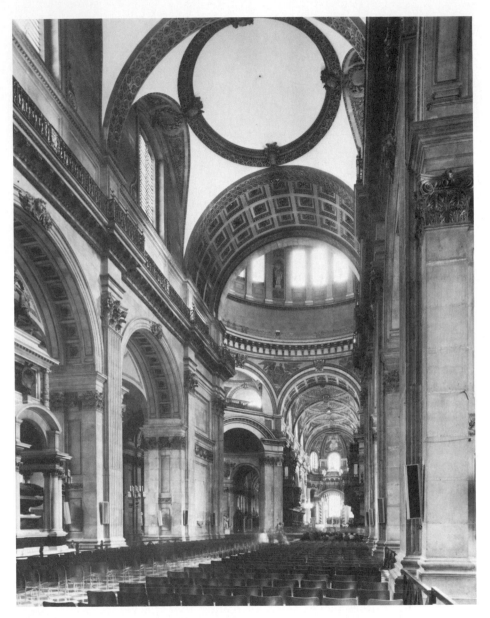

Figure 8.12 Interior of *St. Paul's Cathedral* [1675–1710]—Christopher Wren. (© A. F. Kersting)

Many of the architectural features of Baroque secular buildings are identical to those of sacred structures. These numerous memorable secular buildings include an increasing number of private residences such as Versailles near Paris, Schönbrunn in Vienna, and *Wilton House* (colorplate 43) in England. The architect's penchant for geometric space is evident in the double cube shape of this room designed by Inigo Jones. At the same time that simple shape is disguised with decorative swags, murals, and ornate furnishings.

Colorplate 43 follows p. 232.

Music

There were two main lines of musical development during the Baroque. One was the development of dramatic vocal music, both secular and religious, such as the opera, oratorio, and cantata. The other was the emancipation of instrumental music from its nearly exclusive use of vocal forms, leading it to a position of dominance by the end of the period. Moreover, for the first time in musical history, two styles were purposely used side by side, the older style of the Renaissance and the modern style of the Baroque. During this time composers became even more conscious of musical conventions. However, certain characteristics of style were developed in this period that tied together such seemingly disparate composers as Peri, Monteverdi, and Frescobaldi of the early seventeenth century with Bach, Handel, and Domenico Scarlatti of the first half of the eighteenth century.

In spite of stylistic differences, there were four unifying elements: (1) the establishment of tonality as the basis of musical organization, (2) the use of the basso continuo, (3) the development of the recitative, and (4) the development of true vocal and instrumental idioms.

The first of these, the establishment of tonality as the basis for harmonic organization, puts Baroque music in complete contrast with Renaissance practice, in which intervallic harmony was dictated by the use of modes. The idea of harmonic depth is as clearly developed in music as plastic perspective is in painting. Contrast the perspective of *The Assumption of the Virgin* (colorplate 39) with that of *Journey of the Magi* (colorplate 21). Note the plasticity of the figures, the feeling of depth, and the sense of planes of distance in the former, and compare with the lack of true plasticity and depth in the latter. Similarly, contrast the opening chorus, verse 1, of the cantata, *Christ lag in Todesbanden* (*Christ lay in the Bonds of Death*) with the *Agnus Dei* from the Palestrina Mass *Veni sponsa Christi*. The feeling for key center in the cantata—in this case E minor—illustrates the importance of tonality to the Baroque style of Bach. The Palestrina work, with its modal harmony, illustrates a completely different concept of tonal organization.

The establishment of tonality as a primary concept in Baroque music gave rise to a number of new methods of handling materials. Homophony became equal in importance to polyphony. In the opera and in instrumental music, such as the dance suite and those forms based on the idea of *basso continuo*, homophony reigned supreme. The system of chordal relationships around a well-defined tonal center emphasized the growing importance of chordal harmony and the dissonant treatment of chords. Tonality was applied to harmony by constructing a series of chords under the melodic line. The series was designed to create a sense of tension and release, of motion and repose, through alternating chordal dissonance and consonance. The tonal center, or tonic chord, acted as a point of gravitation for the harmony, whose function was to define this focal point. This concern with tonality determined not only the organization of homophonic composition but also the treatment of counterpoint. The counterpoint of Bach and Handel was tonal rather than modal. The combinations of lines of melody in a Bach fugal passage, such as the "Hallelujah" at the end of the first chorus in the cantata *Christ Lay in the Bonds of Death*, were determined by chordal and tonal considerations. In contrast, the counterpoint of Palestrina's *Agnus Dei* was determined by the modal polyphony of the Renaissance.

To systematize tonality further, there arose a contrapuntal relationship between the bass line and the melody. A system of musical shorthand called *basso continuo*, or figured bass, was invented. This system of numbers and symbols indicated to the performer the chordal structure of the music. The figured bass was "realized" by the keyboard instrumentalist, who played the harmonies indicated by figures under the bass line in support of the melody. The basso continuo part functioned continuously, supplying the harmony with both its lowest written tones and chordal formulae. This bass line was reinforced by instruments such as the cello, bassoon, or string bass to supply tonal coloring and volume. The solid character of the bass in the homophonic Baroque style results from this emphasis placed upon it. Actually, there arose a sort of polarity between the bass and the melody, with the inner parts assuming lesser importance. This characteristic becomes a striking and readily recognizable feature of Baroque homophonic music, whether vocal or instrumental, whether from the early seventeenth or the early eighteenth century. The system of figured bass became so much a part of this new harmonic concept that it was, in one variant or another, the basis of the teaching of harmony for the next 200 years.

One of the most striking and effective devices originating in the early Baroque was the recitative. The recitative attempted to give musical setting to texts of dramatic significance so that the words would be clearly intelligible and yet have the assistance of musical texture. The texts were set to a declamatory vocal solo, in which the speech inflections were emphasized but balance and contour of melodic line were avoided. Recitatives were accompanied by

either simple figured bass realized on a keyboard instrument or by an orchestral texture. The recitative was developed by a literary and artistic group in Florence, known as the Camerata, who wanted to give effective representation to the words of their new dramatic venture, *dramma per musica*, later known as opera.

This new form, opera, fused drama and music in three ways: (1) through the use of recitatives, which carried the narrative text of the drama; (2) through arias and solo ensembles, which were the expression of highly emotional situations; and (3) through choral ensembles, which provided massed effects. The desire to fuse text and music into an indissoluble whole in the early music-drama was the counterpart of the same tendency to fuse elements of architecture, sculpture, and painting in the Baroque visual arts. For dramatic purposes, it is clear that a single vocal line conveys the meaning of words far better than a contrapuntal texture. At first, this led to the highly inflected declamation represented by the recitative. Gradually, more lyric and florid sections developed in contrast to the narrative character of the pure recitative until, by the middle of the seventeenth century, two distinct types of dramatic vocal settings were evident—the pure recitative and the aria.

The development of two distinct idioms, one vocal and one instrumental, is still another Baroque contribution. In earlier periods, most instrumental and vocal music could be played or sung interchangeably. In the Baroque, music was written specifically for instruments or for voices and could no longer be played or sung interchangeably. A **concerto grosso** or a **sonata** for violin and cembalo could not be conceived as vocal. The *Passacaglia and Fugue in C Minor* by Bach can be performed only as an instrumental work, though some of the idioms used are vocal in origin. (For example, the last section of this work is a **fugue** in which separate lines of melody are used as "voices.") On the other hand, such excerpts from Handel's *Messiah* as the recitative, *Comfort Ye My People*, and the following aria *Every Valley* are suitable only for a vocal performance.

Within these general stylistic characteristics common to the whole Baroque era, composers developed their technical mastery of chromatic harmonies and musically dramatic situations. They tried to lead the listeners out of and beyond themselves, to make them forget the limits of ordinary existence, and to open new aesthetic experiences through the emotions. The cultural and ultrarefined art of the elite was no longer satisfying. With the rise of the middle class came a desire among artists to identify themselves with their new world of the spirit and intensified experience. The result can be seen in the music of the seventeenth-century Baroque, an art of ecstasy and exuberance, of dynamic tension and monumental forms, an art of longing and self-denial in contrast to the assuredness and self-reliance of the Renaissance. Quite naturally, therefore, Baroque music became enriched by expressive melody, pathetic recitative, frequent **chromaticism,** and rhythm.

The growing humanism of the Renaissance had resulted in a greater interest in entertainment that would appeal to all classes of people, whether cultured or uncultured. The complexities of the polyphonic style did not appeal to the common people, who were more interested in dance forms and popular songs than in madrigals and Masses. Moreover, the Reformation had weakened the authority of the Roman church. Since ecclesiastical domination over the world of art was no longer possible, the work of the artist became increasingly secularized. Finally, the Renaissance veneration for classical antiquity, especially for Greek drama, set the stage for the invention of opera. Music was on its way to becoming an expression of human experience, an art of romantic idealism, a language of emotions. The beginning of the seventeenth century thus saw the fading of one epoch of music and the laying of the foundation for a musical revolution from which there eventually arose the whole edifice of modern music.

Vocal Music

Within the two main lines of musical development during the Baroque, the rise of the secular dramatic form of the opera was of earliest importance. In fact, the rapid increase of interest in this form spurred on the interest in instruments themselves. The opera also led to the great wave of independent instrumental composition that was to dominate the latter part of the Baroque period.

Monteverdi

The greatest of the early operatic composers was Claudio Monteverdi (1567–1643), who laid down the principles for combining the most important innovations of the Baroque. Monteverdi's great masterpiece *Orfeo* may be of little more than antiquarian interest to many twentieth-century listeners. Because of the stilted formality of the drama, there is also an obvious stress on the short independent forms in the music that gives a "posed" character to the opera. As in the Renaissance, this music is made up of many short pieces—such as dances, madrigal-like choruses, recitatives, and instrumental interludes called ritornelli—each of which can be removed without damaging the unity of form. The fact that Monteverdi was able to make these formal miniatures serve a truly dramatic purpose attests to his own genius and to the power of the Baroque spirit.

Monteverdi used recitative as the vehicle for carrying the most intensely dramatic and emotional scenes of the drama. This is unlike the later development when the aria, the more lyric vocal form, became the idiom for intensified emotional expression and the recitative was used only to carry the narrative. His use of this new recitative style was the realization of the desire to unify music, word, and action into one form. No need was felt to please

the ear with pleasant song or spectacular vocal display. However, this new musical dramatic form was so successful that by the end of the Baroque it had become the most popular form of musical entertainment. By this time, the sound principles of Monteverdi had been laid aside to give vocal and visual thrills for a great popular audience. It was not until Gluck restated the principles of Monteverdi in the middle of the eighteenth century that opera gained a new vitality. Despite their great popularity, the operas of the Baroque, by then, with a few rare exceptions, were completely forgotten. Recently, increasing numbers of productions of Baroque operas are reversing this pattern of neglect.

One must listen to Monteverdi's *Orfeo* within the framework of the early seventeenth century. Contrasted to the serenity and restraint of Renaissance choral music, religious or secular (*Ave Maria* by Des Prés or *Pour ung plaisir* by Créquillon), *Orfeo* presents a dramatic power that is as dynamic as that of Tintoretto's *Last Supper* (colorplate 33) in contrast to Leonardo da Vinci's work on the same subject (colorplate 25). The unity of the entire opera depends upon several factors. Most important is the purposeful attempt to make the music, text, and dramatic action combine into a completed expression. In much the same manner, Tintoretto repeated lines and masses of color to link his figures in the dynamic emotions of the *Last Supper*.

Opera's appeal, then, was in the vigorous, spectacular, and romantic dramas presented. That appeal continues even today. Evidence of this is the frequent performance of another of Monteverdi's operas, *L'Incoronazione di Poppea* in the past decade. These plots, gleaned from Greek mythology and historic events, presented a variety of actions and emotions that could be intensified by music and staging. Everything about Baroque opera was impressive and dazzling. Unique stage machinery produced striking effects of supernaturalism and realism. Stage settings taxed the Baroque artists to produce canvases that would reveal the excitement and pathos of the dramas. Music, staging, and the text—in short, everything—marshaled all their forces in a tremendous onslaught on the ear, eye, and mind (fig. 8.13).

Gabrieli

While Monteverdi succeeded in arousing and intensifying emotion through a combination of words and music, another early Baroque composer achieved the same success by other means. Giovanni Gabrieli (c. 1557–1612), a Venetian like Tintoretto, overwhelmed the listener with sheer masses of sound, both vocal and instrumental. His musical style was in large measure determined by the performing spaces for which he composed. St. Mark's Cathedral was the site of countless ceremonies and pageants for the church as well as for the ruling families of Venice. Gabrieli's music was designed for multiple ensembles that often occupied the four balconies of the interior of St. Mark's Cathedral. The resulting **antiphonal** sound is typical of Gabrieli's music. The

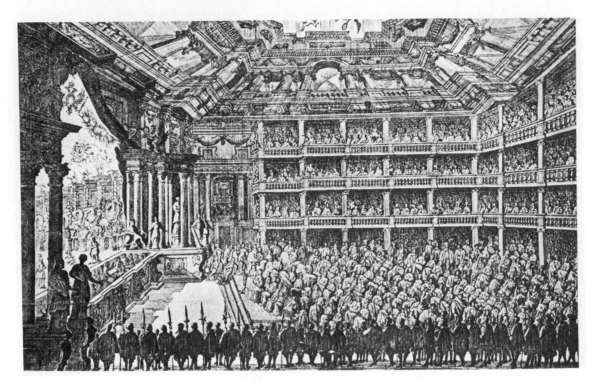

Figure 8.13 *Performance of Il Pomo d' Oro by Cesti* [1668]. (Historical Pictures
Service–Chicago)

effect of rich and colorful sonority he achieves in his *Symphoniae sacrae (Sacred
Symphonies)* is that of highly intensified, dramatic emotion. Rich and dis-
sonant harmony, rhythmic irregularity, melodic motives, and strong rhythmic
patterns all combine in a dramatic force that is different from that of Mon-
teverdi but just as effective. The Baroque spirit of both masters is clearly ap-
parent in their great power to move the emotions of their listeners.

The *Symphoniae sacrae* were published in two parts: part one contains forty-
five vocal and sixteen instrumental compositions, while part two contains
twenty-one purely instrumental compositions. The fact that some are instru-
mental and others vocal does not alter Gabrieli's preoccupation with tonal
masses. The music is polyphonic; some of the sections have as many as sixteen
independent parts. However, the obvious emphasis is upon a harmonic tex-
ture resulting from a purposeful and planned harmonic and tonal concept.
This concept of tonal mass is truly Baroque in spirit. In these early Baroque
instrumental works by Gabrieli, we sense the exploitation of sonority and

mass of tonal color, qualities that find even greater expression in the instrumental concerti grossi of the later Baroque of Corelli, Vivaldi, Bach, and Handel.

Schütz

The Baroque dramatic element was further revealed in other religious music, especially in the oratorio, passion music, and cantata. The oratorio and passion music were, in effect, opera without staging and action. An early master of these forms for the Lutheran church was Heinrich Schütz (1585–1673), whose use of polyphonic choruses owed much to his Venetian teacher, Giovanni Gabrieli. His homophonic recitative and aria presaged the enormous output of Lutheran church music that came to full bloom with Bach. The cantata became particularly identified with the liturgy of the Lutheran church in Germany. In a sense it was a miniature liturgical oratorio, often based on a short hymn text. The massive strength of the Baroque church cantata often results from the use of Lutheran chorale tunes as thematic material.

Instrumental Music

The Baroque musical activity most important to our musical heritage is the development of instrumental music, both solo and orchestral. The forms were derived from the vocal styles of earlier times, both homophonic and polyphonic. Because of the technical demands made by the Baroque spirit, many of our common instruments reached a degree of mechanical perfection that has never been surpassed. This is particularly true of the stringed instruments such as the violin, viola, and cello. To meet the musical needs of the Church, the organ also reached a high state of perfection.

Baroque instrumental music has two general textural styles, both equally popular. The first is the homophonic texture, with an extended and predominant melodic line. The second is the polyphonic texture, which develops a short thematic motive in various voices.

Homophonic Texture—Instrumental

In the homophonic forms, the polarity of the melody and the bass suggests a contrapuntal relationship between them. In fact, the techniques of contrapuntal treatment are often found mixed in the texture of homophonic forms and vice versa. In this type of musical texture, melodic line is treated as a simple statement of thematic material at contrasting dynamic levels in a few closely related keys. This gives unity and variety to the work, and it keeps the homophonic compositions, or movements, comparatively short and concise. As yet, themes and motives were not extended to supply length, as is common in the eighteenth-century classic sonata.

The homophonic texture of Baroque instrumental music may be best observed in the forms of the solo sonata, the suite, and the concerto. The sonata derived its name from the Italian word *sonare*, to sound, and was applied to instrumental music to distinguish it from vocal music. No specific form was implied in using the term, and compositions called sonatas varied from single-movement works for a solo instrument to works for small ensembles in several movements. Keyboard sonatas, which were played on the clavichord or harpsichord, were among the most popular, and the hundreds of harpsichord sonatas composed by Domenico Scarlatti (1685–1757) are among the finest examples of this genre. His *Sonata in C Minor* is typical of the binary or two-part form of these works. Both A and B parts are repeated. The harmonic contrast of the dominant key of G major, with which the A or first half of the sonata ends, and the tonic key of C minor, with which the B or second half concludes, is striking evidence of the importance of tonality in Baroque music. The work is also characterized by specific technical devices peculiar to the keyboard instrument, such as crossing of hands and both rapid scale and full chordal passages.

The suite, which was essentially a composition made up of a number of short dances, is found in its purest form in the many works written for the harpsichord during the Baroque. In its final form in the late Baroque, it was based on four specific dances appearing in the following order: Allemande, Courante, Sarabande, and Gigue (Jig). The dance movements were often preceded by a Prelude, and sometimes additional dances were interspersed, usually when the suite was written for an instrumental ensemble or orchestra. Ensemble suites were often called by such names as Sonata da Camera, Sinfonia, and Overture. The four dances included in the suite represented four different nationalities: German, French, Spanish, and English.

A typical suite for the keyboard is the *Suite in E Minor* by J. J. Froberger (1616–1667). This short work makes exclusive use of the four basic dances, each in two parts that are invariably repeated. Their common key is an important element of unity in the complete work. Tempo, meter, and thematic material differ entirely from one dance to the other. While each dance is essentially homophonic in texture, there are short, imitative figures that appear frequently and suggest a texture of several voices. This is especially true in the slower Allemande and Sarabande. Ornamentation is frequent, often notated and at other times merely suggested. Such ornamentation was an integral part of the Baroque performance technique and was one of the mannerisms affected by the virtuoso performers, of whom Froberger was an early example. Later suites, such as those by Bach, retained the fundamental characteristics of Froberger's, but the dance movements were greatly extended, and almost without exception other dances were interpolated.

The **concertato** style of the early Baroque, in which competing or contrasting groups of instruments and voices were played off against each other, developed gradually into the purely instrumental concerto in which a single instrument or a group of solo instruments were contrasted with a larger accompanying body or orchestra. The use of a single solo instrument with orchestra was called a **solo concerto.** When several solo instruments were used the work was called a **concerto grosso.** The style and form in each case was similar. The music of the solo, or soloists, was contrasted with that of the orchestral body in dynamic and thematic material. Passages in which all the instruments, both orchestral and solo, were used were known as the **tutti** or **ripieno** passages, and passages in which the solo or soloists dominated were called the solo or **concertino** passages. These alternated in the course of each movement. Concertos were usually in three movements of fast, slow, and fast tempos. Besides the contrast of dynamic and thematic material, there was also contrast of tonal color between the solo and the orchestra. Sometimes this was achieved by different use of the solo and orchestral bodies and sometimes by the use of totally different instruments in the solo parts. The latter was especially true in the concerto grosso, where several solo instruments were used, giving the composer an additional opportunity for tonal contrast.

Corelli

One of the earliest composers of the concerto grosso was Arcangelo Corelli (1653–1713). His twelve concerti grossi are written for a solo concertino group of violins and cello, with an accompanying group of first and second violins and violas, and a figured bass part played by cellos, string bass, and harpsichord. *Concerto no. 8,* op. 6 is one of Corelli's most popular works. It is titled *Concerto fatto per la notte di Natale (Concerto Composed for Christmas Eve).* While it has more than the usual three movements, these fall into the three general sections of fast, slow, and fast, with an additional movement labeled *Pastorale ad libitum* (Pastoral to be played if desired). Actually, this additional movement gives the work the character of a Christmas concerto, since the pastoral movement was commonly associated with works written for the Christmas season. Other examples are the pastoral symphony in Handel's *Messiah* and the similar movement in Bach's *Weihnachtsoratorium (Christmas Oratorio).*

While Corelli used the usual three alternating tempos of fast, slow, and fast, he deviated from the pattern, a relatively common practice, of only one tempo to each movement. The composition begins with an introduction in two parts (marked allegro and grave), in which the concertino plays the same notes as the larger ripieno. The typical first movement then follows an allegro, with its alternation of soloists and accompanying orchestra. The slow

movement, marked adagio, has a brief, fast passage in which the soloists and orchestra are again joined in unison. This separates the two presentations of the slow movement proper, in which the solo instruments are played off against the accompaniment. The final, fast section of the work is actually two short movements in very quick tempos. They are again typical of the concerto grosso style in juxtaposing the soloists and orchestra. The second fast movement likewise is characteristic of the driving rhythm usually associated with the final movement of the concerto grosso.

Concluding the work is the pastoral movement in the rocking metric pattern often associated with lullabies, and hence, the nativity. Here the soloists are given even more conspicuous passages than those in the main body of the work. The contrast of tonal color and dynamic levels between soloists and orchestra, the rhythmic drive of the fast movement in contrast to the expressive character of the slow movement, and the allusion to scene painting in the final movement all make this work a fitting musical counterpart of the highly ornamental and expressive Baroque murals of the seventeenth-and eighteenth-century churches. Corelli was in the employ of a cardinal of the Church, and these compositions for church and festive occasions were in great demand.

Vivaldi

The concertos of Antonio Vivaldi (1678–1741) are perhaps the most varied and colorful of those composed in the last fifty years of the Baroque. In the Venetian tradition of a predilection for tonal color, Vivaldi employs an exhaustive variety of solo and concertino instruments as well as varied orchestral groups for the concerto grosso. He used brass and woodwinds common during his time—trumpet, horn, flute, piccolo, oboe, and bassoon—as well as such little-used stringed instruments as the mandolin with equal success. In all of these concertos, which usually have three movements, the distinguishing feature of the form is the contrast between the solo, or soloists, and the main orchestral body, or tutti. The contrast is due not only to the difference in tonal color and tonal mass but also to the difference in treatment of the melodic material. While Vivaldi wrote over 450 concertos, the great preponderance of the works are for solo instruments. Even in those works properly called concerti grossi, the solo instruments are given much that is in a virtuoso style and foreshadows the solo treatment in the classical concertos of later times.

Among the concertos that Vivaldi wrote are a number grouped under specific titles that indicate the composer's acknowledgment of the Baroque tendency to combine the arts. This desire, expressed in the dramatic combination of word and music in vocal works for the stage and the Church, finds a naive counterpart in some of the purely instrumental music of the period.

Vivaldi wrote a series of twelve concertos, each for a solo violin with the exception of one for oboe, under the title of *Il Cimento dell' Armonica e dell' Invenzione (The Contest between Harmony and Invention)* and grouped these works further into sets of four. The first is entitled *The Four Seasons,* in which each season is represented by a single concerto. Apart from the evident desire to have the music portray the general events as well as specific details of the respective seasons, these are all cast in the traditional fast-slow-fast sequence of the concerto form.

Vivaldi wrote poems, or had them written, for each movement of these four concertos. In the first concerto, called *Spring,* the poems set the general tone of the movement and furnish the detail for musical expression. They also relate in words what Vivaldi had already accomplished in music.

Quotations from the poems are printed in accordance with Vivaldi's instructions at the beginning and where appropriate in the course of each movement. Translated, the poem for the first movement reads as follows: "Spring has returned and the birds joyously salute him with their gay songs. The streams set free by the breath of spring flow again with their sweet murmur. Thunder and lightning cover the sky with veils of darkness and proclaim him king. Their fury is soon spent and the birds once more sing sweetly." Vivaldi had this poem printed line for line at the appropriate sections of the first movement for the instruction of the performers. In addition, specific program details are noted, such as the passage that designates the "Song of the Birds" (ex. 8.1). Other such details as the "Flowing of the Stream" and "The Thunderstorm" are also printed in the score.

The first movement contains as much material for the orchestra as for the solo instrument. Most of the solo passages are virtuoso sections that elaborate upon the musical material of the movement in a very decorative fashion, accentuating the program at hand. The slow second movement is a two-part arioso that is played by the solo violin to an accompaniment of violins and violas. The solo part represents a sleeping goatherd, while the two violin parts are labeled "the murmuring of the forest trees" and the viola part "the barking of the goatherd's dog." The final allegro is a shepherds' dance in a gay jig tempo and rhythm, in which the solo violin is exploited and contrasted in virtuoso passages with the string orchestra.

Despite the naive program and the pictorial musical passages, Vivaldi has, with his usual mastery, written a work that is musically and aesthetically satisfying in its handling of form, brilliant tonal color, and expressive quality. He is certainly one of the great representatives of the Baroque love of dramatic tension and elaborate ornamentation. *The Four Seasons* is akin to the Renaissance word painting in the madrigal, now used in a purely instrumental manner.

Example 8.1: *Canto de Gl'ucelli (Song of the Birds)*—Vivaldi

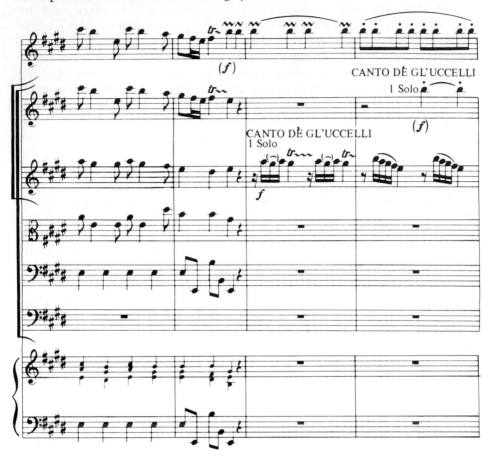

Polyphonic Texture—Instrumental

The second style of Baroque instrumental texture, the polyphonic, develops motives and thematic subjects in various voices and is completely contrapuntal in nature. In fact, the **fugue,** which is one of the best known of these forms, can be regarded more as a device of contrapuntal writing than as an actual form. In addition, the fugue is not exclusively an instrumental form, since it is found in Baroque vocal music as well.

The devices of fugal writing were derived from earlier polyphonic writing and the fugue itself is described as written in two or more voices even though designed exclusively for instrumental performance. The fugue is essentially a contrapuntal work built on a single theme called the **subject.** Several compositional devices long associated with polyphonic writing are used to achieve unity and variety in the presentation of the single theme. The fundamental

unifying device is imitation of the subject in all voices. The subject is characteristically a melodic idea that is stated in the tonic key and ends in the dominant. Its answer is an imitation of itself that begins in the dominant key and ends in the tonic. While such contrast already provides a measure of variety, the single subject is consistently treated in more varied ways. The subject, or parts of it, may appear in different keys after different intervals of time. It may be played more slowly than the original statement **(augmentation)** or faster **(diminution).** The subject may be used upside down **(inversion)** or in reverse order **(retrograde).** The subject and answer may appear quite separately in any of their forms or they may overlap each other **(stretto).**

Bach

It would be difficult to propose a spot more fitting for the birthplace of Bach (1685–1750) than Eisenach. Romance, religion, and music had all put their special stamp upon this town in the heart of Germany. Just outside of the town was the stately Wartburg Castle. Here lived the saintly Elizabeth of the Tannhäuser legend, here the famous tourney of song was held, and here the German minstrels and meistersingers sang their many songs. It was in this castle that Luther came to hide from the wrath of the pope and made the first translation of the Bible into German. Here also Luther composed many of the old hymn tunes that were to shake the world's religious life as well as to provide material for the works of Bach. The most important influence on Bach was the work of Martin Luther, for without the foundations laid down by the Lutheran church it is hardly possible that Bach would have done what he did. He was full of the comparative newness of Protestantism on the one hand, and yet steeped in the traditions of Catholicism on the other—truly a combination that had the possibilities of producing inspired works.

Bach gave his life to composing music for the Church. Most of his great music was written from necessity. As an organist, he had to supply music for the Sunday services, and in order to have music he had to compose his own. Most of it remained unpublished until long after his death. He had little intercourse with other musicians of his time, being unable to travel and mingle in places where they were to be found. He did not comprehend his own greatness, and it never entered his mind that his music had qualities that would place it among the most inspired of the world.

At a very early age, Bach dedicated himself to the task of creating "a regulated Church music to the honor of God." By "regulated" he meant systematized musical form and expression. In the spirit of the Baroque, Bach achieved a technical mastery of all the available devices and forms of his time and molded them into an expression of a great religious faith. He invented nothing new, but he organized and codified the art of music in such a way that to this day he is looked upon as the final authority in the craft of Baroque musical composition. The subjective relationship between music and text makes his

technical mastery more of a means to an end than an end in itself. His crafts-manship always served the meaning of the text, or subject. This is more apparent in the sacred music, where the spiritual meaning was the objective. He utilized every device of his day in melody, harmony, rhythm, and form to achieve this meaning.

Bach's pen was prolific. His music includes cantatas for every Sunday and Church festival of the year, three Passions (music for Holy Week), including the magnificent *Passion According to St. Matthew*, the great *Mass in B Minor*, and many lesser choral works. Among the instrumental works we find *The Well-Tempered Clavier*, violin sonatas, choral preludes, orchestral suites, and numerous pieces for clavier and organ.

In addition to the fugue, some other contrapuntal compositions are the **canon, chaconne,** and **passacaglia.** An example of one of these is Bach's *Passacaglia and Fugue in C Minor* (ex. 8.2), which provides an excellent study in the theme and variation method of Baroque composing with a polyphonic texture. The composition was originally written for organ, but it has been transcribed for orchestra and is often performed as an orchestral work. A passacaglia is a dance form in which the melody (ex. 8.2) appears in the bass and is constantly repeated in voices or parts. The first announcement of the theme comes in the bass with no accompaniment.

The melody is characterized by rather large skips upward and downward. In spite of these skips, it has a sustained quality and a good deal of pathetic expressiveness. Bach is not trying to tell a story; he is creating a melody and using his skill to develop that melody. As the music progresses, the theme is constantly repeated, usually in the bass, but on occasion in other voices. After a robustly climactic announcement of the melody, there follows a double fugue. For his fugue subject, Bach takes the first half of the main melody and combines it with a newly-created theme, a countersubject. He then develops these two simultaneously. The music is repetitious but not monotonous because he created contrasts with vigorous differences in loudness, texture, and speed. This is one example of the technical way in which Baroque music is put together. Its expressive qualities come from the sincerity of expression of the themes themselves and from the rich, full harmonic substance.

Harmonic contrast in Baroque music is achieved by dissonance and consonance in proper relation to each other. Dissonance sets up tension, while consonance affords release or repose. In the *Passacaglia*, Bach develops the melody in the polyphonic style. He also varies the harmonic structure and, consequently, the relationship between consonance and dissonance. This music creates a chamber of sound by the very massiveness of the tonal fabric. A sense of infinite musical space is created by this mass of sound as it rises and falls in degrees, only to reach a powerful climax. The listener is led on by the flowing lines of melody and by the combination of sounds.

Example 8.2: *Passacaglia and Fugue in C Minor—Bach*

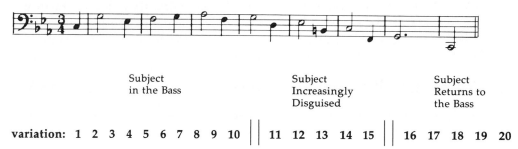

| Subject in the Bass | Subject Increasingly Disguised | Subject Returns to the Bass |

variation: 1 2 3 4 5 6 7 8 9 10 ‖ 11 12 13 14 15 ‖ 16 17 18 19 20

Subject: Theme is stated alone in the bass in connected style
Var. 1: Syncopated three-part treble accompaniment
Var. 2: Syncopated three-part treble accompaniment, somewhat lower
Var. 3: Continuous eighth-note motion in upper voices
Var. 4: Rhythmic interest enhanced by sixteenth notes on second halves of beats
Var. 5: Subject is disguised
Var. 6: Subject returns to original rhythm; rapid ascending scale passages
Var. 7: Rapid descending scale passages
Var. 8: Continued active rhythms with contrary motion
Var. 9: Subject altered rhythmically; gestures imitated in upper voices
Var. 10: Subject becomes the basis for chords beneath a countermelody
Var. 11: Two-voice texture with rapid motion in the lower voice
Var. 12: Four-voice texture returns
Var. 13: Three-voice texture; subject hidden in the inner voice
Var. 14: Two-voice arpeggiated texture with contrary motion
Var. 15: Ascending arpeggios
Var. 16: Many dissonances in the accumulating chords
Var. 17: Triplet figures dominate the three-voice texture
Var. 18: Subject altered rhythmically; new irregular rhythms
Var. 19– Rhythmic complexity and harmonic density increase; five-voice texture
 20: for much of the final statement

(A double fugue follows)

An excellent example of pathos and dramatic power in Bach's music is found in the Easter cantata *Christ lag in Todesbanden* (*Christ Lay in the Bonds of Death*). While the structure of this cantata is unique among the more than 200 extant cantatas that Bach wrote, it brilliantly illustrates his most consistent compositional device by which he linked the cantata both to the scriptural lesson of the particular Sunday's service and to the musical tradition of the Lutheran congregation. In most cantatas, Bach was content to paraphrase a chorale tune—whose text was a commentary on the scriptural lesson of the day—in the large-scale opening chorus. But in this cantata for chorus and small orchestra, *Christ Lay in the Bonds of Death*, each of the first six choral

movements is a paraphrase or variation on the chorale melody, and beyond that each of these movements employs one of the first six verses of the original hymn text written by Martin Luther. The theme of these variations is found in the setting of the seventh and final verse, where it appears in the simple, four-part setting of the chorale or hymn.

The cantata's orchestral prelude paraphrases the chorale tune and presents the musical gesture in a chromatically drooping figure. This chromatic movement creates a tension that suggests death. In the opening verse there is a decorative but sturdy statement of the chorale tune in the soprano part, which is in contrast to the highly complex counterpoint of the other three voices. The succeeding five verses in their variations on the chorale tune vividly support the texts of the hymn.

The second verse weaves the melody over a mystic, death-stalking basso ostinato figure. In the third verse, the driving and jubilantly decorative line of the unison violins goes far beyond the words set to the original tune in announcing Christ as the heroic conqueror of Death. A short halt in the driving rhythm at the word "Tod" (death) in the German text accentuates the complete destruction of death and gives contrast to the subsequent jubilation of the final line and the "hallelujah." Verse four depicts the struggle between life and death. The soprano, tenor, and bass voices in powerful fugal writing accompany the alto's presentation of the simple chorale tune. Canon and stretto tend to intensify the struggle and wrestling between the opponents. This is especially true in the setting of the last line of the text: "The one death consumed the other," where the canonic stretto disintegrates to nothing, just as death was consumed and destroyed. The major chord at the final cadence of this verse is a confirmation of this victory. The elimination of death by the power of Christ calls for a "hallelujah" on a cheerful major chord after the consistent minor tonality.

In verse five, the opening, death-haunting figure is again heard as the music expresses Christ on the cross in atonement for humanity's sins. The chromatic elements of melody and bass create a sense of harmonic tension that emphasizes the pathetic character of sin and death. Movement suggested by the impelling bass figure, along with the melody, creates a special chamber of sound into which the listener enters. The total effect suggests an emotional tone or state that can be translated in terms of the text.

There are similarities in the emotional expression of this cantata with Bernini's *St. Theresa*. The supernatural atmosphere that Bernini achieved by light and shade, Bach achieved harmonically. With the chromatic motion of melodic line and rhythm, he established the same tension of the implied motion of the angel and St. Theresa.

The completed cantata is a moving expression of the sense of sin and atonement and of the joyous hope of salvation by the cross. This was music that expressed not only Bach's own religious faith but also the very essence

of Protestantism. This kind of music is the peak of the Baroque spirit in religious music, for it faithfully interprets the true meaning of that spirit in music.

Typical of many of the cantatas of Bach is the work *Wachet auf* (*Sleepers Awake*). While *Christ Lay in the Bonds of Death* was among the earliest of Bach's cantatas (having been written in 1707), *Sleepers Awake* was composed in 1731 during his more mature years. It also incorporates a chorale tune and a text that elaborates the imagery of the Church as the bride of Christ. The text is appropriate to the gospel for the twenty-seventh Sunday after Trinity, which deals with the parable of the ten virgins (Matthew 25: 1–13). In this setting, however, Bach uses the tune and text of the old chorale in only the first, fourth, and final movements of the cantata. The second and fifth movements are recitatives, and the third and sixth are duets in the form of arias in which the musical themes and texts are in no way derived from the chorale. In each instance, the recitatives act as introductions to the duets whose solo voices portray the characters of the Church (soprano) and Christ (bass). The final verse of the chorale, as was customary in Bach cantatas, was a hymnlike setting for voices and instruments in which the congregation could participate.

The inclusion of recitatives and the aria duets with their sensuous mood of love indicates the close connection of church and secular dramatic music of the Baroque period.

In spite of his avowed goal of music for the glory of God, Bach did accept a number of positions where church music was minimized. The influence of his employers is plainly imprinted on his creative works, wherever he worked. When he was organist at Arnstadt, most of his music was written for the organ. When he moved to the Court of Weimar as organist and violinist, he conformed to the needs of the Duke. It was a Lutheran court that had a strong religious tone; he naturally wrote some church music especially for organ and some short works for voices. It was, however, a court position and there was a demand for entertainment music—music with a virtuoso display and music for dancing. His violin sonatas, chamber orchestra concertos, and clavier (a predecessor of the piano) music filled these needs.

When Bach went to the court at Anhalt-Cöthen, he found a Calvinist establishment that did not have a chapel or an organ. Because the Calvinists permitted very little music in their churches, there was no opportunity for sacred music. Bach then turned his attention to the clavier, orchestra, and secular music for voices. Because part of his duties were pedagogic in nature, he wrote a number of pieces for teaching purposes, notably the *Inventions* and *Clavier Exercises*. When he finally was granted the position at the Church of St. Thomas in Leipzig, his whole output was sacred music because that was what was demanded of him. This is, without doubt, his greatest creative period, because he was a mature composer by this time and because he was finally doing the kind of work to which he had dedicated his life many years before.

Handel

George Frideric Handel (1685–1759) was born in the same year as Bach in Halle, Saxony. Handel had to overcome the opposition of his parents to a musical career. He learned to play the violin, piano, and organ at an early age and studied law to satisfy his father's wishes. He studied music and law at the same time, but after the death of his father he gave up law and went to Italy to study music. There he learned to write in the Italian style. After three years he went to England, where he achieved financial success with the popularity of his Italian operas. He became an English subject and lived in England until his death in 1759.

We know Handel as a composer of instrumental and choral music, as well as opera. Such compositions as the *Water Music Suite* and his organ concertos are part of the standard repertory. His operas are in the **opera seria** style, and include *Giulio Cesare* (*Julius Caesar*) and *Xerxes*. He became an opera director, but as conditions changed, including public taste, he turned to writing oratorios. He admitted he had always wanted to write in this form but that financial gain had kept him composing operas. In the dozen years before his death, he composed about nineteen oratorios, *Messiah* being the greatest of all. *Messiah*, written in 1741, is one of the most popular of all oratorios. There are generous borrowings from other of Handel's works contained in *Messiah*; nonetheless it was a prodigious feat for Handel to have composed this oratorio in just twenty-four days. Its appeal to both singer and audience has made it a favorite with choral organizations, and it has probably been sung more often than any other choral work.

The style of music in *Messiah* is a combination of German polyphony and the Italian operatic tradition. The choruses are usually in polyphonic style. It is in the recitatives and arias that the full forces of the Italian opera show their influence. While Handel's melodies certainly are singable, they have a tendency to be instrumental in character. His harmonic structure is blocklike and simple, suggesting a feeling of great majesty but not the intense pathos of Bach.

The recitative *Comfort Ye My People* and the following air *Every Valley* exemplify the Baroque dramatic element as it was applied to the oratorio. The recitative is accompanied by a series of chords, giving the singer freedom for declamation in a personal manner. The air *Every Valley* is built upon a short, lilting melody that is repeated and extended by a variety of quick-running passages and ornamentations. It is an aria with a contrasting middle section and repetition of the first melody. Handel does not repeat the first section exactly but makes a few changes for interest and to accommodate the text. The total effect is of great musical lyricism combined with vivid realism of the text. The bass aria *Why Do the Nations* has been often quoted as a typical example of the florid, agitated "rage" aria of Baroque opera. Handel often

achieves an objective realism by suggesting the meaning of the text in the music. *The People That Walked in Darkness* shows this realism by its writing, in which the bass voice, singing in unison with the lower strings on a wandering, chromatic figure imitates the visual impression of mystery and darkness.

Handel's knowledge of voices enabled him to place the various vocal parts for maximum effect at all times. The polyphonic chorus *For unto Us a Child Is Born*—with its climactic sonority on the words *Wonderful, Counselor, the Mighty God, the Everlasting Father, the Prince of Peace*—can certainly be included with those few great choruses of all time. In the *Hallelujah Chorus,* one of the most exuberant choruses in all music, Handel has caught the simple majesty of the text by clear-cut melodic motives stated in vigorous rhythmic patterns. In his development of this material he never loses sight of this majesty. No wonder that when the *Messiah* was first performed in London, King George II rose from his seat when he heard this imposing chorus, thus establishing a custom that has become traditional whenever it is sung. (Incidentally, the *Hallelujah Chorus* was included note for note in the *Foundling Hospital Anthem,* an example of Handel borrowing from himself.)

While Bach and Handel were contemporaries, they represented two entirely different personalities. Both were considered among the greatest organists of their day; they composed in the conventional style of their time, and they produced lasting choral music. Bach admired Handel. He knew Handel's music and was eager to know him personally. Handel, on the other hand, never had any desire to know Bach and probably knew very little of his music. The two men never met. Bach had no wish for fame and fortune. Handel wanted fame and luxury, but it was only after fate had made him poor that he found his true artistic expression.

Handel's music is most often on a monumental scale. Having spent his apprenticeship in the school of Italian opera, he thought in elaborate and spectacular terms. His melodies are always broad, full of energy, and seldom obscured by technical devices. He often used the same melody many different times in different compositions, gaining variety and interest in the manner of treatment rather than in the originality of the material. He did not have the personal touch that marks the music of Bach. As a Baroque composer, Handel was committed to the expressive content of music. Handel's expressiveness is in terms of broad, general emotions. Bach is more subtle, personal, and intensive. The appeal of Handel to the present listening generation is the appeal of realism, of a programmatic presentation, and of an active rhythmic development. In the music of Handel there are fewer demands on the intellect than in the music of Bach.

Both of these men represent the Baroque spirit in art. If they seem to contradict, such contradiction is a part of that spirit. The horizons of art were being widened, and both Bach, the idealist, and Handel, the realist, were universal in their appeal.

Summary

The Baroque was an age of systematic action in all areas of activity—intellectual, spiritual, technological, and artistic. It saw the beginning of the scientific method of inquiry that laid the foundations for our modern scientific age. All intellectual pursuits were concerned with the achievement of orderly systems, especially in mathematics, philosophy, and economics. There was also a wave of religious activity, and in both Catholicism and Protestantism, sects arose that imposed strict rules of thought and conduct as an important part of the search for salvation.

The center of wealth had gradually shifted from southern Europe to northern Europe where foreign trade and shipping flourished. The extensive program of colonization, especially in the Americas and the East Indies, helped to build a middle class of wealthy, capitalistic merchants who often became enthusiastic patrons of the arts. This rise of a wealthy middle class brought about a desire for magnificence, even to a point of vulgarity, in ornamentation and decoration. This overabundance of outward display of material wealth was partly responsible for the rejection of the true value of the Baroque until fairly recent times.

While the Church, especially Catholicism, still patronized the arts, it was more in the sense of a personalized religious experience than as an institution in the manner of the Gothic and Renaissance. More and more of the middle class became patrons, and everyday activities became suitable subjects with which the artist could appeal to the uncultivated emotions of the nonaristocrat and the common man as well. Music also reached out for a wider audience. Both sacred and secular music spoke with expressive, singable melodies that could appeal to the average person.

Baroque painting can be characterized as full of vitality, movement, emotion, and often mysticism. Lines are usually made up of short curves with lost edges, showing vigor and a merging of one figure with another. Color is often used monochromatically with varying values and intensities. Space is expanded through unlimited recession. Evidences of action extend beyond the visual limits of the canvas vertically, horizontally, and in perspective. Form is usually open without classic balance and symmetry. Moreover, expression and a show of emotion are achieved by the combination of color, diffused line, and space together with the emotional behavior of the figures. Baroque painters systematically explored the effect of light and shade on color, line, and space. The aim was to make the experience represent reality to the observer and to bring the observer into the canvas to partake of the action, whether it be a religious scene, a landscape, or the everyday experience of ordinary people.

Baroque sculpture revealed the same action, expressiveness, and personalized feeling as painting. In comparison with the Renaissance, Baroque sculpture shows more strong emotion, more spatial quality, and more sense of movement in stone and metal. Deeply carved and flowing robes with elaborate decoration also enhanced the impression of movement. Sculptors did not hesitate to include sculptured backgrounds to make the illusion of space more real and to bring the observer into the scene.

It is in Baroque architecture that the desire for magnificence and dramatic spectacle shows itself in its most flamboyant form. While it remained classic in form, architecture achieved vigor and motion by elaborate decoration of design. Undulating facades, scrolls, twisting columns, and other ornamental decorations give a feeling of motion and light and shadow to an otherwise classic facade. Interiors are often complex variations on the curve of a rounded arch that leads the eye of the spectator from one point to another. The interiors may be filled with ornate ceiling paintings that create the illusion of being open to the very heavens.

Some of the more dramatic changes in Baroque art took place in music. While Baroque painting, sculpture, and architecture are in a sense dated in our time, Baroque music is almost timeless; even today it remains as a foundation for much of our musical experiences. There were two main lines of development in Baroque music. One was the development of vocal dramatic music, both secular and sacred, that led to the cantata and the oratorio, as well as to the opera. (Opera, of course, has developed through the years into the musical theater of today.) The other important development was that of pure instrumental music. Emancipating instrumental from vocal music made it necessary to develop forms that were based solely on melodic and harmonic considerations. Composers systematically organized tonal material into such forms as the sonata, concerto, suite, fugue, and other forms.

The Baroque also saw the technical development of most musical instruments. In fact, the stringed instruments—violin, viola, and cello—reached such a high state of tonal perfection that they still have not been surpassed. Keyboard instruments like the organ and harpsichord also reached a high state of excellence.

The homophonic texture in music became equal in importance to the polyphonic texture. In opera, oratorio, and cantata, the recitative and aria were homophonic, while choruses were more likely to be polyphonic in texture. In instrumental music, such forms as the fugue were totally polyphonic. Other instrumental forms, like the sonata and concerto grosso, often alternated homophonic and polyphonic textures. The development of tonal harmony was also a Baroque accomplishment. This gave rise to a number of new devices for handling tonal materials. The system of chordal relationships around a well-defined tonal center emphasized the importance of dissonant harmony

that created tension and its release by consonant harmony. While Baroque music systematically developed the tonal resources of music, its expressive content was aimed at the emotional experiences of the listener. With their technical mastery of chromatic harmony and musically dramatic situations, composers tried to lead the listener beyond the limits of ordinary existence and to open new aesthetic experiences through the emotions. An analogy can be drawn between the texture of tonal harmony in music and perspective in painting. The feeling of tension that comes from the dissonance and consonance of tonal harmony and the feeling of expanding space that comes from the effect of light and shade of Baroque painting suggests such an analogy. The result of the many new musical developments during the Baroque was an immense body of musical literature from such masters as Bach, Handel, Vivaldi, and Scarlatti, masters who became the inspiration for composers into our own time and even for the composers of twentieth-century popular music.

Suggested Readings

In addition to the specific sources that follow, the general readings on pages xxi and xxii contain valuable information about the topic of this chapter.

Bukofzer, Manfred F. *Music in the Baroque Era.* New York: W. W. Norton, 1947.

Clark, Kenneth. *Rembrandt and the Italian Renaissance.* New York: W. W. Norton, 1966.

Haskell, Francis. *Patrons and Painters: Art and Society in Baroque Italy.* New Haven, CT.: Yale University Press, 1980.

Held, Julius, and Posner, Donald. *Seventeenth and Eighteenth Century Art.* Englewood Cliffs, N.J.: Prentice-Hall, 1972.

Rifkin, Joshua, et al. *The New Grove North European Masters.* New York: W. W. Norton, 1986.

Wölfflin, Heinrich. *Principles of Art History.* New York: Dover Publications, n.d.

9

THE ROCOCO AND CLASSIC
(1725-1800)

Chronology of the Rococo and Classic

Visual Arts	Music	Historical Figures and Events
■ Christopher Wren (1632–1723)		
	■ François Couperin (1668–1733)	
■ Antoine Watteau (1684–1721)		■ François Voltaire (1694–1778)
■ Giovanni Tiepolo (1696–1770)		
■ François Boucher (1703–1770)		
		■ Louis XV (1710–1774)
		■ Jean Jacques Rousseau (1712–1778)
	■ Willibald von Gluck (1714–1787)	
■ Étienne Maurice Falconet (1716–1791)		
■ Sir Joshua Reynolds (1723–1792)		
		■ Immanuel Kant (1724–1804)
	■ Charles Burney (1726–1814)	
■ Jean Honoré Fragonard (1732–1806)	■ Franz Joseph Haydn (1732–1809)	
■ Benjamin West (1738–1820)		■ Maria Theresa, Empress of Austria (1740–1780)
	■ First New York performance of *Messiah* (1742)	
■ Jacques Louis David (1748–1825)		■ Johann Wolfgang von Goethe (1749–1832)
		■ Benjamin Franklin experiments with electricity (1751)
	■ Wolfgang Amadeus Mozart (1756–1791)	
■ Antonio Canova (1757–1822)		■ George III of England reigned (1760–1820)
■ Constance Marie Charpentier (1767–1849)		

[Continued]

221

Chronology [*Continued*]

Visual Arts	Music	Historical Figures and Events
		■ Watt's steam engine patented (1769)
		■ Napoleon Bonaparte (1769–1821)
	■ Ludwig van Beethoven (1770–1827)	■ First Edition of the *Encyclopaedia Britannica* (1771)
		■ Discovery of oxygen (1774)
		■ Marie Antoinette's reign as Queen of France (1774–1793)
	■ Burney's *History of Music* published (1776)	■ American Declaration of Independence (1776)
		■ Discovery of hydrogen (1776)
■ Jean Auguste Dominique Ingres (1780–1867)		■ Steamboat invented (1788)
		■ Beginning of the French Revolution (1789)
	■ Haydn's first trip to London (1790)	
		■ White House built (1792)
		■ Louis XVI and Marie Antoinette of France beheaded (1793)
	■ Haydn's second trip to London (1794)	
	■ Paris Conservatory founded (1795)	
	■ Beethoven's First Symphony finished (1799)	

Pronunciation Guide

Amalienburg (Ah-mah'-lee-en-burg)
Antoinette (An-twah-net)
Beaumarchais (Boh-mahr-shay)
Borghese (Bohr-gay'-ze)
Boucher, Francois (Boo-shay', Frăn-swah')
Canova (Kah-noh'-vah)
Charpentier (Shahr-păn-tee-yay)
Cherubino (Kay-roo-bee'-noh)
Cosí fan tutte (Ko-zee' fan too'-te)
Couperin, François (Koo-per-ă, Frăn-swah')
Cythera (Si'-the-rah)

David, Jacques (Dah-veed, Zhahk)
Diderot (Dee-de-roh)
Falconet (Fall-koh-nay)
Fragonard (Frah-goh-nahr)
Ingres (Ang-reh)
Mannheim (Mahn'-hihm)
Mezzetin (Me-za-tă)
Nymphenburg (Nim'-fen-burg)
Pompadour (Pohm-pah-door)
Val d'Ognes (Vahl dohn-yeh)
Versailles (Vayr-sigh)
Watteau (Wah-toh)

Study Objectives

1. To study the Rococo artistic style as it relates to the Baroque and the Classic.
2. To learn about the sonata as a classic form.

As the Baroque ran its course, there came a gradual revolution in all phases of life. The seventeenth-century urge for systematizing was carried to its ultimate. Reason was thought to be the key that would unlock the doors of utopias in every field, from politics to art. This philosophy was so commonly held that the eighteenth century has often been called the Age of Reason. Indeed, it was a century of order and symmetry. Everything was codified and formalized through the intellect; economics, science, religion, politics, art, even manners were affected. Diderot's *Encyclopaedia* was a compendium of eighteenth-century logic that reduced all areas of human endeavor to mathematical exactness. It was the supreme symbol of the era.

Common people were also beginning to take their rightful place in society, and, by the latter decades of the century, freedom became the object of reason. There was an urge for intellectual, political, economic, spiritual, and artistic freedom. This struggle for liberty reached its catastrophic climax in the French Revolution near the end of the century. (The artistic fruits of this struggle, however, are to be found in the Romantic movement, which will be studied in chapters 10 and 11.)

Rococo

In the meantime, a style of painting, sculpture, and decoration called Rococo flourished in the wealthy, despotic society whose greed and avarice was the object of the forthcoming revolution. The term *rococo* derives from the French word *rocaille*, which refers to the delicate scroll of the seashell, a conspicuous motif in ornamentation. The style was characteristic of the courts of Louis XIV and Louis XV, but traces of it are also found in the Italian and German aristocratic circles that imitated the French manner. The Rococo style dominated during the period from about 1725 to 1775. With emphasis on pleasantness and prettiness, it forms a bridge between the grandeur of the Baroque and the poise and clarity of the Classic. It mirrored the beauty of life among the upper classes before the French Revolution and the rise of democracy. The Baroque and Rococo overlap in time. While the Baroque spirit was still strong in Germany until near the middle of the century, the Rococo had already come of age in France.

One of the dominant characteristics of the Baroque was its intellectual activity and the demand for systematizing everything—economics, government, religion, art, and social intercourse. All this had many beneficial effects

during the seventeenth and early eighteenth centuries, and there was a tremendous vitality, a healthy activity, in almost every field of human endeavor. However, as with almost any set of rules, in time they tended to become absolute. Instead of being a means to a better society and to the progress for which they were first conceived, they often became impediments to progressive thought.

The seventeenth and eighteenth centuries flow into each other without any definite line of demarcation, just as their two styles of art flow into each other without any great revolution in style. The intellectual life of the eighteenth century produced many scholars who were often more concerned with forms and niceties of expression than with the content of their works. The economy had produced a very wealthy middle class, which took on the attitudes of culture without ever discovering its real meaning. The absolutism of rulers was possible with the fruits of the mercantile system. Wealth was concentrated in a small group of people, with no provision or thought given to the welfare of the average person. The spiritual fires of both Protestantism and Catholicism had burned low by the middle of the century. The systematic advance in science, political absolutism, and economics had all but turned the hearts of the upper classes away from spiritual values. There was a marked change in emphasis between the healthy, vigorous seventeenth century and the decadent court society of the later eighteenth century.

This change in emphasis is nowhere so clearly evident as in the French court of Louis XV. At the royal residence in Versailles, the most elegant and, perhaps, the most mediocre people of France gathered. The aristocracy lived in great leisure and in great luxury on wealth squeezed out of the common people by unscrupulous tax collectors. Rococo art and music were naturally colored by the patronage of this society, taking on the light and frivolous character of the court. Artists acceded to the amorous and playful whims of their clients. Painters, sculptors, and decorators created charming and sentimental works designed to flatter and please. The delicacy and fragility of their art was a mirror of the facade of aristocratic life, as artificial as its art.

Life itself became art. Society and manners were reduced to a formula, with elegance, grace, refinement, and love as motivating forces. The tendencies of the Baroque were carried to the extreme. The worship of wealth, pleasure, and power superseded the worship of God. The Baroque art of expression and spiritual values was cast out, for this society was interested in gossiping, conversing, dancing, and flirting. It preferred the tête-à-tête to large receptions; it preferred music for dancing to music for worship; it preferred paintings of sentimental love to paintings depicting the reality of human experience. The heart of Rococo aristocratic culture lay in this superficial manner of living, open only to the wealthy and devoid of great passion and noble pleasures.

Painting

There were a few painters who were influenced by the spirit of their time whose works show more vitality and genuine expression than we would expect from such a decadent society. Watteau and Fragonard, both painters of the French Rococo, reveal a great debt to Rembrandt and Rubens in their styles. Boucher, who was a favorite at Versailles, painted in a delicately superficial manner that breathes the very air of aristocratic eroticism. The art of these painters was the frivolous counterpart of the Baroque. Emotion gave way to sentimentalism and love to flirtation. Art had to meet the demands of a society that was artificial, with insistence upon luxurious display and elegance, no matter what the cost in money or morals. It is a wonder that a period of such mediocrity could produce art with such strength and vitality.

Given the functions of Rococo art, artists generally used techniques to achieve effects of grace and refinement. After the lessons of the Baroque in the use of light, shade, and expanding space, we would not expect any radical changes. The methods and organizations of the Rococo remained about the same but with less vigor and on a smaller scale. Spatial awareness was usually less strong. Lines were not quite so diffused, and there was a tendency to break up masses into smaller fragments with shorter, more animated curves and more ornate detail. Formal organization was still multiple and color remained monochromatic, as it was in the seventeenth century. Formal organization was also less open than the Baroque, denoting less action as well as less space. As we examine the works of Rococo artists, we will find it difficult to distinguish them from those of the Baroque on purely technical grounds. It is the degree of emphasis, coupled with subject matter and general attitude, that makes the style Rococo.

Watteau

Watteau (1684–1721) is perhaps the most important painter to mirror the fastidious life of the Rococo, for in his works the courtly customs and morals take on a grandeur of sentiment that transcends the actual conditions of the Rococo. He represented the period of change from the Baroque to the Rococo. His work was still imbued with the vitality of the Baroque, but at the same time he was meeting the artificial demands of the French court. His *Embarkation for Cythera* (colorplate 44) is not only one of his best-known works but is highly representative of the era. The mythological subject tells the story of the successive courtly steps involved in convincing a lady to join the festivities and set sail for the mythical island of love. It was the kind of sentimental and amorous myth that court society loved to act out.

The outlook of the Baroque still prevailed in this work. The lines are still diffused and edges are still lost in the mass of color, but there is a partial return of the clearly molded lines, as in the treatment of trees and the outlines

Colorplate 44 follows p. 232.

of the figures. Mass melts into mass, but the fragments do not encompass as great an area as in the Baroque. This is due in part to the slight emphasis on clear-cut lines. The treatment of light and shade, so strong in the works of Rembrandt, has been weakened greatly. The light seems more evenly distributed, giving an almost pastel quality to the color. Tension of movement seems to be lost; open form is less direct and more static. Action is lessened; it is more delicate and restrained. There is little strong, expressive appeal in this work. It speaks gently and softly, murmuring amorous sentiments in depicting the curious morals of the age.

Colorplate 45 follows p. 232.

Le Mezzetin (colorplate 45) is another of Watteau's delicate canvases that portrays the Rococo spirit. The subject is an actor who appears to be singing a sentimental song of pathos, but one is more impressed by the effeminate costume than by the pathos. The colors are pale; line is broken into fragments; and space seems carefully controlled. In true Rococo style the cheerful costume belies the obvious heartbreak of the song.

Boucher

Colorplate 46 follows p. 232.

While Boucher (1703–1770) painted many miniature scenes of questionable taste for the King, his portrait *Madame de Pompadour* (colorplate 46) is a happy combination of his consummate skill as a painter and the Rococo spirit of elegance. Boucher was the favorite artist of this woman of intrigue and power in French aristocratic circles. It is said that he was her constant advisor in matters of interior decoration, in selection of costumes, and in all matters pertaining to the purchase and commissioning of works of art. In this particular portrait of Madame de Pompadour—he painted many—Boucher has captured the spirit of aristocracy in every detail. Her posture and elegance of dress suggest her exalted position, even though she was not of noble birth. He has given her an aura of the intellectual by including an open book in her hand. Through a skillful use of light and shade, he has painted the "feel" of the silken gown. The Baroque technique is still present, as in Watteau, but on a miniature scale, and without as much feeling or sentiment.

Sculpture

Rococo sculpture merits but brief mention. The same general spirit that is found in painting prevailed. Gardens were generously supplied with marble cupids coyly chaperoning amorous couples in their games of love. Even painters included such statues in their paintings, as in Watteau's *Embarkation for Cythera*. Falconet (1716–1791) was an artist who applied his whimsical and light touch to the Rococo scene. The *Punishment of Cupid* (fig. 9.1) shows the spirit of frivolity and superficiality that prevailed. There is no expression and no firm modeling of form. The statue served only as a reminder of a playful attitude toward love.

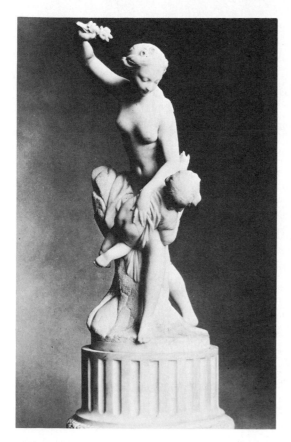

Figure 9.1 *Punishment of Cupid* [c. 1755]—Falconet. (Courtesy University Prints)

Architecture

The decorative aspect of the Rococo style is most obvious in the interior decoration used in palaces and salons. The *Salon of Marie Antoinette* (fig. 9.2) is a striking example of the use of delicately curved motifs in interior design. A floral wreath pattern is used on the carved wall paneling and on the ceiling. This same pattern is repeated in the upholstery fabric of the chairs and divan. Another typical, decorative feature is the chandelier, with its crystal prisms that sparkled like diamonds in the sunlight. The huge mirror, because of its height, could reflect the beauty and fashion of everyone in the room. The salon is a spacious and elegant setting for the charming conversation of a very elite segment of court society.

The interior of the Amalienburg Lodge at Nymphenburg (colorplate 47) is another example of the Rococo style. It is lavish in the use of mirrors, the

Colorplate 47 follows p. 232.

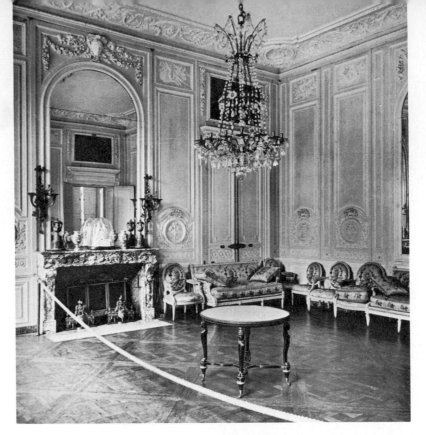

Figure 9.2 *Salon of Marie Antoinette* [1762–1764]—Versailles. (Keystone View Company)

delicate carvings that cover every bit of wall space, and the elegant furnishings. This same decorative filigree can be found in almost every eighteenth-century palace, especially in France, Germany, and Austria.

Music

The musical counterpart of Watteau and Boucher is found in the delicately ornamented keyboard pieces of François Couperin (1668–1733). His work was personal, intimate music in miniature. It avoided passion; it avoided the grand manner; it was fragile in texture and luminous in color, like the canvases of Watteau and Boucher. Couperin's *La Galante,* with its exquisite style, its playful ornaments, and restrained manner, is a musical symbol of the Rococo, as is *The Bells of Cythera.*

The pervasive spirit of the Rococo was present not only in the refined ornamentation of the music but also in the decorative details of the musical instruments. The shapes of the cases and their decorations incorporated architectural elements of the Rococo, as did many of the formal furnishings of aristocratic homes of the period. The sides of keyboard instruments were also frequently painted with graceful, sentimental scenes by artists who are today largely anonymous.

Neoclassicism in the Visual Arts

There was another movement that coexisted with the Rococo but was in opposition to it. This was Neoclassicism (new classicism)—a return to the classic ideals of the ancients. The French Academy had been founded in the seventeenth century to serve as a guardian and purifier of French intellectual life. So far as the arts were concerned, the Academy controlled art, education, and exhibitions, and set the "official" standards of taste and style. In the latter part of the century, in protest against the superficial elegance of the Rococo, the Academy sponsored a return to classic ideals based on Greek and Roman models. The movement gained real headway about the time of the Revolution, when public opinion joined in the denunciation of almost anything that represented the court.

Neoclassicists sought to express classic ideals by using models from Greece, Rome, and the Italian Renaissance. These models served a dual purpose. They reminded the observer of the need for patriotism and stiff morality in the struggle for liberty. They also served to make the modeling of forms more realistic and stripped art of its sentimentality. The calm, emotionless art of Greece and Rome became a symbol of detachment from mere superficial feeling. Neoclassicism would be prized during the deluge of blood that was to follow.

Panini's *Interior of the Pantheon* (colorplate 11) is a Neoclassic painting of a classic subject. By presenting the humans as inconsequential figures in a monumental building the painter brings attention to the importance of the classic features of the *Pantheon*. The linear perspective is dramatic, receding through open doors into infinite space. The distortion of perspective and depth in the top half of the picture is largely responsible for the drama. The source for the light that bathes the interior is of uncertain origin. Through the opening at the center of the dome a focused beam of light falls on the wall to the right of the entrance, contributing to the balance of the picture.

Painting

David

Jacques Louis David (1748–1825) was the leader of the Neoclassic movement of the revolutionary period. After a visit to Greece and Rome, he returned full of enthusiasm for the glories of the ancient world. His first great success was the *Oath of the Horatii* (colorplate 48), painted four years before the French Revolution. Its subject is a Roman father pledging his three sons to fight against the enemies of Rome. Thus, Roman virtue and readiness to die for liberty became the subject of Neoclassic French painting almost on the eve of the Revolution. The style and forms of the painting show a return to Renaissance classicism. The lines are sharply defined—severe and angular—conveying strength. Its formal organization is not quite separate, but separate groups make up the whole—the three sons to the left, the father and the weeping women on the right. The focal point, the swords, is exactly in the center. Each group is framed against the background of a Roman arch set on Greek columns. For all its heroism, there is little expressive feeling in this canvas. Its subject is from a bygone age; its style is formal, intellectual, and unreal. Many of David's paintings emphasized the idea of dedication to freedom and the glory of the sacrifice necessary to attain it.

Colorplate 48 follows p. 232.

Charpentier

Colorplate 49 follows p. 232.

Portrait of a Young Woman, called Mlle. Charlotte du Val d'Ognes (colorplate 49) was attributed to David for many years. Recent research assigns the painting instead to Constance Marie Charpentier (1767–1849), an artist given wide recognition among Parisian connoisseurs during her lifetime. Her reputation may explain why she was chosen to paint this portrait, in which Mlle. Val d'Ognes is presented as a willowy young woman seated before a window that provides the light. The work is realistic in its details, even to the broken pane in the window. The form is modeled firmly and clearly against the darkened background. The interior of the room is painted with virtually no detail. The static, dark wall against which the figure is placed focuses the attention of the viewer on the face and hair of Mlle. Val d'Ognes and also on the details of her clothing. Compared with Boucher's *Madame de Pompadour* (colorplate 46), the change from Rococo to Neoclassic is obvious. The lines are sharply drawn to emphasize the severity of the figure, in contrast to the fragile quality of Boucher's portrait.

Ingres

Colorplate 50 follows p. 232.

Jean Auguste Dominique Ingres (1780–1867) held to principles of Neoclassicism before the onslaught of Romanticism. He trained and worked in Italy, and returned to France, becoming an advocate of the Davidian style. In contrast to David, his own drawings and paintings are characterized by sensuousness of line and exotic color, as in *The Odalisque with the Slave* (colorplate 50). This theatrical painting is only one of many in which Ingres reflected his preoccupation with the exotic. The central figure of the nude concubine is

placed in an opulent Turkish harem. The frontal plane is occupied by the odalisque and her musician. A Moorish servant is barely visible behind the balustrade. The light from an unidentified source focuses on the two main figures, calling attention to the sensuous rendering of the flesh tones and the rich and lustrous fabrics in the room. A spirit of calm pervades the picture, caused in part by the repeated horizontals of the reclining figure, the musical instrument, and the balustrade. The spirit is reinforced by the casual poses of the odalisque and musician, their sentimental gazes, and the lazy falling of the drape on the right. In opposition to the horizontals are the repeated vertical lines of the column, the Moorish servant, and the individual balusters of the railing. Together the horizontal and vertical lines create a grid system that is the essence of formality.

Benjamin West

One of the first noteworthy painters from America was Benjamin West (1738–1820). He began his training in Philadelphia, but subsequently studied in Italy, finally settling in England, where he became a close friend of King George III. He was not only a painter; he was also a pedagogue, and as such was responsible for teaching a whole generation of American painters. Of his numerous paintings (he left over three thousand), *The Death of General Wolfe* (colorplate 51) is characteristic. Such historical subjects were the source of many of his commissions.

Colorplate 51 follows p. 264.

During the siege of Quebec, which was noted with great interest in England, General Wolfe met his death. West chose to represent this event with the characters in traditional classic poses and arrangement, but wearing contemporary dress. The inclusion of the Indian ties the event unmistakably to the New World. The figures are arranged in three groups, two pyramids on the left, and a third, smaller group on the right. These create a rhythm across the painting both vertically and horizontally. On the horizon the bright sky above the burning city of Quebec is contrasted with the threatening darkness on the right. Between the frontal space and deep space West has chosen to simplify and omit almost all detail. The concerned gazes of the figures, the line of the unfurled banner, and the theatrical lighting all focus attention on the dying general.

Sculpture

Neoclassic sculpture followed the lead of painting in its debt to the ancients. Canova (1757–1822) employed his technical facility to make his patroness appear as the Greek goddess of love in *Pauline Borghese as Venus* (fig. 9.3). While the lines and plastic forms are classic in character, there is something different. This is only the outward appearance of classic form, for it does not portray the Greek ideal of beauty but a woman of the world. Canova's debt to the classic style is made all the more apparent by comparing *Pauline Borghese as Venus* with the *Odalisque* of Ingres.

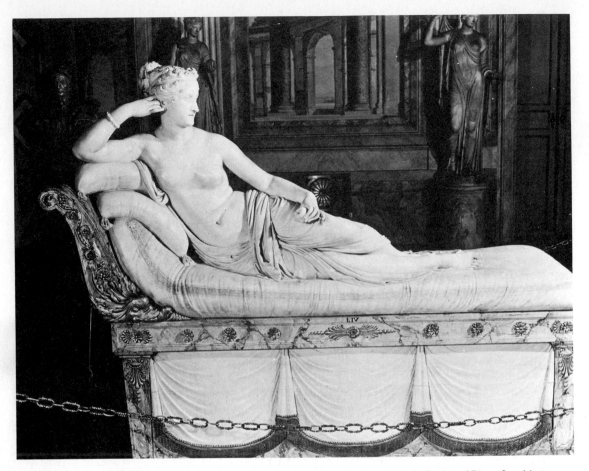

Figure 9.3 *Pauline Borghese as Venus* [1808]—Canova. Life size. (Giraudon/Art Resource, N.Y.)

Classicism in Music

The art of music never succumbed so completely to the Rococo spirit that it was dominated by it. Rather, the Rococo ideal colored both the dying Baroque and the new Classicism in music in the same way the court practices of the kings of France colored the social and artistic customs of every court in Europe—both petty and great—during the eighteenth century. The great and lasting music of the Classic period was a product of Germany, not of France, and it stressed perfection of form rather than the superficial lightness of the

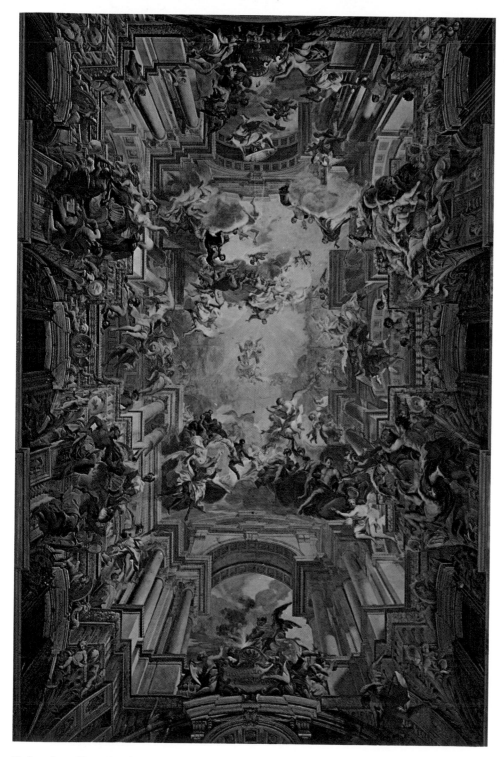

Colorplate 42 *Apotheosis of Saint Ignatius,* Saint Ignatius, Rome [1691]—Pozzo.
(Scala/Art Resource, N.Y.)

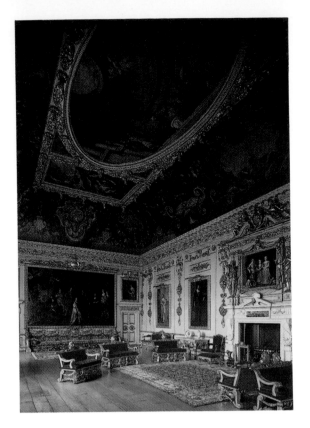

Colorplate 43 Double Cube Room, Wilton House [1649–53]. 60′ × 30′ × 30′.
(© A. F. Kersting)

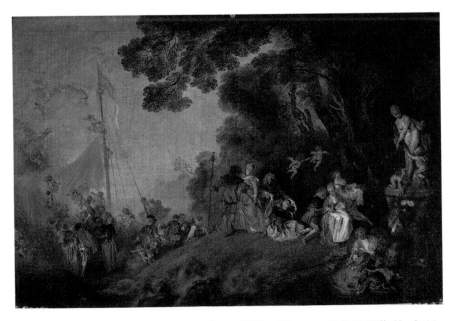

Colorplate 44 *Embarkation for Cythera* [1717]—Watteau. 51″ × 76″. (Scala/Art
Resource, N.Y.)

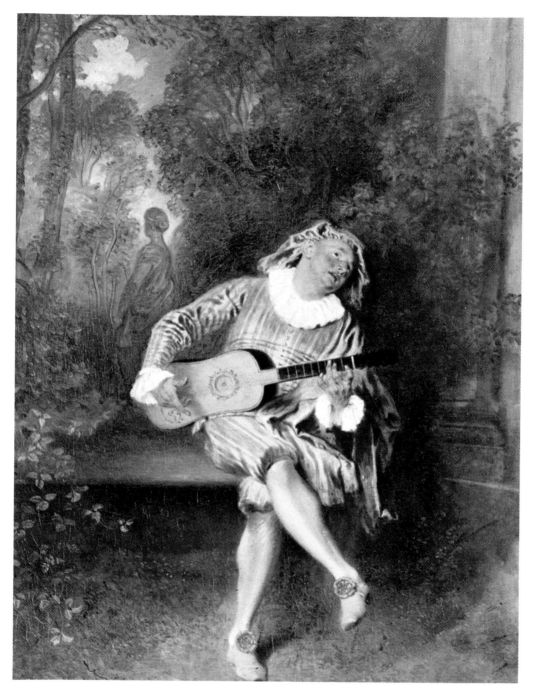

Colorplate 45 *Le Mezzetin* [1718]—Watteau. 22¾″ × 17″. (The Metropolitan Museum of Art, Munsey Fund, 1934)

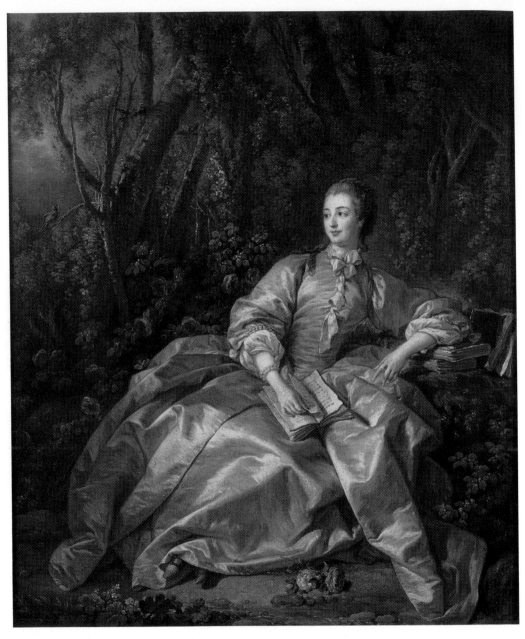

Colorplate 46 *Madame de Pompadour* [1758]—Boucher. 34¼″ × 26″. (Victoria and Albert Museum, London/Art Resource, N.Y.)

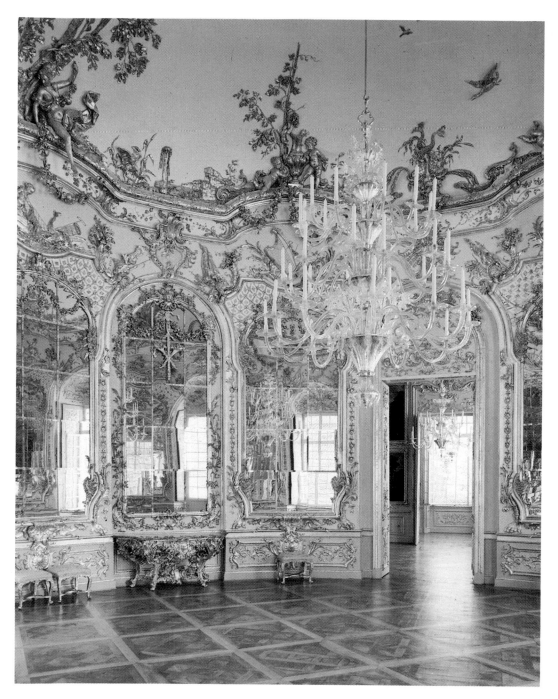

Colorplate 47 Interior of Amalienburg Lodge [1734–1739]—François de Cuvilliés. Nymphenburg Gardens, Munich, Germany. (Sandak/A Division of G. K. Hall & Co.)

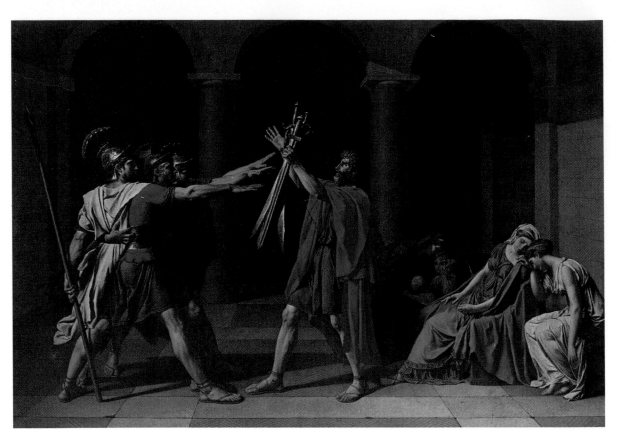

Colorplate 48 *Oath of the Horatii* [1785]—Jacques-Louis David. 10′ × 14′. Louvre.
(Art Resource, N.Y.)

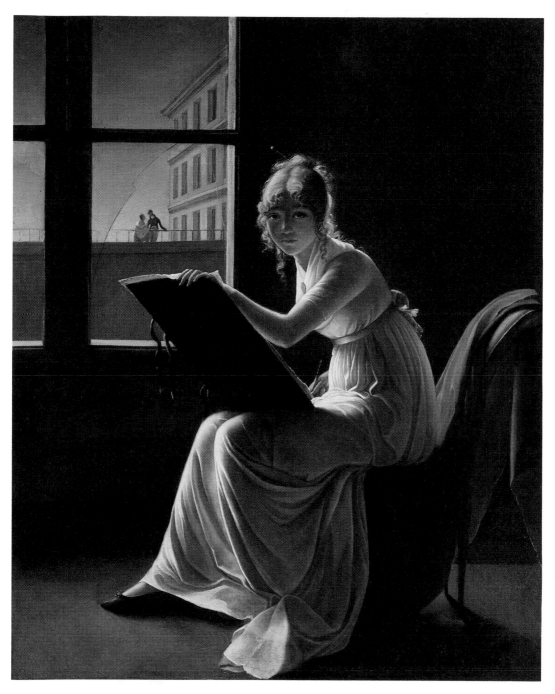

Colorplate 49 *Portrait of a Young Woman, called Mlle. Charlotte du Val â Ognes*
[1785]—Charpentier. Oil on canvas, 63½″ × 50⅝″, formerly attributed to David.
(The Metropolitan Museum of Art. The Mr. and Mrs. Isaac D. Fletcher Collection,
Bequest of Isaac D. Fletcher, 1917)

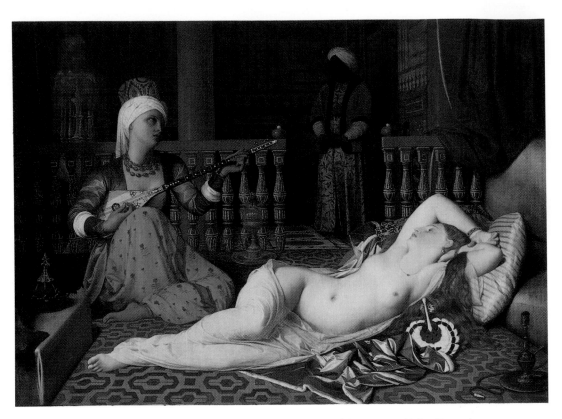

Colorplate 50 *The Odalisque with the Slave*—Ingres. (Courtesy of The Fogg Art Museum, Harvard University, Cambridge, Massachusetts. Bequest-Grenville L. Winthrop)

Rococo, though this was often present and recognizable. The French monarchy was absolute and extreme in its disregard for the average man; in Germany, there was an enlightened absolutism. This new absolutism was operative in all fields of cultural activity, and the patronage of the French monarchy and the German absolutists promoted artistic progress. Never was music more widely cultivated. This enlightened absolutism could claim as part of its enormous musical productivity the works of Mozart and Haydn. Both depended, either directly or indirectly, on the patronage of a court or aristocratic society possessed of a considerable degree of discriminating cultural as well as musical taste. In the works of these masters, one detects within the clarity and perfection of classic form both the fantasy of the Rococo and the seriousness of the impending new Romanticism.

The Classic era, in its revolt against the multistylistic expression of the Baroque, depended on the wedding of lyricism and formal perfection to accomplish its success. The Baroque was the first period in western European music history that lacked a unity of style in all forms. In opera, the new music of the early Baroque had degenerated by the eighteenth century into an extravagant and shallow show for aristocratic society. Music in the Roman church was largely an imitation of Renaissance ideals.

In the seventeenth-century Lutheran church, music had become highly intellectualized through the use of complex polyphonic style. Popular acceptance of this intellectualized Baroque style was not to be forthcoming for another one hundred years. Baroque instrumental music was still dependent to a major degree on vocal and dance models.

The lyric quality, whereby music reaches the understanding of the widest audience, was essentially absent from the music of the Baroque. The folklike simplicity of the melodic inventions of Haydn and Mozart supplied the lyricism that, when coupled with the formal perfection of their works, yielded some of the world's most beautiful music.

Composers after Bach found the complicated, contrapuntal textures of music too involved to express the refinement of the social scene in which they moved and worked. They resorted to the use of clearly defined and expressive melodic material that could be readily grasped by the cultured aristocrats who were their patrons. This lyricism lent a new and fresh appeal to their art.

Composers of musical Classicism (eighteenth century) were more fortunate than the Neoclassic painters and decorators in that they did not have models for the classic ideal they wanted to express. In music, Classicism was purely an ideal form, not a reworking of an earlier classic model as it so often was in the plastic arts. However, the operatic and instrumental forms of the Italian Baroque were influential in the development of classic forms. The Classicist used lyric and expressive melody, inventing a musical form predicated on the idea of one melody contrasted with a second. The harmonic and rhythmic accompaniment was always subordinate to these melodic lines.

The most striking result was the instrumental form of music called the **sonata.** Originally the term sonata meant that the music was to be played, not sung. Little by little it was modified until the eighteenth century, when western European composers were able for the first time to embody their ideals of formal structure in an abstract instrumental form of large proportions. While the sonata is built upon ideas that come from music's long association with ritual, literature, and dance, the music of the sonata stands completely free from these associations. The sonata as a form of musical expression must stand or fall on the handling of abstract ideas in the abstract medium of instrumental music.

The sonata of the Classic period is an extended composition in three or four separate movements written for a single instrument, such as the piano, or for a combination of instruments. In some cases, the sonata has taken on the specific name of the group for which it was written. For example, a sonata written for four stringed instruments (two violins, viola, and cello) is called a string quartet; a sonata written for an orchestra is called a symphony; a sonata written for a solo instrument and orchestra is called a concerto. The composer of the sonata lends unity and variety to the several movements of the work by several means. Variety is achieved by contrasting tempos. The first movement is usually in a fast tempo; the second, slow; the third, stately-to-lively; the fourth, very fast. Harmonically, there is emphasis on unity, with the first, third, and fourth movements in the same key and the second in a closely related key. Another means of achieving variety is the formal organization for each of the movements. With few exceptions, the first movement is in what is known as **sonata-allegro** form. The second movement is often in **song** or **variation form.** The third movement, the last to have been included in the sonata and the one often omitted, is a **minuet.** The fourth movement is most often a **rondo** or sonata-allegro form.

Of all these forms, the sonata-allegro is by far the most representative of the striving for the classic ideal in music and represents most clearly the inventive genius of the Classic period. The fundamental structural idea of the sonata-allegro form is the presentation of two contrasting musical ideas in (1) a section called the **statement** or **exposition,** (2) their **development,** and (3) their final reconciliation in a **recapitulation,** often called the restatement. The statement, or A section, is constructed of two contrasting key sections, each of which contains at least one melodic theme. In the Classic sonata-allegro movements, these themes were generally contrasting in melodic outline and affective style; a more vigorous theme was presented first in the tonic key and a more lyrical theme in a contrasting key. The B section of the sonata-allegro form is called the development. Here the themes are broken into

smaller bits and are subjected to various inventive musical techniques according to the ability of the composer. In the third section, also called A, the themes are repeated in the manner of the exposition, except that here the key difference is reconciled. This section, then, and with it the whole movement, is brought to a close in the original key.

The following is the plan of the Classic sonata-allegro form:

(Th. I is first theme; trans. is transition; Th. II is second theme; Cl. Th. is closing theme. The pattern below the line is followed when the movement is cast in a minor key.)

| Statement or Exposition | ‖:Th. I. (maj.) trans. Th. II. (dom.) trans. Cl. Th.:‖ |
| | ‖:Th. I. (min.) trans. Th. II. (rel.) trans. Cl. Th.:‖ |

| Development | Varied treatment of material of the exposition in distant keys followed by a cadence leading to . . . |

| Restatement or Recapitulation | Th. I. tonic maj. trans. Th. II. tonic trans. Cl. Th. tonic |
| | Th. II. tonic min. trans. Th. I. tonic maj. trans. Cl. Th. tonic |

(Th. I is first theme; trans. is transition; Th. II is second theme; Cl. Th. is closing theme. The pattern below the line is followed when the movement is cast in a minor key.)

The sonata-allegro form gave composers the opportunity to present lyric melodies and tonal harmony so clearly that listeners could not fail to understand them. They could also develop material so logically that the listeners could not easily forget it.

In much of the music of the Classic period, the Rococo spirit shows up in the lyrical treatment of the material. The music is often light, gay, and full of rhythmic subtleties and bright melodies. The harmony is free-flowing, without the prolonged dissonant tension of the Baroque. In general, it is not "heavy" and does not pretend to delve into problems of philosophic expression. It is "occasional" music, moving freely, with a grace and lightness to fit almost any cultural activity. It appeals to the listener because of two primary attributes—the purity of melodic invention and the varied simplicity of form. This music reflects the well-regulated society of which it was a part. With the coming Romantic movement and its dramatic struggle for freedom, music became strong, violent, and full of personal passion. The Baroque had experienced some of this in intense religious movements. The Classic period was an ebb between these two great tides; it provided time for reflective thinking as demonstrated in the music of Haydn and Mozart.

While both vocal and instrumental music flourished in the Classic period, instrumental forms commanded the greater interest of important composers and represented the truly Classic spirit in a more vivid way. Church music continued the tradition of the Baroque in the liturgical music of the Catholic church but virtually ceased to be of any importance in the services of the Protestant church. Choral works, such as Haydn's *Creation*, were patterned after Handel but lacked the virility of their Baroque models. The operas of Gluck and Mozart, however, set a new standard in this field. Gluck honored the old themes of classical mythology in *Orfeo* (as did Monteverdi) and *Alceste,* while bringing about badly needed reforms of earlier Baroque excesses. Mozart's consummate skill and inherent dramatic sense enabled him to write masterpieces in a form that differed little, if at all, from the Baroque models. In the Mozartean operas, the treatment of the form sets the works apart from all others and makes them the oldest and perhaps the most perfect in the repertory of the modern opera house. The formal treatment is that of classic balance and restraint.

Let us turn first, then, to some examples of the great literature of instrumental music. Because music is an art that moves in time, a great amount of time is needed for a listener to become thoroughly acquainted with a major work. Therefore the number of examples we use must be few in order to strike some reasonable balance with those of the other arts. Countless excellent works and whole areas of composition must be omitted.

Haydn

Franz Joseph Haydn (1732–1809) is an ideal example of the Classic composer in tune with the social conditions of his time. Born in a provincial village of the Austrian Empire, he turned early toward music. With the exception of a few months in which he was tutored by Nicola Porpora, a renowned Italian composer, he was chiefly self-taught, both in performance and in composition. His ability as a violinist and his early compositions for chamber ensembles caught the attention of an Austrian nobleman. In 1761, he entered the service of Prince Esterházy where he was to remain for the next twenty-eight years.

While this long period of employment in one household was perhaps not typical of the fortunes of most performers and composers, Haydn's long life in the service of the aristocracy represents the normal career of the eighteenth-century musician. As one of the household servants, Haydn's work was the composition and direction of music for the court. In line with his duties, Haydn wrote a tremendous amount of music—solo works, chamber music, orchestral music, operas, and church music of all sorts. Much of this great wealth of composition has been lost, but an enormous quantity has come down to us today. For example, there are over one hundred known symphonies of Haydn and some eighty-three string quartets.

In 1790, at the death of Prince Nicholas Esterházy, Haydn was pensioned and relieved of the duties he had so long performed. A commission for the composition of a set of symphonies and their performance in London brought him to England for the first of two visits. While these last symphonies were more pretentious than most of the works written during his years with Esterházy, they still serve as excellent examples of the mature Classic sonata as written for the orchestra. One of the best-known of the London symphonies is *Symphony no. 101 in D Major,* popularly known to concert audiences today as the *Clock Symphony.* It is scored for the mature Classic orchestra. Its instrumentation calls for the usual complement of stringed instruments divided into four parts, analogous to a mixed choir of sopranos, altos, tenors, and basses. The soprano and alto parts are played by the two groups of violins, the tenor part by the violas, and the bass part by the combined cellos and string basses. Depending on the wealth of the orchestral sponsor or patron and upon the physical conditions under which the orchestra performed, the strings were augmented so that there would be from four to eight performers in each of the four groups, making a total of approximately twenty-five string players. This group was established as the core of the symphony orchestra and has remained so to the present time. To this string foundation the composer added wind and percussion instruments as desired.

In addition to the strings, the *Clock Symphony* is scored for a full complement of woodwinds—two flutes, two oboes, two clarinets, and two bassoons. With the exception of the clarinets, woodwinds were to be found regularly in various combinations in all the Classic symphonic works. The clarinets were the latest addition and were used only in a very few of the last Haydn and Mozart works for orchestra. In this symphony, the brass choir is made up of only two horns and two trumpets, which are used principally for sustaining harmonies, reinforcing volume, and marking rhythm. The percussion is represented by a pair of tympani used to stress rhythm and to reinforce loud and full orchestral passages.

In general, even in such a late work as the *Clock Symphony,* Haydn does little in the way of exploiting the varied tonal qualities of the orchestral instruments. There is little dependence on instrumental color for affective expression. Passages where the particular qualities of an instrument or group of instruments are exploited stand out rather obviously, as in the trio of the minuet where flute and bassoon are used against a subdued string tone. The Classic orchestra is essentially an organization in which the string section constitutes the aristocracy and the first violins are the ruling family.

The first movement of this symphony is composed in sonata-allegro form. At the beginning of the movement, however, Haydn added a slow introduction to gain audience attention. This seems a rather pompous foil to the sparkling and lively material out of which he fashions the actual first movement. The introduction is cast in a minor key, which tends to add to its solemnity, or at least to add contrast to the first theme of the movement as it enters in the major tonality.

The first theme of the first movement proper (ex. 9.1), introduced by the first violins in very rapid tempo, is of a driving, dancelike character. Its main musical materials are to be found in the first few measures.

This main theme is a completely lyrical idea expressed by the first violins and accompanied by the other strings. Immediately, both melodic idea and accompaniment are enriched by the addition of the rest of the orchestra. Haydn then leads this first theme from its original key of D major to the key of A major where he introduces the second theme (ex. 9.1), which is very closely related, rhythmically as well as melodically, to the first. The second theme is also introduced by the first violins with only a string accompaniment.

The second theme is shorter and is rushed to a conclusion in the new key of A major by two descending figures in the strings. This comprises the A section, or exposition, of the first movement, which the composer, in the Classic tradition, asks to be repeated. In most modern performances, however, this is not done. Following the repetition, the B section, or development, is played. A listener familiar with some of the musical bricks and stones out of which the two principal themes are constructed will hear how Haydn treats these in the development section. At first, short motives from the second theme are traded back and forth between first and second violins. Eventually, violas and cellos are called into the action. Then a loud passage for full orchestra follows in which short bits of musical materials of the first theme are subjected to musical exploitation. The development section ends with a very obvious, full orchestral silence after a big climax. The first theme reappears as at the beginning of the A section, followed by the second theme. Both themes are now in their original melodic form, but Haydn avoids monotony by using different instruments and by recalling the second theme in the same key as the first, a standard method for reconciling key differences. A final farewell is sounded by a repetition of the first theme and a reiteration of the final chords so as to leave no doubt as to the key.

The second movement is the traditional slow movement based on a three-part song form with a simple statement, contrast, and restatement. Its key is G major, closely related to the main key of D (that is, they share all but one pitch within their scales). The second movement, with its insistent, clocklike rhythm, suggests the name given to the symphony by Haydn's publisher. The lyrical, songlike first part of the second movement is again carried by the first violins, aided at times by the oboe and flute. The middle section is marked by an abrupt change of key from G major to G minor; it is characterized by less attention to lyrical quality and more to contrapuntal devices in handling short melodic fragments and rhythmic-melodic patterns from one part to another. A gradual transition back to the original key restates the melody of the first section in two repetitions. The first one is an example of the exploiting of tone color, as the first violins sing the theme against the accompaniment of flute, oboe, and bassoon. The second is a full orchestral repetition in which all the violins elaborately vary the opening theme with brilliant figuration in the manner of Rococo ornament.

Example 9.1: *Symphony no. 101 in D Major* (the *Clock Symphony,* First Movement)—Haydn

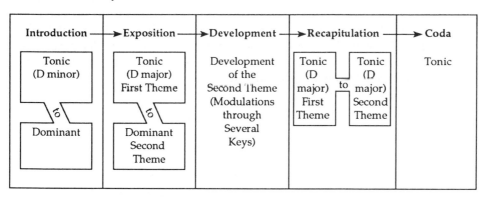

Introduction ──►	Exposition ──►	Development ──►	Recapitulation ──►	Coda
Tonic (D minor) *to* Dominant	Tonic (D major) First Theme *to* Dominant Second Theme	Development of the Second Theme (Modulations through Several Keys)	Tonic (D major) First Theme *to* Tonic (D major) Second Theme	Tonic

First Theme

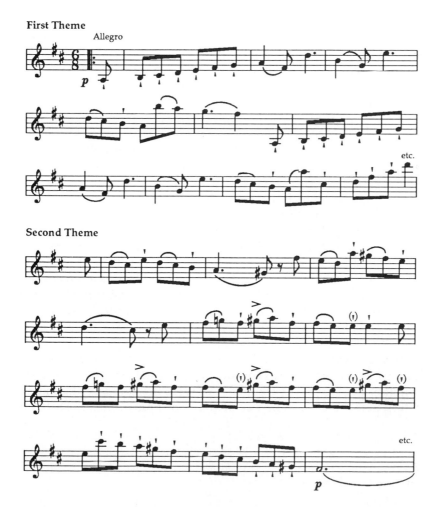

Second Theme

The third movement, again in D major, is a traditional minuet and a good example of how a simple dance became a Classic form. Balance is neatly achieved by two independent three-part forms welded into a larger three-part form. The minuet and **trio** are essentially two independent minuets. Both are constructed on the same formal pattern as follows: (1) an A part, repeated; (2) a contrasting B part plus the return of the A part, all of which is repeated. At the conclusion of the trio, or second minuet, the first minuet is repeated so that the following scheme is realized:

Minuet	(A repeated, B plus A repeated)	‖: A:‖: B A:‖
Trio	(C repeated, D plus C repeated)	‖:C:‖:D C:‖
Minuet	(A-B-A, all without repetition)	∣ A B A ‖

The fourth movement, also in D major, is another common form, the rondo. The essential idea of the rondo is contrast and restatement. In this case, the thematic pattern is A-B-A-B-A. In contrast to the sonata-allegro form, the rondo lacks an actual development section, and, strictly speaking, the form is based on the dominance of the principal theme (theme A). In this movement, theme A is presented by the first violins with only string accompaniment. A full orchestral transition follows this statement and leads to theme B in the key of A major. The opening measures of theme B are strikingly like A, but the **syncopation** of the melody distinguishes it from A. It is introduced by the first violins and oboe. Another full orchestral transition leads back to A in the original key of D major. A digression to D minor leads to the second appearance of theme B. The return to D major ushers in a return of theme A, this time treated in Baroque fugal fashion, showing that the Classic composer in no way had lost the skill of composing in a past style. In fact, so skillful is Haydn in contrapuntal technique that this short section contains elements of both themes adroitly woven into the texture of the fugue. A full orchestral treatment of the fugal form of A, followed by a simple, quiet statement of the original theme A, leads to a climax in the final cadence and brings the symphony to a close.

The Classic symphony, as represented by the *Clock*, is a musical work of rather large dimensions in which the composer depended entirely on the logic of formal treatment and abstract design to communicate his aesthetic message. The classic ideals of restraint, balance, and formal design as expressed in the idealized art of Greek sculpture and architecture were expressed in the purely abstract form of western European music. Unlike the architect, painter, and sculptor of the eighteenth century, who turned not only to the spirit of the ancient era but to its subject matter as well, the composer had no models to follow. There were no examples of Greek or Roman music. The composer

had to invent the vehicle for the expression of classic ideals. The sonata and sonata-allegro form, as developed in the symphony, concerto, and chamber music, afforded the greatest opportunity for this expression. The abstract realization of Classicism in music became the ideal toward which all the other arts continued to strive during the next two centuries.

Mozart

Mozart (1756–1791) was perhaps the most nearly perfect musical creator in the history of Western music. His first cries of infancy must have had musical significance, for at four years of age he was already showing remarkable signs of musical precocity, and at ten he was composing works that ranked him with the masters of his time. Gifted as a performer both on the violin and the keyboard instruments of his day, he worked in every known field of composition with equal competency and genius. By the time of his death in 1791, at the early age of thirty-five, he had left behind a remarkable wealth of masterpieces. Their utter beauty and timelessness have kept them as alive and fresh during the two hundred years of their existence as they were at the time of their creation.

His works so faithfully embody the Classic period's ideal of objectivity and balance that it is difficult to realize the personal tragedy that haunted most of Mozart's short life. Here and there we sense a note of deep personal feeling in the works of this master, but the consummate artistry of the creative genius so beguiles us that somehow we are never conscious of the person Mozart, only of his musical spirit. His works make him the personification of immortal youthfulness. Perhaps the most outstanding characteristic of his incomparable genius is melodic inventiveness. Whatever musical material Mozart touched found expression in lyric beauty. His magic made everything sing, whether instruments or voices.

Mozart, unlike Haydn, was never successful in gaining the kind of a position that would have pleased him most—that of court composer. He had only one regular appointment during his lifetime, with the Archbishop of Salzburg, and he resigned that at an early age. This left him at the mercy of a society that was passing through a revolutionary period and had as yet made no provision for those artists with no aristocratic attachments. Mozart was compelled, therefore, to spread his compositional activities in many directions—from the operatic stage to the chamber music salon, from the church to the ballroom. Perhaps we can be thankful that his great desire for an operatic post was never realized, for it forced him into many activities he might otherwise have passed by.

The *Clarinet Quintet in A Major* (ex. 9.2) is characterized by the personal detachment with which Mozart usually wrote. It was written within two years of his death and followed a bitterly disappointing tour of north Germany. He wrote despairingly to a friend of the dismal outlook for himself and his family. Yet the work shows little but tranquil beauty in its musical expression. It is typical of the intimate mood of chamber music. The usual string quartet—two violins, viola, and cello—are joined by the clarinet, of which Mozart was especially fond.

The formal structure of the individual movements shows little deviation from contemporary models. The first movement is a clearly defined sonata-allegro form. With a great wealth of melodic invention, Mozart rarely repeated a melodic idea, even a short one, without some very simple change sufficient to add a striking new beauty to the old idea. The opening measures of the first movement present the first theme directly. Note the repetition of these same measures immediately after a very brief clarinet entrance. Only a single note of the melody (note marked with *) is changed in the repetition, and the harmonies are slightly altered, but a tremendous change in musical feeling is aroused by this inspiration.

The forty-one symphonies of Mozart represent a continuous concern with this form from early childhood to the last years of his life. The first thirty symphonies, while typical of Mozart's individual style, follow the techniques of the Viennese and Mannheim schools and particularly that of Haydn. In these works, orchestration, form, and harmonic design follow the early classic models. Of the final ten symphonies, the last three stand out as landmarks in the history of this form. The *Symphony in G Minor* (*no. 40*) reveals Mozart as a mature orchestral composer. The Classic orchestra, though somewhat smaller than the full orchestra of the nineteenth and twentieth centuries, had now been established. While Mozart did not use all the instruments in any one of his last works, the balance of woodwinds, brass, percussion, and strings is present in the orchestras of his symphonies, concertos, and operas. This instrumental force became the orchestra of the next 150 years. Expansion of the various instrumental choirs occurred in the Romantic and Modern eras, but the Classic balance was maintained.

The *Symphony in G Minor* is scored for the full complement of woodwinds, flutes, oboes, clarinets, and bassoons, but only two horns represent the brass choir, and percussion is entirely absent. The strings are divided into four parts: first and second violins, violas, cellos, and string basses doubling the bass line. This symphony is one of the most compact of Mozart's last great works. The entire work might be said to be based on the two-note figure heard at the very beginning, played by the violins. The first, second, and final movements are all in sonata-allegro form. The third movement is the traditional

Example 9.2: *Clarinet Quintet in A Major*, k. 521 (First Movement)—Mozart

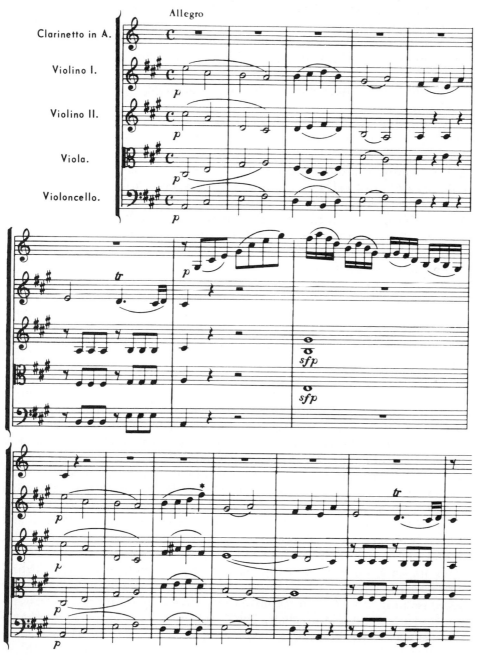

minuet and trio. There are no slow introductory passages to any of the movements, for all of them begin straightaway with the thematic material upon which each is built. The development sections of the three sonata-allegro movements are concise and compact, based solely on the material of the main themes of each of the movements, and employ contrapuntal treatment in bold fashion.

While the essential character of opera is opposed to the eighteenth-century Classic idea, even this form shows the strong influence of restraint and formalism. The hybrid form known as opera was a child of the Baroque and assumed, during the seventeenth century, all the excesses of an era known for its emphasis on the highly emotional and spectacular. The late Baroque operatic composers found it difficult to achieve or to maintain artistic value in the face of these excesses. As an example, Handel, after composing forty-three operas, abandoned the form in favor of oratorio. In the last half of the eighteenth century, Gluck very determinedly set about to correct the abuses of opera. Mozart, on the other hand, had no preconceived ideas of reform, but his refined classic taste and his innate feeling for, and love of, the theater led him to write what are perhaps the happiest solutions to the problem of combining pure music and extramusical ideas. These were his operatic works, among which *Don Giovanni, Così fan tutte, The Abduction from the Seraglio, The Magic Flute,* and *The Marriage of Figaro* are the finest examples. The genius of Mozart enabled him to keep his operatic works in the tradition of theatrical entertainment while at the same time the music was cast in the finest classical mold.

The overture and the first scene of *The Marriage of Figaro* illustrate the manner in which Mozart re-formed the decadent operatic form without in any way acting as a conscious reformer. The opera is founded on a comedy by the French dramatist Beaumarchais. Figaro is about to marry Susanna, the Countess Almaviva's waiting maid. He realizes that Susanna is the object of the affection of his master, the Count (duets #1 and #2 of Figaro and Susanna). Figaro determines to effect a counterplot against his master, as well as Don Basilio, one of the Count's aides, in his designs on Susanna (cavatina of Figaro). A secondary plot is introduced in the persons of Marcellina and Dr. Bartolo, who desire revenge on Figaro and Susanna (aria of Bartolo and duet of Marcellina and Susanna). Cherubino, the Count's page (a part sung by a mezzo-soprano), has a secret passion for the Countess, and becomes an eager assistant to Figaro. The page is in disfavor with the Count for flirting with Barbarina, a cousin of Susanna. He begs Susanna to intercede with the Countess (aria of Cherubino). During this scene, the Count arrives. Cherubino hides behind a large chair. The Count, not realizing that he is being overheard by Cherubino, tries to advance his designs on Susanna and is interrupted by the arrival of Basilio. Not wanting to be found alone with Susanna, he hides behind the large chair. At the same time, Cherubino slips

around and curls up in this same chair, where Susanna covers him with a dress of the Countess. Basilio enters and tries to advance the Count's cause with Susanna, mentioning also Cherubino's love for the Countess. The Count, unable to contain himself any longer, jumps from his hiding place and, in a rage against Cherubino, tells how he discovered the page concealed in Barbarina's room. He illustrates his action by snatching the dress off the chair, only to find Cherubino again (trio of Susanna, Basilio, and the Count). But Cherubino has heard too much, and the Count is forced to forgive them. However, the Count succeeds in ridding himself of the page by commissioning him as a captain in the army. Figaro bids Cherubino farewell (aria of Figaro). Thus, the first act ends with the laying of a framework of an intrigue that finally resolves itself in the happy marriage of Figaro and Susanna.

The music represented in the overture and vocal numbers follows the same Classic design as the purely instrumental works of Mozart. The overture is a reduced sonata-allegro form lacking a development section. The vivacious spirit of the music makes a fitting prelude to the sparkling comedy that follows though no attempt is made either through musical connection or extramusical device to connect the overture with the opera itself.

Although we will not discuss them, there are recitatives that connect the various arias, duets, etc. The recitatives carry the narrative of the story in the traditional operatic manner and are of little significance as far as formal structure is concerned. Mozart employed the style of secco or dry recitative, which signifies the use of a keyboard instrument as an accompaniment to the sung declamation.

In the eight solo and ensemble numbers in the first act, the vocal and instrumental ensemble, which is characteristic of all Mozart's operatic writing, is strikingly important. Each of these numbers is a closed form quite complete in itself, even when removed from context. The same skill that Mozart demonstrated in the handling of instruments in chamber music is characteristic of the handling of the voices and instruments in this work; the opera itself, presented in the intimate surroundings of the eighteenth-century court theater of Vienna, was also a sort of chamber music.

In addition to the formal beauty of each number, Mozart voiced the musical counterpart of each theatrical situation in a most happy wedding of extramusical idea (text) and pure musical utterance. This is accomplished in the cavatina in which Figaro says, "If you want to dance, Sir Count, I'll play the tune." The first part is actually a minuet. It gives way to a contrasting middle section that voices the determination of Figaro to outwit his master, only to return again to the suave minuet form in which Figaro restates his confidence in being able to make the Count bend to his desires. The whole is formally a three-part song form with a strikingly contrasting middle section.

Cherubino's aria, in which he voices his disturbance over the fevers of love that beset him, is another example of Mozart's ability to frame the musical counterpart to the breathless utterances of the lovesick youth. The aria is a three-part song form with an extended **coda** section. In the coda, the simple means of breaking the musical ideas into shorter and shorter repetitive patterns suggests a feeling of musical frustration that reveals more of the tender self-pity and hopelessness of first love than the words of Cherubino themselves.

The trio that follows this aria is a masterful dramatic characterization of the three persons within the formal musical structure of a free rondo form.

Figaro's final aria is another example of Mozart's use of a Classic form, in this case another rondo, to characterize the change that is to take place in the person of Cherubino. The first episode is in the rhythmic form of a march that parades before Cherubino the soft and gay life of his past. This is done in the first section of the aria, A-B-A. A second episode, C, presents the more grim and bombastic military character of the life he is soon to lead in the army. The whole is rounded out formally with the repetition of the gay opening section.

Such is the skill of Mozart that perfection of musical form tends to heighten the dramatic incident. He was a Classicist who by pure musical handling of his materials beguiles us into the dramatic situation so adroitly that we even eagerly accept the whole as an expression of a unified art form. This is the goal of every operatic composer, but few have been as successful as Mozart.

Summary

The Rococo style in the arts was a contrast to that of the Baroque. It was mainly the product of the French court, but since the court at Versailles became the model for aristocratic life and manners, the Rococo was imitated in other places, especially in Germany and Italy. The Rococo developed naturally from the intense systematization of the Baroque. As a result of absolutism in government, wealth became concentrated in the hands of the nobility. Society and manners were reduced to a formula. There was an emphasis on elegance, refinement, amorous pursuits, and sentimental love. Gone were the great passions and noble pleasures of the Baroque. Gone also were the intense spiritual values of the past. Life at the court was artificial and so was its art.

Amorous scenes, courtly life, and manners provided the most popular subjects for both painters and sculptors. The method and organization of the elements remained essentially as in the Baroque; however, there is less vigor and everything is on a much smaller scale. Lines are less diffused and are broken up into smaller fragments. Spatial awareness is reduced, and color, while still monochromatic, is less intense and shows more of a pastel quality.

Decoration in architecture reveals the Rococo style at its best, where generous use is made of floral patterns with delicately carved motifs. This kind of decoration is also found in the design of furniture and in almost every kind of household furnishing, including dishes, silverware, and other items in the homes of the aristocracy.

The Neoclassic aspect of the Rococo-Classic was in direct opposition to the Rococo. In protest against the superficial elegance of the Rococo, the French Academy urged a return to classic ideals with models from the Greeks, the Romans, and the Renaissance. This calm, cool art became a symbol of the revolt against the frivolity and elegance of the French court. In place of the amorous and artificial manners, the subjects of Neoclassic painters and sculptors were often patriotic, or at least they revealed intellectual pursuits. Lines were clear with formal balance, in keeping with the ideals of restraint and balance.

The music of the Rococo-Classic has survived the test of time. Music never entirely succumbed to the Rococo, but it did respond to the ideals of classic simplicity and clarity. In fact this music is referred to as the Classic style. The finest music of the period was mainly the product of Germany and stresses perfection of form, lyric melody, and homophonic texture. While opera claimed the attention of the Classic composer, it is in instrumental music that the Classic style reached its culmination. The most important forms were the sonata-allegro and the composite sonata. In these forms, composers embodied their ideals of formal structure in an abstract instrumental form of large proportions. The principle of design is repetition and contrast, with repetition of melodic material after contrasting melodies in varying tonal centers. Classic music is full of lyric melody, subtle rhythms, and restrained emotional expression. Often light and gay, it is rarely profound or full of strong passion. It appeals to the listener through its melodic invention and simplicity.

Suggested Readings

In addition to the specific sources that follow, the general readings on pages xxi and xxii contain valuable information about the topic of this chapter.

Held, Julius, and Posner, Donald. *Seventeenth and Eighteenth Century Art.* Englewood Cliffs, N.J.: Prentice-Hall, 1972.

Pauly, Reinhard G. *Music in the Classic Period.* 2d ed. Englewood Cliffs, N.J.: Prentice-Hall, 1973.

Rosen, Charles. *The Classical Style: Haydn, Mozart and Beethoven.* New York: W. W. Norton, 1972.

10

THE ROMANTIC

(1800-1900)

Chronology of Romanticism (Including Realism and Nationalism in Music)

Visual Arts	Music	Historical Figures and Events
▪ Francisco José de Goya (1746–1828)		
	▪ Ludwig van Beethoven (1770–1827)	
▪ J. M. W. Turner (1775–1851)		
▪ John Constable (1776–1837)		
	▪ Niccolò Paganini (1782–1840)	
	▪ Carl Maria von Weber (1786–1826)	
▪ Theodore Géricault (1791–1824)	▪ Gioacchino Rossini (1792–1868)	
▪ Jean Baptiste Camille Corot (1796–1875)		
	▪ Franz Schubert (1797–1828)	
▪ Eugène Delacroix (1798–1863)		
	▪ Hector Berlioz (1803–1869)	▪ Napoleon becomes Emperor (1804)
	▪ Fanny Mendelssohn-Hensel (1805–1847)	▪ Lewis and Clark reach the Pacific (1806)
▪ Honoré Daumier (1808–1879)	▪ Felix Mendelssohn (1809–1847)	▪ Abraham Lincoln (1809–1865)
		▪ Charles Darwin (1809–1882)
	▪ Frederic Chopin (1810–1849)	
	▪ Robert Schumann (1810–1856)	
	▪ Franz Liszt (1811–1886)	
		▪ Charles Dickens (1812–1870)
		▪ *Fairy Tales* by the Grimm Brothers (1812)
		▪ War of 1812 between England and the United States (1812)

[*Continued*]

Chronology [*Continued*]

Visual Arts	Music	Historical Figures and Events
	■ Richard Wagner (1813–1883) ■ Giuseppe Verdi (1813–1901)	
■ Gustav Courbet (1819–1877)	■ Clara Wieck Schumann (1819–1896) ■ Bedřich Smetana (1824–1884)	■ Battle of Waterloo (1815) ■ Karl Marx (1818–1883) ■ Walt Whitman (1819–1892) ■ Louis Pasteur (1822–1895) ■ Monroe Doctrine promulgated (1823) ■ First performance of Goethe's *Faust* (1828) ■ Beginning of antislavery movement (1831)
■ Edouard Manet (1832–1883) ■ Edgar Degas (1834–1917)	■ Johannes Brahms (1833–1897)	
■ First photograph taken by Daguerre (1838)	■ Modest Moussorgsky (1839–1881) ■ Piotr Ilyitch Tchaikovsky (1840–1893) ■ Antonin Dvořák (1841–1904) ■ Saxophone invented by Adolphe Sax (c.1841–1842)	■ Froebel founded the first kindergarten (1836) ■ Morse invents the telegraph (1837) ■ Victoria, Queen of England's Reign (1837–1901)
■ Thomas Eakins (1844–1916)	■ Nicolai Rimsky-Korsakov (1844–1908)	■ Friederich Nietsche (1844–1900) ■ Marx and Engels publish the *Communist Manifesto* (1848) ■ Japan opened to the West (1853) ■ Thoreau's *Walden* published (1854)
■ Elizabeth Thompson Butler (1850–1933)		
	■ Giacomo Puccini (1858–1924)	■ Darwin's *Origin of Species* published (1859)
	■ Hugo Wolf (1860–1903) ■ Gustav Mahler (1860–1911)	
		■ Russia emancipates the serfs (1861) ■ American Civil War (1861–1865)
	■ Richard Strauss (1864–1949) ■ Jean Sibelius (1865–1957)	■ Slavery outlawed in the United States by the Thirteenth Amendment (1865) ■ Site of Troy excavated (1870) ■ Edison invents the phonograph (1877) ■ Automobile engine patented by Daimler (1883) ■ Universal adoption of solar day as unit of time (1884) ■ Koch discovers the tuberculosis germ (1885) ■ Roentgen discovers the X-ray (1895)

Pronunciation Guide

Balzac (Bahl-zahk)
Baudelaire (Boh-de-layr)
Chopin (Shoh-pȧ)
Corot, Camille (Koh-roh, Kah-meel)
Delacroix (Duh-la-krwah)
Dvořák (Dvor'-zhahk)
Eroica (Eh-roh'-i-kah)
Géricault (Zhay-ree-koh)
Goethe (Goé-te)
Goya (Goy'-ah)

Heine (Hih'-ne)
Hugo (U-goh)
Mendelssohn (Men'-del-zohn)
Paganini (Pah-gah-nee'-nee)
Puccini (Poo-chee'-nee)
Rousseau, Jean Jacques (Roo-soh, Zhan Zhahk)
Sand (Sȧn)
Schubert (Shoo'-bert)
Schumann (Shoo'-mahn)
Verdi (Ver'-dee)

Study Objectives

1. To learn how the Revolutions influenced the Romantic period.
2. To learn about the conflicts and contradictions expressed in the individualism and emotionalism of Romantic artists.
3. To study the added tensions in harmony, melody, and rhythm characteristic of most Romantic music.

Romanticism

Romantic is the term used to designate the style of art and literature of a large part of the nineteenth century. The word itself has a rather vague and mysterious connotation of sentimentality. In fact, the first use of the term was to designate the chivalrous and sentimental writings of medieval Italy, France, and Spain. These "romances" had a marked predilection for moonlit forests, enchanted castles, dragons, and other devices to lend mythical atmosphere to the story.

By the turn of the nineteenth century, Romanticism had come to mean something very different. As a movement, it no longer sought inspiration in the legends and myths of the Middle Ages but rather a new freedom in the expression of personal feelings. Romanticism became a revolt against convention and authority, whether in personal, religious, civil, or artistic matters. The search for individual freedom in life and art was its motivating force, even when it was at the expense of formal perfection. This search distinguished the Romanticist from the Classicist, who sought perfection of form and design and who preferred intellectuality to personal feelings. Romantic artists did not completely ignore Classic design, but used it only when it served their artistic purposes. Personal feeling was primary and design was secondary in importance.

For a period of about one hundred years, artists were concerned with the search for ways to express individualism and to intensify the emotional expressiveness of their art. One such trend was to impress the observer by being realistic, both visually and musically. This development became important enough to be called Realism. Another Romantic trend that became especially strong in music was Nationalism: the individuality of ethnic groups expressed in folk music, legend, and historical events of the past. The aspects of the Romantic spirit will continue to be a focus of the following chapter on Realism and Nationalism of the nineteenth century. Realism, especially in music, is only one facet of Romanticism. Nationalism in music is the application of the Romantic spirit to the music heritage of sovereign states.

The eighteenth century had been an age of reason, and all phases of intellectual activity were to a great extent dominated by the scientific attitude. The human element was largely eliminated from life. People believed they had worked out a perfect system and had extended this system to government, economics, art, society, and even to religion. But they reckoned without human personality and emotions. The whole system exploded in the French Revolution. Reason had not solved all of society's problems, nor had it been enough to satisfy the humanistic longing for spiritual consciousness. The human being has both intellect and emotions to be considered. Had not reason been overcultivated at the expense of sentiment and liberty? This question probably directed the thinking that led to the Romantic attitude. The new way, called Romanticism, produced new movements in religion, politics, art, and social life. The urge for freedom that had started in the eighteenth century was finally brought to a point where it had a real effect on human life. The realization that everyone is an individual with feelings who has the right to agree or disagree is an integral part of the Romantic spirit.

Jean Jacques Rousseau is the figure who stands out as the popularizer of the Romantic movement. His *Social Contract*, written in 1762, sets forth his philosophy of individualism. Rousseau reflects one of the primary causes of the French Revolution for his thesis is emotional individualism. He asserted that science and civilization had taken people away from nature and that natural instincts should be their guide. In order to "return to nature," the taboos and artificialities of civilization must be cast aside. Previous philosophies held that people are inherently evil and must be subordinated to the beneficial laws of society. Rousseau asserted that humans are inherently good and are evil only to the extent that they are influenced by evil. To be one's natural self should be the guiding principle of life. The following lines from Rousseau's *Confessions* represent the whole Romantic spirit as it applies to individualism: "I am different from all men I have seen. If I am not better, at least I am different." Paganini, the great Romantic virtuoso of the violin, put it another way when he said, "Paganini avoids mediocrity in everything."

This emphasis upon individual feeling led to a feverish activity in all phases of life. European society was experiencing a demand for a fresh interpretation of man and nature. There was a revival of the "cult of feeling" that

was to serve as a basis for much of the poetry, drama, art, and music of passion during the nineteenth century. To no creative activity could intense emotion mean so much as to music and the visual arts.

The philosophy of Romanticism gave people the freedom to give voice to their passion, fear, love, and longing. Artists could now celebrate "natural man" and break the bonds of formalism imposed by Classicism. This meant that new subjects for art were now available. All kinds of subjects and experiences previously considered in bad taste now found artistic expression. There was a renewed interest in nature. Landscape again became a favorite theme, as it had in the seventeenth century. Folklore and folk song became expressions of the simple, unaffected peasantry. The mysteries of love and death brought passion and drama back into the arts. The new ideals of freedom were dramatized both visually and tonally. Atypical experience fascinated the Romantic artist because of its mystery or supernaturalism. Violence and shocking events were often used because such subjects gave more opportunity for the projection of strong emotions. Romantic subjects were almost unlimited, for any subject seen through an individual temperament could be highly charged with passion and intense emotions.

There was also a tendency to mix the arts. Painting and sculpture often depended upon literary and poetic ideas and sometimes were actual illustrations of literary works, as was the case with Delacroix in his paintings of scenes from *Hamlet* and the *Divine Comedy*. In this style period, much music was written that was descriptive and is known today as **program music**—music that recreates a story or scene in terms of melody, rhythm, and harmony. All Romanticists had emotional response as their immediate aim in their revolt against the intellectual Classicism of the past. Whatever the subject or art, the listener or spectator was made to feel the whole scale of emotional sensations.

Because Romantic art expresses the individual temperament of its creators, the personal lives of artists take on a new importance. Biographical details can serve as keys to the motivating experiences that are intensified in their art. Their lives came to be as romantic as their works. Freedom extended to personal behavior. Their love affairs, their relations with publishers and museum directors, their economic problems, and their eccentricities became an integral part of the record of their creative lives. Beethoven is such a case. Every scrap of information regarding his personal ideals, his love of nature, his illness, and his unfortunate love affairs colors our understanding of his music. Delacroix's literary associations with George Sand and Baudelaire, his friendship with Chopin, his travels, and his political friends reveal facts that influence our concepts of the Romantic qualities of his paintings. One must, however, be on guard against romanticizing the lives of artists at the expense of appreciating their works. After all, creative artists stand or fall on the quality of their works, not on the Romantic character of their personal affairs.

There was also a change in the patronage of Romantic art. No longer were artists attached to courts for the purpose of providing entertainment in keeping with courtly customs. Nor was the Church a particularly ambitious art patron.

Romantic artists depended on their abilities to arouse the interest of a greater public—the common people. Composers and writers relied upon the sale of published works. Painters and sculptors depended upon the sale of their works to the public and upon fees for exhibitions. While they were not bound by the demands of the court or Church, they were influenced by public taste. Because there were very close economic ties with the general public, they were very sensitive to public reaction. Fortunately, the public generally accepted Romanticism as the artists had accepted it.

This new patronage also brought a change in the social status of creative artists. They were no longer servants; instead they held a place in society fairly commensurate with their artistic and economic success. Haydn was a servant at the court of Prince Esterházy, but Beethoven, only a few decades later, was a free, independent, and financially successful composer. In general, successful artists came to be honored members of society and often reaped abundant rewards for their efforts. Not all achieved financial success early enough to be of much satisfaction to them, however. This was the case with Schubert, who died at the age of thirty-one, apparently on the threshold of worldly success, though artistic success had come much earlier.

It is almost impossible to formulate a set of rules for evaluating Romantic art because it reflects a spirit of revolt, of individualism. There are many contrasts and paradoxes within the movement itself. If any guide can be suggested, it is contrast to the Classic. For example, the Classic tendency in music and visual arts is toward a centralization, toward closed form; in the Romantic, we find open form, the predilection for action and soaring emotions. The Classic is logical and intellectual, while the Romantic is irrational, untypical, and often experimental. The Classic deals in sharply defined lines and melodies; the Romantic in vague, shadowy, conjectural forms and suggestive harmonies. One can also contrast the strong, positive objectivity of Classicism to the often loosely formed subjectivity of Romanticism.

As we look back at the art and music of previous epochs, we see elements of Romanticism in all great art of the past. The Gothic cathedral, Leonardo da Vinci, Rembrandt, Bach, and even Mozart show the tinge of the Romantic spirit. Perhaps this is what gave these works and artists expressive values that have made them almost timeless. It was not until the nineteenth century, however, that the Romantic spirit ruled and dominated the arts.

Painting

As we have noted, the painters of Romanticism rejected the doctrine of Classicism and turned their attention to subject matters of a wide range, treating them with greater individuality than did artists of the Rococo and Neoclassic. They also rejected the rigid system of Classical patronage. For the first time, artists were able on a large scale to depend on selling their works after they were created. Art was finally free, unfettered by previous standards of taste; it could express the personal feelings of the artist. The emotions of violence

and excitement replaced the social niceties of the previous era. Painters turned to the Dutch art of Rembrandt and Rubens for inspiration in the use of color, light, and shade in depicting strong emotions.

Géricault

Colorplate 52 follows p. 264.

Theodore Géricault (1791–1824) was one of the first painters of the French Romantic movement. His *Raft of the Medusa* (colorplate 52) was inspired by a newspaper account of the sinking of the ship *Medusa* off the coast of West Africa. After many days on a raft in the storm-tossed ocean, only a handful of survivors reached safety. In an effort to recreate the emotions of the tragedy, Géricault revitalized in his imagination the scenes aboard the raft. It was reported that he even hired the survivors as models and made studies of corpses in order to accurately render the victims. He endeavored to express the despair, the hunger and thirst, and the struggle for life aboard the raft. He tried to engulf the observer in the whole range of emotions in the disaster. Through color, twisting diagonal lines, and the emotional postures and gestures of the participants, he made this painting a profound experience for viewers. He chose a supremely appropriate Romantic subject matter—man against the sea—in which the odds against the human spirit seem overwhelmingly unfavorable to the actors in the drama.

Delacroix

Colorplate 53 follows p. 264.

Eugène Delacroix (1798–1863) became the leader of the Romantic movement in painting. In his famous work *Liberty Leading the People* (colorplate 53), Delacroix recaptured the spirit of the Romantic revolution. He symbolized the struggle for freedom against the forces of tyranny in his portrayal of an allegorical goddess of liberty leading the people of France over the barricades. The event that suggested this work was the July Revolution of 1830 and not the Revolution of 1789, as is popularly supposed. Some Romantic aspects of the work are immediately apparent. This is more than a group of people engaged in a scene of violent action. The figure of the goddess, tall and placed in a central position, dominates the whole scene. She is not a static figure but is going forward, raising the tricolor of France high above everything. In short, she is a symbol of the energy and action that are necessary not only to gain freedom but to retain it. The figures around her symbolize the various classes of people that make up a nation. They, too, under the leadership of the ideal, are forging ahead, trampling over the fallen bodies of their enemies and their own comrades.

The elements are arranged in much the same manner as in the typical Baroque style. While the goddess is the central figure, spatial awareness is enhanced by the diffused lines and forms melting into one another in multiple organization. Color is still monochromatic in spite of the patches of color contrast. The use of the human form as a motive shows the theme and variation principle of design.

Delacroix himself was regarded as a flagrant revolutionary in his own day. As an artist, he was described as a barbarian and a savage with a paintbrush. He never thought of himself, however, as a leader of the new movement nor as a particularly savage Romanticist. He merely desired to express his unfettered feelings about subjects and scenes that attracted him. He came from a wealthy family and was a well-read, sensitive, and intelligent person. He numbered among his friends such literary figures as Balzac, Victor Hugo, and George Sand. He was also a friend of the composer Chopin. Undoubtedly, these connections with fellow Romanticists served to fuse the elements of Romanticism more deeply into his personality. The hostility of the French Academy did not deter him; it served only to confirm his own ideals.

The Romantic tendency to mix the arts is shown in Delacroix's illustrations for Dante's *Divine Comedy. Dante and Virgil in Hell* (colorplate 54) depicts the two poets being ferried through a murky and bloody hell, with anguished and tortured souls clinging to the boat. Delacroix shocked viewers with a painting of horror; even the two poets are appalled by the scene before them. The shadowy background with its faint spot of light gives a sense of the infinity of hell itself. There is action, both physical and emotional. The raised hand, the twisting torsos, the waves, and the flowing robes suggest a feeling of motion. The agony of facial expressions provides a powerful emotional climax. The artist used the mass of form without line drawing to mold his subject together. While the color is monochromatic, there are contrasts in shades, highlighting the bodies clinging to the boat. It is the feeling that is most important; the forms are only a means to that end. The whole canvas intensifies the horror of the story that Dante already had described verbally.

Colorplate 54 follows p. 264.

Goya

The Romantic movement was not confined to any particular country. From each emerged its special brand of Romantic feeling and its own few artists who best portrayed that feeling. Francisco Goya (1746–1828) was one of the great Spanish individualistic painters. He was an artist of tremendous imaginative and technical powers with the courage to paint whatever his feelings dictated. He used a wide range of subjects, from painstaking portraits to scenes of violence and horror. As a Romanticist, Goya felt that art should do more than entertain or decorate. He was convinced that painting could, and must, focus attention on moral issues. He made a set of prints called *Disasters of War* in which he suggests, with unbelievable literalness, the rape, mutilation, and desecration of men and women that took place during the French invasion of Spain in 1808. This series of prints is one of the greatest artistic comments on the tragedy of war. In each of his works, Goya appeals to the emotions through the power of suggestion. He is not a realist, but he expects the observers to supply the details from their own imaginations. Through this suggestive quality, Goya not only supplies the detail of action but also intensifies the impact of the subject upon the viewer's feelings.

Colorplate 55
follows p. 264.

May 3, 1808 (colorplate 55) is a painting in which Goya displays his powers to suggest the drama of terror, blood, and violence and to moralize upon the event at the same time. The subject is the execution of Spanish loyalists at the hands of the French. It is said that the artist, who witnessed the terrible event, went by night to sketch the pile of bloody corpses in preparation for his painting. Goya used a great economy of line and color to suggest the impact of his message of horror. The dull colors add a feeling of terror and doom to the scene. The dim outline of the building and the sloping contour of the hill in the background impart a sense of space. There is little detailed line in either the soldiers or their victims. They are volumes of mass rather than realistic bodies. The upraised arms of one of the victims, highlighted in white, symbolize, in effect, the sacrifice of life for liberty. There is action in the line of soldiers with pointed rifles and in the crowd that turns toward the executioners in resignation. Goya used color and mass to intensify the drama of death for liberty.

Turner

This influential English painter of landscapes and seascapes worked in both oils and watercolors. Whereas the Dutch painters of seascapes rendered works that were almost photographic in their realism, J. M. W. Turner (1775–1851) employed looseness of brushstrokes, almost violent application of paint, and a high degree of abstraction to create works that anticipated the French Impressionists by several decades. These characteristics are present in *Rain,*

Colorplate 56
follows p. 264.

Steam and Speed (colorplate 56). Line has become secondary as texture and color have been employed to create the atmosphere of the painting. Turner's technique allowed him to capture something of the speed and power of the Great Western Railway. The objects in the painting are loosely defined as a result of the free way in which Turner applied the pigment to the canvas. Although this predates by some fifty years the painting by Monet of *Rouen Cathedral, West Facade* (colorplate 66), both artists used rapid brush techniques to create the spirit of the object rather than a photographic likeness.

Corot

One of the characteristics of Romantic painting was the return of the landscape as a favored theme. Camille Corot (1796–1875) was one of the prominent and prolific painters of Romantic pastoral scenes. There is a sentimental quality about his landscapes, for the mood is always gentle. His painted fields and trees seem to be immersed in mist and their forms are dissolved in soft

Colorplate 57
follows p. 280.

light, color, and lines. His *View Near Volterra* (colorplate 57) shows Corot's personal interpretation of nature. It displays a Romantic feeling for light, space, and color. A strong sense of structure is shown in the solid mass of rocks and in the figures of horse and rider. Sentiment, however, overtakes structure to create an escape from the stuffiness and turmoil of the city in favor of the quiet peace of a shepherd's world.

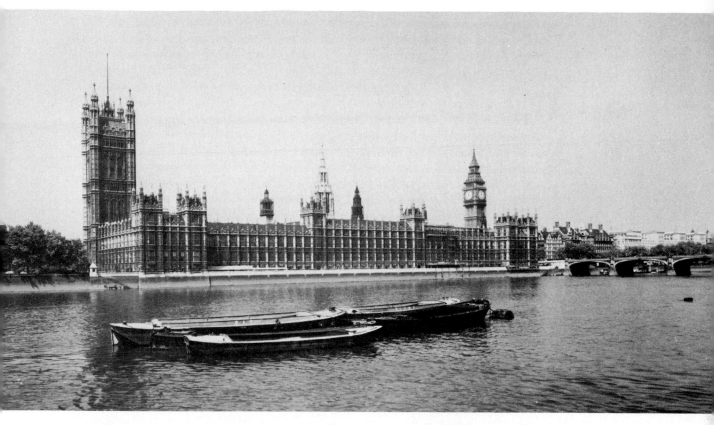

Figure 10.1 *Houses of Parliament,* London [1840–1860]—Barry and Pugin. (National Monuments Record, London-Art Reference Bureau)

Architecture

There was no one style to distinguish architecture as Romantic. It could, perhaps, be called revivalist architecture because most architecture consisted of revivals of past styles such as the Gothic, Renaissance, and Baroque. The Gothic revival is very apparent in the Neo-Gothic style of the *Houses of Parliament* in London (fig. 10.1), designed by Charles Barry and A. Welby Pugin and built during the period between 1840–1860. There is a symmetry about the main structure that encloses the governmental spaces. The Gothic influence is evident in the various towers that give the building an irregular appearance.

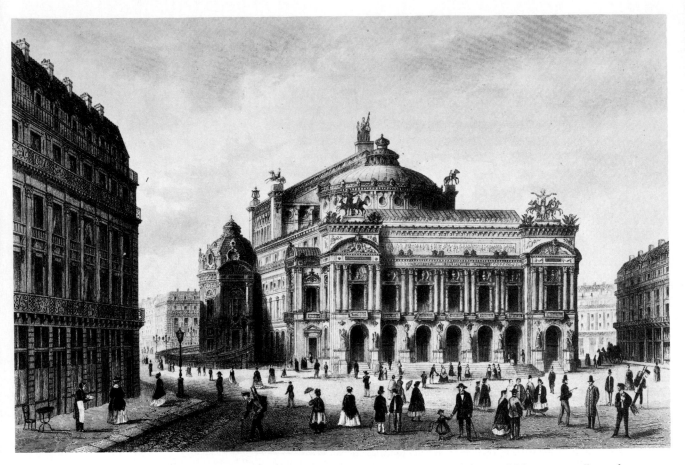

Figure 10.2 *Paris Opera*, Paris [1861–1874]—Garnier. (National Monuments Record, London-Art Reference Bureau)

Another example of revivalist architecture is the *Paris Opera* (fig. 10.2), designed by Charles Garnier and built in 1861–74. It is often referred to as a Neo-Baroque structure, partly because of the multiplicity of its sculpture and ornaments both outside and within. There is an opulence about the building that reflects the tastes of the newly rich and powerful captains of the Industrial Revolution.

There were a few structures that reflected the technological developments of the Industrial Revolution in their use of cast iron and glass. One of the most famous of these was the *Crystal Palace* in London, built for the Great Exhibition of the Works of Industry of all Nations, constructed in 1851. Unfortunately it was destroyed by fire in 1937. Another technological tour de force is the *Eiffel Tower* in Paris, constructed in 1889.

Music

In the Romantic period, music offered a highly effective medium for personal artistic expression. Although music deals only with abstract ideas and therefore lacks specific or concrete meaning, listeners translate these sonorous materials into specific personal feelings and experiences. In the nineteenth century, with its emphasis on individual freedom, music, of all the arts, afforded the most liberal opportunity for the exercise of such freedom. The visual arts in their dependence upon subject matter either limited their appeal to a specific group or period of time, or in their desire for wider expression, employed subjects of such trivial sentimental nature that the artistic value of their work suffered. There is a great quantity of sculpture, painting, and architecture of the Romantic period that tends to be exaggerated, irrational, or sentimental. This is partly because of a desire to appeal to the individual's free exercise of emotional response. It is possible for music, however, to sustain a feeling of intensity that no visual art can do without becoming exaggerated or irrational. In fact, we often approve of things in music that would be intolerable in literature or the visual arts. Music is, then, the most Romantic of all the arts because it is the most abstract and therefore less dependent upon objective facts, which often are meaningful only to those who have experienced their history.

In earlier periods, the social and professional positions of such composers as Palestrina, Bach, and Haydn colored their creative efforts. With the Romantic struggle for freedom came the emancipation of composers, as well as other artists, from the system of Church or aristocratic patronage. From this period on, composers responded either to their public or to their own impulses. A great number of works in the nineteenth century were still written at the commission of a small, elite, and discriminating musical aristocracy; by and large, however, the great mass of works was written either for public performance or to satisfy the individual composer's intense feeling for expression. Insofar as Romantic composers wrote works that succeeded in appealing to the general musical public, they achieved a modicum of material success. Insofar as they wrote to satisfy their personal desires, to express their personal musical thoughts, they could experiment with new materials and forms. They should not have been surprised, however, if such a path led to general disregard, if not to outright antagonism and obscurity, during their lifetimes.

A more generally democratic society growing out of the revolutionary struggles of the late eighteenth century had replaced the cultured and discriminating aristocracy of the earlier periods. This democratic society now became the patron whose acceptance, or at least tolerance, the artist of the nineteenth century had to win. Failing this, composers had to write for a continually shrinking circle of admirers who were incapable of making it economically possible to continue as creative artists. This is a condition that becomes more aggravated throughout the nineteenth and twentieth centuries.

In the nineteenth century there was, for the first time, a situation in which a composer's works failed to find performance before their intended audience. By whom were the last works of Beethoven heard during his lifetime? How many knew the great songs or instrumental works of Schubert until a generation after his death? With what personal sacrifice and expense of energy did Wagner succeed in gaining a hearing for his music drama? Romantic composers either had to write for prevailing tastes or to be persons of intense vigor and energy in order to succeed in gaining public acceptance or even public performances.

As in the field of the visual arts, it is impossible to formulate a set of rules that describes Romantic music. However, all Romantic music is based on the premise that musical tension is necessary to achieve a corresponding intensification of emotional response. Romantic music therefore concentrated on achieving this tension. This means that the exploitation of sonorities and dynamics and the exploration of sheer masses of sound were of deep concern to the composer. Tone color—the use of instruments in combination and the use of individual instrumental qualities heretofore unexplored—was also a focus. Romantic composers were interested in all the possibilities of setting up harmonic tension. The further exploitation of the duality of key, so neatly couched in the sonata-allegro form of the Classic period, was pushed on to plurality of keys. This is reflected in the rich harmonic texture of Romantic music with its chromaticism or dissonance. Concomitant with this increased richness of harmony, of course, was an increased richness of melodic line. Melodies were intensified by choice of instrumental tone color and often seemed inseparable from their initial association with a particular instrument or voice. Schubert's *Erlkönig* is unthinkable for a soprano voice, and a performance of the Largo movement of Dvořák's *New World Symphony* played on anything but the English horn would be a totally different experience and would miss the musical pathos of the original.

Finally, the composer sought tension and, of course, its ultimate release in the problem of formal structure. The nineteenth century offered no essentially new formal plans, but the breaking-up of the thematic ideas into motives and the detailed development of both themes and motives also indicate the concern with musical tension. Beethoven and Wagner, to mention only two, are particularly noteworthy in this respect.

Apart from these common concerns, it is difficult to stereotype musical Romanticism. There were Romantic idealists and Romantic realists. The idealists insisted that music could exist for its own sake; the realists insisted that music must tell a story that could be verbalized or possibly visualized. There were Romanticists who excelled in spectacular virtuosity, dazzling the listener by brilliant technique. There were also those who emphasized intimacy as the best approach to personalized feelings, writing chamber music and solo songs. Others combined literature and landscape with music in the invention of the symphonic poem.

There were three favorite media of expression for Romantic composers—the orchestra, the piano, and the human voice. Most composers wrote for all three. The orchestra grew into the favorite large instrument of the century. It had those qualities of bigness, colorfulness, and brilliance that went with Romantic expression. It could run the gamut of musical ideas from a whisper to an overpowering thunder and therefore lent itself well to the descriptive desires of certain composers. The piano could quite successfully emulate the orchestra, and, what is more, it could be played by one person. Consequently, the piano became almost a musical symbol of the Romantic spirit of freedom and individualism. The voice is also a personalized instrument, and it combined with the literary element of Romanticism to give an added intensity to the poetic text. Of course, other instruments were also used during this period, particularly those that lent themselves to virtuoso exploitation, such as the violin.

Beethoven

While arguments can be justifiably made for placing Beethoven in the Classic period or between the Classic and the Romantic, it is clear from an analysis of his music that his compositions reveal those characteristics generally recognized as Romantic.

Ludwig van Beethoven (1770–1827), born in Bonn, Germany, exhibited strong musical gifts as a young boy. He suffered severely at the hands of his father, who hoped to exploit his son's talents by launching him on a musical career. His father, an incompetent manager, failed in this attempt. Despite his father's role of taskmaster, Beethoven developed a deep love for music and acquired great skill as a pianist, organist, and violinist. Because of his musical skill, he was employed as a court musician in his early teens and was the sole family support until his final departure from Bonn in 1792. From then on, his residence in Vienna was interrupted only in the early years by concert tours of Germany and Austria. The last twenty years of his life were spent entirely within the city and suburbs of the Austrian capital.

While he began to devote himself to composition before his twentieth birthday, he was known in Vienna primarily as a magnificent concert pianist. Beethoven's creative life falls conveniently into three periods. Roughly speaking, the first period ends about 1802. This was the period of the pianist-composer, and while the works written during this time exhibit the seeds of the unfolding Romantic period, they are still substantially of the Classic era of Mozart and Haydn. The composition of the Third Symphony in the years 1802–1804 ushered in the middle period, which was truly Romantic in character. Classic restraint was cast aside whenever intensity of expression demanded. Increasing deafness forced Beethoven to abandon his concert career and to accept his fate as a composer. What performance could have accomplished in personal expression had to find voice only through composition, and Beethoven's works became the vehicle for individualized personal expression.

Such a work is the *Symphony no. 3 in E-flat Major*, op. 55 (*Eroica*). In general, it is based upon the Classic precepts of Haydn and Mozart, but it goes far beyond the Classic style in its expressive quality. Countless pages have been written concerning the meaning of this work. Much has been made of the destruction by Beethoven of the dedication to Napoleon Bonaparte when he heard of the latter's assumption of the crown. All such attempts to bring understanding to the music of Beethoven are of little consequence. Nothing can take the place of a direct approach to the music itself. To one who has some appreciation of the temper of the last decade of the eighteenth century and the first of the nineteenth, this work will voice the spirit of Romanticism in its purely musical expression as surely as does *Liberty Leading the People* by Delacroix. Beethoven never felt it necessary to explain his works by means of a descriptive narrative. The title given to this work, *Eroica*, was undoubtedly prompted by the desire to dedicate a work to Napoleon, whom he had admired purely as a liberator. Disgust with Napoleon's act of crowning himself Emperor prompted Beethoven to reword his dedication, but the title remained as a concession to the promise that remained unfulfilled. It is extremely doubtful if Beethoven ever had anything more in mind than this when he wrote the symphony.

The work itself is in the tradition of Classic models. It has the traditional four movements, the first of which is in a greatly expanded sonata-allegro form. Particularly noteworthy is the fact that the musical materials of both the first and second themes are not melodies in the sense of the themes of the Haydn symphony or the Mozart quintet discussed previously. These are themes made up of melodic fragments that lend themselves in a most spectacular way to development. The first theme group of Beethoven's *Symphony no. 3* is more a collection of melodic and rhythmic motives than a complete melody in itself. It first appears as a combination between cellos and violas (ex. 10.1). From these motives, Beethoven typically constructed the first section of the exposition in the tonic key.

There are not just two contrasting themes but two groups of thematic motives, none of which can be lifted from context (as can a melody from Haydn or Mozart) and still remain a complete entity. Moreover, these are themes in a purely instrumental idiom. The second theme group was placed in the key of B-flat, the dominant of E-flat, in keeping with tradition. Beethoven felt no great need of harmonic deviation from tradition—as yet. He relied on striking dynamic contrasts and violent accentuations of regularly weak rhythmic beats to secure tension. This is particularly noticeable in the extraordinarily long development section. This section was not simply a return to the tonic key to restate the first theme in its original form. It was used to exploit thoroughly the composer's ingenuity and imagination. After the lengthy and violent development, the thematic material is restated, and Beethoven added to it a very

Example 10.1: *Symphony no. 3 (Partial Score)*—Beethoven

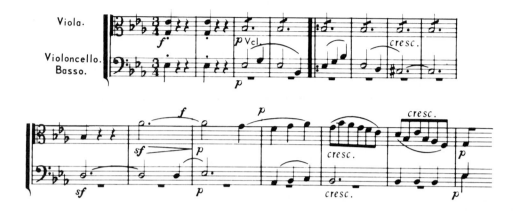

lengthy musical summary in the coda. No longer content to close the restatement with a climactic cadence, Beethoven reiterated his ideas in the coda in ever new guises, as if his inventive genius knew no limits.

The second movement, in the relative key of C minor, is a funeral march with the distinctive rhythmic pattern associated with funeral music. It does not rely on dynamic contrasts alone but exploits tone color with melodic line. The opening melody, for example, is first played in the lower register of the violins and then is given to the oboe, with its rather mournful timbre. The form is loosely that of a march and trio. The trio in this instance is in the contrasting key of C major, which tends to accentuate the somberness of the C minor on its return. The conclusion of this movement aptly illustrates Beethoven's ability to accomplish a rather complete disintegration of the thematic material. Repose is finally achieved by the gradual dissolution of the main theme.

The third movement is one of the most striking examples of Romantic transformation of an originally simple dance form into a vehicle for violent and intense action. The basic form of the movement is the minuet, but its speed, length, and entire melodic character belie its origin. Beethoven employed the term *scherzo* (Italian for "joke") to characterize the spirit of the movement. The trio, with its main theme given to three horns, shows Beethoven's interest in tone color as a means of Romantic expression.

The fourth movement is a brilliant set of variations freely contrived on a theme that the composer had used in three previous works. After an opening flourish of strings and full orchestra, the bass of the theme is presented as a sort of skeleton over which the theme and its subsequent variations will be

stretched. The skill with which Beethoven adds contrasting material to this bass is remarkable. Again, dynamic contrasts, rhythmic complexities, and brilliance of thematic invention all unite in a blaze of spectacular musical expressiveness.

While Beethoven's expressiveness undoubtedly is revealed most widely in his orchestral works, it is nonetheless equally present in other genre as well. The poignant relationships in his opera *Fidelio* is a case in point, as is the *Piano Sonata no. 23,* op. 57. Because of this sonata's character it is commonly known as the *Appassionata.* The terseness of the thematic material of the first movement and the driving, motoric fashion in which the thematic material is used are as evident here as in the *Symphony no. 3.* This sonata exhibits certain compositional devices that Beethoven applied to the piano to make this instrument an expressive vehicle for his music. The extended pitch range of the first twenty-five measures of the first movement, the great use made of the low register of the instrument, the heavy, thick chords placed low in the bass, the wide skips between consecutive motive groups, the abrupt dynamic changes, the sweeping chordal passages—these pianistic compositional devices displayed Beethoven's command of the instrument. In this sonata, and in many others as well, Beethoven made the piano a more expressive instrument than it had been before, setting the stage for its Romantic exploitation, and making the piano second in importance only to the orchestra as a musical means of personal expression.

The *String Quartet no. 16,* op. 135 was written in the third period of Beethoven's life only a year before his death. Shorter and in some respects less radical in deviation from Classical form than the other quartets of this period, it is nevertheless an example of the intensely personal, late style of the composer. Beethoven packed into the rather limited medium of the string quartet a magnificent range of expressive qualities, from the wild, incessant rhythm and leaping melody of the trio of the second movement to the tender, exquisite melodic line in the third movement. The continuous changes of rhythm and key are typical of Beethoven's late compositions. He seemed to be searching for all means at his disposal in the desire to give full scope of expression to his inventive genius. No Romantic composer to follow Beethoven was able to handle the string quartet in such an expressive manner. Most attempts on the part of the later Romanticists resulted either in weak imitations of Beethoven or in works that failed to realize the limitations of the medium.

Schubert

Another Romanticist and a contemporary of Beethoven was Franz Schubert (1797–1828). He was the only great Viennese composer who could claim that city as his birthplace. Schubert's life illustrates a certain kind of bohemianism often associated with the age of Romanticism. He was never in the employ

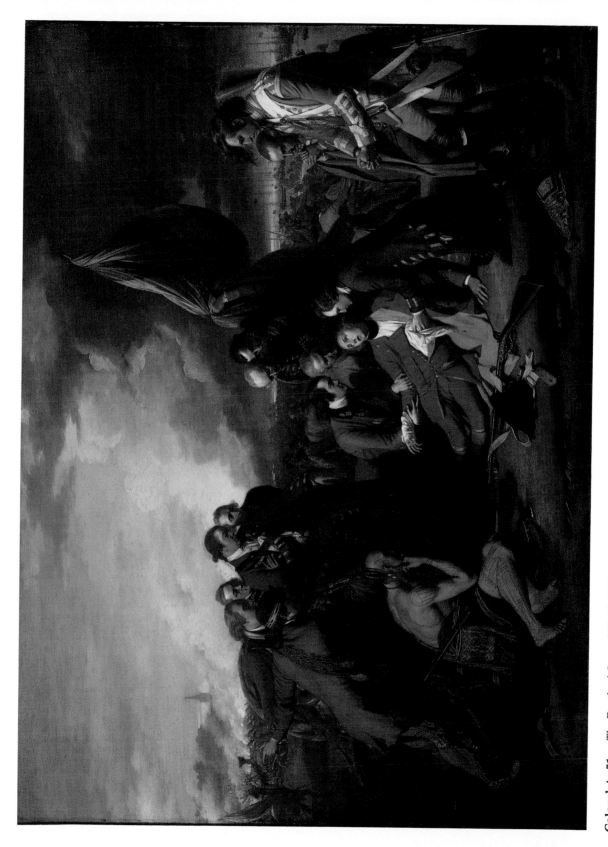

Colorplate 51 *The Death of General Wolfe* [1771]—Benjamin West. Oil on canvas, 60″ × 96″. (National Gallery of Canada, Ottawa. Transfer from the Canadian War Memorials, 1921. Gift of the 2nd Duke of Westminster, Eaton Hall, Cheshire, 1918)

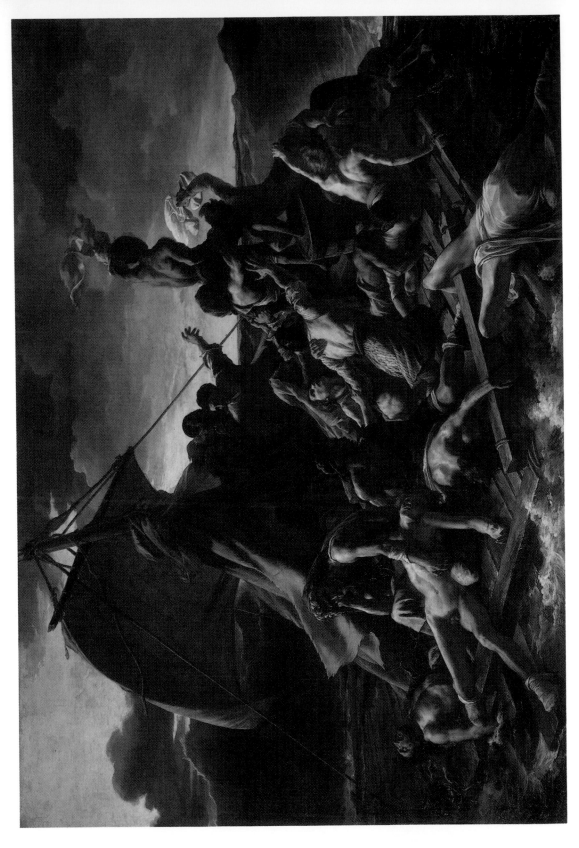

Colorplate 52 *Raft of the Medusa*—Géricault. 16′ × 23′6″. Louvre. (Giraudon/Art Resource, N.Y.)

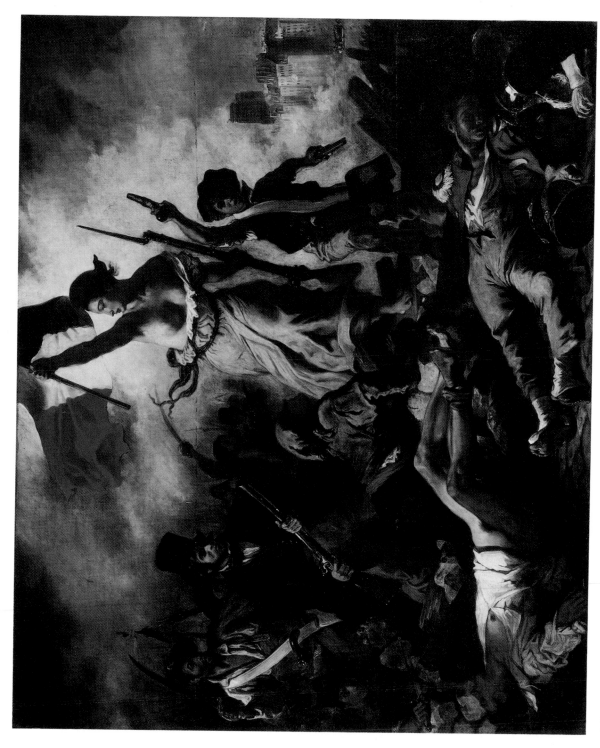

Colorplate 53 *Liberty Leading the People* [1831]—Delacroix. 8'6⅜" × 10'8". Louvre. (Giraudon/Art Resource, N.Y.)

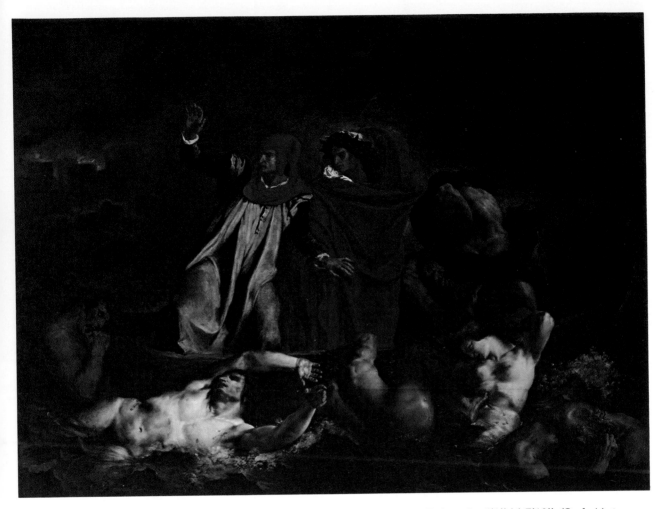

Colorplate 54 *Dante and Virgil in Hell* [1822]—Delacroix. 6′1″ × 7′10″. (Scala / Art Resource, N.Y.)

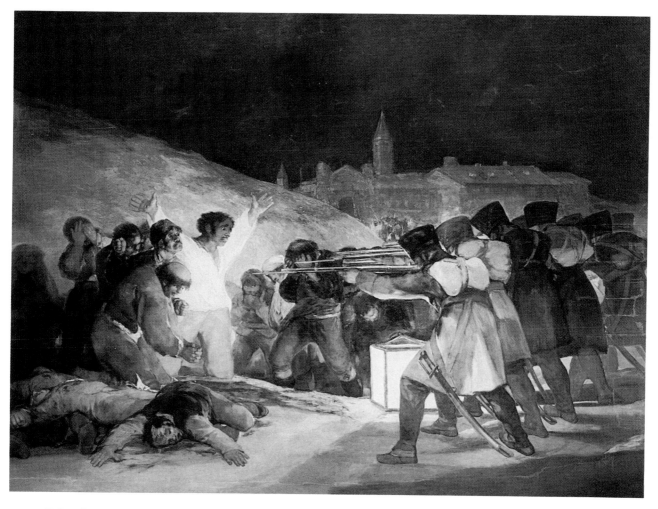

Colorplate 55 *May 3, 1808* [1808]—Goya. 8'8¾'' × 10'3⅞''. (Scala/Art Resource, N.Y.)

Colorplate 56 *Rain, Steam and Speed* [1844]—Turner. 36″ × 48″. (National Gallery of Art, London)

of any institution or aristocratic patron. Moreover, he did not even have the security of benevolent patronage that Beethoven enjoyed. He eked out a slim existence as a private teacher, sold a few compositions to publishers, and had a few commissions for works. His early death was unquestionably hastened by actual poverty. The greatest portion of his compositional output could be ascribed to art for art's sake. This is particularly true for his more than 600 **Lieder** or art songs. These were not written on commission; few of them found publication during his life, and most of them were largely unknown and unsung until years after his death. While his chamber, piano, and orchestral works are significant contributions to Romantic music literature, Schubert's art songs illustrate his most important contribution to the field of Romantic musical expression.

Two short works illustrate the manner in which Schubert treats this form. Individual solo songs were not the invention of the Romantic era, certainly not of Schubert. The great wealth of German lyric poetry, with its tendency toward the sentimental, however, stimulated the Romantic trend for combining music with extramusical ideas. This contributed to a great interest in art song settings through the entire nineteenth and even into the twentieth century. Similarly, the Romantic love for the intimate and small form encouraged this medium of composition. Two distinct forms of the art song were used by Schubert. The first, known as the strophic song, is illustrated by the composition *Heidenröslein*. In this form, the several strophes or stanzas of the poem are set to the same melodic line. Actually, Schubert's song, though entirely original with him, is so much in the folk tradition that it is often thought to be a German folk song. The poem by Goethe is simple and whimsically philosophical. Schubert matches its simplicity with a charming, straightforward melody and an accompaniment that, while written for the piano, might be realized on any chordal instrument such as the guitar or lute.

In contrast to *Heidenröslein*, Schubert's *Erlkönig*, (ex. 10.2) is a powerful, dramatic ballad on a poem by Goethe. In this ballad, Goethe relates the story of an anxious father riding through the night with his sick son in his arms. As the father journeys through the dark forest, the erlking, the specter of death, entreats the child to come to him. Upon arrival at their destination, the father discovers the child is dead. This poem, Schubert felt, called for something more than mere repetition of a suitable rhythmic melody for its eight stanzas. Schubert was concerned with a musical characterization of the four persons involved in this story, and the repetition of a melody in each verse would have defeated such a treatment. There are repetitions of melodic idea, but they accompany the reappearance of the respective characters of this miniature drama. Underlying the entire vocal setting is the piano part, which in a true art song such as this, is no longer a mere accompaniment but rather a vital part of the song's musical expression. In the *Erlkönig*, the piano part suggests, in both rhythm and melodic motive, a ceaseless and driving quality

Example 10.2: *Der Erlkönig*—Franz Schubert

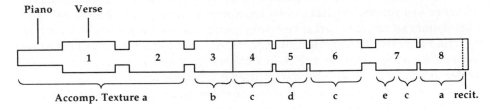

— Piano Introduction

Verse 1: Narrator sets the stage for the story.

(Four measure piano interlude)

Verse 2: Father questions the son's fears. Son sees the Erlking.

(Three measure piano interlude) .

Verse 3: Erlking invites the child to join him in play.

(No interlude)

Verse 4: The son hallucinates and the father comforts him.

(One measure piano interlude)

Verse 5: Erlking promises his daughters as nannies.

(One measure piano interlude)

Verse 6: Son becomes more hysterical and sees the Erlking's daughters. The father quietly reassures him.

(Four measure piano interlude)

Verse 7: Erlking declares his determination to have the child. The son screams, "My father! He has taken hold of me!"

(One measure piano interlude)

Verse 8: Narrator describes the father's arrival at home only to find that his son is dead.

that sets up a musical tension as the counterpart of the tension of the poetic idea. Each of the four characters—the narrator, the father, his son, and the erlking (the specter of death)—is delineated musically and represented by one singer. The whole song, however, has a remarkable unity. After a rather long piano introduction, the first stanza of the song is given by the narrator. The second stanza is carried by the father and his young son. Schubert pitched their respective parts at levels appropriate to each one. With a specific indication of quiet performance and a change of melody and accompaniment, the erlking appears in the third stanza as a wheedling enticer. With the further development of these characters, the song is rushed to its tragic end, a fine example of the combination of purely musical and extramusical ideas in Romantic composition.

In addition to his wealth of song literature, Schubert was also very active as a composer of piano and chamber music, as well as orchestral works. His eighth and ninth symphonies give him a permanent place in the history of symphonic literature. The eighth symphony, known as the *Unfinished*, is a work in only two movements that would normally be considered as the first and second movements of a typical symphony. Whether it was Schubert's intention to add two more movements or whether he considered the work complete remains forever a question. The continued inclusion of the *Unfinished* in the orchestral repertoire attests to the satisfaction it gives as a complete work. Both movements are rich in lyrical melodies. The *Symphony in C Major* (*The Great*), Schubert's last work in this form, is typically Romantic in its great length, its contrapuntal treatment, and its deep, expressive power. In it Schubert rivals Beethoven. The *C Major Symphony* is both a realization and a promise of Schubert's growing command of symphonic form, which his untimely death unfortunately left unfulfilled.

Fanny Mendelssohn-Hensel, Robert Schumann, Felix Mendelssohn, Frédéric Chopin, Clara Schumann

Fanny Mendelssohn-Hensel (1805–1847), Mendelssohn (1809–1847), Chopin (1810–1849), Robert Schumann (1810–1856), and Clara Schumann (1819–1896), are each representative in some individual way of the general Romantic trends of the nineteenth century. Like Beethoven and Schubert, they all represent a certain Classic restraint in an age of Romantic emphasis. Their respective lives are indicative of the new place musicians were forced to find for themselves in the society of the nineteenth century. Schumann became a conservatory director and musical journalist. Both occupations became possible in the nineteenth century, which saw the founding of the first state music schools or conservatories in the face of the withdrawal of the Church and the aristocracy as musical patrons. Mendelssohn, privately wealthy, founded one of the first public orchestral societies and served as its director. Chopin made his living through widespread concertizing in which his own works were featured.

Schumann's Romanticism can be heard in his piano works. In these he employs small forms as vehicles for poetic moods usually suggested in their titles. *Carnaval,* is a series of such short works connected by extramusical ideas. It is a musical representation of a pre-Lenten carnival ball. Most of the twenty-two short pieces are in dance rhythms, particularly the waltz. The individual names of the pieces suggest Schumann's desire to give musical characterization to certain individuals, real and fictitious. Besides this descriptive element, Schumann set himself the task of using the notes A, E-flat, C, and B, which in German represent the letters ASCH, the name of a town where an early sweetheart lived. They also represented four letters of his own name, which could be musically stated. Practically every one of these short pieces is based on the use of these four notes, constructed in one order or another. Most of them are in some version of the three-part song form or simple rondo form. Harmonies are enriched with chromatically altered tones to lend color through dissonance. There is no actual program to give specific meaning to the individual numbers other than the oftentimes ambiguous titles. The parts most stimulating to the imagination are those most dancelike, in which the listener may project the movement of appropriate dance figures into the musical work. *Pierrot* and *Arlequin* are examples. While in general *Carnaval* represents nineteenth-century tonal painting at the piano, there is an obvious concession to formal considerations characteristic of all Schumann's compositions.

Though Schumann's piano works are usually considered his most Romantic expression, he also made an impressive contribution to the literature of the German Lied. One of the best known is the song cycle *Dichterliebe (Poet's Love).* In sixteen songs, each on a text by the Romantic poet Heine, Schumann treated the various emotions of love, from humor, intimacy, and irony to unrequited love and pathos. Each poem deals with one aspect of love, and most of them are through-composed. A notable characteristic of Lieder is their use of the piano in strongly supportive accompaniments. Schumann captured the mood of the text through imaginative writing for the piano as an equal partner with the voice.

Mendelssohn was almost more interested in conserving the Classical tradition than Schumann. The bulk of his great works—the symphonies, the piano and violin concertos, the oratorios—show a deep regard for Classic form. However, Romanticism is particularly apparent in one specific musical mood, the fanciful fairylike nature of his scherzo movements. In fact, this particular stylistic invention of Mendelssohn is the distinguishing feature of many of his compositions, even where the term *scherzo* is not used.

Mendelssohn was only seventeen when he composed the atmospheric *Scherzo* from *A Midsummer Night's Dream.* Written to be used with the performance of the Shakespeare play, it has become one of the great orchestral virtuoso pieces of symphonic literature. With Mendelssohn, the scherzo was no longer a piece of boisterous humor, such as Beethoven wrote, but a dancelike

bit of imagery, in which the actual tones dance as if they were indeed the imaginative sprites of fairyland. The short movement is based on the alternation of two closely related themes, both of which are developed briefly and restated. This work represents another facet of nineteenth-century musical Romanticism, the invoking of literary fantasy through musical technique and invention.

Two remarkable women composers also emerged in the first half of the nineteenth century. One was the sister and the other the wife of the now famous composers we have just discussed. Both were virtuoso pianists. Fanny Mendelssohn-Hensel (1805–1847) was as gifted as her brother Felix, and she composed in a style indistinguishable from his. When his songs of op. 8 and op. 9 were published, six of her songs were included but not identified as hers. Recent scholarship attributes approximately 500 compositions to Mendelssohn-Hensel, but many of her works remain unpublished.

Clara Wieck Schumann (1819–1896) was one of the most highly regarded virtuoso pianists of her time. Liszt and Chopin were admirers of her pianistic talents. Among her many works are songs, preludes and fugues, a piano concerto, and some chamber music, as well as **cadenzas** for some of the concertos of Beethoven and Mozart.

Chopin was the poet of musical fantasy. With the exception of some songs rarely heard today and the orchestral parts of his concertos, Chopin composed exclusively for the piano. The fact that a composer of such enormous talent could find realization for that talent through a single instrument is evidence of how greatly the piano had expanded its expressive possibilities. This was not accomplished merely by mechanical perfection but by newer concepts of pianistic composition and performance. Composers for piano, who were almost always concert performers, exploited the new technical advances; by the middle of the nineteenth century, they had so thoroughly developed the varied possibilities of the instrument that a man, such as Chopin, could find complete expression through it. For Chopin, the piano was capable of expressing all varieties of musical moods and feelings. His more typical writing style, however, exploited the tender, singing quality of the instrument through compositions that shrouded the melodic line in patterns of harmonic fantasy. Typically his works were short, and often carried titles that suggested a mood. They were of rather intimate character, meant for performance in the salons of the nineteenth-century aristocracy and literati rather than for the large public concert hall. Such compositions were the nocturnes, scherzos, preludes, etudes, and many dance forms, such as the polonaise, mazurka, and waltz, which were elevated from their folk background to a refined level of sophistication. Besides Chopin's great importance in the exploitation of the piano, his use of harmony is noteworthy. His small works illustrate the use of harmonic tension and release so readily translated into poetic feeling.

Example 10.3: *Prelude in A Minor, no. 2*—Chopin

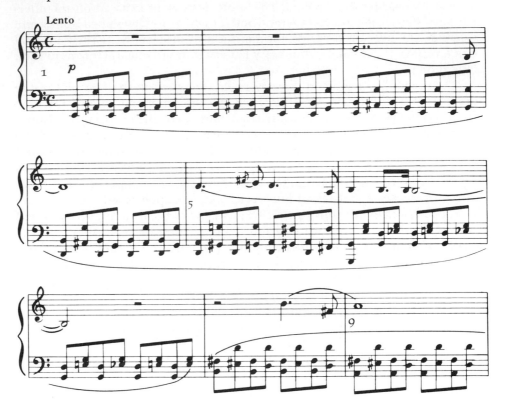

The *Prelude no. 2 in A Minor* (ex. 10.3) is a rather extreme example of the dissonant idiom of Chopin's Romanticism. In this brief work, a short melodic idea is repeated four times. The harmonic structure is of central importance because of its tonal indecision. Not until the next to the last measure does the composer establish the tonality of this work. The final harmonic resolution, though late, is still satisfactory. Chopin contrived so well harmonically that one is led to expect this ending. Its long delay, however, adds tension to the work. The composition also illustrates a technique of harmonic illusion that came to be employed more and more by Romantic composers. The technique depends particularly on the use of chromatic pitches, actually dissonances, which heretofore had required careful preparation and resolution. Chopin, however, not only introduced such dissonances without preparation but followed one dissonance with another without resolution. This was a use of notes quite outside the idiom of normal harmonic function. Without question, the dissonances were used to add confusion to orderly, traditional harmonic

thinking, to heighten the tension created by the mere suggestion of a harmonic plan, and to make the eventual announcement of the key in the last two measures of special emotional significance by its effect of musical release and repose. Harmonic suspense, accentuated by rhythmic and dynamic effects, became one of the principal methods employed by Romantic realists and nationalists of the nineteenth century.

The juxtaposition of two rhythmic patterns can be used to create tension as in Chopin's *Valse in A-flat*, op. 42. After a few introductory bars, while the triple meter of the waltz is maintained regularly in the left hand, the right hand plays a melody that divides the measure into two even beats. At the same time, an inner part made up of a constant pattern of six notes to the measure is being maintained by the right hand. This ingenious rhythmic pattern results in the two strong patterns of three and two being opposed to one another, while a pattern of six (divisible by either three or two) acts as a sort of mediator between the two basic rhythms. Rhythmic tension such as this was employed by many other Romanticists, particularly Brahms.

Brahms, Verdi, Mahler, Puccini

It should not be assumed that only the rather radical trends of Romanticism—i.e. Realism, Nationalism, and Impressionism, which are taken up in subsequent chapters—characterized the second half of the nineteenth century. A large number of composers continued the fusion of traditional forms and the Romantic usages of the composers of the first half of the century. Such creative spirits as Brahms (1833–1897), Mahler (1860–1911), Verdi (1813–1901), and Puccini (1858–1924) are still among the most widely performed in the concert halls and opera houses of the twentieth century.

They represent a large group of composers who neither broke with tradition nor repudiated the Romantic practices of the nineteenth century. In general, they expanded the traditional forms and called for added volume, especially in the enlarged orchestra; they adapted the harmonic and expressive traits of their own time and made use of the Romantic characteristics expressed in literature and art when using texts for their works.

Brahms was perhaps the most given to employing the Classic forms in his instrumental works. His four symphonies are among the greatest works in the orchestral repertoire and follow the tradition of the Classic form developed by Haydn and Mozart and expanded by Beethoven. His *Symphony no. 4*, for example, is characterized by rich harmonic structure, the use of motival repetition in all the movements, (as introduced by Beethoven in his Fifth Symphony), the introduction of folklike melodic themes, and the frequent use of old forms and devices, such as fugal passages and the passacaglia.

Mahler, known chiefly for his symphonies, took his cue from Beethoven's *Symphony no. 9* in his great love for combining choral and solo voices with symphonic form. With Mahler, the symphony often became a symphonic cantata. The selection of Romantic literature and the frequent employment of folk tunes and poems indicate his devotion to Romantic ideals. The formal structure of his symphonies reflects his respect for tradition and for Beethoven. Mahler's *Symphony no. 4* features (1) folk themes, (2) the solo voice, (3) the inclusion of Romantic texts taken from the collection of poems known as *Das Knaben Wunderhorn (The Children's Horn of Wonder)*, (4) the expansion of the individual movements of the symphony to enormous lengths, and (5) an obsession with death in the selection of literary as well as musical material (e.g., funeral march in the second movement).

In opera, Verdi shared the center of the stage with Wagner (whose works are dealt with in chapter 11 under Romantic Realism). Verdi remained faithful to the tradition of the Italian opera in which the solo voice was the dominating vehicle. However, Verdi established a number of Romantic trends within the tradition itself. His last operas, *Aida, Otello,* and *Falstaff,* represent his ultimate achievement. *Otello* and *Falstaff* are the epitome of tragedy and comedy on the operatic stage; while both retain the vocal character of Italian opera, the orchestra has now become a vital part of the work. It is no longer a mere accompaniment. The individual characters of the opera still sing closed arias, but these are less differentiated than previously. Recitative passages as understood in the eighteenth century have disappeared. There are fewer set arias that can be lifted from the works as independent songs. Each **libretto** was chosen by Verdi from a drama of great literary significance. While he did not use the Wagnerian device of **Leitmotif** (see chapter 11), he did make use of thematic material to relate certain dramatic events by means of music. The melodic theme in the love duet of Act One of *Otello* is recalled in the death scene at the end of the opera, thereby providing both a psychological as well as musical formal link between the two scenes.

Puccini was the foremost Italian opera composer at the close of the nineteenth century. His style was labeled *verismo* (realism), in reference to his choice of realistic stories and melodramatic musical settings. Whether tragic or comic, they were dramas not about heroic figures of history but rather about persons, generally everyday character types. *La Bohème,* a story of the life struggles of young artists in the Latin quarter of Paris and the tragic love story of one of them, represents the verismo style in Puccini's works. Puccini retained the traditional predominant role of the singers with some set arias. The continuous musical line, however, generally does not differentiate recitative from aria; the very colorful orchestration and the use of a chorus accentuates the role of these two facets of opera writing, which had been relegated to minor roles in the Classical Italian operas of the eighteenth century.

Any discussion of nineteenth-century opera would be flawed if it excluded Bizet's *Carmen,* and Gounod's *Faust.* The former is perhaps the most popular opera ever written, and the latter is based on Goethe's famous *Faust* legend.

Summary

The revolutions of the late eighteenth to the mid-nineteenth centuries caused a great upheaval in the political and economic systems of Europe. The urge for freedom of all kinds, which had started in the eighteenth century, finally had a profound effect on all activities of society. New movements in politics, religion, philosophy, social life, and the arts arose in a revolt against the past.

Romanticism in the arts was also a revolt against the past. It was anti-Classic, repudiating symmetry, simplicity, and emotional restraint. Romantic artists strove for emotion rather than rationalism, for individualism rather than conformity. There was no typical Romantic style in any of the arts, for each creative artist had a personal way of expressing Romantic ideas and feelings.

The patronage of Romantic art had also changed. The courts of the nobility and the wealthy merchant class were no longer the sole patrons. For the first time, the general public became the consumers of the arts. Creative artists sought to interest the common people in their works through literature, exhibitions, and concerts.

The philosophy of Romanticism encouraged new sources of subjects for the arts. Subjects and experiences that were previously considered in bad taste were acceptable. Violent and shocking scenes provided the opportunity for representing strong emotions. There was also a renewed interest in nature. The atypical experience fascinated artists because of its mystery and supernaturalism. The arts were often mixed, with painting and sculptural illustrations of literary and poetic ideas. Even pure instrumental music attempted to recreate a story or a scene in terms of melody, rhythm, tone color, and harmony. Whatever the subject, the aim was to make the spectator or listener feel the whole range of emotional sensations by whatever means the artist could muster.

Romantic painters often turned to the Dutch and Flemish art of Rembrandt and Rubens as their inspiration for the use of color, light, and shade in depicting emotion. Subjects often had a moral message or were propaganda for a political or social issue. Violent scenes of carnage captured the imagination of both artists and the public, especially if they were related to an actual event that had taken place. Some artists turned their attention to scenes of nature in all its varied moods. In any event, whatever the subject, there was usually asymmetrical balance, lost edges of line, and a variety of hues and intensities of one or two basic colors. Diagonal movement gave depth and recession, which expanded space well beyond the center of the canvas.

Music is the most Romantic of all the arts because it is the most abstract and least dependent upon objective facts or scenes, which often are meaningful only to those who have experienced their history. Like Romantic visual art, Romantic music was a revolt against Classic melody, harmony, formal balance, and restraint of expression. As in the visual arts, the evocation of emotion was its principal aim. Romantic music was based on the premise that a feeling of musical tension is necessary to achieve an intensification of emotional response. As a consequence, Romantic music reveals a rich harmonic texture, with chromaticism and dissonance to suggest tension. Melody is not stylized and is sometimes fragmentary or extremely long. It is often intensified by a particular tone color that supports its character and mood.

While formal organization of some Romantic music was based on the Classic principle of sonata-allegro form, the sections were often enlarged by detailed developments of motives and harmonic sequences. Many short, ambiguous forms also emerged in solo instrumental and vocal literature.

The most popular media for Romantic music were the orchestra, the piano, and the human voice. Most composers wrote for all three, which suggests a wide variety of musical expression. A great body of musical literature currently in the concert and opera repertory comes to us from Romantic composers such as Beethoven, Schubert, Schumann, Mendelssohn, Chopin, Verdi, and Brahms.

Suggested Readings

In addition to the specific sources that follow, the general readings listed on pages xxi and xxii contain valuable information about the topic of this chapter.

Clark, Kenneth. *The Romantic Rebellion: Romantic vs. Classic Art.* New York: Harper & Row, 1973.

Dalhaus, Carl. *Nineteenth-Century Music.* Berkeley: University of California Press, 1989.

Einstein, Alfred. *Music in the Romantic Era.* New York: W. W. Norton, 1947.

Gossett, Philip, et al. *The New Grove Masters of the Italian Opera.* New York: W. W. Norton, 1986.

Hamilton, George H. *19th and 20th Century Art.* Englewood Cliffs, N.J.: Prentice-Hall, n.d.

Licht, Fred. *Goya, The Origins of the Modern Temper in Art.* New York: Harper & Row, 1983.

Longyear, Rey M. *Nineteenth-Century Romanticism in Music.* 2d ed. Englewood Cliffs, N.J.: Prentice-Hall, 1973.

Newton, Eric. *The Romantic Rebellion.* New York: Schocken Books, 1962.

Rosenblum, Robert, and Jansen, H. W. *Nineteenth Century Art.* New York: Abrams, 1984.

Vaughan, William. *Romantic Art.* New York: Thames and Hudson, 1978.

11

NINETEENTH-CENTURY REALISM AND NATIONALISM
(1840–1900)

For a chronology of Nineteenth-Century Realism and Nationalism, refer to pages 248–249.

Pronunciation Guide

Berlioz (Bayr-lee-ohz)
Courbet, Gustave (Koor-bay, Gustahv)
Daumier, Honoré (Dohm-yay, Hohnor-ay)
Dies Irae (Dee'-ays Ee'-rih)
Eulenspiegel (Oy-len-shpee'-gel)
Glinka (Gleen'-kah)
Grieg (Greeg)
Godunov, Boris (Goh'-doo-nuf, Boh'-ris)
Idée fixe (Ee-day feex)
Lamartine (Lah-mahr-teen)

Liszt (List)
Moldau (Mohl'-dow)
Mussorgsky (Moo-sohrg'-skee)
Pater (Pay'-ter)
Préludes, Les (Preh-lüd, Leh)
Pushkin (Poosh'-keen)
Rimsky-Korsakov (Rim'-skee Kor'-sah-koff)
Smetana, Bedřich (Sme'-tah-nah, Bedr'-zheekh)
Tchaikovsky (Chai-kof'-skee)
Vltava (Vul'-tah-vah)
Wagner (Vahg'-ner)

Study Objectives

1. To study program music as a means of suggesting Realism.
2. To learn how the photographic image influenced the visual arts as a means of portraying social realism and natural scenes.
3. To study Nationalism as a type of Romantic program music applied to ethnic groups.
4. To learn about the conscious effort to incorporate folk melody and folklore into musical composition.

Romanticism had focused attention on feeling and sentimentality in the arts. Artists, both visual and musical, were viewing the world through a misty atmosphere of sentiment and fantasy. As the century progressed, there emerged those who, while still Romantic, were beginning to be concerned with actualities. There was a growing consciousness of the facts and problems of a world of reality, not fantasy. These artists began to express their feelings about the real world in art.

The Industrial Revolution created a great many social and economic problems, and its impact upon society was both good and bad. The poverty of industrial workers gave increased recognition to social theory and made people more conscious of social problems. The concentration of population in urban centers also drew attention to problems of human relationships. The problems of the mid-nineteenth century were the problems of the masses, and the artists of Realism made them their problems.

Realism was not anti-Romantic. On the contrary, it was an integral part of the Romantic ideal but applied to more objective subjects. Artists sought to be more "photographic," to view things with a closeness denied them by Classicism. Feeling was still a primary consideration, but it was feeling about a specific problem or event that touched the lives of real people. Because of the prevalence of sentiment, form was still of secondary importance, and the feeling about the subject was the motivating force of art.

Visual Realism

Visual Realism is perhaps the easiest to grasp because it dealt with the burning issues of social injustice, poverty, labor, and morals. In laying bare the facts of these issues in simple, realistic forms, it could intensify public sentiment regarding them. Visual art also could deal in a realistic manner with other subjects, such as simple acts of everyday living, portraits, or scenes from nature.

Realism is not an epoch of art in the manner of the Gothic or the Baroque. It was a style within a style, for it continued the basic tenets of Romanticism.

Its aim was the same, and its patronage was essentially the same. Because of their realistic devices, painting and sculpture were less vague and sentimental. In this movement toward Realism, music was more firmly knit together by means of extramusical connotations. Visual arts were more prone to distinct lines and more visual objectivity.

Courbet

Gustave Courbet (1819–1877) was one of the first painters to use the term Realism in connection with his art. He chose subjects from nature and from simple acts of ordinary people. As a Romanticist, he was a supreme egoist, taking great care that he as well as his works should have the greatest possible publicity. He was well aware of his own talent and did not hesitate to proclaim his Realism. He is said to have told a friend, "Show me an angel, and I'll paint one." One of his famous pieces of Realism is the *Burial at Ornans* (colorplate 58). There is nothing literary or spectacular about this work. It is a simple, straightforward account of a common social act, the burial of the dead, and its function is to portray this act. It communicates nobility and unashamed humility. The lines of the faces are clearly drawn to emphasize the sentiment of the moment. Its formal organization is multiple, but the faces are quite separate. The blue sky and the gray and violet coloring of the figures produce a monochromatic effect that is broken by patches of red. Space is controlled by the vertical arrangement of the mourners positioned around the grave. The painting is a realistic portrait of those who mourn a departed member of their group. Its sentiment is Romantic, but the feeling is aroused through Realism.

Colorplate 58 follows p. 280.

Daumier

Honoré Daumier (1818–1879) was one of those Realists who emphasized the social and economic inequality that resulted from the Industrial Revolution. His *Third Class Carriage* (colorplate 59) is not a pretty picture. It depicts the weariness, the poverty, and the futility of the working class. Crowded into the dark carriage are people with tired, bitter, and insolent faces. They are poor, but they are also imitators of the elite, with their tall hats as symbols of respectability. The drabness of the garments and the almost empty countenances seem to express a life of toil and hardship. The lines denoting form are vague, but short, curved lines are used to emphasize the facial and physical features of weariness. Monochromatic browns fill the atmosphere with a drabness not unlike that of its occupants. Most of Daumier's works show the lower class, people both hardworking and miserable. His representation of them going through their weary days is a protest against the social and economic conditions of their time.

Colorplate 59 follows p. 280.

Eakins

Colorplate 60
follows p. 280.

Thomas Eakins (1844–1916) was an American painter whose realism bordered on the photographic. *Max Schmitt in a Single Scull* (colorplate 60) suggests the detailed clarity of a deep, sharp-focus lens. Eakins shows minute detail, from the foreground to the distant horizon. The subject, Max Schmitt, is turning toward us as if he were posing for a camera portrait.

Colorplate 61
follows p. 280.

An instructive comparison can be made between Eakin's *The Agnew Clinic* (colorplate 61), a Realist painting completed in 1889, and Rembrandt's *Dr. Tulp's Anatomy Lesson* (colorplate 34). In the earlier work Rembrandt used the event as an opportunity to create a group portrait. The dissected arm of the cadaver is but of minor importance to the painting. The viewer's eyes are much more forcefully drawn to the faces of the individual participants and their personalities. In Eakin's painting the focus is on the drama of the instruction. In the foreground the isolated figure of Dr. Agnew provides psychological balance for the surgical team on the right. The attentive students, while rendered with considerable detail, only constitute a patterned background.

Thompson

Colorplate 62
follows p. 280.

Elizabeth Thompson (1850–1933), like many English women of the nineteenth century, traveled widely throughout the British Empire. She spent time in India with her husband Sir Francis Butler (hence her formal title, Lady Butler). Her paintings chronicle the military exploits of the British Empire with an uncanny realism and an eye for detail that served to document many aspects of military life at that time. In *The Remnants of an Army* (colorplate 62), the subjects are a war-weary horse and rider. Their depiction in an expansive and arid landscape lends poignancy to the work. The realism is not only physical but also psychological, evoking a response in the viewer appropriate to the desolate scene. The Romantic spirit is indicated by the idealized mountains in the distance and by her capture of such a moment on the canvas.

Winslow Homer

Colorplate 63
follows p. 280.

Like Eakins, Winslow Homer (1836–1910) was an American Romantic Realist. The subjects for his paintings range from scenes from ordinary life (genre painting) to dramatic scenes such as *The Gulf Stream* (colorplate 63). In this realistic painting Homer unites two of his frequently employed subjects; man against the sea, and black people. Through the use of a high horizon the magnitude of the ocean overwhelms the disabled boat and its solitary passenger. Two diagonals of dark blue water strengthen the sense of turbulence in the ocean and reiterate the shape of the boat. Homer's approach to the topic of man against the sea differs in some remarkable ways from that of Géricault (colorplate 52).

Musical Realism

As cited earlier in this chapter, Realism in music lay in the rise of program music, music with a specific, extramusical idea that was generally literary in nature but could be represented by plastic form as well. Music, as an abstract art, found it more difficult to tell a story in tone or to suggest a story or a poetic idea. Various realistic musical devices were used: the most common were motives, melodies, or harmonic sequences identified with ideas or objects. The composer could then tell or suggest a story realistically by the use of these symbols and could reach the sensibilities of the audience through both the music and the literary suggestion. A number of factors tended to make program music the criterion by which all music of the Romantic nineteenth century was judged. The most suitable medium for program music was the orchestra, with its very colorful tonal palette. The rise of the orchestra as a concert organization was an important phenomenon of the nineteenth century, as important as the opera. Listeners were impressed by the seeming ability of composers to portray specific ideas by means of the orchestra. Since the harmonic, melodic, and rhythmic devices used by the Realists to effect their aims were essentially those of the Romantic period in general, listeners came to expect all nineteenth-century music to have a specific meaning. They even read into the works of Beethoven and Brahms the same kind of programs that Berlioz and Wagner consciously tried to express in their compositions. Even simple nonorchestral works, such as the nocturnes and preludes of Chopin, were given realistic titles by listeners.

Berlioz

Hector Berlioz (1803–1869) was one of the significant composers whose works illustrate the techniques of program music. He and his great contemporary Richard Wagner (1813–1883) were men of distinct literary abilities. As a music critic, Berlioz wrote a great deal for the Parisian newspapers. His *Evenings in the Orchestra* is a collection of important essays expressing his own philosophy of music as well as the current musical ideas of the nineteenth century.

Berlioz's *Symphonie fantastique (Fantastic Symphony)* was avowedly written to create a musical representation of a literary idea. The following is the translation of Berlioz's statement published with the musical score of the work:

Program of the Symphony

A young musician of unhealthy sensitive nature endowed with vivid imagination has poisoned himself with opium in a paroxysm of lovesick despair. The narcotic dose he had taken was too weak to cause death, but it has thrown him into a long sleep accompanied by the most extraordinary visions. In this condition his sensations, his feelings, and his memories find utterance in his sick brain in the form of musical imagery. Even the Beloved One takes the form of a melody in his mind, like a fixed idea which is ever returning and which he hears everywhere.

First Movement—[Dreams, Passions]
At first he thinks of the uneasy and nervous condition of his mind, of somber longings, of depression and joyous elation without any recognizable cause, which he experienced before the Beloved One had appeared to him. Then he remembers the ardent love with which she suddenly inspired him; he thinks of his almost insane anxiety of mind, of his raging jealousy, of his reawakening love, of his religious consolation.

Second Movement—[A Ball]
In a ballroom, amidst the confusion of a brilliant festival, he finds the Beloved One again.

Third Movement—[Scene in the Meadows]
It is a summer evening. He is in the country musing when he hears two shepherd lads who play, in alternation, the *Ranz des vaches* (the tune used by Swiss shepherds to call their flocks). This pastoral duet, the quiet scene, the soft whisperings of the trees stirred by the zephyr wind, some prospects of hope recently made known to him—all these sensations unite to impart a long unknown repose to his heart and to lend a smiling color to his imagination. And then She appears once more. His heart stops beating; painful forebodings fill his soul. "Should she prove false to him!" One of the shepherds resumes the melody, but the other answers him no more . . . sunset . . . distant rolling of thunder . . . loneliness . . . silence.

Fourth Movement—[March to the Scaffold]
He dreams that he murdered his Beloved, that he has been condemned to death and is being led to execution. A march that is alternately somber and wild, brilliant and solemn, accompanied without modulation by measured steps. At last the fixed idea returns—for a moment a last thought of love is revived, which is cut short by the death blow of the axe.

Fifth Movement—[Dream of a Witches' Sabbath]
He dreams that he is present at a witches' revel, surrounded by horrible spirits, amidst sorcerers and monsters in many fearful forms who have come together for his funeral. Strange sounds, groans, shrill laughter, distant yells, which other cries seem to answer. The Beloved melody is here again, but it has lost its shy and noble character; it has become vulgar, trivial, a grotesque dance tune. It is she who comes to attend the witches' meeting. Riotous howls and shouts greet her arrival . . . she joins the infernal orgy . . . bells toll for the dead . . . a burlesque parody of the *Dies Irae* . . . the witches' round dance . . . the dance and the *Dies Irae* are heard together.

We need not go beyond this detailed program of Berlioz except to point out some of the ways that these details find their musical counterparts. The opening of the first movement, entitled *Dreams, Passions*, obviously tries to portray the ephemeral quality of dreaminess through the vague manner in which the thematic material is presented. Actually, the principal theme, Berlioz's *idée fixe*, is not presented in its complete form until about four minutes of the first movement have passed, although the composer kept hinting at it with fragmentary motives derived from the theme itself. The opening two

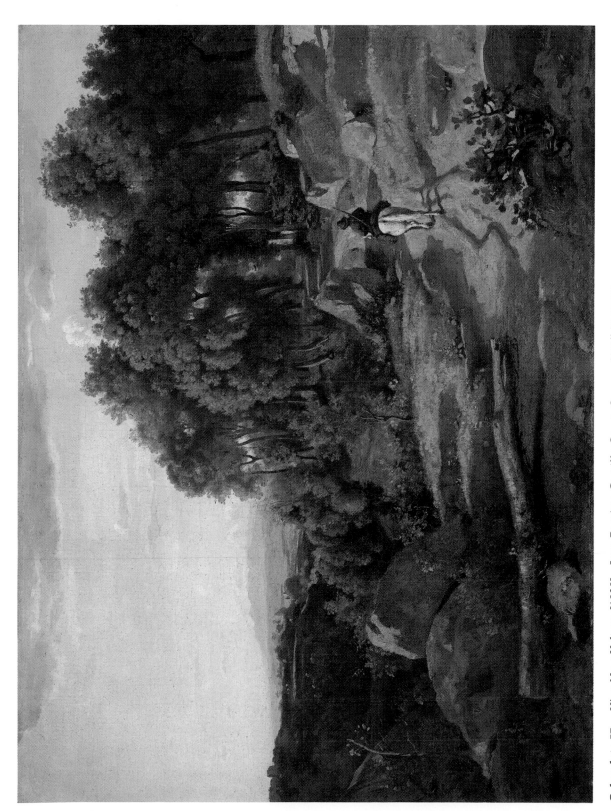

Colorplate 57 *View Near Volterra* [1838]—Jean Baptiste Camille Corot. Canvas, 27⅜″ × 37½″. (National Gallery of Art, Washington, D.C., Chester Dale Collection)

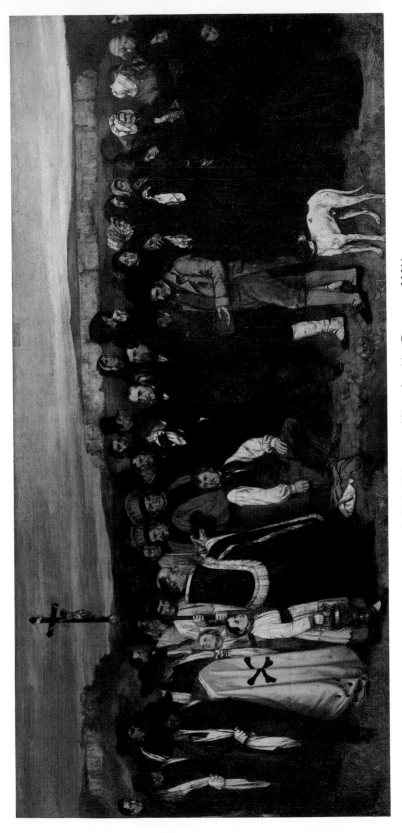

Colorplate 58 *Burial at Ornans* [1849]—Courbet. 10'3" × 20'. Louvre. (Giraudon/Art Resource, N.Y.)

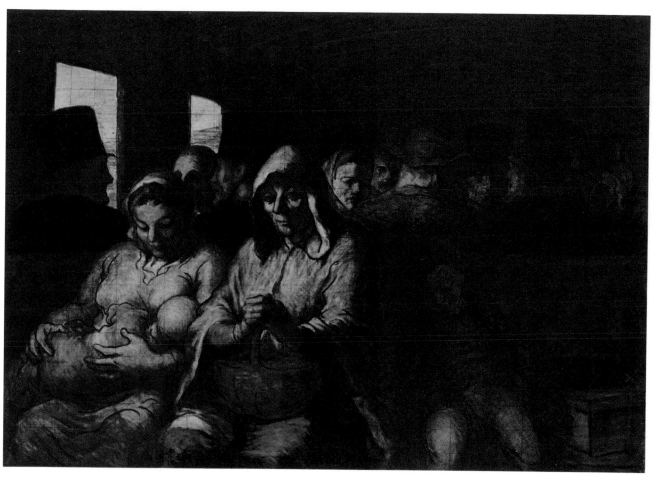

Colorplate 59 *The Third Class Carriage* [c. 1862]—Daumier. Oil on canvas,
25¾″ × 35½″. (The Metropolitan Museum of Art. Bequest of Mrs. H. O. Havemeyer
[1929] The H. O. Havemeyer Collection)

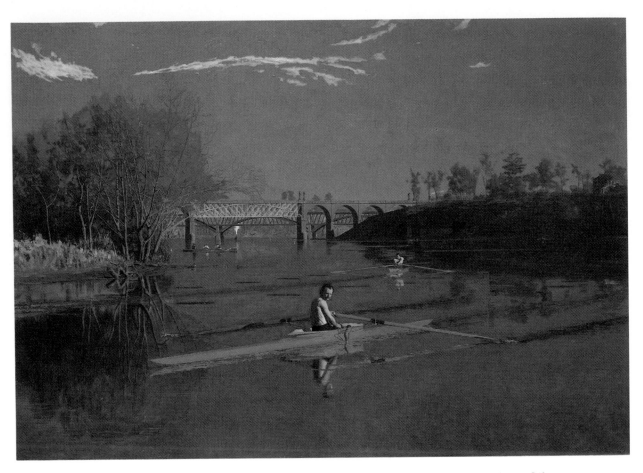

Colorplate 60 *Max Schmitt in a Single Scull* [1871]—Thomas Eakins. Oil on canvas, 32¼″ × 46¼″. (The Metropolitan Museum of Art, New York. Purchase 1934, Alfred N. Punnett Fund and Gift of George D. Pratt)

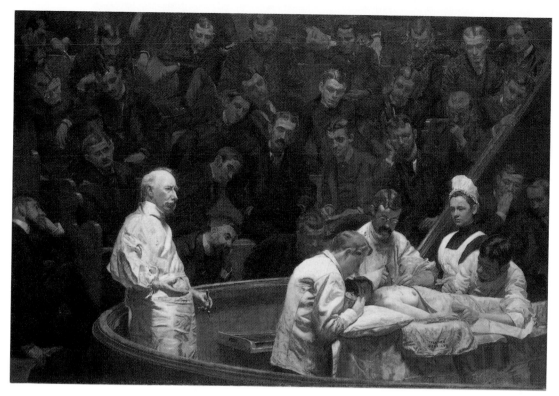

Colorplate 61 *The Agnew Clinic* [1889]—Thomas Eakins. 74″ × 130″. (University of Pennsylvania School of Medicine)

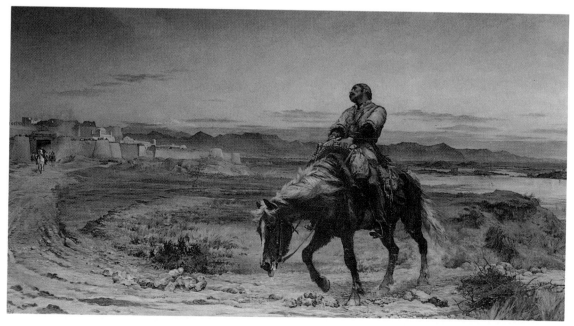

Colorplate 62 *The Remnants of an Army*—Elizabeth Thompson (Lady Butler). Oil on canvas, 52″ × 92″. (The Tate Gallery, London)

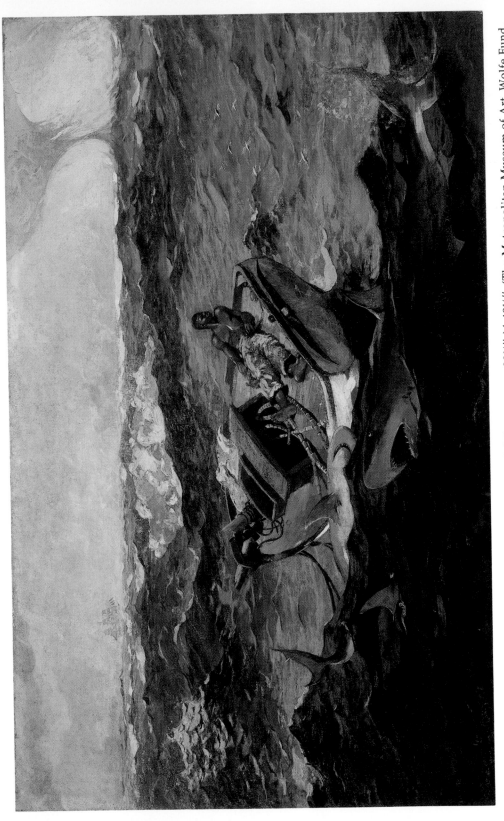

Colorplate 63 *The Gulf Stream* [1906]—Winslow Homer. [1899] Oil on canvas, 28⅛″ × 49⅛″. (The Metropolitan Museum of Art, Wolfe Fund, 1906. Catherine Lorillard Wolfe Collection (06.1234))

measures constitute a cadence in the key of C minor, such as one would expect at the close of a composition. Berlioz apparently hoped to evoke the vague feelings one has in remembering a dream—something has gone before, but the ending is all that can be recalled. So it is here—a cadence implies something preceding it, but here we have only the cadence, and it opens a work rather than closes it. The musical mind must interpret this as a peculiarly vague musical reference to something nonexistent. When this musical vagueness is coupled with an explicit literary program, or even to the title *Dreams, Passions,* the listeners are persuaded that the music has realistically portrayed an actual event or mental state. Strictly speaking, the composer merely made use of a simple and usual cadential device in a very unusual place. Besides, he scored it for instruments with a certain hollow tone quality, particularly when they are played with extreme softness. All of this heightens the connection between musical effect and literary allusion, and Berlioz, in a measure, succeeded in persuading listeners of the realism of his work.

This first section in the minor key acts as an introduction and leads to the major key of C, which presents the main theme not only of this movement but of the entire symphony. Again, Berlioz attached a definite, extramusical meaning to this theme by means of his program. While the first movement itself has the general outline of the sonata-allegro form traditional with symphonic first movements, Berlioz felt no compulsion to restrict himself to formal devices. The principal theme, the *idée fixe* (ex. 11.1), serves as the source of musical material for the whole movement. Its presentation in various episodic passages is the musical counterpart of the literary program Berlioz used to justify his treatment of it. There is no difficulty in following Berlioz's program in the music. Its success, however, rests upon an exclusively musical treatment of thematic material. Berlioz's success is achieved not only by the realistic combination of musical and extramusical ideas but also by the masterly use of harmony, rhythm, dynamics, and instrumentation in the development of themes and motives.

Example 11.1: *Symphonie fantastique, Dreams and Passions* (First Movement)— Berlioz

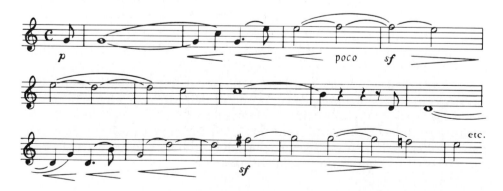

When one listens to the music quite apart from its program, the unity achieved through the use of a central theme is clear. Likewise, listeners will be struck with Berlioz's inventive genius exploiting this single theme by various musical devices. Form is not discarded; it is, however, made subservient to the composer's expressive desires. Whether these desires are dictated by purely musical or extramusical ideas is difficult, if not impossible, to say. It was also probably difficult for the composer to determine. Perhaps the broad general concept of the program acted as a point of departure for the composer. Its realization through music was possible only if the composer first acceded to principles of musical composition. The details of the program had to be fitted to the musical result. The reverse procedure could only have produced a sound track that had little or no artistic value as a work of art. A good example of the latter procedure is the writing of music for motion pictures. After more than fifty years of such endeavor by some of our best composers, there are few substantial pieces of music that have come from association with motion pictures.

In the second movement of Berlioz's work, the *idée fixe* (ex. 11.2) is a rather slight reminder of the connection, both musical and programmatic, of the several movements. The choice of a waltz rhythm is an obvious one, as Berlioz's program notes indicated. The opening makes use of vague harmonic progressions of a chromatic character that are finally resolved to the key of A major, in which the waltz is cast. The first part of the dance has its own theme closely allied to the *idée fixe*. The fixed idea itself is soon introduced to form a contrasting middle section. The first part returns, this time almost in a frenzied manner. A coda, in which the fixed idea is once more recalled in dramatic fashion, brings the movement to a fiery and impetuous close.

Example 11.2: *Symphonie fantastique, A Ball* (Second Movement)—Berlioz

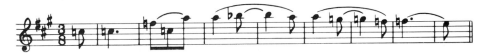

In the third movement, Berlioz is concerned almost exclusively with instrumental tone color, and thematic idea is of secondary importance. Three sections particularly illustrate this treatment: the pastoral duet played by the English horn and the oboe at the opening of the movement, the thunderstorm played by the tympani, and the lonely utterance of the oboe at the very close of the movement, when this instrument plays only its portion of the opening duet. All these sections provide more sound than thematic effect. Even the fixed idea is used only as a faint reminiscence of the "Beloved One" in the tonal atmosphere of a pastoral scene (ex. 11.3). Through the use of woodwind instruments, traditionally associated with the outdoors, and high strings, Berlioz paints a touching musical scene of nature.

Example 11.3: *Symphonie fantastique, Scene in the Meadows* (Third Movement)—Berlioz

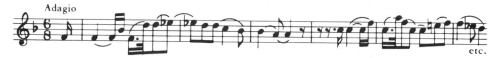

The fourth movement is a grotesque and noisy march. Its grotesque quality is achieved mainly by the use of unusual instrumental combinations and even more unusual demands upon these instruments. In the opening measure, two sets of tympani employing two performers together with cellos and string basses, set the march rhythm. The basses are called upon to fix the tonality by playing the tonic chord of G minor in a closed chord in their lowest range. The first theme of the march grows out of this ominous-sounding background. By using extreme ranges of the bassoon and string basses, Berlioz created weird tonal colors that lend credence to his program. The second theme of the march is noisy and blatant, employing the brasses and woodwinds as if they were an actual wind band. These two themes alternate in brilliant treatment, made particularly significant to the program by the contrasting instrumental groups in cleverly distributed rhythmic patterns. The fixed idea comes into this movement only as a pure piece of Realism explained completely by Berlioz's program (ex. 11.4).

Example 11.4: *Symphonie fantastique, March to the Scaffold* (Fourth Movement)—Berlioz

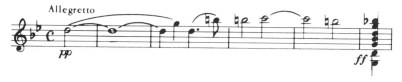

In the final movement, Berlioz stakes everything on the virtuosity of his orchestration. This is particularly true in the opening measures, where he tried to set a mood through sound effects achieved by fantastic demands upon the orchestral instruments. The demands are made not only upon individual performers but also upon the orchestra as a whole. It was treated as a huge palette with enormous resources. The opening measures, for example, divide the string section into ten separate parts, and the full score calls for such unusual instruments as the E-flat clarinet, valve cornets, tuba, four tympani, bells, bass drum. What a change from the Classical orchestra of the eighteenth century! Berlioz called for other new effects also, such as muted horns, the playing of strings with the wood of the bow instead of the hair, the playing of tympani with sponge mallets. The grotesque is heightened in this movement by

the parodying and burlesquing of two thematic ideas: one, the fixed idea (ex. 11.5) used to portray the "Beloved One," and the other, the solemn chant of the *Dies Irae* from the *Mass for the Dead* (ex. 11.6) and its parody (ex. 11.7).

Example 11.5: *Symphonie fantastique, Dream of a Witches' Sabbath* (Fifth Movement)—Berlioz

Example 11.6: *Dies Irae* from the *Mass for the Dead*—Berlioz

Example 11.7: Parody of the *Dies Irae*—Berlioz

The parody is attained by rhythmic and melodic distortion of these two themes. The last movement is climaxed by a witches' dance that, strangely enough, Berlioz commences in fugal fashion. This is formalism that one suspects is used to emphasize the parody, for Berlioz is known to have disliked the fugue as a musical form. This vigorous fugue subject is finally joined by the *Dies Irae*, and the symphony ends in a wild setting of musical frenzy.

Such is Realism as represented by one of the most revolutionary composers of the nineteenth century. In his work, Berlioz deliberately associated a nonmusical idea with a specific musical theme. His musical treatment of this theme and his development of the nonmusical idea illustrate the power of Realism. Berlioz achieved a convincing realism, as well as a musical work of art that could justify its existence independent of all extramusical ideas.

Wagner

Richard Wagner's realism is achieved in much the same manner as that of Berlioz. Even more than Berlioz, Wagner (1813–1883) sacrificed formal musical considerations to the end that all the arts, including music, might be synthesized into a new and compelling medium of artistic expression. His last great music dramas (he disliked the term opera) are examples of his realization of such an "artwork of the future."

One of these later music dramas, *Die Meistersinger von Nürnberg* (*The Mastersingers of Nuremberg*), illustrates Wagner's theories concerning the "artwork of the future." It also illustrates Wagner's technique of realistic expression. In this work, as in his later works, he employed the device of the **Leitmotif** both as a means of musical organization and construction and as a means of making the music realistically express the literary-dramatic implications of the work. Leitmotifs are short melodic and harmonic ideas to which a certain literary or dramatic idea is attached. This association is achieved by means of the libretto, dramatic action, or even manipulation of stage properties or lighting. In this way each Leitmotif gains a definite extramusical meaning. In *The Mastersingers*, one motif opens the Prelude and represents the mastersingers themselves. Another one immediately following this is associated with the lovemaking of Walter. The overture itself contains many more, such as the motifs of David, of the apprentices, of the call of spring—all of which become extramusically significant in the course of the drama.

Musically, these motifs are used in the course of the music drama just as themes are used in any piece of **absolute music.** They are subjected to repetition, development, variation, and similar musical treatments, as are the themes of a symphony or sonata. In this respect, they were used by Wagner in much the same way that Berlioz used his *idée fixe.* However, Wagner needed many more motifs because they have very specific dramatic significance and are called for by the necessities of the dramatic action. Their musical treatment, however, calls for more than mere vocal use. In fact, as a single part of this "new complete art," the music expresses the inner meaning, while the libretto, drama, and even architecture and painting express the outward meaning. Wagner used the orchestra rather than the voice as the vehicle for musical expression. As a consequence, the motifs are rarely sung in their pure form but are treated symphonically by the orchestra.

The voice parts are conceived as continuous, decorative melodies that assist in expressing the outward meaning of the drama by means of texts. Generally there are no traditional complete forms in the course of the work. The vocal part is neither aria nor recitative, as in traditional operas, but a sort of spoken melody.

Wagner's realism is convincing to the degree that the Leitmotifs are satisfactory musical expressions of the literary and dramatic ideas to which they are attached. If the musically strong rhythmic and harmonic quality of the Leitmotif representing the mastersingers can be persuasively linked to the actual mastersingers as they are dramatically presented and developed, then we are likely to be willing to accept Wagner's realism. If the musical device of long-delayed resolutions, achieved by the use of continuously altered and dissonant harmonies, can be represented as realistic expression of longing, renunciation, and other psychological states, then again Wagner's realism is successful. It would seem that, despite great opposition to his works in the

latter half of the nineteenth century, Wagner not only persuaded the listening public of the validity of his aesthetic principles but, generally speaking, also persuaded most of the composers of his own time and those immediately following him, particularly those who wrote music dramas.

The Mastersingers of Nuremberg is Wagner's only comedy. His intuitive feeling for the stage led him to write this work in a less-labored style than is felt in works such as *Tristan and Isolde* or *Parsifal.* Wagner came close to the closed form of the aria in such a passage as the *Prize Song* of Walter. This, however, does not contradict his idea of continuous melody and motif development because the dramatic story calls for the creation and singing of an actual closed song.

Wagner created a realistic work by the deliberate association of musical idea with extramusical meaning, and he made this association most convincing in several ways. First, he invented motifs that in their melodic outline seem to have a real relationship to the ideas with which they are associated. He then strengthened these melodic ideas with rhythmic, harmonic, and tonal qualities—all of which seem eminently suitable for enhancing the illusion of Realism. In the last analysis, listeners must allow themselves to become the victims of a fascinating and delightful illusion. The tones making up the opening theme of the Prelude to *The Mastersingers* do not actually depict the mastersingers, but this musical conjurer, this tremendous creative spirit, convinces listeners that they do. Many are not only convinced but are delighted in this illusion.

No other nineteenth-century Romanticist achieved such convincing realism and, at the same time, such well-knit musical expression. The fact that Wagner's works are heard so frequently on the concert stage, apart from all dramatic action, settings, and even voice, indicates the musical solidity with which he constructed them. On the other hand, this very fact also indicates that Wagner failed to achieve his own goal. Despite his contention that the "art of the future" was to be a synthesis of all the arts and that his own works were of this nature, the music still is of greatest import in his drama.

Liszt / Richard Strauss

Two other Realists of the nineteenth century are Franz Liszt (1811–1886) and Richard Strauss (1864–1949). Liszt combined virtuosity with Realism, both in his composition and in his performance as a pianist. He was the greatest technical virtuoso of his age, and his piano compositions, whether in a realistic vein as *La Campanella* or in a more classical form such as the *Piano Concerto in E-flat,* exploit the virtuosity of the pianist. His thirteen tone poems for orchestra are virtuoso pieces that were deliberately realistic in their intent. In these works, he used the Leitmotif to effect his realistic purpose, relating the motifs to the poem or other program that he attached to the work. In *Les Preludes,* Liszt tried to express, through the musical idiom of nineteenth-century

Romanticism, the poetic ideas of the French poet Lamartine's poem *Les Preludes,* the text of which Liszt attached to the published score of the work. With the Leitmotifs that correspond to the ideas of the poem and the technically elaborate and spectacular orchestration of these motifs, Liszt wove a musical counterpart to the poetic idea.

Richard Strauss, a composer in the tradition of Wagner and Liszt, used the same devices of musical construction and the same principles of Realistic expression in his operas and in his symphonic tone poems. He made harmonies richer and more dissonant and expanded the orchestra even more. The tone poem *Till Eulenspiegel* is a composition of wit and humor in music, quite apart from any program that has been attached to it. Till was a sort of half-real character of the German Low Countries who was at least as well known then as Robin Hood is today. Everyone knew of his more famous pranks, which fill several volumes. It was easy to associate them with their obvious musical references.

The traditional pranks ascribed to Till—such as upsetting the market ladies' baskets, parading as a priest, having a love affair, and many others— and finally his trial, judgment, and execution at the close of the work can be supplied by the listener familiar with the prankster and his escapades. Strauss refused to write an explicit program for the work but gave it a complete title that when translated reads: *Till Eulenspiegel's Merry Pranks, in an Old Roguish Manner—in Rondo Form.* Furthermore, when pressed for an explanation of the work, Strauss merely said that he would leave it to the listeners to crack the nuts that the rogue gives them. He indicated that the two motives (exs. 11.8, 11.9) represented Till in his many disguises, moods, and situations, and that the whole story ends in a catastrophe when he is condemned and strung up on the gibbet. In Strauss's time, of course, the audience for this work actually knew the stories of Till.

Example 11.8: Theme from *Till Eulenspiegel*—Richard Strauss

Example 11.9: Theme from *Till Eulenspiegel*—Richard Strauss

Musically, the work is a free rondo form. The two motives constantly recur in various guises—changed in their melodic and harmonic forms, put into new tempos, or rhythmically and tonally altered, always in a gay or wistful manner. This rondo is unlike the Classical rondo where the themes maintain their forms quite consistently, for the motives of Till undergo many transformations.

Till Eulenspiegel illustrates the fact that no piece of music, no matter how detailed its realistic expression or how successful its relation to extramusical ideas, can base its success as a work of art solely on its Realism. It must first be a viable piece of music. For all successful Realists in music, success rests primarily upon their artistic skill as creative musicians and only secondarily on their ability as storytellers or painters in tones.

Nineteenth-Century Nationalism

We have seen Romantic and Realistic art as the expression of individualism, as an expression of the struggle for freedom and liberation from all kinds of tyranny. So far those struggles depicted have been personal, but when the collective efforts of a people are directed toward freedom and liberty from oppression, there is Nationalism. Nationalism is the application of the Romantic spirit to the sovereign state. It is the natural development of individualism on a national scale.

After the defeat of Napoleon, the map of Europe was completely revised. His conquests had so changed the political map that for each country to gain back some of its territory, innumerable treaties had to be made. In the ensuing process, there was a tendency to draw lines according to nationalities. One after another of those smaller groups of European states and districts began the slow process of national unification. Germany, the last of the major national groups to achieve unity, finally became united in 1871 under Bismark. The smaller states, like Poland, Bohemia, Norway, and Finland, did not realize this aim immediately, but a growing patriotism kept a feeling of national identity alive.

All that was true of Romanticism and Realism is also true of the new movement. The difference is in emphasis and subject matter. Anything that could inspire the person in the street with pride and patriotism was a legitimate subject. Folklore reappeared in serious music. For centuries it had been repressed because of its association with the common people; it had not been considered a fit subject for the courtly life. It was natural that during the Romantic period the rise of the common person should also bring folklore and folk music into the realm of creative art. Ballet provided an outlet for this burgeoning interest. Romantic stories, folk tales and myths formed the basis for such works as Tchaikovsky's *Romeo and Juliet*, *The Nutcracker*, and *Swan Lake*. Ballet became, and continues to be, a justifiable source of national pride for the Russian nation.

Nationalist art had a propaganda value for the sovereign state in that it glorified its traditions. The resulting jealousy of national power and culture have been both a blessing and a curse to society. German Nationalism, born with Bismark, was one of the major causes of two world conflicts. Nationalism is not a period of time, but an attitude that will remain as long as there are strongly nationalistic feelings within nations. Often, the smaller the state, the stronger the Nationalist movement in art. Small nations cannot boast of military, political, or economic power, but art is something that is not dependent upon large armies.

Whereas Realism had its greatest success in the visual arts, it is in music that we find the most powerful and lasting Romantic Nationalism. Patriotism is a feeling and can best be expressed by music, the art that best lends itself to intensified emotions.

As Romanticists, artists of the Nationalist movement made no marked changes in techniques or methods of organizing the basic elements of the arts. Nationalism appears only in the artistic function and in the use of materials indigenous to a particular country. For example, listeners can identify Spanish music by a particular rhythmic pattern, Russian music by a certain oriental quality of melodic intervals, and Polish music by the use of folk dances, such as the polonaise and mazurka.

As in the case of Romanticism, the visual arts of Nationalism have a lesser appeal to the world today than does its music. Their depiction of contemporary events limits the appeal to those who are familiar with their history. But beyond the borders of the specific country and beyond the span of memory, these events often lose their power and significance. However, the means to express Nationalism musically were developed in the compositions of nineteenth-century Romanticism. They were already familiar to all peoples of the western European tradition, since they were much the same as those used by the Realists. In addition, while the Nationalistic extramusical ideas would never impress the non-national public, the purely musical values remained the same for all groups. When music of artistic worth was combined with Nationalistic Realism, it found wide audiences. Within the confines of its own immediate national group, it spoke to a people sympathetic with its musical and extramusical subjects. Outside its own national confines, it appealed to the romantic sense of all people as an artistic medium with a certain strange and unusual idiom. Walter Pater defined "romanticism" as "the combination of the beautiful and the unusual." This is perhaps the key to the widespread acceptance of the works of Nationalistic composers, even where people are entirely unsympathetic, or even opposed, to the patriotic ideas the composer tried to express.

Nationalism in music was not only an attempt to express the political independence of national groups but was also a conscious revolt for musical independence. German music had grown in its domination over European

music, particularly that of central and eastern Europe, since the beginning of the eighteenth century. By the beginning of the nineteenth century, Germany provided practically all the performing musicians and teachers, as well as the music itself, for the numerous smaller national groups. These groups felt a need to reflect their hopes for independence with musical independence.

The same elements that were responsible for Wagner's use of old epics and legends brought about the new trend of Nationalism. Composers began to identify themselves with their nation's histories. Music had always contained the elements of Nationalism, and there were always traces of Italian, German, and Spanish influence, but never before had there been such a conscious effort to exploit the national traits of the immediate society as there was during the last half of the nineteenth century.

Nationalism, as would be expected, was strongest among those who were politically and culturally dominated by foreign forces. The largest national groups to feel such domination were the Slavic peoples. As a consequence, there was a very conscious Nationalism in the music of the Russians, the Poles, and the Czechoslovakians.

The latter group was the smallest numerically and the most completely dominated by a foreign people. Since the first part of the seventeenth century, Germanic culture and political organization had been imposed upon the Czechoslovakians. The liberating tendencies of the Romantic nineteenth century, however, gave hope to an unquenchable desire for freedom that could find expression only in art, and particularly in music, until the twentieth century. As a result, Czechoslovakian music in the middle of the nineteenth century was intensely Nationalistic.

Smetana

Bedřich Smetana (1824–1884) was a strong fighter for Czechoslovakian independence, particularly in artistic and musical matters. He was, in many respects, a disciple of the musical aesthetics of Wagner and Liszt. He tried to use their techniques, coupled with the idiom of the Czechoslovakian national folk song and dance, to express the extramusical ideas of Czech nationalism through the folktales and acts of patriotism cherished by the Czech and Slovak peoples. His great cycle of tone poems under the title *Ma Vlast (My Fatherland)* represents his adaptation of Romantic musical procedures to this purpose. The work consists of six individual symphonic poems, each dealing with a certain aspect of Czechoslovakian countryside, life, mythology, and history.

Vltava (The Moldau), the second poem of the cycle, is a Nationalistic expression that has won wide acceptance in concert halls everywhere. Fundamentally this work is a typical symphonic poem in the Lisztian tradition

with several Leitmotifs, the most important of which is the first and main theme depicting the river Vltava itself. This theme is closely allied to Czechoslovakian folk song. In the course of the work, and in keeping with a detailed descriptive analysis published in the score, Smetana suggests the course of this beautiful river with appropriate musical episodes through which the principal theme continues to flow. A reading of Smetana's own program reveals the same detailed Realism found in Berlioz's *Symphonie fantastique.* In this case, however, the composer is playing upon the patriotic sentiments of his compatriots. The Vltava, which flows through the length of Bohemia, stood as a symbol of Czechoslovakian strength and patriotism long before this work was written. The castles on its banks, the countryside along its broad valley, the rapids that interrupt its swift course—all these were very close to the hearts of a people who for three centuries symbolized their own unity and strength by this river. By associating these "real" objects of patriotic feeling with music often closely related to the rich folk music tradition of his homeland, Smetana appealed to the deepest sympathies of his compatriots. This is the extramusical idea that can never, in Nationalistic music, be fully understood by one who is not "of the nation." For those who are outside this intimate relationship, the work must appeal by virtue of its musical artistry. The listener may understand the program, but only as a passive observer from a distant city might view a baseball game between the Dodgers and the Yankees. To someone from Los Angeles, a Dodger victory will be all that matters. To the visitor, a skillfully played game would be of prime importance. To the Czechoslovakian who listens to *Vltava,* whatever clichés of Romanticism Smetana may have fallen into are irrelevant. The story and its musical counterpart, the beauty of the melodies and their likeness to folk song—the whole sentiment is of prime importance. The skill of workmanship is secondary in consideration.

In this respect, listeners can seldom have a deep attachment to, and an understanding sympathy for, the National music of any people other than those with whom they are intimately related. As a result, much Nationalistic music is heard less frequently outside the country in which it was composed. That which is successfully performed abroad is valued because, in addition to its peculiar Nationalistic idiom, it has intrinsic musical worth.

Russia, while it was not under the political domination of a foreign power, felt a complete dependence on western Europe in the realm of art music until the performance of Glinka's opera *A Life for the Czar* in 1836. After this first essay into the field of musical Nationalism, Russia soon produced a number of composers who were determined to free Russian music from the bondage of German Romanticism.

Actually, they adapted the techniques of this same Romanticism, flavoring their work with the melodic, harmonic, and rhythmic idioms of Russian folk music to express their Nationalism. Two groups of composers arose,

rather strongly antagonistic to one another. The one group, the Russian Five, felt themselves to be the true representatives of Russian Nationalism. They opposed other composers, such as Tchaikovsky, who in their minds represented an alliance with German Romanticism.

The Russian Five	*Others*
Balakirev (1837–1910)	A. Rubinstein (1829–1894)
Borodin (1833–1887)	Tchaikovsky (1840–1893)
Cui (1835–1918)	
Mussorgsky (1839–1881)	
Rimsky-Korsakov (1844–1908)	

Tchaikovsky/Mussorgsky

A work of Tchaikovsky and one of Mussorgsky, the most original genius of the Russian Five, will reveal the differences between these two groups. In the *Symphony no. 4* Tchaikovsky used the Classic forms for his personal expression. This work illustrates the composer's close relationship to the German symphonic tradition of Haydn, Beethoven, and Brahms. However, his Nationalism is also very evident in the use of melodies idiomatic in Russian folk songs. This is especially apparent in the second theme group of the first movement and in the trio of the scherzo. In the Finale, Tchaikovsky actually used a popular Russian tune (ex. 11.10). While there was no program given for this symphony, nor was one intended, Tchaikovsky acknowledged in his letters the composition's Russian Nationalism.

Example 11.10: *In the Field There Stood a Birch Tree* (Russian Folk Song)

Such Nationalism as Tchaikovsky reveals in the Fourth Symphony was not acceptable, however, to the Russian Five; they felt that Russian composers must not only employ the idioms of Russian folk music but must link the musical idea to Russian subject matter and, above all, must create a musical tradition of their own. Perhaps the most original example of such purpose is the opera *Boris Godunov* by Mussorgsky. The first two scenes from this work reveal the connection of extramusical idea, as represented by the dramatic situation, to musical expression in the composer's magnificent orchestral and choral writing—all based upon an idiom that reveals his intimate knowledge of Russian folk and liturgical music. In this opera, Mussorgsky portrayed the

Russian people as the central heroic character. It is truly a work of Nationalistic significance. While the musical language is that of the Romantic nineteenth century, Mussorgsky did not pay tribute to Wagner by employing his aesthetic principles of music drama, nor did he follow the Italian tradition. He set out on a rather narrow Nationalistic path and, despite the dangers of such a restrictive procedure, succeeded in writing a work of musical artistry and magnificence. Its Nationalistic ideas, both musical and extramusical, are evident throughout. It is in essence a set of choral-symphonic scenes, of which the first two scenes serve as the Prologue to Act 1. Scene 1 takes place in the courtyard of a monastery near Moscow, and through its folklike melodic and harmonic idiom suggests a setting of true Nationalistic meaning. The irregularity of meter characteristic of eastern European and Slavic folk music is pervasive. The song of the pilgrims that ends the first scene introduces the liturgical music of the Russian church, which had a long history, and was an important part of the life of every Russian. The second scene, commonly called the "Coronation Scene," is made realistically Nationalist by the skill with which Mussorgsky simulated the sounds of the great bells of Moscow, not only by the use of orchestral bells but also by careful orchestration and harmonic understanding. The use of folk and folklike melody likewise strikes a Nationalistic note. Beyond these musical means, he based his libretto on a drama by Pushkin, which, in turn, was based on an actual period in Russian history, so that the whole dramatic side of the opera possessed an intensely Russian character.

Countless Nationalistic works ranging from short piano pieces in the folk dance idiom of various peoples to such large forms as those previously described engaged many composers in the nineteenth century and continue to do so. Sometimes, as with Smetana, Mussorgsky, Grieg, and others, the traits of Nationalism never seem absent from the composer's music. Others, such as Chopin and Liszt, pay some respect to this phase of Romanticism but are not entirely given over to it. All in all, it represents another facet of Romantic Realism. It included an enormous mass of musical works, only a fraction of which ever find performance outside their very restricted national areas. Only occasionally do any of these works overcome the restrictive confines of their Nationalist messages. However, their purpose was to serve the needs of their own people. For those groups who were struggling for cultural independence, this great musical literature was, and still is, of tremendous significance in its expression of Nationalism.

Summary

As noted in the preceding chapter, Realism is only a facet of the Romantic spirit. It was an integral part of the Romantic ideal but was applied to more objective subjects. Emotion was still a primary consideration, but the aim was

to arouse feelings over a specific problem or event, often mundane, that touched the lives of ordinary people. Visual Realism often dealt with the issues of poverty, social injustice, labor, or morality. Most Realistic painters tried to present their subjects in an almost photographic manner; there was little mysticism or imagination, only the scene as they saw and experienced it objectively.

With music, an abstract art, composers found it more difficult to be objective, to tell a story, or to convince the listeners of a particular scene. Program music was the result of their attempts to be Realistic. Various Realistic devices were used to try to convince the listeners of objectivity. The orchestra, with its vast resources of tone color and harmonic possibilities, was the most popular medium for program music. By suggesting that certain melodic configurations, harmonic progressions, tonal colorings, or rhythmic patterns were identifiable with poetic ideas, physical movement, or specific personalities, composers could in fact tell a story or paint a picture in tone. However, their music had to be based on a firm foundation of formal structure in order to survive. In most of the more successful program music, the music was probably conceived before the program it was to illustrate was completed.

Nationalism was likewise a phase of Romanticism. The ingredients of Nationalistic music are the folk songs and dances of particular countries or ethnic groups. If true folk material was not always used, composers created their own melodies in the spirit and style of folk music. In addition, legends or stories of historical events were often used as programs in the same manner as the musical Realists tried to tell stories or suggest scenes in terms of music. In any case, it is the extramusical ideas of Nationalistic interests, added to the music itself, that make such music dear to those of that particular nationalistic origin. The acceptance of such music by those outside a specific national culture depends mainly on its musical worth in its own right and on its Romantic and exotic appeal to all people.

Suggested Readings

In addition to the specific sources that follow, the general readings listed on pages xxi and xxii contain valuable information about the topic of this chapter.

Einstein, Alfred. *Music in the Romantic Era*. New York: W. W. Norton, 1947.
Licht, Fred. *Goya, The Origins of the Modern Temper in Art*. New York: Harper & Row, 1983.
Longyear, Rey M. *Nineteenth-Century Romanticism in Music*. 2d ed. Englewood Cliffs, N.J.: Prentice-Hall, 1973.
Rosenblum, Robert, and Jansen, H. W. *Nineteenth Century Art*. New York: Abrams, 1984.

12

IMPRESSIONISM AND POST-IMPRESSIONISM
(1860–1900)

Chronology of Impressionism

Visual Arts	Music
■ Edgar Degas (1834–1917)	
■ Paul Cézanne (1839–1906)	
■ Auguste Rodin (1840–1917)	
■ Claude Monet (1840–1926)	
■ Pierre Auguste Renoir (1841–1919)	
■ Mary Cassatt (1845–1926)	
■ Paul Gauguin (1848–1903)	
■ Vincent van Gogh (1853–1890)	
■ Georges Pierre Seurat (1859–1891)	
	■ Claude Debussy (1862–1918)
	■ Lili Boulanger (1893–1918)

Pronunciation Guide

Boulanger (Boo-lăn-zhay)
Cassatt (Kah-sáht)
Cézanne (Say-zahn)
Debussy (Deh-boo-see)
Degas (Day-gah)
Gauguin (Go-găn)
Grande Jatte (Grănd Zhaht)
Jas de Bouffan (Zha de Boo-fă)
Mallarmé (Mahl-lahr-may)
Manet (Man-ay)
Monet, Claude (Moh-nay, Klohd)

Moulin de la Galette (Moo-lăn duh lah Gah-let)
Nuages (Noo-ahzh)
Renoir, Auguste (Ren-wahr, Oh-goost)
Rodin (Roh-dă)
Scriabin (Skree-yah'-been)
Seurat (Soe-rah)
van Gogh (van Gokh)
Verlaine (Ver-layn)
Vétheuil (Vay-too-ee)

Study Objectives

1. To study Impressionism and Post-Impressionism as the final stages of and revolts against Romanticism.
2. To learn about the use of tone color in music and color in the visual arts as the primary vehicles of artistic expression.

Impressionism

As the Romantic spirit ran its course, there was an increased effort among artists to express "feeling." "Art is an expression of the soul, a communication of emotional states from one soul to another"—this was the creed of the later Romanticists, an attitude that sensitized the whole field of art to the Impressionist movement. The passionate, violent outpourings of the Romanticists slackened off; in their place there arose vague suggestions of mood and atmosphere.

Even before the turn of the twentieth century it became evident that there was little left in the Romantic conventions of art. One writer calls it a period of culture-weary art because there had been such a concentration of emotional forces that people's feelings were almost immune to further effort. In the first half of the nineteenth century, people found emotional release and spiritual values in the Romantic offerings of its artists. As the century advanced, there was an intensification of materialism that brought forth Realism and Nationalism. Finally, the shift was complete. By the beginning of the twentieth century, art had moved from a subjective point of view to a more nearly objective point of view.

Impressionism was the connecting link between these two extremes. It was a protest against the exuberance and the excess of Romanticism, and yet it was still Romantic in that it was based on feeling. It was Realistic and objective in its attempts to portray the subject, but as seen through the eyes of the artist at a particular moment and under the particular conditions of that moment. Its final aim was to evoke an image, to suggest an emotion. There was no passion, no deep feeling; it was a cult of suggestive colors, lines, and sounds, a fleeting glance, an incomplete melody; the viewer and the listener supplied the details and completed the art object. Impressionism was thus a sensuous art without moral character.

Literature provided both the painter and the composer with suggestive poetry with which to fuse their arts. Just as the painters and composers rebelled against the structural patterns of Classic and Romantic art, the Impressionistic poets rebelled against the restrictions of poetic forms. Words were used for their musical qualities rather than for their meanings; they were used as visual symbols rather than for thought content; they were more than just words—they became a means of suggesting musical sounds and visual colors.

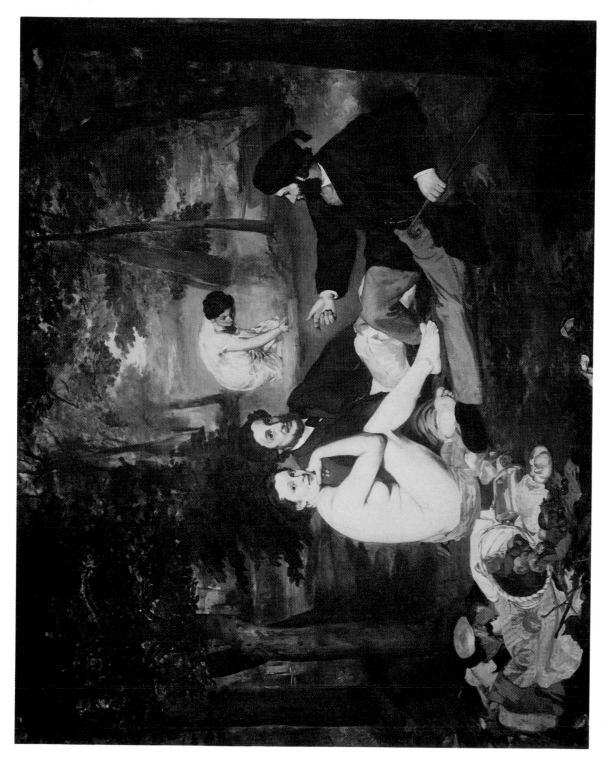

Colorplate 64 Le DeJeuner Sur L'herbe [1863]—Edouard Manet. 84″ × 106″ Paris, Mus. d'Orsay (Giraudon/Art Resource, N.Y.)

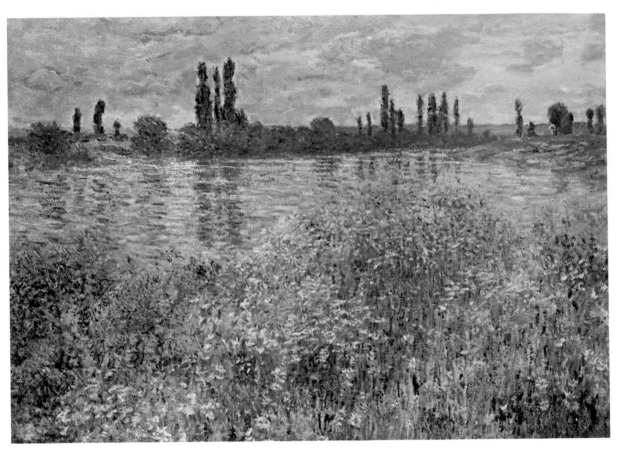

Colorplate 65 *Banks of the Seine, Vétheuil* [1880]—Claude Monet. Canvas, 28⅞″ × 39⅝″. (National Gallery of Art, Washington, D.C., Chester Dale Collection)

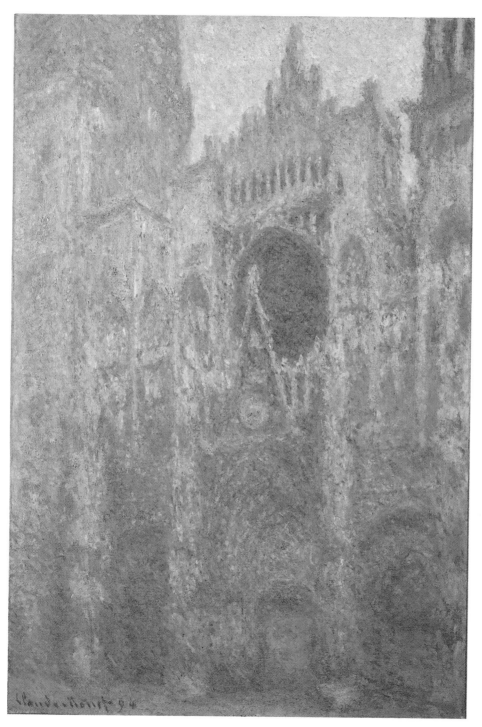

Colorplate 66 *Rouen Cathedral, West Facade* [1894]—Claude Monet. Canvas, 39½″ × 26″. (National Gallery of Art, Washington, D.C., Chester Dale Collection)

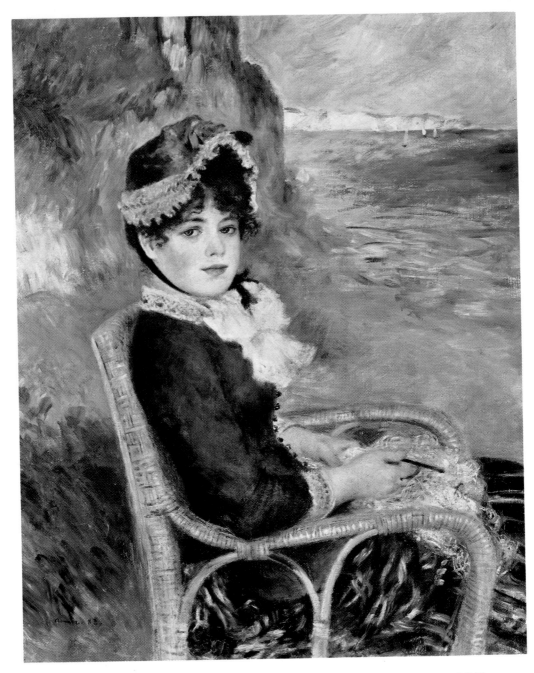

Colorplate 67 *By the Seashore* [1883]—Auguste Renoir. Oil on canvas, 36¼″ × 28½″. (The Metropolitan Museum of Art, bequest of Mrs. H. O. Havemeyer, 1929. The H. O. Havemeyer Collection)

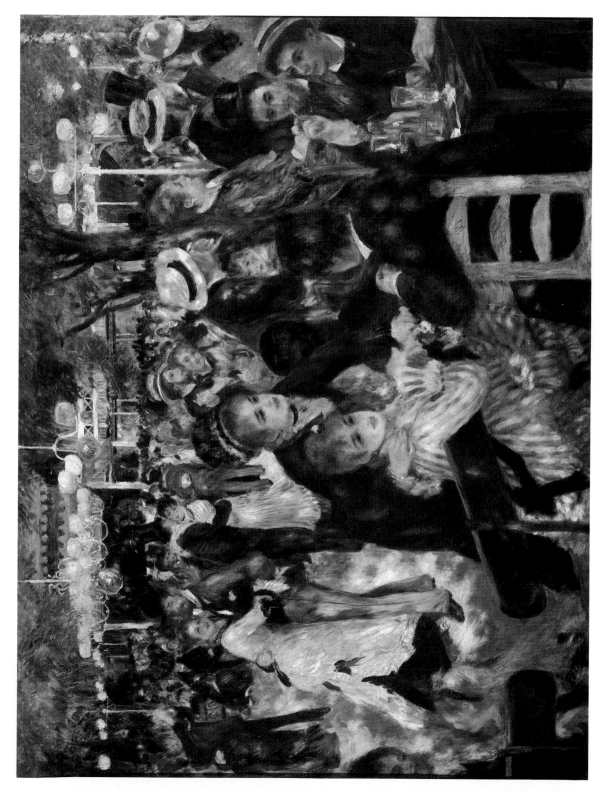

Colorplate 68 *Le Moulin de la Galette* [1876]—Auguste Renoir. 51½″ × 69″. (Alinari/Art Resource, N.Y.)

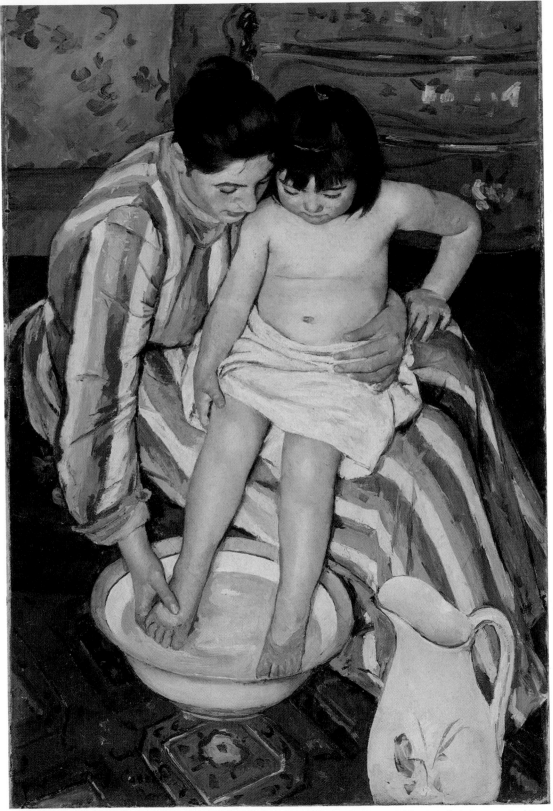

Colorplate 69 *The Bath* [c. 1891–1892]—Mary Cassatt. Oil on canvas, 39½″ × 26″. (The Art Institute of Chicago. Robert A. Waller Fund 1910.2 © The Art Institute of Chicago. All Rights Reserved)

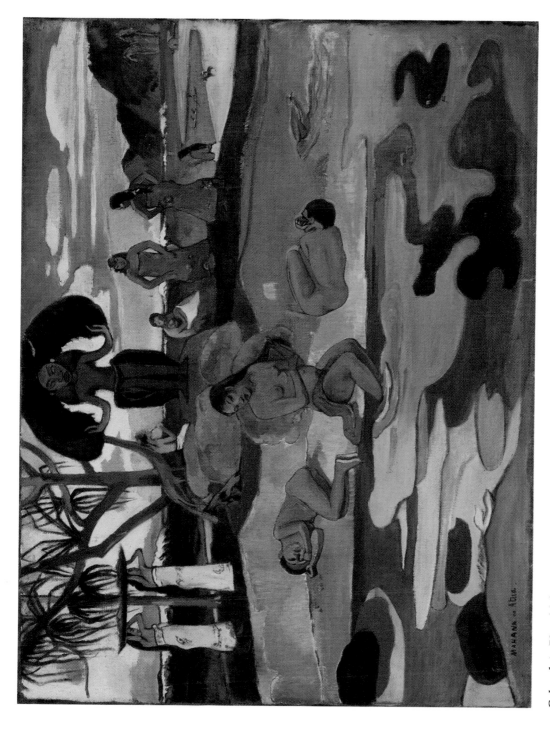

Colorplate 70 *Mahana No Atua (Day of the Gods)* [1894]—Paul Gauguin. Oil on canvas, 27⅜″ × 35⅝″. (The Art Institute of Chicago, Helen Birch Bartlett Memorial Collection, 1926.198. © The Art Institute of Chicago. All Rights Reserved)

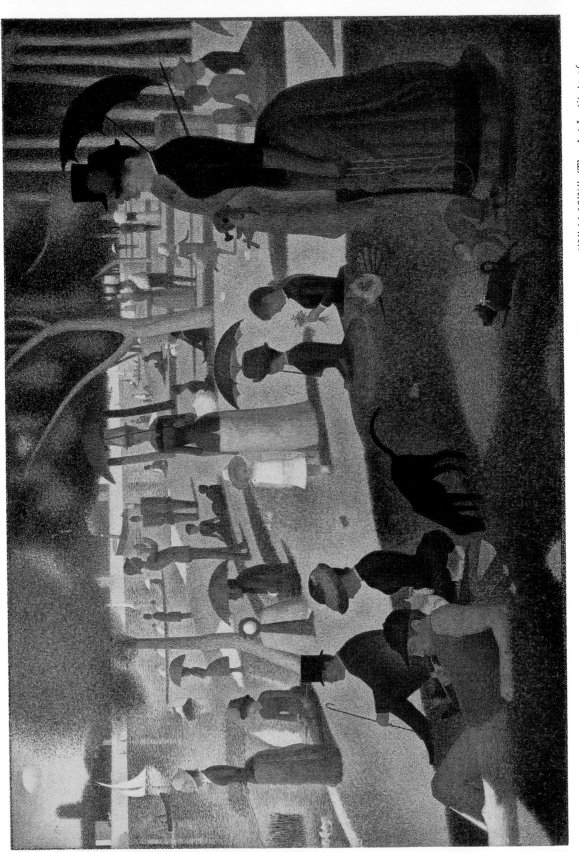

Colorplate 71 *Sunday Afternoon on the Island of La Grande Jatte* [1884–1886]—George Seurat. Oil on canvas, 6'3" × 10'⅜". (The Art Institute of Chicago, Helen Birch Bartlett Memorial Collection 1926.224 © The Art Institute of Chicago. All Rights Reserved)

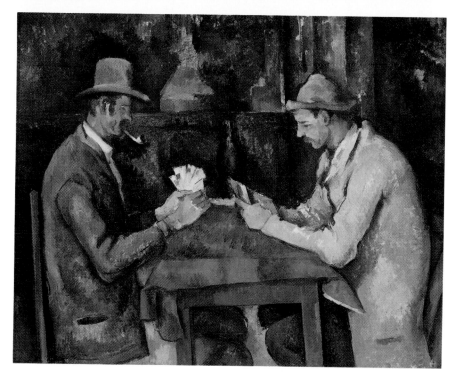

Colorplate 72 *The Card Players* [1891]—Paul Cézanne. 3'2'' × 4'3''.
(Courtauld Institute Galleries, London. Courtauld Collection)

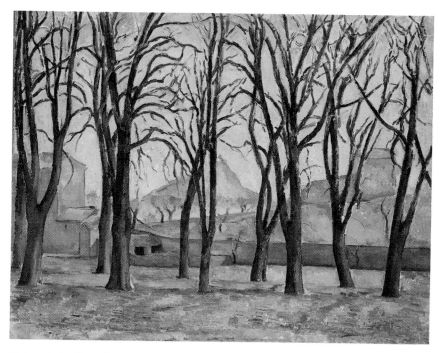

Colorplate 73 *Chestnut Trees at Jas de Bouffan in Winter* [1886]—Paul
Cézanne. 29'' × 36''. (The Minneapolis Institute of Art)

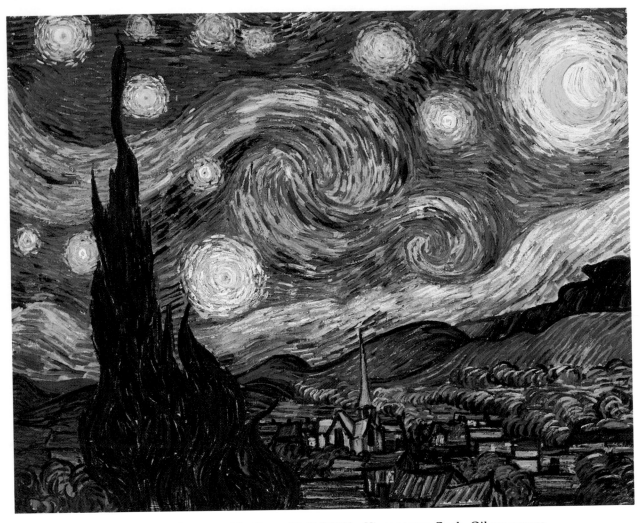

Colorplate 74 *The Starry Night* [1889]—Vincent van Gogh. Oil on canvas, 29″ × 36¼″. (Collection, The Museum of Modern Art, New York. Acquired through the Lillie P. Bliss Bequest)

Both painters and composers were strongly influenced by the symbolic imagery of Verlaine and Mallarmé, who headed a group of "symbolist" poets. Theirs was a fragile, erotic poetry that stimulated the imagination of their fellow artists.

The relationship between artists and the public was also a factor in the rise of Impressionism. Artists had been gradually drifting away from the public. Some of the functions of artwork were no longer valid. Photography, for example, was taking away the job of portraiture from the painter. Courtly life was on the decline, and composers could no longer look forward to the kind of patronage enjoyed by Haydn. Official Academy painting and sculpture was stilted and stagnant, but it had public approval. Impressionism embodied a new and fresh view of reality. While it did not ignore social conditions, it avoided preachment and moralizing. Instead, the artists focused on the act of seeing the everyday world as influenced by light and movement.

The musical public, likewise, was still tied to Romantic sentiment. In an effort to entice the public from its normal path of artistic taste, artists were experimenting with new theories and new methods. One of these experiments resulted in the Impressionistic style. New vistas of art were the theoretical goal of its innovators, but public attention was also a strong motive.

Post-Impressionism

The fact that Post-Impressionism does not have a name distinct from Impressionism indicates both its connection to, and its difference from the earlier style. The term refers to the styles of several artists' painting in the mid-1880s: Gauguin, van Gogh, Cézanne, and Seurat. These artists constitute a bridge from Impressionism to such early twentieth-century movements as Expressionism and Cubism. These artists had decidedly individual styles, and their works resist simple categorization.

Painting

The initial innovations that led to Impressionism in art were made by a group of painters in France. In their protest against the traditional methods and exuberance of Romanticism, they concerned themselves with the objectivity of the eye. They painted what they saw under specific conditions of light and shade. At first glance Impressionism seems unreal, but a close observation of nature suggests that this can be a realistic art. Color changes according to the atmospheric conditions that control the intensity and amount of light. There is a difference, for example, in the color of grass in sunlight and in shade. The grass itself does not change, but the atmosphere causes it to take on different shades of green. Distance not only has the effect of making objects appear smaller but it also cuts out details that we may know are present but cannot actually see. The Impressionists explored almost every possibility of the effect of light on color and mass.

By calling attention to the delight of instantaneous vision, Impressionistic painters opened a new area of human experience for the artist to explore. This was to play an important part in the development of the various "isms" of twentieth-century painting.

Landscapes, houses, people—anything that could be observed was a legitimate subject for Impressionistic painting. The only stipulation was that it must be presented as it appeared at the moment of artistic creation. This made artists change their techniques. Design was no longer of major concern. Even line, space, and formal organization were subordinated to color. Artists no longer confined painting to the studio; they brought their work out into nature, and they had to devise a method of working that was quick and sure. They used only a few basic colors and brushed them on quickly with bold strokes, for they realized that blending of colors could take place in the eyes of the viewer. A canvas had to be finished at once before the light effects changed. At times it was necessary for the artists to wait days, even weeks, for the same conditions of light and atmosphere to return. Landscapes with water were particularly popular with painters because of the fact that water responds to the slightest change of light and wind.

Manet

The most immediate precursor of the Impressionist painters was Edouard Manet (1832–1883). One of his most important contributions to painting was his unrelenting attention to the effect of light on objects in space. Another was his commitment to paint the world without idealizing. Although he was trained in an academic style, Manet regularly chose subjects that were deemed scandalous by the establishment, and as a consequence it was necessary to band together with other artists to exhibit their works in the Salon des Refusés.

Colorplate 64
follows p. 296.

In 1863 the Salon des Refusés hung Manet's *Déjeuner sur l'Herbe (Luncheon on the Grass)* (colorplate 64), creating an uproar because of its nude female in the presence of formally dressed gentlemen. Copying masterpieces was a standard part of an artist's training, and this painting was an outgrowth of a year's study and copying of Giorgione's *Pastoral Concert*. Many of the objects in the painting, especially the vegetation in the background, are defined by loose application of pigment, which only suggests line. The sharp contrasts in the painting are achieved by Manet's extreme light and dark colors, with few colors of middle value.

Monet

Claude Monet (1840–1926) was one of the successful painters using the Impressionistic technique. In fact, it was his painting *Impression: Sunrise*, which he exhibited in 1874, that gave the movement its name. The *Banks of the Seine, Vétheuil* (colorplate 65) is his color study of the effect of light and atmosphere

Colorplate 65
follows p. 296.

on water, trees, and foliage. The painting contains no people, no action, no social problems—only the quiet beauty of the shimmering reflections on the water. Monet applied colors in bold patches, with no effort to integrate them on the canvas. Details of the trees and foreground foliage are vague and obscure. Space is made apparent in various ways. By placing the horizon high in the painting the artist created a large area of foreground foliage. He also used the technique of clear brush marks on the foreground. Each leaf is only a bit of color, with no outline for individual leaves or flowers. There is little sense of formal organization, for the painting is an impression of a segment of real life and not a carefully arranged pattern.

In *Rouen Cathedral, West Facade* (colorplate 66), Monet caught the full force of bright sunlight on the facade of the cathedral. This is one of many canvases painted of the same subject, each under a different light condition. The intense light has a tendency to break down the massiveness of the building. Lines are shadowy. There is no idea of ordered structure or calculated design except that determined by the architectural subject itself. Color is in patches of grays and tans that mean nothing when viewed closely but integrate into a whole when viewed from a distance. Monet only suggests to the spectator the idea of the cathedral in the brilliance of a noonday sun.

Colorplate 66 follows p. 296.

Renoir

Auguste Renoir (1841–1919) is another French painter who adopted the Impressionistic style. Renoir was not wholly concerned with color, however, for he carried on the tradition of structural form from the Romanticists. Consequently, there is more emphasis on the plastic quality of figures, even while he painted them with the realistic technique of Impressionism. *By the Seashore* (colorplate 67) is such a canvas. Renoir placed his subject against the background of sky and water. There is a fragile and scintillating quality about the landscape. Pastel colors scarcely define anything except the rocky cliff. The lady, however, is boldly modeled in a traditional fashion, except for the effect of light and color apparent in the soft tones of flesh and in the reflecting folds of her dress.

Colorplate 67 follows p. 296.

Le Moulin de la Galette (colorplate 68) shows Renoir's treatment of a group of figures. There is an intentional blurring of outlines, for here he paid little attention to the details of form. The effect of light on color and form is the most important impression one receives. The patches of light contrast with the dark shadows. The stripes of the dress of the figure at the table are bleached by light. The background figures are merely brushstrokes of pastel color. The feeling of formal balance is concealed by the busy activity of the figures and by the light in the canvas. Renoir painted the gaiety of color, creating a realistic impression of a whirling throng in the sunlight. If it has any sense of motion, it is that of including the observer in the creative process. Unlike the Baroque, in which the spectator is only sometimes drawn into the picture, Impressionism forces the viewer to synthesize and complete the picture.

Colorplate 68 follows p. 296.

Cassatt

Though the Impressionist movement was begun in France by French painters, it attracted adherents from all over the Western world. Two noteworthy examples from North America were James Whistler and Mary Cassatt. Cassatt (1845–1926) was born in Pittsburgh, Pennsylvania. When she traveled to France, it was with the intent of studying in the academic style of the day. Very soon, however, she was attracted to the works of Manet and Degas. In 1877, she met Degas. He invited her to exhibit her works with the Impressionists. She accepted, showing her works in at least four exhibitions between 1879 and 1886. Her style is bold, with broad brush strokes and vivid colors. The subject matter that she chose tended toward the domestic, with frequent representations of mothers with their children, as in *The Bath* (colorplate 69). There is a tenderness conveyed in her choices of color and character. The formal composition of this painting is dominated by the S-curve formed by the figure of the mother, and made subtle by the figure of the child.

Colorplate 69 follows p. 296.

Gauguin

Paul Gauguin (1848–1903) can be called a Post-Impressionist. Disenchanted with the industrial civilization of his time, he escaped to Tahiti in search of the simple primitivism of the South Seas. There he began to use color to depict flat surfaces without three-dimensional modeling, with the aim of decorative organization. Unity resulted from the juxtaposition of patterns of color symbolic of primitive forms. His *Mahana No Atua (Day of the Gods)* (colorplate 70) gives viewers a vicarious experience of a simple life-style in an exotic setting. It is a quiet, two-dimensional decorative design devoid of action or sensuousness.

Colorplate 70 follows p. 296.

Seurat

George Seurat (1859–1891) is sometimes called a Post-Impressionist. He seemed to exploit the Impressionistic theories to their logical end as a bridge to the twentieth century. He was still mainly concerned with color and light, but in a more disciplined manner. He built up his colors with thousands of small dots of color. These were of uniform size and were designed to merge into shapes in the eye of the beholder, much like the bold patches of color used by Monet. Seurat's style is called "pointillism" and is sometimes compared to the fragmentary musical fabric of Anton Webern. *Sunday Afternoon on the Island of La Grande Jatte* (colorplate 71), the subject of a Broadway musical by Stephen Sondheim, is one of his best-known paintings. The forms are geometrically stylized and employ the integration of dots of color in varying hues and values. A strong sense of spatial recession is achieved by the progressively smaller size of background figures. The painting has no sense of movement and is a static portrait of people in a park.

Colorplate 71 follows p. 296.

Cézanne

Of the Post-Impressionists, Paul Cézanne (1839–1906), more than any other, explored the possibilities that were later employed by the Cubists. For Cézanne, nature was not what it seemed when photographed, but was something that could be reduced to simple and monumental forms. He tried to reveal the character of objects, people, and landscapes through cylinders, cubes, cones, and spheres. While landscapes were his favorite subject, Cézanne also painted still-life subjects and group pictures. One common subject, often repeated by Cézanne, was men playing cards. In one of the simpler versions, the *Card Players* (colorplate 72), he created an intimate arch by his arrangement of the two elongated figures. A triangle is created by the men's forearms and the table top. Such geometric forms are, together with color, typical of Cézanne's style. The artist was not interested in the act of card playing, but strove only to make an interesting arrangement of what were actually three-dimensional forms. He modestly distorted nature, and simplified it by bringing out its natural forms.

Chestnut Trees at Jas de Bouffan in Winter (colorplate 73) employs painting techniques that led to Cubism. A photograph of the same scene (fig. 12.1) is different in the amount of detail and background. Many limbs were left out of the painting to emphasize the cylindrical shapes of the trees. Buildings were used sparingly, and then only as simplified shapes. The mountain, Ste. Victoire, shows clearly through the trees as a block of earth in nature. Unlike the photograph, Cézanne's painting creates an artistic pattern of angular lines that define the volume and mass of structural forms.

Colorplate 72 follows p. 296.

Colorplate 73 follows p. 296.

Van Gogh

This forerunner of Expressionism lived out his short life before the turn of the twentieth century. Vincent van Gogh (1853–1890) was a deeply religious man—a man aware of the cosmic, or divine, forces of the universe. He attempted to paint his feelings about the natural world—not only what he could see of it, but what he knew of it. Van Gogh thought of himself as a missionary of kindness. He lived a simple, humble life with miners, giving away his meager funds to the needy. He even shared his rooms with a prostitute and her child because he could not bear to let their suffering go unheeded. He was tormented by the suffering and agony of the human race and finally, to escape the reality of life, ended his own life in suicide. Like Beethoven, van Gogh had a profound conviction that his destiny was to try to bring humankind closer together.

The Starry Night (colorplate 74) expresses van Gogh's feelings about nature. The twisting cypress, the stark simplicity of the horizon and houses, and the swirling forces of the atmosphere of night combine to make this canvas an expression of the rhythm of the universe. Indeed, one can almost experience the movement of the earth against the stars. The realism, however, is not photographic; it is the realism of the painter's feelings about the scene. Van Gogh

Colorplate 74 follows p. 296.

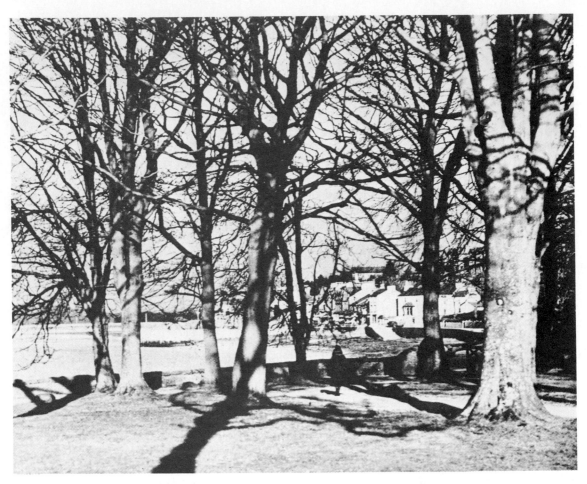

Figure 12.1 Photograph of Scene of Avenue of Chestnuts. (Keystone View Company)

sought to reveal the mysteries and the moving forces of nature. He used heavy oil paint in pure colors, which he applied in bold strokes and heavy lines. He did not bother with detailed drawings but preferred to portray the elemental character of nature with strong, contrasting curves of color. The inconsistent directions of the curves gives the canvas a swirling rather than a directional motion. Van Gogh even painted the motion of the atmosphere, which we know exists but cannot actually be seen. His coloring is daringly polychromatic, with brilliant blues, yellows and oranges. In fact, the most obvious elements of this work are color and line. All other elements seem quite unimportant, for van Gogh expressed his feelings about the internal forces of the universe through color and line.

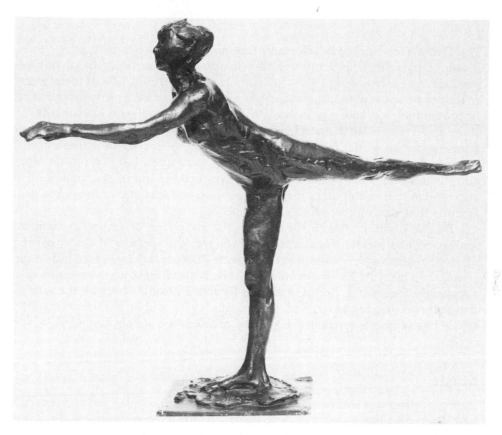

Figure 12.2 *Arabesque Ouverte Sur La Jambe Droite*—Degas. 11⅜″ high. (Los Angeles County Museum of Art/Mr. and Mrs. George Gard de Sylva Collection)

Sculpture

Degas

Ballet dancers and horses were two favorite subjects of the painter-sculptor Edgar Degas (1834–1917). Movement in space was his true preoccupation, as demonstrated in the *Arabesque Ouverte Sur La Jambe Droite* [Open Arabesque on the Right Leg (fig. 12.2)]. The balance, the poise, and the gesture create a bouyant, graceful sense of movement. The lines of the torso and limbs contribute to its dynamic effect. Degas sculptures were created originally in wax, and were even exhibited in that form. Cast later in bronze, they are eminent examples of Impressionistic sculpture.

Rodin

The feeling for luminous color and fragmentary form was primarily a technique of painting, but sculpture was also touched by the spirit of Impressionism. Auguste Rodin (1840–1917) was, without a doubt, one of the greatest sculptors of the nineteenth century. While he cannot be truthfully called an Impressionist, his later works show this influence. He began to "suggest" in stone and bronze. He liked to leave something to the imagination of the spectator—something that could be completed only in the visual experience of the beholder. To achieve this effect, Rodin sometimes left the plastic modeling of form incomplete and let his figures emerge out of the material. He also tended to dematerialize form by modeling surfaces into hollows and projections that catch light, producing shadows.

Colorplate 75 follows p. 328.

The Kiss (colorplate 75) illustrates this influence of Impressionism on sculpture. The play of lights and shadows over the surfaces of the entwined figures suggests warm flesh tones. The same effect of light seems to lessen the sense of weight and hardness of the marble. It also breaks up the volume into suggestive fragments. Rodin made his figures almost abstract by the lack of detail, by veiling the heads with the woman's arm, and by the use of shadow. While the subject is sensual, the passion of the scene is only suggested to the spectator.

Music

Impressionism was also carried over into music. Composers experimented with new ways and means of achieving coloristic effects in response to the luminosity of the painters. Many of these experiments seem fantastic to us today. Cyril Scott, the English composer, went so far as to work out a scientific analogy between the color spectrum and vibrations of sound. He then proceeded to compose according to this analogy. Scriabin, the late nineteenth- and early twentieth-century Russian composer, decided to include the sense of smell in his onslaught of the senses. The performance of his last work, *Mysterium*, which he never completed, was to include a screen with changing colors and the release of certain perfumes as an accompaniment to the music. These experiments were generally failures. However, Impressionism did find its successful counterpart in the music of Claude Debussy (1862–1918).

Debussy

Like the French painters, Debussy raised his voice in protest against the exuberance of Romanticism. His music was directly influenced by painting and literature, for Debussy was greatly stimulated by the paintings of Monet and the literary Impressionists. Debussy was also influenced by the music of the Orient, especially that from Bali and Indonesia, which was performed at the Paris Exposition of 1889. Naturally, the materials and techniques of music

differ greatly from those of the visual arts, and Debussy did not attempt to imitate the effects of coloristic scenes. He did, however, try to suggest the same kinds of feelings in his music as his colleagues did in painting and poetry. He sought to express the shimmering effects of light and shade in painting by means of tone color and chordal structure in music. Debussy sacrificed lyric melody, traditional form, and polyphonic complexities for suggestive harmonic progressions. In order to achieve a more luminous tonal coloring, he destroyed the traditional relationships of the successive scale steps and, in the **whole-tone scale,** he endowed each note with a subtle persuasion all its own. He weakened his musical cadences by parallel chord progressions that helped to dissolve harmonic tensions. Debussy's music is almost formless in its vague meandering of melody and harmony.

His *Prelude to the Afternoon of a Faun,* written in 1894, was the first of a series of Impressionistic compositions and, perhaps, the most successful of all. It is a brief symphonic poem based on Mallarmé's poem of the same title dealing with a mythical creature, a faun, half man and half beast. It describes the awakening of a faun in the forest and his recollection of the previous day, in which he wonders whether his experiences were dreams or whether the visit of the nymphs was real. Debussy captured the fanciful spirit of the poem with a tonal fabric that suggests the feeling of the poetic idea.

There is no obvious formal organization in this music, but Debussy implied the use of the repetition-after-contrast device by using three quite contrasting melodic ideas and repeating the first more than once. This main melody (ex. 12.1), played by the flute, rises and falls gently and chromatically, at first alone, then weaving in and out of subtle harmonic progressions that seldom reach a complete cadence.

Example 12.1: *Prelude to the Afternoon of a Faun*—Debussy

Climaxes are only anticipated, for they never reach the full force of tonal power that is promised. Rhythm is exceedingly complex, moving in and out of measures of nine, six, twelve, and four beats without establishing an easily recognizable pattern for any one of them. The fragile and lazy melodic line of the flute, the soft sweep of slightly dissonant chords on the harp, the restrained climaxes of the full orchestra—all of these suggest to the listener just the feeling of blissful drowsiness that the poet implies.

An analysis has already been made in chapter 2 of another of Debussy's works, *Nuages*. Debussy used the same techniques in both *The Afternoon of a Faun* and *Nuages*. In each he achieved a high degree of coloring and subjective feeling. Like Monet's paintings, *Rouen Cathedral* and *Banks of the Seine*, Debussy's music is evasive. It suggests a "feeling," thereby forcing the listeners into the creative process. The music is bathed in the soft glow of subtle harmonies, outlined by delicately shaded melodic lines that fade into the shadow of musical imagery.

Debussy reflected the oversensitive, restless mind of the late nineteenth century. He avoided the passion and sentiment of earlier composers, and yet there was little hint of the harsh, brittle materialism to come. His work is the very quintessence of musical Impressionism. No other composer, with the possible exception of Ravel (1875–1937), so consistently created works in this style. Suite I and II from Ravel's ballet, *Daphnis et Chloé*, are excellent examples of his Impressionistic style and skill in orchestration.

Boulanger

Lili Boulanger (1893–1918) lived a short and painful life. Her musical promise was enormous. In 1913 she became the first woman to be awarded the first prize in the Prix de Rome competition. Lili Boulanger's works are in a transitional style, moving somewhat beyond Impressionism. They possess formal clarity and abundant chromaticism; when they involve texts, as in *La Tempête* and *Les Sirènes*, they incline toward exotic subjects. Her sister, Nadia, was to achieve great fame as a teacher of many twentieth-century American as well as European composers.

Because much of the artwork of this period was lacking in vitality and spiritual ideals, Impressionism in music, as well as in painting, was destined to be short-lived. All the arts were to enter a period of radical revolt against the nineteenth-century traditions of music and art, including Impressionism.

Summary

Impressionism can be considered a bridge between Romanticism and twentieth-century abstract art. On one hand, it was a revolt against the emotional exuberance of the Romantic; on the other hand, it was an art of color attempting to achieve coloristic objectivity, both visually and in terms of tone color in music. Impressionistic painters were interested in the phenomena of instantaneous vision, the integration of color and line in the eye of the spectator. Artists painted what they actually saw at a particular moment, under the immediate conditions of atmosphere, light, and shade, and from a specific angle or perspective of vision. Impressionists usually went outdoors for their subjects. Landscapes, and especially water scenes, where the play of light and

wind could change color and forms, were favorite subjects. There is little movement, for the subject remains static. There is no passion or deep feeling evoked. Line, spatial concepts, and formal organization were subordinated to the technique of juxtaposing bold strokes of color that would blend in the eyes of the beholders.

Music came under the influence of Impressionistic painters and poets. In fact, some composers consciously tried to suggest the same kinds of feelings in music as those evoked in painting and poetry. Tone color and harmonic progressions took precedence over formal organizations, polyphonic complexities, and even over lyric melody in many instances. Composers weakened the strong tonal center of earlier music and thereby lessened the sense of tension and release associated with the emotion and passion of the Romantic period. Impressionistic music was written to suggest "feeling" with vague melodic lines, static harmonies, and rhythmic complexities. It invites listeners into the creative process in music in the same manner as color and line in Impressionistic painting invite the beholder to complete the scene.

Suggested Readings

In addition to the specific sources that follow, the general readings listed on pages xxi and xxii contain valuable information about the topic of this chapter.

Arnason, H. H. *History of Modern Art.*New York: Harry N. Abrams, Inc., n.d.

Austin, William W. *Music in the Twentieth Century: From Debussy through Stravinsky.* New York: W. W. Norton, 1966.

Canaday, John. *Mainstreams of Modern Art.* 2d ed. New York: Holt, Rinehart & Winston, 1981.

Davies, Laurence. *The Gallic Muse.* London: J. M. Dent, 1967.

Lockspeiser, Edward. *Music and Painting.* London: Cassell, 1973.

Rosenblum, Robert, and Jansen, H. W. *Nineteenth-Century Art.* New York: Abrams, 1984.

13

MODERN TO 1945

Chronology of the Twentieth Century

Visual Arts	Music	Historical Figures and Events
		■ Sigmund Freud (1856–1939)
■ Gustav Klimt (1862–1918)	■ Leoš Janáček (1864–1928)	
■ Wassily Kandinsky (1866–1944)	■ Scott Joplin (1868–1917)	
■ Käthe Kollwitz (1867–1945)		
■ Henri Matisse (1869–1954)		
■ Frank Lloyd Wright (1869–1959)		
■ Ernst Barlach (1870–1938)		
■ Georges Rouault (1871–1958)		
■ Julia Morgan (1872–1957)		
■ Piet Mondrian (1872–1944)		
	■ W. C. Handy (1873–1958)	
	■ Arnold Schoenberg (1874–1951)	■ Winston Churchill (1874–1965)
	■ Charles Ives (1874–1954)	
	■ Maurice Ravel (1875–1937)	
■ Constantin Brancusi (1876–1957)		
■ Raoul Dufy (1879–1953)		■ Josef Stalin (1879–1953)
■ Paul Klee (1879–1940)		■ Albert Einstein (1879–1955)
■ Pablo Picasso (1881–1973)	■ Béla Bartók (1881–1945)	■ James Joyce (1882–1941)
■ Wilhelm Lehmbruck (1881–1919)	■ Igor Stravinsky (1882–1971)	
■ Walter Gropius (1883–1969)	■ Anton Webern (1883–1945)	
		■ Franklin D. Roosevelt (1884–1945)
	■ Alban Berg (1885–1935)	
	■ Edgar Varèse (1885–1965)	
■ Diego Rivera (1886–1957)		
■ Charles Eduard Jeaneret (Corbusier) (1887–1965)		
■ Marc Chagall (1887–1985)		
■ Georgia O'Keeffe (1887–1986)		
■ Jean Arp (1888–1966)		■ T. S. Eliot (1888–1965)
■ Naum Gabo (1890–1977)		
■ Palmer Hayden (1893–1973)	■ Sergey Prokofiev (1891–1953)	
■ Joan Miró (1893–1983)		

[Continued]

Chronology [*Continued*]

Visual Arts	Music	Historical Figures and Events
	■ Paul Hindemith (1895–1963) ■ Ragtime (c.1897–1915)	
■ Alexander Calder (1898–1976) ■ Henry Moore (1898–1986)	■ George Gershwin (1898–1937)	■ Bertold Brecht (1898–1956) ■ Ernest Hemingway (1898–1961)
	■ Duke Ellington (1899–1974) ■ Aaron Copland (1900–) ■ Louis Armstrong (1900–1971)	
■ Alberto Giacometti (1901–1966) ■ Barbara Hepworth (1903–1975) ■ Salvador Dali (1904–1989) ■ Willem de Kooning (1904–) ■ Peter Blume (1906–) ■ David Smith (1906–1965)	■ Glen Miller (1904–1944) ■ Luigi Dallapiccola (1904–1975)	
	■ Elliott Carter (1908–) ■ Olivier Messiaen (1908–) ■ Benny Goodman (1909–1986)	
■ Jackson Pollock (1912–1956)	■ John Cage (1912–)	
		■ First World War begins (1914) ■ Panama Canal opens (1914)
	■ First printed use of the term *Jazz* (1917) ■ Leonard Bernstein (1918–)	■ First World War ends (1918)
■ Roy Lichtenstein (1923–) ■ Robert Rauschenberg (1925–) ■ Agam (1928–)	■ Gyorgi Ligeti (1923–) ■ Gunther Schuller (1925–) ■ Karlheinz Stockhausen (1928–) ■ Thea Musgrave (1928–)	
■ Claes Oldenburg (1929–) ■ Andy Warhol (1930–1989) ■ Bridget Riley (1931–)	■ Krzysztof Penderecki (1933–) ■ Morton Subotnick (1933–) ■ Peter Maxwell Davies (1934–) ■ Steve Reich (1936–) ■ Philip Glass (1937–)	
■ Robert Smithson (1938–1973)		
		■ Nuclear fission discovered (1938) ■ Atomic bomb destroys Hiroshima and Nagasaki (1945) ■ First assembly of the United Nations (1946)
■ Pop and Op art (c.1950)	■ Rock and Roll begins (ca. 1955)	■ First satellite (sputnik) launched by Russia (1957) ■ First man landed on the moon (1969) ■ First space shuttle launched (1971) ■ Vietnam War ends (1975)

Pronunciation Guide

Arp, Jean (Ahrp, Zhăh)
Bartók (Bahr'-tok)
Bauhaus (Bow'-hows)
Berg (Bayrg)
Bloch (Blokh)
Brancusi (Bran-koo'-zee)
Chagall (Shah-gahl)
Corbusier (Kohr-boo-see-ay)
Dali (Dah-lee)
Freud (Froyd)
Gabo (Gah-boh)
Giacometti (Jah-koh-met'-tee)
Gropius (Groh'-pee-oos)
Guernica (Gwer'-nee-kah)
Hába (Hah'-bah)
Kandinsky, Wassily (Kahn-din'-skee, Vah-see-lee)

Klee (Klay)
Klimt (Klimt)
Kollwitz, Käthe (Kohl'-vitz, Kay-te)
Koussevitsky (Koo-se-vit'-skee)
Lehmbruck (Laym'-brook)
Mahler (Mah'-ler)
Matisse (Mah-tees)
Miro (Mee-roh)
Mondrian (Mon-dree-ăn)
Petrouchka (Pe-troo'-shka)
Picasso (Pee-kah'-soh)
Pogany (Poh-gah'-nee)
Ravel (Rah-vel)
Rouault (Roo-oh)
Schoenberg (Shoen'-berg)
Stravinsky (Strah-vin'-skee)
Webern (Vay'-bern)

Study Objectives

1. To learn about the revolt against the excesses of Romanticism.
2. To learn about the rise of jazz as a phenomenon of the early twentieth century.
3. To learn about the influence that mass media has had on all the arts.
4. To study the technical development of new materials and new sounds.

This book is based on the thesis that art reflects the cultural forces of the age. What, then, are some of these forces in the twentieth century, and how have they affected art?

The first fifty years of the twentieth century brought drastic changes to the Western world. Many of these changes can be attributed to technological and scientific advances, with technical experiments and developments that resulted in a scientific view of life. It led to a society that was in many ways a chaos of over-organization and was almost brutally indifferent to individual human personality. The two world conflicts in the first half of the century showed the twentieth century to be an age of doubt and distrust, an age of uncertainty, dissatisfaction, and disillusionment.

In addition to scientific advances, there were changes taking place in the economic, social, and moral spheres of life. These innumerable changes represent signs of a new era.

In spite of the technical nature of modern civilization and our distrust and disillusionment, artists have been generally expected to continue to function as they had in previous times, producing romantic art of feeling and sentiment. While society was living in a mechanical world, it often condemned the artists who embodied in their art the intellectual, spiritual, social, scientific, and economic trends of the time. Artists have always been prophets of the future and reliable indexes of the present, for they have the intuitive power to sense relationships and trends. If we fail to acknowledge this, we are guilty of ignorance and of denying our own culture.

Artistic growth, like physical growth, is essential to life. The trends in music and art at the beginning of the century were nothing more than growth or change, which came about by breaking down old boundaries and widening the horizons of artistic expression. The Renaissance was a response to the medieval period, Romanticism was a reaction to Classicism, and Impressionism was a rebellion against Romanticism. Modern art, some of whose proponents even issued manifestos, might be called a revolt, a revolt against the sentimentality of Romanticism and, at the same time, an affirmation of the scientific attitude.

After the turn of the century, artists began to question not only the emotionalism and sentimentality of the Romantics, but also the real, material world that had seemed so authentic and permanent to their predecessors. There arose a demand for some sort of artistic response to the scientific phenomena being explored and a need for their integration into society. The research with X rays and the microscope, the splitting of the atom, the new concepts of time and space, the psychological research of such people as Freud—these challenged Western artists. The result was a rejection of the Renaissance theory that art must be based on natural representation. In their attempts to understand and express what lay beyond natural appearances, artists developed a new conception of the world based on inner exploration, not outward appearance. The essence of things came to be of greater importance than their outward forms to the artist as well as to the scientist. Creative minds emulated scientists; they tried to make of art some sort of universal vision, freed from physical appearances and, at the same time, a truthful mirror of their age.

How can people of any age tell whether contemporary artists are truly incorporating truthful remembrances of their time into art? This difficult question troubled the public in the first half of the twentieth century and was to persist in its latter half. Only the slow and cumbersome processes of time can state: "Here is a rich consummation of the spiritual influences and tendencies of a hectic age." We who live in that hectic age do not want to wait; we desire a final statement immediately. If we cannot have it, we are likely to retreat to the work of those artists on whom time has already placed its stamp of approval. We must have the tolerance and the courage to face our artistic future. We must endeavor to understand what contemporary artists are trying to do, and we must set values on their work.

While we cannot state with finality that this or that contemporary artist is "great," there are certain trends that we can observe and evaluate. Artists of all periods, whether painters, sculptors, architects, or composers, can be grouped into three types. Since we are so close to the artists of this century and cannot always separate the great from the less than great, it will be advantageous to know what these three types are.

One type of artist can be called "sensationalist." Sensationalists break down convention and throw overboard the ballast of accepted methods and values. They are often brilliant, but, because their art is most often aimed at gaining attention through shocking subjects and techniques, their works frequently lack expressive qualities and sometimes even sincerity.

The second type can be called the "experimentalist." As is the case with most innovators, they are seeking new methods and combinations of materials to express themselves. They are treading on new ground and are basing their art on untried theories. They are sincere, but their art often lacks unity and coherence. Experimentalists pay the price of most innovators, for they seldom perfect what they invent.

The third type consists of artists who are great enough to combine what is good from the first two types and what is valid from the past in personalized artistic expressions. Their art is usually less brilliant but it shines with a more steady light than that of the sensationalist or experimentalist.

Like Romantic art, early twentieth-century art was difficult to reduce to a set of rules. Many experimental styles left their mark. Because of the accelerated tempo of life, there were rapidly changing movements in art. There was such a general overlapping of styles that they could not be separated chronologically. A few basic principles, however, seem to be common to most twentieth-century artists. These principles were not subscribed to by all artists, nor were they necessarily applicable to the works of those who did accept them.

The first principle held that artists must break with the past. For many artists working in the early half of the twentieth century, this dictated the rejection of nineteenth-century Romanticism. The so-called Modern movement was a revolt against all that the Romantics stood for—their techniques, their subjects, and their expressions. If these artists had any attachment to the past, it was to the Classic ideal, for they were more concerned with method than with subject.

Second was the principle that artists should reject subjective emotion as the primary basis for art. Modern artists rejected the idea that personal feeling or emotion had a place in artistic expression. This attitude was perhaps born of the scientific age, dominated by the machine made of steel.

The third principle was the rejection of the concept that art must be realistic or literal. Artists insisted that art was a matter of representing abstract patterns—something that could exist as an absolute in itself rather than as a means for suggesting ideas, experiences, or definite objects. This also demonstrated the scientific attitude of understanding the world in terms of mathematical formulas.

The last principle was the rejection of unnecessary ornaments and of attempts to "dress up" art. "Form follows function" became a motto for Modern artists. As a result, there was a demand for simplicity, terseness, and often brutality of expression. There was little attempt to please or to entertain, but only a desire to reflect the age directly and unashamedly.

From the previous discussion it might appear that most twentieth-century art would be cold, intellectual, and perhaps cynical. This was sometimes true during the early decades, but there followed a softening, a realization that feelings do have a place in art. From about 1930 there was a tendency on the part of some artists to return to Romantic ideals—not to a point of sentimentality but to the recognition that people have souls and even the machine must be guided by human hands.

Another factor that should be taken into consideration in the study of twentieth-century art is the relationship of artists to their public. Creative artists are sometimes alienated from the public for a number of reasons. First, the public cannot keep pace with the changes in art styles. It takes time to become acclimated to a style and, in this century, the public barely comes to a point of accepting a particular style when that style is no longer current. Consequently, the gulf between patron and artist is widened and the patron may seek aesthetic pleasure in something more firmly established in the past.

The second reason for the alienation of creative artists from their public is closely related to the first. Because of the technical advances in mass production of copies and because of the availability of recordings, the public no longer has to depend upon the gallery or concert hall for artistic experience. There is less urge to explore the new and the untried. Mass education and mass communication have made available an unprecedented range of artistic creations from all eras. Trade publishing, recordings, radio, television, and motion pictures give to the public artists and old masters heretofore unknown.

Because modern art has often explored unknown territory, artists have had to retreat into teaching or some other means of making a living. Seldom could they live by their creative efforts. Architects, however, were among the few remaining artists whose works received broad recognition and who generally reaped reasonable rewards from society. This was due in part to the functional nature of architecture, and this new architecture evoked an enthusiastic response from a society that worshiped efficiency and usefulness.

Painting

There was no dominant style in painting during the first half of the twentieth century. Furthermore, because we are still relatively close to these artists, it is impossible to pick out for study only those who will stand the test of time. We will therefore confine our study to what seem to be the most important movements and to the works of artists who seem to have had great influence on their contemporaries. From our vantage point near the end of the century, they seem to have endowed their art with something of the spirit of the Modern age. Expressionism, Cubism, and Surrealism are three major movements among many that flourished during the opening decades of the twentieth century (e.g., Fauvism, Constructivism, Der Blaue Reiter (Blue Rider), Art Nouveau, Dada).

Expressionism

Some artists of this period desired to go beyond natural appearances and to present the inner meaning of natural phenomena. One aspect of this influence is called **Expressionism.** Expressionist artists gave primary attention to the expression of intense, elemental feelings rather than the visible world. They were neither Romanticists, nor realists. They had no desire to depict the world as they saw it but rather as it was perceived psychologically. As a consequence their style included distortion of color, line, and form. Their style frequently involved almost violent application of paint to the canvas. They were aware of the conflicts inherent in the world—conflicts in both nature and human nature—and sought to express those in their art.

Matisse

Art historians place Henri Matisse (1869–1954) in the French Expressionist school called **Fauves** (wild beasts). During the course of his life he was not committed to this one style, but rather experimented with several artistic styles, including pointillism. His simple but strong forms, together with his innovative use of color, were startling to his contemporaries. He used color without reference to three-dimensional forms or to the reality of forms. *Blue Window* (colorplate 76) demonstrates his interest in strong color harmonies, decorative motifs, and the elimination of detail. It is an abstract, still life study that blends into a kind of stylized landscape. A sense of recession is suggested by a lessening of the intensities of color in the background. The colors do not fuse into a scheme of color harmony but seem to retain their own intense identities.

*Colorplate 76
follows p. 328.*

Klimt

This imaginative Austrian painter represented Art Nouveau as well as Austrian Expressionism. Gustav Klimt (1862–1918) painted rich, decorative surfaces in his often erotic works. The surfaces frequently appear flat, denying the third dimension, and rely on pattern to create intense visual images. *Expectation* (colorplate 77) has the appearance of a rich, gold, Oriental quilt. The human figure is rendered almost invisible in the two repeated patterns. The flat surface decorations are strongly suggestive of Egyptian wall painting and even contain the repeated figure of an Egyptian eye. The result produces a two-dimensional sensuality that is in many ways unique.

Colorplate 77 follows p. 328.

Rouault

An example of late Expressionism is found in the works of Georges Rouault (1871–1958), an original member of the Fauve group. His *Christ Mocked by Soldiers* (colorplate 78) is one of a small number of religious paintings in the modern Expressionistic idiom. The artist used broad heavy lines of black to give a forceful linear quality to his figure. He expressed the pathos of Christ and the brutality of the soldiers by deep reds and greens and by minimal but dramatic use of cobalt blue, colors characteristic of stained glass windows. In fact, Rouault worked at the trade of stained glass for a time and carried this technique over into his paintings. Somewhat like van Gogh, he conveyed the feeling for his subject by heavy applications of colors and forceful lines. Organization and spatial depth seem secondary. In addition to the psychological realism of the incident, Rouault saw in the mocking of Christ a symbol of the mocking and brutality of the modern world.

Colorplate 78 follows p. 328.

Kandinsky

Another painter, Wassily Kandinsky (1866–1944), was an important figure in the artistic politics of the 1917 Russian Revolution. He was forced to leave Russia when the Soviets decided that nonrepresentational art did not fit their plan of Marxist propaganda. He went to Germany, where he was associated with the Blaue Reiter, and taught at the Bauhaus School until the Nazi regime closed it. He eventually went to Paris, where he worked until his death.

Kandinsky's abstractions used color as the basis for artistic expression. In fact, he wrote extensive essays on the psychological and expressive meaning of color. His *Painting Number 198* (colorplate 79) is one of a series of nonobjective paintings in which he used a complex rhythmic flow of line and color that seems to move from the bottom to the top with energized movement and dramatically contrasting colors. The viewer's eye constantly moves along the line from color to color in much the same manner as the ear absorbs the line and tonal coloring of much of twentieth-century music by composers such as Schoenberg and Webern.

Colorplate 79 follows p. 328.

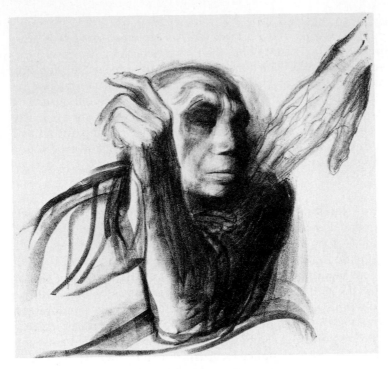

Figure 13.1 *Hand of Death* [1934]—Käthe Kollwitz, p.c. (Art Resource Ruf des Todes)

Kollwitz

Käthe Kollwitz (1867–1945), a contemporary of Rouault, is recognized as one of the major artists of the first half of the twentieth century. Her predominant focus was the harsh side of life, particularly as it was experienced by the poor. She found the world of graphics, with its dependence on black and white, to be a powerful medium of expression for such themes. The *Circle of Mothers*, a sculpture done in 1937, and such graphics as *Hand of Death* (fig. 13.1), *Home Industry*, and the *Peasants' War* series demonstrate her lifelong commitment to themes of the downtrodden.

Cubism

Cubism was a style of twentieth-century art that reduced nature to its basic geometric patterns, such as circles, squares, triangles and rectangles, and to three-dimensional forms, such as the cone, sphere, cube, and cylinder. Like scientists, these artists saw the mechanical side of nature in recurring geometric forms, and they eliminated all superficial detail in order to reveal these

forms. Again, the artists painted what they knew, not what they saw. In pursuing this style, they were concerned more with *how* a work was painted and less with *what* was painted.

Picasso

The best-known painter in the twentieth century is Pablo Picasso (1881–1973). He did not limit himself to any one modern idiom but experimented and changed his style many times. He was one of the first artists to be influenced by the sculpture of primitive Africa and by artifacts from other non-Western cultures. Three of the five faces in *Les Demoiselles d'Avignon* (colorplate 80) are in varying degrees Cubist renderings of African masks. The female figures are an early experiment with the faceting which was characteristic of Cubism. They are distinguishable from the background to a large degree only through their color.

Colorplate 80 follows p. 328.

Building upon Cézanne's approach, Picasso made notable advances in the techniques of Cubism. In addition to breaking natural forms into geometric designs, he expressed new space relationships by reordering the components of his subject matter. He rejected all rules of perspective and showed several points of view at the same time. *Girl Before a Mirror* (colorplate 81) is one of Picasso's best-known paintings in Cubist style. He not only divided the female figure into its elemental forms but also presented it from different points of view simultaneously, cleverly employing the mirrored image, an old formal device. He also reflected the recent scientific discoveries in the field of time-space relationships by destroying the traditional sense of time and space in painting. He superimposed a profile view of the body on a frontal view of the face and then reflected the image in the mirror. In reducing the figure to geometric forms, Picasso emphasized the breasts, abdomen, and hips, symbolic of womanhood. His lines are sharply delineated with brilliant colors of black, red, yellow, green, and purple, suggesting, as did Rouault, the techniques of stained glass. Picasso created a nonrealistic painting of the idea of woman in its geometric forms.

Colorplate 81 follows p. 328.

Mondrian/Klee

An example of Cubism carried to the point of abstraction is *Composition in White, Black, and Red* (colorplate 82) by Piet Mondrian (1872–1944). Mondrian dispensed with all suggestion of real objects and even eliminated an objective title. This painting is purely abstract. It suggests that just as music can appeal to one's aesthetic sense through its melody, harmony, and rhythm, painting can appeal through pure line, color, and organization. While the painting looks simple, it is really very complex. Every line is of a different thickness (although this is difficult to detect in such a small reproduction), and each area of white is of a different size. The whole is organized and balanced with a mathematical exactness that makes it very difficult to imitate.

Colorplate 82 follows p. 328.

An important painter whose works verged on Surrealism, but were based on Cubism, is Paul Klee (1879–1940). His art is one of delicate line, used with subtle pastel coloring. His *Twittering Machine* (colorplate 83) is almost a comic-strip drawing. By linear means, it amuses viewers with the subject of symbolic birds operated by a mechanical device as a satire on the mechanistic world. By the same devices, the painter even suggested the experience of sounds; the exclamation point coming from the beak of one of the birds suggests loudness. The sensation of piercing shrillness is suggested by an arrow through the beak of one of the twitterers.

Colorplate 83 follows p. 328.

Surrealism

Perhaps the most spectacular of all the movements of the twentieth century is **Surrealism,** a style of art that aims to portray the reality and intensity of the subconscious mind. This movement in art was inspired by scientific research, for it was linked closely to post-World War I developments in Freudian psychology and the interpretation of dreams. Surrealism freed those drives that are usually suppressed in normal life and laid bare the motivating forces that influence our thoughts, actions, and desires. It utilized the stream-of-consciousness technique to record feelings or thoughts that are normally considered outside the realm of expression, using symbols to convey the meanings of dreams. As a result, all sorts of fantastic and unreal forms appear in Surrealistic art.

Dali

Colorplate 84 follows p. 328.

Salvador Dali (1904–1989) is the best-known and most sensational of the Surrealists. His *Persistence of Memory* (colorplate 84), with its fantastically limp watches, is an unforgettable painting. Dali painted everything with the greatest detail; even the rocks in the distance are almost photographic in their realism. Space seems limitless because of the elimination of atmosphere and because the distant objects are as detailed as the closer ones. The most unnatural parts of this painting are the limp watches hanging over a barren tree limb and over the edge of a table. The distorted central figure, and the juxtaposition of unrelated objects (ants and pocket watch) evoke the feeling of a dream. The observer may not immediately understand all that Dali symbolized but will never forget the painting. Perhaps this is what Dali had in mind when he gave it the title *Persistence of Memory.*

Blume

Contemporary events provided many subjects for early twentieth-century artists. This was especially true of the rise of Fascism, Nazism, and Communism. Modern wars were frequently chosen as the subject for Expressionistic and Surrealistic treatment. In the early thirties, the young American artist Peter Blume (1906–) spent some time observing the rise of Fascism in Italy and came home to put on canvas what he had seen and felt. *Eternal City*

(colorplate 85), an allegorical picture of wartime Rome complete with a church, Mussolini, and the crushing weight of Fascism, was the result. Blume gathered together a great variety of symbols to remind the spectator of the lost beauty and tradition, the decadence, and the violence of Mussolini's Rome. The painting is divided in half on the diagonal from the upper left to the lower right. The ancient, stable past, represented in the upper right background, is painted in a style and technique that would have been the envy of many fifteenth- and sixteenth-century Italian painters. Its illumination and clarity contrasts starkly with the detailed Fascist world. The picture is allegorical. It represents the forces that lead eventually to carnage and war. Every symbol is painted in minute detail, and colors are sharply contrasted. The bright green head of Mussolini contrasts with the blinding white of broken marble. Christ, placed in a grotto with the symbols and medals of war, overlooks the great chasm into which humanity has been plunged and from which the monster Jack-in-the-box originates. Blume used the techniques of realistic detail to achieve his effects. His message is transmitted by the impact of incompatible forms that symbolize the various forces of Fascism. This is an intentionally ugly picture, for Blume wanted to make clear his prophecy of the end of Mussolini and Fascism years before it happened.

Colorplate 85 follows p. 328.

Picasso

Another shocking picture that came out of the war was painted by Picasso. As mentioned earlier, Picasso did not subscribe to any one style; he changed as the times changed and grew as his insight into life grew. It is still too early to tell, but of all twentieth-century painters, Picasso seems most likely to be remembered the longest. *Guernica* (fig. 13.2) is a huge painting depicting the horrors of an air raid. In 1937, the German Air Force, flying for Franco in the Spanish Civil War, bombed the Spanish village of Guernica as an experiment in modern warfare (the "Blitzkrieg"). Judging from the number of people killed and the destruction caused, the experiment was indeed a success, and the technique was to be used again and again. Picasso, a Spaniard, was shocked by this brutality, and set about to create a great canvas in protest against all war. He used linear drawings of fragments to symbolize the manifold horrors of destruction. There is no spatial depth, for these are patterns on a two-dimensional plane. The colors are gray, black, and white—colors symbolic of death and mourning. Some of the allegorical forms seem quite obvious: a woman with her dead child, a broken sword, a dying horse, newsprint telling the horrible story. Other forms are clothed in the mystery of a dream world: the illuminated light bulb, the hand with a lamp (both perhaps revealing these horrors to the world), the violent but pathetic bull. All these, and many more, make up Picasso's artistic protest against twentieth-century brutality. Despite his strong feelings about the subject, Picasso retained the abstract quality of twentieth-century painting. Every symbol does more than suggest a scene of terror, it also fits into the organization of abstract patterns of pure design.

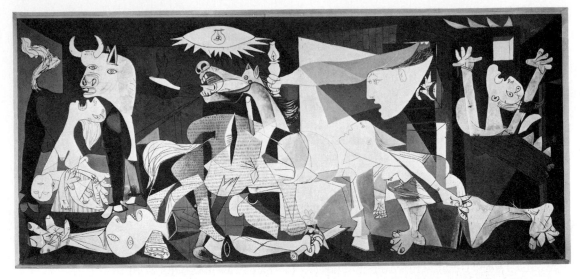

Figure 13.2 *Guernica* [1937]—Picasso. 11′6″ × 25′8″. (© SPADEM, Paris/VAGA, New York, 1982)

Miro

Colorplate 86 follows p. 328.

An artist who demonstrated both Surrealism and Abstractionism was Joan Miró (1893–1983). He suggested Surrealistic symbols by forms that appear as if they had developed as living organisms. These forms are often called biomorphic in modern art. In Miró's *Person Throwing a Stone at a Bird* (colorplate 86), the title stimulates the viewer, and a whimsical fantasy is created by color and the almost childlike biomorphic forms. Its most striking aspects of formal organization are its two-dimensional, sharply defined curvilinear lines and the brightly contrasting colors.

Chagall

Colorplate 87 follows p. 328.

Marc Chagall (1887–1985) was a Russian artist who never abandoned his affinity for Russian life and its folklore. While he was influenced in his early works by Cubism and its geometric forms, he revolted against its rationalism. His preference for irrational arrangements of natural objects led to a use of dream imagery in his paintings. *I and the Village* (colorplate 87) grew out of memories of his youth. The painting transports the viewer magically into the world of childhood dreams associated with Russian folklore. The composition consists of simple peasant figures, roosters, and floating cows, with a richly colored and irrational organization of figures that seem to float in space. Chagall was also responsible for numerous theatrical sets, as well as decorations for the opera house at Lincoln Center in New York and for the Paris Opera.

Chagall was active in the Yiddish theater in Moscow where he designed scenery and costumes and painted decorative murals for theater interiors. The *Green Violinist* (fig. 13.3) was one of several studies of this "Fiddler on the

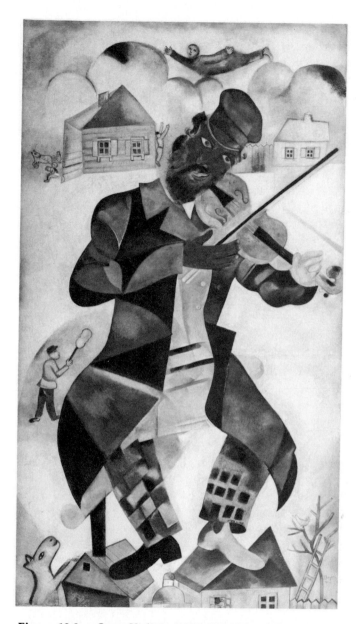

Figure 13.3 *Green Violinist* [1923–24]—Marc Chagall. Oil on canvas, 78″ × 42¾″ (198 × 108.6 cm). (Solomon R. Guggenheim Museum, New York, Gift of Solomon R. Guggenheim 1937. Photo: David Heald)

Roof," the subject of a Yiddish folktale, and was used by Chagall in one of the murals of the Yiddish theater. The violin and the figure's location on the roof were symbolic of the precarious position of the Jews in a very repressive society. The vivid colors are typical of Chagall's love of startling and dramatic contrasts. The whole is another example of his deep immersion in fantasy.

Rivera

One of Mexico's greatest twentieth-century painters was Diego Rivera (1886–1957). In many of his works, his leftist political commitment is evident. While he was an easel painter as well as a graphic artist he is best known in the United States as a muralist. He did frescoes in San Francisco, Detroit and New York. Those decorating the Detroit Institute of Arts teem with machines, workers, and the activities of industry (colorplate 88). While many murals by Rivera remain in Mexico, the Detroit mural is his most important work in the United States.

Colorplate 88 follows p. 328.

Hayden

When Tricky Sam Shot Father Lamb (fig. 13.4) explores the folk idiom in painting. Palmer Hayden (1893–1973) works in a realistic style that might even be called genre painting. Using flat, decorative color, much as did Matisse, there is little modeling of faces or figures. The psychological focus is achieved by the intense lighting on the tenement wall, and the attention of the concerned neighbors.

O'Keeffe

There is a surrealistic quality in many of the works of Georgia O'Keeffe (1887–1986). This renowned American painter lived in New Mexico for much of her life, and the landscapes and artifacts of that region strongly influenced the choice of content in her paintings. In *Cow's Skull with Calico Roses* (colorplate 89), a background of sand-colored rocks separated by a black void divides the background into two vertical sections. The chalky gray-white of the skull and roses lends a pallor to the whole. The gentle colors are interrupted by the tan section in the broken nose of the skull and the black vertical void. The bold symmetry of the painting is challenged by the slightly off-center void and the flower superimposed on the right horn of the skull. O'Keeffe's paintings seem to move between the fecundity of opulent flowers and arid symbols of the desert.

Colorplate 89 follows p. 328.

Sculpture

Sculptors reacted to the twentieth-century scene in much the same manner as painters. Cut loose from the patronage of the Church and the aristocracy, they also had to seek new functions and new markets for their works. They too were alienated from the public because of the nonobjectivity of their art

Figure 13.4 *When Tricky Sam Shot Father Lamb* [1893–1973]—Palmer Hayden, United States. [H. 30½" (77.5 cm.) W: 39⅞" (101.3 cm.)] Oil on canvas. Photo Courtesy of the Los Angeles County Museum of Art)

and public conservatism. Like painters, sculptors experimented with new techniques and new materials, seeking new expressiveness and a sensitive patronage.

There appears to have been at least one important trend in the function and patronage of sculpture. Artists began to create works in scale and design that fit into the modern home. In the past, they conceived monumental pieces for the Church, for palaces and gardens of the nobility, or for public buildings and memorials. With the decrease in this market, they turned to the home as a gallery, creating works especially designed as decorative pieces for modern living. New timesaving tools with which to work and new processes of reproduction also helped to bring the pleasures of sculpture within the economic possibilities of those with modest incomes, whereas in the past, it was only the wealthy who could afford this pleasure.

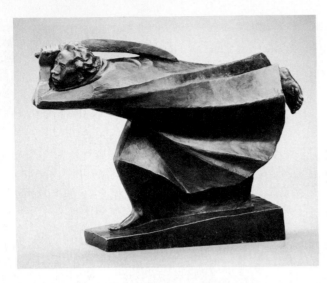

Figure 13.5 *The Avenger*—Barlach. [17½″ × 8½″ × 23½″] (Gift of Mrs. George Kamperman in memory of her husband Dr. George Kamperman, © Detroit Institute of Arts, 1989)

Another factor also influenced the techniques and expressions of twentieth-century sculptors. Unlike painters, who in general used the same materials as in the past, sculptors had a variety of new materials and new processes at their disposal. Aluminum, chrome, and plastic are but a few that were successfully used. The physical characteristics of these new materials provided artists with many new possibilities of form and surface finishes with which to express modern life.

In general, the sculptors followed the lead of the painters in their attempts to go beyond natural appearances and to express inner meanings. They also subscribed to the same artistic creed—the revolt against Romanticism, the rejection of emotion, objectivity, and ornamentation. Expressionism, Cubism, and Surrealism in painting had their counterparts in sculpture. Sculptors expressed their feelings about the times in the same manner as their colleagues of the canvas and brush, except that they used different techniques and a different medium.

Sculptors

The German sculptor Ernst Barlach (1870–1938) exemplifies early twentieth-century sculpture through the use of elemental planes, reduction of detail, and expressive distortion. *The Avenger* (fig. 13.5) is a dynamic image, infused with power achieved through its appearance of imbalance and motion. As in many of Barlach's works, line plays a critical role. Though *The Avenger* has an aggressive stance with its raised sword, like so much of Barlach's work, there is a benign spirit present.

The Expressionistic movement in sculpture is well represented by Wilhelm Lehmbruck (1881–1919). He distorted and elongated forms in order to realize the expressive feeling he was seeking. In the *Kneeling Woman* (fig. 13.6)

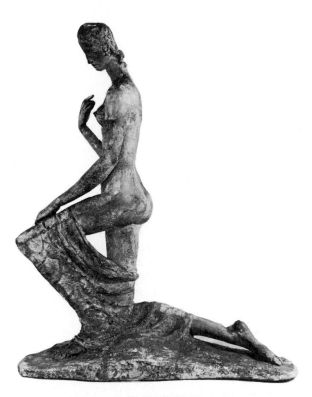

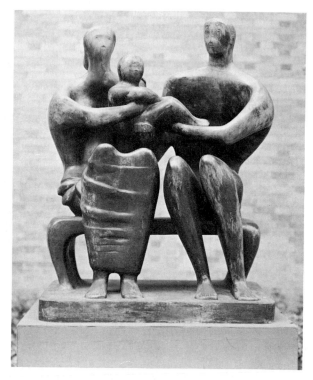

Figure 13.6 *Kneeling Woman* [1911]—Wilhelm Lehmbruck. Cast stone, 69½″ high, at base 56″ × 27″. (Collection, The Museum of Modern Art, New York. Abby Aldrich Rockefeller Fund)

Figure 13.7 *Family Group* [1948–1949]—Henry Moore. Bronze (cast 1950), 59¼″ × 46½″, at base 45″ × 29⅞″. (Collection, The Museum of Modern Art, New York. A. Conger Goodyear Fund)

of cast stone, Lehmbruck endowed his figure with a feeling of simplicity and naturalness without being literal or objective. He distorted the neck, torso, arms, thighs, and legs to suggest an almost medieval feeling of asceticism. The open spaces only add to the linear quality and to the feeling of elongation. Like van Gogh, Lehmbruck was not realistic about anything except the expression of the humanity, the pathos, and serenity of his subject.

Many sculptors employed the style of Cubism in their works. Some broke up the forms into cubes and spheres while retaining the recognizable features of the subject. Others reduced their forms to almost complete abstractions. Henry Moore's (1898–1986) *Family Group* (fig. 13.7) typifies a style of organic free forms, with just enough physical realism to be representational. Moore was strongly influenced by primitivism, and this work shows a predilection for smooth, rounded forms that symbolize the basic shapes of the human figure without realistic detail. Moreover, there is unity among the figures that gives strength to the expressive idea of the family unit.

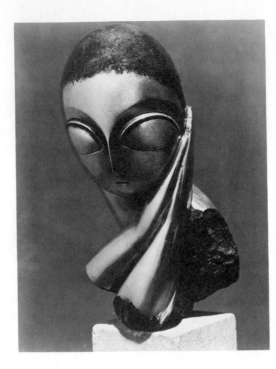

Figure 13.8 *Mlle. Pogany.* Version I [1913]—Constantin Brancusi. After a marble of 1912; bronze, 17¼″ high. (Collection, The Museum of Modern Art, New York. Acquired through the Lillie P. Bliss Bequest)

Constantin Brancusi (1876–1957) used polished surfaces of silver and bronze to show the play of light and dark in bringing out the natural shapes of his geometric forms. *Mlle. Pogany* (fig. 13.8) is one of his best pieces in the Cubist tradition that still retains identifiable features. The young lady's head is a prolate spheroid, and the eyes are two great curves that meet at the nose. Contrast is provided by the texture of the hair and by the elegantly attenuated wrists and hands. This is simple Cubism using curved forms. There is little decoration, emotion, or realism, but there is a play of light and shadow over the surface of the metal that gives rhythmic movement to the mass. There is also a formal organization of the sculptural masses that clearly suggests a human head.

An even more abstract piece of Cubism in sculpture is *Spiral Theme* (fig. 13.9) by Naum Gabo (1890–1977). Using only plastic, he experimented with both time and space in the manner of Picasso's *Girl Before a Mirror*. The translucent quality of the material makes it possible to impose one plane upon another simultaneously. This quality creates a sense of rhythm and motion in both time and space.

Human Concretion (fig. 13.10) by Jean (Hans) Arp (1888–1966), is related to the Surrealistic technique of symbolic imagery. The softly molded forms

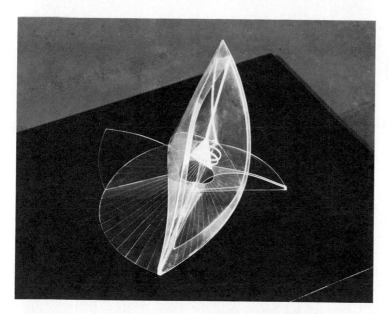

Figure 13.9 *Spiral Theme* [1941]—Naum Gabo. Construction in plastic, 5½″ × 13¼″ × 9⅜″, on base 24″ square. (Collection, The Museum of Modern Art, New York. Advisory Committee Fund)

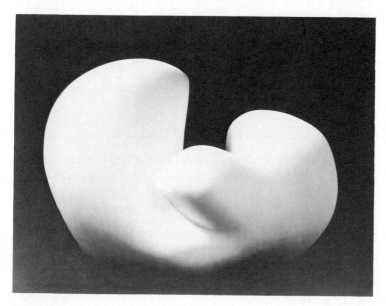

Figure 13.10 *Human Concretion* [1935]—Jean Arp. Original plaster, 19½″ × 18¾″. (Collection, The Museum of Modern Art, New York. Gift of the Advisory Committee)

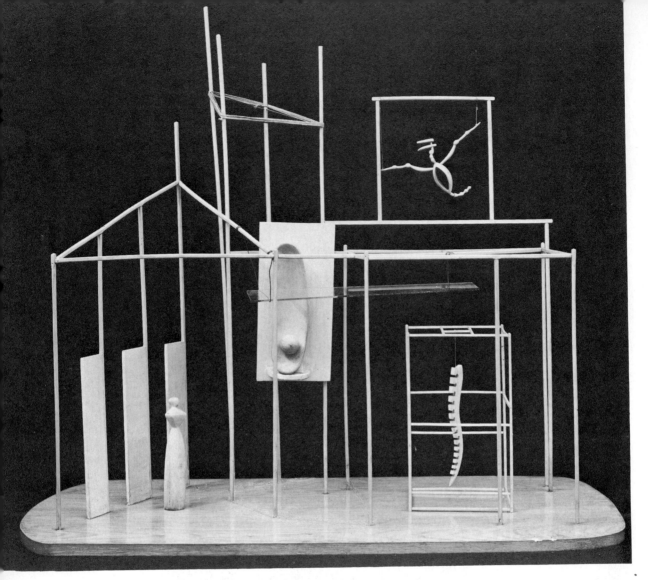

Figure 13.11 *The Palace at 4* A.M. [1932–1933]—Alberto Giacometti. Construction in wood, glass, wire, string, 25″ × 28¼″ × 15¾″. (Collection, The Museum of Modern Art, New York. Purchase)

are abstract and are rhythmically balanced by the repetition of similar shapes of different sizes. These would be purely abstract but for the title *Human Concretion*, which means the concreteness of something that is human and relates the forms to some organic or protoplasmic matter. Arp brought Surrealism into his work by his choice of title, creating both interest and confusion but nevertheless introducing an element of the subconscious.

Alberto Giacometti (1901–1966) was one of the important sculptors who joined the Surrealistic movement. His *Palace at 4* A.M. (fig. 13.11) is a fantasy

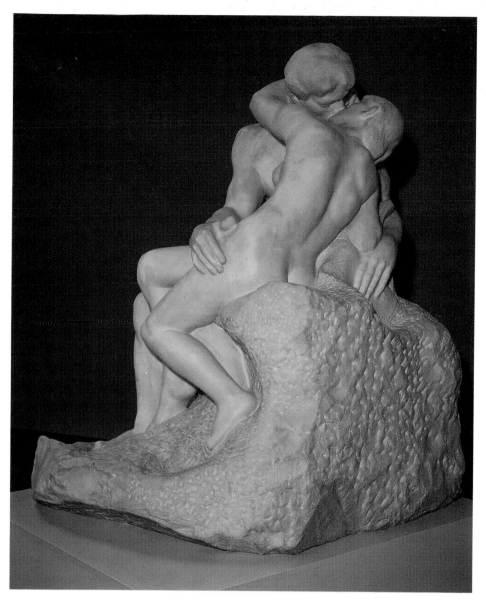

Colorplate 75 *The Kiss* [1886]—Auguste Rodin. Over life size. (Tate Gallery, London/Art Resource, N.Y.)

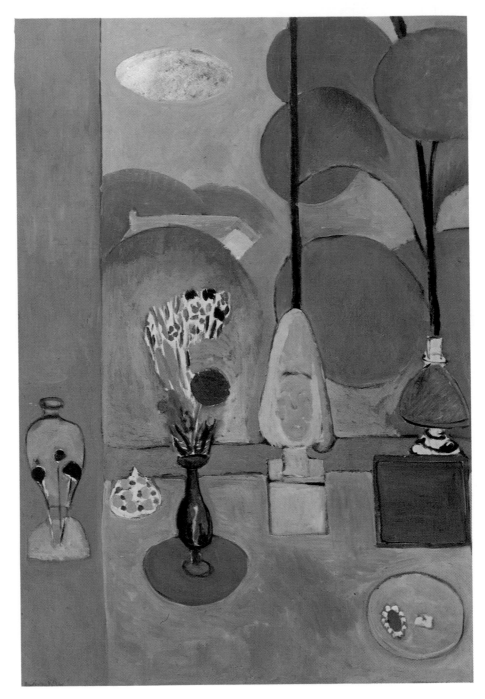

Colorplate 76 *The Blue Window* [1911] autumn—Henri Matisse. Oil on canvas, 51½″ × 35⅝″. (Collection, The Museum of Modern Art, New York. Abby Aldrich Rockefeller Fund)

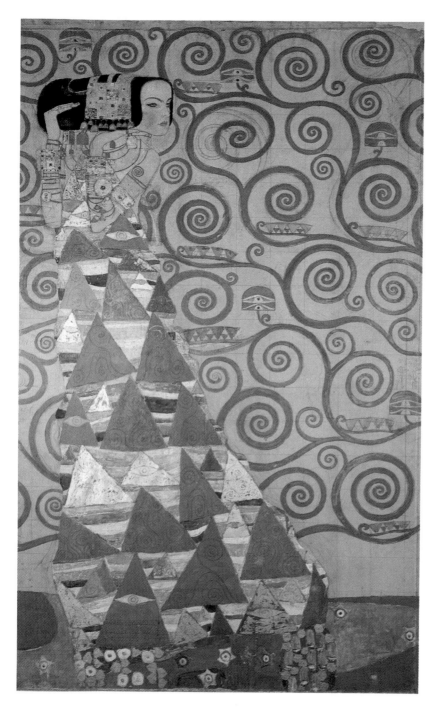

Colorplate 77 *Expectation*—Gustav Klimt. (The Austrian Museum of Applied Arts)

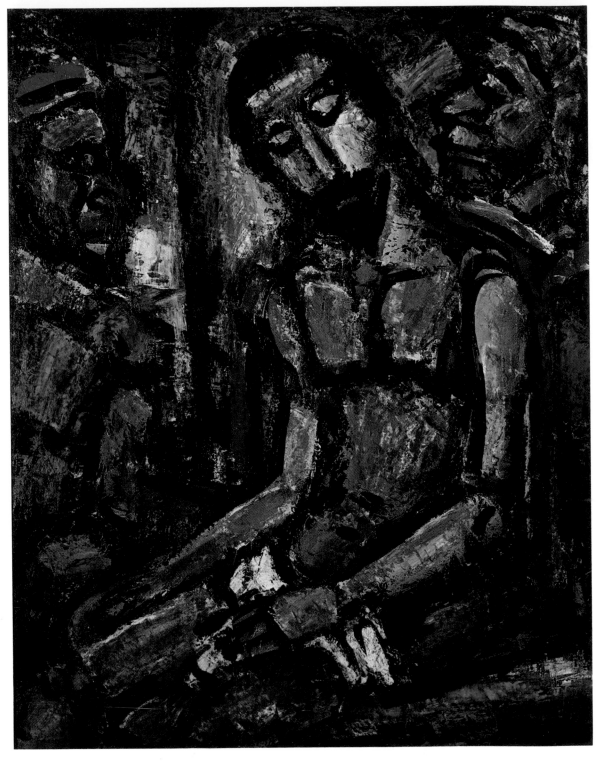

Colorplate 78 *Christ Mocked by Soldiers* [1932]—Georges Rouault. Oil on canvas, 36¼″ × 28½″. (Collection, The Museum of Modern Art, New York. Given anonymously)

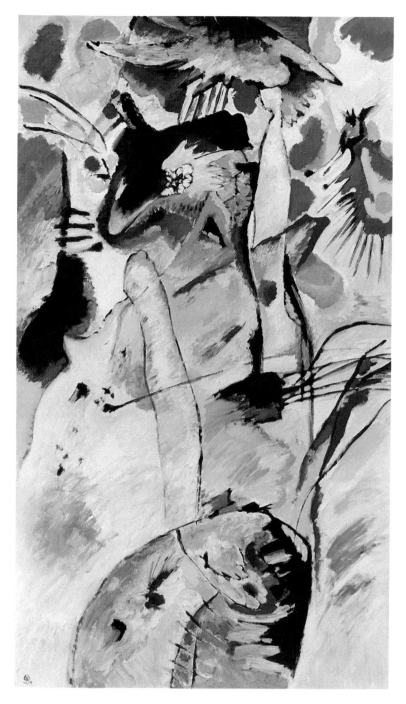

Colorplate 79 *Painting No. 198* [1914]—Vassily Kandinsky. Oil on canvas, 64″ × 36¼″. (Collection, The Museum of Modern Art, New York. Mrs. Simon Guggenheim Fund)

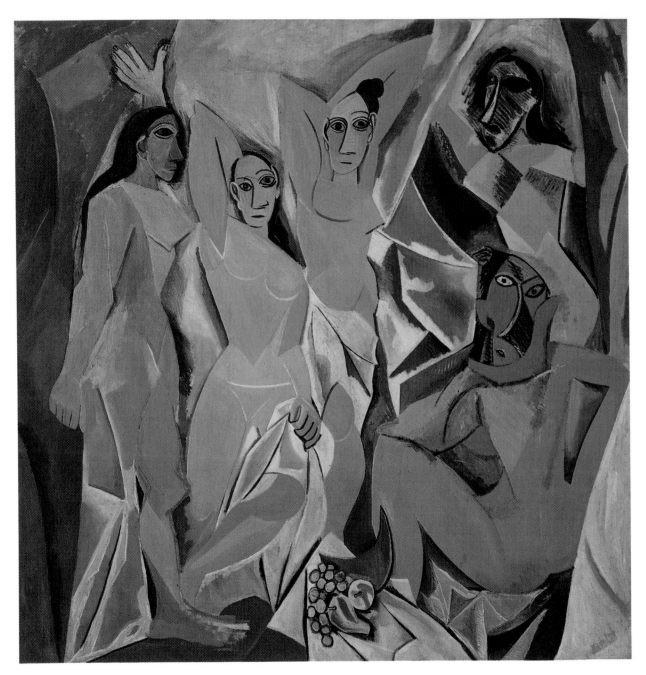

Colorplate 80 *Les Demoiselles à Avignon* [1907]—Pablo Picasso. 96″ × 92″
(Collection, The Museum of Modern Art, New York. Acquired through the Lillie P.
Bliss Bequest)

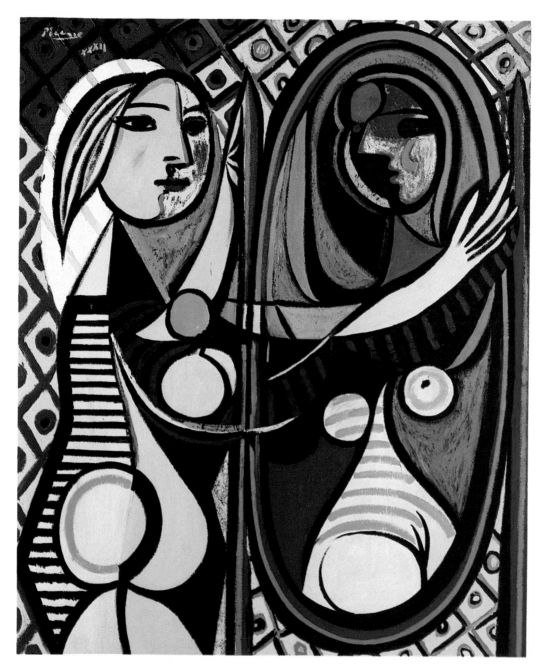

Colorplate 81 *Girl Before a Mirror* [1932, March 14]—Pablo Picasso. Oil on canvas, 64″ × 51¼″. (Collection, The Museum of Modern Art, New York. Gift of Mrs. Simon Guggenheim)

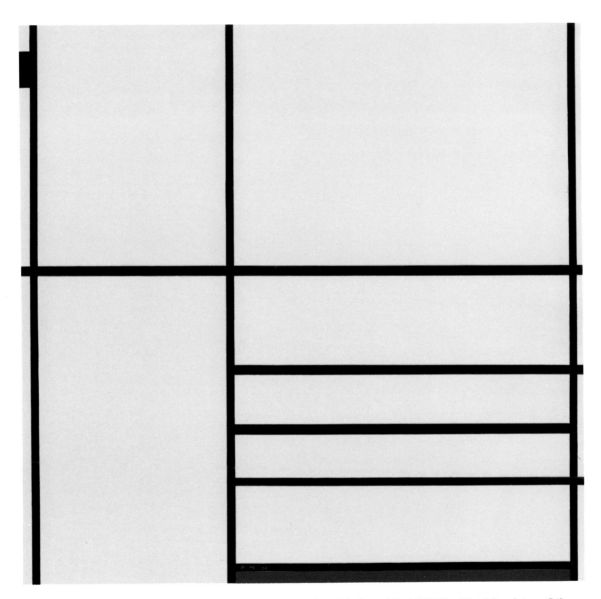

Colorplate 82 *Composition in White, Black, and Red* [1936]—Piet Mondrian. Oil on canvas, 40¼″ × 41″. (Collection, The Museum of Modern Art, New York. Gift of the Advisory Committee)

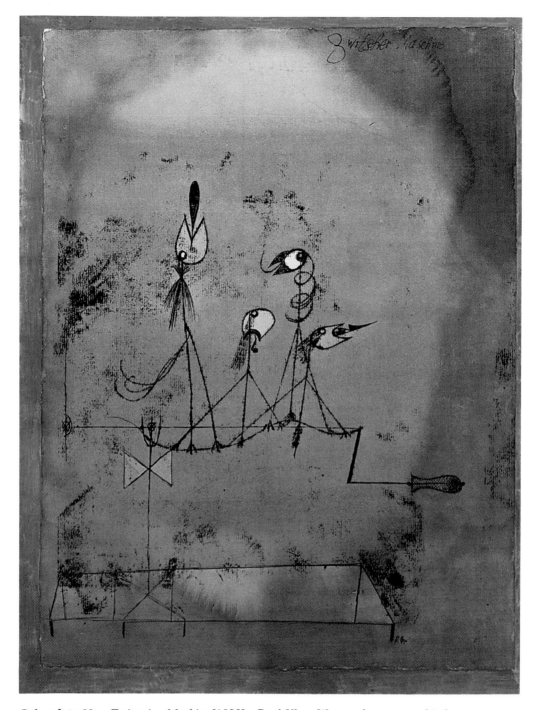

Colorplate 83 *Twittering Machine* [1922]—Paul Klee. Watercolor, pen and ink on oil, transfer drawing on paper, mounted on cardboard, 25¼ × 19″. (Collection, The Museum of Modern Art, New York. Purchase)

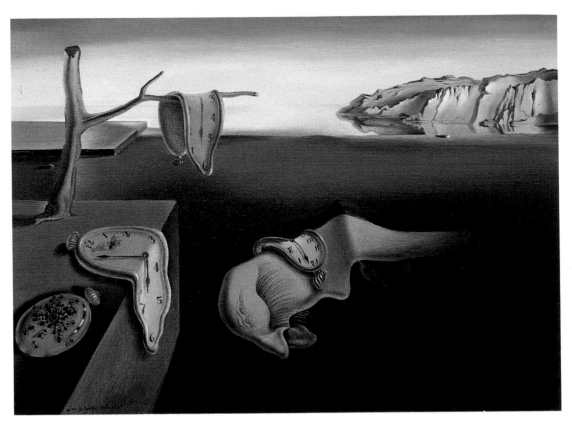

Colorplate 84 *The Persistence of Memory* [1931]—Salvador Dali. Oil on canvas, 9½" × 13". (Collection, The Museum of Modern Art, New York. Given anonymously)

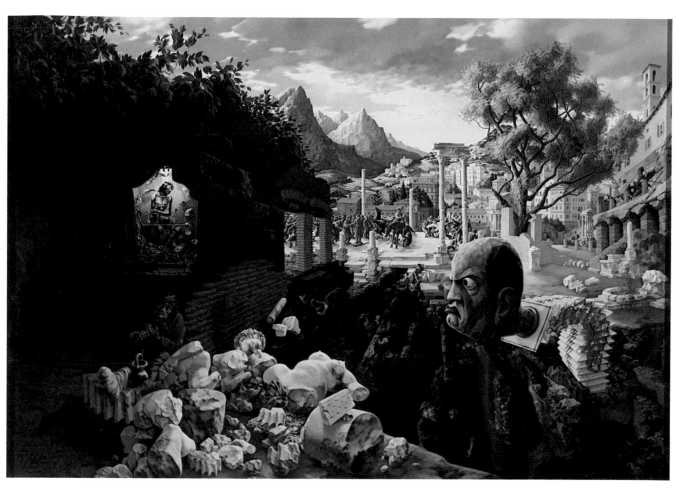

Colorplate 85 *The Eternal City* [1934–37. Dated on painting 1937]—Peter Blume. Oil on composition board, 34″ × 47⅞″. (Collection, The Museum of Modern Art, New York. Mrs. Simon Guggenheim Fund)

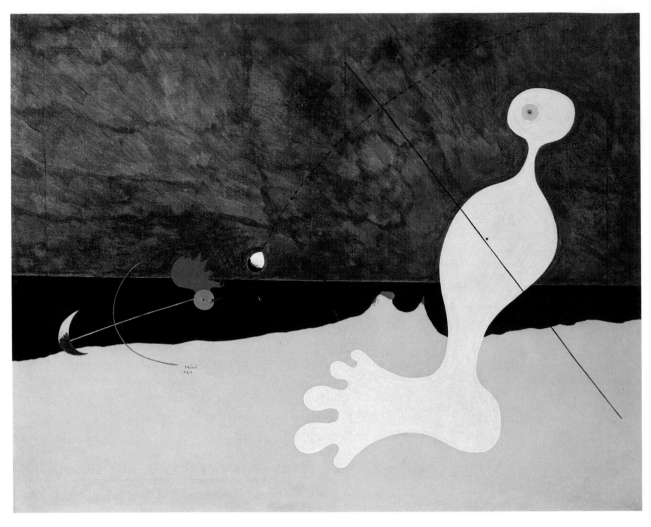

Colorplate 86 *Person Throwing a Stone at a Bird* [1926]—Joan Miró. Oil on canvas, 29″ × 36¼″. (Collection, The Museum of Modern Art, New York. Purchase)

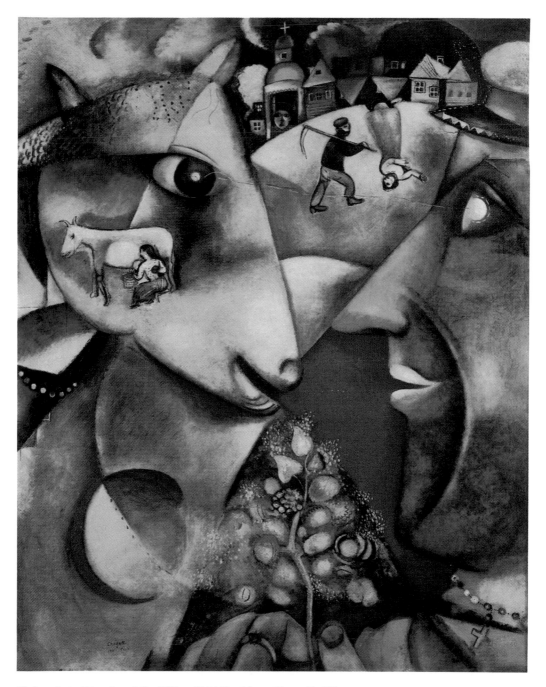

Colorplate 87 *I and the Village* [1911]—Marc Chagall. Oil on canvas,
6′3⅝″ × 4′11⅝″. (Collection, The Museum of Modern Art, New York. Mrs. Simon
Guggenheim Fund)

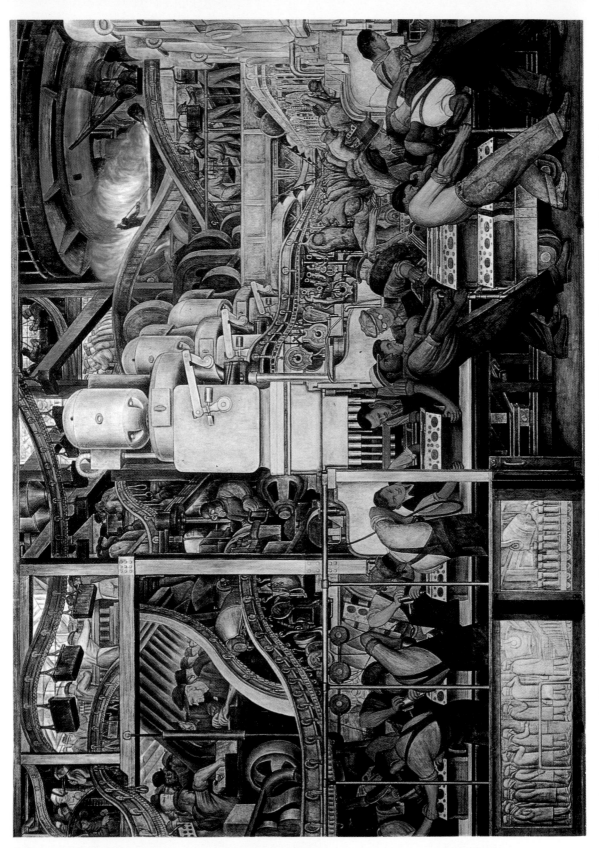

Colorplate 88 Detail of *Fresco in the Fountain Hall of the Detroit Institute of Arts* [1932]—Diego Rivera. (© Detroit Institute of Arts)

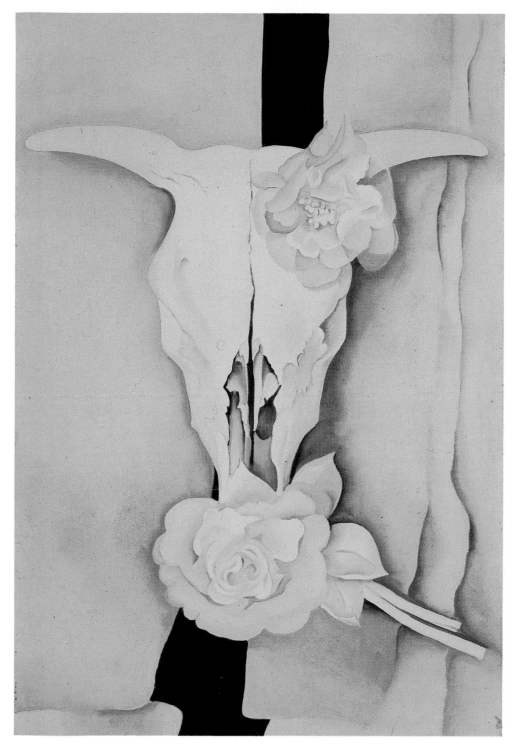

Colorplate 89 *Cow's Skull with Calico Roses* [1931]—Georgia O'Keeffe. Oil on canvas, 91.2 × 61 cm. (The Art Institute of Chicago, Gift of Georgia O'Keeffe, 1947.712 © The Art Institute of Chicago, All Rights Reserved)

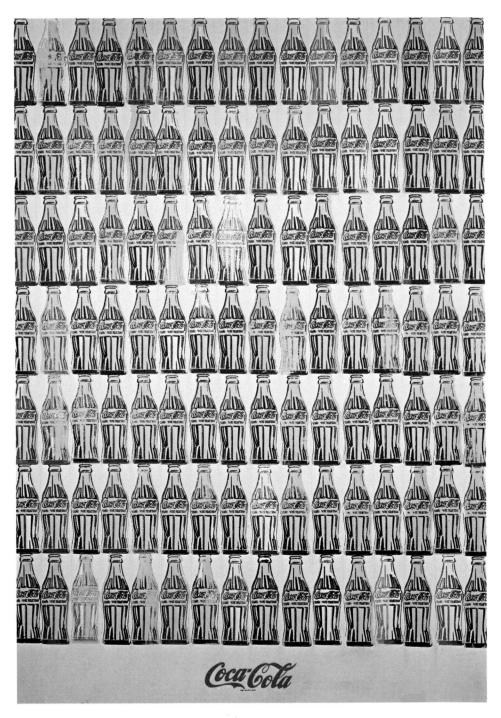

Colorplate 90 *Green Coca-Cola Bottles* [1962]—Andy Warhol. Oil on canvas, 82½″ × 57″. (Collection of Whitney Museum of American Art. Purchase with funds from the friends of the Whitney Museum of American Art. Acq. #68.25)

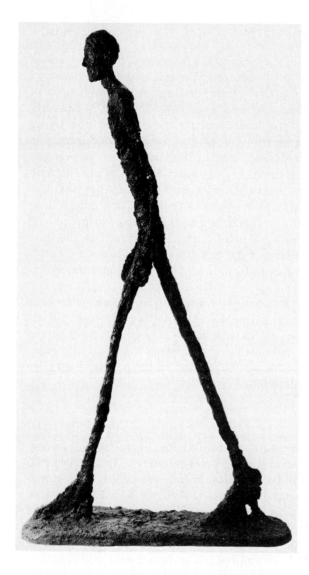

Figure 13.12 *Man Walking*—Giacometti [1960]. [71¾″ × 10½″ × 38″]. (Albright-Knox Art Gallery/Buffalo, New York. Gift of Seymour H. Knox, 1961)

in Constructivism that gives a Surrealistic expression to a variety of subconscious memories. The artist said its details were suggested by a variety of incidents ranging over a long period of time. Each detail of the construction is symbolic of the artist's imagery reduced to abstract ideas, such as the spine hanging from the scaffold of a tower and the abstract figure representing womanhood. The work seems to define a spatial area enclosed by symbolic walls. His *Man Walking* (fig. 13.12) typifies his commitment to reducing objects to their elemental form. Elongation of line and rough, unpolished texture characterize his human and animal figures.

Kinetic Art

Kinetic art, visual art that employs movement, has opened new avenues of creativity for the artist, especially for the sculptor. Some Kinetic artworks move by means of motorized units and others by depending on the movement of air against delicately balanced forms. Alexander Calder (1898–1976) was a pioneer in Kinetic art and is the best-known artist to use this medium. Using air currents to set his **mobiles** in motion, he introduced what amounted to a new art form in the 1930s. He suspended metal plates, painted with primary colors and black and white, from metal rods in such a way that they could move in any direction. When set in motion by currents of air they revolve, exhibiting a varied pattern of forms and colors in their motion. *Lobster Trap and Fish Tails* (fig. 13.13) is one of his earlier works of Kinetic sculpture. His last monumental mobile was created for the Central Courtyard of the new East Building of the National Gallery of Art (colorplate 99). Calder's mobiles have become very popular with the public and are widely imitated as objects for home decoration.

While Calder's mobiles get their energy from natural sources, there are some sculptors who resort to artificial means of providing motion, such as electric motors and clock springs. In an attempt to reflect our mechanized society some have even created machines that add noise to the artistic experience. As was noted earlier, this idea was suggested by the painter Paul Klee in his *Twittering Machine* (colorplate 83).

Architecture

In architecture, the scientific and mechanical influences of the twentieth century have had their most obvious and most practical effects. In the first half of the century, the changes in industrial life, in transportation, in communications, as well as those in economic and social life, all greatly influenced the function of architecture. Builders tried to adapt the planning, style, and construction of their architecture to meet the demands of a mechanistic and complex society. The new standards of living that made it possible for the average family to own its own home challenged architects to build efficient, comfortable, and low-cost dwellings. In urban society, the large apartment house was developed into an economic and efficient machine for modern living. Mass education brought the problem of building suitable educational plants in keeping with current philosophies of education. The supermarket and large department store were created to assist in the distribution of the

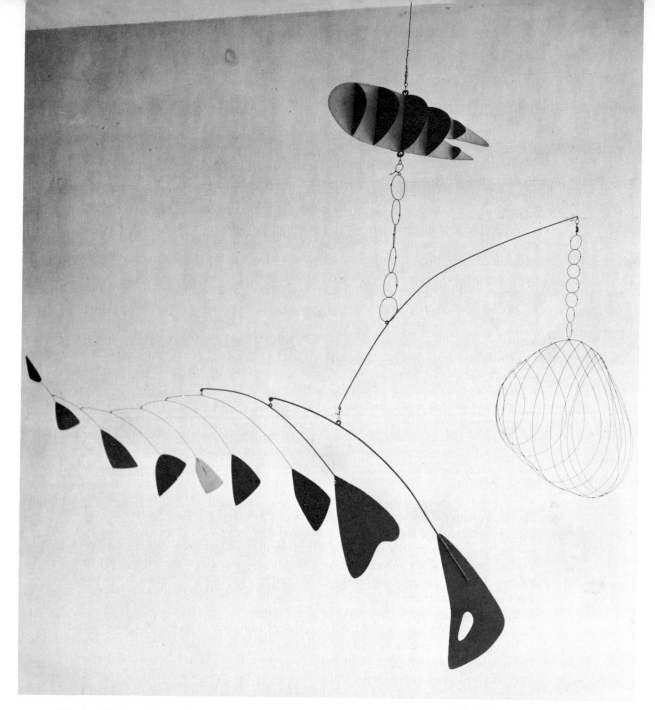

Figure 13.13 *Lobster Trap and Fish Tails* [1939]—Alexander Calder. Hanging mobile: painted steel wire and sheet aluminum, about 8'6" × 9'6". (Collection, The Museum of Modern Art, New York. Commissioned by the Advisory Committee for the stairwell of the Museum)

enormous production of farms and factories. The factories themselves became magnificent architectural achievements, providing open space for the machines of production and safe, pleasant surroundings for the workers. In the cities, the skyscraper became the symbol of the scientifically organized business life of the twentieth century.

In dealing with these manifold changes, architects subscribed to the motto "Form follows function." For example, they viewed the home from a sociological point of view. They sought to make their plans according to the personalities of the owners, taking into consideration their professions, hobbies, social, and cultural preferences. Consequently, the home was functionally designed to fit the needs of its occupants. This was also true for other kinds of structures. Architects let the efficient *function* of their buildings—whether home, apartment house, supermarket, factory, or skyscraper—determine their outward *form*. They eliminated sentimental decoration; they rejected traditional or derivative styles; they dared to let the inside speak for the outside. In general, the appearance of new buildings was a straightforward and simple expression of their functions. For their efforts, architects received more recognition and more patronage than any other artists. Conservatism was their great barrier for a time, but the efficient practicability of their designs soon won the approval of the doubtful.

Architectural innovations were possible only because of new materials and processes that were developed, including steel, aluminum, reinforced concrete, glass, plywood, and plastics. In addition, central heating, the elevator, and electrical appliances helped make new designs more practical. The influence of the automobile on modern buildings was so great that it is almost immeasurable.

New materials encouraged new methods of construction, notably the **cantilever** method and **steel cage** construction (fig. 13.14). The cantilever is the projection of a slab, or beam, anchored at only one end. This was done by the use of steel and reinforced concrete material of great tensile strength. The steel cage is just what the name implies—a cagelike skeleton with steel beams. Both of these new methods made it possible to use glass for outside wall surfaces, for the weight is not borne by the walls but by the steel cage or by the cantilevered projection and its anchor.

Another important trend, especially in domestic architecture, attempted to bring the out-of-doors into the building. Nature was no longer shut out of the house but was brought inside with large walls of glass. Nature also became part of the living space, with enclosed patios for outdoor living. The public became more conscious of view also, and there was a tendency to integrate homes with the natural surroundings and to use materials indigenous to the

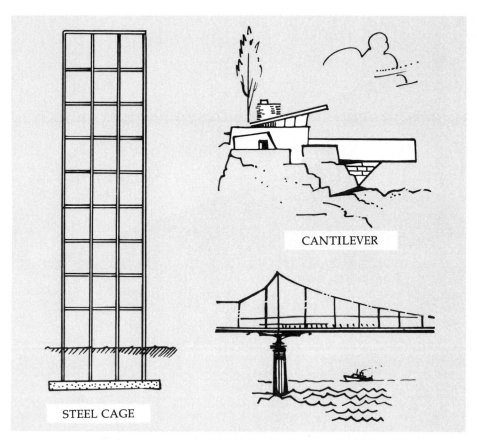

CANTILEVER

STEEL CAGE

Figure 13.14 Steel cage and cantilever construction—Sandgren.

locale. One of the finest examples is the famous *Kaufmann House* (fig. 13.15) in Bear Run, Pennsylvania, designed by Frank Lloyd Wright (1869–1959) for Edgar Kaufmann. Wright made the most of a stream and a waterfall that were on the site. He used cantilevers for overhanging balconies and brought nature into the house with large expanses of glass. Note that the outside appearance is Cubistic. Wright used elemental forms without decoration to express the function and simple beauty of the house in its natural surroundings.

Another striking example of integration with natural surroundings is the *Watzek House* (fig. 13.16) in Portland, Oregon, designed by the firm of Yeon and Doyle. The house was built on a hill overlooking the city and majestic

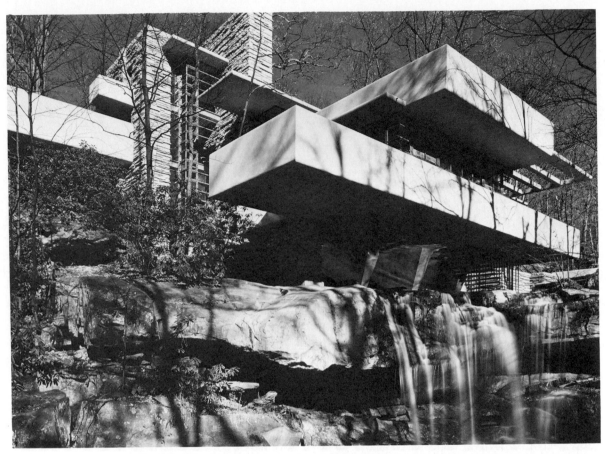

Figure 13.15 *Kaufmann House* [1939]—Wright. (Keystone View Company)

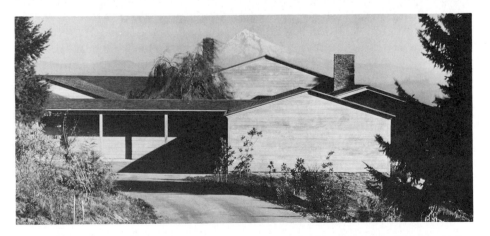

Figure 13.16 *Watzek House* [1938]—Yeon and Doyle. (Courtesy Boychuk Studio)

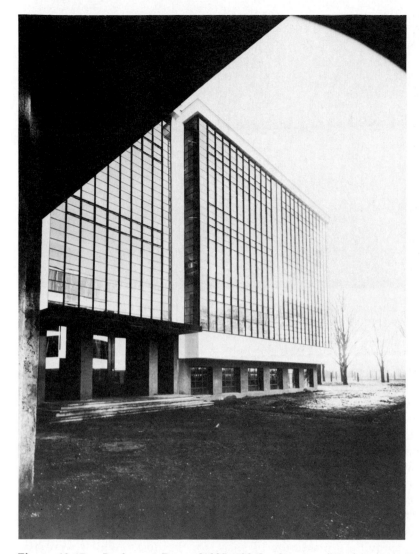

Figure 13.17 *Bauhaus at Dessau* [1925–1926]—Gropius. (Marburg/Art Resource, N.Y.)

Mount Hood. The lines of the structure imitate the contours of the distant mountain, making the building a form in a well-organized visual design. An exterior finish of natural wood helps blend the building into its setting among the shrubs and towering trees.

The *Bauhaus* (fig. 13.17) at Dessau, Germany, is important not only from an architectural point of view but also because of its function. It was designed by Walter Gropius (1883–1969) as a technical school for the specific purpose of creating designs and techniques for the twentieth century. Each workshop

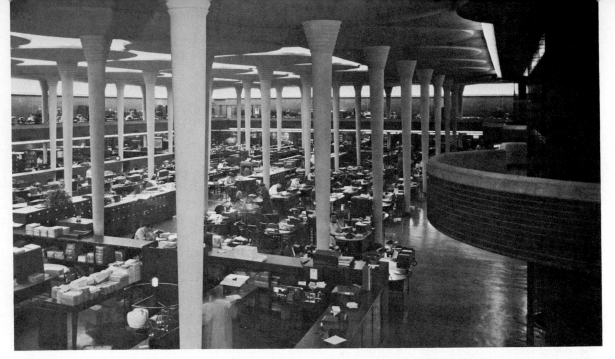

Figure 13.18 Interior of *Johnson Wax Building* [1937]—Wright. (Courtesy Johnson Wax Company)

was a separate unit and, as such, had its own design commensurate with its activities, but all the units were connected with covered passageways. Gropius used the steel-cage method of construction with glass for the outer walls. The exterior has the appearance of a curtain of glass hung over a masonry frame. The lack of ornament and the simple, angular pattern of the bands of glass and masonry are obvious.

Frank Lloyd Wright also utilized glass and concrete in solving the problems of an industrial office building in the *Johnson Wax Building* (fig. 13.18) in Racine, Wisconsin. To support the great weight of the ceiling, he used hollow concrete piers that taper at the bottom and flare at the top. Indirect lighting through a diffused glass ceiling gives equal illumination without glare. The tapered piers provide a maximum of space for the desks, which were also designed by Wright.

The impact of the first woman architect to graduate from the Ecóle des Beaux Arts in Paris was strongest in the western United States. Julia Morgan (1872–1957) founded a firm in California that had as many as sixteen architects, and designed and supervised the construction of hundreds of homes, churches, and institutional buildings. She was known for her determination, and that quality characterizes all her work. Her legacy includes elegant and beautiful buildings for Mills College in Oakland and the *Berkeley City Club* in California, countless residences in the San Francisco area, and the Hearst Castle in San Simeon, California.

Music

At the opening of the twentieth century, music—like the plastic arts—was influenced by a number of forces, all of which were used to break with the nineteenth century and its Nationalistic, Realistic, and Impressionistic practices. This revolt is apparent not only in concert music but also in the production of popular music and music of the theater as well.

The musical techniques employed in the nineteenth century had been pushed as far as possible by the opening of the twentieth century. Composers had to find new ways to express new things. Musically this meant that melody, harmony, rhythm, and tone quality had to be reassessed if composers were to keep pace with their artistic colleagues in other media.

Melodically and harmonically, there were at least two ways to change: to divide the twelve tones of the scale into smaller intervals and thereby create new musical material, or to find new principles of construction so that the old materials could be used in new ways. While the former was attempted by Hába and Barth and used to a slight degree by others such as Bloch and Bartók, so far it has not succeeded in winning any significant place as a solution for modern melodic or harmonic problems. The other solution, to find new principles of construction, has been applied in various ways throughout the century. In a sense, all the attempts grew out of the practices of the nineteenth century. Harmonically as well as melodically, the Romantic composer piled dissonance upon dissonance to the end that musical tension or expressive quality might be heightened. Yet these dissonances were all part of a scheme of harmony that functioned around a central tonality. No matter how reluctant Chopin might have been to reveal the tonality in a short prelude, or how interminable might be the delayed resolutions and ultimate establishment of key in a Wagnerian opera, the fact remained that these works, whether long or short, were governed by tonal considerations. Dissonances were used only to intensify them. However, twentieth-century composers came to appreciate the musical value of dissonant treatment for the sake of the dissonance itself. They found a certain expressive beauty in dissonance that seemed compatible with twentieth-century ideas and justified its use by various principles of construction. Among these were **polytonality** (the use of two or more keys simultaneously); the use of free dissonant tones, greatly expanded but still within traditional harmonic principles; the principle of the twelve-tone row, or "composition with twelve tones," as Schoenberg called it; or the deliberate denial of tonality as a principle, without any formalized system to replace it.

The result of these practices was the dissonance that characterizes much of twentieth-century music. Most people, after listening to such a work, would describe it as extremely dissonant. They are unable to reconcile the harmonies with the familiar—and therefore "correct"—harmonic practices of eighteenth- and nineteenth-century music.

In the practice of rhythm, composers revolted not only against regularity and symmetry of phrase but also against regularity of meter. Indications of this revolt were already apparent in the music of some late nineteenth-century composers. As usual, the seeds of destruction are to be found within the thing destroyed. Nationalism particularly exploited the unusual rhythmic and metric patterns of folk music, especially of the eastern Europeans who were less affected by the regularity of centuries of art music. Meters such as 5/4 were commonly found in the music of Slavic composers, notably Tchaikovsky and Mussorgsky. Twentieth-century composers have expanded these rhythmic irregularities to an enormous degree. In the works of some composers, there is scarcely a set meter, and some have written without meter signatures. Such patterns as 5/4, 7/16, and 11/8 are commonly used, not always consistently, but rather liberally interspersed with the other conventional patterns so that the total effect is one of great irregularity. Moreover, many works achieve rhythmic complexity by the juxtaposition of one or more independent rhythms. While such rhythmic complexities make great difficulties for the performer, average listeners are not as disturbed by them as they are by dissonances. Difficulties of performance, however, militate against widespread acceptance of contemporary music by many musicians and result in poor performance by others.

Exploitation of tone color is a province in which even the most traditional twentieth-century composers dared to indulge. Modern audiences do not resist cacophony when it is only cacophony of tone color. Some composers have added immeasurably to the orchestral tonal palette by making new demands on old instruments or by calling for new sound devices, such as wind machines, electronic instruments, sirens, and noisemakers of all sorts—even to the dropping of glass in a bucket and shaking it!

In addition to these developments, several others arose in the twentieth century. One was the new popular style known as jazz, which distinctly influenced a number of twentieth-century composers. (A more detailed discussion of jazz is found in chapter 14.) Another influence was the revived interest in the music and instruments of the medieval and Renaissance eras. The interest in tonal color also led to the use of instruments of non-European origin, such as African drums of all types, the sitar from India, and the Balinese instruments from the gamelan (orchestra). These interests were taken up by composers in many styles. The use of electronics in music began in the first half of the twentieth century, but its main influence was not felt until the post-World War II era.

In each of these ways, and by the combination of two or more, twentieth-century music has challenged the twentieth-century listener. In the early years, only a few decades had passed since Romanticism, with its phases of Realism,

Nationalism, and Impressionism, was widely accepted. Most early twentieth-century composers were actively interested in doing away with Romanticism, and their efforts led in many different directions, each of which challenged the listener in a somewhat different way.

A few representative examples follow. In each case, the composer mentioned wielded a great influence not only on musical audiences but also on later composers. Only a few significant composers and works and compositions from among many can be discussed here.

Schoenberg

Arnold Schoenberg (1874–1951) is probably one of the most controversial composers of the twentieth century. At first a vigorous follower of the Wagnerian tradition, he soon felt the necessity for a new system of composition. As a result, he constructed a new technique of musical composition based on the independence of each of the twelve tones of the chromatic scale, often referred to as the dodecaphonic or twelve-tone system. In it, harmonic and melodic relationships were not governed by procedures of traditional and functional harmony but by an arbitrary pattern of twelve tones. This "tone row" was the unifying element of the composition. It served as a sort of theme for countless variations; it made tonality unnecessary in that it was the nucleus out of which all musical material grew, and hence, the germ of the form itself. Its constant reappearance provided a new kind of unity. Its constant variation provided variety. The resulting works were compositions alien to the harmonic style of the eighteenth and nineteenth centuries, in which harmony was the result of a closely knit, formal organization. The harmony of Schoenberg's work, on the other hand, purposely avoids any suggestion of traditional tonality and sounds thoroughly dissonant if one uses traditional harmonic ideas as a frame of reference. For this reason it is often referred to as "atonal" music.

One of the early works of Schoenberg from the period 1921 to 1923 is the *Serenade*, op. 24. In this Expressionistic work, Schoenberg gained full mastery over his new technique. Each of the seven movements is based on a different arrangement of the twelve tones of the octave. The formal organization of each movement is traditional—in fact, in most instances, somewhat archaic. March, variation, minuet, song, dance—these are forms long employed by composers. But the composer's treatment of harmonic material is in no way traditional. Melody, even when given to the voice as in the fourth movement, is no longer subservient to vocal considerations. Melody and harmony move in deference to the new principles established by the composer, and whatever difficulties this raises for instrument or voice must be mastered. Rhythm is one of the principal means of varying the tone row and is therefore very free

and irregular. The unusual combination of instruments for which the *Serenade* is scored indicates Schoenberg's interest in tonal color. Moreover, each of the instruments used is exploited in most extraordinary ways.

Movements one, two, four, five, and seven are all based on strict application of the principle of composing with twelve tones. Movement three uses only eleven tones, and movement six employs a theme of eighteen tones in which six of the twelve are repeated. Movement four, which is a setting for voice and instruments of a sonnet by Petrarch, is written so that the voice consistently repeats the twelve-tone row throughout the movement while the instruments accompany it. In this instance, the tone row consists of the notes: E, D, E-flat, B, C, D-flat, A-flat, G-flat, A, F, G, B-flat (ex. 13.1).

Example 13.1: Tone Row

One syllable is set to each note and, since the sonnet has eleven syllables to each line of verse, each line begins with a different note of the repeated row. For example: the first line starts on the first note of the row, E; the second line on note twelve, B-flat; the third on note eleven, G; the fourth on note ten, F, and so forth. This gives a great variety to the verse settings, which is heightened by the fact that the notes can be in any octave within the possibilities of the vocal range and can be treated in various rhythmic fashions— all within the rigid repetition of the basic row. The total effect of the work is one of intense expressive power through dissonance, rhythmic strength, and unique tonal colors. Like all new ideas in music, this work must be heard many times until its first impression of unusualness is no longer a disturbing element.

Unfortunately a great number of factors join together in keeping music of this kind from frequent performance. Among these are the reluctance of audiences to adopt a new style, the difficulty of its execution, a lack of sympathetic and willing performers among those technically capable, and a reluctance of those who control music commercially to essay new ideas. An analogy can be drawn to the failure of the first streamlined automobile, put out by the Chrysler Corporation in the 1930s, to capture the public's acceptance. When a number of companies in the post-World War II period turned to streamlining, however, the uniqueness wore off in the first year, and all cars competed with each other in achieving new extremes in this style. Acceptance of new art styles moves much more slowly, and music meets, perhaps, the greatest opposition to a wide understanding of new stylistic trends.

Berg

One composer, however, has been able in a large degree to break through the public opposition to contemporary idioms. Alban Berg (1885–1935) was one of the most successful of Schoenberg's pupils. His *Violin Concerto* is analogous to the increasingly decorative design in architecture of the mid-twentieth century, following a period of decidedly stripped and functional form. Berg was an exponent of the twelve-tone system of composition and used it in the varied areas of his work: opera, chamber music, and orchestral and vocal compositions. In all of these he succeeded in tempering the strict dissonance of the twelve-tone system with a freedom that has made his works widely accepted in the opera houses and concert halls of the world. The *Violin Concerto,* written in 1935, was his last completed composition. It was commissioned by the American violinist Louis Krasner and was dedicated to the memory of Manon Gropius, the eighteen-year-old daughter of Alma Mahler, the widow of Gustav Mahler, and Walter Gropius, the architect. The young girl had died after a year of painful infantile paralysis, and the concerto's form and expression was in great part determined by the affection and admiration Berg held for this lovely girl.

The work is based on a most extraordinary tone row (exs. 13.2, 13.3) that enabled the composer to incorporate the modern dissonance of twelve-tone music with traditional harmony. If certain successive notes of the tone row are played together or consecutively, they constitute traditional-sounding harmonies: 1, 2, 3; 5, 6, 7; 2, 3, 4; 7, 8, 9; and 3, 4, 5, 6. The first, third, fifth, and seventh notes of the tone row constitute the tuning of the strings of the violin, and the last four notes of the tone row are each one whole step apart from one another and form a segment of the whole-tone scale. Berg makes use of all these potentialities of the tone row. In addition to the tone row, he employed a Bach chorale.

Example 13.2: Tone Row in the *Violin Concerto*—Alban Berg

Example 13.3: Tone Row in the *Violin Concerto*—(Solo Violin Passage of the First Movement)—Alban Berg

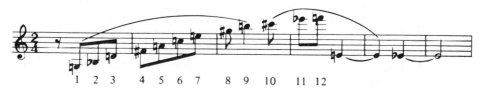

The concerto falls into two large parts, or movements. Each of the movements is divided into further sections joined together without pause. The first movement is an attempt to describe the beauty of the young Manon, and the second movement her suffering and death. In the first movement, the introduction is a dialogue between the violin and the orchestra that exposes the tone row in various forms. The first section then presents a development of the tone row in an andante tempo. The four-note whole-tone figure is noteworthy, for it becomes a most important part of the second movement. The second section of the first movement depicts the youthful character of the young girl with its ready reference to Viennese waltz rhythms and the eventual inclusion of an actual Austrian folk dance toward the end of the movement.

The second movement is a presentation of the tragic death and the ultimate deliverance of the "Angel." The four-note whole-tone scale already heard in the first movement here assumes more and more importance and finally leads to a full presentation of the chorale tune *O Ewigkeit, du Donnerwort (Oh Eternity, Thou Thunderous Word)* in the original Bach harmonization. The four last notes of the tone row in the whole-tone scale are the opening four notes of another chorale tune, *Es ist genug so nimm Herr.* The importance of these two chorales is revealed most clearly to those who are familiar with the German texts and would connect the meaning to the tragic death of Manon Gropius. A superb dramatist, Berg made full use of the modern idiom in tying the present to the past. At the same time, he did not hesitate to draw upon the romantic, emotional power of music and its tradition to realize the purpose he had stated in the dedication of the concerto.

Webern

While Schoenberg will probably always mark a period and a school of musical thought, one of his pupils, Anton Webern (1883–1945), is often considered one of the most gifted and influential composers of the twentieth century. Webern is recognized as a composer who not only adopted the twelve-tone technique of his teacher but extended its implications to what could be called completely organized **serialism.** That is to say, not only is each of the twelve tones used before any one is repeated, but the tonal qualities are organized so that no instrument plays two successive tones of a theme. Dynamics are similarly treated. The thematic material is extremely epigrammatic and terse so that the compositions seem to be a counterpart of the paintings of such an artist as Klee.

The *Five Orchestral Pieces*, op. 10 were written in 1913 before Webern had adopted the twelve-tone system of composition. They illustrate the succinct manner of Webern's writing, which he never abandoned and which, in turn, was extremely influential on other composers of the twentieth century. This was particularly true of Stravinsky in the 1950s as well as of the whole school of electronic composers.

Some facts concerning the fourth piece (ex. 13.4) of the set will give an idea of Webern's terseness and economy of means. The entire work is only six measures long with a metronomic marking of sixty beats to the minute. Allowing for the two ritardando (slowing-down) passages, the total playing time would not exceed twenty-four seconds. Only solo instruments are used, with a total of nine performers. There are fifty-seven printed notes in the score, and many of these are sustained or repeated. The mandolin has the greatest number of different pitches to play, a total of seven. Two instruments play only one pitch, three play two pitches, and, of the remaining three instruments, two have four and one has five different pitches. If one analyzes the work technically, it will be discovered that two intervals which have been traditionally treated as dissonances constitute the basic motives of the work; the major second (two half steps) and the long-feared **tritone** (three whole steps). The latter had been known for centuries as the diabolical interval. Based on such economic structural and formal means, Webern fashioned an extremely concise expression of fleeting, kaleidoscopic tonal changes. Only an art form that is presented in time could be truly analogous to Webern's work. Subliminal vision in motion pictures and television perhaps offer the best analogy.

Music and painting have also been analogous in many ways in the twentieth century. In fact, a number of composers have been quite successful painters and a number of painters have shown intense interest in musical symbols and ideas. Schoenberg, for example, was a close friend of Kandinsky and was a talented painter with a number of public showings of his works. The close friendship between Picasso and Stravinsky is also well known.

Stravinsky

Of all twentieth-century composers, Igor Stravinsky (1882–1971) has unquestionably been the most successful in winning acceptance from the general public. This was not accomplished easily, however, and many of his finest early works are, after forty years, still rarely heard. Stravinsky's music stems from quite a different tradition than that of Schoenberg. His musical education was in the school of the realistic Nationalism of the Russian Five, one of whom, Rimsky-Korsakov, was his teacher. This influence is particularly evident in the works he wrote in the first twenty-five years of the century, of which all the important ones were ballets or at least stage works, many with Russian themes—*L'Oiseau de feu* (The Firebird), *Petrouchka*, *Le Sacre du Printemps* (The Rite of Spring), *Les Noces* (The Wedding), and *Mavra*, among others.

Two of these works, *Petrouchka* and *The Rite of Spring*, have become standard works in the field of ballet and are also widely heard in Stravinsky's own versions for orchestral performance. *The Rite of Spring* created a near riot at its first performance in Paris in 1913 and can be considered a landmark of the "new" twentieth-century revolt against Romanticism.

Example 13.4: *Five Orchestral Pieces*, op. 10, no. 4—Webern

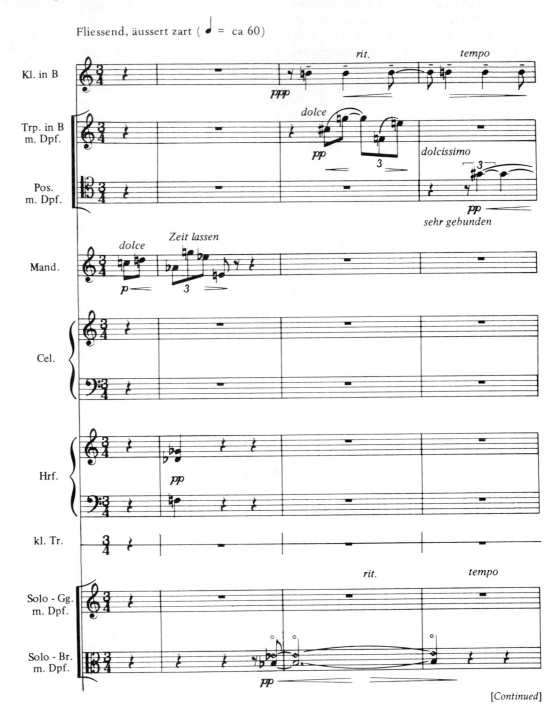

[Continued]

Example 13.4 [Continued]

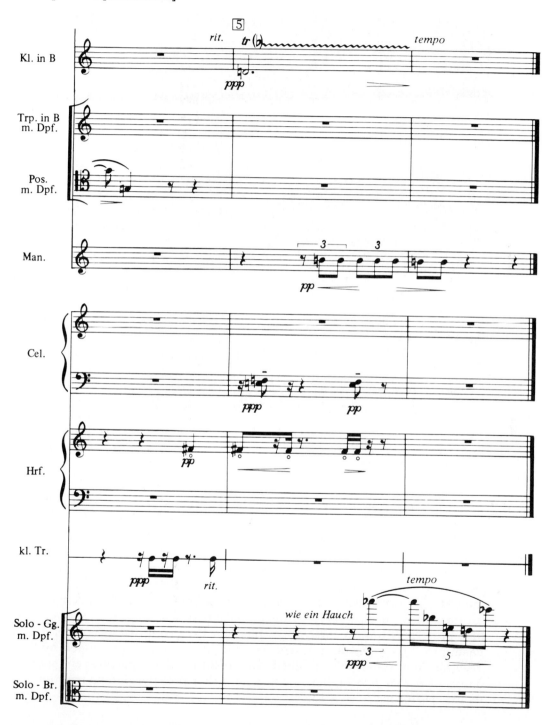

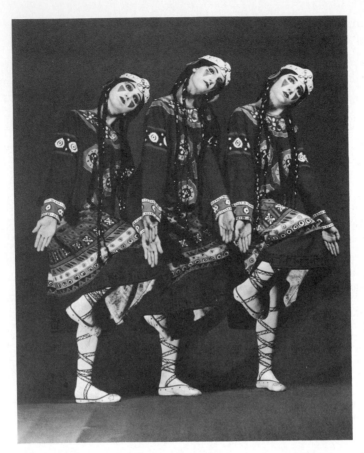

Figure 13.19 Costumes for Stravinsky's *Le Sacre du Printemps*. [1913] The Joffrey Ballet Dancers: Jill Davidson, Julie Janus, Meg Gurin. Choreography by Millicent Hodson. (Photo by Herb Migdoll)

In *The Rite of Spring*, as in almost all of his subsequent works, Stravinsky neither followed nor formulated any set theory of composition. His music is characterized by a free use of dissonance that reached the extreme of atonality in only a few instances. Rhythmic drive, often resulting in brutal reiteration within very complex and irregular patterns, characterizes his works. They are also known for an inventive and daring use of timbres, combining instruments with great effectiveness. Stravinsky not only combined instruments in unusual ways but also explored the extreme ranges of instruments for effects of timbre, resulting in tone colors that run the gamut from those of great beauty to those of cruel ugliness. The primitive costumes provided by the designer Roerich, and the eccentric and unconventional postures and movements of the choreographer Nijinsky contributed to the riotous rejection of its first performance (fig. 13.19).

Bartók

Béla Bartók (1881–1945) is another twentieth-century composer who set up no theory or formula but arrived at results quite as opposed to nineteenth-century Romanticism as did either Schoenberg or Stravinsky. His background is the folk idiom, not only of his native Hungary, but of all the Balkan peoples. So great was his interest in folk music that he studied seriously the folk music of North Africa. The harmonies and rhythms of the untutored folk musicians of the Balkan states, untouched by the tradition of western Europe, intrigued Bartók. Many of his piano pieces are original settings of simple folk songs and dances. Moreover, his large works in the more traditional forms are likewise influenced by his long and serious study of folk music, which led him to collect over ten thousand of these works.

The *Sonata for Two Pianos and Percussion* dates from 1937. It indicates in melody, harmony, and rhythm Bartók's deep knowledge and love of the folk idiom. Its use of the piano illustrates his close affinity with the music of the people. The Hungarian cimbalom, a folk form of the psaltry (of which the piano is a highly mechanized type), is an instrument struck with hand-held hammers. Bartók frequently, if not always, treated the piano as a descendent of this percussive instrument. It is not unusual, then, that he should combine it here with other percussive instruments.

In this work, percussion and piano blend into a tonal texture in which they are remarkably complementary. Dissonance, the hallmark of twentieth-century music, is the result of various techniques. Sometimes it is bitonality, as in the opening of the first movement where the pianos enter, each in a different key. Sometimes it is the result of free dissonances used to heighten the harmonic tension. Sometimes it is the result of free contrapuntal treatment, as in the final movement. Basically, it is the result of the folk background in which Bartók discovered unusual scale patterns that produce dissonances when used harmonically.

The *Concerto for Orchestra* is one of the last great works of Bartók composed during those terrible final years of illness in New York. It was written for the Boston Symphony on commission by its conductor, Serge Koussevitzky. Bartók explained his use of the term *concerto* in the title as a wish "to treat the single instruments in a concertante or soloistic style." This was a reversion to the Baroque concerto style of the early eighteenth century.

The *Concerto* consists of five movements. The first contains a slow introduction in the grand manner of the eighteenth-century symphonic introduction, which is then followed by an allegro-vivace section. The introduction is based on the intervallic motive of a fourth. Bartók was particularly fond of using this rather dissonant interval in many of his compositions, since it frequently occurred in the folk-song tradition with which he was familiar. The first movement proper is built on the traditional sonata-allegro form, and the use of the interval of the fourth is prominent in the thematic material. The

second movement is given the title *Game of Pairs,* since Bartók presented five pairs of wind instruments in a series of short sections. Each pair is combined at a specific and individual interval; bassoons at the sixth, oboes at the third, clarinets at the seventh, flutes at the fifth, and trumpets at the second. During the restatement of the five sections, Bartók used an elaborate instrumentation. The third movement is called *Elegia* and is a song of death. The fourth movement is called *Interrupted Intermezzo.* A tune of folk character followed by a lyric melody is interrupted in mood and melodic idiom by a more popularly styled tune, after which the first part returns. Characteristic of the rhythm of the entire movement is its alternation of 2/4, 3/4, 5/8, 6/8, and 7/8, making an obviously asymmetrical scheme. The *Finale* marked *pesante* (heavy), which brings the work to a close, is filled with primitive folk tune material. The interval of the fourth is again prominent and the movement employs a fugue, making use of all the devices of counterpoint.

Bartók's complicated rhythmic patterns are the result of deep interest in the rhythmic subtleties expressed in folk song and dance. All of these—dissonances and rhythmic and timbral complexities—contrive to give this music a freshness and spontaneity that mark it as typical of the twentieth century.

Ives

Charles Ives (1874–1954) used the folk songs and gospel hymns of his native New England in much the same way that Bartók used Hungarian folk music as a point of departure in his compositions. Ives is one of those creative spirits who arose out of a traditional background and foreshadowed musical techniques that became widely used and accepted only years after he had used them. Almost his entire compositional output predates World War I, yet most of it was never heard until after World War II. *Central Park in the Dark Some Forty Years Ago* represents Ives's predilection for quoting folk tunes and popular songs in his compositional structure. These tunes are used contrapuntally against one another, usually in different simultaneous tonalities and polyrhythms. Written early in the twentieth century (the composing of the work continued from 1898 to 1907), this is, in the words of Ives, "a picture in sounds of the sounds of nature and of happenings that men would hear when sitting on a bench in Central Park on a hot summer night."

The Unanswered Question (ex. 13.5) is an orchestral work that presents a quiet string background (designated by Ives as "The Silence of the Druids—Who Know, See, and Hear Nothing") against which a solo trumpet reiterates an angular melodic gesture ("The Perennial Question of Existence") to which the woodwinds respond with increasing agitation ("The Fighting Answerers"). The strings and trumpet are marked *Largo molto sempre* or "very slow throughout." The woodwinds have no less than eight different accelerating tempo indications, making them independent of the strings and trumpet.

Example 13.5: *The Unanswered Question*—Charles Ives

Gershwin

The composer George Gershwin (1898–1937) is somewhat difficult to place in this chapter. While his style is distinctly related to jazz, he achieved stature because of his notated music for the concert stage and theater, as opposed to the predominantly improvised and spontaneous jazz of his contemporaries. *Rhapsody in Blue, An American in Paris,* and his *Piano Concerto in F* have successfully incorporated the jazz idiom of his time into the more-or-less traditional forms of concert music. Because of the adaptability of *An American in Paris* for movement and gesture it has been choreographed very successfully. His musicals, such as *Of Thee I Sing* and *Girl Crazy,* supplied a number of the hit tunes that were popularized throughout the world by jazz bands, but they also instilled a new life into the fading romantic operetta form that resulted in a whole new era of so-called Broadway musicals. His opera *Porgy and Bess* is a successful amalgam of jazz, blues, spiritual, and folk song idiom with a highly dramatic quality that makes this work a true folk opera whose musical achievement places it favorably among the more traditional operatic masterworks.

Popular Music

In this century there have been at least six major movements in popular music, as well as numerous smaller movements, some of which are very well known. The six major movements are ragtime, blues, jazz, swing, Broadway musical, and rock and roll. The last of these movements belongs exclusively to the period after 1945. Although the term *jazz* was once used to denote all the phases of twentieth-century American popular music, that usage is no longer accurate. The phrase *popular music* is probably better, and will therefore be used here, although that term has some difficulties as well. Furthermore, since popular music is a musical practice and not a form of composition, it tends to be ever-changing in character and style. If success is judged by financial reward and acceptance by large numbers of people in many cultures, this music has become the most successful music of the twentieth century.

Among the most important sources of ragtime, blues, and jazz were the spirituals of the black religious communities and the working songs, called hollers, of the black field-workers of the South. A curious blend of African religion and music, Christian religion, American popular music, Civil War instruments, and the creative talents of early black musicians combined to form this highly popular art form.

One of the earliest movements in popular American music was known as ragtime, a name that appeared in the 1890s and described a style that was popular through the first two decades of the twentieth century. Ragtime was largely a style of piano playing in which syncopation and at least two layers of rhythmic activity were applied to the slow, duple rhythms of dance music. The works of Scott Joplin (1868–1917), which were revived after World War II, are good examples of this early ragtime. Many of his rags, such as *Maple Leaf Rag* and *Pineapple Rag,* are well known today.

Although many aspects of the so-called blues style go back into the nineteenth century and the black rural life of the South, the blues came to the attention of white American listeners around 1920. It became one of the dominant movements of jazz during the next few decades and has continued to influence it ever since. Blues typically are based on twelve-measure patterns in which the option for a good deal of improvisation is left to the performers. In addition to the twelve-measure phrase, some blues lyrics are written in iambic pentameter, but there are sufficient departures from these formulas that they cannot be identified as necessary ingredients. Certain alterations in the major scale, namely the lowering of the third and seventh degrees, gave rise to the term *blue notes,* which in turn led to the term *blues* as a name of this type of song. The interplay between these flatted notes in the melody and those of the normal scale in the harmony is one chief characteristic of the blues. Another of its pervasive characteristics is the double meaning of many of its lyrics, e.g., expressing pain over the misery of life while simultaneously

laughing at the same problems. "Memphis Blues" and "St. Louis Blues" by W. C. Handy (1873–1958), two examples of this style, have become classics in the repertoire of popular music.

Toward the end of the first decade of the twentieth century, another popular musical style began to emerge, and a word of obscure origins was used to describe it. The word was **jazz,** and it came to be applied originally to the popular tunes of eight and sixteen measures into which ragtime and blues were incorporated. These were regularly performed by small groups of instrumentalists consisting of cornet, clarinet, trombone, drums, and piano. The music was highly syncopated, and it relied heavily on improvisation by the various soloists. It was, above all else, dance music and had for many years a very unsavory reputation associated with drinking, promiscuous sex, and "loose" living. One style during this time was known as Dixieland jazz, which emphasized polyphonic improvisation by the performers. In the 1920s, jazz came to be the accepted name for all types of popular music and remained so until challenged by the rock-and-roll style of the post-World War II era.

The movement of black people to northern urban centers after World War I moved the centers of jazz from New Orleans to such cities as St. Louis, Chicago, and Kansas City, each of which developed a style of its own. Several of the original instruments were superseded—for example, the banjo, which had been occasionally used, was replaced by the guitar, the cornet by the trumpet, and the tuba by the string bass. The band was divided into melody and harmony sections. The clarinet, trumpet, trombone, and saxophone usually comprised the melody section; and the piano, string bass, and percussion were parts of the harmony and rhythm sections.

One of the common forms of the jazz tune was that of the traditional three-part song typical of the music of western Europe since the sixteenth century. This form was the so-called chorus or refrain of the popular song. The verse was rarely used as part of the instrumental rendition. In the chorus four eight-measure phrases (A-A-B-A) made up the dance tune; these were repeated a number of times to allow for improvised solos based on the tune by various members of the ensemble. Two styles of jazz were the generally accepted modes of performance in the 1920s: hot jazz and sweet jazz. Personal appearances as well as recordings made such performers as Louis (Satchmo) Armstrong, Duke Ellington, and Bix Beiderbecke, among many others, known to a worldwide audience. Paul Whiteman directed a jazz orchestra that had the distinction of premiering Gershwin's *Rhapsody in Blue* and thereby established itself as one of the leading groups in the 1920s.

Just prior to World War II, a new jazz style called swing was ushered in. While it was not an abrupt departure from earlier performance practices, swing emphasized danceable, easy-flowing rhythms. It suited the timbres of dance orchestras of around fifteen members rather than the smaller combos (combinations) of four, five, or six players so popular earlier. Swing also featured compositions by the white band leaders rather than those of the black composers who had dominated previous styles.

In this new era of big bands and swing, improvisation gave way to some extent to written arrangements. The big bands of Guy Lombardo, Benny Goodman (the King of Swing), Duke Ellington, Tommy and Jimmy Dorsey, Harry James, and Glenn Miller, to name but a few, dominated popular music, particularly on the radio and in the recording business. Bebop and funky jazz, as well as the return of the small combo, led into the rock-and-roll era of post-World War II.

From about the 1920s on there developed an important field of musical entertainment known as musical comedy or the Broadway musical. Closely related to the European tradition of the operetta in the late nineteenth century, these musical plays incorporated the popular musical styles of the day so successfully that many so-called current hits were drawn directly from the plays. Such teams as George and Ira Gershwin, Rodgers and Hart, Rodgers and Hammerstein, and Lerner and Loewe created a treasure trove of musical plays squarely in the popular musical tradition.

Summary

The problem of summarizing any period of twentieth-century art and music is made exceedingly complicated by the tremendous speed of the changes that have come about in every area of life. These changes have included massive technological and scientific developments, as well as the dramatic economic, political, intellectual, and social changes that have come about since the turn of the century. The arts responded to and are affected by all these developments. The technological innovations have had an especially important impact on the arts, both in terms of patronage and in terms of communication of the artist's message to the public. The advances made in transportation and in the media of communication, including radio, television, and reproductions through recordings and color photography, have made it possible for great masses of the public to experience artworks that in the past were available only to a few people.

Unfortunately, the mass media have led to an abundance of popular art and "kitsch," that appeals to the aesthetically uneducated public, created by sensationalists and those who try to give the public what they think it wants and will buy. In spite of this, however, there have been a number of "isms," especially in visual art, that have captured the spirit of the twentieth century in one way or another. Expressionism, Cubism, Abstractionism, and Surrealism have in their own way focused attention on some of the important facets of twentieth-century culture. While music cannot be defined in terms of the same "isms" as the visual arts, there are certain analogous relationships that can be discerned. For example, some music by Webern can be considered analogous to the art of the Surrealists. Schoenberg was not only a composer but a painter as well, and was closely associated with the ideas of Kandinsky. Moreover, Picasso and Stravinsky were good friends and were aesthetically very compatible.

The rise of jazz, with its varied styles of blues, ragtime, and Dixieland, is also a facet of the spirit of the early twentieth century. The improvisational style in which the music was composed during the performance was reminiscent of the Gothic and Renaissance periods.

There are a few abiding principles that seem to prevail in almost all twentieth-century art. One is the denial of the emotional excess of Romanticism. Instead there seems to be an emphasis on the technical development of handling the basic elements, both visual and musical, according to new principles of construction. Another is the functionalism of most twentieth-century art. "Form follows function" is a creed that affected architecture, sculpture, and even music. Decoration and ornamentation have been discarded in favor of the aesthetic beauty of basic materials of stone, metal, plastic, color, simple lines, and even individual sounds in music. New concepts of time and space are suggested by various means in all the arts including music.

The arts of the first half of the twentieth century were in revolt against the Romanticism and Impressionism of the nineteenth century and revealed the spirit of change that was taking place in the technological and sociocultural climate. World War II and its dramatic aftermath, however, precipitated more movements, fads, and avant-garde artists and composers than ever before.

Suggested Readings

In addition to the specific sources that follow, the general readings listed on pages xxi and xxii contain valuable information about the topic of this chapter.

Austin, William W. *Music in the Twentieth Century.* New York: W. W. Norton, 1966.

Barr, Alfred Jr. *What Is Modern Painting?* 5th ed. New York: Museum of Modern Art, 1966.

———. *What Is Modern Architecture?* New York: Museum of Modern Art, 1946.

Jones, LeRoi. *Blues People: Negro Music in White America.* New York: Wm. Morrow and Co., 1963.

Machlis, Joseph. *Introduction to Contemporary Music.* 2d ed. New York: W. W. Norton, 1979.

Neighbor, Oliver; Griffiths, Paul; and Perle, George. *The New Grove Second Viennese School: Schoenberg, Webern, Berg.* New York: W. W. Norton, 1983.

Salzman, Eric. *Twentieth-Century Music: An Introduction.* 2d ed. Englewood Cliffs, N.J.: Prentice-Hall, 1974.

Somfai, Laszlo, et al. *The New Grove Modern Masters: Bartok, Stravinsky, Hindemith.* New York: W. W. Norton, 1984.

Wilder, Alec. American Popular Song: *The Great Innovators 1900–1950.* New York: Oxford University Press, 1972.

14

THE ARTS: 1945 TO THE PRESENT

For a chronology of The Arts: 1945 to the Present, refer to pages 308–309.

Pronunciation Guide

Agam (Ah'-gahm)

Berio, Luciano (Bay'-ree-oh, Loo-chah'-noh)

Bernstein (Bern'-stine)

Boulez (Boo-lez)

Dallapiccola (Dahl-lah-peek'-koh-lah)

Henze (Hen'-tse)

Krenek (Kre'-nek)

Leger (Lay-zhay)

Lichtenstein (Likh'-ten-stine)

Ligeti (Li-get'-ee)

Messiaen (Mes-ee-yă)

Milhaud (Mee-yoh)

Nono (Noh'-noh)

Pei (Pay'-ee)

Penderecki (Pen-der-et'-skee)

Rauschenberg (Row'-shen-berg)

Rochberg (Rokh'-berg)

Rothko (Roth'-koh)

Schuller (Shool'-ler)

Stockhausen (Shtock'-how-zen)

Tinguely (Tăn-glee)

Study Objectives

1. To study the reordering of principles of design and composition.
2. To learn about the influence of pop culture upon the visual and musical arts.
3. To become familiar with a wide diversity of contemporary styles.
4. To study the spirit of post-World War II culture as revealed in the visual arts and music.

The end of World War II in 1945 marked a genuine crisis in the development of artistic expression. It was about this time that the arts embarked on new courses that were difficult to foresee in 1939. With the world greatly altered politically, economically, socially, and technologically, the arts could hardly expect to continue untouched by the events of the war. It would be an error, however, to suggest that postwar art and music represented something entirely new and unprecedented. As suggested in earlier chapters, all artistic development has its roots in the past, and the roots of postwar art lay deep in the soil of the modernism of the late nineteenth and early twentieth centuries. Also, as in other periods, some of the more important postwar developments that have affected the lives of everyone have captured the imagination of recent creative artists.

A veritable explosion of postwar technology drastically changed the lifestyle of people the world over. While the mass media had been a powerful factor before 1939, they became even more efficient as a result of developments related to television and satellite communication. Data processing and the computer made possible instant information on almost everything that touches our lives. Refinements in the techniques and psychology of advertising have made household words of a vast variety of products over the entire world. The mobility of people also increased dramatically since World War II. Air transportation made travel to every part of the globe easily accessible. As a result, there has been a cross-fertilization of cultures that threatens to destroy the long-standing integrity of racial and ethnic groups and their indigenous cultures. Countless terms, such as Coca-Cola and jazz, that in the first half of the twentieth century had been symbols of American culture are now global "property." Some recent popular influences include the Grateful Dead, Michael Jackson, Madonna, and Rambo. What was formerly peculiar and exclusive to the people of a certain nation or race has been torn from its native soil and spread worldwide.

As technology has changed, so have the moral and ethical values by which people regulate themselves and relate to each other. The use of drugs as a protest and escape, and the corruption of expressive language are regrettable but undeniable. The denial of individual freedom has prompted social concern for civil and human rights worldwide. Terrorism, kidnapping, murder, and bombing have become almost commonplace responses to grievances in several parts of the world. The protests in the United States to the Vietnam War, and more recently the response of students and citizens to years of oppression in eastern Europe have been timely responses to injustice.

Another important development following World War II has been the emphasis on environmental issues—issues that have focused on clean air, land use, preservation of wilderness areas and endangered species, and, of prime importance, the arguments over the effects of nuclear power. In addition, the

concentration on consumer protection has had an important influence on the health and economic welfare of people over a wide area of the world. All of the above have had a significant impact on the sociocultural climate of the world since 1945.

What, then, are the connections between these technological, social, and economic changes and the creative activities of music and art in the last half of the twentieth century? It would be unwise to try to relate specific works of art and music to specific ideas and events. It can, however, be shown that creative artists have been, and still are, influenced by events, as they interpret and relate to them in individual ways. Certainly Penderecki's reaction to the atomic bombing resulted in *Threnody in Memory of Victims of Hiroshima* and Benjamin Britten's *War Requiem* was a musical comment on war with its tragedies and victories. The marvels of the computer and the electronic synthesizer have been the catalysts for a variety of electronic music such as that of Milton Babbitt and Karlheinz Stockhausen.

The protest movements of the fifties and sixties that were part of the civil and human rights movements, as well as the opposition to the Vietnam War resulted in a wave of protest songs that became an important part of popular music. Pop culture came to be exploited by the mass media, which recognized the enormous purchasing power of the youth of the United States, Europe, and parts of Asia. They have championed rock music, with all its styles and fads, as a constantly changing, and therefore highly profitable, industry. In the visual arts, the mass media and mass production caught the attention of pop artists who turned to banal, everyday subjects such as that portrayed in
Colorplate 90 follows p. 328.
Warhol's *Green Coca-Cola Bottles* (colorplate 90). More recently, pop culture has turned to MTV (music television), a continuous presentation of rock music and surrealistic television imagery. It is an important innovation in this volatile industry. Pop culture, both musical and visual, generates fads at a tremendous rate. The speed with which these popular arts change seems to result from incompletely developed ideas and styles, making it easier to replace the popular with the new.

One recent positive trend has been increased federal, state, and foundation support for cultural activities of all kinds. Laws requiring that a certain percentage of monies for public buildings be given over to the visual arts have provided opportunities for many artists, while visually enriching the environment of cities. Foundations and business corporations have become aware of the public relations impact of their support of the arts. This has resulted in the purchase of individual artist's works and in the underwriting of cultural activities such as symphony concerts. There has been an unanticipated aspect to this corporate involvement in the arts as investors have moved to acquire works, not so much for their intrinsic artistic merit as for their value as investments. Cultural exchange programs between nations have dramatically widened the horizons for artistic creativity. Serious art and music as well as popular art forms have benefited from these programs.

Dealing with the current period, however, poses a new problem. The examples of art and music chosen for this book to represent past eras have been influenced by the choices of past generations. The works of only a small percentage of highly regarded artists and composers have been used as examples. The art and music patrons of past generations have done much of the selecting. The artists and composers whose works have been chosen were not necessarily the most celebrated or even the most widely known in their own day. This is especially true in the case of music and musicians. There have been countless composers whose works were popular in their lifetimes but whose efforts were not appreciated by succeeding generations. Schoenberg recognized, as have many others, that "contemporaries are not final judges, but are generally overruled by history" (Style and Idea, 1941).

Popular art and music, though, have always been present in a part of people's lives. People of all economic and intellectual levels enjoy the cultural aspects of life. We cannot reconstruct or reproduce much of the popular art and music of the past since today's means of reproduction—the color press, photography, sound recordings, and television—did not exist in any great quantity or sophistication before the twentieth century. The means of reproduction that did exist in earlier times were either largely unavailable or functioned so slowly that popular art and musical works, because they always had a short life span, were rarely recorded. We know relatively little about the origins of folk songs, for example, because few collections were made until the middle of the nineteenth century.

The tunes of eleventh and twelfth century minstrels were rarely written down, whereas there are hundreds of song lyrics recorded in elaborate manuscript books. The generations of fifteen or more centuries have winnowed out the lasting gems from among this great wealth of folk and popular music and art, and we are indebted to them for that which remains.

In contrast, there is now an overwhelming abundance of art forms, popular and classical. They pour out on us at every moment of the day and night through the mass media. As an example, folk songs by such composers as Pete Seeger, John Jacob Niles, Woody Guthrie, Arlo Guthrie, and Joan Baez are not only widely known but also copyrighted and protected. Their ready availability allows them to be heard and learned by millions of avid folk singers. Some of these songs have lived for a few months or years; some will probably live for many generations; and some will die aborning.

In this chapter, no attempt has been made to evaluate individual works or to present one style as more important than another. A few works and a few creative artists seem to stand out as representative. Others might have served as well, perhaps better. Only time will tell.

Painting

Since 1945, some of the styles and fads of the earlier twentieth century art have survived. Some have become more narrow; others have evolved into new styles. Expressionism became **Abstract Expressionism** only to be succeeded by Pop art, Op art, Kinetic art, Minimalism, and Photo-Realism. All these movements, however, are rooted in the modernism of the early twentieth century. As Abstract Expressionism came out of Expressionism and Surrealism, Pop art developed out of Surrealism. Op and Kinetic art are related to the works derived from the Bauhaus School of Design in the 1920s and 1930s. **Conceptual art** and Photo-Realism seem to be at opposite poles in their attitude toward visual objects; the former nearly denying aesthetic/material reality, and the latter reproducing its appearance with eerie realism.

In more recent decades, there has been an emphasis on the artist's own uniqueness, on originality at any cost, in what appears to be an effort toward sensationalism. Artists may try to be socially shocking, erotic, and antiestablishment. Art happenings, assemblages, minimal art, even nonart, catch the attention of the public. In this industrial-technological age, some painters represent humanity in an environment of their own creation rather than the natural presentations preferred by the Romantics. Fernand Leger (1881–1955) combines the machine and other industrial images in a style that derives from Cubism, but with colors that align it with Expressionism. *The Great Constructors* (fig. 14.1) glorifies one of the marvels of twentieth-century architecture, the skyscraper. Through the use of strong lines and simplified images Leger illustrates an important aspect of life in the second half of the twentieth century. Despite the visual impact of the building, human figures capture the viewer's eye almost immediately. The American black artist Jacob Lawrence (1916?–) makes people of central importance in his paintings. *Vaudeville* (colorplate 91) presents two entertainers before a "staccato" decorative screen. Three-dimensionality is kept to a minimum. There is no apparent source of illumination, although the character on the left casts a shadow while the one on the right does not. Its colors are playful and arbitrary.

Colorplate 91 follows p. 376.

In some cases the arts began to overlap. Painting, photography, motion pictures, sculpture, and industrial design are combined in various ways, creating hybrid art. Sculpture moves and sometimes makes sounds and projects images, blurring the distinction between art and technology. All these developments vie with each other for attention and acceptance. Because of the proliferation of styles, only some of the most prominent will be treated here.

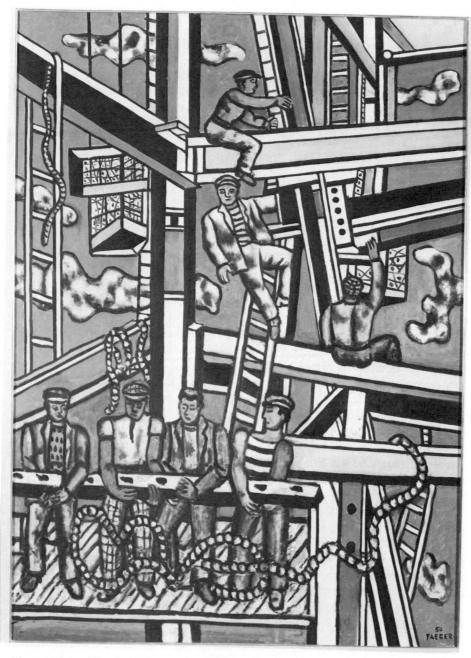

Figure 14.1 *The Great Constructors* [1950]—Leger. [9'11'' × 7'1'']. (Giraudon/Art Resource, N.Y.)

Abstract Expressionism

Abstract Expressionism, sometimes called **action painting,** is related to earlier Surrealism, to the Expressionism of the early twentieth century, and to the Abstractionism of Mondrian, Kandinsky, and others. It is a free and spontaneous kind of abstraction that emphasizes color, energetic and emotionally suggestive line, and dynamic spatial qualities that led to the creation of very large canvases. Even the method of line and color application is a part of the expressive character of these works. Jackson Pollock (1912–1956), Willem de Kooning (1904–), and Mark Rothko (1903–1970) have been the principal protagonists of this style.

Colorplate 92 follows p. 376.

Pollock, with his technique of drip painting, placed his canvases on the floor and brought his whole body into action while he splashed and dripped colors in swirling configurations. Without any set pattern or design, the paint was applied according to his feelings at that moment. In his *Number 1, 1948* (colorplate 92), the splashed and spilled lines appear to have been created in an intense and unrehearsed frenzy of action. However, the structure does seem to be carefully organized. Color combinations are rationally controlled and emotionally charged, and the design is developed through the rhythm of the painter's bodily movements. The lines of color take our eyes into the painting and encourage us to explore the swirling paths of line and color that are woven into the surface. Nothing is static; there is both physical and emotional movement.

Colorplate 93 follows p. 376.

De Kooning also uses violent strokes of color that seem to have been angrily applied to the canvas. His *Woman, I* (colorplate 93) seems to be closely connected to the Expressionism of van Gogh and Rouault. Through use of slashing lines and heavy coloring, he expressed the vulgarity of his subject in an almost completely abstract manner. De Kooning seems to have captured his inner feelings about the woman as well as her appearance. He has, in effect, gone beyond the realistic appearance and superficial meaning of his subject.

Colorplate 94 follows p. 376.

Rothko was moving away from Abstract Expressionism when he painted *Number 19* (colorplate 94) in 1958. In his search for expression, he abandoned all reference to objects, and color became both content and form. The work is completely without forms from nature. Patches of color are superimposed one upon another with no hard edges. Color spreads quietly from one form to another because their values are closely related. There is little spatial consciousness, but the colors do set up a gentle, rhythmic movement of abstract forms and gradations of hues that evoke an almost mystical expression.

Pop Art

The sources of **Pop art** lie in our pop culture, which itself results from the combined effects of mass communication, advertising, mass production, the leveling of social strata, and fashion. In earlier times, high fashion was for the wealthy elite. However, with more money, more leisure, and mechanization, fashion is available to a worldwide market for all people. Democracy has led to the idea that everyone has the right to be fashionable if they wish. Fashion uses visual ideas at a prodigious rate, and there is a constant search for novelties and gimmicks to further intrigue the public and make what people currently have obsolete. Almost all the objects we use or wear are mass produced. Pop artists have seized on this reality as a source, as they cultivate an audience for their artistic activities.

Pop art emphasizes mass-produced objects and symbols of the mass media. It can also be said that Pop art is opposed to the so-called fine arts. It is almost the opposite of Abstract or Expressionist art for it presents the commonplace, mass-produced visual experiences of society in a blatantly realistic manner. Posters, soup cans, comic strips, and banal objects of everyday existence become subject matter for the artist's efforts. These items are usually depicted with photographic realism, often in exaggerated sizes and arbitrary colors. Because of size or repetitive images, there is an intensity that makes us conscious, often for the first time, of what we see around us in our everyday existence.

Robert Rauschenberg (1925–) is one of the artists whose works precipitated the Pop art movement. His work constitutes a link between Abstract Expressionism and Pop art. He attaches real objects, or groups of objects, to his canvases in a kind of collage technique. Sometimes the objects are covered with paint and sometimes not. In one of his early works, he exhibited a real bed that was all made up and covered with paint. In *Quote* (fig. 14.2), painted in 1964, he created a review of passing events and symbols, the varied ideas and events that affected our lives at a particular moment. Using silk-screen technique, he juxtaposed such images as the well-known photo of President Kennedy, parachute jumping, traffic signs, and other common visual objects. He also used color to intensify the painting's expressive quality. The association of dissimilar images, the unusual placement of the images, and the irrational spatial character suggest a connection with both Surrealism and Abstract Expressionism.

Andy Warhol (1930–1987), also one of the pioneers of Pop art, used multiple images of mass-produced items as symbols to characterize our culture. His *Green Coca-Cola Bottles* (colorplate 90) proclaims the skills of the world of

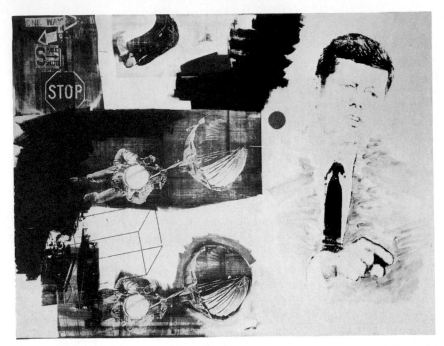

Figure 14.2 *Quote* [1964]—Rauschenberg. (Courtesy Leo Castelli Gallery, New York)

advertising, which has more respect for the container than for the material contained. His subjects in other works range from multiple images of Marilyn Monroe to Brillo boxes and Campbell soup cans—all symbols of American pop culture.

Another Pop artist is Robert Indiana (1928–), who uses word images and symbols of commercialism. *The American Dream* (colorplate 95) shows a painting of stenciled signs with such words as "tilt" and "take all" to suggest a pinball machine obsession and to comment on the American dream of getting rich quick. Like the works of Warhol, there is nothing personalized about Indiana's work; it is a statement about the commercialism of today.

Roy Lichtenstein (1923–) shocked the public with his giant comic book illustrations. In an era when the comics are an integral part of our culture for people of all ages, he has exalted such comic book heroes as Steve Canyon and others. His technique even includes the dots which are a part of the cheap color-printing process. In his *Drowning Girl* (fig. 14.3), the exaggerated teardrops and the verbal message suggest the melodrama of the scene.

One can hardly discuss Pop art without reference to Claes Oldenburg (1929–) who was more a maker of objects than a painter. Influenced by Warhol, he created giant hamburgers and fur-lined cups. He distorted the

Colorplate 95 follows p. 376.

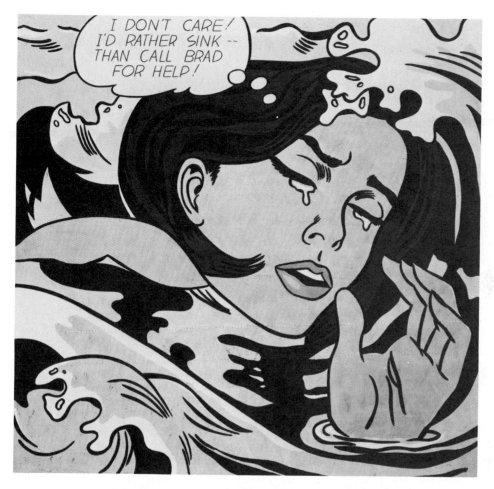

Figure 14.3 *Drowning Girl* [1963]—Roy Lichtenstein. Oil and synthetic polymer paint on canvas, 67⅝″ × 66¾″. (Collection, The Museum of Modern Art, New York. Philip Johnson Fund (by exchange) and gift of Mr. and Mrs. Bagley Wright)

reality of almost every object he portrayed, taking them out of context, changing their forms from hard to soft, and usually exaggerating their size. *The Toilet* (fig. 14.4) is constructed from metal, wood, foam rubber, vinyl, and plastic tubing. The work comes through as a satire on the efficient machine culture of today.

The *Target with Four Faces* (fig. 14.5) by Jasper Johns is dominated by a familiar object, a target, over which are superimposed, in bas-relief, four truncated plaster masks. This truncation of the faces, together with the target, depersonalizes humanity and the result is a collective image that suggests a macabre social statement.

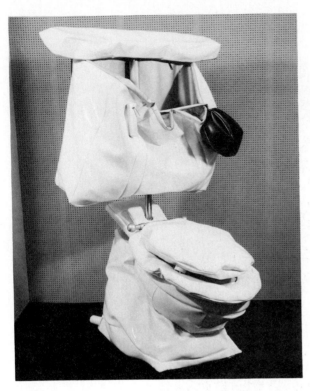

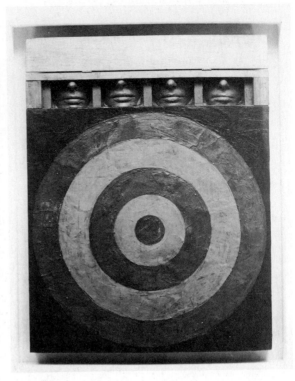

Figure 14.4 *The Toilet* [1966]—Claes Oldenburg. (Soft model) Vinyl filled w/kapok, wood painted with liquitex. 50½" × 30⅜". (Collection of the Whitney Museum of American Art, N.Y.)

Figure 14.5 *Target with Four Faces* [1955]—Jasper Johns. [33⅝" × 26" × 3"]. (Collection, The Museum of Modern Art, New York. Gift of Mr. and Mrs. Robert C. Scull)

Op Art

Optical art, or **Op art** as it is generally called, is a term usually applied to those two- and three-dimensional works that explore optical responses generated by color and line. While it is abstract, it is essentially formal and exact. It is a trend that grew out of the ideas developed in the Bauhaus School of Design in the 1930s. Nonobjective patterns of line, shape, and color act as stimuli to the eye and mind of the viewer. Whatever the expressive result, it is a new kind of subjective experience in which illusion, afterimages, and visual movement are real in the mind of the observer but do not exist objectively in the artwork. Op art does not lend itself to intellectual exploration or explanation. Its only impact is usually the unique and immediate experience it provides.

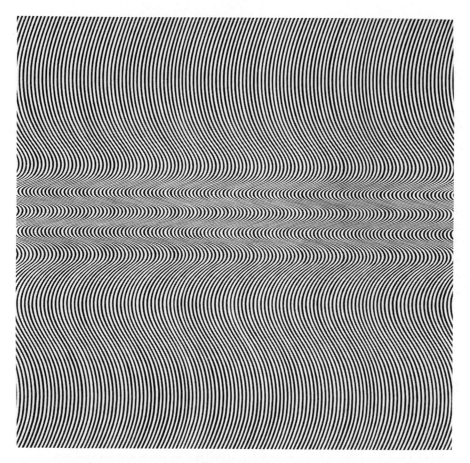

Figure 14.6 *Current* [1964]—Bridget Riley. Synthetic polymer paint on composition board, 58⅜″ × 58⅞″. (Collection, The Museum of Modern Art, New York. Philip Johnson Fund)

Double Metamorphosis II (colorplate 96) by Agam (Yaacov Gipstein) (1928–) is a structure made of long wooden pieces, and the facets of each strip of wood are painted differently. The strips are organized in such a way that the visual pattern changes as the viewer moves from one point of view in the room to another.

Colorplate 96 follows p. 376.

A further example of Op art is the work of Bridget Riley (1931–). Her *Current* (fig. 14.6) consists of black-and-white undulating stripes and a formal progression of line. The work depends on the phenomenon of optical illusion to suggest movement.

More recently, Op artists have used psychedelic light shows in an obvious attempt to intensify visual experience by adding both movement and artificial lighting in the same manner as rock music intensifies the experience of sound by electronic amplification and the movement of the performers themselves.

Photo-Realism

Colorplate 97 follows p. 376.

Critics distinguish between Realism and Photo-Realism by whether the artist paints from photographs. Many Photo-Realists actually project photographs on the canvas to replicate with oils. *Differing Views* (colorplate 97) by James Valerio (1938–) presents an urban apartment occupied by what appears to be two alienated people. The interior lighting derives from the television set, which consumes the attention of the lady, and the exterior lighting from the fast-fading twilight. Although valid statements may be made about the vivid colors of the painting, the artist's technique, and the elevated exterior view, the feature that immediately captures the viewer's imagination is the superrealism of Valerio's painting.

Kinetic Art

In the previous chapter, two examples of Kinetic art by Alexander Calder were discussed. Len Lye (1901–1980) in his *Fountain* (fig. 14.7) uses an electric motor to make vertical metal rods sway gently to suggest the flow of water affected by currents of air. With the addition of illuminated fiber optics this work has been commercially imitated and marketed widely.

Others have created machines that move, rattle, and groan and have no relationship to anything except our mechanized culture. Columbia Records even produced an album, *Chronophagie*, devoted to sound-creating sculpture with selected instruments, created by the brothers François and Bernard Baschet. One of the more sensational mechanized sculptures, by Jean Tinguely (1925–), was called *Homage to New York*. Its many parts clanged, rattled, and screeched. It was programmed to self-destruct, which it did in a cloud of smoke, supervised, according to reports, by the New York Fire Department and witnessed by a large audience.

Sculpture

Minimal art, or primary structures as it is often called, grew out of the work of the Constructivists. In some ways it is related to Cubism. Minimal art is usually three-dimensional and consists of either a single unit or a series of

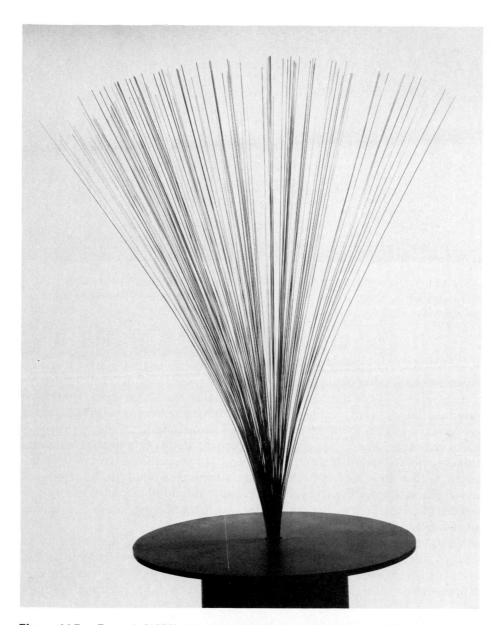

Figure 14.7 *Fountain* [1959]—Len Lye. Stainless steel and motor, 85″ × 72″ × 72″. (Collection of Whitney Museum of American Art. Gift of the Ford Foundation Purchase Program Acq. # 63.10)

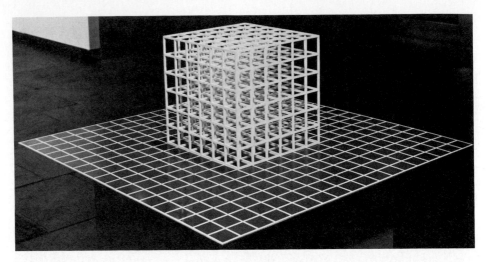

Figure 14.8 *Untitled Cube (6)* [1968]—Sol LeWitt. Painted metal, 15¼″ × 15¼″ × 15¼″, with a base of ¼″ × 45″ × 45″. (Collection of the Whitney Museum of American Art. Gift of the Howard and Jean Lipman Foundation, Inc. Acq. # 68.45)

identically shaped primary forms, not necessarily of the same size. It is a reduction to basic shapes without ornament or an attempt to improve the geometry or volume of the basic form. Often this kind of sculpture seems to penetrate the space we occupy. The work can intrigue the spectator by evoking responses to spaces, to volumes and to enclosures. *Untitled Cube (6)* (fig. 14.8) by Sol LeWitt (1928–) is a steel-cage construction with painted metal rods. It makes no statement beyond the cubical shapes and the volume encompassed within these cubes. It expresses nothing more than itself, a series of cubes connected together. The artist probably intended the spectator to have the idea of cubes; hence, the idea of cubes becomes not only the subject matter but the artwork itself.

David Smith's (1906–1965) *Cubi X* (fig. 14.9) is in some ways Minimalist, but it is more firmly rooted in Constructivism. It is over ten feet tall, and its small base emphasizes the balance among various geometric forms. The burnished surfaces mitigate the feeling created by intractable nature of stainless steel.

Barbara Hepworth (1903–1975) was one of Britain's finest twentieth-century sculptors. Like so much art, her work does not fit neatly into any of the specific sub-groups of her artistic age. Her focus on primitive, almost organic shapes relates in some way to the Minimalists, but more directly to the

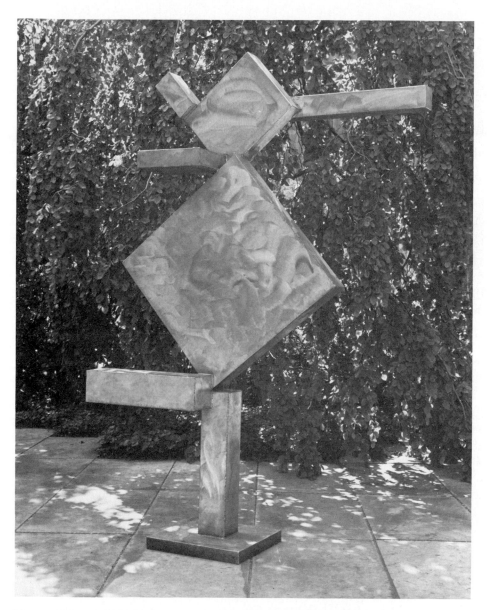

Figure 14.9 *Cubi X* [1963]—David Smith. Stainless steel, 10'1⅜" × 6'6¾" × 2', including steel base 2⅞" × 25" × 23". (Collection, The Museum of Modern Art, New York. Robert O. Lord Fund)

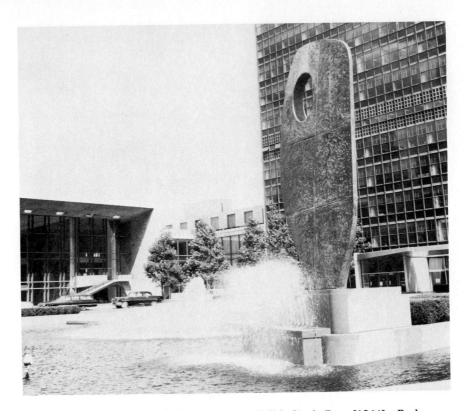

Figure 14.10 Memorial to Dag Hammarskjöld. *Single Form* [1964]—Barbara Hepworth. Bronze with granite base. Height 21'. (United Nations, New York, through a grant by the Jacob and Hilda Blaustein Foundation. Courtesy photo UN 161, 123 by Nicholas Kuskin)

work of her compatriot, Henry Moore. One of her representative works is the memorial to Dag Hammarskjöld, *Single Form* (fig. 14.10). This monument stands in front of the United Nations Building in New York and may be her best-known work. Its dependence on simple shapes is representative of her style. What appears at first glance to be a curved monolithic figure in fact consists of several pieces, each of which has at least two straight sides. The pieces are joined securely to create the larger shape, which is interrupted only by the circular hole toward the top.

By incorporating human shapes and representations of human body parts in unusual sculptural settings Marisol (1930–) plays games with the viewer's perceptions of reality. Her mixed media sculptures are close enough to human figures that they are identifiable, yet far enough away to awaken strange responses. In *La Vista* (colorplate 98) four human figures are portrayed by using realistically painted representations, found objects, and painted and carved wood for their bodies.

Colorplate 98 follows p. 376.

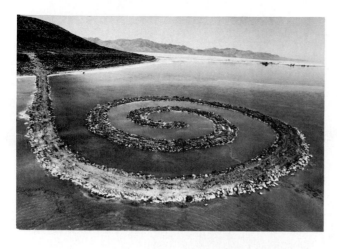

Figure 14.11 *Spiral Jetty*—Smithson. (Gianfranco Gorgoni)

Typical of the works of many artists who are in the vanguard of their profession, those of Robert Smithson (1938–1973) are difficult to categorize. Throughout his artistic career his works were characterized by exploration. In Robert Hobbs's book on the works of Smithson, the author finds it necessary to divide a thirteen-year period of Smithson's career into nine categories. In spite of its monumental scale, *Spiral Jetty* (fig. 14.11) illustrates Smithson's interest in Minimalism, by using 6,650 tons of material to create a simple spiral figure in the Great Salt Lake in Utah. It also relates to prehistoric monumental earthen works (the Serpent Mound in Ohio and the earth drawings on the Nazca desert in Peru).

Permanence has been one of the criteria that aestheticians have used to apply to art. It is this principle that Christo Javachef (1935-) consistently defies as he creates wrappings for anything from castles to coastlines on three continents. These works impinge on the environment, and are never confined by museum walls. Consequently, the dismantling of them after a fixed period of time is part of the creative process. *Running Fence* (fig. 14.12) was a nylon fabric "fence" 18 feet high that extended 24 1/2 miles from Bodega Bay on the west to beyond US Highway 101 near Petaluma, California. It stood complete for only two weeks, and approximately one month later all traces of its existence were removed. *Running Fence* piqued the imaginations of thousands of people, who traveled to the site to witness this unique object. Works such as this defy all artistic traditions and aesthetic dogmas.

The works of artists such as Smithson and Christo encourage people to see the environment in a new way. By dramatically moving outside ordinary experience they challenge our notions of beauty and art.

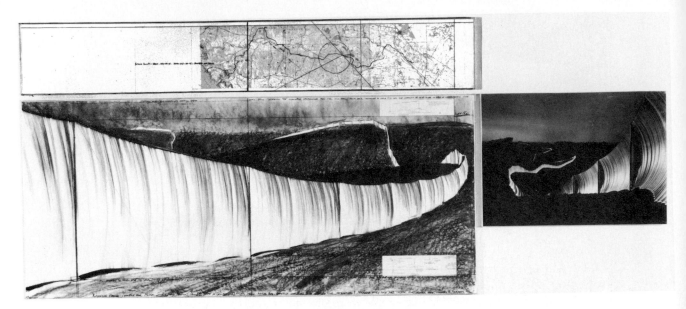

Figure 14.12 *Running Fence* [1976]—Christo. (San Francisco Museum of Modern Art. Gift of the Modern Art Council)

Architecture

Architecture after World War II continued on the course of functionalism that marked the best and most exciting prewar buildings. With an emphasis on technology, architects searched for the practical solution for a given function or set of needs. In recent years, they have taken into consideration environmental compatibiity and land use as well as aesthetic quality. Efficiency of operation has included such things as climate control, solar energy, and ease of ingress and egress. In spite of the idea that a building must be an efficient, functioning machine, architects have managed to find a basis for unique individual expression. Moreover, in recent years architects have utilized the talents of sculptors and painters to enhance and symbolize the function of the building and to relate it to human activities by their collaborative efforts.

One of the most exciting and artistic solutions to the problem of function and aesthetics is the *East Building of the National Gallery of Art* in Washington, D.C., designed by I. M. Pei (1917–) and completed in 1978. It was designed to achieve harmony with the other buildings along Pennsylvania Avenue. Moreover, Pei, whose recent pyramidal additions to the Louvre have been met with mixed reactions, was able to orient the structure in such a manner that the dome of the Capitol is visible from almost any window or corner. The *Central Courtyard* (colorplate 99) is filled with geometric forms;

Colorplate 99 follows p. 376.

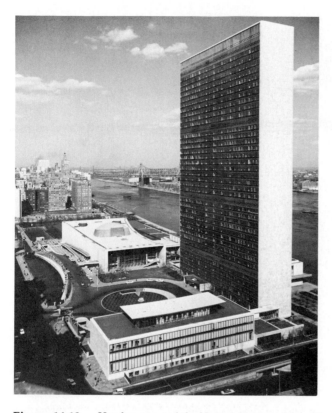

Figure 14.13 *Headquarters of the United Nations,* New York [1950]—Wallace K. Harrison, Architect in Charge. (Courtesy United Nations)

triangles and rectangles that confront one everywhere—in the stairwell, exhibit space, the ceiling, walls, and floor. Calder's last monumental kinetic sculpture is suspended from an eighty-foot-high ceiling. A huge tapestry by Joan Miró hangs on a nearby wall.

Of all buildings, skyscrapers have continued to be the symbols of twentieth-century economic life and a unique American contribution to architecture. The congestion in the city of New York made it necessary to build vertically in order to create more floor space on a small piece of ground. The *Headquarters of the United Nations Building* (fig. 14.13) shows the use of steel-cage construction in a skyscraper. Note the horizontal bands of windows that run completely across the face of the building, one band for each of the thirty-nine stories. The arrangement of the well-lighted airy offices and suites makes this a functional building for the transaction of business and government in the important branches of the United Nations. From the exterior, it appears almost abstract in design, like LeWitt's *Untitled Cube* (fig. 14.8). The *General Assembly Building* of the United Nations is shown in the background. The main

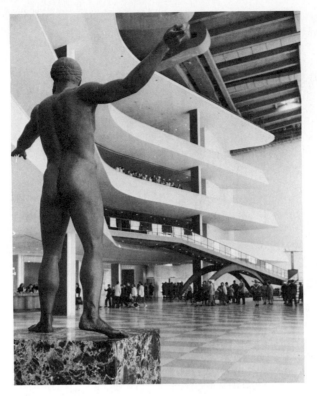

Figure 14.14 *Main Lobby of the General Assembly Building*, United Nations, New York [1950]—Wallace K. Harrison, Architect in Charge. (Courtesy United Nations)

lobby of the *General Assembly Building* (fig. 14.14) includes cantilevered balconies in free organic forms, a sharp contrast to the geometric design of the exterior of the *Headquarters Building*. The figure of *Zeus* in the foreground is a gift of the Greek government.

As engineering technology has been refined the heights of skyscrapers have increased. The building of a skyscraper is both an engineering and an architectural feat. The *Columbia Seafirst Center* (fig. 14.15) in Seattle, Washington, designed by Chris Simons, is the tallest building by number of stories west of the Mississippi, with six parking levels below ground and seventy-six floors above ground. Its exterior combines granite quarried in South Dakota and gray-tinted glass, giving a black appearance. Although it is a unit, it gives the appearance of interlocking concave and convex forms, offering dramatic contrast to the predominantly rectangular buildings surrounding it.

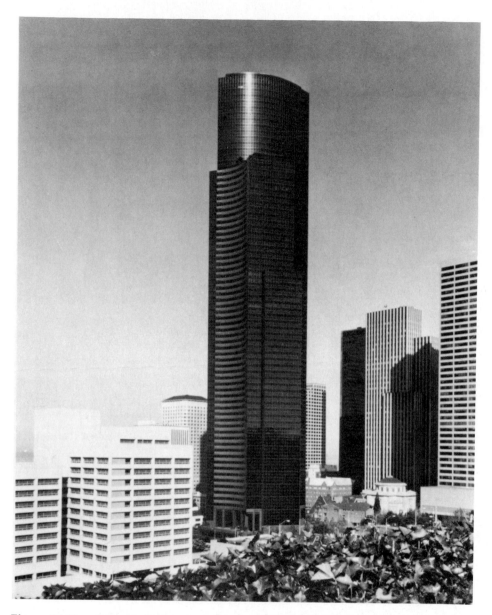

Figure 14.15 *Columbia Seafirst Center*, Seattle, Washington [1983–84]. (Chris Simons)

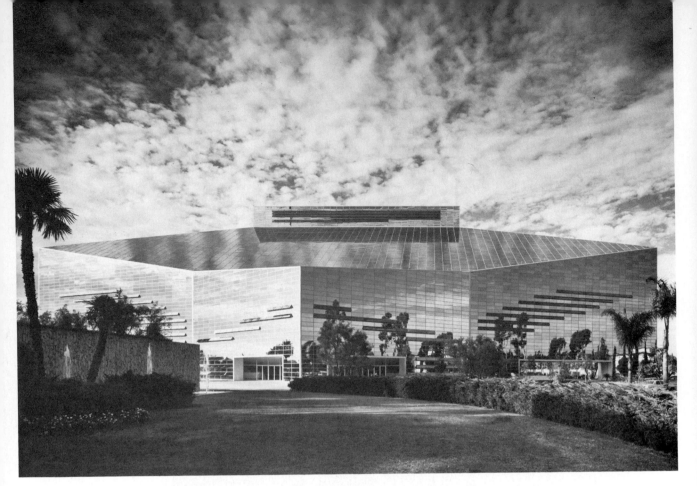

Figure 14.16 Exterior of *Crystal Cathedral*—Johnson/Burgee, Architects. (Gordon H. Schenck, Jr.)

Another important architectural structure, which emphasizes the very recent tendency to do more than merely enclose a space with a steel and glass cage, is the *Crystal Cathedral* in Garden Grove, California (figs. 14.16, 14.17). This edifice grew out of the desire of the pastor of a large congregation to represent not only the "drive-in" portion of his flock (to which he had been preaching for a number of years) but also to house another large portion of his people in an enclosed space; the enclosed space, however, had to retain the "openness" of the drive-in theater where the congregation first met. What resulted was a spectacular building that retained the open-air character and at the same time captured some of the religious ambience of a Gothic cathedral, not by imitation of style, but rather by skillful engineering to achieve spiritual serenity on an enormous scale.

The structure is essentially a steel frame covered with more than ten thousand specially fabricated glass panes that give a feeling of light and the

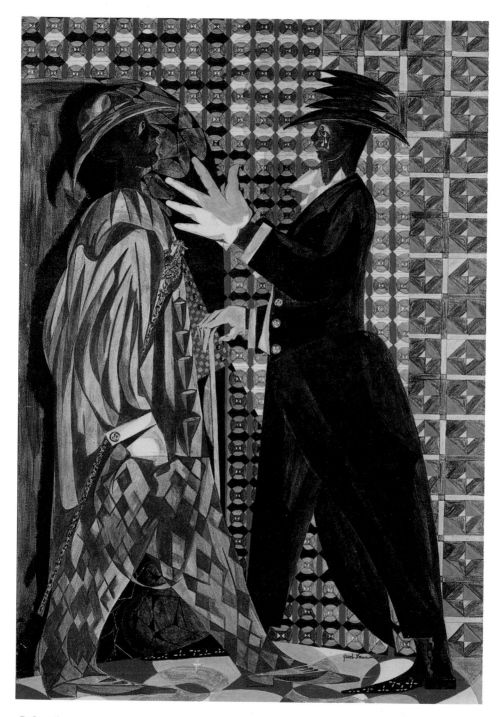

Colorplate 91 *Vaudeville* [1951]—Jacob Lawrence. Tempera on fiberboard with pencil [29⅞" × 19¹⁵⁄₁₆"]. (Hirshhorn Museum and Sculpture Garden, Smithsonian Institution. Gift of Joseph H. Hirshhorn, 1966)

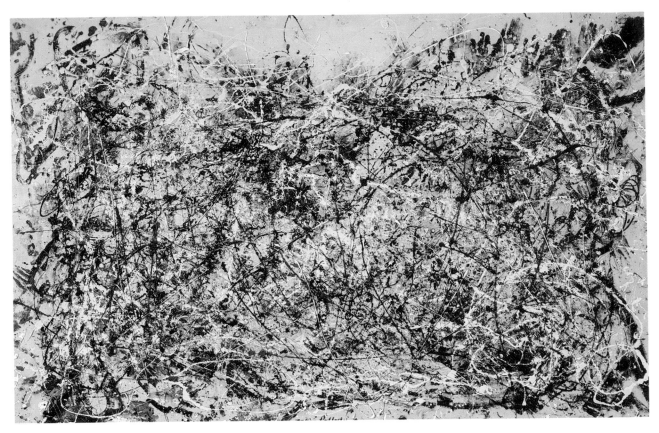

Colorplate 92 *Number 1, 1948.* [1948]—Jackson Pollock. Oil and enamel on unprimed canvas, 5'8'' × 8'8''. (Collection, The Museum of Modern Art, New York, Purchase)

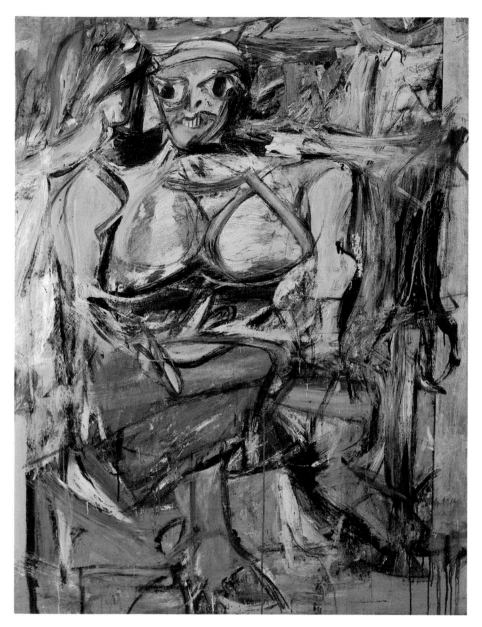

Colorplate 93 *Woman, I.* [1950–52]—Willem de Kooning. Oil on canvas,
6'3⅞'' × 4'10''. (Collection, The Museum of Modern Art, New York. Purchase)

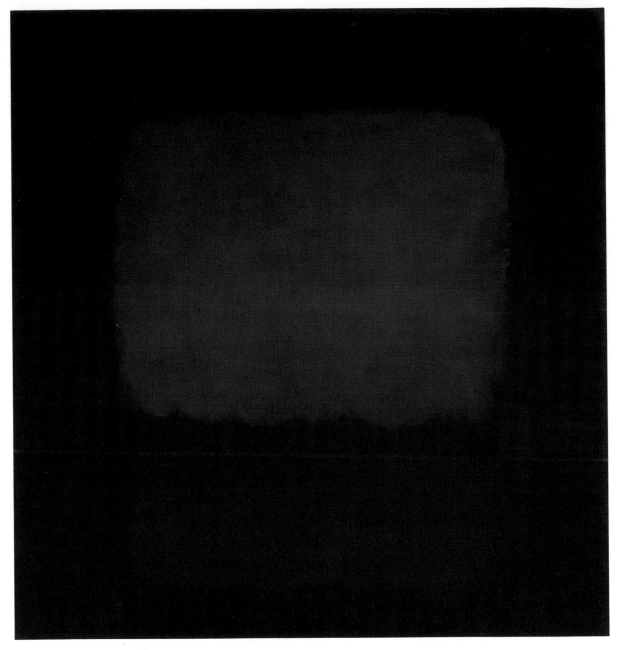

Colorplate 94 *Number 19* [1958]—Mark Rothko. Oil on canvas, 7'11¼" × 7'6¼". (Collection, The Museum of Modern Art, New York. Given anonymously)

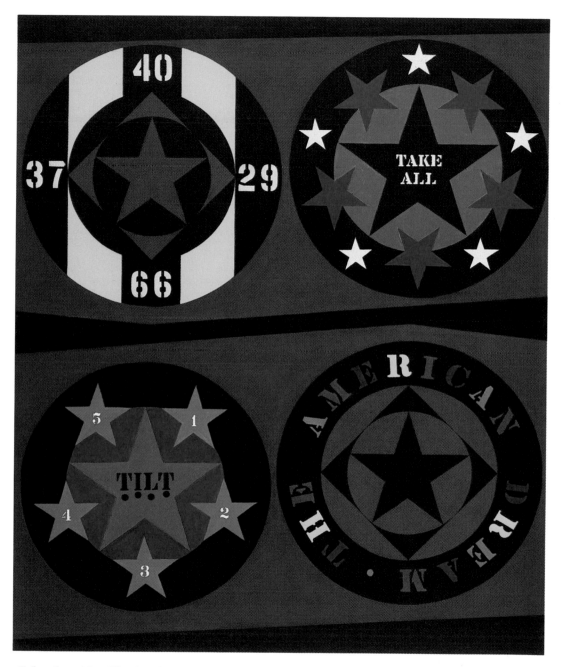

Colorplate 95 *The American Dream, I* [1961]—Robert Indiana. Oil on canvas,
72″ × 60⅛″. (Collection, The Museum of Modern Art, New York. Larry Aldrich
Foundation Fund)

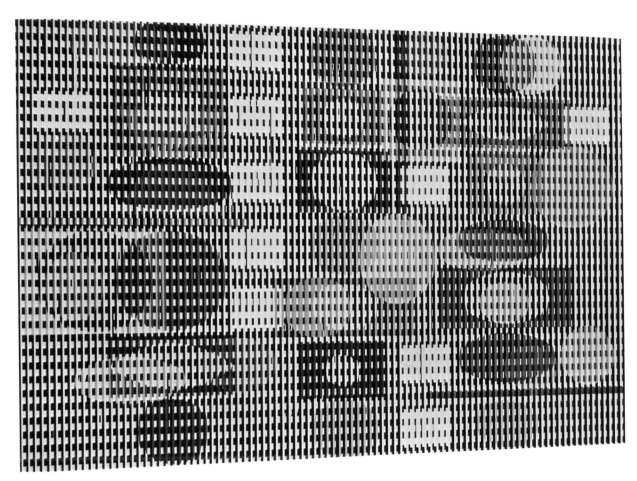

Colorplate 96 *Double Metamorphosis II* [1964]—Agam (Yaacov Gipstein). Oil on corrugated aluminum, in eleven parts, 8'10" × 13'2¼". (Collection, The Museum of Modern Art, New York. Gift of Mr. and Mrs. George M. Jaffin)

Colorplate 97 *Differing Views* [1980–81]—Valerio. 102″ × 92″. (Frumkin/Adams Gallery, NY)

Colorplate 98 *La Vista*—Marisol. (Stadt. Koln/Verwaltung der Museen)

Colorplate 99 Central Courtyard of National Gallery of Art in Washington, D.C., East Building [1978]—I. M. Pei. (Courtesy Robert Lautman)

Colorplate 100 *Christ in Glory* tapestry at Coventry Cathedral. [1962] Designed by Graham Sutherland 74′ × 38′. (© Woodmansterne Ltd.)

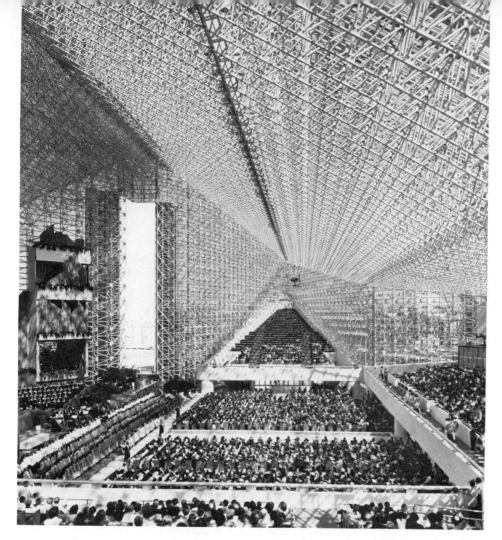

Figure 14.17 Interior of *Crystal Cathedral*—Johnson/Burgee, Architects. (Gordon H. Schenck, Jr.)

out-of-doors to both the interior and exterior views. The *Crystal Cathedral* weds contemporary religious purpose to twentieth-century architectural techniques: the outdoor "drive-in" element induced by the automobile, the beauty of interior setting as a consideration of TV broadcasting, the use of structural steel frame and glass, the solving of acoustical problems both within and outside the building by the most recent electronic systems rather than by any restrictions placed on the structural elements. All in all, this fantastic building is "in truth—extraordinary architecture: with its magic of light and structure, it is a building that reaches out to people and that people reach out to—a fair litmus test for any serious piece of architecture" (Robert E. Fischer, *Architectural Record*, November 1980).

Colorplate 100
follows p. 376.

Much of the success of a building has to do with its interior design and furnishings. The cathedral at Coventry, England was constructed adjacent to the ruins of a Gothic cathedral. The building incorporates beautiful objects created by numerous international artists and artisans to enhance the liturgical life within. Among these are: modern German and Swedish stained-glass windows; a baptismal font made from a huge boulder from Israel; Danish mosaics; and a giant tapestry of Christ made in France from a design by the English artist, Graham Sutherland. The tapestry *Christ in Glory* (colorplate 100) is situated behind the altar, and presents the dominating figure of Christ triumphant, surrounded by four gospel symbols. This configuration was traditionally placed in the tympanum above the main portal of cathedrals. The four symbols, man, eagle, lion, and ox are strikingly modern, while the figure of Christ is more traditional. Between his feet is a human figure, and below that is a small panel representing the crucified Christ. The enormity of the tapestry and its vivid colors dominate the entire interior.

These examples by no means exhaust the innovations in architecture since World War II. They do, however, demonstrate that architects have responded to their time. They have kept art alive and vital by incorporating new materials and new techniques that meet today's functional demand and at the same time express contemporary culture.

Music

While technology has tremendously influenced the dissemination of musical performances of all kinds, no aspect of musical creativity has proliferated more than popular music. The universal availability of technical media that receive and reproduce music has made the dissemination of music one of the biggest industries in the world, particularly in industrial countries. Interestingly, this mass distribution of recordings has given a vast audience impeccable standards of performance against which they are inclined to judge all performances.

In much popular music, the situation is peculiar in that every original performance is unique because spontaneous improvisation is the sine qua non of that style. In contrast to the traditional musical forms that are documented in notated scores, the works of jazz and rock artists find permanence almost exclusively in recorded performances.

Many modern composers outside the world of popular music have also provided opportunities for improvisatory performance. Aleatoric or indeterminate music is also a kind of improvisation. Aleatoric compositions attempt to satisfy the compositional urge to which performing musicians feel they are entitled. The modern composer of art music has used a number of new devices of notation which are, in effect, indications for directed or even free improvisation.

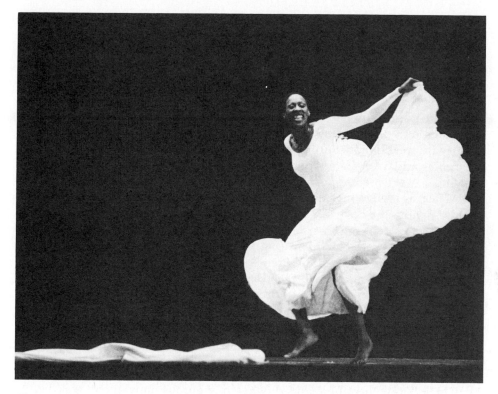

Figure 14.18 Judith Jamison in "Cry". (© Jack Vartoogian)

Another factor influencing twentieth-century music is the mass audience. Music is no longer the property of a few highly selected persons as it was traditionally. The electronic media, and the proliferation of recordings all bring music to an unprecedented number of people.

Popular Music

An essential feature of popular music is its rhythmic emphasis. Regularity and emphasis of duple meter dominates this musical style, but it is effectively countered by a freedom that results from the improvisatory character of the performance. This foundation on predictable meter stems naturally from the dance, with which popular music is often closely associated. The rhythmic freedom of the melody operating over an established meter has intrigued composers and choreographers since the beginning of the century. It continues to do so today, as dance troupes perform regularly to a wide variety of popular music. One recent successful example is Alvin Ailey's *Cry* (fig. 14.18), which is set to jazz, blues, and soul music.

Tone color is another central element of popular music. The unique tone qualities of vocal and instrumental timbres of jazz are critical to the style. The unique effects achieved in jazz and popular music with such traditional instruments as the trumpet, trombone, and saxophone are recognized worldwide, and have been exploited by performers of art music as well as popular music. In recent years there has been an enormous expansion of timbres employed in popular music as electronic synthesizers have become standard instruments in popular ensembles of almost every kind. The late twentieth-century interest in non-European cultures is manifest in the instrumentation of popular and art music as non-European instruments are called for in performance. A great variety of percussion instruments from the South Pacific and Africa, as well as instruments from East Asia, are regularly heard in some popular bands, and have had an effect on both popular and art music of today.

Performers and composers associated with the styles of the 1940s are Duke Ellington and Benny Goodman (big bands); Charlie Parker and Dizzy Gillespie (funky jazz and bebop); Stan Kenton (progressive jazz); John Lewis, Dave Brubeck, and Miles Davis (cool jazz); and Gunther Schuller (third-stream jazz). Examples of the various jazz idioms since World War II can be found in the countless recordings made at the time by these and other performers. The very nature of the jazz improvisatory idiom makes it impossible to separate the composer from the performer. In almost all instances they are one and the same.

When Bill Haley and the Comets introduced the world to "Rock Around the Clock," few people realized what a vigorous movement was being launched. Since that time, rock music has continued unabated, growing to one of the biggest industries in the world of music and adjusting to the individual creative and performing styles of countless rock artists. Rock and roll's earliest roots may be similar to those of jazz, but it would be incorrect to consider it an outgrowth of jazz music. After the great success of the early king of rock music, Elvis Presley, there developed an unprecedented domination of popular music (in this case, rock and roll) by English musicians. It started, of course, with that country's first international rock stars, the Beatles. They have been followed by a long list of modern rock composers and performers who have maintained rock and roll as one of the dominant forces of popular music.

The earlier forms of the blues (e.g., the twelve-bar phrase) were characteristic of earlier rock and roll, but a repeated bass figure often destroyed any semblance of formal balance of phrases. Rock and roll was an expression of adolescents in defiance of the traditional mores in dress, vocabulary, and music. The earliest of the rock and roll stars, Elvis Presley, personified this revolt for millions of youths not only in America but all over the world. Another characteristic was the dominating volume of sound that was only possible through the use of electronic amplification that added immeasurably to the hallucinatory character of rock and roll. This was not only dance music.

Rock and roll was also music for performance to large admiring audiences of youths whose activity consisted of a kind of hypnotic, nervous, gut response to amplified sounds and glaring lights. Such a performance had all the aspects of a "happening" in which light, sound, movement, and words were combined into a single emotional impression.

In the 1960s, the Beatles represented a phase of rock and roll that was marked by its interest in philosophical and social concerns, particularly those of Eastern religions. Another English group, the Rolling Stones, represented a more violent emotional phase of rock and roll that eventually led to a style known as "acid rock" in which the drug culture was emphasized as well as the social revolt of youth. Groups such as the Grateful Dead and The Jefferson Airplane represented such a style also. The naming of rock groups seems to place this enterprise in a spiritual relationship with the earlier art movements of Dada and Surrealism.

The late 1970s and 1980s have seen something of retrenchment of the excesses of rock and roll. There have been attempts at various degrees of eclecticism. Jazz, East Indian music, electronic music, and blues have all been combined in one way or another. Chuck Mangione and groups such as Blood, Sweat, and Tears have combined more-or-less traditional musical training with elements of jazz, while staying generally within the rock tradition. Mangione has even used the symphony orchestra with success, although his main emphasis has been the combo. During this same period there has been a resurgence of interest in the big band, with Don Ellis as one of its leading proponents.

Modal harmonies and scales outside major-minor systems have been used by the more enterprising bands. In general, the trends, while not yet completely distinguishable, seem to be toward a more mild form of presentation as well as musical effect. The apparent turn to nostalgia of the 1950s and 1960s has affected many aspects of rock and roll.

Music in the Concert Hall

The term *classical music* is of dubious value. Substitutions for that term, such as *serious music* or *concert music* are nearly as objectionable. The authors use this term to refer to music in the long tradition of notated art music.

In classical music, the general trends of the first half of the twentieth century have continued and have been further exploited in the second half of the century. The twelve-tone construction of Arnold Schoenberg became a tool of many composers, some of whom used it in a rather free manner, while others have abandoned the entire scheme in increasing numbers. The complete serialism of Anton Webern was seized upon by a number of avant-garde composers, and Webern's pointilistic style was a kind of forerunner of composing with the electronic sounds of the newly invented synthesizer. The development of the synthesizer and computer as tools for achieving new tonal colors and rhythmic complexities that were unobtainable through any other medium is one of the most novel and influential trends of this period. The

improvisatory techniques of jazz performance and the rhythmic freedom of popular music have been reflected in concert music as well. A new type of music known as aleatoric, chance, or indeterminate music goes beyond improvisation. This style of musical composition is only partially dictated by the notation of the composer. In fact, the composer merely suggests certain patterns of sound, if any, in a notation that varies from the traditional to that completely lacking in definite pitch or rhythm. The performer, following these broad and general instructions, uses them as a basis for improvisation. In some instances, only duration of the improvisatory section is indicated.

Two areas of traditional music—the musical stage and the church—have been highly influenced by popular music. In this tradition, a long succession of musical plays dates back to the early decades of the century. These involved many gifted composers, lyricists, and performers. Recent theatrical successes that owe some of their musical character to the popular idiom include *The Phantom of the Opera,* and *Les Misérables.* The influence of rock and roll is evident in the stage works *Hair* and *Jesus Christ, Superstar.* In recent decades music for the church has included numerous jazz anthems and a variety of other popular styles. In addition, Bernstein's *Mass,* composed for the opening of the Kennedy Center in Washington, D.C., includes popular music in a variety of styles.

The list of composers active in the latter part of the twentieth century is of enormous length. It is impossible to select any one as the most representative. In this period of great diversity, each composer reflects his or her personal idiom along with one or more of the common, and almost universal, characteristics of musical composition. A few composers have already enjoyed rather widespread recognition. Whether they or others of their contemporaries will be most representative of the last half of this century remains to be seen.

In the following pages, certain obvious trends of the present era are indicated and representative examples listed. In some instances, composers may be found under more than one category since they have been involved in several styles.

Electronic music is a development that has taken place mainly since World War II. In its beginning, most electronic music was in the nature of experimental exercises, with tonal materials gathered from various sources. Electronic composers first recorded and manipulated all manner of sounds and noises and composed these by means of tape recording into arbitrarily organized forms. In some instances, the sounds are those of musical instruments distorted through the manipulation of the tape recorder. The development of the synthesizer, (fig. 14.19), however, gave composers the opportunity to use sounds generated directly by means of electrical equipment. Experiments in combining such manipulated sounds with traditional instruments are also a part of the electronic composer's expression. Many composers have used

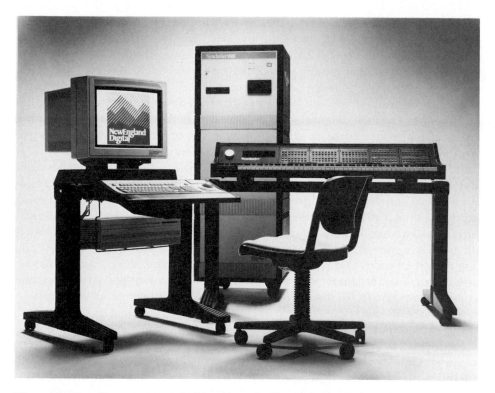

Figure 14.19 Computer musical instrument. Synclavier music work station. (New England Digital)

electronic devices of one kind or another. Karlheinz Stockhausen (1928–), a German musician, has been one of the leading composers in this field. A pupil of Messiaen, his work has centered around the electronic studio of the Cologne radio and the Darmstadt Center for Contemporary Music. In his *Gesang der Jünglinge* and *Kontakte,* Stockhausen has combined natural sounds with electronically generated ones. Edgard Varèse (1883–1965), who was one of the exploiters of tonal color, also used the synthesizer in his works *Deserts* and *Poème Electronique.*

Composers using electronic music often closely followed the principles of twelve-tone construction, but they extended these principles beyond the practices of Schoenberg and Webern. Twelve-tone composition was serialism confined to the element of musical pitch. Most post-World War II composers were content to keep within the restriction of this concept, though they often treated the technique with considerable freedom. A notable example of such twelve-tone composition was the work of the Italian Luigi Dallapiccola (1904–

1975). Among his many works, the opera *Il Prigioniero (The Prisoner)* manages to combine the twelve-tone technique with the lyrical tradition of Italian opera. Dallapiccola never abandoned his close ties to traditional Italian lyricism despite his loyalty to the principles of Schoenberg and twelve-tone composition.

A number of composers, however, contrived to extend the idea of pitch serialism to the other elements of music, such as duration, intensity, timbre, texture, and even silence. A series of pitches might be combined with a series of another element, or even with all other elements, to produce a state of "total serialism." Such music lacks the traditional aspect of thematic basis and development, and the result is a great complexity of sounds. The unifying element of serialism is recognizable only to someone who has devoted much study to such works and who has had the opportunity to hear them repeatedly. Stockhausen has used such total serialism in his work *Zeitmass,* in which all the elements of music are controlled by detailed markings of every note for the five woodwind instruments employed in the work. Milton Babbitt (1916–) is an American composer who has also worked with electronic composition and in total serialism. His *Ensembles for Synthesizer* is a representative work in this style.

In stark contrast to these completely controlled techniques are those of aleatoric (random or indeterminacy technique) composers. Stockhausen's works exemplify this trend. His *Klavierstuck XI (Piano Piece XI),* written in 1956, includes aleatoric features. The work consists of nineteen fragments of notation that are printed on a large cardboard placed on the piano music rack. The performer plays any one of these nineteen patterns that he or she happens to see, and may play this pattern and any succeeding ones that catch the eye, treating each in accordance with certain suggested directions. Any segment may be repeated and all need not be played. The piece ends when the performer has repeated any segment three times.

The American composer John Cage (1912–) held musical aesthetics so revolutionary that, driven to the ultimate, his works become nonmusic. He "composed" a work entitled *Imaginary Landscape,* which calls for twelve radio receivers tuned by chance to different radio frequencies. The resulting sounds are the musical composition. In a sense, this performance is an aural "happening" paralleling the visual "happenings" of the avant-garde.

These developments all suggest a parallel with the arts of painting and sculpture in which new materials, improvisation, and chance play a controlling part. Cage has gone so far as to compose nonmusical works in which neither the composer nor the performer contributes a sound and the audience must "compose" those natural sounds and noises they might hear into a piece of "music." In his *Four Minutes and Thirty-three Seconds,* Cage asks the "performer" only to sit before an open piano with a stopwatch and allow the natural sounds of life to be "composed" into a musical expression by the participating audience.

Multimedia expression, as the term implies, consists of the synthesis of various art media, such as music, dance, dramatic movement, light, painting, and sculpture. Generally, such attempts have ended in the predominance of the musical element, though the other media have added to the expressive quality of the whole composition. This was, of course, the operatic thesis of Monteverdi, Gluck, and Wagner, which also was never completely realized. The late twentieth century saw many such attempts in both the serious and popular fields of musical production. Rock and roll has always depended in great part on movement of performers, light, and costuming, all of which are essential parts of the performance. More traditional composers have used some of these elements, mainly in the area of choral composition. An example of multimedia expression in which physical movement and music are combined is the composition *Circles* (ex. 14.1) by Luciano Berio (1925–). The work is a setting of poems by e. e. cummings for voice and percussionists, in which the performers' physical movements are calculated to give shape to the composition.

Gunther Schuller (1925–) has also composed a kind of multimedia work in *Seven Studies on Themes of Paul Klee,* composed in 1959. This is a musical translation of the "musical" elements in some of Klee's paintings. Klee was an amateur musician and frequently used musical terms and forms in his paintings. Among the paintings that Schuller chose was Klee's *Twittering Machine* (colorplate 83). He made the music "twitter" with a mechanical application of the twelve-tone technique in a manner analagous to the pointillism of Webern. Schuller's work seems to realize the aural experience of the sounds of the symbolic mechanical birds that Klee expressed visually.

Popular music, particularly jazz, has influenced a number of composers of the twentieth century. Even in the first half of the century, several composers wrote works that showed a rather naive attempt to incorporate ragtime and jazz into their works, notably Debussy in *Golliwog's Cake Walk;* Krenek in his opera, *Jonny spielt auf (Johnny Strikes up the Band),* and Milhaud in his ballet *Le Création du Monde (The Creation of the World),* among many others. Continued efforts of this kind can be found in the work of Gunther Schuller, who is known not only for his expressionism in which serial technique, highly imaginative tonal coloring, and chromatic atonality are employed, but also for his interest in jazz. Schuller was deeply engaged in the setting up of the third-stream jazz movement with John Lewis. He founded the Third-Stream Performance Ensembles at the New England Conservatory where he taught. The results were a cross-fertilization of classic forms with all the modern techniques, including jazz and its improvisatory elements.

The theater has provided opportunity for two types of performances employing music to flower in the period since World War II, namely the musical theater and the ballet. The ballet has achieved a spectacular popularity in the

Example 14.1: *Circles*—Luciano Berio. Page 21 of score from setting of e. e. cummings's poems [1923–1945]. Courtesy of Universal Editions, London, England, copyright owners.

second half of this century in America. A great part of the music used, however, has been works that were not immediately written for ballet performance, such as instrumental works extending from Bach to Schoenberg. A few contemporary composers such as Copland have written specifically for ballet. Among Copland's successful ballets are *Billy the Kid, Rodeo,* and *Appalachian Spring.* A number of popular musicians also have written short works using modern popular dance styles.

The musical theater, a descendent of the Viennese operetta, has also provided opportunities for composers in the popular style to write for dramatic entertainment. Such works vary from the more traditional musical comedies such as *My Fair Lady* and *Fiddler on the Roof,* to rock musicals such as *Hair* and *Jesus Christ Superstar,* and more recently, *Les Misérables* and *Phantom of the Opera.* These works often contain a considerable amount of ballet music, some of which has become the basis for independent ballet performances.

Leonard Bernstein (1918–), an internationally known American conductor and composer, is equally at home in the classical and popular idioms of composition. Among his classical works is *Symphony No. 1 (Jeremiah)* and in the popular style, several stage works, among which are *Wonderful Town* and *West Side Story. Candide,* the libretto of which is based on Voltaire, blends the traditional operatic style with the more popular style of Broadway musicals. It has been widely accepted and performed on both sides of the Atlantic. Bernstein's *Mass,* written for the opening of the John F. Kennedy Center in Washington, D.C., incorporates jazz and the popular idiom with one of the oldest forms of church music, the Mass.

There have been a number of composers who have experimented with new techniques since World War II who have not adopted any one of them exclusively, thereby avoiding becoming advocates of any one school of composition. Most of them have exploited one or another, or even several of the modern idioms, such as electronic music, serialism, multimedia, and so forth, or at least have been influenced by these trends. They are not necessarily the only successful composers of the second half of the twentieth century, but they represent a kind of composer for whom the maintenance of personal identity and individuality supersedes the necessity of alliance with a particular trend or school. The composers who represent this individuality have been selected since their works have attracted international attention.

Olivier Messiaen (1908–) is a French composer of unique abilities and techniques. His works date from the 1920s, but his greatest compositions and influence as a teacher came after the middle of the century. His interest in tonal color and rhythmic complexities, combined with a deeply religious sense and highly developed literary capabilities, give his music a very personal flavor. His religious intensity is reflected in the numerous works for organ and church performance. His interest in rhythmic problems is characteristic of such works as *Chronochromie* and *Mode de Valeurs et d'Intensité.* Among those

works that display his preoccupation with tonal colors is a long list of piano pieces under the title *Catalogue des Oiseaux* (*Catalog of the Birds*), in which Messiaen's lifelong interest in nature and particularly in the songs and calls of birds is exploited to the utmost. This work is based on actual bird songs and calls notated by Messiaen during countless field observations of birds in their natural habitats. His influence as a teacher is indicated by the fact that among his students at the Paris Conservatory were such important young composers as Stockhausen, Boulez, Nono, and many others.

The American composer Elliott Carter (1908–) used a highly contrapuntal style that gave way in the 1950s to a serialism of intervals and rhythms that characterize his later works. Among his large number of compositions, his string quartets have probably achieved a wider audience than any of his other works.

Gyorgi Ligeti (1923–), a Hungarian who fled to Germany in 1956, has worked closely with the electronic studio in Cologne and with the International Courses in New Music in Darmstadt. His works cover the whole gamut of compositional genres, both vocal and instrumental. He has employed electronic devices, serialism, chance, and experiments in tonal color, but has managed in all his works to maintain a personal idiom. His *Wind Quintet* and the vocal work for sixteen solo voices *Lux Aeterna* both indicate his mastery of tonal coloring for instruments as well as voices.

Thea Musgrave (1928–) was born in Scotland where she began her composition studies. Later she studied with Nadia Boulanger, as did so many of her contemporaries. Musgrave's style has moved from the traditional diatonic to serial technique. Her output is prodigious, including works in almost all major forms. Among her recent works is an opera, *Mary, Queen of Scots*, written for the 1979 Edinburgh Festival.

Krzysztof Penderecki (1933–) of Poland is probably the most widely heard composer of the post-World War II period. He is one of a rather large number of Polish composers who have ventured into the most advanced styles and idioms of the time. His works embrace all genres, and his orchestral and choral compositions have won international attention and acclaim. Since its premiere in 1984, his *Polish Requiem* has been performed over 60 times. He has chosen both old texts, as in the *St. Luke Passion,* and modern subject matter, as in *Threnody in Memory of the Victims of Hiroshima.* This latter work, while scored for traditional instruments—fifty-two string instruments—represents Penderecki's concern with sound groups and instrumental coloration. Much of the score (ex. 14.2) does not even indicate definite pitch, and there is actually no traditional indication of rhythmic pulse or meter. These are indicated rather by blocks of time. The figures 15″, 11″, 4″, 6″, and so forth in example 14.2 are the number of seconds that the notation is to be played. The symbols are explained in a preface to the score. The figure ▲ indicates the highest pitch possible on the respective instrument (indefinite pitch), and the

Example 14.2: *Threnody in Memory of the Victims of Hiroshima*—Penderecki. Copyright © 1961 by Deshon Music, Inc., New York, by assignment. By permission of Deshon Music, Inc., a division of the Belwin Mills Publishing Corp., Rockville Centre, N.Y.

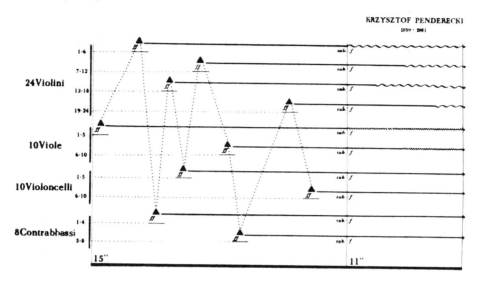

only traditional indications are those of dynamic change. The work is obviously not built on melodic or harmonic patterns, motifs, or themes but rather on blocks of tone colors achieved by all sorts of manipulations by the performers—striking on the wood of the instruments, playing behind the bridge, and slow **vibrato** with wide pitch differences, playing on the tailpiece of the instrument. The overall effect is one of striking tonal combinations through which Penderecki tries to transmit his deeply felt reaction to the Hiroshima holocaust. Tone color, improvisation, and absence of thematic statement in the traditional sense are all characteristics of this new music of the second half of the twentieth century and are to be found in the works of countless composers of this time.

Peter Maxwell Davies (1934–) is an English composer whose compositional techniques reflect an interest in styles that range from pre-Bach polyphony to serial and improvisatory styles. A number of his works deal with sacred themes. Among these are a cycle of carols and instrumental sonatas based on the plainsong version and text of *O Magnum Mysterium*.

Experiments in electronic music also have been continued by a number of the younger composers. These experiments have led to multimedia events in which music, film, and light are combined. Composers Steve Reich (1936–) and Philip Glass (1937–), among others, have combined electronic sounds with a minimum of tonal material in what is called "minimal music."

In the works of these composers, we can see several aspects of twentieth-century music. Yet all of these composers have certain common traits. There are many other composers equally characteristic of this period. While time and space do not allow for the mention of all of them or their works, it is important that the person interested in music become acquainted with the works of as many contemporary composers as possible. In addition to the composers already discussed who have made valuable contributions to the present-day scene are Boulez, Henze, Xenakis, and Tippett among the Europeans, and Rochberg, Crumb, Oliveros, and Riley among the Americans.

Summary

The rapidity of change in so many aspects of life since the end of World War II has been even greater than in the first half of the twentieth century. The impact of this accelerated change on the creativity of art and music has led to a proliferation of "isms" and fads that preclude the establishment of consistent stylistic characteristics in any of the arts.

The sophistication of technology has led to tremendous advances in communication and in the psychology and techniques of the mass media. Technology has also led to the development of new synthetic materials for visual art and new resources of sound and sound amplification in music.

The sociocultural forces that have affected the arts have not only been numerous but have also come within a short time span. They have had a powerful impact on artistic creativity and have provided artists with a variety of new and sometimes exotic subject matter.

Another important factor is the tremendous buying power of the public—not only of the economic elite, as in previous times, but also of the huge middle class and especially youth. The majority of society is an indifferent and passive population, content to be spectators. Many artists and composers, especially composers of popular music, have focused their efforts on manipulating consumer demand. The effect of this relationship between the consumer and the creative artist is seen most clearly in popular music, which has become an enormous business venture with literally billions of dollars in yearly sales.

There has been a tendency toward improvisation in all the arts since World War II. While the visual arts have been influenced by the element of chance in the arrangements of the basic materials to some degree, it is music that has been affected more directly. Post-World War II composers have experimented extensively with aleatory, or chance music, in which all elements of music are determined by the uncontrollable chance happenings of sounds.

Another important development has been the use of new materials from which to construct works of art. These have ranged from the synthetic materials of plastic, stainless steel, and reinforced concrete to new developments in paints and the means of applying them to a variety of surfaces. In music, new sounds, some produced by electronic means such as sound generators and computers, as well as the new sounds directly from the world of industry, have given composers a whole range of tonal possibilities with which to work.

There seem to be many paradoxes in twentieth-century art. One paradox lies in the strict and systematic discipline of materials and technique proclaimed on the one hand and the aleatory or haphazard combination of materials and elements exhibited on the other hand. Another paradox is the apparent denial of emotion in art, especially in the early part of the century, and a move toward an almost hysteria of emotion following World War II. The latter is most apparent in recent popular music, in which a complete freedom of emotional expression is the accepted mode. These paradoxes partly explain why it is impossible to place all art after World War II, into a strict stylistic framework.

There are indications—some of them rather distinct, as in the case of architecture, and others more covert, as in painting and music—that the desire for some element of emotional interest and expressive quality is softening the earlier tendencies of the twentieth century to make technique and structure the dominating elements of artworks. The music of the electronic synthesizer, for example, has already lost its novelty and is becoming a means to an end rather than an end in itself. The same can be said of compositional devices such as serial construction. Even in the area of popular entertainment

music there are indications of less emphasis on the frenetic and psychedelic elements of hard rock, disco, etc., and a return in many instances to the sweeter combinations, such as the big bands of the first half of the century. Painting, too, has its representational advocates, although not with traditional application.

Artists of every medium have tried, or are trying, to be compatible with and to reflect the dramatic changes that have taken place in our understanding of ourselves and the universe in which we live. Nothing is so permanent as change. This, in effect, can be the key to understanding the art of our century. Only time will sift the worthy from the unworthy, the good from the "kitsch." Only time will put its stamp of approval on the few great creative artists of our time who have created, or will create, truthful remembrances of the important conditions of our time. If our cultural heritage is to be maintained and furthered, our society must give its creative artists a fair reception and fair criticism, whether they are painters, sculptors, architects, or composers. Only in this manner can the arts be kept alive and flourishing.

Suggested Readings

In addition to the specific sources that follow, the general readings listed on pages xxi and xxii contain valuable information about the topic of this chapter.

Austin, William W. *Music in the Twentieth Century*. New York: W. W. Norton, 1966.

Gridley, Mark C. *Jazz Styles*. 2d ed. Englewood, N.J.: Prentice-Hall, 1985.

Herbert, Robert L., ed. *Modern Artists on Art*. Englewood Cliffs, N.J.: Prentice-Hall, 1964.

Hobbs, Robert. *Robert Smithson: Sculpture*. Ithaca, N.Y.: Cornell University Press, 1981.

Lippard, Lucy R. *Pop Art*. New York: Thames Hudson, 1985.

Lucie-Smith, Edward. *Late Modern: The Visual Arts Since 1945*. Oxford: Oxford University Press, 1975.

Machlis, Joseph. *Introduction to Contemporary Music*. 2d ed. New York: W. W. Norton, 1979.

Pellegrini, Aldo. *New Tendencies in Art*. New York: Crown, 1966.

Rodman, Selden. *Conversations with Artists*. New York: Capricorn Books, 1961.

Salzman, Eric. *Twentieth-Century Music: An Introduction*. 2d ed. Englewood Cliffs, N.J.: Prentice-Hall, 1974.

Singerman, Howard ed. *Individualism: A Selected History of Contemporary Art, 1945–1986*. New York: Abbeville Press, 1986.

Southern, Eileen. *Music of Black Americans* 2d ed. New York: W. W. Norton, 1983.

Spies, Werner. *The Running Fence Project*. New York: Harry Abrams, 1977.

Stangos, Nikos, and Richardson, Tony, eds. *Concepts of Modern Art*. 2d ed. New York: Harper and Row, 1981.

Tirro, Frank. *Jazz: A History*. New York: W. W. Norton & Co., 1977.

Glossary

Abacus A thin slab of stone that rests on top of the capital of a Greek column.

Absolute music Music that has no extramusical implications.

Abstract art Art that is not concerned with realistic representation of nature.

Abstract Expressionism A style of painting that combines personal expression with abstract forms.

A cappella Unaccompanied choral singing. Music written for voices alone.

Accidental A symbol used to raise or lower a pitch by one half step (sharp = ♯; flat = ♭; natural = ♮)

Acropolis A hill town or fortified hill, usually associated with Greek temples.

Action painting A technique in which painters use their entire bodies to achieve rhythm and line, usually on a large canvas.

Aesthetics The study of the nature of the beautiful.

Aleatory A type of musical composition in which the performer is given liberty in choosing pitches, rhythms, durations, and so forth. Chance improvisation.

Ambulatory An aisle or walkway around the apse, or cloister of a church or monastery.

Antiphonal Music in which alternating choirs perform in separate locations, as in the opposite sides of a cathedral chancel.

Apse A semicircular part of a church that projects from its main axis.

Arcade A row of covered arches supported by piers or columns.

Aria An extended vocal solo, usually with instrumental accompaniment, as in operas, oratorios, and cantatas.

Atonality Absence of fixed tonality.

Atrium An enclosed but unroofed courtyard.

Augmentation The doubling of the note values of a musical motive or theme.

Aulos An ancient wind instrument of Greece.

Baptistry A building used for baptism, usually circular in shape.

Bar The vertical line separating the measures in written musical notation. The term is often used as a synonym for *measure*.

Baroque The style period that followed the Renaissance, encompassing roughly the dates 1600–1725. The period is characterized by a vigorous spirit of ornamentation, action, and elaborate design.

Barrel vault A semicylindrical vault.

Basilica A rectangular hall flanked by aisles.

Basso continuo Literally, continuous bass. An important aspect of Baroque compositional style in which a bass instrument, most frequently a viola da gamba, a violoncello or bassoon, is joined by a keyboard instrument to provide an accompaniment to the other voices. The basso continuo music is indicated by a single bass line and numbers that specify the harmonies to be played by the keyboard instrument.

Bay The architectural space defined by pillars or columns, usually spanned by arches.

Beam A horizontal piece of wood, metal, or stone that supports other building components over an opening.

Blaue Reiter, Der A school of painting centered in Munich beginning around 1910. It was related to Expressionism. Kandinsky and Marc were among its founders. The composer Arnold Schoenberg was associated with them.

Buttress A masonry support built against a wall to resist the outward thrust of the wall and roof.

Cadence The point of rest in a melody or harmonic progression that marks the end of a phrase or section.

Cadenza A highly ornamental passage that culminates in a cadence played by the soloist near the end of a movement in a concerto.

Canon A contrapuntal device in which the melody of one voice is imitated exactly by one or more other voices. The term also refers to an entire composition using this device. See *round*.

Cantilever A method of construction in which beams project beyond their supports and are balanced by weights on the attached ends.

Cantus firmus A melody, either composed or taken from another source, upon which certain polyphonic works are constructed.

Canzona alla francese An instrumental composition derived from the sixteenth-century French chanson.

Capital The top part of a column, wider than the upright section and usually decorated.

Casting The process of pouring a liquid material into a mold, in which it hardens to take the shape of the mold.

Chamber music Music written for small ensembles, such as duos, trios, and quartets. The term usually refers to instrumental music but may include vocal forces as well.

Chancel The area of a Christian church around the high altar, usually reserved for the clergy.

Chanson French word for *song*. Also, a sixteenth-century French vocal form similar to the madrigal.

Chant, plainchant Early monophonic music in free rhythm associated with the Christian church. See *Gregorian chant.*

Chiaroscuro A union of two Italian words whose meanings refer to bright and obscure. Hence, the term applies to the treatment of light and shade in painting or drawing. It frequently is used to describe the light effects found in paintings of Rembrandt.

Choir The portion of a church between the altar and the nave reserved for the lower clergy and singers.

Chorale Traditionally, a hymn tune of the German Protestant church. Lutheran chorales.

Chord A pitch complex of two or more simultaneously sounded tones. The study of harmony deals with chordal functions.

Chromaticism The melodic or harmonic use of tones not in the seven-tone diatonic scale of a composition.

Clavier A term loosely used to designate a keyboard instrument, such as the clavichord harpsichord.

Clef The sign used at the beginning of the staff to designate the pitch of one note; hence, the term *C clef, G clef, F clef.*

Cloister A rectangular courtyard along the side of a medieval church that provides a sheltered walkway. Sometimes a residence for people in religious orders.

Cluster An effect in modern music achieved by striking a number of adjacent keys of the piano or organ or by having several instruments play tones within close proximity of one another.

Coda The section of a composition that brings it to a conclusion. Codas are of varying length.

Collage A composition in the visual arts created by attaching bits of paper and/or other materials to a flat surface.

Colonnade A row of columns supporting beams or lintels.

Color Visually, the experience of reflected light that we identify with the names red, yellow, blue, and so forth. Aurally, the tone quality of individual instruments or voices or a combination of instruments or voices. Synonymous with *timbre*.

Column An upright support, usually cylindrical, for a roof or the upper part of a building. Those associated with Greek architecture bear the names Doric, Ionic, and Corinthian.

Complementary colors The hues that are opposite each other on a color wheel, such as green and red, blue and orange.

Conceptual art A theory that tangible art objects are imperfect manifestations of true art, which is found only in the imagination or mind (i.e., the concept is the artistic entity).

Concertato An Italian term designating the interaction among unequal sound sources.

Concertino See *principale*.

Concerto An orchestral genre practiced since the Baroque that employs unequal sound sources. The solo concerto reached its greatest development in the Classic and Romantic periods. See also *concerto grosso*.

Concerto grosso An ensemble composition written for two groups of unequal size; most widely written during the Baroque.

Consonance Traditionally, a combination of tones that are pleasing or restful in contrast to dissonance.

Constructivism A movement in the visual arts that originated around 1920 in Russia and is related to Cubism. It is an abstract art that later influenced architecture and furniture design.

Contour The shaping edge of a form in sculpture or painting.

Contrary motion In contrapuntal compositions, the movement of two voices in opposite directions, one ascending and one descending.

Corinthian See *column*.

Counterpoint The setting of one melodic line against one or more other lines.

Cubism An early twentieth-century style of painting, and to a lesser degree sculpture, that utilized geometric shapes as underlying primary forms. In contrast to Impressionism, which it succeeded, the primary concern of Cubism was with form rather than color.

Design The structure or organization of the various components of a work of art.

Development The section of a sonata-allegro form in which the thematic material is varied rhythmically, melodically, harmonically, dynamically, and in other ways.

Diatonic The seven tones of the octave forming a major, minor, or modal scale.

Diminution Reducing the note values of a musical motive or theme to smaller time values.

Dissonance A combination of tones that, because of its tension, seeks resolution to a restful consonance.

Dodecaphonic A method of composing in which the twelve tones of the chromatic scale are used in some prearranged form throughout the composition.

Dome A hemispherical vault supported on columns or walls.

Dominant In tonal music, the fifth degree of the diatonic scale or key. In modal music, one of the two main tones around which the other tones move.

Dorian See *modes*.

Doric See *column*.

Drone A consistently sustained tone or tones in the bass, used throughout a section or even a whole composition.

Dynamics The gradations of sound volume in a composition.

Echinus The upper portion of the capital that supports the abacus.

Enharmonic Tones in equal-tempered scales that are identical in sound but are notated differently; for example, F♯ and G♭.

Ensemble A term applied to any group of performers.

Entablature The portion above the column and below the roof in Greek architecture.

Equal temperament The tuning of the octave in twelve equal parts.

Exposition The first section of the sonata-allegro form in which the thematic material is exposed or stated. See *statement*.

Expressionism A style of art in which the artist's expression of emotions is the principal concern.

Façade The front or main entrance of a building.

Fauvism Derived from the French word *fauve*, meaning "wild beast." It was used in a derogatory way to describe those Post-Impressionistic painters who used garish and unreal colors in a wild manner.

Final In modal music, the note on which the modal melody rests.

Flying buttress A half arch used to counteract the outward thrust of the vault, and to transfer the thrust to piers outside the walls.

Foreshortening The application of linear perspective to human and other forms to help achieve a dramatic illusion of three-dimensional space.

Fresco The technique of painting on wet plaster.

Frieze The decorated horizontal band of the entablature in architecture.

Fugue A style of contrapuntal composition based on one or more short themes called subjects and on related connective materials.

Gregorian chant That kind of chant named after Pope Gregory I. See *chant.*

Groined vault A type of vault created by the intersection of two barrel vaults.

Half step The smallest interval used in the division of the octave in the equal-tempered scale. Also called a halftone.

Harmony The simultaneous sounding of tones, as in chords.

Homophony Music in which a dominant melodic line is supported by chordal accompaniment.

Hue A synonym for *color.*

Humanism A word with varied meanings. In this book it describes the broadest study of the intellectual and artistic efforts of humankind.

Imitation A device of polyphonic texture in which one voice restates the melody of another voice. The imitation can be strict (exact) or free (similar).

Impressionism A nineteenth-century French style of painting that tried to capture the painter's immediate impressions, usually of the out-of-doors. In music, a term generally associated with Debussy.

Intaglio A graphic technique in which the cutaway parts retain ink for printing, as in engraving.

Interval The distance between two pitches.

Intonation The accuracy of singing or playing on pitch.

Inversion Melodic inversion requires that every ascending interval be replaced by an equal descending one, and every descending interval by an equal ascending one. Chordal inversion implies that some pitch other than the root of the chord is in the bass.

Ionian See *modes.*

Ionic See *column.*

Key The tonal center of a composition. The key note is the first note of the scale upon which the composition is based. The term *key* is also used for the levers or elements that are manipulated by the fingers of an instrumentalist, such as the keys of the flute or the black and white keys of the piano.

Keystone The central stone in a round arch that locks the stones of the arch together.

Kinetic art Visual art that depends on the movement of its various parts for its artistic message.

Kitsch The popular art that caters to the aesthetically illiterate, and sometimes presents trashy copies of original artworks that are created in haste, with commercial intent.

Leitmotif A compositional technique made famous by Wagner in which musical fragments are associated with specific persons, ideas, or events, forming the building blocks for larger works.

Libretto The text of an opera, oratorio, or cantata.

Lied/Lieder The German word for *song*. Generally used to refer to the German song literature of the late eighteenth, nineteenth, and twentieth centuries accompanied by piano.

Linear perspective A method of representing the size of objects as they recede into space by the use of lines that imply a vanishing point.

Lintel A beam over the rectangular opening between two posts or columns.

Liturgy The formalized program of worship in the church, consisting of musical and nonmusical parts.

Lydian See *modes.*

Lyra An ancient stringed instrument native to Greece.

Madrigal The most common form of secular vocal music in the sixteenth and early seventeenth centuries.

Major A pattern of steps and half steps within the octave in the following ascending order—two whole steps, a half step, three whole steps, and a half step. Defined another way, a scale of eight tones in which the third and fourth tones and the seventh and eighth ones are separated by half steps while all the others are separated by whole steps.

Mass The central liturgical service of the Catholic church, parts of which are often set to music.

Measure A small rhythmic unit in a composition set off by bar lines that includes the number of beats indicated in the meter signature.

Medium The technique or material used by an artist to create a work of art.

Melisma In music with text, the assignment of many notes to one syllable, as found in plainchant.

Melody A series of pitches that conveys a sense of beginning and ending.

Meter The organization of accented and unaccented pulses.

Meter signature The symbol (most frequently numerical) written on the staff at the beginning of a composition indicating its meter. The top number identifies the number of a certain kind of notes in a measure, and the bottom number identifies the kind of note. For example, $\frac{3}{4}$ time or meter signifies that there are the equivalent of 3 quarter notes in each measure.

Metope In Greek architecture, an area between two roof joists, usually square and often decorated with sculpture.

Minimal art A style of art or music with severely reduced resources.

Minor A scale pattern that may take any of three forms— harmonic, melodic, and natural. The distinguishing feature of all minor scales is the half step between the second and third notes of the scale.

Minuet An early popular dance form in triple meter that became part of the suite and the symphony.

Mixolydian See *modes*.

Mobile A kind of sculpture that utilizes movement to achieve relationships among its various components.

Modes The system of tonal organization that predates the modern major and minor. Dorian, Phrygian, Lydian, and Mixolydian are the names of some of the most common modes. Scales built on each of these modes carry the same names.

Modulation Changing from one key to another in the course of a composition. For example, the change from the tonic key to the dominant in the statement section of the sonata-allegro form.

Monochromatic A color arrangement that uses only one hue with varying degrees of saturation and value.

Monophony A musical texture consisting of a single unaccompanied line of melody.

Mosaic A design composed of small units of stone, glass, or porcelain set in mortar.

Motet A polyphonic vocal composition with sacred text that emerged in the Middle Ages and was especially popular in the Renaissance.

Motive The smallest unit of musical form. The term *motif* is also used.

Mural A painting on a wall. Murals may be painted with any kind of paint or technique and are usually very large.

Nave The central portion or aisle of a church.

Non-objective art A post-Cubist movement that attempted to record direct feelings on canvas by exploring relationships among colors and shapes without reference to the world of objects.

Note The symbol of musical writing that directs the performer to produce a sound of specific pitch and duration.

Op art A style of painting that features optical illusions and other devices that call attention to the way the eye sees.

Opera seria The predominant form of opera in the seventeenth and eighteenth centuries. Usually to mythological texts, it employed a succession of recitatives and arias rather than continuous dramatic unfoldment.

Opus Latin word for *work*. A numbering scheme introduced in the early nineteenth century that indicates the order of publication and the general order of composition of a composer's works.

Organum An early form of counterpoint.

Ornament Decorative notes added to a musical line either by the composer through symbols or by the performer through improvisation.

Ostinato A melodic or rhythmic figure repeated consistently throughout a section of a composition or a complete work.

Parallel motion Two melodic lines moving at the same intervals.

Pediment A triangular space formed by the gable of a two-pitched roof in classical architecture.

Pentatonic A division of the octave into five tones. Normally, the pattern consists of a whole step, a step and a half, a whole step, a whole step, and a step and a half.

Phrase A musical idea corresponding to a sentence in prose. A phrase consists of one or more motives and ends in a cadence.

Phrygian See *modes*.

Pitch The highness or lowness of a musical sound. More accurately, the number of vibrations or cycles per second.

Pier An architectural support, usually masonry.

Plainchant See *chant*.

Polphony A texture in which two or more melodic lines are interwoven.

Polychromatic A color scheme involving many hues.

Polytonality The simultaneous use of two or more keys or tonal centers in a composition.

Pop art A style of art that uses commercial and popular images as subject matter.

Portico A porch, the roof of which is supported by columns or piers.

Post and lintel A system of construction in which vertical supports carry horizontal beams.

Primary colors The hues that can be mixed to produce all other hues. The primary colors are red, yellow, and blue.

Principale The smaller group in the concerto grosso—the concertino.

Program music Music that attempts to convey an extramusical idea, such as a story, landscape, or painting.

Recapitulation A synonymous term for *restatement*. The third section of the sonata-allegro form, in which the themes of the statement or exposition are repeated.

Recitative A type of vocal performance in which the words are sung with a minimum of melodic interest and usually based on speech rhythms, inflections, and syntax. That which is accompanied by the orchestra is called "recitativo accompagnato." That which is accompanied by the basso continuo only is called "recitativo secco" (*secco* is the Italian word for *dry*).

Relief sculpture Sculpture in which three-dimensional forms emerge from a flat background.

Resolution Progression from active tones to relatively static tones.

Retrogression Reversing the sequence of notes in a theme or melody.

Rhythm The temporal element in music; that which moves the music through time.

Rib A component of arch used to support a vault.

Ricercare An instrumental form that often bears similarities to the motet.

Ripieno The larger ensemble in the concerto grosso.

Rococo A style of art and music that is delicate and decorative, which occupies a position between the end of the Baroque era and the beginning of the Classic era.

Rondo The statement and restatement of a principal theme alternating with one or more contrasting themes, e.g., A B A C A.

Round A canon for voices that is repeated as often as desired.

Rubato A slight variation of the rhythmic beat made by the performer for expressive purposes.

Saturation That aspect of color that relates to its vividness.

Scale The arrangement of the tones of the octave as used in a composition. See *major* and *minor*.

Score The notated parts of an instrumental or vocal ensemble composition in a composite form from which the entire work can be conducted or studied.

Sequence A compositional technique in which a melodic figure is repeated successively at different pitch levels.

Serialism A method of composition by which the composer extends the technique of twelve-tone composition to other areas, such as rhythm, dynamics, timbre, duration, and so on.

Signature The symbols set on the staff at the beginning of a piece of music to designate the tonality or key (key signature) and the metric organization (meter signature).

Sonata In eighteenth- and nineteenth-century practice, an instrumental composition, usually of three or four movements.

Statement A synonym for exposition. See *exposition*.

Steel cage A construction method in which steel supports in a post-and-lintel system are made to be a self-supporting framework.

Stretto A section of a fugal or canonic composition in which two or more subject entries overlap.

Stylobate The platform or step upon which Greek columns are placed.

Subject A theme, particularly that of the fugue.

Surrealism A style of art that attempts to portray the reality of the subconscious mind.

Symphony A sonata for orchestra; sometimes used to refer to the orchestra, as in symphony orchestra.

Syncopation The displacement of the accent from a strong beat to a weak beat or to a weak part of a beat.

Tempo The speed of performance of a piece of music suggested either by a metronomic rate (i.e., the number of beats per minute) or by a more general term, such as *adagio, andante, presto,* and so on.

Texture In the visual arts, the surface character of an object or its representation by paint or other material. In music, the use of one or the other techniques of monophony, homophony, or polyphony.

Theme Generally used to describe the tune or melodic subject of a musical work. Can be used, however, to describe a rhythmic or harmonic pattern out of which a composition is built.

Thrust The lateral pressure of an arch or vault.

Timbre See *color.*

Tonality The organization of a part or the whole of a composition around a home tone.

Tone The result of vibrations of a resonating body, received by the ear and processed by the auditory system. Musically, tones have the properties of pitch, intensity, duration, and timbre.

Tonic The first or key note of a scale, e.g., the note C in the C major scale.

Transept The crossing arms projecting from the central axis of a cruciform church.

Triad A three-tone chord reducible to notes a third apart (for example, C-E-G, F-A-C, and so on).

Trio A composition for three performers. Also, the second section of a minuet or scherzo in the Classic concerto or sonata.

Tritone The interval of an augmented fourth (containing three whole tones). An interval forbidden in strict counterpoint.

Twelve-tone music Music consistently constructed on a pattern of the twelve chromatic tones selected prior to composition.

Tutti A term applied to passages in which all performers play, in contrast to solo passages.

Tympanum The surface above a door and below an arch, usually filled with sculptured figures, especially in medieval and Gothic architecture.

Value The measure of darkness or lightness of a color.

Vault A method of covering an area based on the principle of the arch.

Vibrato A device of performance used by singers and instrumentalists, especially string players, to achieve expressive quality by alternately deviating from the prescribed pitch and returning to it.

Voice A term applied to vocal and instrumental parts in music, especially in polyphonic music (e.g., music in three voices).

Whole-tone scale A scale dividing the octave into six equal whole-tone intervals.

Name Index

Subject Index

H

Greek, 61–63
Gregorian chant, 26, 35, 84, 101–4, 162
harmony, 29–30, 33, 34
Impressionism and Post-
 Impressionism, 304–6
jazz, 349, 350, 351, 379, 380, 381, 382,
 385
of Lutheran Church, 2, 161, 163, 205,
 211–12, 233
melody, 25, 33, 34
modulation, 33
nationalistic, 251, 288–93, 343
opera, 201, 203, 216
pitch, 24
popular, 350–51, 357, 379–81, 385
post-World War II, 378–90
ragtime, 350, 385
Realism, 279–88
Renaissance secular, 164–70
rhythm, 21–24, 32, 34
rock and roll, 2, 350, 351, 380–81, 385
Rococo, 208–29
Roman, 78
Romanesque, 100–105
Romantic, 259–73
soul, 379
swing, 351–52
texture, 26–28, 33
tonality, 29, 30, 161, 199–20
tone color, 30–31, 33, 34, 338, 380
twentieth century, pre-World War II,
 337–52
Mycerinus and His Queen, 44–45
My Fair Lady, 387
Mysterium, 304

N

Nationalistic art, 4, 6
Nationalistic music, 251, 288–93, 343
Nationalistic Romanticism, 288–90
Naturalism, Gothic sculpture, 121
Natural representation, 311
Nave, 94, 96, 112
Neo-Baroque, 258
Neoclassic
 painting, 229–31
 sculpture, 231–32

Neo-Gothic, 257
Neumatic musical notation, 101
New World Symphony, 260
Night Watch (colorplate 35, following
 184), 183
Nike of Samothrace, 38, 60
Notre Dame la Grande, 94–95, 113
Notre Dame of Paris, 112, 113
Nuages, 33–35, 36, 306
Nude, 141–42
Nude Descending a Staircase (colorplate 3,
 following 8), 18
Nudes, 12
Number 1, 1948 (colorplate 92, following
 376), 360
Number 19 (colorplate 94, following 376),
 360
Numbers, religious symbolism of, 111
Nutcracker, 288

O

Oath of the Horatii (colorplate 48,
 following 232), 230
Obelisk, 41
Odalisque with the Slave, The (colorplate
 50, following 232), 230–31
Of Thee I Sing, 349
Old St. Peter's Basilica, 79–80
O Magnum Mysterium, 390
Op art, 35, 264–66, 358
Opera, 201, 203, 216
Opera seria style, 216
Oratorio, 216
Ordinary, of mass, 104
Orfeo, 202, 203, 236
Organum, 128
Otello, 272
Overture, 206

P

Painting
 Abstract Expressionism, 358, 360, 361
 Baroque, 181–87
 compared with sculpture in ancient
 Greece, 6
 Conceptual art, 358

Twentieth-century artists, basic
principles of, 312–13
Twittering Machine (colorplate 83,
following 328), 318, 330, 385
Tympanum, 99

U

Unanswered Question, The, 348–49
Unfinished Symphony, 267
Unity, 17
Untitled Cube (6), 368, 373
Urban development, Gothic period, 110

V

Valse in A-flat, 271
Value, 16
Variation form, 234
Variety, 17
Vaudeville (colorplate 91, following 376),
358
Vaulting, 69
Veni Creator Spiritus, 163
Veni sponsa Christi, 162–63, 199
Venus (colorplate 1, following 8), 18
Venus and Adonis (colorplate 28,
following 152), 149
Venus of Willendorf, 38, 39, 40
Verismo, 272
Versailles, 15, 16, 199, 224, 225
Vibrato, 390
View Near Volterra (colorplate 57,
following 280), 256
Villa Rotonda, 157–58
Violin Concerto, 341–42
Virginal, 167, 169
Virgin Mary cult, 110
Visual arts
color, 16–17, 20
compared with music, 35–36
critical analysis, painting, 19–21
expressive control in, 18–19
formal organization, 20–21
form and design, 17–18

line, 14, 20
medium, 14, 20
space, 15–16, 20
Viva la musica, 26–27
Vltava, 290–91
Vocal music, Baroque, 202–5
Voice, 26

W

Wachet auf, 215
War Requiem, 356
Washington Monument, 41
Water Music Suite, 216
Watzek House, 333–34
Wealthy patronage, Renaissance and,
140
Wedding Dance, The (colorplate 31,
following 184), 152
Weihnachtsoratorium, 207
Wells Cathedral, 118
Well-Tempered Clavier, 212
West Side Story, 387
Wheatfields (colorplate 5, following 8),
16, 18
When Tricky Sam Shot Father Lamb, 322,
323
Whole-tone scale, 305
Why Do the Nations, 216
Wilton House (colorplate 43, following
232), 199
Wind Quintet, 388
Winged Victory, 60
Winter (Return of the Hunters) (colorplate
30, following 152), 150
Woman, I (colorplate 93, following 376),
360
Wonderful Town, 387

X

Xerxes, 216

Z

Zeitmass, 384